Richard Parkes Bonington
'On the Pleasure of Painting'

Richard Parkes Bonington

The Exhibition and Catalogue Sponsored by United Technologies Corporation

Patrick Noon

'On the Pleasure of Painting'

Yale Center for British Art / *Yale University Press* / New Haven and London 1991

This book is published to accompany an exhibition
at the Yale Center for British Art, New Haven
(13 November 1991 – 19 January 1992)
and at the Petit Palais, Paris
(5 March 1992 – 17 May 1992)

This Exhibition and catalogue made possible by a
grant from United Technologies Corporation.
Additional support for the exhibition has come from
the National Endowment for the Arts, a federal agency,
and an indemnity from the Federal Council on the Arts and the Humanities.

Designed by Derek Birdsall RDI
Production Supervised by Martin Lee
Typeset in Monophoto Van Dijck by August Filmsetting
and printed in England by Balding + Mansell plc
on Parilux matt cream

Library of Congress Catalog Card Number 91–065083
ISBN 0–300–05108–5 (clothbound)
ISBN 0–930606–67–1 (softbound)

Photography Credits:
Bonham's, London, fig. 42; Bulloz, fig. 30; Richard Caspole, 3, 16, 17, 20,
21, 22, 25, 29, 34, 44, 46, 48, 52, 53, 68, 72, 80, 96, 109, 111, 112, 113,
151, 155, 157, 158, 164, figs. 1, 3, 11, 24, 27, 33, 35, 39, 41, 49, 61, 64;
Michael Cavanagh, 8; Christie's, London, figs. 4, 6; Photographic
Records Limited, 7, 50, 88, 92, 159, figs. 12, 37, 44, 45, 47; Prudence
Cuming, 107, Claude O'Sughrue, 123, fig. 5; Musées de Narbonne cliché
Jean Lepage, 14; Réunion des musées nationaux, 2, 6, 39, 41, 56, 66, 67,
69, 83, 100, 101, 106, 118, 121, 132, 135, 138, 149, figs. 22, 23, 25, 26,
36, 52, 54, 63, SPADEM, figs. 8, 9.

Contents

Foreword

In the early nineteenth-century a community of interests between British and French artists reduced the Channel to insignificance. It was in Paris rather than in London that the quintessentially English Constable received the honors of the academy in 1824, and he did so in the company of both English and French painters. One among them, twenty-two years old could claim to epitomize the new internationalism; Richard Parkes Bonington was Anglo-French by birth and training, combining the best of both his native traditions in what was already an exquisitely distinctive personal style. Four years later his death robbed European romanticism of one of its brightest stars.

In the twentieth century Bonington's reputation has remained secure among collectors and experts in nineteenth-century European painting, in spite of the daunting task of separating from his oeuvre those doubtful attributions which have accrued to it. Perhaps for that very reason there has been no international exhibition to demonstrate to a wider public the singular importance of "the Keats of painting." Ten years ago Patrick Noon, Curator of Prints, Drawings, and Rare Books at the Yale Center for British Art, set about the task, with his formidable powers of connoisseurship and, equally importantly, with his overwhelming enthusiasm for an artist whose every oil and watercolor speaks, bilingually, of the pleasures of painting. We are indebted to Mr. Noon's devotion to the cause of Bonington.

In his acknowledgements Patrick Noon thanks the colleagues and friends in this country, Britain, and France who have helped in countless ways to realize the exhibition. To all of our lenders we owe a special debt of gratitude for making their works available. From the outset we have planned the exhibition in conjunction with our colleagues in France; especial thanks are due to Pierre Rosenberg and Irène Bizot of the Réunion des musées nationaux and to Thérèse Burollet and Bernard Notari of the Petit Palais. We are grateful to Yale University Press for distributing the English-language edition of the catalogue and to Judy Metro for her early encouragement. Finally, I would like to underscore Mr. Noon's acknowledgment of support from the National Endowment for the Arts and United Technologies Corporation. It is thanks to the generosity of a federal agency and a multinational corporation that the work of Richard Parkes Bonington can be seen in both New Haven and Paris.

Duncan Robinson, Director
Yale Center for British Art

Preface

Richard Parkes Bonington is credited by art historians with influencing an entire generation of artists and critics. Although his work is ranked with Turner and Constable as a landscape painter, it has not brought him similar public acclaim. We hope this exhibition and catalogue will provide many pleasant and rewarding discoveries about an important painter who has been, until now, relatively overlooked.

Robert F. Daniell
Chairman and Chief Executive Officer
United Technologies Corporation

Lenders to the Exhibition

Her Majesty Queen Elizabeth II 76*
Amsterdam Historical Museum 59
The National Trust, Anglesey Abbey (Fairhaven Collection) 35**
Athens, The Benaki Museum 64
Bedford, The Trustees, Cecil Higgins Art Gallery 11, 161
Birmingham Museum and Art Gallery 163
Boston, Museum of Fine Arts 127, 140
Cambridge, The Syndics of the Fitzwilliam Museum 71, 91, 104
Cambridge, Fogg Art Museum, Harvard University 134
Cincinnati, The Taft Museum 77
Cleveland Museum of Art 94
Dijon, Musée des Beaux-Arts (Donation Granville) 62, 105
Edinburgh, National Galleries of Scotland 103, 156
Richard L. Feigen 60, 63, 97, 153, 154
Glasgow Art Gallery and Museum 124
Hartford, The Wadsworth Atheneum 144**
Hull, Ferens Art Gallery 119
Mr. and Mrs. Deane F. Johnson 116, 117, 133
The National Trust, Knightshayes (Heathcoat-Amory Collection) 31**
Liverpool, National Museums and Galleries on Merseyside, Sudley Art Gallery 45
Liverpool, National Museums and Galleries on Merseyside, Walker Art Gallery 13
London, The Trustees of the British Museum 10, 12, 30, 36, 37, 38, 58, 84, 122, 145, 162
London, Hertford House Library 40**
London, Royal Academy 4
London, The Tate Gallery 26, 99, 131, 152
London, Victoria and Albert Museum 47, 85, 87, 89, 115
Lyon, Musée des Beaux-Arts 137*
Manchester City Art Gallery 129
Whitworth Art Gallery, University of Manchester 54, 160
Melbourne, National Gallery of Victoria 73**
Montpellier, Musée Fabre 123
Narbonne, Musée d'Art et d'Histoire 14
New Haven, Yale Center for British Art 3, 16, 17, 20, 21, 22, 25, 29, 32, 34, 44, 46, 48, 52, 53, 68, 72, 80, 96, 109, 111, 112, 146, 151, 155, 157, 158, 164
New York, The Metropolitan Museum of Art 78
Nottingham Castle Museum and Art Gallery 28, 65, 70, 81, 108, 125, 128, 143, 165
Ottawa, National Gallery of Canada 15, 90
Oxford, The Visitors of the Ashmolean Museum 95, 141
Palo Alto, Stanford University Museum of Art 19, 23, 114
Paris, Bibliothèque Nationale 42, 57*
Paris, Fondation Custodia (Coll. Fritz Lugt), Institut Néerlandais 61*, 93
Paris, Musée du Louvre 2*, 39*, 41*, 56, 66, 67, 69*, 83*, 100*, 101**, 118, 132, 135**, 138, 149*
Perth, Art Gallery of Western Australia 86
Philadelphia, Rosenbach Museum and Library 5
Mr. and Mrs. John Pomerantz 98
Private Collections 1, 6, 8, 9, 18, 24, 27, 33, 49, 55, 74, 75, 79, 82, 102, 106, 107, 110, 113, 121, 126, 130, 136, 139, 142, 147, 148, 150
Richmond, Virginia Museum of Fine Arts 51
The Earl of Shelburne 7, 88, 92, 159
The Marquess of Tavistock and Trustees of the Bedford Estate 120**
Toronto, Art Gallery of Ontario 43
The Duke of Westminster 50

* Exhibited in Paris only
** Exhibited in New Haven only

Author's Acknowledgments

There have been only two major retrospectives devoted to the art of Richard Parkes Bonington, those organized by Paul Oppé for the Burlington Fine Arts Club in 1937 and by Marion Spencer for the Nottingham Castle Museum in 1965. Both of these seminal exhibitions enlarged our knowledge of Bonington's oeuvre while leaving unresolved a number of perplexing issues of chronology, connoisseurship, and interpretation. The aim of the present exhibition is to address several of the more obvious ones.

The daunting prospect of mounting an exhibition without representation from the largest and most impressive single collection of Bonington's oils and watercolors, the Wallace Collection, could account for the reluctance of previous generations to introduce his work to a more international audience. By electing to present this exhibition in North America and France, we deliberately redress that oversight, and by uniting the resources of the two most important Bonington collections outside the United Kingdom, those of the Yale Center and the Louvre, we have compensated, somewhat, for the absence of pictures from Hertford House. The most dedicated collector of Bonington's work since the 4th Marquess of Hertford, who was the artist's contemporary, has been Paul Mellon, and this is the first public display of the complete fruits of his collecting acumen. A genuinely representative exhibition could never have been orchestrated, however, without the total support of colleagues in other institutions, especially the British Museum and the Nottingham Castle Museum and Art Gallery, where Lindsay Stainton and Neil Walker have been most obliging, nor without the enthusiastic participation of our many private lenders, whose generosity has been extraordinary and whose requests for anonymity I have respected. The Earl of Shelburne has been particularly kind in offering to remove temporarily a choice selection of graphic studies from the public display of Bonington's drawings at Bowood House.

For their help in locating, documenting, or securing loans, or for their counsel and warm hospitality, I extend my sincere thanks to the following individuals: Clifford S. Ackley, Martyn Anglesea, Claudie Barral, James Bergquist, David Berkeley, David Bindman, William Bradford, Martin Butlin, Richard Campbell, Sara Campbell, T. H. Carter, Mimi Cazort, Jane Clark, Larry Clarke, Michael Clarke, Mrs. R. N. S. Clarke, Timothy Clifford, Christopher Comer, Roy Davis, Geneviève DeBlock, Simon Dickinson, William Drummond, Ellen S. Dunlap, Judy Egerton, Lindsay Errington, Gary Essar, The Hon. D. D. Everett, Lord Fairhaven, Kate Fielden, Burton B. Fredericksen, Betsy Fryberger, David Fuller, Andrea George, Richard Godfrey, Halina Graham, Pierre Granville, Anthony Griffiths, David Moore-Gwyn, Carlos van Hasselt, The Hon. Diana Holland-Hibbert, Francina Irwin, John Ittmann, Michael Jaffé, Michiel Jonker, Louise Karlsen, Alex Kidson, Alastair Laing, Susan Lambert, Lionel Lambourne, Cecily Langdale, Ann Laurie, Patrick Le Nouëne, Christopher Lloyd, Katherine Lochnan, Richard Lockett, Patrick McCaughey, Hugh Meller, Ruth K. Meyer, James Miller, Jane Montgomery, Graham Moran, Edward Morris, John Morton Morris, Jane Munro, John Murdoch, Ruth-Maria Muthmann, Gabriel Naughton, Jill Newhouse, Stephen Nonack, The Earl of Normanton, Charles Nugent, Nicholas Penny, Paul N. Perrot, Marcia Pointon, Hubert Prouté, Janice Reading, Anthony Reed, The Hon. Jane Roberts, William Robinson, Marianne Roland-Michel, Kim Rorschach, John Rowlands, Nick Savage, David Scrase, Alan Shestack, Peyton Skipwith, Gregory Smith, Shaw Smith, Sheenah Smith, Françoise Soulier-François, Anthony Spink, Adolphe Stein, MaryAnne Stevens, Julian Treuherz, Samuel Trower, Nadia Tscherny, Fani-Maria Tsigakou, Evan H. Turner, Mrs. Joyce Turner, Julia Webb, Lavinia Wellicome, Christopher White, Stephen Wildman, Andrew Wilton, Andrew Wyld, Henry Wemyss, and Michael Wynne.

Among the scholars and collectors to whom I am indebted for their published research and for many an hour of engrossing conversation are Richard L. Feigen, John Ingamells, Lee Johnson, Evelyn Joll, and James Mackinnon. I hope this effort approaches their expectations.

At the Louvre, Pierre Rosenberg's irrepressible admiration for the artist has been both inspiring and much appreciated. His colleague in the Department of Paintings, Stéphane Loire, has provided administrative assistance in so many areas, at such crucial moments, and with such alacrity over the last five years that any expression of my heartfelt gratitude somehow seems inadequate. Equally decisive has been the enthusiasm of their colleagues at the Petit Palais, Thérèse Burollet and Bernard Notari.

The success of any exhibition is always a measure of the commitment and cooperation of the professional staffs of the host institutions. I would like to thank collectively those many individuals in New Haven and Paris who have contributed so positively and diversely. I appreciate especially the support of the Directors, Duncan Robinson and Jacques Sallois, and the assistance of Suzanne Beebe, Irène Bizot, Richard Caspole, Constance Clement, Malcolm Cormack, A. Daguerre de Hureaux, Theresa Fairbanks, Claire Filhos-Petit, Christopher Foster, Timothy Goodhue, Stéphane Guégan, Marilyn Hunt, Anne-Marie Logan, Joy Pepe, Martha Pigott, Françoise Viatte and Scott Wilcox. At the Paul Mellon Centre in London, Brian Allen, Kasha Jenkinson, and Evelyn Newby have provided many kind services. Robert Shepherd contributed his valuable experience in the conservation of several oils, while the onerous task of editing this publication fell to Debra Edelstein, who has saved me from the embarrassment of numerous oversights.

There might be no exhibition or catalogue without the generous financial contribution of our sponsor. At United Technologies Corporation, Carol Palm and Gordon Bowman deserve my special acknowledgment for their confidence and encouragement. With characteristic grace and insight, Derek Birdsall has designed a catalogue as expressive and as beautiful as the works it describes. It has been a delightful education to work with him and his colleague Martin Lee.

This exhibition has received financial support also from the National Endowment for the Arts. I am further indebted to that Federal agency for a 1986 grant under its program for museum professionals that enabled me to pursue research in France on a related but much broader topic of Anglo-French cultural relations in the early nineteenth century. During my stay in Paris, Jacqueline Grislain could not have been more gracious or more helpful.

Finally, I dedicate this entire project to Diane Tsurutani, who has patiently and cheerfully shared in its development over so many years.

Bonington Chronology

1802

October 25: Richard Parkes Bonington born in Arnold, near Nottingham, the only child of Richard Bonington and Eleanor Parkes.
November 9: Death in London of the artist Thomas Girtin (born 1775).
November 28: Bonington baptized at the High Pavement Unitarian Chapel, Nottingham.

1813

Richard Bonington exhibits paintings at the Liverpool Academy.

1814

Under Louis XVIII, the Bourbon Restoration commences in France.

1817

The actor S. W. Ryley visits Nottingham and leaves a flattering account of Richard Bonington's personality, charity, and industry.
August 17: The Nottingham Review advertises the sale of the Boningtons' personal possessions and house to be conducted on 26–28 August; the sale postponed until September.
Autumn: The family moves to Calais for the formation of the lace-making firm of Clarke, Bonington, and Webster at St-Pierre-les-Calais. The watercolorist Louis Francia, having returned to Calais sometime before April, adopts Bonington as a casual student.

1818

October 28: Partnership of Clarke, Bonington, and Webster dissolved in favor of a new arrangement between Bonington and Webster, which continues until April 1819.
Autumn or winter: The family moves to Paris to establish a retail outlet.

1819

Spring: Meets James Roberts, and probably Eugène Delacroix and Hippolyte Poterlet, while copying pictures in the Louvre. On Roberts's recommendation, enrolls in the atelier of Baron Antoine-Jean Gros.
August 25: Salon exhibition opens. Théodore Géricault exhibits Raft of the Medusa.

1820

April 18: Isadore Taylor and Charles Nodier begin publishing the first volume of their Voyages pittoresques et romantiques dans l'ancienne France.
June 24: The Ecole des Beaux-Arts announces the opening of a new facility for the study of antique casts (Salle de la bosse).
August 6: Places 25th of 64 in the inaugural competition for places in the cast room.
September 11: Places 19th of 53 in the competition for places in the cast room for the winter semester (October–April).
October 3: Places 60th of 61 in the competition for places in the Salle de la modèle for the winter semester.
Continues painting landscape watercolors and conducts sketching tours in the Paris suburbs with fellow pupil, Jules-Armand Valentin.

1821

May 5: Death of Napoleon. Places 46th of 72 in the competition for places in the cast room for the summer semester (April–October), but his disenchantment with Gros intensifies.
Autumn: First tour of Normandy, stopping at Rouen, Lillebonne, Abbeville, Honfleur, Le Havre, Trouville, Dîves, Sallinelles, Ouistreham and Caen.
First mention of family's business address in the Paris Commercial Almanac as 22, rue des Moulins, but they would shortly move to 27, rue Michel le Comte, and, in 1824, to 16, rue des Mauvaises-Paroles.

1822

Spring: Exhibits Normandy watercolors with Madame Hulin and Claude Schroth in their gallery at 18, rue de la Paix. Gros publicly acknowledges his talent, but by the end of the year Bonington would quit the atelier permanently.
April 24: Exhibits at the Salon: no. 123, Vue prise à Lillebonne (watercolor), and no. 124, Vue prise au Havre (watercolor). The publisher d'Ostervald exhibits under his own name (no. 994) watercolors and oils for his publication Voyage pittoresque en Sicile. These include Bonington's watercolor Vue de Catane. Other English artists exhibiting in this Salon are the engravers William Ensom, Abraham Raimbach, Joseph West, and Charles Thompson. Ensom and West will become his intimate friends.
April 25: Receives 430 francs (£17) from the Société des Amis des Arts for his two Salon exhibits.
May 7: Publication of the first part of d'Ostervald's Voyage pittoresque en Sicile.
May 11: Places 21st of 53 in the competition for places in the cast room for the summer semester.
September 9: Places 46th of 80 in the competition for places in the cast room for the winter semester. This is the last concours that he enters.
September 31: The poor reception of the English troupe of Shakespearean actors at the Théâtre Porte-Saint-Martin prompts Stendhal's manifesto Racine et Shakespeare.
November 19: The Société des Amis des Arts opens its annual exhibition, which includes Bonington's Salon watercolors.

1823

Spring–Summer: Probable period of a trip, or trips, to Bruges, Ghent, Bethune, Hazebrook, Bergues, Gravelines, Dunkerque, St-Omer, and Normandy in connection with a commission for d'Ostervald's Excursions sur les côtes et dans les ports de France, and for his own publication Restes et Fragmens [sic].
September 29: Victor Hugo, Charles Nodier, et al., found the romantic journal La Muse Française.
Autumn: Begins work on the Restes et Fragmens and probably his first lithographs for Taylor's Voyages pittoresques.
December 22–24: D'Ostervald's sale at the Hôtel de Bullion, Paris, includes ten Bonington watercolors: Catane, Sicily; Trepani, Sicily; Château Chillon; Boulogne (two views); Le Havre; Honfleur; Rouen; St-Valery-sur-Somme (two views). The sale also offered watercolors by other English artists: George Barret; Copley, Newton, and Thales Fielding; Louis Francia; James Duffield Harding; Samuel Prout; and George Shepherd.
December 30: L.-J.-A. Coutan purchases Delacroix's oil Rebecca and the Wounded Ivanhoe. Coutan would emerge shortly as Bonington's most devoted French patron.

1824

January 17: The Paris-based dealer John Arrowsmith purchases John Constable's Landscape with Haywain and View on the Stour.
January 26: Death of Théodore Géricault.
Late February: With Alexandre Colin, leaves Paris for Dunkerque, where, at the boardinghouse of Madame Perrier, quai des Furnes, he passes "the happiest year of my life." He will visit Paris briefly during the summer.
February 24: Delacroix notes in his diary the postponement of the Salon.
April 19: Death of Lord Byron at Missolonghi.
May or June: Returns to Paris for the publication of Restes et Fragmens

(June 8 and September 8). Deposits Salon entries at this time; may have met the British artists Clarkson Stanfield and William Collins, who were then in Paris; undoubtedly saw Constable's paintings at Schroth's and Arrowsmith's galleries.

June 19: Publication of the lithograph *Le Matin*.

June 25: Receives 1500 Francs (£60) from the Société des Amis des Arts for two oil paintings and one watercolor accepted for the Salon.

July 9: Writes to Baron Taylor that he is about to leave Paris. Meets Newton Fielding at Dieppe on the 24th.

August 25: Exhibits at the Salon: no. 188, *Etude de Flandre*; no. 189, *Marine*; no. 190, *Vue d'Abbeville; aquarelle*; no. 191, *Marine. Des pêcheurs débarquent leur poisson*; no. 192, *Une plage sablonneuse*; no. 2101, *Rue de Grosse-Horloge à Rouen* (lithograph); and nos. 1280–81, various watercolors for *Voyage pittoresque en Sicile* and *Excursions sur les côtes et dans les ports de France*.

September 16: Death of Louis XVIII.

October: Delacroix moves into Thales Fielding's studio, 20, rue Jacob.

November 1: Writes from Dunkerque to Colin mentioning Francia's departure from Calais for Paris.

December 3: Having returned to Paris, writes to Madame Perrier that he plans to visit London in the spring with Colin. Begins working on the lithographs for the Franche-Comté volume of Taylor's *Voyages pittoresques*.

December 13: In delivering a eulogy at Girodet's funeral, Gros succeeds in insulting the entire French school, but especially Horace Vernet, Ary Scheffer, and Delacroix.

1825

January 10–21: The British watercolor painter Samuel Prout probably visits Bonington in Paris on his return from a trip to Italy.

January 14: Charles X presents awards at the close of the Salon. Bonington receives a gold medal in the painting class.

April 28: Colin granted a passport for the lowlands and England.

May 29: Coronation of Charles X at Rheims.

June–August: Travels to London with Colin. Meets Delacroix (who had arrived on May 24), Henri Monnier, Eugène Isabey, the Fieldings, Hippolyte Poterlet, Edouard Bertin, and Augustin Enfantin. Studies with Delacroix and Bertin at both Samuel Meyrick's collection (July 8–9) and Westminster. In early August returns to France, but remains at Dunkerque or St-Omer, where he is joined by Delacroix and Isabey.

Autumn: Sketching tours along the channel coast with Eugène Isabey and along the Seine with Paul Huet. At the end of the year shares Delacroix's studio. Coutan purchases Constable's *View on the River Stour* from Arrowsmith.

December 22: Publication of the first of twelve installments of Amédée Pichot's *Vues pittoresques de l'Ecosse*, for which Bonington is the principal lithographer.

December 29: Death of Jacques-Louis David in Brussels.

1826

January: Exhibits at the British Institution: no. 242, *French Coast Scenery*, and no. 256, *French Coast, with Fishermen*.

January 31: Delacroix writes that Bonington has been with him for some time. Shortly afterward, Bonington moves to his own studio at 11, rue des Martyrs, a building owned by the artist Jules-Robert Auguste.

April–June: On April 4 leaves Paris for Italy with Charles Rivet, arriving for an evening at Semur; April 6 at Dôle; April 7 to Geneva, and then St-Gingolph and Brig via St-Maurice and Sion; April 11–14 at Milan; April 15–18 Lago di Garda and Brescia; April 18 Verona, and then to Venice, from where Rivet writes:

Our life is always the same. After the walks and the work of the day we return at half past five, when dinner is served in our room. The menu does not vary. Then we go and take coffee in the Piazza San Marco. Sometimes at 9 o'clock we go for 17 sous to the theater where La Semiramide is being played indefinitely. Then we have an ice, at 6 sous Austrian money.

May 19 leaves Venice for Padua and Ferrara; May 24–31 Florence and Pisa, after which they return to France by way of Sarzana, Lerici, Spezzia (June 7), Genoa, Alessandria, Turin (June 11), and Switzerland. On June 20 they are back in Paris.

April 21: Delacroix finishes *Execution of the Doge Marino Faliero*.

May 17: Exhibits *Turc Assis* in the *Exposition au profit des Grecs* at the Galerie LeBrun.

December 30: Publication of *Cahier de six sujets*.

1827

Remains at 11, rue des Martyrs until the end of the year, when he moves to 32, rue St-Lazare.

Late Spring: Second trip to London; lodges at Green's Hotel.

May 4: Exhibits at the Royal Academy: no. 373, *Scene on the French Coast*.

May 19: Publication of the first part of Maurice Rugendas's *Voyage pittoresque dans le Brésil*, to which Bonington would contribute three lithographs.

June 2: Receives payment from George Fennel Robson for the watercolor *An Old Man and Child*.

July 13: Writes from Paris to the publisher John Barnett concerning his work on various commissions from London patrons.

September 28: Delacroix writes to Charles Soulier suggesting that he and the collector Jovet visit Bonington.

November 4: Exhibits at the Salon: no. 123, *Vue du palais ducal à Venise*; no. 124, *Vue de la cathédrale de Rouen*; no. 125, *Tombeau de Saint Omer dans l'église cathédrale de Saint-Omer* (watercolor); no. 1382, *Façade de l'église de Brou* (lithograph); no. 1589, unidentified lithographs for *Voyage pittoresque dans le Brésil*.

November 5: Writes to the engraver W. B. Cooke asking him to submit his oil *The Piazzetta* for exhibition at the British Institution.

November 21: Delacroix is finishing his lithographs to *Faust* and his painting *Death of Sardanapalus*.

December: Publication of Victor Hugo's *Préface de Cromwell*.

December 25: Publication of *Contes du Gai Sçavoir*.

1828

January 25: Salon closes for rehanging.

January 31: Bonington certainly in London by this date. Stays with John Barnett at 29 Tottenham Street; meets Sir Thomas Lawrence for the first time.

February 4: Exhibits at the British Institution: no. 198, *View of the Piazzetta near the Square of St. Mark, Venice*, and no. 314, *The Ducal Palace, Venice* (which the artist had removed from the Salon). Delacroix exhibits no. 102, *The Execution of the Doge Marino Faliero*.

February 13: Victor Hugo's dramatic adaptation *Amy Robsart* opens in Paris.

February 23: Receives payment of £131 from the publisher James Carpenter for the oil *Entrance to the Grand Canal*.

February 28: The Salon reopens. Exhibits: no. 1604, *François Ier et la reine de Navarre*; no. 1605, *Henri IV et l'ambassadeur d'Espagne*; no. 1606, *Vue de l'entrée du grand canal à Venise* (Carpenter's commission); no. 1607, *Une aquarelle* (three watercolors actually included under this number).

May: Exhibits at the Royal Academy: no. 248, *Henry III of France*; no. 330, *Coast scene*; no. 470, *The Grand Canal, with the church of La Virgine del Salute, Venice* (Carpenter's commission).

June: Cancels a planned trip with Huet to Normandy after a reported bout of sunstroke while sketching on the Seine. Huet proceeds to Honfleur and on June 21 meets Isabey. Recovers briefly, but his condition deteriorates rapidly in July and August. His only etching, *Corso Sant'Anastasia, Verona*, executed at this time.

August 6–7: Paints his last watercolor, *The Undercliff*.

September 6: Eleanor Bonington writes from Abbeville to alert John Barnett of her son's grave condition and of their pending arrival in London.

September 23: Bonington dies at the house of John Barnett. He is buried at St. James's Chapel, Pentonville, but reinterred at Kensal Green in 1837.

1829

February 16: Richard Bonington writes to Sir Thomas Lawrence thanking him for his help in arranging the export to London of his son's studio effects.

April 1: Moon, Boys, and Graves, London, and Giraldon-Bouvinet, Paris, publish four mezzotints by S. W. Reynolds after Bonington's *Anne Page and Slender*, *Use of Tears*, *Antiquary*, and *Le Billet Douce* (*The Green Dress*).

April 10: Richard Bonington turns over the arrangements for the forthcoming sale of his son's studio to the dealer Domenic Colnaghi. Clarkson Stanfield and Samuel Prout will assist.

June 29–30: First Bonington studio sale conducted at Sotheby's.

August 1: James Carpenter commences publication of *A Series of Subjects from the works of the late R. P. Bonington*, drawn on the stone by *J. D. Harding*. In the autumn, d'Ostervald publishes six lithographs by Jaime after Bonington: *Environs de Mantes*, *Environs du Havre*, *Femmes de Pécheurs*, *Marée Basse*, *Vue prise sur la bord du canal de Tourry*, and *à Venise*.

1832

September 25: Richard Bonington asks Carpenter for an introduction to Sir Martin Archer Shee, President of the Royal Academy, with a view to selling his son's works to the nation. An exhibition is organized at Suffolk Street.

1834

May: Richard Bonington and William Seguier organize an exhibition of loans and of the remaining studio effects at the Cosmorama Gallery. This is followed by the second studio auction at Christie's on May 23–24.

1836

Death of Richard Bonington is followed by the third studio sale at Fosters on May 6.

1838

Death of Eleanor Bonington is followed by the fourth studio sale at Sotheby's on February 10 and the sale of Richard Bonington's print collection, also at Sotheby's, on February 24. The sale of February 10 also included drawings that were acquired by Bonington or his parents from numerous contemporary artists, including: N.-T. Charlet, François Grenier, Eugène Isabey, A.-V. Joly, George Barret, Charles Bentley, T. S. Boys, William Brockedon, David Cox, James Holland, William Linton, Samuel Prout, Thomas Stothard, John or Cornelius Varley, and Alfred Vickers.

1861

Eugène Delacroix writes to Théophile Thoré:

My dear friend,

I have only lately received and in the country the letter in which you requested details on Bonington: I send with pleasure the little information I possess.

I knew him well and loved him much. His British composure, which was imperturbable, in no way diminished those qualities which make life enjoyable. When I met him for the first time, I too was very young and I was making studies in the Louvre: this was around 1816 or 1817. I saw a tall adolescent in a short jacket, who was making, also alone and silently, watercolor studies, in general after flemish landscapes. Already in this genre, which was an English novelty at that time, he had an astonishing ability. A short time later, I saw at Schroth's, who had just opened a small gallery for drawings and little pictures (the first, I believe, to be established) watercolors that were charming in their color and composition. He possessed even then all the charm that would later prove his excellence. To my mind, one can find in other modern artists qualities of strength and of precision in rendering that are superior to those in Bonington's pictures, but no one in this modern school, and perhaps even before, has possessed that lightness of touch which,

especially in watercolors, makes his works a type of diamond which flatters and ravishes the eye, independently of any subject and any imitation.

At that time (around 1820), he was with Gros, with whom, I believe, he did not long remain; Gros actually counseled him to give himself over completely to his own talent, which he already admired. At that time, he did not paint oils, and the first that he made were marines: those early ones are recognizable by their heavy impasto. He later renounced this excess: this was particularly so when he set about painting figure subjects in which costumes played a major role: this happened around 1824 or 1825.

We met in 1825, in England, and together made studies at the home of a celebrated English antiquary, Doctor Meyrick, who owned the most beautiful collection of armor that has perhaps ever existed. We were together a great deal during this trip, and when we finally returned to Paris, we worked for some time in my atelier.

I could never cease to admire his marvelous grasp of effects and the facility of his execution; not that he was easily satisfied. On the contrary, he frequently repainted entire finished passages which seemed wonderful to us; but his ability was such that his brush instantly recovered new effects as charming as the first. He turned to good account all sorts of details that he found in the old masters and adapted them with great skill in his compositions. In his works one saw figures borrowed almost without alteration from paintings that everyone knew well, and this scarcely concerned him. This practice in no way diminished their merits; those details taken from the life, so to speak, and which he appropriated as his own (this was especially true of costumes), enhanced the air of verisimilitude of his historical characters and never smacked of pastiche.

At the end of this life too soon extinguished, he seemed afflicted with depression, and especially because of his keenly felt desire to paint large pictures. Yet he made no attempt, to my knowledge, to enlarge markedly the size of his canvases; however those in which the figures are the largest date to this period, notably the Henri III *that was exhibited last year in the boulevard and that is one of his last.*

His name was Richard Parkes Bonington. We all loved him. I would sometimes tell him: "You are a king of your domain and Raphael could not do what you do. Don't worry about other artists' qualities, nor the proportions of their pictures, since yours are masterworks."

He had produced, sometime before, Views of Paris which I don't remember and which were done, I believe, for the publishers; I bring them up only to mention the method he devised for studying out of doors without being troubled by passersby: he installed himself in a cabriolet and worked there for as long as he wished.

He died in 1828. What charming works in so short a life! I learned suddenly that he suffered a chest ailment that took a dangerous turn. He was tall and strong to look at, and we greeted his death with as much surprise as sadness. He had gone to die in England. He was born at Nottingham. At his death, he was 25 or 26 years old.

In 1837, a M. Brown, of Bordeaux, sold a magnificent collection of Bonington watercolors; I don't think it possible to ever again assemble the likes of this splendid group. It comprised examples from every period of his talent, but especially the last, which is the finest. Enormous prices were paid for those works; during his lifetime he sold everything he painted, but he had never received anything like those enormous prices which, for my part, I find legitimate and a fair recognition of so rare and so exquisite a talent.

My dear friend, you have given me an opportunity to recall fond moments and to honor the memory of a man whom I loved and admired. I am all the more pleased, in that there have been attempts to denigrate him, since he is, to my eyes, very superior to the majority of those who are now considered superior. Attribute, if you wish, to my ancient recollections and my friendship for Bonington, anything that might seem biased in these notes.

A thousand sincere best wishes from your old and dear friend.

Eugène Delacroix

Seductively original and in many respects profoundly influential, Richard Parkes Bonington nevertheless remains something of an enigma — a footnote or aside in most modern accounts of nineteenth-century painting. His professional career spanned less than a decade, so a predictable scarcity of documentation relating to his activities, personality, interests, and friends may partially account for the present incomplete picture of his achievement. Unlike his fellow artists, Eugène Delacroix and Paul Huet, he kept no journal and was an infrequent, even reluctant, correspondent. Most of his letters to Alexandre-Marie Colin and the diaries of Baron Charles Rivet, who, with Delacroix and Huet, formed the nucleus of his immediate circle in Paris, have vanished since their selective publication by his first modern biographers in 1924.[1] A proper life of this artist consequently becomes a matter of considerable conjecture built precariously on facts sifted from the mass of apocryphal observations proliferated during the decades following his death, when it served the interests of his family and colleagues to mythicize his character and performance. The very orthography of his surname was still the subject of dispute as late as 1900; while as recently as forty years ago an otherwise meticulous biographer, Sydney Race, dismissed the incontrovertible evidence of the baptismal record of the High Pavement Unitarian Chapel of Nottingham and of the engraved death notice circulated by his parents that the artist was born on 25 October 1802 (not 1801 as traditionally maintained) and that he died in the last month of his twenty-fifth year.[2] Apparently, even this scholar could not resist embellishing the profile with an inference that Bonington had been conceived out of wedlock.

Bonington's persona, created in part by his own diffidence and wildly exaggerated by his admirers, was that of the quintessential romantic hero — a melancholic and untutored genius, solitary, haunted, irrationally yet inevitably destroyed at the peak of his youthful promise by a hyperkinetic creative faculty. He could have been the prototype for the character Joseph Brideau in Honoré de Balzac's novel *The Black Sheep*, who dreamed in the 1820s of destroying the classical tradition, whose pictures were mistaken by Baron Gros as the works of Titian, whose tastes were exclusively for the medieval and Venetian, and whose "ideal" comprised the poetry of Byron, the painting of Géricault, the music of Rossini, and the romances of Walter Scott. More often than not, fictive historiography has been the hallmark of Bonington studies.

The absence of a *catalogue raisonné* and of any sustained and focused analysis of the relationship between French and English painting and aesthetics during the crucial first decades of the century have sorely contributed to our perception of Bonington as a subsidiary flash of genius in the tumultuous ferment of romanticism.[3] Was he an English artist active in France or a French artist born in England; or was he simply blessed by his rare intimacy with both cultures? It is indisputable that Bonington was a uniquely gifted painter in the sense of technical proficiency; whether he remains a great artist I leave to individual bias to decide.

It was certainly the consensus of his contemporaries, especially those in France, that he was both; and, as we approach Bonington's bicentenary, it is perhaps the moment to recall Théophile Gautier's contention that the modern revolution in French painting proceeded from Bonington, just as surely as her literary revolution proceeded from Shakespeare, because he was "the most natural colorist" of an era for which the great symphony was color.[4] Or the critic Gustave Planche's assertion that at the mere sight of a Bonington oil any sensitive spirit was involuntarily driven to a desire to paint.[5] Or the aged Camille Corot's admission that Bonington was not only his inspiration in youth, but also the first artist in France to approach nature with sincerity.[6] Or that for Sainte-Beuve, his was the clear and luminous vision which, together with Géricault's powerful realism and Delacroix's impassioned imagination, defined the parameters of romantic excellence.[7] Or that his art was, for Charles Baudelaire, the very embodiment of modernity — "intimacy, spirituality, color, and aspirations toward the infinite" — an antiphon to his beloved Goya's ferocity.[8]

In one of his earliest "naturalistic" poems of 1830, "Pan de Mur," inspired by a stretch of dilapidated wall outside his leaded window in the Marais, Gautier pointedly acknowledged his own debt to Bonington.[9] The thread that links this paean on introspection and sight to the diverse appreciations already mentioned, to William Hazlitt's seminal essay that furnishes the subtitle of our own catalogue,[10] and, ultimately, to Marcel Proust's more famous rhapsody on the exquisitely painted yellow wall in Vermeer's *View of Delft*[11] is an unshakable belief that the *poetry* of representational painting is an indefinable but instantly perceived coalescence of impeccable craftsmanship and emotive revelation, functioning irrespective of any other meanings that a subject might hold or any other intentions an artist might harbor. Baudelaire reiterated the point in 1859 when he chided the factious "spoiled children" of his own generation for squandering romanticism's legacy by upsetting this delicate chemistry in favor of technical chicanery or vacuous imagery.[12] That he and many others should invoke Bonington's name when extolling that legacy is an affirmation of the artist's sustained importance to the formulators of aesthetic theory through the nineteenth century. Stated succinctly, Bonington's life was a celebration of the *art* of painting; to undervalue the historical relevance of that achievement is to misunderstand by half the romantic genius.

* * *

WHO IS R. P. BONINGTON?

The Literary Gazette, 4 February 1826

The family into which Richard Parkes Bonington was born was a flurry of professional activity. On attaining his majority in 1789, the artist's father, Richard Bonington (1768–1835), inherited the post of Nottinghamshire gaoler. Eight years later he voluntarily abandoned this sinecure for the profession of drawing master and portrait painter, although his earliest known work of art, a somewhat coarse three-quarter-length graphite portrait of 1791 (Columbia University), suggests that he may well have been plodding toward a career change for some time. He exhibited landscapes and portraits in oil at the Royal Academy in London in 1797 and again in 1808 and at the Liverpool Academy in 1811 and 1813. His activity as a topographical watercolorist was sustained with equal perseverance and included a requisite tour of the Lake District and watercolor views of Sheffield (1801), where he also taught drawing,[13] of Nottingham (1808–13), and of Belvoir Castle, which became picturesquely ruinous after a conflagration of 1816. Since most of these views were etched in aquatint in London by T. Cartwright (fig. 1), we can presume that Bonington made periodic business excursions to the capital. The prints alone survive, thus making it difficult to measure his talent as a draftsman; Cartwright's own *Six Landscapes in Aquatint* (London, 1791) are only marginally more accomplished in perspective, composition, and drawing than his prints after the elder Bonington. However, allowing for any expertise he might have gained through his studious copying of his sons' pictures in the 1820s, a recently discovered view of London in oils of 1833 may indicate the level of competence in his earliest original landscapes.[14] On the evidence at hand, one can deduce that Richard Bonington was, at least, a reasonably successful provincial artist of modest pretensions, who industriously satisfied a medley of artistic needs for his local community.

Fig. 1: T Cartwright after Richard Bonington (1768-1835)
North East View of Nottingham, from Mr. James's Coffee House, 1815
Aquatint $7 \times 9\frac{1}{4}$ in. (17.8 × 24 cm.)
Yale Center for British Art, New Haven

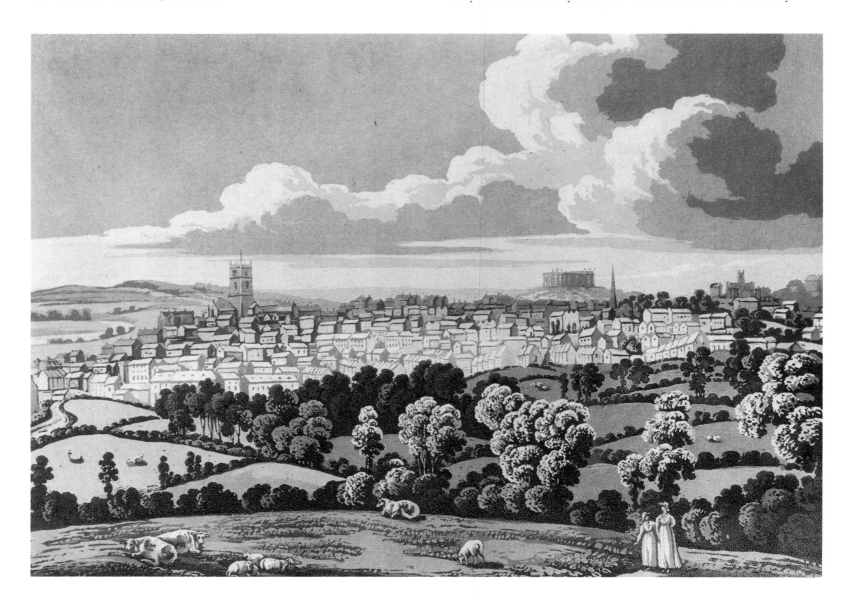

In London in July 1801 Bonington married Eleanor Parkes, a disciplined and educated woman with prior experience tutoring children. Together they immediately opened a finishing school for young ladies, which his activities as a drawing master complemented and which functioned in Arnold and then Nottingham until 1813. In 1806 he endeavored to expand the scope of this small enterprise by advertising the incorporation of a "repository of the arts" similar, in principle, to that of Rudolph Ackermann's vastly successful London emporium. The rental of original drawings, prints, and watercolors, presumably for amateurs to copy, the sale of artists' supplies, and the exhibition of his own pictures were the primary thrusts of this commercial venture.[15] The type of graphic merchandise gathered for, and during, this enterprise can be identified perhaps among the lots and titles of the nearly three thousand prints and drawings by old and modern masters auctioned by his estate in 1838: the then fashionable engravings for the Boydell *Shakespeare Gallery* (1789–1805) and the smaller plates for the George Steevens edition of 1802; Bowyer's ambitious illustrated edition of David Hume's *History of England* (1805); Thomas Macklin's *The Holy Bible* (1800–16); and Edward Forster's *British Gallery of Engravings* (1807–13). All of these would figure in the artistic training of his son and the future interests of the generation of French history painters with whom the younger Bonington would most closely associate.

The second decade of the nineteenth century was one of economic stagnation throughout much of England, with Nottingham's textile industry especially encumbered. By 1814 the various businesses engaging the Boningtons could scarcely support themselves. Richard Bonington returned, initially, to politics, but after an unsuccessful Whig candidacy for the Junior Council of the Nottingham Corporation in 1815, he resorted to connections cultivated previously in the machine lace-making industry, which was rapidly transplanting itself from Nottingham to Calais. The editors of the *Nottingham Journal* lamented that in May 1816 alone two thousand passports for the continent had been issued to the "distressed noblemen, gentlemen, and manufacturers" of the region.[16] In the same spirit of entrepreneurial daring, as much a product of desperation as inflated optimism, the Boningtons decided on a similar course of expatriation, advertising in the *Nottingham Review*:

Mr. Bonington, having relinquished his profession of drawing master, solicits the nobility, gentry, and public to his collection of original paintings and drawings, etc., which will be offered for sale August 26, 27, and 28, 1817 ... together with the whole of the valuable, neat and very useful household furniture ... also, will be sold by auction that truly eligible freehold dwelling ... being one of the best and most centrical situations in the town of Nottingham.[17]

A less opportune moment could not have been chosen. The duc de Richelieu, in his correspondence to the French ambassador in London during April and May 1817, observed the "frightful distress" of the economy with "famine in most of France and food shortages in the rest."[18] Nevertheless, the decision had been made to enter into the tulle manufacturing business in partnership with two Nottingham lace-makers then active in Calais, James Clarke and Robert Webster; by late September, their material possessions converted to currency, the Boningtons removed to France.

Several months prior to their arrival, Louis Francia (1772–1839; no. 17), the landscape and marine watercolorist who had resided in London from 1790, returned to his native city of Calais. Most accounts credit him with having adopted the younger Bonington informally as a student after encountering him sketching by the quay. His advocacy of Bonington's juvenile interests nettled the father, who was apparently

1. A. Dubuisson and C. E. Hughes, *Richard Parkes Bonington: His Life and Work* (London, 1924).
2. Sydney Race, *Notes on the Boningtons: Richard Bonington the Elder (1730–1803); Richard Bonington the Younger (1768–1835); Richard Parkes Bonington (1801–1828)* (Nottingham, 1950).
3. The exception to this statement is a lucid collection of essays in Charles Rosen and Henri Zerner, *Romanticism and Realism* (New York, 1984). Marcia Pointon has also contributed valuable documentation on Bonington's associates in *The Bonington Circle* (Brighton, 1985).
4. Théophile Gautier, *Les Beaux-Arts en Europe* (Paris, 1855): "la révolution romantique commencée par Scheffer, Devéria, Poterlet, Delacroix, L. Boulanger et surtout Bonington, le peintre le plus naturellement coloriste de l'école moderne"; and Huet, *Huet*, 48:
With regard to color, the revolution in painting proceeded from Bonington just as the literary revolution proceeded from Shakespeare. The influence of this young English painter, or of English origin, is visible in the first works of romanticism. Eugène Delacroix, that fiery genius, so profoundly original, received from him a light that illuminates Combat of the Giaour and Hassan *... and that blazes in such superb fashion in* Sardanapalus.
5. Planche, *Salon 1831*, 25.
6. Dubuisson 1912, 123.
7. C.-A. Sainte-Beuve, *Nouveaux Lundis* (Paris, 1865), 3: 97–98.
8. See Baudelaire's letter of 1859 to Nadar concerning Goya's portraits of the Duchess of Alba, reprinted in Rosemary Lloyd, ed. and trans., *Selected Letters of Charles Baudelaire* (Chicago, 1986), 127.
9. Théophile Gautier, "Pan de Mur," *Poésies complètes* (Paris, 1889), 1: 91–92.
10. William Hazlitt, "On the Pleasure of Painting," *Table-Talk* (London, 1821).
11. Marcel Proust, *A la recherche du temps perdu — La Prisonnière* (Paris, 1923):
A critic had written that in Vermeer's View of Delft *... a picture [Bergotte] adored and thought he knew well, a small stretch of yellow wall (which he did not recall) was so well painted that it was, if viewed by itself, like a precious work of Chinese art, of a beauty sufficient in itself. Bergotte ... passed by several paintings and sensed the dryness and uselessness of so factitious an art that could not equal the atmosphere and sunlight bathing a Venetian palazzo, or even a simple dwelling by the sea. Finally, he was before the Vermeer ... he fixed his gaze, as would a child on a yellow butterfly he desired to know, on the precious little wall. "This is how I should have written, he said. My last books are too dry, several layers of color are needed to make my phrases precious in themselves, like this small yellow wall." However, the gravity of his illness did not escape him. In a celestial balance it appeared to him that one of its plates held his entire life while the other contained this beautifully painted bit of yellow wall.*
Proust is known to have admired Bonington's work and was probably familiar with his Venice views.
12. Baudelaire, *Salons*, 147–48 (Salon of 1859):
The artist is today ... nothing but a spoiled child The spoiled child has inherited privileges, once legitimate, from his predecessors. The enthusiasm which greeted David, Guérin, Girodet, Gros, Delacroix and Bonington, still sheds its charitable light upon his sorry person Discredit of the imagination, disdain of the great, love (no, this is too fine a word) exclusive practice, rather, of technique, — such, I believe, are the principal reasons for the artist's degradation He who possesses no more than technical skill is but a beast, and the imagination which attempts to do without it is insane.
13. Bonington Sr. conducted weekly drawing lessons at the Jennings Circulating Library, Sheffield, according to J. H. Plumb, "The New World of Children in Eighteenth-Century England," *Past and Present* 67 (May 1975): 76 and n.53. I would like to thank Marcia Pointon for sharing this reference.
14. Sotheby's, 11 July 1990, lot 80, *View of London from Highgate*, oil on panel, reproduced in color.
15. He had advertised in a local newspaper, "connexions with Mssrs. Boydell & Co. and other eminent houses in London"; see Hughes, *Notes*, 103.
16. Dubuisson and Hughes, 20.
17. Ibid., 19.
18. See Miquel, *Isabey* 1: 32 n.2. Until recently the allied powers were exacting from the French government £100,000 per annum for the expenses of its occupation forces.

not enthusiastic at the prospect of his son pursuing a career from which he had derived only erratic remuneration and which would obviously interfere with any dynastic commercial ambitions that he might then have entertained. Most scholars have accepted the anecdote[19] that Francia rescued his protégé from paternal insensitivity by sending him in 1818 to Benjamin Morel, a wealthy shipbuilder from Arras and mayor of Dunkerque, who subsequently shunted the boy to Paris with a letter of introduction to Eugène Delacroix.[20] His parents eventually followed him to Paris, where father and son were reconciled.

It is verifiable that in October 1818 the partnership of Clarke, Webster, and Bonington was dissolved in favor of a new arrangement between Webster and Bonington, which survived at least until the following spring. It is defying credulity, however, to accept that an adolescent would be slipped surreptitiously to Dunkerque by a professional artist just then straining to establish his own reputation as a respectable drawing master and then on to Paris by that very pillar of bourgeois probity, a provincial mayor, with an introduction to an artist who was virtually unknown and without resources. In fact, Delacroix later recalled meeting Bonington only accidentally in the Louvre. A more reasonable reconstruction of events would be that shortly after the dissolution of the initial partnership the entire Bonington household moved from Calais to their first recorded address in Paris, 22, rue des Moulins, from which they would advertise themselves as "fabricants de tulles uni et brodé." By 1824, when they had again relocated to the rue des Mauvais-Paroles near the Louvre, the commercial directories listed them under the category of lace merchants. In effect, the family had moved to Paris in order to establish a retail outlet for the goods that Webster, and probably others, were manufacturing in Calais. They would continue this business until about 1825, when the income from their son's art became sufficient to guarantee their financial security.

From this first brief period of approximately one year's duration at Calais date the younger Bonington's earliest traceable works of art (no. 1; fig. 4). Considerable claims have been proffered recently for both the stature of Louis Francia as an artist and his influence at this formative stage of Bonington's career.[21] When Francia departed London, he was a professional watercolor painter of reputability and connections.

Fig. 2: *Shipping Off Calais Pier*, ca. 1818
Watercolor $7\frac{7}{8} \times 10$ in. (20 × 25.4 cm.)
Private Collection

Fig. 3: Thomas Girtin (1775–1802) and J. B. Harraden
View of Pont St. Michel taken from Pont Neuf, 1802/3
Etching and aquatint 10 × 18 in. (25.4 × 45.5 cm.)
Yale Center for British Art, New Haven

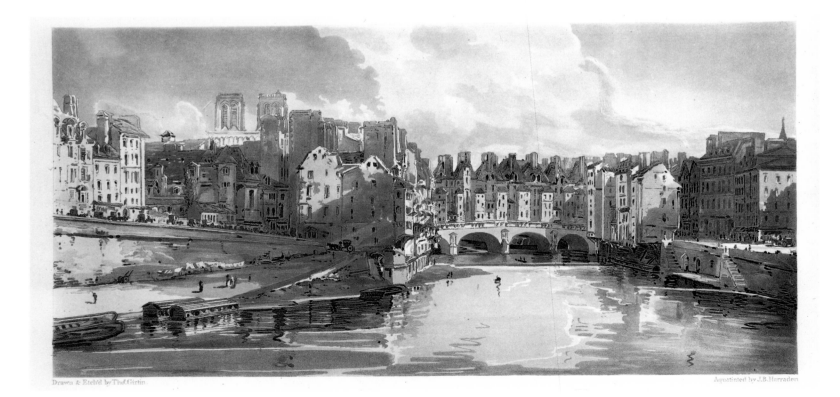

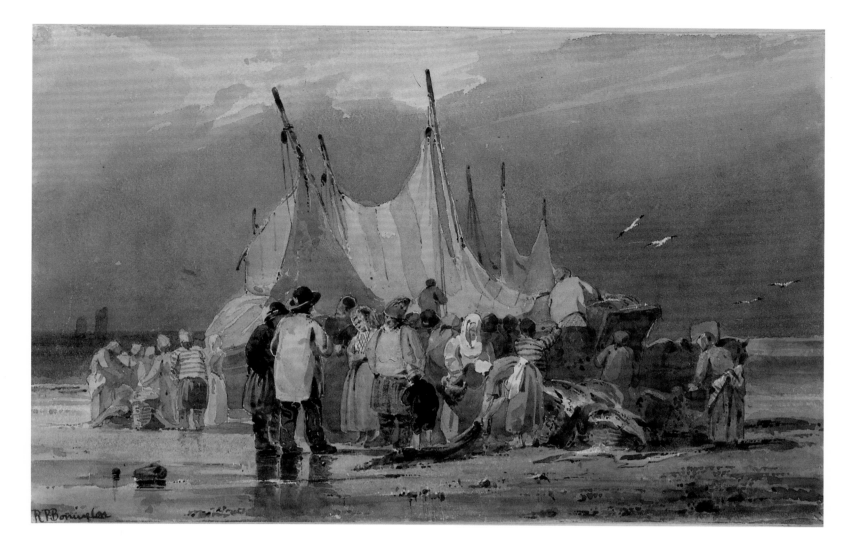

Fig. 4: *A Fishmarket on the French Coast*, ca. 1817-18
Watercolor $5\frac{7}{8} \times 9$ in. (15 × 23 cm.)
Private Collection

With Thomas Girtin (1775–1802; fig. 3), Copley Fielding (1787–1855), Samuel Prout (1783–1852; no. 89), and others, he had championed, against the prejudices of tradition and of patronage, the cause of naturalistic landscape painting in watercolors. But Bonington's father would have been no less familiar with these developments, the most progressive of any sphere of British pictorial art during the first two decades of the century, and it was undoubtedly from him, modest as his own talents were, that Bonington learned the rudiments of watercolor painting as a normal concomitant to his general education. Francia would have helped him to sophisticate his watercolor technique, and, by his own example, would have reinforced Bonington's predilection for marine subjects; but any preponderant stylistic indebtedness to the senior artist is decidedly lacking at this point, except insofar as the watercolors produced by Bonington in Calais and shortly afterward in Paris (no. 3; figs. 2, 5) exhibit the same interests in economically segmented and at times almost abstract applications of wash in the sombrous palette of the sublime that epitomizes what has come to be known as the "corporate style" of the first London Watercolour Societies. Commencing where Girtin had left off, Bonington would outpace, within four or five years, many of the most progressive masters of this school.

The principal source of information on Bonington's initial activities in Paris is the manuscript notes that the artist James Roberts (fl. 1818–1846) wrote in response to a brief, and essentially flawed, biography of Bonington published by Allen Cunningham in 1832.[22] In 1818 Roberts was also a student in Paris, and he would eventually achieve some recognition as a drawing master and minor topographer in France. His pedigree is uncharted, but he might have been the son or nephew of the portraitist and drawing master of the same name whose manual for dilettantes, *Introductory Lessons, with familiar examples in landscape for the use*

19. First recounted by Dubuisson (1909, 86) on the authority of a descendent of Francia's friend, M. Isaac.

20. For the works by Delacroix in this exhibition, see nos. 37, 39, 40, 41, 66, 69, 110, 134, 137, 142.

21. The relevant publications are Smith, *Francia*; Calais, *Francia*; and Pointon, *Circle*.

22. Cunningham, *Lives*, passim. Roberts's notes, written in English to an unidentified correspondent, together with most of the original Bonington correspondence first published by Dubuisson and Hughes, are in the Bibliothèque Nationale, Cabinet des dessins, réserve, Bonington Dossier, hereafter referred to as Roberts, BN Bonington Dossier and as BN Bonington Dossier.

Fig. 5: *An Unidentified French Town*, ca. 1820
Watercolor $5\frac{7}{8} \times 8\frac{1}{2}$ in. (15 × 21.6 cm.)
Musée Fabre, Montpellier

Fig. 6: James Roberts (fl. 1818-1846)
Château Azay-le-Rideau, 1831
Watercolor $5\frac{1}{2} \times 9$ in. (14.2 × 23 cm.)
Christie's, London

Fig. 7: Anonymous (19th Century)
Portrait of R. P. Bonington, ca. 1820
Watercolor $8\frac{1}{8} \times 6\frac{1}{2}$ in. (20.6 × 16.5 cm.)
Musée des Beaux-Arts et d'Archéologie, Besançon

Fig. 8: Alexandre-Marie Colin (1798-1873)
Portrait of R. P. Bonington, ca. 1824
Graphite $4\frac{7}{8} \times 4$ in. (12.5 × 10 cm.)
Musée Carnavalet, Paris

of those who are desirous of gaining some knowledge of the pleasing art of painting in watercolours (London, 1800), was one of the earliest to recommend the works of Girtin and J. M. W. Turner (1775–1851; no. 48). Roberts's rare watercolors of the 1820s and 1830s (fig. 6) are in a conventional wash style similar to that of other British watercolorists then active in Paris, but particularly that of Thales and Newton Fielding (1797–1856; no. 146). One finds occasional examples of Bonington's flirtation with this essentially decorative naturalism in works of ca.1820–21. Since Roberts was probably the first artist that Bonington encountered in Paris, and since they would remain the best of friends, his recollections are not without compelling claims to both accuracy and our attention:

[Bonington's father] *had undoubtedly encouraged and given the first instruction to his son in drawing and painting. Very soon after the family came to Paris, I became acquainted with them I was myself painting in the Louvre and such was the facility awarded to foreigners and the public in general for study that any person who chose might sit down at an easel and copy any work of art they pleased without any previous permission. So young Bonington who was at that time about 15 years old set immediately to work and copied in watercolor a small picture which I remember such to have been by Gerard Dou, a Dutch woman at a window holding a dead cock — this picture I suppose was pointed out to him by his father as I doubt much even at that early period his natural choice would have hit upon a picture of that master. About the same time, his father, very eager to obtain the best instruction in art for his son, consulted with me on the subject. I recommended the studio of Baron Gros, to whom we went . . . and the result of our application was young Bonington's immediate reception into the atelier of that distinguished painter. Here he worked very assiduously for some time in the morning He very soon got through the preliminary drudgery of copying the master's drawings hung upon the walls and then proceeded to draw from the life* [antique casts] *. . . . The commencement of Bonington's rise might be said to date from the moment he studied in the Louvre and when he became a pupil of Gros. His first appearance in the atelier excited no more sensation than would that of an arrival of an ordinary boy except that it was immediately remarked that he had "une boule anglaise bien characterisé," according to the habitual phrenology of that place* [figs. 7, 8].

Bonington's outward appearance at the time was particularly boyish owing to his plump round cheeks and as he had not a large mouth the fleshy rotundity of his lips contributed to the effect of boyhood and yet a nice observer would observe in his eyes unequivocal marks of intelligence [He] soon got tired of the monotonous drudgery . . . and after some months application in drawing from the life he naturally felt a desire to paint from the life. This desire was very unwisely opposed by the master who tho' evidently very much interested by the remarkable facility of the pupil manipulated that interest in a way particularly unpleasant to the pupil. He was daily reproached for idleness and carelessness, of being linked with and encouraged in that idleness by another pupil worse than himself [Jules-Armand Valentin]. *The reproaches of the master were that violent nervous vehemence characteristic of the man and altho at the time the flagrant injustice and absurd severity of the master towards his interesting pupil excited a mingled feeling of indignation and derision, it was one of the incidents in the life of Mr. Gros which was afterwards charitably accounted for when that nervous excitement to which he was subject terminated so fatally in suicide.*[23]

Since both Paul Mantz and J.-B. Delestre claimed that Bonington enrolled in the atelier of Baron Antoine-Jean Gros (1771–1835) in April 1819,[24] it can be deduced from Roberts's account that he had been copying paintings in the Louvre during the spring under the direct tutelage of his father. From the titles of certain early oil paintings, now regrettably lost, that appeared in the auction following the death of

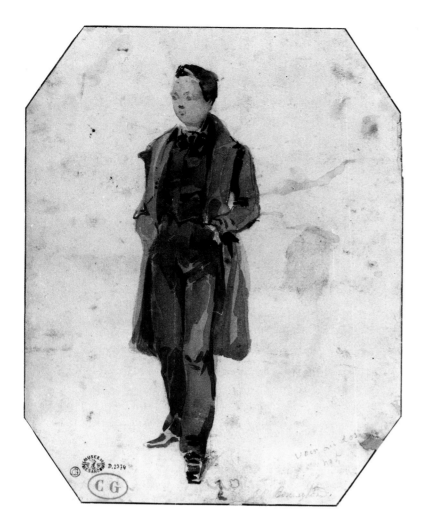

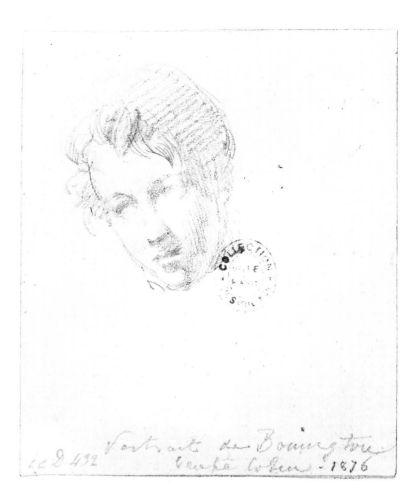

Bonington's mother in 1838, it is apparent that his father's instruction also included that medium. The models for those compositions — *Holy Maid of Kent* and *Jephtha and His Daughter*, for instance — were certainly engravings after paintings by British artists,[25] since they were executed in March 1818 when the family was still in Calais. Of interest in the context of Bonington's initial tuition are the contents of the sale of the graphics collection that father and son had amassed during their lifetimes. In over two hundred lots were works by the Master of the Die, Dürer's complete *Triumphal Arch of Maximilian*, approximately sixty etchings by Rembrandt, not to mention another twenty lots of prints by Jan Both, Karel Dujardin, Anthonie Waterloo, Claude Lorrain, the Van de Veldes, and Nicolaes Berchem; engravings by Marcantonio Raimondi; and the complete works of Canaletto. Certainly, many of these old master prints were acquired over the decade of the 1820s, but it is reasonable to assume that a portion were the residue of the "repository" stock and that when Bonington was taken in hand to display his juvenilia to Gros, he was already advanced in his studies and familiar with a considerable range of the history of Western design. That his father would have set him the task of copying Dou's picture is thoroughly reasonable in the context of the prevailing taste in England for seventeenth-century Northern genre painting, but also quite perceptive of a dominant strain of Restoration taste. Théodore Géricault's *Raft of the Medusa* might well have been the most significant and controversial painting on view at the Salon in August 1819, but it was the cabinet art of the troubadour painters that enthralled most private collectors, especially that of the Lyon school, for whom Dou's pictures (fig. 54) were the *ne plus ultra* of art.

Gros's studio, located in the Institut de France (no. 161) and capable of accommodating sixty pupils of varying levels of proficiency, was the most prestigious in Paris, and although Gros was not the easiest or most regular of masters, he conducted his business efficiently. Bonington

23. Roberts, BN Bonington Dossier. The author identified Bonington's idle atelier companion only by the initial V. Marcia Pointon sensibly suggested that this was the minor landscape painter J.-A. Valentin (b. 1802).

24. Mantz, *Bonington*, 291; J.-B. Delestre, *Gros, sa vie et ses ouvrages* (Paris, 1867), 365.

25. John Opie's *Jeptha Sacrificing His Daughter* was engraved for Macklin's *Bible*.

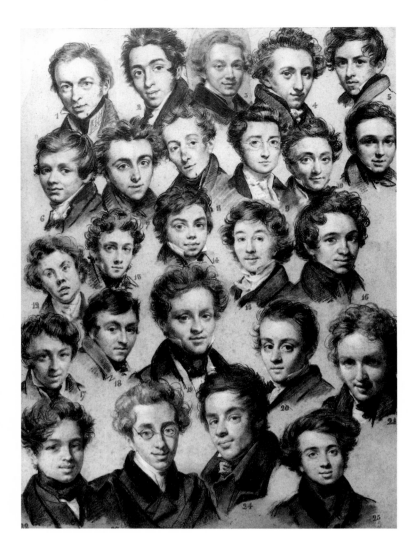

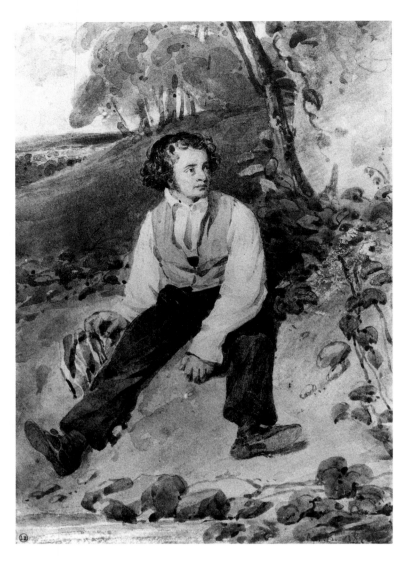

Fig. 9: Louis-Léopold Boilly (1761-1845)
The Students of Baron Gros in 1820
Black and white chalks $23\frac{1}{4} \times 15\frac{3}{8}$ in. (59.5 × 39.1 cm.)
Musée Carnavalet, Paris
R. P. Bonington (no. 17); Paul Delaroche (no. 9);
J.-A. Valentin (no. 11); J.-A. Carrier (no. 13);
N.-T. Charlet (no. 21); Eugne Lami (no. 22).

Fig. 10: *Portrait of Young Man (P.-J. Gaudefroy?)*, dated 1820
Watercolor $9 \times 6\frac{3}{8}$ in. (22.8 × 16.3 cm.)
Musée Bonnat, Bayonne

Fig. 11: *Piping Faun*, 1820
Black and white chalk on blue-gray paper 23 × 15 in. (58.4 × 38.2 cm.)
Yale Center for British Art, New Haven

devoted his mornings to study in the atelier, where Gros presided from 11 am to 1 pm, and his afternoons copying in the Louvre, open daily to artists and foreigners from 10 am to 4 pm, and at the Ecole des Beaux-Arts, to which he was permitted access as a benefit of Gros's sponsorship. Among Gros's pupils in 1819 (fig. 9) were several who would achieve distinction as artists or historians — Paul Delaroche (1797–1856), Joseph-Nicolas Robert-Fleury (1797–1890), Nicolas-Toussaint Charlet (1792–1845), Johann-David Passavant (1787–1861), for example — and most of the artists with whom Bonington would share his closest ties — Eugène Lami (1800–1890; no. 5), Camille Roqueplan (1800–1855; nos. 74, 117), and Auguste-Joseph Carrier (1800–1875). Roberts, Pierre-Julien Gaudefroy (b. 1804; fig. 10), Paul Huet (1803–1869; nos. 56, 79), and Henri Monnier (1799–1877; see no. 57) also overlapped at the end of Bonington's period with Gros.

A few surviving studies from the antique faintly track Bonington's progress as an academic. The students of the several ateliers necessarily had to compete for places in the rooms set aside for studies from the live model, while the less experienced scrambled for benches in the rooms housing the antique casts or found comparable sculpture in the Louvre or the studios of their respective masters. Because of an ever-increasing number of applicants, the Ecole des Beaux-Arts faculty voted in June 1820 to inaugurate a biannual competition for places in their cast room as well. The first competition of 6 August, in the middle of the summer semester (April to October), was for immediate assignment. Of the 64 competitors, Bonington placed 25th. Delacroix, then nominally a student of Guérin, placed 32nd, and Achille Devéria (1800–1857) at 50th. Artists like Alexandre-Marie Colin (1798–1873; no. 136), who had earlier competed successfully for places in the model room, were exempted from having to participate. A second competition followed on

11 September for placement during the upcoming winter semester (October to April). In this, Bonington did considerably better, finishing 19th of 53. His competition entry, the chalk drawing *Piping Faun* (fig. 11), typifies the Ecole style with its emphatic contours and delicate interior modeling.[26] A contest for placement in the model room for the winter semester was held on 3 October, and in this Bonington slid to a humiliating 60th of 61 aspirants. Even though he was competing against many more advanced students, his abysmal showing surprises in that a life study drawn in a private studio the preceding April (no. 6) is as competent as any comparable exercise by Colin, for instance, who finished 13th. Bonington never repeated the trial for admission to the model room, although he would again compete for places in the cast room in May 1821 (46th of 72), May 1822 (21st of 53; Delacroix was 31st), and September 1822 (46th of 80; Huet was 51st). He also abstained, or was barred, from the other annual competitions organized to determine the awards of the academy's ultimate benefactions, the *Prix de Rome* for history painting and for historical landscape.

Every contemporary account of Bonington's period with Gros refers first to a major breach in their relationship and then to some form of reconciliation. The explanations for Gros's hostility are not uniform, although all touch on his frequently cited intransigence against Bonington's wish to either draw or paint from the live model. When the engraver Abraham Raimbach (1776–1843) visited Gros about this time, he found him "in opulent circumstances, of eccentric character, and as I was told (tho I did not find him so) of harsh and repulsive manners."[27] Doubtless, Gros was a difficult man, but the severity of his public chastisement of Bonington, as noted by Roberts and others, seems both excessive and unfair. It would serve Bonington's reputation well in several years, but at the time it must have been exceedingly irksome and disheartening. In analyzing Gros's career, Delacroix would later mark the beginning of his decline into the spiritless and cold neo-classical conceptions of his later years — his "fall from the sublime" — to the moment he assumed responsibility for Jacques-Louis David's school. In 1817 Gros transformed himself into a pedagogue, "intent on continuing in his teaching the traditions of David."

It even seemed that he wished to make his students forget just how much his own manner diverged from that of his master. "My aim," he often said, "is to form artists and to send them to Italy at the expense of the government." And in this tendency he was encouraged all too much by David. Certain that he was reviving his own principles in Gros's teaching, he insisted that Gros himself practice these in his own work . . . but [Gros] was ill at ease in this pedantic form and under this academic guise.[28]

As David's anointed proxy, Gros was in the awkward position of having to enforce a regimen and inculcate a taste that, for nearly three decades, he had himself brilliantly skirted (fig. 22). Perhaps he divined in Bonington's enthusiasms an unmalleable sensitivity subverting the principles he was now endeavoring to instill in other students. Even after entering the atelier, Bonington continued to refine his proficiency in the denigrated genre of landscape watercolor painting, and his works were flaunted by friends in the atelier. Bonington's literary predilections were also already entrenched:

Classical literature he never thought of. Indeed, he frequently evinced an aversion to it probably because it was remotely connected with the unhappiness of his atelier studies . . . de Malinet, de Monstrelet, Froissart and their antiquated language had particular charm for him. In his possession always might be frequently seen the romances of early French literature such as Gerard de Nevers, le petit Saintré, Lancelot du Lac, etc. — all modern romances too that were characterized by a merit for archaeological truth were always sought by him.[29]

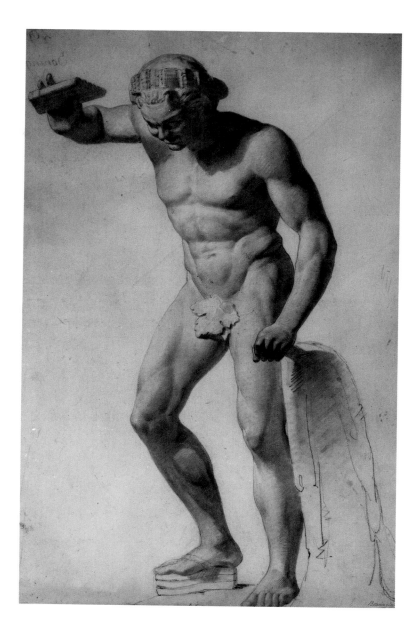

26. Other examples are in the British Museum and the Nottingham Castle Museum. The homogeneity of this style can be appreciated by comparing Bonington's studies with those of other students, like Eugène Devéria (Bibliothèque Nationale, Cabinet des dessins, réserve, Devéria).

27. Raimbach, *Memoirs*, 56 n.77.

28. Piron, *Delacroix*, 251. Delacroix's essay on Gros was originally published in *Revue des Deux Mondes* (1 September 1848).

29. Roberts, BN Bonington Dossier.

Obviously the *Prix de Rome* and the erudition in classical history it required were remote from Bonington's thinking, but perhaps more alarming to Gros would have been his palpable contempt for David, whose insistence on the scrupulous copying of the model he considered "the embodiment of the absurd, the preposterous and the unnatural." Roberts recounts:

We were walking together through the gallery of the Louvre in company with a friend who had been a contemporary of David and in coming opposite the great picture of the Sabines by that artist, said do you see the figure holding the spear in the foreground? Well ... David [said] that not one of those fellows, our ordinary models, could pose for that figure. "I was obliged to beg the bon Vestris (the dancer) to come and stand for it." This I remember elicited in Bonington's features (which by the way were not remarkable for their expression) a mingled look of sorrow terminated by one of pity manifested by a slight shrug of the shoulders.[30]

By the summer of 1821 the relationship between student and professor had become insupportable. In September Bonington's name was missing, for the first time, from the list of students competing for placement. With money garnered from the sale of his watercolor views of Paris and its suburbs and of his vignette illustrations to fashionable literary publications (no. 4), he embarked in the fall on his first extensive sketching tour.

Disregarding the expected observance of the time, Bonington ventured not to Italy but to Normandy. Roberts informs us that he returned via Rouen, but the actual course of his perambulations can only be surmised on the evidence of surviving studies of identifiable sites. Among the graphite sketches are conscientious renderings of the architectural monuments at Caen and Abbeville, the two towns that probably mark the geographical limits of this tour. He also stopped at Trouville, Ouistreham, Honfleur, Dîves, and Beauvais. Two untraced watercolors exhibited at the Salon in April 1822 indicate that he worked at Le Havre and Lillebonne. Thus far, no drawings of ports north of the Somme — Boulogne, Calais, Dunkerque, etc. — can be associated stylistically with this group. The duration of this tour, which might have been made in Roberts's company, was only a month or two.

Bonington's exhilaration at escaping the monotonous routine of the atelier and the constraining precepts of academic design manifested itself immediately in such studies as *Pile Drivers at Rouen* (nos. 10, 11). Their exuberance of line and defiance of the plasticity of antique sculpture betray a youthful spirit intoxicated with its first freedom and enchanted with its rare powers of autographic expression. Common laborers absorbed in the vitality of daily secular existence oust piping fauns and Roman wrestlers as the objects of scrutiny. With the exception of Géricault's near-contemporary, but remarkably different, depictions of English laborers, there are few works by French artists at this moment that contest so unequivocally the popular anecdotal banalities of Martin Drölling's (1752–1817) sanitized scullery maids and his reigning school of *ancien régime* genre.[31]

In electing to tour Normandy, Bonington was pursuing the impulses of his interest in coastal landscapes, a specialized branch of naturalistic painting not abundantly practiced in France but rapidly finding favor, and of contemporary fascination with the monuments and historical associations of postclassical European history. The revival of interest in the Middle Ages, that 'don quixotism' of the era as Théophile Gautier later derided it,[32] was well advanced in France by this date, but it was not until the publication of the first volume of *Voyages pittoresques et romantiques dans l'ancienne France* in April 1820 that opportunities existed for the subsidy of draftsmen specializing in the antiquarian/

topographical discipline. Commenced as a speculation by Isadore Taylor, Charles Nodier, and Alexandre de Cailleux, the twenty-six volumes that eventually comprised *Voyages pittoresques* were unquestionably the most monumental and arguably the most influential illustrated publication of the nineteenth century. The intentions of the publishers and authors were multifarious. The prose — erudite, sarcastic, punctuated with regional anecdotes — set a new standard for the writing of history in France, while the accompanying plates established and legitimized the still novel art of lithography. In defending the length and the content of the first two volumes devoted to Normandy, Nodier wrote:

This region offered us the opportunity to develop extremely radical theories on the architecture of the Middle Ages ... [also] we found, in describing the ruins of Normandy, that the monuments to which the epithet Gothic had been applied disdainfully, and of which we relegated the construction to an age of barbarism, were of a period that was neither so savage nor so barbarous.[33]

In general it might be argued that *Voyages pittoresques* awakened in the French nation a sense of its own history, shifted the emphasis of the educational system from Homer to Froissart, publicly acknowledged the vitality of provincial traditions, and helped ban the wanton destruction of medieval architecture that had begun as iconoclasm in the eighteenth century but had persisted through cupidity and ignorance well into the Restoration.[34]

Bonington would not participate immediately in this program, but he was clearly committed to preparing himself for future service in this field, the taste for which had contributed so decisively to the popularization of watercolor painting four decades earlier in Britain. Characterizing the studies from (fig. 12), and the consequences of, the Normandy trip, Roberts observed that Bonington, "evinced always a sort of instinctive predilection for historical reminiscences Indeed, from this time forward his works, whether consisting of picturesque architecture or of poetical compositions, exhibited a decided attention to costume and archeological truth. This was derived from and in harmony with his literary predilections."[35] Like most artists of his generation, Bonington was enamored of that enchanting blend of historical pageantry and exacting archeological research that distinguished the novels of Sir Walter Scott. These initial studies of Gothic monuments, scrupulously observed yet drawn with an élan and candor for which we are ill-prepared, are the first evidence of this fully mature taste and direction. These drawings also divulge a growing familiarity with English art in that their technique has less in common with French draftsmanship than with the contemporary antiquarian styles of John Sell Cotman (1782–1842), Henry Edridge (1769–1821), and Samuel Prout, all of whom were working in northern France at this time, or Charles Wild (1781–1835), who was collecting material for his *Select Cathedrals of France* (London, ca.1826) in the early 1820s.

At the beginning of 1822 Bonington was back in Paris satisfying a commission from J.-F. d'Ostervald, a Swiss national with a publishing firm on the quai des Augustins soon to become a clearinghouse for modern British art. His father also published, and between them they dominated the Parisian trade in illustrated travel books. In May the younger d'Ostervald announced the imminent publication of the first installment of a monumental *Voyage pittoresque en Sicile*. The text, descriptive of the history of Sicily, had been furnished by Achille Gigault de la Salle, an antiquarian and correspondent of the Institute. The illustrations were designed principally by Auguste, Comte de Forbin (1777–1841), director of the Royal Museums, with additional contributions by the English architect C. R. Cockerell (1788–1863), by Achille Michallon (1796–1822), who was then considered the premier

landscape painter in France but who would die in September at age 26, and by two future Bonington patrons, Comte de Pourtalès-Gorgier (see no. 44) and Jean-Charles, Comte de Vèze (see no. 34), both of whom were amateur artists. D'Ostervald's publication, in two volumes of forty-four (1822) and forty-nine (1826) plates, was a tour-de-force of British technology and taste, for he imported not only superior plate paper from the firm of James Whatman for printing, but also no fewer than eight British aquatint engravers.

Prior to engraving, the sketches by de Forbin and others were to be translated into watercolors, and once again d'Ostervald sought British expertise. Among those who worked with Bonington on this project were the Fielding brothers Theodore (1781–1851), Thales (1793–1837), who became in this year Delacroix's close friend, Newton, and Copley, the most accomplished of the four. Also engaged were Charles Bentley (1806–1854), the marine watercolorist whose mature style was indebted to Bonington, and George Fennel Robson (1788–1833), a senior member of the Society of Painters in Watercolours. Bonington's modest contribution were two watercolors after de Forbin of views at Trapani and Catania. The last was exhibited at the Salon in April 1822 under d'Ostervald's name, together with nineteen watercolor and oil sketches by a sampling of other contributors, including the debut performance of Eugène Isabey (1803–1886; see no. 150). The variety and richness of the watercolor styles represented by the few, if distinguished, representatives of the British school must only have encouraged Bonington in the direction to which he seemed innately propelled. Roberts observed of the watercolors painted in this year that they were often "reminiscences of art rather than nature," and although he was referring primarily to Bonington's figure subjects, a watercolor like *The Harbor at Le Havre* (no. 8) might well qualify for inclusion. The precision with which the washes are applied and the daring juxtaposition of oranges and blues have close parallels in Robson's distinctive style.

Under his own name Bonington exhibited at the Salon the two previously cited watercolor views of Lillebonne and Le Havre. Although they are not mentioned specifically in any reviews, both were acquired by the philanthropic Société des Amis des Arts for 430 francs, which represented a respectable advance beyond the 15 francs he was receiving for a watercolor only a year earlier. In December the Société held its annual exhibition prior to the public lottery of the seventy-eight works of art they had acquired since January. Boutard, the art critic for the *Journal des Débats*, after commending the Société's patronage of "genre," a period catch phrase for any artwork that was neither classical in its subject matter nor academic in its style, designated as "precious" the watercolors of Bonington and Johann Heinrich Luttringshausen, another of d'Ostervald's draftsmen.[36] Since Bonington competed for places in the cast room in May and, for the final time, in September, we may reasonably assume that he had returned, at least temporarily, to Gros's studio. According to both Delacroix, who was in a position to comment, and Huet, who was enrolled in the atelier this year, Gros eventually did acknowledge his pupil's talent, persuading him to pursue his metier as a watercolorist but offering him the studio's facilities.[37] It is likely that Bonington remained in Paris for much of the year, but he was occupied primarily with commissions for watercolors like *Eglise Notre Dame de Dives* (no. 13), which in its scale and elaborate applications of wash marks a departure from the modest sheets thus far produced.

The first coherent and substantial body of surviving works indicates that by 1823 Bonington's watercolors had become, if not the rage, then quite desirable with publishers, dealers, and private collectors. For as Roberts noted of the taste of the period, "everyone felt bound to have an album and everyone felt also bound to fill it in some shape as others."

Fig. 12: *Colombage Facade, Caen*, ca. 1821
Graphite $13\frac{1}{2} \times 9\frac{1}{4}$ in. $(34.5 \times 23.5$ cm.)
The Earl of Shelburne, Bowood

30. Ibid.
31. See, for instance, Drölling's *Interior of a Kitchen* (1815, Louvre), which was allowed by academics to be "acceptable" genre painting.
32. Théophile Gautier, "Voyages Littéraire," *La Charte de 1830* (6 January 1837), reprinted in *Fusains et Eaux-Fortes* (Paris, 1880), 41–44.
33. Preface to *Voyages pittoresques, Franche-Comté* (Paris, 1825), 1: 5.
34. As Nodier's friend Amédée Pichot argued (*Tour* 1: 67), the fundamental aim of the project was to describe, verbally and visually, "the architectural monuments which impart a moral physiognomy to our soil." Other contemporary reviewers were unanimous in this opinion; see, for instance, the *Journal des Débats* (24 March 1826): 2–4, and Victor Hugo, "Sur la destruction des monuments en France," *Revue de Paris* (August 1829; *Oeuvres complètes* 2: 569–71).
35. Roberts, BN Bonington Dossier.
36. "Exposition de 1822," *Journal des Débats* (7 December 1822): 3.
37. The artist P.-A. Labouchère also independently confirmed this reconciliation, although his account of Gros warmly embracing Bonington in front of the assembled studio was probably overstated; see "R. P. Bonington," *Notes and Queries* (10 June 1871): 503.

ST. VALERY

VUE PRISE SUR LES BORDS DE LA SOMME.

Fig. 13: *Sketch of the Choir Screen at Amiens Cathedral*, ca. 1823–24
Graphite $9\frac{1}{8} \times 10\frac{5}{8}$ in. (23.3 × 27.2 cm.)
Private Collection

Fig. 14: Thales Fielding (1793–1837) after R. P. Bonington
St-Valery-sur-Somme, 1825
Aquatint $8\frac{1}{4} \times 11\frac{3}{8}$ in. (21 × 29 cm.)
The British Museum, London

Fig. 15: *Rouen: Fontaine de la Crosse*, ca. 1823
Lithograph (working proof) $12\frac{3}{4} \times 10\frac{5}{8}$ in. (32.5 × 27.2 cm.) (sheet)
Stanford University Museum of Art, Palo Alto
The R. E. Lewis collection of Bonington prints and
books given in memory of Dr. Alfred J. Goldyne
by the Goldyne Family

To help satisfy this demand the dealer Madame Hulin had recently opened a drawings gallery in the rue de la Paix, and Bonington rapidly became her most profitable artist. In addition to those professionals who would later adopt Bonington's style — the future president of the Ecole des Beaux-Arts Robert-Fleury, for instance — there were many now obscure imitators, like Jules Joyant (1803–1854), who were also promoted by this dealer because of her own and her clients' enthusiasm for the Englishman's watercolors. Joyant admitted as much when he wrote, "During Bonington's lifetime Madame Hulin was known to be very partial to his drawings, and I have no doubt that she decided to purchase several of mine because they reminded her of those by my master in watercolors."[38] On a different front, the *Sicile* plates and Bonington's modest success at the Salon persuaded d'Ostervald to engage him in another ambitious project, *Excursions sur les côtes et dans les ports de France*, the details of which are discussed under *The Inner Port, Dieppe* (no. 14). This commission subsidized a second tour in 1823, ranging north from Rouen along the coast to Calais and Flanders and then back to Paris via Amiens and Beauvais. Most of the graphic material culled from this itinerary — sketches and finished watercolor delineations of the ports from Le Havre to Dunkerque — would appear subsequently as aquatint illustrations in d'Ostervald's publication (fig. 14).

A further incentive for this trip was the artist's desire to enlarge his store of antiquarian studies (nos. 20, 22; fig. 13), for by the spring, committed as he had become to supporting himself as a draftsman, Bonington had envisaged the publication of his own set of Gothic architectural illustrations. Employment in Baron Taylor's more grandiose project was also an aspiration. To succeed in either ambition, he had first to learn the technique of lithography, and for this he undoubtedly sought the advice of his first mentor. Louis Francia definitely resided in Paris for part of the spring, publishing several lithographic views of the environs of the city and gathering additional material for a larger publication (no. 17). Of the three known impressions of Bonington's earliest lithograph, a view of the port of Dunkerque,[39] two in the Bibliothèque Nationale are printed on a chocolate-brown paper and heightened with white bodycolor. These technical idiosyncrasies are typical of Francia's engraved imitations of drawings. A known Francia watercolor of the subject might also have served as the model. Francia, in turn, had probably only recently learned the process from Samuel Prout, just prior to the publication of his own first suite of lithographs, *Marine Subjects* (London, 1822). Bonington also scrutinized the style of watercolor painting that Francia was then practicing. The more pronounced tautness of design and the delicate finish of the watercolors executed for d'Ostervald this year are the only overt imitations of the senior watercolorist's technique to manifest themselves in Bonington's oeuvre.

The ten lithographic plates for his own publication, *Restes et Fragmens* [sic] *d'architecture du moyen age*, or "le petit Normandie" as it is often titled to distinguish it from the Normandy volumes of Taylor's *Voyages pittoresques*, represented a material effort in time and resources not without financial risks. Bonington was still relatively unknown as an artist, and he had yet to demonstrate his skill as a lithographer, but he secured the backing of two of the most important graphics publishers of the period, Motte and Gihaut, who were then publishing lithographs by Gros and Géricault among others, of Madame Hulin, and of the London firm of S. and J. Fuller. Since he listed himself as a copublisher at his parents' address, it is also probable that his family shared in the speculation.

Mimicking in certain respects Taylor's format, but lacking any text, the set comprised three views each at Caen and Rouen (see nos. 19–22), and one each at Lillebonne, Abbeville, Beauvais, and Berques. The

selected "bits and pieces" were not strictly confined to Normandy but included monuments in Picardy and Flanders. In effect, there was some effort to capitalize on the nearly simultaneous publication of Taylor's Rouen suite in *Voyages pittoresques, Normandie II*, while offering a glimpse of treasures in provinces not yet addressed by that "parent" enterprise. As in *Voyages pittoresques*, the selection of images interlaced panoramic views of cities with renderings of entire ecclesiastical and civic monuments and of decorative fragments. Similarly, the figures introduced to animate these primarily urban scenes were dressed in medieval, Renaissance, or modern garb. This mélange of types, in itself a picturesque conceit, underscored the societal and religious continuity implicit in such monuments.

Feillet began printing the stones by late 1823 but delayed release of the sets until the summer, owing perhaps to difficulties in perfecting a two-color printing process. The images were intended to be printed in black on a tea-colored ground, but there are few surviving sets in which the tint stone printed uniformly. A search of the contemporary periodical literature has failed to identify any published advertisements for, or reviews of, this set of prints, but in his obituary notice for Bonington in *Le Globe*, the critic Auguste Jal observed that "the *Fragmens* in which Bonington had put so much of his originality had only a mediocre success; collectors did not appreciate these delicious designs, some of which recall Lamartine; the reception accorded them by artists was a consolation for the bad taste of the public and the monetary loss that Bonington suffered from the poor sale of his work."[40] Undoubtedly contributing to the tepid public reception were the lack of any descriptive text by an established antiquarian, the flawed printing, and the competition from *Voyages pittoresques*, in which had already appeared illustrations by other artists of two of the Rouen monuments: the courtyard of the Palais du Justice (no. 20) and the Fontaine de la Crosse (fig. 15).

As Feillet was printing *Restes et Fragmens*, Bonington was perhaps also unwittingly helping to undermine his own effort, since he had accepted a commission from Taylor to contribute to *Voyages pittoresques*. His *morceau de reception* was the grand and exceptionally beautiful *Rue du Gros-Horloge à Rouen* (no. 23), published in spring 1824 and far superior to anything in the *Restes* set. Much of Taylor's second Normandy volume was devoted to Rouen for the obvious reasons stated in the text by Charles Nodier: "There hardly exists a city ... that offers a more individual physiognomy, with more character, more distinct from that of our modern cities ... richer in the magnificent monuments that attest to the joyous inspiration and the courageous patience of the artists of the Middle Ages."[41] But there was more of interest in Rouen than its medieval remains — there was the vital integration of these monuments, steeped in dynastic and catholic associations, into the fabric of contemporary urban life:

The sight of Rouen conjures the image of a completely Gothic city which, having recently cleared the towers of its basilicas and the pinnacles of its palaces from beneath the debris which had concealed them for ages, brings together a population at once rushing with curiosity to contemplate it and desirous of raising in its open spaces the disparate and fragile architecture of hotels and stores. Such is this Palmyra or Herculaneum of the Middle Ages.[42]

The conviction that the figurative "excavation" of this city, lost to previous generations, would have as profound an impact on modern culture as had, in the last century, the literal unearthing of Greek and Roman antiquities could not be avowed with more candor.

In his prospect of the main commercial street of Rouen, Bonington adapted the delicate, luminous technique characteristic of the plates

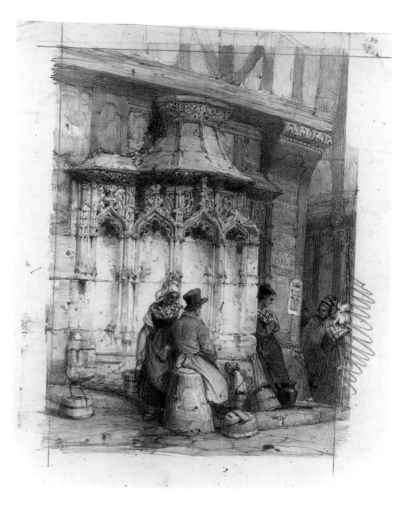

38. Jules Joyant, *Lettres et Tableaux d'Italie* (Paris, 1936), 96.
39. Curtis, no. 1.
40. Jal, *Bonington*, 746.
41. *Voyages pittoresques, Normandie II*, 47.
42. Ibid., 48.

Fig. 16: *Children at Dunkerque*, 1824
Graphite 5 × 3⅜ in. (13 × 8.7 cm.)
Bibliothèque Nationale, Paris

Fig. 17: *Figures in Carnival Costume, Dunkerque*, 1824
Graphite 3¾ × 5¼ in. (9.5 × 13.5 cm.)
Bibliothèque Nationale, Paris

Fig. 18: *French Coast with Fisherfolk*, ca. 1824
Oil on canvas 25¾ × 37¾ in. (65.4 × 96 cm.)
The Viscountess Boyd of Merton

contributed by Alexandre-Evariste Fragonard (1780–1850) and Jean-Baptiste Isabey (1767–1855), both established history painters and former students of David, who were recognized at the time as the principal collaborators in the Taylor-Nodier scheme. But the soft and all-pervasive luminosity of their technique was calculated to convey an impression of numinous mystery. With a few judicious strokes of jet black in his vivacious figures, Bonington transformed this convention into a vehicle for exacting naturalism.

In February 1824 Bonington and Colin, who had emerged by then as an intimate, departed for Dunkerque, where they planned to spend a fortnight. Colin returned to Paris in March, but Bonington stayed considerably longer. The Salon had been postponed to August, and he possibly viewed this reprieve as an opportunity to prepare his exhibition pictures unimpeded by the relentless distraction of the socializing mandatory of any artist residing in the capital. Although rapidly expanding, Dunkerque had yet to be overrun by Parisian fashionables who would stream to the channel ports for amusement and sea bathing, and it was equally untouched by the rapid industrialization occurring just down the coast in Calais. For Bonington's temperament, it was an idyllic retreat.

Roberts was meant to be of the party, but domestic commitments intruded; consequently, he was the recipient of what is now the earliest known piece of correspondence in Bonington's hand, coauthored with Colin and posted from Dunkerque on Ash Wednesday, 3 March.

My Dear Friend,
We have taken a room here for 15 days. It was nice and clean when we entered, but however it is somewhat changed since then, as for Colin he does not even know how to put a thing by after him — see what it is to have a wife — lets the fire go out — loses himself — spills the lamp oil etc. etc. [In Colin's hand] *I demand the pen from Bonington to say two words to you, dear Roberts. Namely, I much regret that you can't be with us here We speak of you often, but it's not the same as having you here. When I do something clumsy, Bonington says immediately, you should see how Roberts extricates himself, and I believe it, although I have yet to have the pleasure of traveling with you* [In Bonington's hand] *It is because of the carnival celebration in which we assisted today that I resume my letter interrupted yesterday evening. You can be assured my friend that the Paris carnival is only a S. Jean's day affair after what we have seen here. A Mexican and all the butchers of the city have taken the roles of Incan chiefs. I hope to send you a specimen at the end of the letter if my memory serves me well My friend Colin works hard but fidgets eternally. I eat for the both of us, and I wish you health as good as mine Write me by return post. I shall be glad to know how Feillet has printed my other stones, or if you have heard any thing respecting the putting off the exhibition — but however, any news will be acceptable — I hope to hear that Mrs. Roberts is better — pray let me know if you have heard anything of Ensom. My friend I am in despair, I make only scratchings.*[43]

Among the Bonington drawings in the Bibliothèque Nationale bequeathed by Atherton Curtis are approximately eighty graphite sketches on pocket sheets that once constituted at least two, if not several, proper sketchbooks. A few are on fragments of writing paper with watermarks identical to that of the preceding letter, and since others are studies of the inhabitants of Dunkerque in Mardi Gras costumes — parading as skates, Incans, Punchinello, and the like — we can date these drawings as a group accurately to this spring. The subjects on which Bonington exercised his pencil record the diurnal business and the landmarks of this provincial community — fishermen mending nets, pile drivers, criminals pilloried in the town square, the discovery of a drowned fisherman, a market day, sand dunes, children, drunkards,

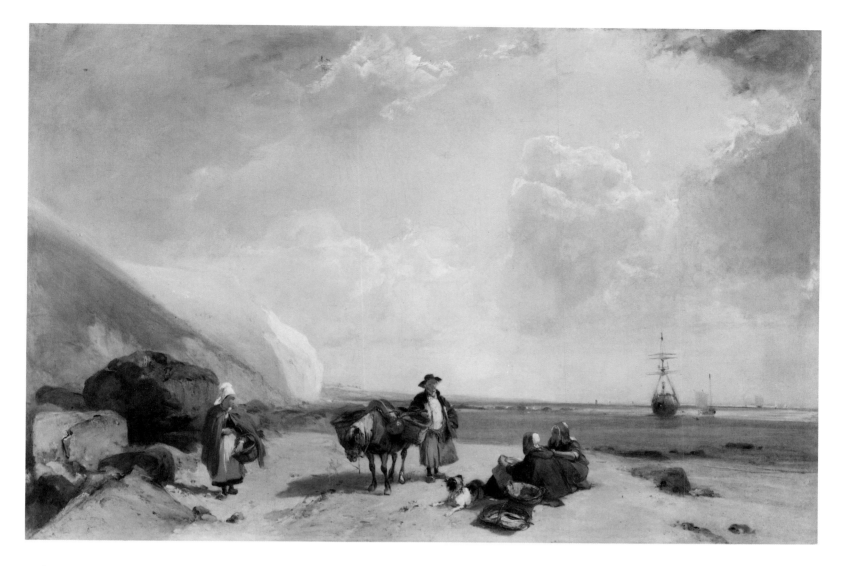

and church spires (figs. 16, 17). Another group of drawings by Colin (Musée Carnavalet), also from the same period, depict Bonington at work, asleep, picnicking, and sketching with Francia. Of this date too are a series of crayon studies of fisherfolk, to which Bonington would refer in composing his first oils (no. 30 and fig. 18).

A second letter of 5 April was addressed to Colin, then back in Paris. Amidst witty references to the cozy domesticity into which he had lapsed at the home of Madame Perrier on the quai de Furnes, and self-criticism for his procrastination, Bonington expressed regrets for having missed a dinner party hosted by the collector of medieval and modern art Alexandre du Sommerard to honor Colin's return.[44] Later in the spring Colin would rejoin him, and it is possible that he was also visited in Dunkerque by William Ensom (d. 1832), whom he mentions in his letter to Roberts. Ensom, a portrait engraver, had trained in London before moving to France around 1818–19. He was a student at the Ecole des Beaux-Arts and, with Roberts and Colin, one of Bonington's earliest acquaintances. In 1822 he and another Englishman, Joseph West, were engraving for the publisher Gosselin. Little else is recorded of his life, but in 1832 his obituarist described him as "an intimate friend of the late Mr. Bonington."[45] How intimate is suggested by the contents of his studio sale at Sotheby's, which included Colin's late portrait of Bonington (see no. 58), drawings by other expatriots of their circle — West and Thomas Shotter Boys (1803–1874; no. 164) — and, by Bonington, an impressive selection of two drawings, five watercolors, four oil sketches, and a complete set of *Restes et Fragmens*. At some point during 1824 Ensom established a permanent practice in London. Within a year he would prove to be a valuable contact in England.

The remaining plates contributed by Bonington to the Normandy volume of *Voyages pittoresques* were *Vue générale d'église des Saint-Gervais et*

43. Extracts from a manuscript letter, written in both French and English and postmarked 3 March 1824 (BN Bonington Dossier, AC 8021); Curtis furnishes a complete transcription of this letter in the preface to his catalogue of Bonington's graphics.

44. Transcription (BN Bonington Dossier) by Dubuisson or Curtis of an untraced manuscript letter, in which Bonington also wrote of a "fameuse tempête depuis ton depart. J'ai vu cela du haut de l'esplanade, ai tout entendu. Mon ami, superbe! mouillé comme une poule." His close association with Francia at this time is confirmed by a further note written at Dunkerque to an unidentified collector (Pierpont Morgan Library MA4060):

Mon cher Monsieur,

Je vous serai obligé de faire voir a mon ami Mr Francia mon confrere les tableaux que vous avez eu la bonte de me faire voir. Vous obligerez notre tres humble serviteur,

R P Bonington

45. *Gentlemen's Magazine* 102 (September 1832): 284.

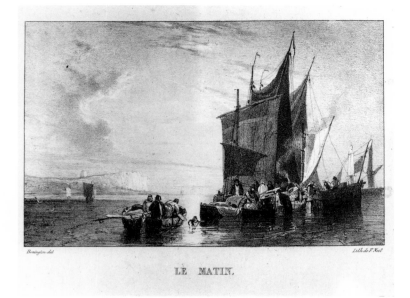

LE MATIN.

Fig. 19: *Le Matin*, 1824
Lithograph $4\frac{3}{8} \times 7\frac{1}{8}$ in. (11.4 × 18.2 cm.)
Stanford University Museum of Art, Palo Alto

Saint-Protais à Gisors, *Tour aux Archives à Vernon*, and two views at Evreux, *Tour du Gros-Horloge* and *Eglise de Saint-Taurin*. All but the last, which was a tailpiece, are dated 1824 in the stone and follow the Rouen section of Taylor's volume. Since it is unlikely that Bonington had arranged for large lithographic stones to be transported to and from Dunkerque, it is reasonable to assume that he produced these in Paris. Since Vernon, Gisors, and Evreux are clustered near the Seine half the distance from Paris to Rouen, he could have sketched the monuments for these lithographs on his journey from Dunkerque to Paris in May or June. In returning to the capital, Bonington undoubtedly hoped to superintend the publication of the first five plates of his *Restes et Fragmens*, which Feillet submitted to the government censors on 8 June. The second and concluding installment appeared on 1 September. On 19 June Bonington also submitted to the censors an impression of the now extremely rare lithograph *Le Matin* (fig. 19). Coincidentally, on the same day, Delacroix and Thales Fielding visited the dealer John Arrowsmith for the purpose of examining the oils by John Constable that Arrowsmith had imported for the Salon. On 25 June Bonington received payment of 1500 francs from the Société des Amis des Arts for two oils, *Etude de Flandre* and *Marine*, and a watercolor, *Vue d'Abbeville*, all of which had been accepted for inclusion in the upcoming Salon. Since he had been receiving approximately 200–300 francs for a watercolor, his two oils, of similar size, were presumably priced individually at 600 francs. By comparison, Arrowsmith had just paid Constable a total of 6200 francs for his *View on the Stour near Dedham* (fig. 28), *Landscape with Haywain* (National Gallery, London), and a small *Hampstead Heath*.

On 9 July Bonington wrote to Baron Taylor that he was on the eve of departing Paris with an unspecified friend and that he had just finished the stone for *Tour aux Archives à Vernon*, for which he requested 200 francs compensation.[46] Not a terribly interesting monument, it had been chosen for illustration in *Voyages pittoresques* because it had the singular recommendation of not having been molested by restorers. The evidence of a Newton Fielding sketchbook (see no. 146) suggests that Bonington and Fielding, perhaps in Colin's company, met at Dieppe on or about 24 July.[47] Fielding was traveling to Paris from London via Calais, the coast as far west as Cherbourg, and the Loire Valley. Bonington was probably returning to Dunkerque via Charles Rivet's château near Mantes, according to plans he had discussed with Francia and communicated to Colin and another artist friend, Hippolyte Poterlet (1803–1835), at Dunkerque.[48]

Beyond the pressing business of his activities as a printmaker, Bonington's reason for returning to Paris at the height of the sketching season was to deposit the works that he had chosen for exhibition in the Salon. With their catalogue numbers and approximate frame sizes,[49] these entries included no. 188, *Etude de Flandre*, oil, 54 × 62 cm., of which no. 31 in this exhibition is possibly a version; no. 189, *Marine*, oil, 59 x 80 cm.; no. 190, *Vue d'Abbeville*, watercolor, 73 × 57 cm.; no. 191, *Marine. Des pêcheurs débarquent leur poisson*, oil, 92 × 116 cm., which is no. 29 in this exhibition; and *Marine. Une Plage Sablonneuse*, oil, 51 × 59 cm., which belonged to Du Sommerard. An impression of the *Rue du Gros-Horloge, Rouen* appeared in the lithography section under the name of its printer, Godefroy Englemann (1788–1839; Salon livret no. 2101), and, according to the critics, Bonington was also represented by a selection of untitled watercolors. These were certainly designs executed for d'Ostervald's ongoing publications and submitted by that publisher (Salon livret nos. 1280–84). Although his letters from Dunkerque suggest otherwise, Bonington had been quite productive during the spring, as evidenced by these exhibition entries. More surprising, since there is little advance notice, is that he has emerged as a serious and accom-

plished oil painter.

An estimation of when Bonington began to paint landscapes in oils is as crucial for an appreciation of his creative prowess as for the urgently desired refinement of his chronology. In this century, the prevailing consensus of scholars has been that he commenced this practice shortly after settling in Paris and that the dearth of pictures assignable to the years prior to the 1824 Salon is largely a historical accident — the oils, having disappeared into private French collections, await rediscovery. Occasionally, a picture has been advanced on the slimmest of circumstantial evidence or on the optimistic assumption that any of the many small landscapes in a free style of execution inscribed with the artist's name may offer the missing link between his abundant watercolors of the years 1821–23 and the remarkable and stylistically coherent group of marine oils painted at Dunkerque in 1824. Among the most frequently reproduced of these pretenders are *View at Rosny-sur-Seine* (fig. 20), which has stood unchallenged as an exemplar of Bonington's pre-Dunkerque style in numerous group and thematic exhibitions,[50] and *View of the Seine from the Terrace at Marly* (Private Collection), falsely inscribed "RPB 1823."[51] Both of these oils represent competent plein-air sketches as surely as they are by two different hands. The inclination to ascribe *Rosny-sur-Seine* to Bonington rests not on stylistic considerations, as there is nothing in Bonington's indisputable oeuvre even remotely like, but rather on the documented fact that the artist visited the grounds of the duchesse de Berry's château at Rosny, an event authentically recorded in a "country-house" view of ca.1825.[52]

Plein-air sketching, the art of painting outdoors directly from nature, was neither the invention nor the monopoly of Bonington's generation. By 1820 it was *de rigueur* for every landscape painter in France, especially those like Michallon, Jean-Joseph Bidauld (1758–1846), Jean-Charles Rémond (1795–1875), Bonington's friend Edouard Bertin (1797–1871), André Giroux (1801–1879), J.-R. Brascassat (1804–1867), François-Edme Riçois (1795–1881), and the Constable collector A.-J. Régnier (1787–1860), most of whom in the 1820s were still committed in varying degrees to the aesthetics of the *paysage composé*. These were the innovators, who, while working within the theoretical precepts of the academic tradition as articulated by Pierre-Henri de Valenciennes (1750–1819), endeavored to infuse greater naturalism into historical or Italianate compositions and who constituted the middle ground of French landscape painting in the second quarter of the century. Many of these now obscure artists benefited from the generous patronage of the duchesse de Berry and some, like Rémond or Riçois, who exhibited a view of her château in 1824, were her frequent guests. Any of them could have painted the *Rosny-sur-Seine* oil sketch, although Rémond, who has ultimately, and sadly, been remembered only for his tutelage of Théodore Rousseau (1812–1867), comes most readily to mind. It is Rousseau's sketches of the late 1820s that the picture curiously anticipates in its taut clarity, lush orchestration of earth colors, and allusions to Dutch antecedents.

As an empirical method, the exercise of plein-air sketching was meant to improve an artist's perceptions of naturalistic phenomena and details and his ability to transcribe those impressions with celerity and accuracy. The inherent difficulty of employing oil to that end simply enhanced the benefits of mastering it. The experience garnered from such practice could then be tapped in the studio for the production of finished compositions. However, as Lawrence Gowing has observed of French practice, there existed an acute disjunction between most artists' plein-air studies and their idealized, or conceptual, studio paintings.[53] It was a problem that discomfited even the academic critics. This disjunction, furthermore, was not peculiar to those landscapists intent

Fig. 20: Anonymous (19th Century)
Rosny-sur-Seine, ca. 1820-30
Oil on paper 7¼ × 11 in. (18.5 × 28 cm.)
On Loan to the Fitzwilliam Museum, Cambridge

46. This letter is reproduced in facsimile by Henri Frantz, "The Art of Richard Parkes Bonington," *The Studio* (November 1904): 99.
47. Pointon, *Circle*, 77.
48. Manuscript letter in the Bibliothèque Nationale, Nouv. Acq. Fr. 25123(f.24).
49. As recorded in the *Registre d'inscription des productions des artistes vivant présentées à l'exposition — Salon de 1824*, Archives du Louvre. This and subsequent citations from the Salon records were kindly communicated by Stéphane Loire.
50. Cormack, *Bonington*, fig. 25; and, as a color plate, in A. Wilton, et al., *Pintura Británica de Hogarth a Turner* (Madrid: Museo del Prado, 1988), no. 62.
51. Reproduced in color by Andrew Ritchie, *Masters of British Painting* (New York: Museum of Modern Art, 1956), 39. More recently, a lovely *View of Lillebonne*, also spuriously signed "R. P. Bonington," was published by me as an early finished picture in the panoramic format employed by Bonington in his first watercolors (Noon 1986, fig. 2). I now believe, however, that while this oil may replicate an untraced Bonington composition, such as the watercolor of similar title exhibited in 1822, its chromatic range and its facture identify it more convincingly as a picture of the 1830s by Camille Flers (1802–1868).
52. Reproduced in A. Wilton, et al., *Pintura Británica de Hogarth a Turner*, no. 63.
53. Lawrence Gowing, *Painting from Nature* (Arts Council of Great Britain, 1981), 3–9.

Fig. 21: *A Sea Piece*, ca. 1824
Oil on canvas 21¾ × 33¼ in. (54.9 × 84.5 cm.)
Wallace Collection, London

solely on winning the *Prix de Rome* or securing official patronage; it tempers also the works of less compromising naturalists like Paul Huet or the brothers Xavier (1799–1827) and Léopold Leprince (1800–1847). The notion of painting a picture entirely from nature was not yet an imperative, and the relentless pursuit of visible truth, which separates the ophthalmic experience of impressionism from the reflective "poetry" of romantic or classical landscape painting, was still conditioned by studio tradition. As Huet maintained until his death:

Emotion before nature is often an obstacle to study; for my part, I have, before her great spectacles, experienced such lively impressions that I am incapable of tracing a single line; only the next day, with the recollection still vibrant, can I retrieve the scene . . . the moment of execution comes later, it is even better to let the subject rest. Then one can see the distinction between a study and a picture.[54]

The pictures presented in this exhibition as Bonington's earliest works in oils were all painted in the studio and deliberately composed. The preponderance of marine subjects accords with Delacroix's recollections and Bonington's foremost interests, but, from a purely technical point of view, marines were also congenial because they offered some of the most difficult challenges of aerial perspective, while at the same time being free of the multiplicity of picturesque detail that dominated other landscape forms. The superbly preserved panel *Calais Pier* (no. 25), which might actually have been painted in Paris just prior to Bonington's departure for Dunkerque, provides an excellent model for studying his first technique. The small wood panel was commercially prepared. The ground is near-black, but over this the artist applied a thick layer of his own near-white ground to create an opaque reflective surface. The sky, sea, and beach were painted first with the most subtle gradations of close-valued hues, the lightest being the palest blue in the upper right corner arching gradually toward the left upper edge. This has been imperceptibly feathered into the more expansive aureate section of the sky, which is more forcefully distinguished from the penumbra on the horizon by the sudden shift from warm to cool tonality and by a contrast of sweeping brush strokes below and shorter latticed strokes above that diffuse the reflected light. The "air" of the composition thus established, the perspective is consolidated and the focus defined by the darker overpainting of the boats, figures, pier, and foreground debris with a smaller but fatter touch. The layering from light to dark is typical of watercolor technique, but so expert is the command of the oil medium that one is naturally prompted to search for less accomplished antecedents.

Should we also expect plein-air studies to have preceded such pictures? The answer is perhaps, but not necessarily studies in oils. Bonington turned to oils, as he had to lithography, with the inevitability of any burgeoning genius intent on bending every vehicle of expression to the force of his graphic imagination[55]; but Bonington was a watercolorist by earliest training, and the peculiar virtues of that medium could not but imperiously command their due. By its nature watercolor painting was as demanding as oil, if not more ruthlessly unforgiving of a misjudgment, and any advantage to be gained from painting directly from nature was as attainable in the one as in the other medium. On the evidence of existing watercolors alone, one can claim for Bonington as well an exceptional visual recall, an elemental understanding of color harmonies, and an uncommon facility of touch. Assuming that he learned the basic technical requirements of oil painting from his father, with helpful advice from friends like Colin, he could have moved easily from one medium to the other. There is no need to conjecture the existence of a lost corpus of "early" paintings or to search for tentative

experiments among the plethora of unsigned oil sketches of the period. It is probably no coincidence that the earliest oils attributable to Bonington on solid documentary evidence are also stylistically inseparable from the watercolors he was painting in 1823 and 1824, nor is it fortuitous that when a version of an oil composition exists that might be construed as a preparatory exercise, that version is a graphite sketch, a sepia wash drawing (nos. 26, 27), or a watercolor (no. 32 and fig. 21). In effect, the oil technique in evidence in the pictures executed at Dunkerque is a logical translation of effects uniquely encouraged by his watercolor practice, and this process of adaptation was similar to that worked out earlier in the century by other English artists who were equally proficient in both media. It is possible that an oil or oils antedating the *Near Ouistreham* (no. 24) will yet emerge from obscurity, but an ascription to Bonington will stand only if convincing stylistic parallels can be drawn between that work and his contemporary watercolors. The sketches at Marly and Rosny-sur-Seine fail that litmus test.

After the initial spring postponement, the Salon finally opened to the public on 25 August. With over two thousand works by nearly seven hundred artists, it far surpassed in size any previous exhibition. In representing every nuance of the shifting aesthetic currents in evidence from the onset of the Restoration, it was also one of the most perplexing and closely contested cultural manifestations of the decade. The ministerial painters[56] and their pupils endeavored to sustain the neoclassical status quo against the onslaught of an agitated generation intent on breaching their hegemony. As Gautier later mused, the barbarians were knocking at the door. Factions were quickly defined, each with its supporters and detractors among the critics of the popular journals, even though the scope of the changes in progress was too manifold for any one theoretical position to quantify. Etienne Delécluze (1781–1863), a student and later biographer of David, had recently assumed the influential post of art correspondent for the *Journal des Débats*, an established newspaper left of center politically but decidedly conservative on the fine arts. In a series of twenty-six articles published between September and January, he launched his critical debut as the declaimer for the enfranchised academics. Stendhal, writing pseudonymously, and Adolphe Thiers, the future president of the Republic, among lesser voices, rose to the defense of the romantics, or more precisely, to their right of expression, for no one had the perspective to define, let alone champion, the insurgents.

According to Saint-Beuve, Delécluze was the "bourgeoisie of Paris, par excellence, neither rich nor poor; honest, a model of probity, informed yet curiously not, an avowed enemy of the Gothic and ruthless on questions of principle."[57] At the time he was actually strenuously exerting himself to comprehend romanticism but was basically frustrated by the vagueness of its doctrines. Much of the content of Stendhal's and Thiers's reviews was the fruit of heated discussions hosted by Delécluze himself. Consequently, the debates conducted in the medium of quotidian print were as often a personal squabble as an exposition of resolute theoretical ideation. Delacroix's assessment of Stendhal as "insolent, too arrogant when correct and often nonsensical," might fairly describe the attitude of both critical camps.[58]

From the outset Delécluze was waging a rear-guard action, for the second and third generation of Davidians whom he was attempting to exonerate were, by his own admission, a rather tepid lot. With David in exile, Girodet infirm (he would die in December), and Gros represented in the Salon by a single portrait, Delécluze and other critics of his stripe were compelled to wax nostalgic for pictures that had been exhibited nearly two decades earlier — Girodet's *Deluge* (Louvre), David's *Inter-*

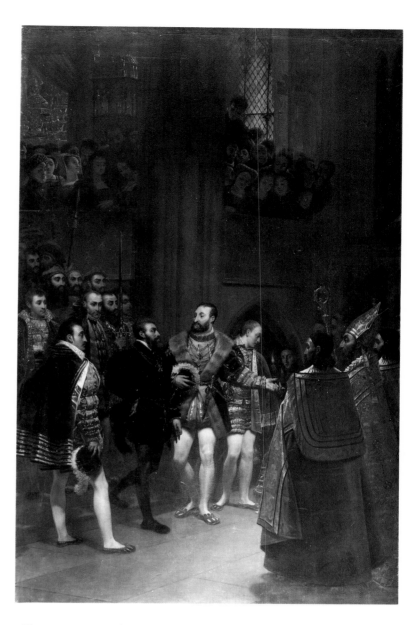

Fig. 22: Baron Antoine-Jean Gros (1771-1835)
Charles V Received by François Ier at St. Denis, 1812
Oil on canvas 105$\frac{3}{4}$ × 66 in. (269 × 168 cm.)
Musée du Louvre, Paris

54. Huet, *Huet*, 77.

55. Adolphe Thiers coined the term in his 1822 review of Delacroix's *Barque of Dante*, to distinguish the painter's formal invention as a colorist and draftsman from his conceptual imagination as a representational narrator. Baudelaire would later use the idea repeatedly in his Salon reviews to advance his support for coloristic invention.

56. The term was used repeatedly by Amédée Pichot to describe the existing system of state patronage (*Tour* 1: vi-vii):

We should not be surprised at the French ministry patronizing... the system pretending to be classical, but which ought to be called ministerial; a system which tends to deprive France of her popular literature, by condemning authors to the continual invocation of the divinities and heroes of Rome and Athens, or to the disfigurement of national subjects, by forms exclusively appertaining to antiquity. The less we attend to our national history, the less watchful we shall be of the existing government.

57. C.-A. Sainte-Beuve, "Souvenirs de soixante années, par M. Etienne-Jean Delécluze," *Nouveaux Lundis* (Paris, 1865), 3: 77–78.

58. Delacroix, *Journal* 1: 55 (24 January 1824); this opinion he recorded after attending a literary salon, quite possibly Delécluze's.

vention of the Sabine Women and *Coronation of Napoleon* (Louvre), or Gros's *François Ier Receiving Charles V at St-Denis* (fig. 22). His criticism of the interlopers needed a justification other than purely theoretical quibbles, and the first review of 1 September established its tone and parameters. It was to be highly politicized, sexist, and xenophobic. Delécluze was immediately abusive of both portraiture and the abundance of landscape paintings and watercolors. In his view, the hierarchy of genres was disintegrating and the taste for the picturesque and the feminine was supplanting the "grand and noble" spirit of earlier history painting after the antique. The malevolent effects of foreign influences and the avarice of dealers and artists were eroding the virtues of the national school, and by inference, national character. The English were to be the culprits with their Byron, Scott, and Shakespeare, their passion for the "products of commerce," especially book illustration and watercolors,[59] and their infatuation with Van Dyck, Hogarth, and the pre-Davidian "boudoir" painters Watteau and Fragonard. For the first time, British artists were also represented at the Salon in significant numbers. With the exception of Sir Thomas Lawrence's two portraits, which unsettled every French critic including Stendhal, almost all of the British exhibits were landscapes in oils or in watercolors. Excluding Lawrence once again, none of these artists had been formally invited to submit pictures, but a triumvirate of Paris's most astute dealers in modern art — Arrowsmith, d'Ostervald, and Schroth[60] — had been importing British art for months in anticipation. Like an abrasive distant cousin from the provinces, they were accepted for exhibition because neither the Salon jury nor the government was prepared to give offense, nor were they insensitive to the anglomania rampant among the most fashionable and economically powerful French circles, nor would they have been completely unsympathetic to the prospect of a mild dilution of the representation of a "school" that was still, despite David's absence, firmly associated with the revolution, the empire, and the specter of "republican virtues."[61] Gros, after all, was still agitating to bring David back from exile, but political considerations outweighed cultural and the ministry's conditions would prove too severe.[62]

Among the artists represented by d'Ostervald were Copley Fielding, Henry Gastineau (1791–1876), John Varley (1778–1842), and Charles Wild, a curious but respectable cross section of the watercolor school. Schroth owned four of the Fieldings submitted, while Arrowsmith, as previously noted, had just purchased Constable's three entries and Samuel Prout's four topographical watercolors. The single example of figure composition was Thales Fielding's watercolor *Macbeth and the Witches*. This haphazard collection of British art reinforced the stereotypical perception in France that the English had little to offer aside from occasional excellences in the minor genres of portraiture and landscape. Of the ninety-eight gold medals awarded by Charles X, however, three went to Copley Fielding, Constable, and Bonington, while Lawrence was made a Chevalier of the Legion of Honor "so as to honor his entire school in the person of its principal representative."[63] Significantly, no British works were acquired, or commissioned, by the ministry or royal household, although overtures had been made by the comte de Forbin for the purchase of Constable's *Haywain*. Arrowsmith obdurately insisted that the state remove from his hands all three of his Constable's and the negotiations collapsed. *View on the Stour*, nevertheless, would eventually find a French purchaser in Louis-Joseph-Auguste Coutan and an admiring copyist in Paul Huet. Among Bonington's friends and business associates, Colin, Roqueplan, Delacroix, Isabey, Lami, Léopold Leprince, d'Ostervald, and Taylor also received gold medals, although Chevalier honors were reserved, as might be expected, for such home-guard candidates as J.-A.-D. Ingres (no. 144) and the

landscapist Louis-Etienne Watelet (1780–1866). As modest as these concessions to the "barbarians" were, they were perceived generally as a triumph, and this cachet of respectability accounts for much of the impassioned vehemence of the critical debates.

As a medalist in the category of oil painting and as an Englishman, Bonington inevitably shared in the accolades or abuse showered on Lawrence and Constable. P.-A. Coupin, critic for the *Revue Encyclopédique*, wrote:

It is evident that English painting has taken a different direction from French painting. The portraits of Lawrence, the landscapes of Constable, and the marines of Bonington are proof of this. In France we do not think of imitation as the absolute end of painting; we prefer that the art, the hand of the painter conceal itself in the process of imitation; we place a premium on what is called the charm, the delicateness of facture; we believe, especially for large works, that one should not exhaust oneself in rendering the effect of nature and in essaying only its breadth, rather it is essential to reproduce its details and delicacy to the utmost. The English pursue an opposite system: seen from a distance their works have considerable truth; but as you approach, the illusion disappears and you discern only poorly applied colors, only a gross toil. This is degenerate.[64]

In a later review, he amplified his objections:

The [English] *desire to produce truthfulness . . . and one must admit that they excel at this;* [Constable and Bonington] *reveal truths unknown in our school; but, I repeat, we have a grandeur of design and of composition that they reject. I will even reproach them for a lack of taste and elevated thought in their choice of subjects To go to the suburbs and to reproduce faithfully the first field one comes upon is to abuse painting. Not everything is worthy of painting, because not everything is worthy of our contemplation. To endeavor to captivate the connoisseurs by the truth of imitation alone is to only partially understand the matter.*[65]

Thiers was only marginally more sympathetic:

In landscape painting, extraordinary efforts have been made to capture nature; unhappy but laudable efforts: this ambition has been forced to the point of representing insignificant beaches in the Dutch manner, in order to engage one's interest only by means of imitative truth, as was their custom . . . however true and original beach scenes are in which a straight [horizon] *line is cut by a single line of figures, they will be commonplace like any artifice when too often repeated.*[66]

Delécluze, in a transparent allusion to Stendhal's *Racine and Shakespeare* (Paris, 1823), divided the contestants into the Homeric and the Shakespearean. Of the landscapists, Achille Michallon was Homeric in such pictures as *Oedipus and Antigone* (which incidentally belonged to Schroth), not only because of his selection of an elevated subject, but also because he subordinated naturalistic effects to a conceptual ideal of nature. The Shakespeareans sought to "distract" by imparting an "imaginative verve" to matters of subsidiary interest. Rembrandt and Ruisdael were the antecedents of Constable, Bonington, Copley Fielding, Horace Vernet, and two French landscape painters who had actually visited England and Scotland, Gassies and Regnier. Among the history painters, Delacroix was "the fifth act to Shakespeare." Delécluze's strategy of derogatorily linking the romantics of his own nationality to the decadence of the *ancien régime* assumed its most extreme expression in his comparison, otherwise inexplicable today, of Watteau's *L'Embarquement pour l'Ile de Cythère*, then the only picture by this artist permitted on public view in the Louvre, and Delacroix's *Massacre at Chios*. He remarked favorably on the energy, freshness, and truth of coloring in Constable's *View on the River Stour* but criticized the execu-

tion as "affected negligence" that fails to "address the precise form of objects" and that calls immediately to mind the "clever but eternal preludes of pianists who make a show of technique The senses are aroused, but the overall impression is a mere trifle."[67] His criticism of Bonington, quoted elsewhere (see no. 29), focuses on the inappropriateness of his subject matter, in particular that of fishmarkets, for landscapes of a larger dimension, and he concludes with the following concession to that "segment of the public and artists who have praised beyond measure MM. Constable and Bonington":

I am not certain that the means employed by the English could not be applied to subjects other than the English countryside, the ocean's storms or scenes with sailors, but I will reserve judgment until some great English painter has successfully treated in this manner the calm, majestic, and enchanting scenes of Italy, can offer works in which the style and execution will permit comparisons with Poussin's Polyphemus.[68]

The vital issues were clearly finish and content, with permissible artistic freedom measured in inverse proportion to the size of the picture. For more liberal sympathies, execution was simply a means to an end. As Amédée Pichot observed in his widely circulated *Picturesque Tour of England and Scotland* (1825):

At 15 paces, the landscapes of Constable, Callcott etc. are admirable; but upon closer inspection, they sometimes resemble mere rough drafts. I am not completely certain of at how many paces distant the pictures of Claude, Watteau, etc. are masterpieces *but have not all pictures a given distance beyond which their illusion vanishes?*[69]

The subjects chosen by the English landscape painters, however, were not so easily defended. Stendhal, for instance, equivocated, praising Constable's technique as the "mirror of nature" but preferring that he prop the mirror before a grander or more conventionally beautiful site than an English stream.[70] He was equally dismissive of watercolor in general. Auguste Jal would argue, in turn, that the appropriate subjects for marine painters were narrative sea battles and tempests or the by now hackneyed imitations by Louis Garneray (1783–1857) of Joseph Vernet's propagandizing "portraits" of French seaports, which had the redemptive virtue of being topographically instructive.[71]

As it had evolved by 1824, the subject of the most progressive English landscape painting was, of course, nature itself, or the transcription of observed natural phenomena for emotive effect and not cerebral or didactic engagement. The compositional vehicle, whether it was a beach scene or the falls at Tivoli, usually mattered little. It was the sincerity of the artist's response to nature and the communication of those insights that were the legitimate and paramount aims of landscape painting. Delécluze was not opposed to naturalism, but the study of nature had to be subordinated to the moral imperative of recreating a more ideal natural order. Otherwise, one stooped to the commercialism of popular entertainments like the Diorama, which is precisely what the vast majority of his fellow citizens preferred. A work of art also had to have "air," which for an academic meant uncompromising legibility — the planes of recession had to be clearly distinct and logically ordered, the objects within those planes precisely defined and circumscribed, and the perspective illusion entirely dependent on diminution in scale. Picturesque effects resulting from the bravura manipulation of color or *clair-obscur*, the thrust of Bonington's efforts, must be suppressed because they fatigue the eye or distract from the narrative subject introduced into the landscape. Moreover — and in this Delécluze would emphatically side with Coupin against Pichot — they are an affront to decorum and the public's supposed right to a carefully worked

59. At the time, the illustrated novel was frequently greeted with scorn or suspicion. Delécluze's generation had been largely deprived of such distractions. The inundation of the French market in the 1820s with translations of British and German literature was, consequently, somewhat alarming, and the popularity of British-style engraved illustrations, especially vignettes, on which Delécluze showered excessive abuse for such relatively insignificant creations, was no less a cause of concern. By the 1830s illustrated novels and Keepsakes by French authors and publishers were almost as plentiful as they had been in London, where similar concerns for the social impact of such fiction had prompted John Ruskin to write in his 1836 "Essay on Literature" (*Works* 1: 357):
It is said that the perusal of works of fiction induces a morbid state of mind, a desire for excitement, and a languorousness if withheld, which is highly detrimental to its intellectual powers and its morality. Now intoxication is detrimental to the health, but a moderate use of wine is beneficial to it; and voracity in works of fiction is detrimental to the mind, but moderation, we hope to prove, is beneficial to it, and much better than total confinement to the thick watergruel of sapient, logical and interminable folios.
He then proceeded to defend the romances of Walter Scott for their psychological accuracy and moral probity. By the 1850s, Scott's novels had become passé in France, but Gustave Flaubert could still rely on his audience's immediate recognition of the importance of British illustrated literature in the formation of his generation's attitudes when introducing his anti-heroine, Emma Bovary, as someone who revolted against the superficial piety of her bourgeois convent education by escaping into the fanciful world of Anne Radcliffe's or Walter Scott's fiction and by overindulging her passion for Keepsake vignettes.

For the role of the vignette in French romantic art, see Rosen and Zerner, *Romanticism and Realism*. The literature on the importance of Walter Scott to French romanticism is massive. The following are particularly relevant: Catherine Gordon, "The Illustration of Sir Walter Scott: Nineteenth-Century Enthusiasm and Adaptation," *Journal of the Warburg and Courtauld Institute* (1971): 34ff.; Beth S. Wright and Paul Joannides, "Les Romans historiques de Sir Walter Scott et la peinture française, 1822–1863," *Bulletin de la Société de l'Histoire de l'Art français* (1982): 119–32, and (1983): 95–115; Beth S. Wright, "Scott's Historical Novels and French Historical Painting 1815–55," *Art Bulletin* (June 1981): 268–87; Martin Kemp, "Scott and Delacroix with some assistance from Hugo and Bonington," *Scott Bicentenary Essays* (Edinburgh, 1973), 213–27.
60. The most reliable discussion of the dealers Arrowsmith and Schroth is in *John Constable's Correspondence IV*, ed. R. B. Beckett (Suffolk, 1966), 177–210. Arrowsmith both traded in and copied Bonington's works.
61. Adolphe Thiers, *Le Globe* (17 September 1824): 7.
62. Delécluze, *Journal*, 113–14 (18 January 1825):
I have heard that Gros has intervened in order to hasten David's return to France but fears that the conditions for that would make it impossible. According to Ingres it would be too humiliating to David David, I believe, is convinced that his presence in Paris would have a great influence on the direction of our school. He deceives himself. In addition to his age, his talent has grown feeble [and] *most of the artists of the new school understand neither his theories nor his works In Belgium, he remains a great artist; in Paris, he would be seen only as a man of the Revolution.*
63. Coupin, *Salon 1824*, 335.
64. Ibid., 597.
65. Ibid., 316–17.
66. Adolphe Thiers, *Le Globe* (24 September 1824): 23.
67. Delécluze, *Salon 1824* (30 November 1824): 2.
68. Ibid.
69. Pichot, *Tour* 2: 185; the text was actually written in autumn 1824.
70. Stendhal, *Mélanges* (27 October 1824).
71. Jal, *Salon 1824*, 400, 414–17.

surface as recompense for their interest or their monetary investment. Although Delécluze claimed to be presenting a case for a "juste milieu," a term he coined in his review of 30 November for the type of painting that would reconcile the extremes of academic pedantry and the negligent execution and "ugly" subjects of the romantics, his unwillingness to compromise on certain principles, especially those pertaining to content, made him appear little more than a reactionary classicist. Ironically, in his private journal he was as critical of Girodet, Gérard, and the late style of David as he was in his published reviews of Delacroix and the English.

For the majority of French critics, nature had to be posed just as David had posed "the bon Vistris." As an example of just how reflexive such thinking was among contemporary French landscape painters, one can examine Xavier Leprince's *Loading of Livestock at Honfleur* (fig. 23), which was acquired by the monarchy for 4000 francs even though it, like Bonington's *Fishmarket*, was considered a scene of modern genre. As had Bonington, Leprince early abandoned the routine of academic training for a regimen of self-tuition, which included studying the Dutch masters in the Louvre and the coastal landscape of Normandy. That the two artists knew each other is likely; Xavier's brother, Léopold, was a Gros pupil. Leprince was a reformer in that he endeavored to reconcile establishment expectations to a more honest expression of nature and contemporary life. His *Honfleur*, therefore, is still within the conceptual and stylistic tradition of Vernet and eminently a "juste milieu" picture. The figures are incidental so as not offend in the meanness of their costumes and activities. A pedagogic justification has been established by making the focal point of the composition the medieval customshouse built by François Ier, a symbol of civic authority, maritime prosperity, and historical continuity. Stendhal observed ingenuously of this oil that in capturing nicely the gaiety of the lower classes in France, it was as replete of truth as any Dutch picture, although it failed to elevate the spirit.[72]

Plein-air sketches in Baltimore and Paris preparatory to the final composition exhibit a spontaneity of touch and a careful observation of natural light and color, but these qualities are severely modified in the final picture, where "air" has replaced atmosphere and the sky is schematized. The limpidity and autobiographical character of the sketches is diminished in the translation, partly because of the increase in size, but primarily because of Leprince's tacit adherence to the traditional relationship between the sketch and the finished picture as one of analysis and synthesis, as a process that would guarantee both proper mediation and the extrinsic morality of diligent application. Despite the topical subject, this was still ethics applied to landscape painting.[73] For Bonington, this relationship did not pertain. The authenticity of the experience of nature was of prime importance, and this he guaranteed his public by the apparent spontaneity of his execution and the ocular proof of his hand. The tension between artifice and reality is fully exploited as a virtue. In treating the subject of a fishmarket dispassionately but directly, he neither exploded the myth of the "gaiety of the lower orders" nor did he pander to it by resorting to sentimentality, as was typical of much contemporary genre painting. In fact, the ostensible subject of a fishmarket, while not without personal significance, is ancillary to that of phenomenal realism. This is even more apparent in Bonington's most common construction for a coastal view of this period, in *Calais Pier* for instance, in which the composition is reduced to the essentials of sky, sea, sand, and a few boats and figures. The awareness of compositional manipulation is diminished, and through his consummate mastery of color alone, he excites admiration for a scene that is otherwise barren and uninteresting. Positively startling to an audience unaccustomed to such veracity, his emphatic, almost clinical, realism asserted the primacy of color, of immediacy, and of individual touch as the new qualitative criteria for judging landscape painting.

Paul Huet, who was soon to become one of Bonington's closest friends, praised his special talent as the "génie de l'aperçu et l'indication" — that is, an extraordinary ability to show powerful and varied effects of color and perspective while simultaneously paying due attention to details. The objective was not the precisely delineated forms of academic practice, but rather a scrupulous fidelity to such commonplace but riveting phenomena as the reflective action of recently moistened sand or the deliquescence of distant objects shrouded in mist. To a great extent, this is what most annoyed or fascinated the respective French camps about British watercolor technique, and the translation into oil of the effects thought to be the special province of the watercolor would become a major formal concern for this generation of French artists, as it had been for an earlier generation of British painters. Neither Corot's early oil studies nor perhaps the entire oeuvres of Alexandre Decamps (1803–1860)[74] and Eugène Isabey can be fully appreciated in any other context. Bonington's exploits in watercolor were well known and highly prized prior to the Salon, and with his debut in the oil medium, he became the acknowledged master of that interplay.

Only through an innate and highly refined understanding of materials and techniques could he sustain in the medium of oils the lightness and verisimilitude of his watercolors. This virtuosity fascinated Delacroix, who later marveled at how Bonington's pictures were able to express a beauty that was independent of any subject or representational quality — the beauty of what he called "the abstract side of painting": organization, light, color, and a facility that was inimitable but not mannered. In effect, Bonington exemplified one of the most persistent paradoxes of romantic theory — its demand for an art that seemed unpremeditated because its creator possessed a perfect command of his or her means of expression. Technique was not, however, Bonington's exclusive absorption, for his marine views do communicate a subjective response to nature and a genuine affection for what is treated. This was certainly also the view of his contemporaries, who invariably saw in such works evidence of profound sentiment. As Delacroix's cousin, the landscape painter Léon Reisner (1808–1878) observed, Bonington may never have sought to depict the extraordinary or sublime events of nature, but his sensibility was no less vivifying for its discretion.[75] And what Hegel contemporaneously observed of Dutch painting, in general, might equally apply to the intent of Bonington's first preponderately Dutch coast scenes: "The true subject matter is the Sunday of life which, by equalizing everything at least for the day, overcomes all evil."[76]

The most vociferous and uncompromising critic of Delécluze's position was neither Stendhal nor Thiers but William Hazlitt, who was in Paris at the time to write a series of articles for the *Morning Chronicle* describing his tour of the continent. The Salon he considered little more than a "vile farrago of Bourbon Restoration pictures," which simply impeded his progress into the galleries housing the old masters, and he spent little time discussing it; however, in response to the initial essays of Delécluze, he submitted for publication in October a vicious attack on the masterworks of David's school then hanging in the Luxembourg palace:

Racine's poetry, and Shakespeare's, however wide apart, do not absolutely prove that the French and English are a distinct race of beings, who can never properly understand one another. But the Luxembourg gallery, I think, settles this point

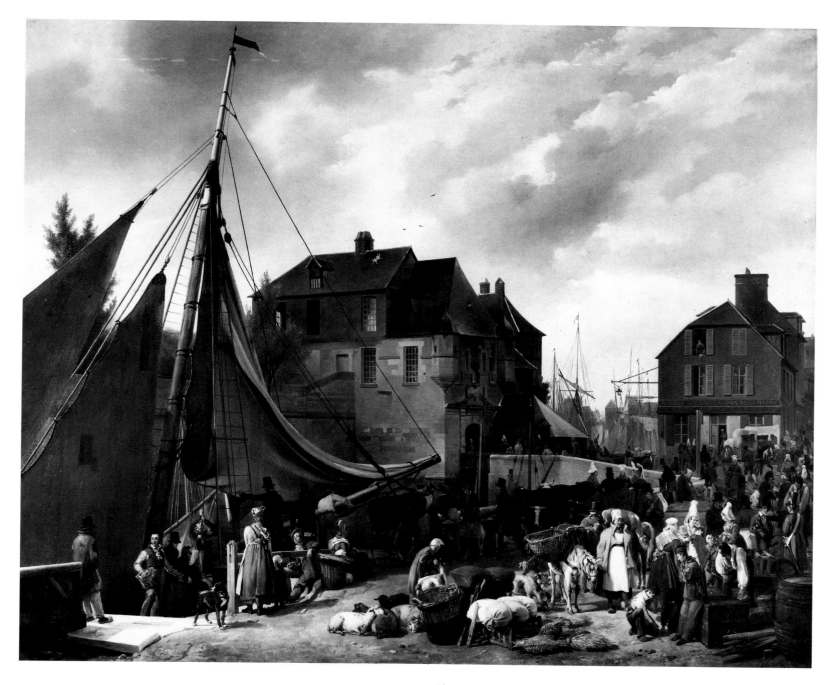

Fig. 23: Anne-Xavier Leprince (1799-1826)
Loading of Livestock at the Port of Honfleur, 1824
Oil on canvas 52 × 65 in. (132 × 165 cm.)
Musée du Louvre, Paris

72. Stendhal, *Mélanges* (29 November 1824).

73. The persistence of this attitude compelled Baudelaire to write in his review of the 1846 Salon (*Salons*, 104):

As for historical landscape, over which I want to say a few words in the manner of a requiem-mass, it is neither free fantasy, nor has it any connection with the admirable slavishness of the naturalists: it is ethics applied to nature. What a contradiction! . . . Nature has no other ethics but the brute facts, because Nature is her own ethics; nevertheless we are asked to believe that she must be reconstructed and set in order according to sounder and purer rules — rules which are not to be found in simple enthusiasm for the ideal, but in esoteric codes which the adepts reveal to no one.

74. Planche, *Salon 1831*, 78–79, and Rosenthal, *Peinture romantique*, chapter 6, 220–27.

75. See Smith, *Francia*, 339: "Ce talent distingué n'a pas cherché l'extraordinaire: ayant devant les yeux une jolie femme, il n'a voulu que la rendre telle C'est à Bonington, chercheur de l'intérêt réel, que l'art doit sa vitalité."

forever . . . decidedly against them, as a people incapable of any thing but the little, the affected, and the extravagant in works of the imagination and Fine Arts French painting, in a word, is not to be considered as an independent art, or original language, coming immediately from nature, and appealing to it — it is a bad translation of sculpture into a language essentially incompatible with it.[77]

After Girodet's *Deluge*, which "soars unconstrained to its native regions of extravagance and bombast," David's pictures were "tame and trite in the comparison" yet completely French in their "little, finical manner, without beauty, grandeur or effect" — in short, meager, constrained, and theatrical: "This hard, *liny*, metallic character is one of the great discriminating features of French painting, which arises partly from their habitual mode of study, partly from the want of an eye for nature, but chiefly, I think, from their craving after precise and definite ideas."[78] Only Horace Vernet's *Massacre of the Mamelucks* and Delacroix's *Barque of Dante* were redeemed by a painterliness that appealed to the imagination.

Stendhal, who admired David and Girodet, dismissed the article as nationalist hyperbole, but Hazlitt's fulminations were not entirely the impetuous reaction of a hypersensitive Englishman in Paris. They were a considered assessment formulated as early as 1802, when he first visited France, and elaborated over the years, but especially in an article of 1815 discussing the picture collection of Lucien Bonaparte then on exhibit in London and in his most important series of essays of a year earlier attacking the thesis of Sir Joshua Reynolds's *Discourses*. Like Delécluze, Hazlitt was convinced that national character dictated the peculiar form of artistic expression of every country, and with French character he had no more sympathy than did Thomas Carlyle or Mark Twain. More to the point, however, was his opinion that academies were destructive of originality since success was measured in terms of a student's ability to imitate the style of his professors rather than nature itself. The existing French academy was therefore doubly at fault because it promoted the imitation of artists whom Hazlitt felt had done little more than pretend to imitate antique sculpture while actually aping the exaggerated mannerisms of theatrical performers. The same objections, incidentally, would constitute the thrust of Stendhal's 1827 Salon review and are encountered repeatedly in Delécluze's private ruminations. As for specific differences and merits of style, Hazlitt complained:

The English seem generally to suppose, that, if they only leave out the subordinate parts, they are sure of a general result. The French on the contrary, as idly imagine, that by attending to each separate part, they must infallibly arrive at a correct whole French painters see only lines and precise differences; — the English only general masses and strong effects . . . the one is dry, hard, and minute, the other is gross, gothic, and unfinished; and they will probably remain forever satisfied with each other's defects.[79]

As far as this brilliant essayist was concerned, and he was enumerating the requirements of many informed collectors in England, painting as a creative enterprise had to combine *gusto* or expression, which he defined as "the conveying to the eye the impressions of the soul, or the other senses connected with the sense of sight, such as the different passions visible in the countenance, the romantic interest connected with scenes of nature, the character and feelings associated with different objects"; the *picturesque*, "that is, the seizing on those objects, or situations and accidents of objects, as light and shade etc., which makes them most striking to the mind as objects of sight only"; and an attention to naturalistic detail within that broader, painterly massing of

forms and colors.[80] For Hazlitt neither the English nor the French possessed all these attributes together in their preferred manners of painting, the French because they were too much the prisoner of their academic prejudices and the English because they were far too preoccupied with capturing the fancy of those rich connoisseurs and private collectors of modest intellectual attainment who placed the highest premium on showy execution.

Had Hazlitt been less contentious in his belief that after Titian painting declined inescapably, he might have acknowledged parallel sympathies among contemporary artists, including Bonington, for the general aesthetic principles dear to both were equally rooted in the traditions of theoretical connoisseurship that had evolved in England over the previous two decades. The same rhetorical contest raging in Paris in 1824 had already been decided in London. Proponents of the "historical style" and its concomitant demands for design over color and for moralizing pictures on a grand scale, such as James Barry (1741–1806), who died destitute, and Benjamin Robert Haydon (1786–1846), who terminated his disillusionment in suicide, had lost decidedly to the connoisseurs who held that the creation and consumption of art were better guided by individual taste than by academic standards and that the ultimate goal of painting was the imitation of visible appearances, of what the eye communicated and not what the intellect knew or ordained, in advance, to be the form or shape or component details of a particular object.

As an advocate of that position, Richard Payne Knight (1751–1824) had argued persuasively in his influential *An Analytical Inquiry into the Principles of Taste* (London, 1805) against the threadbare Reynoldsian notion that the art of painting had an ethical or civic-minded mission, "as if men ever applied to such sources of information for directions on how to act in the moral or prudential concerns of life; or ever looked at pictures for anything but amusement."[81] Hence, he could also write with regard to such mundane subjects as flesh or fishmarkets:

In nature we are not pleased with them, nor ever consider them as beautiful. Yet in the pictures of Rembrandt, Ostade, Teniers, and Fyt, the imitations of them are unquestionably beautiful and pleasing to all mankind . . . [because] in judging of the imitative representation of them, we do not consult our understandings, but merely our senses and imaginations; and to them they are pleasing and beautiful.[82]

According to both Delécluze and Knight, the pleasures afforded by painting were the pleasures of sight, but for Delécluze those delights were inexorably bound to the subject and its philosophical weight; consequently, he could admit to enjoyable stimulation from popular painted panoramas and dioramas while distancing those sensual pleasures from the loftier sentiments of the Fine Arts. For Delécluze sensual overindulgence was egotistical escapism: "Lord Byron, Rossini, and Cayenne pepper are the three stimulants to which we succumb in order to escape the numbness of death."[83] It was symptomatic of the age and had to be combated in every sphere of human endeavor. For Knight, on the other hand, these pleasures of sight were physiological and had nothing to do with cognition, ethics, or received notions of what was beautiful in nature or appropriate to art. A fishmarket, which all the world knew to be a foul and unpleasant experience, became a subject of beauty in a painting because the purely visible, formal properties that gave pleasure — the myriad colors and tints and the play of light and shade — were distinct, because of the artist's magic, from any disagreeable traits endemic to the experience of a market in real life. Fifty years later, in an objection to the persistent hierarchy based on subject matter, Delacroix would apply the same reasoning in praising the

inherent formal beauty of Géricault's bizarre and disturbing paintings of truncated limbs and heads.

Invoking historical justification for his thesis, Knight further argued that exact imitation, as can be discerned in early Italian painting, had the virtue of novelty, but that it soon became tedious. Sensitive spirits thus began to cast about for examples of character, expression, and ultimately technical virtuosity or the "abstract perfection" of the art: "that masterly intelligence in the execution — that union between the conceptions of the mind and the operations of the hand, which constitutes the superior merit and . . . might be supposed to proceed from supernatural inspiration."[84] How parallel in sentiment, once again, are Delacroix's negative reflections on the academic tradition:

David is naive in his manner of rendering objects; he rarely affects to make them other than they are The most careful execution in details does not give the unity which results from the, how do I express it, creative power whose source is undefinable.[85]

Or, more to the point, his private assessment of the appeal of Bonington's painterly skills to the initiated:

Some talents come into the world fully armed and prepared. The kind of pleasure men of experience find in their work must have existed from the beginning of time. I mean a sense of mastery, a sureness of touch going hand in hand with clear ideas. Bonington had it, but especially in his hand . . . note the importance of color to this type of improvisation.[86]

One could multiply indefinitely the examples in which the mature reflections of Delacroix, Huet, and other romantics seem the exact transcriptions into French of ideas promoted much earlier and more rigorously in London. What Henri Zerner and Charles Rosen have isolated as the most significant characteristic of later realism and impressionism — "the aesthetic autonomy of the means of representation" — is implicit in British theory at the turn of the century. It may seem surprising that such a transparent and innocent notion could generate such protracted controversy, but it was confronting, especially in France, an intractability of entrenched ideas; and as Goethe observed in *Sorrows of Young Werther*, old men always have at their disposal the means to channel the floodwaters of youthful ambitions away from their tidy gardens.

To support his emphasis on executive skill, Knight again sought historical precedents, redefining the picturesque as that which "was after the manner of painters," but specifically those painters for whom, according to Knight, the term was originally created — Giorgione and Titian. The Venetian manner of painting, with its broad massing of color and chiaroscuro and its attention to naturalistic detail, with its consummate blend of the general and the particular that Knight understood as echoing the process of visual perception, was the apotheosis of achievement, although Rembrandt's genius for innovative techniques led to an equally genuine appreciation of the Dutch school. Perfect imitation in the sphere of illusionistic painting, therefore, was a convergence of immediate and acute observation and the "felicity in catching the little transitory effects of nature and expressing them in the imitation, so that they may appear to be dropped, as it were, fortuitously from the pencil, rather than produced by labor, study, or design; it is that, in short, which distinguishes a work of taste and genius from one of mere science and industry."[87]

Knight also reaffirmed a pet premise of traditional picturesque theory that the contemplation of nature itself can become a heightened aesthetic experience through the connoisseur's association of what he is contemplating with his knowledge of how great artists had treated similar

76. Hegel, *Aesthetics*, 125.

77. Hazlitt, *Notes*, 129–30. C. R. Cockerell, the friend of Ingres, Géricault, Auguste, and later Delacroix, wrote in his diary on visiting the Salon with Auguste on 13 October, "Passed an hour at the Louvre in modern gallery. The number and barrenness of these works are mortifying and humiliating." (Manuscript diary in the Library of the Royal Institute of British Architects, London).

78. Hazlitt, *Notes*, 136.

79. William Hazlitt, "On the Imitation of Nature," *The Champion* (25 December 1814; *Complete Works* 18: 74).

80. William Hazlitt, "The Catalogue Raisonné of the British Institution," *The Examiner* (3 November 1816; *Complete Works* 18: 106–7); see also his essay "On Gusto," *The Round Table* (*Complete Works* 4: 77–80).

81. Knight, *Principles*, 453. Concerning Knight's philosophy and the complexities of Regency taste, I can only touch upon principles lucidly analyzed in depth in Peter Funnell, "Richard Payne Knight 1751–1824: Aspects of aesthetics and art criticism in late eighteenth and early nineteenth century England," D.Phil. Thesis, Oxford, 1985, and in Michael Clarke and Nicholas Penny, *The Arrogant Connoisseur: Richard Payne Knight* (Manchester, 1982). Also very informative is Hugh Brigstocke, *William Buchanan and the 19th Century Art Trade: 100 Letters to His Agents in London and Italy* (London: Paul Mellon Centre for Studies in British Art, 1982).

82. Knight, *Principles*, 72–73.

83. Delécluze, *Journal*, 76 (25 December 1824). In this he unwittingly shared the opinion of many English visitors; note, for instance, Thomas Carlyle's rant to his fiancée of 28 October 1824:

[The French] *cannot live without artificial excitements, without sensations agréable The people's character seems like their shops and faces; gilding and rouge without; hollowness and rottenness within . . . the pink of elegance . . . yet addicted to the basest practices and most beastly vices To live in Paris for a fortnight is a treat; to live in it continually would be martyrdom.*

Quoted from C. R. Sanders, ed., *The Collected Letters of Thomas and Jane Welsh Carlyle* (Durham: Duke University Press, 1970) 3: 180.

84. Knight, *Principles*, 99–102.

85. Piron, *Delacroix*, 402–10.

86. Delacroix, *Journal* 3: 187–88 (31 December 1856).

87. Knight, *Principles*, 238. In his essay "On the Imitation of Nature," *The Champion* (25 December 1814; *Complete Works* 18: 71), Hazlitt offered a slightly different slant to the same idea: "If the lights and shades are disposed in fine and large masses, the breadth of the picture, as it is called, cannot possibly be effected by the filling up of those masses with detail." This definition of naturalism would subsequently prove crucial to John Ruskin's defense of Turner in *Modern Painters*.

subjects. Such a theoretical approach inevitably devalued the traditional hierarchy of genres, and while education or other cultural factors might influence a refined individual to prefer Raphael to Teniers or vice versa, neither could be discriminated against *de facto* because of their subject matter or technique of painting. Every artist had to be judged on his or her peculiar merits alone within a relative and not absolute art historical context. Thus Hazlitt could admit to being undecided as to whether he would prefer a Raphael cartoon or a Teniers genre subject, but was certain that he would prefer a Teniers genre subject to a cartoon by the same master.[88] And Delacroix could define romanticism tersely as "a reaction against a school, a call for artistic freedom, a return to a larger tradition: we wanted to do justice to all the great epochs, even to David!"[89]

A final point of Knight's thesis was that the active engagement of the spectator was enhanced in proportion to the extent that the representation was not static in its finish and allowed the viewer some scope for imaginative participation. Here he betrayed his indebtedness to a dominant strain of eighteenth-century connoisseurship. Denis Diderot, in reviewing the debut of Hubert Robert (1733–1808) at the 1767 Salon, stated the case succinctly in an analysis of Robert's landscape oil sketches:

Why does a beautiful sketch please us more than a beautiful painting? It is because there is more life and less form. To the extent that one introduces form, life disappears How can the young student, incapable of making even a mediocre picture, produce a marvelous sketch? The sketch is the work of heated inspiration and of genius, and the picture a work of toil, patience, long study and a consummate knowledge of art The sketch is so seductive because, being indeterminate, it affords greater freedom to our imaginations which see what pleases them. It is like the story of a child who ponders the clouds, and we are all that child more or less Movement, action, passion are indicated by a few characteristic traits and my imagination does the rest. I am inspired by the divine breath of the artist.[90]

The corollary to this fundamentally romantic exaltation of an effusion of genius unconstrained by conventions of subject and technique is the more expansive, albeit to us dubious, proposition adopted by Hazlitt from Knight that, "those arts which depend on individual genius and incommunicable power have always leaped from infancy to manhood, from the rude dawn of invention to their meridian height and dizzying lustre."[91]

Ultimately, for both Hazlitt and Knight, no modern artist could ever hope to surpass the achievements of Titian or Rembrandt or Claude; but the consequence of formulating a system of evaluation based principally on formal considerations was to fuel an existing climate of anticipation for a prodigy of modern art whose inspiration proceeded from nature alone and who could rival the originality of the greatest masters in their painterly ingenuity. For, like most theorists, Knight was simply providing a conceptual framework for sentiments of taste already prevalent, if not actually ascendant, among artists and a significant portion of the British collecting public, but especially the elite group of connoisseurs who, with Knight, had founded the British Institution in 1805.[92] If anything, Bonington was just such a connoisseur's painter or, more precisely, a painter capable of arousing the enthusiasms of collectors conversant with the history of pictorial art and craving persuasive allusions to it in their modern pictures. It is no coincidence, therefore, that when Bonington decided to make his exhibition debut in London in 1826, he chose to do so at the British Institution (fig. 24) or that his foremost British patrons during his lifetime were the private collectors who constituted the governing board of that body. For many observers

on both sides of the channel, Bonington came appreciably close to attaining the status of the mythical "boy genius" whom collectors were always passionate to discover and critics and established artists prone to distrust. Both Delacroix and Huet privately, and Auguste Jal in his obituary notice, avowed this perception of Bonington in France, which his early death and his breach with Gros simply amplified. Constable's observation to William Carpenter in 1830 — "You do me an injustice in supposing I despise poor Bonnington But there is moral feeling in art as well as everything else — it is not right in a young man to assume great dash — great compleation — without study or pains. 'Labor with genius' is the price the Gods have set upon excellence"[93] — came after a career of neglect from the same prestigious collectors who competed furiously for Bonington's pictures during Constable's final years.

Although published theoretical opinions comparable to Knight's are wanting in France, similar sentiments were not. Delécluze, after all, was defending a state-subsidized "public art," but the driving force for change, and the realization that English art had something to offer in this process, was not the ministry or its Institute but the private sector.[94] With regard to Bonington, at least, Jal would have to admit in 1824 that, "he has created a mania. For some time, the amateurs have judged only by him; he has proselytes and imitators."[95] It should be recalled that three of Bonington's five Salon entries had been acquired prior to the exhibition by the Société des Amis des Arts, which was responsive to private interests and which, like the British Institution, was committed to promoting modern art in whatever manifestation it took, including nonhistorical genre and the frowned-upon medium of watercolor. In his review of the Salon, Jal quite nicely sliced through the rhetoric of other theorists in describing the actual state of patronage in France:

Voice your preference for historical painting, that's fine; but do not decry genre's success. Look in good faith for the reasons The more the number of the rich multiplies, the more books, beautiful furnishings, beautiful pieces of silver, and also pictures are required for their consumption. Anyone who has 6000 F in rents can form a small cabinet. They require pictures and these must be fine I don't claim that is good or bad for art . . . it is simply difficult for matters to be otherwise. In France, there are only five galleries that can hold a capital production of historical painting; there are 600 cabinets in which can be ranged fine studies, precious drawings, and pretty pictures . . . all the world from the rich banker to the petty functionary forms a collection in proportion to his income . . . why should the people support an art that only the state can afford? The public should define the route of history painting and the state should adopt its ideas.[96]

"Fine studies, precious drawings, and pretty pictures" were decidedly the rage. The resounding success of the troubadour painters at the beginning of the century or of François-Marius Granet's (1775–1849) tenebrous monastic interiors a decade later were primarily the result of private patronage. Furthermore, it appears to have surprised no one, except perhaps Louis-François Bertin, owner of the *Journal des Débats* and the father of the landscape painter Edouard Bertin, that the oil sketches painted by Michallon in Italy (fig. 25) fetched extraordinary prices in his 1822 studio sale. The director of the mint, de l'Espine, was the most aggressive acquisitor, paying as much as 400 francs for a single sketch. Gros, in his public eulogy at Girodet's funeral in December 1824, attributed the decline of the entire school — romantics and classicists alike — to a pandering to the connoisseurs' interests in "feeble facility." And did not Delacroix admit to beginning to paint cabinet pictures for private collectors, with subjects drawn from fashionable literary sources like Byron and Scott and in a new "pictur-

Fig. 24: John Scarlett Davis (1804-1845)
Interior of the British Institution Gallery, 1829
Oil on canvas $44\frac{1}{2} \times 56$ in. (113×142 cm.)
Yale Center for British Art, New Haven

88. William Hazlitt, "Fine Arts," *Encyclopaedia Britannica* (London, 1817; *Complete Works* 18: 123).

89. Huet, *Huet*, 74. Delacroix's theoretical elaboration of this idea appeared in his essay "Questions sur le Beau," *Revue des Deux Mondes* (15 July 1854).

90. Diderot, *Salon 3*: 241ff.; see also Philippe Grunchec and Bruno Foucart, *Les Concours d'esquisses peintes, 1816–1863* (Paris, 1986).

91. William Hazlitt, "Why the Arts are not progressive," *The Morning Chronicle* (11 January 1814; *Complete Works* 18: 6).

92. Although highly emotional, Hazlitt's account of his discovery of the old masters just prior to 1800 well describes the attitude of many of his generation: *My first initiation in the mysteries of the art was at the Orleans Gallery: it was there that I formed my taste, such as it is; so that I am irreclaimably of the old school of painting. I was staggered when I saw the works there collected, and looked at them with wondering and with longing eyes. A mist passed away from my sight: the scales fell off We had all heard of the names of Titian, Raphael, Guido, Domenichino, the Caracci — but to see them face to face, to be in the same room with their deathless productions, was like breaking some mighty spell — was almost an effect of necromancy! From that time I lived in a world of pictures. Battles, sieges, speeches in parliament seemed mere idle noise and fury, 'signifying nothing,' compared with those mighty works and dreaded names that spoke to me in the eternal silence of thought.* "On the Pleasure of Painting," *Table-Talk* (London, 1821), 14.

93. *John Constable's Correspondence IV*, 140.

94. See Charles Nodier, *Promenade de Dieppe aux Montagnes d'Ecosse* (Paris, 1822), 84–89, as well as Géricault's well-documented remarks in his correspondence from London.

95. Jal, *Salon 1824*, 417.

96. Ibid., 16–18.

Fig. 25: Achille-Etna Michallon (1796-1822)
Forum at Pompeii, ca. 1820
Oil on paper 10⅜ × 14¾ in. (26.5 × 37.5 cm.)
Musée du Louvre, Paris

Fig. 26: Sir Thomas Lawrence (1769-1830)
Marie-Caroline, Duchesse de Berry (1798-1870), ca. 1825
Oil on canvas 35¾ × 28 in. (91 × 71 cm.)
Musée National du Château de Versailles

Fig. 27: Auguste Raffet (1804-1860)
Gâres les Albums, 1828
Lithograph 7⅞ × 11 in. (20 × 28 cm.)
Private Collection

esque" style, for purely monetary reasons?[97] There is hardly a critic of the period who did not acknowledge or castigate the profound impact of the private collectors in shaping contemporary taste. Antipodes of aesthetic inclination like Ingres and Huet would complain equally of the preoccupation of collectors with "touch" — Ingres, in defending its effacement in his own enamel-like finishes, which of course were as fascinating to some collectors as gestural extravagance was to others, and Huet, in pleading for the primacy of a picture's poetic sentiment. Even the critic Gustave Planche, who rallied to the younger generation of innovators that had adopted "Veronese, Rubens, and the English" as their models, would grumble in the 1830s that they had produced few superior works because "they cater to the cabinets of the curious and their idle pleasures for improvisation and not for hard work."[98] Delécluze, therefore, was only partially justified in heaping approbium on the English, for by 1824 the true enemy of his canon was the taste of his compatriots, which had simmered quietly during the reign of David and was now resurgent.

But who were these Maecenas of the new order? In Bonington's case the scant documentation prevents an inclusive identification. William Wyld (1806-1889), a pupil of Francia in the mid-1820s, observed that Bonington had been on intimate terms with a number of aristocratic patrons, the most important of whom was Charles Rivet, although Rivet was not actually created baron until after Bonington's death. In his youth he was an aspiring politician with an interest in the arts and a companion of Delacroix and the Fieldings, through whom Bonington probably made his acquaintance. According to Philippe Burty, Rivet was "a man of great sensibility and agreeable habits. He was more than Bonington's atelier comrade: he obliged him with infinite attention from the moment of his debut and throughout his troubles."[99] Of Bonington's earliest marine oils, *Near Ouistreham* (no. 24) and *Near St-Valery-sur-Somme* (no. 35) were probably Rivet commissions. Other early works, such as the various studies of Mademoiselle Rose (no. 6), and later pictures (no. 121) and oil sketches, which are still in the possession of Rivet's descendants, were likely gifts from the artist.

It is no longer possible to enlarge this circle of patrician patrons with any degree of assurance, but from the provenances of Bonington's first works emerge the names of some of the most consequential figures of the Restoration: Comte de Faucigny, who was a member of the household of the duchesse de Berry (fig. 26); Comte de Pourtalès-Gorgier and Baron de Vèze, both amateur artists and, through d'Ostervald, collectors of modern landscape paintings; Baron Mainnemaire, who also supported Delacroix and Paul Delaroche; and Zoé Talon, Comtesse du Cayla, mistress of Louis XVIII and a patron of Francia and the Isabeys. At a later date these ranks swelled to include the duchesse de Berry, probably the most generous and catholic arbiter of taste in the 1820s; Louis-Philippe, Duc d'Orléans and future monarch; and Anatole Demidoff, Duc de Rivoli, who was accused by Huet of amassing a fortune through art speculation. Most of these patrons were anglophiles, and with a few exceptions were following the dictates of fashion in acquiring their smattering of pictures or watercolors by British artists.

Far more important to Bonington and his circle was the elusive substratum of bourgeoisie, who had survived, and in many cases actually flourished economically as a consequence of, the political and social turmoil of the preceding quarter century. These ranged from a relatively minor stockbroker named Valedau, who bequeathed an extraordinary collection of contemporary drawings to the Musée Fabre, to the powerful dynastic families of the cultivated bankers and industrialists Benjamin Delessert and Paul Périer. Most of these collectors tended to be liberal in their political and artistic interests and mainly caught up

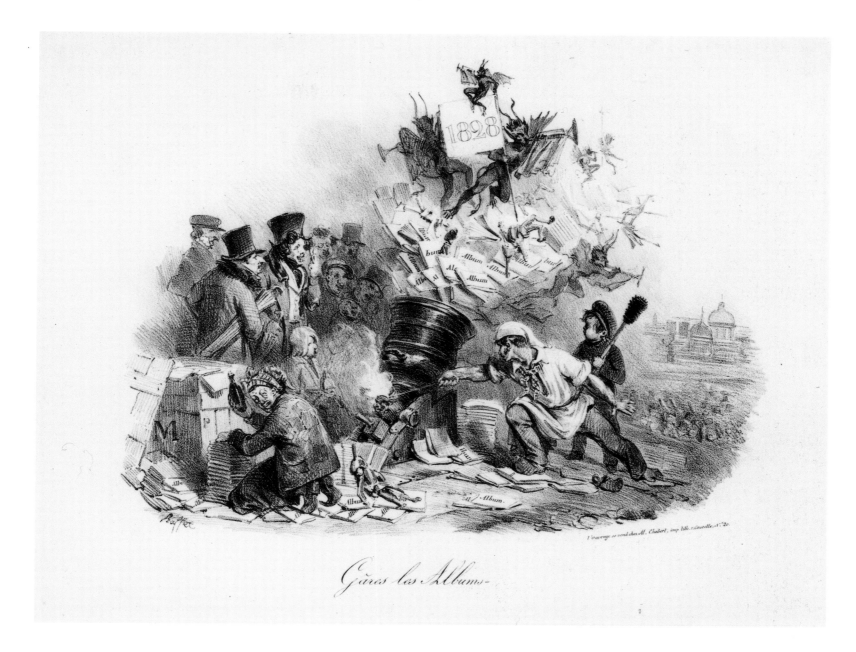

Gâres les Albums.

in the contemporary passion for assembling volumes of drawings and watercolors. They constituted the elite of that substantial middle-class audience for whom the portfolios of topographical, antiquarian, and satirical prints, especially lithographs, and the publications of illustrated editions of French and English novels, history, and periodical literature were proliferated in unprecedented quantity during this decade. They are the umbrella-toting dandies and fashionable *nouveaux riches* who, in Auguste Raffet's satire of 1828 (fig. 27), delight in laying siege to the capital and in bombarding the Institute with albums, the emblem of the emancipatory power of their own aesthetic proclivities. Their pervasive and irrepressible taste was a significant factor in what the ministerial *Journal des Artistes* described, also in 1828, as "the war of extermination against the classical beauty of the French school."[100]

Three early Bonington patrons deserve special notice, Alexandre Du Sommerard (1779–1842), Louis-Joseph-Auguste Coutan (d. 1830), and Lewis Brown (d. 1836). Du Sommerard had served the Empire in both the military and the financial courts. With the Restoration he began seriously to collect medieval and Renaissance antiquities and decorative arts, as well as modern pictures. In addition to Bonington's *Marine. Plage Sablonneuse*, the 1824 Salon catalogue cites him as the owner of landscapes exhibited by Léon Cogniet, Colin, Jean-Louis Demarne, Théodore Gudin, Riçois, and L.-J.-F. Villeneuve, two by Léopold Leprince and four by Xavier Leprince, and of several genre pictures, including Charles Renoux's adulatory depiction of the collector surrounded by his antiquities in his home at Pantin.[101] It would appear

97. Delacroix, *Journal* 1: 63ff. The relevant observations are recorded in a series of entries between March and May 1824.

98. Planche, *Salon 1833*, 184.

99. Quoted from P. Burty, ed., *Lettres de Eugène Delacroix* (Paris, 1880) 1: 127.

100. *Journal des Artistes* (24 February 1828): 119. For the most detailed analysis of Restoration patronage, see Miquel, *Art et argent*.

101. Stephen Bann, *The Clothing of Clio* (Cambridge, 1984), fig. 8.

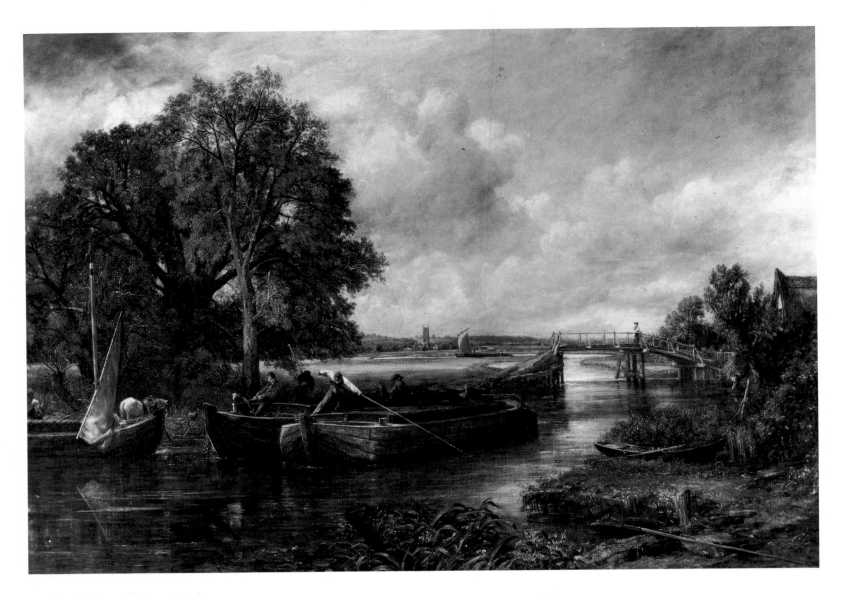

Fig. 28: John Constable (1776-1839)
View on the Stour Near Dedham, 1822
Oil on canvas 51 × 74 in. (129.5 × 180.8 cm.)
Huntington Art Gallery, San Marino

Fig. 29: *Henri IV and the Spanish Ambassador*, ca. 1825
Watercolor 6 × 6¾ in. (15.5 × 17.2 cm.)
Wallace Collection, London

Fig. 30: Jean-Auguste-Dominique Ingres (1780-1867)
Henri IV and the Spanish Ambassador, Salon 1824
Oil on canvas 16 × 24 in. (40.5 × 61 cm.)
Musée du Petit Palais, Paris

that Bonington met Du Sommerard before 1824 and possibly as early as
1822, when Colin was employed as an illustrator for his publication *Vues
de Provins*. This "prince of bric-a-brac"[102] eventually sacrificed every-
thing to his passion for medieval art and to creating a proper public
museum for it at the Hôtel (now Musée) de Cluny in Paris. It was to this
end that he ceased collecting modern pictures and that he auctioned, in
1825, many of those already acquired. Although he did not actually own
many works by Bonington, his investment came at a crucial moment.
Indirectly, the artist may also have benefitted from Du Sommerard's
involvement with the Société des Amis des Arts, which he helped to
revive in 1815, and, as will be seen later, from the antiquarian's pro-
nounced and meticulous Gothic historicism.[103]

Coutan, a manufacturer and wholesaler of fabrics, was simply a dis-
cerning and impassioned admirer of modern painting who dedicated the
final decade of his life to collecting and commissioning pictures and
drawings for his house on the Place Vendôme. Undoubtedly a rank
above the average collector, he nevertheless reflected in his tastes the
attitudes of his peers, which were emphatically less divisive than the
critical literature of the period alone would lead one to suspect. A
significant portion of Coutan's collection was auctioned immediately
after his death in February 1830. As noted in the catalogue introduction,
which was possibly written by Schroth, "Besides works that are serious
and in the severe style, one will discover gracious ideas rendered with
facility and pleasing compositions in which the fire and the genius
forgive the boldness of the execution."[104]

Works of the British school included Constable's *View on the Stour near
Dedham*, then the most celebrated landscape painting in France and
possibly the largest picture in Coutan's possession, three oils and eight

watercolors by Bonington (nos. 78, 81, 149), an unexpected oil by the Scottish landscape painter Patrick Nasmyth (1787–1831), and watercolors by Frederick and Newton Fielding, J. D. Harding (1798–1863) and Frederick Tayler (1802–1889). Of the French artists, Charlet and Ary Scheffer were obviously Coutan's favorites, but there is hardly any painter of talent or renown active at the time who does not figure in this cabinet, including David, Gros, Girodet, Hersent, Michallon and Watelet. It should be noted, however, that these painters of the "serious and severe style" were represented almost exclusively by oil sketches or studies. In addition to the representations of landscape, of sentimental and literary genre, and of sporting art that predominate, there was also a range of historical genre subjects. Next to Ingres's replica of his *Henri IV and the Spanish Ambassador*, the primary version of which (fig. 30) had been warmly received at the 1824 Salon, was Bonington's own interpretation of that subject as well as an earlier watercolor version (fig. 29). As stunning as this collection was, an equally magnificent and varied group of several hundred works remained the property of his heirs, until it, in turn, was auctioned in 1889. This remaining group included two Bonington oils (nos. 118, 132) and thirteen more drawings and watercolors (nos. 2, 111, 139).

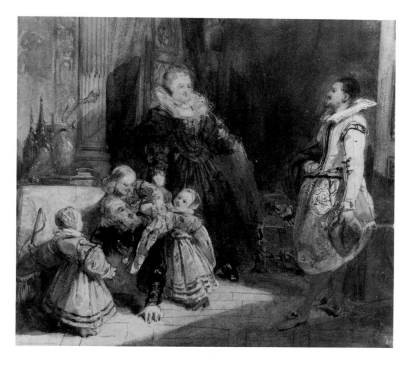

Finally, there was the Bordeaux wine merchant of British extraction, Lewis Brown, who was a collector of watercolors almost exclusively and who probably began buying directly from Bonington or from the dealers Schroth and Hulin at about this time. A friend of Francia, he was described by his obituarist as a zealot who would pay any price and travel any distance to secure a drawing by a distinguished artist for his legendary album. But the preoccupation, bordering on obsessive compulsion, of the last ten years of his life was to amass the largest collection of Bonington's watercolors, and in this effort he was supremely successful.[105] He died of dropsy and is reported to have expired in the act of painting watercolor copies of his Boningtons. His ambition to open a gallery devoted to his idol never materialized, but since he traveled throughout Europe, always with his album — the modern equivalent of Charles I's portable gallery of miniature replicas of his favorite Italian oils —, he probably contributed more to promoting Bonington's reputation and style than he imagined.

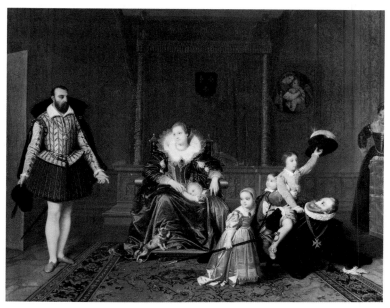

102. Such was Balzac's description of this renowned collector in *Cousin Pons* (Paris, 1848).

103. The relevant bibliography is the preface to volume five of Du Sommerard's magnificent *Les Arts au Moyen Age* (Paris, 1838–46), with its biographical notice by his son and a reprint of Jules Janin's obituary notice. For more recent appreciations of this singular collector, see Bann, *The Clothing of Clio*, chapter 4, and Clive Wainwright, *The Romantic Interior* (New Haven and London, 1989), passim.

104. Coutan sale, Paris, 17–18 April 1830.

105. In this exhibition, see nos. 3, 13, 59, 60, 73, 100, 101, 105, 108, 116, 124, 126, 130, and 135.

'PAINTING IS IN THE AIR'

Eugène Delacroix, Autumn 1827

Fig. 31: Alexandre-Marie Colin (1798-1873)
Bonington Dozing, ca. 1825
Graphite $7\frac{3}{8} \times 5\frac{1}{2}$ in. (18.8 × 14.1 cm.)
Winnipeg Art Gallery
Donation from the Arnold O. Brigden Estate

In addition to sharpening the debate as to what direction the French school was and should be following, the Salon had the immediate effect of convincing a sizable group of younger artists of the efficacy of a journey to London. Bonington had apparently decided on that course in the fall, for in a letter to Madame Perrier he notes that "in the spring, Colin and I are returning from our trip to England and hope, with your kind permission, to return by way of your region, which I greatly miss."[106] After visiting Paris to deposit his works at the Salon, Bonington had resumed his activities in Dunkerque. Though it is reasonable to suppose that he returned at least briefly to view the Salon in the autumn, when we next hear of him he is writing again to Colin from Dunkerque on All Saint's Day. In addition to gossip and chronic complaints about his inability to concentrate on work, the artist refers to a commission from Taylor that Colin was managing and that was almost certainly the lithographs for the first Franche-Comté volume of the *Voyages pittoresques*.[107] Of the nine lithographs executed for this set over the next two years, some of those dated 1825 in the stone were undoubtedly drawn during this winter. As discussed below (no. 151), all of Bonington's prints were based on designs by other artists, including Taylor and Isabey's brother-in-law Pierre-Charles Ciceri (1782–1868), who was then set designer for the Opéra.

By 3 December, Bonington was reinstalled in Paris and writing to Madame Perrier:

Whereas I spent happy days in your company, I did not know what awaited my return. I found my father bedridden these 18 days, and I cursed my friends, who for fear of upsetting me, kept me ignorant of this; thank god he is now convalescing and I am no longer anxious. I have surveyed this city of mud and filth which seems disgusting to me in comparison to that which I have just left where everything appears so smiling and so clean and which agrees so well with my tastes. I am impatient to have news of your health. If you were to see me now you would no longer ask M. Bonington to come downstairs to amuse you, boredom has taken hold since I returned. I am going to work, if I can, just to distract myself . . . Eh, mesdames, I will frequent the fashionable world, but I will find nothing here comparable to my evenings in Dunkerque.[108]

In keeping with his practice of corresponding on major feast days, Bonington once again wrote to Madame Perrier on New Year's Eve, thanking her for "the most happy year of my life passed at your house" and displaying some of the playful wit for which he was loved:

You can tell your good son, since he asked for news of it, my pimples are doing so well that with a bit of fine weather I shall be able to exhibit myself as a rosebush at the first village fair — and with great success! I have worked little since my return. I run about, I dine with one person, talk with another, it never ends. I do nothing but eat and drink. I am becoming Flemish completely.[109]

It can be presumed that he was present for the awarding of medals by Charles X in January at the close of the Salon and that he passed the spring occupied with commissions accruing from such prestige.

The trip to London materialized in the late spring and early summer of 1825. It was not the junket of young dandies, as is often supposed, but a carefully prepared itinerary for the purpose of study and the cultivation of potential new clients. Samuel Prout, who had passed through Paris in January, was possibly instrumental in arranging their visit to the collection of Dr. Samuel Meyrick (nos. 37–40), although he was summering on the English coast when his friends finally arrived. On 28 April Colin received his passport for the lowlands and England, and on 8 May Francia wrote to John Thomas Smith, keeper of prints at the British Museum, requesting that he introduce Bonington and Colin to the renowned collector of early Northern painting, Karl Aders. They

Fig. 32: Alexandre-Marie Colin (1798-1873)
Quayside: Awaiting the Channel Ferry, ca. 1825
Graphite $3 \times 5\frac{3}{8}$ in. (7.9 × 13.9 cm.)
Winnipeg Art Gallery
Donation from the Arnold O. Brigden Estate

106. Transcription (BN Bonington Dossier) by Dubuisson or Curtis of an untraced manuscript letter dated 3 December 1824: "au printemps prochain Colin et moi au retour de notre voyage d'angleterre nous ésperons avec votre bonne permission revenir par votre pays et que je regrette toujours."
107. Manuscript letter dated 1 November 1824 (Fondation Custodia, coll. F. Lugt, Institut Néerlandais, Paris).
108. Transcription (BN Bonington Dossier) by Dubuisson or Curtis of an untraced manuscript letter dated 3 December 1824:
Tandis que je passais des jours heureux auprès de vous, je ne savais pas ce que m'attendait à mon retour, j'ai trouvé mon pere au lit depuis 18 jours, et j'ai maudit les amis qui dans la crainte de m'[?] me l'avaient laissé ignorer; grâce à dieu il est convalescent dans ce moment et je n'ai plus d'inquietude. J'ai revu cette ville de boue et de mal propreté qui m'a paru bien dégoutante en me rapallant celle que je viens de quitter où tout me semblent si riant et si propre et qui s'arrangeait si bien avec mes gouts. Je suis impatient d'avoir des nouvelles de votre santé. Si vous me voyez maintenant, vous ne demanderez plus à M. Bonington de descendre pour vous distraire un instant, l'ennui m'a gagné depuis mon arrivé, je vais travailler si je peux pour m'en distraire Eh Mesdames, je courirai le monde mais je ne retrouverai point ici des soirées comme celles de Dunkerque.
109. Transcription (BN Bonington Dossier) by Dubuisson or Curtis of an untraced manuscript letter:
Vous pouvez dire à votre bon fils que puisque il a bien voulu avoir des nouvelles, mes boutons vont tant et si bien qu'avec un peu de beau temps je pourrai me présenter comme rosière à la premier fête de village qui aura lieu — et même avec succès. J'ai peu travaillé depuis mon retour. Je cours, je dejeune chez un, dire chez un autre, cela n'en finit pas, je ne fais que boire et manger. Je devienne flamand tout à fait.

were also seeking from Smith permission to draw the Elgin marbles and to study in the print room. Francia asked especially that they be shown the "Cries of London," probably a reference to Smith's own *Etchings of Remarkable Beggars* (London, 1815) or his *Vagabondia* (London, 1817), which Celina Fox has seen as an influence on Géricault.[110] As they were probably with Francia in Calais when this note was drafted, their arrival in London in late May or early June is most plausible. Several French artists of their acquaintance, who had made separate travel and lodging arrangements, were already in England. Delacroix arrived on 20 May to discover Augustin Enfantin (1793–1827), a student of the landscape painter J.-V. Bertin, busy making copies after Constable. Bonington scribbled his name and London address on a slip of paper and presumably went to see him before Enfantin's departure on 27 June. Henri Monnier was also already in London, and in a letter to his friend Wattier, dated 24 June, he noted that in addition to the artists already mentioned both Hippolyte Poterlet and Eugène Isabey had recently arrived.[111] Edouard Bertin would appear slightly later. The portraitist Auguste Mayer (1805–1890), another of Delacroix's friends, was also about.

In London Bonington sought permission from the artist William Westall (1781–1850) to visit Westminster for the purpose of sketching from the funerary monuments (no. 36). Delacroix had already visited Westminster in late May, but he would probably join Bonington, Colin, and Bertin for a second visit in July. Westall's brief response is of interest in that it furnishes the address at which Bonington and Colin were then staying.[112] Delacroix had relied on his old atelier comrade Thales Fielding to arrange rooms in a public house, although he later moved to the home of the horse broker Adam Elmore, who had earlier entertained Géricault. The address to which Westall posted his permission ticket, 7 Acton Street, Gray's Inn Road, was identical to 9 Constitution Row, Gray's Inn Road, which Bonington would use as his foreign address in 1826 when he sent from Paris two oils for exhibition at the British Institution. The establishment belonged to the widow of the influential engraver Charles Warren (d. 1823), his brother, A. W. Warren, also an engraver, and his apprentice and son-in-law H. C. Stenton, who would later engrave certain Bonington compositions for the Keepsakes. This was also the address to which William Ensom returned when he left France in 1824 and from which he would advertise his practice for several years. Clearly, Ensom functioned as Bonington's and Colin's principal London contact and host.

Another engraver with close ties to Charles Warren and who also might have assisted Bonington and Colin was Abraham Raimbach, best remembered for his reproductive prints after Sir David Wilkie. Raimbach frequently traveled to Paris in the 1820s, and he had been there the preceding autumn to view the Salon and to renew contacts with potentially influential patrons or supporters. Among these were Rev. Edward Forster (1769–1828), then protestant chaplain to the British Embassy in Paris, where his family had resided since 1816. At the turn of the century, however, Forster was a print publisher of the stature of Macklin or Bowyer. Both Raimbach and Warren had contributed to his most ambitious ventures — his illustrated translation of *Arabian Nights* (1801) and his *British Gallery of Engravings* (1806–13). Bonington's father might have had business contacts with Forster at that time, but what is certain is that by 1827 at the latest Bonington was on intimate terms with the family. The purpose of this digression is to suggest some common point of contact for Bonington and Raimbach, for on 16 April the latter sent a note to his friend and fellow engraver William Cooke requesting that he secure for two unnamed "foreign friends" introductions to Sir Walter Fawkes, Sir John Leicester, and the Marquess of Stafford.[113] Stafford and Leicester owned superb old master and modern collections that any artist would have desired to visit. The architect C. R. Cockerell took Delacroix to see the Stafford collection on 15 June. Fawkes, on the other hand, was the beneficent patron of J. M. W. Turner, whose works Bonington was most anxious to study (no. 48).

Since the Cooke family were also Turner's most important engravers, Bonington would almost certainly have sought them out with or without a proper introduction from Ensom or Raimbach. Reproductive prints by the Cookes after Bonington's watercolors begin to appear in the Keepsakes in the autumn. Since Bonington and Colin seem to have functioned independently of Delacroix until July, it is unlikely that they accompanied the French painter to the studios of Thomas Phillips (late May), William Etty (6 June), or David Wilkie (18 June). Furthermore, it is generally supposed that he and Colin were back in France by early August, which might explain why Bonington did not accompany Delacroix to the studio of Sir Thomas Lawrence at the very end of July, or join Delacroix and Isabey on their sea excursion to Cornwall in August.

The studies which have survived indicate that Bonington spent much of his time visiting private and public collections. He was also afforded the opportunity to see the annual presentations of the modern school at the Society of Painters in Watercolours, the Royal Academy, and the British Institution. Lawrence's *Portrait of John Kemble as Hamlet* and Wilkie's *Chelsea Pensioners* were the centerpieces of the last show. There were also exhibitions of the studios of Benjamin West and Sir Joshua Reynolds. Delacroix was not impressed by this surfeit of public exhibitions, nor by what he perceived as the pervasive flaw of the English school — its overdependence on old master painting styles. He was critical also of the Royal Academy for purchasing William Hilton's (1786–1839) *Christ Crowned With Thorns*, but unnecessarily concerned that such encouragement would distract the British school from the course of its true originality in genre pictures of modest dimensions. He immediately realized, however, that this country "overflowing in gold" offered a potentially lucrative market for his own paintings.[114] Bonington would have been no less cognizant of these opportunities and undoubtedly concentrated on meeting as many patrons and publishers as his brief stay permitted. Existing watercolors with titles suggesting that he also traveled to Burnham in Surrey or St. Michael's Mount, Cornwall, are misidentified or misattributed, and stories that he ventured as far as Nottingham are without foundation. With the exception of possible day excursions to Richmond, he appears to have gone no farther from the center of London than Greenwich.[115]

But as Delacroix observed, London in 1825 was a metropolis of infinite diversions, not least of which for this group of young tourists was its lively theater scene. Delacroix later recalled having spent much time in England in Bonington's company, and in addition to those working sessions already mentioned, one can imagine the bilingual Englishman acting as a commentator and translator for his French companions at many an evening performance. Delacroix wrote of a steady diet of Shakespeare, which included productions of *Richard III*, *The Tempest*, *Othello*, *Hamlet*, and *The Merchant of Venice*, and which were all the more interesting because the greatest virtuoso actor of the century, Edmund Kean, was performing in most of them. An operatic adaptation of Goethe's *Faust*, which also profoundly impressed Delacroix, was hailed universally by the critics as a pantomime of unprecedented ingenuity and splendor, featuring the most complicated set changes, costumes derived from Moritz Retzsch's (1779–1857) engraved illustrations to the original play, and an overture by Karl Maria von Weber. Other operas attended by Delacroix and his friends were Mozart's *Marriage of Figaro*,

Rossini's *Barber of Seville*, and Weber's *Der Freischütz*. Total immersion in contemporary British cultural life was obviously the objective of this trip for all parties, and their experiences would have brought into sharp focus the gulf that separated French and English taste. For Bonington, it also must have been a pivotal event vindicating the very British course he had chosen for his own art.

There is no reason to doubt that Bonington and Colin remained faithful to their original plan of visiting Dunkerque on their return to France, nor to dismiss the anecdote reported by the St-Omer artist Jules Jouets that they worked briefly in that town with Francia, Delacroix, and Isabey in mid-to-late August. Delacroix had informed his friend Charles Soulier that he would be back in Paris by the end of the month, and Colin, with a family to consider, probably returned with him. Bonington on the other hand appears, from the evidence of pictures that can be dated stylistically to late 1825 and early 1826, to have made a tour of the coast as far as Trouville (no. 44). Furthermore, the existence of versions by both Bonington and Isabey of identical compositions at St-Valery-sur-Somme (no. 119) suggests that Isabey may have accompanied him. Also in the early autumn, he appears to have made a separate excursion from Paris to Rouen in the company of Paul Huet. Both Huet and Isabey, whom Bonington had known casually for several years, were becoming, with Delacroix, his boon companions. A letter of 14 December to Colin, alluding to some neglect of their friendship on Bonington's part, is indicative of the latter's expanding alliances within the Parisian art world following the London trip.[116]

One immediate consequence of Bonington's London visit was that his landscapes became more varied in their subjects and more complex in their technique and stylistic directions. Views in the interior, especially canal and river scenes in which a picturesque lyricism supersedes any topographical considerations, would preoccupy the artist for the next year. Behind these new concerns was the firsthand experience of the extraordinary diversity of English landscape painting and an opportune assessment of the taste that supported it. Delacroix might object to English artists consciously echoing the styles and subjects of old master paintings, but Turner's overt allusions to Claude, Augustus Wall Callcott's imitations of Cuyp, David Wilkie's approximation of Dutch genre, and Sir Thomas Lawrence's overtures to Reynolds and Van Dyck were certainly more successful with cosmopolitan patrons than Constable's resolute "nature painting." It is not surprising then that at about this time Bonington begins to introduce compositions which engage in a more direct dialogue with past and modern masters, either through the appropriation of recognizable compositions like Rembrandt's *Cottage with White Paling* (see no. 71), by undisguised allusions to formal devices invariably associated with specific masters like Claude, or by mimicking certain technical felicities peculiar to artists like Turner.

To the autumn of 1825 also date his earliest plein-air oil sketches, *Near Rouen* (no. 55) and *In the Forest at Fontainebleau* (no. 52), both of which have persuasive stylistic parallels in either Huet's nearly contemporary oils (no. 56) or Bonington's own dated watercolors (no. 54). Both pictures were painted on a type of millboard with a prepared near-white gesso ground that was the specialty of the London firm of R. Davy, whose business address on Newman Street was not far from the drawing academy run by the Fielding family. Bonington returned to Paris with a supply of these portable, rigid supports with brilliant reflective properties, and he would use them repeatedly for both plein-air and studio pictures until his death. He was probably encouraged to paint plein-air sketches by Huet, but would have found the business too cumbersome had he not discovered this commercial product. Like sev-

Fig. 33: *Glenfinlas*, 1826
Lithograph 6¼ × 8¾ in. (15.9 × 22.2 cm.)
Yale Center for British Art, New Haven

110. Celina Fox, "Géricault's Lithographs of the London Poor," *Print Quarterly* 5 (March 1988): 62–65.
111. Manuscript letter, Monnier to Wattier, dated 24 June 1825 (Bibliothèque d'art et d'archéologie, Paris).
112. Manuscript letter (BN Bonington Dossier, AC 8020):

Bonington Esq.
7 Acton St.
Gray's Inn Road.
Mr. Westall presents his best compts to Mr Colin and Mr Bonington and is very glad to enclose his permission which they wished from the Dean of Westminster.
South Crescent Thursday Morn.
The letter also bears a small Bonington pen and ink sketch of shipping near cliffs (Dover ?) and his pencil notation "Enfantin Haymarket / Hotel Giraudier / Jermyn Street Corner."
113. Manuscript letter, Raimbach to W. Cooke, dated 16 April 1825 (Free Public Library of Philadelphia, John F. Lewis Collection):

Dear Sir
Can you put me in the way of obtaining permission for two foreign friends to view the collections of Mr Walter Fawkes, the Marquess of Stafford, Sir John Leicester or any one of them.
Your obliged,
Abraham Raimbach

114. The activities and interests of Bonington's circle can be inferred from Delacroix's letters to friends in Paris (*Correspondence* 1: 153–71), and from a letter of 31 December 1858 to Silvestre (*Correspondence* 4: 57–62). See also Lee Johnson, "Géricault and Delacroix seen by Cockerell," *Burlington Magazine* (September 1971): 547.
115. It was assumed previously that he visited Hampton Court since the figure of Surrey in his watercolor *The Earl of Surrey and Fair Geraldine* (fig.40) derives from a portrait of the poet at that palace; however, Bonington's immediate source was probably an engraving by Edward Scriven, published by James Carpenter in June 1821, although he may also have known Scriven's half-length version, which illustrated G. F. Nott's edition of *The Works of Henry Howard Earl of Surrey* (London, 1815–16), as noted by Ingamells (*Catalogue* 1: 47 n.2).
116. Transcription (BN Bonington Dossier) by Dubuisson or Curtis of a fragment of an untraced manuscript letter to Colin.

Fig. 34: Eugène Delacroix (1798-1863)
The Execution of Doge Marino Faliero, 1825/6
Oil on canvas 57½ × 44¾ in. (146 × 114 cm.)
Wallace Collection, London

Fig. 35: James Duffield Harding (1797-1863) after R. P. Bonington
An Albanian (Portrait Sketch of Count Demetrius de Palatiano), 1830
Lithograph 7¼ × 4⅜ in. (18.6 × 11.2 cm.)
Yale Center for British Art, New Haven

Fig. 36: Eugène Delacroix (1798-1863)
Sketch of Count Demetrius de Palatiano, 1825
Graphite 9⅞ × 4 in. (25.2 × 10 cm.)
Musée du Louvre, Paris

Fig. 37: *Study of Model in Turkish Costume*, ca. 1825-26
Graphite 6⅞ × 4¼ in. (17.5 × 10.9 cm.)
The Earl of Shelburne, Bowood

eral of the slightly later oils sketched in Italy, the Rouen view has flattened peaks in the most thickly painted areas, which is usually caused by pressure from another stiff surface against the partially dry paint film. A plein-air sketch packed closely for transport might well evidence such flattening, whereas a studio picture generally would not. An attestation on the back of the Fontainebleau oil and its casual composition suggest that it too was painted mostly outdoors. What is most important to note, however, is that both pictures, if judged strictly in terms of technique and of naturalistic description, could just as easily have been painted in the studio, since the differences in facture and definition are negligible between such sketches *en premier coup* and what are more obviously his composed studio productions — from the earlier *Calais Pier* to the more contemporary *Beach at Trouville* (no. 44) or *River Scene* (no. 72), in which the surfaces exhibit distinct drying layers of pigment. Such optical parity confounds the sketch-finish distinction. Diderot preferred sketches and Delécluze elaborate studio productions, but each respected the idea that to finish meant to moderate, through labor, the impressions of a heated imagination recorded initially in more spontaneous studies. By most contemporary standards, Bonington's oils were neither simply sketched nor fully finished; they are, however, *complete* in the sense proposed by Baudelaire much later in his defense of Corot's or Manet's styles:

A work of genius will always be well executed when it is sufficiently *so. There is this great difference between a work that is* complete *and a work that is* finished; *that in general, what is* complete *is not* finished *and that a thing that is highly* finished *need not be* complete *at all; and that the value of a telling, expressive, and well-placed touch is enormous.*[117]

Possibly the most significant result of the trip to England was Delacroix's invitation for Bonington to share his studio in the rue Jacob. In a letter of 31 January 1826 Delacroix acknowledged that Bonington had been with him for some time and that he had benefited greatly from the arrangement.[118] At that moment he was painting, or about to commence, his *Execution of the Doge Marino Faliero* (fig. 34). Dissatisfied with his own studio arrangements at home, Bonington probably settled in with Delacroix in the winter after concluding his several sketching tours. They were certainly working together at the end of the year when the Greek refugee Count Demetrius de Palatiano passed through Paris and agreed to pose for Delacroix's friends (nos. 64, 65; figs. 35, 36).

This was also a period of ever-increasing commissions from the Paris publishers. Taylor, who had been made a baron the preceding May, had just completed a tour to Mount Blanc with Nodier and Victor Hugo. His drawings at Brou and Tournus were transformed by Bonington into lithographs for the *Voyages pittoresques*. Although there exists no solid evidence that Bonington ever attended any of the weekly soirées at Nodier's famous literary salon in the Arsenal — indeed, if William Wyld is to be trusted, "he had but little social intercourse beyond the circle of his contemporary fellow-craftsmen"[119] — it must be presumed that, like Delacroix, Huet, and Isabey, he was at least an occasional guest, for it was undoubtedly this connection that led to his unique illustration of a *chanson* by Comte Jules de Resseguier and Amédée de Beauplan, the "Villageoise" (no. 42). Many of Isabey's first lithographs were similar ephemera for Beauplan scores.

A more important commission resulting from this increased involvement with Nodier's circle were the lithographic plates to Amédée Pichot's *Vues pittoresques de l'Ecosse* (no. 113), the first installments of which appeared in December and January and on which Bonington would be engaged, as the primary contributor, over the next year. Never having visited Scotland, he once again contentedly transformed

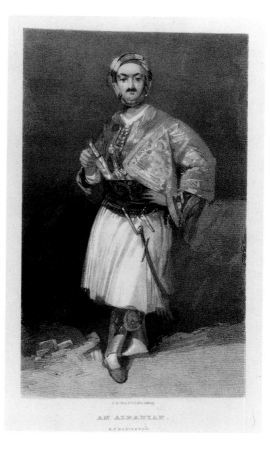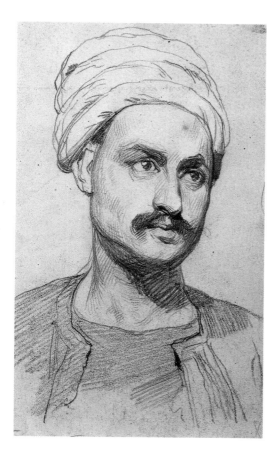

the designs of a much inferior draftsman, in this instance, François-Alexandre Pernot (1793–1865), into visually engaging images (fig. 33). The second installment, which focused on Edinburgh, established Bonington's preeminence among the several lithographers, including Francia and Enfantin, working for Pichot on this influential publication. In the opinion of one critic, "the amateurs will recognize that M. Bonington's two plates are lithographic masterpieces: it is with supreme art that he has rendered the vaporous shroud that habitually covers Edinburgh."[120]

Pichot was probably the most articulate defender of English literature and art during the 1820s. Like most of his acquaintances, he began reading Byron's poetry in the teens "because it was singularly in harmony with the disordered and passionate atmosphere in which we lived." He would translate Scott, Byron, and Thomas Moore in 1820, Shakespeare in 1821 and *Tom Jones* in 1828. His later collaborations were with Bulwer Lytton, Thackeray, Dickens, and Thomas Wright, with whom he coauthored a history of caricature.[121] When he published his *Voyage historique et littéraire en Angleterre et en Ecosse* simultaneously in French and English in 1825, his personal library already bulged with the works of every major contemporary British author from de Quincey and Southey to Beckford and Wordsworth. This three-volume survey of British culture, which was clearly inspired by the success of his friend Nodier's similar publication of 1822, but which surpassed that in the depth of its investigations and its intellectual rigor, offered original and balanced assessments of the Lake poets and of Turner's paintings, while unabashedly paying homage to Pichot's idol, Walter Scott. So compatible were their interests, it is difficult to imagine that Pichot and Bonington were little more than occasional collaborators on such publications as the Scottish views or that Bonington was not encouraged as much by Pichot's circle of literati as by Delacroix to essay seriously the genre of narrative and historical illustration, which, until this autumn, had been only a marginal interest. For without warning, there is a profusion of such works in both watercolors and oils.

117. Baudelaire, *Salons*, 24 (Salon of 1845).

118. Delacroix, *Correspondence* 1: 172 (31 January 1826).

119. P. G. Hamerton, "A Sketchbook by Bonington in the British Museum," *Portfolio* (1881).

120. *Journal des Débats* (4 March 1826): 2.

121. William Makepeace Thackeray (1811–1863), who had studied to be a painter, once wrote to Edward FitzGerald: "I herewith send a very bad copy of a bad copy by me of the Bonnington which I have managed to rob of all its grace and fantasticalness, and of its extraordinary delicacy of colour — the original is I think the finest water-colour drawing I ever saw in the world." See Lady Ritchie, *W. M. Thackeray and Edward FitzGerald, a Literary Friendship* (privately published, n.d.), 9. Thackeray does not identify the composition of the original watercolor. I thank William Drummond for sharing this reference.

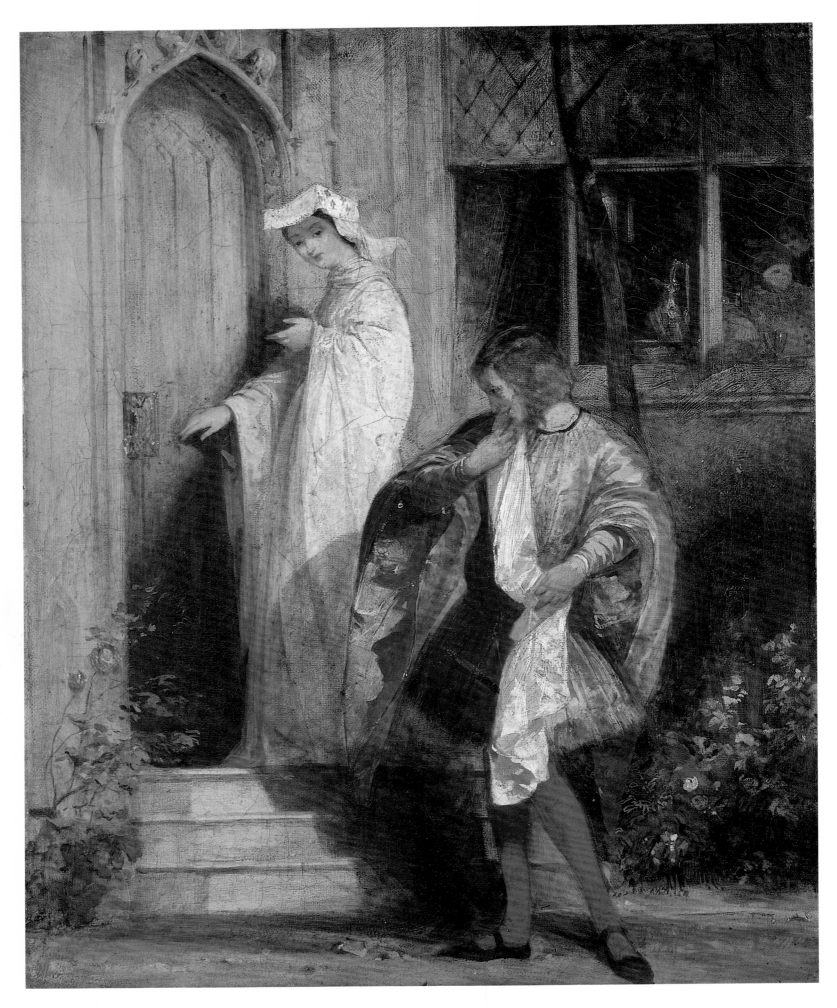

Fig. 38: *Anne Page and Slender*, ca. 1825*
Oil on canvas 18 × 14⅞ in. (45.7 × 37.8 cm.)
Wallace Collection, London

Of the figure subjects in watercolors dated 1825, two are illustrations to Scott's *Quentin Durward* (nos. 59, 60), and a third is to *One Thousand and One Nights* (Wallace Collection). E. Gauttier's new French translation of the latter had appeared in September 1825, but the immediate stimulus for treating such an unlikely subject was undoubtedly Delacroix's pronounced orientalism. It is an awkward production, both in its use of opaque colors and in its composition, with the figures of Scheherazade and her sister lifted from copies drawn by Delacroix from original Persian illuminations in the Bibliothèque Nationale.[122] Slightly more assured are the Scott illustrations, the dated watercolor, *Staircase of a Château* (Wallace Collection), and the undated, but certainly contemporary, *Earl of Surrey and the Fair Geraldine* (fig. 40), both of which reflect Delacroix's extraordinary spatial construction for *Marino Faliero*. Surrey also figured prominently in Pichot's survey of Elizabethan literature.[123]

What relates these earliest datable works is the exceptional degree to which Bonington has relied on borrowings, copied in either graphite or watercolor (no. 61), from published engravings or well-known pictures. His *Souvenir of Van Dyck* (Wallace Collection) is pieced together from several of that artist's works. Surrey derives from an engraved portrait thought at the time to be by Holbein. Rubens and Adriaen van de Venne furnished some of the figures for his watercolor version of *Henri IV and the Spanish Ambassador* (fig. 29). Less obvious are his quotations from Bernard de Montfaucon's *Monuments de la monarchie française* (Paris, 1729–33), Willemin's *Monuments français inédits pour servir à l'histoire des arts* (Paris, 1808–39), both equally plundered by Delacroix and Ingres; engravings by Dürer and Schongauer (fig. 65); and even the fifteenth-century choir screen at Amiens Cathedral (fig. 13) for the *Quentin Durward* watercolors. In every instance, historical decorum was fastidiously pursued. If Rubens furnished the figure of Marie de' Medici in the *Henri IV* watercolor, there were also preparatory, but unused, studies of the monarch's children copied from the engraved plates to Gaultier's seventeenth-century *Vie de Henri IV*. If nothing else, Bonington was exhaustive in his archeological research, yet perfectly at ease in translating these monochromatic or painted sources into his own stylistic language, so that there remains little trace, as Delacroix observed, of pastiche or slavish imitation.[124]

Also during this period with Delacroix, the winter of 1825–26, appear the first figure paintings in oil. Probably the earliest of these was the Shakespearean subject *Anne Page and Slender* (fig. 38), for which the artist borrowed the poses and costumes of the figures from Joseph Strutt's *Complete Book of English Costumes and Vestments* (London, 1797). The facture is somewhat fussy and the architectural elements extensively reworked. The chiaroscuro is also tentative, as in the watercolors dated 1825. Perhaps C. R. Leslie's oil *Slender Courting Anne Page* (fig. 39), exhibited at the Royal Academy that year, encouraged Bonington's selection of the subject[125]; but in adapting the contorted pose of a medieval courtier for Slender, he brilliantly conveys what is absent from Leslie's conception — the awkwardness of that character whom Hazlitt nicely described as "the most potent piece of imbecility" in all of English literature.[126] More will be said later of Bonington's reliance on visual sources, but for the moment it should suffice to observe that in composing his *Marino Faliero* Delacroix, the far more experienced history painter, also deliberately cribbed, for dramatic, historical, or emotional effect, from a range of Renaissance sources.

In an entirely different direction, and considerably more advanced in their understanding of light and shade, are the overtly Rembrandtesque *Henri IV at Roche-Guyon* (see no. 63), *Don Quixote in His Study* (no. 70), and *A Seated Turk* (no. 68), all of which Bonington attempted as compositions first in watercolors. If Delacroix's admission to Soulier that there

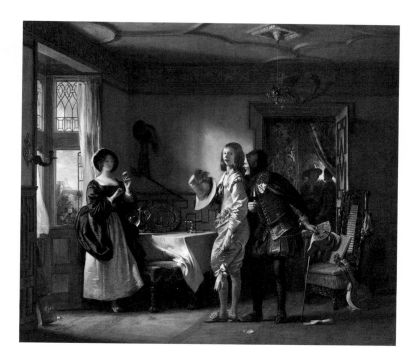

Fig. 39: Charles Robert Leslie (1794-1859)
Slender, with the Assistance of Shallow, Courting Anne Page, 1825
Oil on canvas 26½ × 30½ in. (67.7 × 77.5 cm.)
Yale Center for British Art, New Haven

122. The Delacroix studies are in a sketchbook in the Louvre (Sérullaz, *Delacroix*, no. 1750). The original designs copied by Delacroix were in *Modèles d'écriture ornées de portraits et costumes de prophètes et autres personnages indiens et persans* (Bibliothèque Nationale; Od. 60 rés, petit fol.) and *Costumes Turcs de la Cour et de la ville de Constantinople peints et coloriés par une artiste turc en 1720* (Bibliothèque Nationale, Od. 6in4), which was a gift of Achmet III to Louis XV. In use in 1826, Delacroix's sketchbook also includes studies for *Greece on the Ruins of Missolonghi* and copies of engravings of the Campo Santo frescoes in Pisa.
123. "The fabulous anecdotes of his wandering life would furnish materials for the novelist ... after the style of Walter Scott," (*Tour* 1: 154–64).
124. Bonington drew or sketched in watercolors numerous copies of figures in old master paintings and engravings. In addition to those cited elsewhere in this catalogue, these sources include: Rembrandt's *Venus and Cupid* (Louvre), *Christ Preaching* (etching), and *The Raising of Lazarus* (etching); Paris Bordone's *Ring of the Fisherman* (Accademia, Venice); Rubens's *Birth of Henri IV*, *Henri IV Conferring the Regency*, and *The Treaty of Angoulême* (Louvre); Terborch's *Concert* and *The Duet* (Louvre); Teniers's *The Prodigal Son* (Louvre); de Hooch's *Card Players* (Louvre); Quentin Metsys's *The Bankers* (Louvre); Philippe de Champaigne's *Louis XIII Crowned by Victory* (Louvre); Van Dyck's *Portrait of the Princess of Orange* (Brera, Milan), *Portrait of a Lady and Her Daughter* (Louvre), and *The Family of the Earl of Pembroke* (engraved version); van der Helst's *Portrait of a Lady* (Louvre); Antonio Moro's *Portrait of a Man* (Louvre); Joos van Craesbeck's *The Painter's Atelier* (Louvre); Tintoretto's *Portrait of a Man* (Louvre); Veronese's *Marriage at Cana* (Louvre); Andrea del Sarto's *Burial of St. Philip* (SS. Annunziata, Florence); Palma Vecchio's *Adoration of the Shepherds* (Louvre).
125. A sepia vignette (Huntington Art Gallery, San Marino) of the same scene may antedate the oil by several years.
126. William Hazlitt, *Characters of Shakespeare's Plays* (London, 1817; *Complete Works* 4: 351).

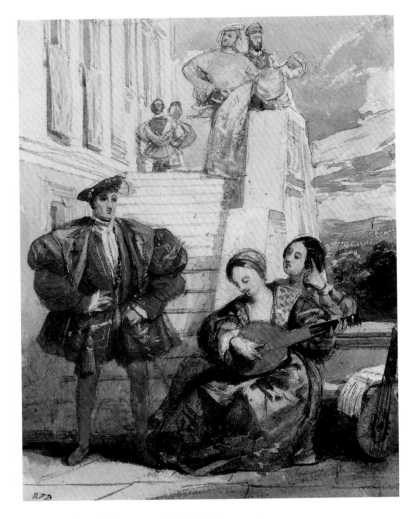

Fig. 40: *The Earl of Surrey and Fair Geraldine*, ca. 1825
Watercolor $5\frac{1}{2} \times 4\frac{5}{8}$ in. (14 × 11.9 cm.)
Wallace Collection, London

was a great deal to be learned from Bonington has any substantive meaning, one would have to search for it not in the conception but in the execution of such pictures, in which the subtlety of the coloring and the command of glazing techniques indicate a genuine and rapid advance beyond *Anne Page and Slender*. Bonington's brilliant coloring, more apparent in his watercolors and in the landscape oils he was then preparing to send to London (no. 49), was the most obvious source of Delacroix's admiration. But he was no less astounded by Bonington's innate mechanical skill:

I never tired of admiring his marvelous grasp of effects and the facility of his execution; not that he was readily satisfied. On the contrary, he frequently redid completely finished passages which had appeared wonderful to us; but his talent was such that he instantly recovered with his brush new effects as charming as the first.[127]

Specifics on how these two artists influenced each other at this critical moment in their careers are difficult to ascertain in the absence of detailed technical analysis. Undoubtedly Delacroix inspired Bonington to expand the scope of his ambitions, while the influence of the Englishman is sensed, as Gautier first observed, in the new éclat of coloring and the assured, vigorous movement of paint in Delacroix's pictures of 1826, in particular *The Combat of the Giaour and Hassan* (Art Institute of Chicago).[128]

While still with Delacroix, Bonington forwarded two paintings to London for the annual exhibition of practicing artists at the British Institution. *French Coast, with Fishermen*, now unidentified (original frame size: three by four feet), was purchased by Amabel, Countess de Grey, a life subscriber to the British Institution. Sir George Warrender, a life governor, purchased the second oil, *French Coast Scenery* (no. 49). The critical reception was no less enthusiastic than that expressed for Bonington's pictures at the Salon; they were praised as much for their beauty and skill as for the previously observed fact that our artist was completely unknown to the general English public. "Who is R. P. Bonnington? We never saw *his name* in any catalogue before and yet here are pictures which would grace the foremost *name* in landscape art," wrote the anonymous critic for *The Literary Gazette* in his initial preview of the exhibition.[129] The journal would subsequently be accused of having misidentified Bonington's pictures as works by William Collins (1788–1847), but actually, it was Clarkson Stanfield's *A Market Boat on the Scheldt* (Victoria and Albert Museum) that its critic freely confessed to having mistaken for a Collins picture.[130] The three artists may well have been acquainted, and Stanfield (1793–1867) would eventually purchase from Bonington's estate the watercolor *Charles V Visiting François Ier* (Wallace Collection). Since Collins was busy consolidating his support at the rival Royal Academy, he did not exhibit this year at the British Institution.

Aside from their shared interest in marine painting, there are striking similarities between Collins's mature style and that which Bonington was evolving after his London visit, and the possibility of Collins having modestly influenced his development at this stage cannot be dismissed.[131] The prominence that Bonington begins to afford discrete clusters of foreground figures was, for instance, one of Collins's favorite compositional devices, although he was certainly not alone in employing this convention. More relevant, perhaps, is that Bonington would also have known that two of Collins's pictures, which he had seen at the 1825 Royal Academy exhibition, *Fisherman with Their Nets* and *Fishmarket on a Beach*, had been commissioned by two of Britain's foremost collectors, Sir Robert Peel and the 6th Duke of Bedford, who were also a hereditary governor and a vice president of the British Institution,

respectively. He might also have known, as it generated something of a scandal the previous autumn, that Peel had commissioned from Collins another picture, *A Winter Scene* (fig. 41), for the unprecedented sum of 500 guineas. This was almost ten times the respectable prices Bonington's oils were commanding in Paris. It is not surprising, therefore, that Bonington would submit two coastal views, even though his current interests were focused more on genre and on broadening his repertoire of landscape subjects.

Collins would rapidly become a somewhat bitter rival, the one trait he had in common with Constable, who otherwise despised him for his self-aggrandizing art politics, for the immediate consequence of Bonington's debut were commissions from, or sales of marine pictures to, the Earl Grosvenor (no. 50) and the Marquess of Lansdowne (no. 76), both patrons of Collins and influential governors of the British Institution. Not to be outmaneuvered were other governors and directors who would shortly follow suit: Sir Thomas Baring, Lord Northwick, Marquess of Stafford, Lord Charles Townshend, Earls Mulgrave and Normanton, Samuel Rogers, William Haldimand, E. Fuller Maitland, the Hon. Gen. Edmund Phipps, and finally, Peel. No less significant than the support of this elite corps of collectors was that of one of the most powerful figures of the London art world, William Seguier (see no. 25). Of French descent, he held successively the offices of superintendent of the British Institution, the first keepership of the National Gallery, and the conservatorship of the Royal Collections. He was the art advisor to Peel, among other notables of that group, and, much to the annoyance of both Constable and Collins, the staunchest British promoter, second only in stature perhaps to Sir Thomas Lawrence, of Bonington's posthumous reputation.

News of Bonington's success and popularity reached Paris rapidly. On the magnanimous advice of the artist Augustus Wall Callcott, the Duke of Bedford, who was then residing in France, hastened to Bonington's parents' establishment to purchase at least one coast scene and to commission another (no. 120). Also in Paris were three important British collectors who began to purchase works from the artist at about this moment: Lord Henry Seymour, who was the younger brother of the 4th Marquess of Hertford, probably the greatest collector of Bonington's works in the nineteenth century; Henry Labouchère, Lord Taunton, who was an intimate of Charles Rivet; and Sir Henry Webb, nephew of Earl Mulgrave, and his brother, the Hon. Gen. Edmund Phipps (see no. 31).

If the social and political views of this varied lot of connoisseurs were divergent, often to the point of hostility, their aesthetic preferences were coherent and decidedly more reconcilable. In listing the pictures that had been purchased during the exhibition, *The Literary Gazette* lamented that little encouragement had been offered the painters of the "classic department," for the vast majority of pictures sold were genre, historical genre, or landscape, catering to the prevailing taste for color and effect. Surely, with their long-standing passion for Titian, Rubens, Rembrandt, or Cuyp, many collectors discovered a flattering realm of patronage in the modern school, in the painterly and chromatic brilliance of Edwin Landseer (1802–1873), Richard Westall (1765–1836; fig. 42), Stanfield, or Bonington, even though it was apparent to many observers, like Hazlitt or Wilkie, that such ardor was often misguided. In a letter from Italy of December 1825 to Collins, Wilkie actually went so far as to criticize the Venetian and Dutch masters for allowing "technicalities to get the better of them, until simplicity giving way to intricacy, they appear to have painted more for the artist and the connoisseur than for the untutored apprehensions of the ordinary man."[132]

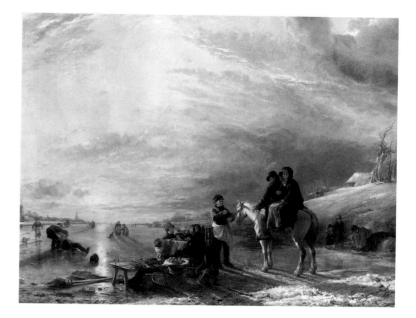

Fig. 41: William Collins (1788-1847)
A Winter Scene, 1825-26
Oil on canvas 33 × 39⅝ in. (84 × 109 cm.)
Yale Center for British Art, New Haven

127. Delacroix, *Correspondence* 4: 287 (30 November 1862).
128. Théophile Gautier, *Histoire du Romantisme*, 2nd ed., (Paris, 1874), 212.
129. *The Literary Gazette* (4 February 1826): 76.
130. Ibid.: "No. 102. A Market Boat on the Scheldt. C. Stanfield. We mistook it for Collins: need we offer a higher encomium?"
131. The possibility of Bonington having influenced Collins, while less likely, cannot be ruled out, since Collins was in Paris in the summer of 1824 and could have seen Bonington's Salon oils.
132. Collins, *Life* 1: 256–57.

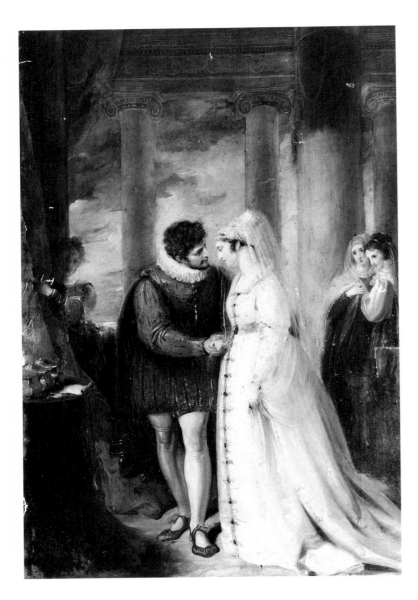

Fig. 42: Richard Westall (1765-1836)
Portia and Bossanio, 1795
Oil on canvas 32¼ × 22 in. (82 × 56 cm.)
Bonham's, London

But there was another factor, beyond historical connoisseurship, that was equally responsible for forming the direction of the contemporary British school and that had no parallel in France — the ascendancy of watercolor painting and its well-documented impact on oil painters of the 1820s. To quote once again from Wilkie's correspondence from Italy:

I perhaps say more of colour than I ought; that being with some of our friends the disputable subject. Sir George Beaumont used to say that water-coloured drawings had tainted our Exhibitions. I have observed . . . this difference between the pictures of the present day and the old masters, that they are never found in the same room, and seldom in the same gallery — collectors never place them together and artists are contented with the exclusion. The Duke of Bedford seems actuated by the same feeling; he has parted with his old pictures, intending to collect modern pictures in their place He once asked me to paint a companion to his Teniers — he had then no thoughts of parting with it.[133]

The dramatic shift in Wilkie's own style from the delicate finish of the teens to the more transparent, richly tinted, bravura treatment of his later work cannot be attributed exclusively to his experience of Italian and Spanish painting during his prolonged tour of the continent in the late 1820s, for evidence of such development is to be found in his *Chelsea Pensioners* of 1824–25 and in the increasing frequency and sophistication of his own use of watercolors at this time. The erosion of arbitrary technical distinctions between media was a trenchant phenomenon, with professional watercolorists abandoning the simpler wash styles of Francia's generation in order to give their ever larger and more elaborate exhibition pieces the visual clout of oils, and with the oil painters exploiting techniques like glazing in an effort to simulate the luminous effects of the watercolorists. Landseer's early masterwork *The Last Hunt of Chevy Chase* (Woburn Abbey), which was commissioned by Bedford in 1825, is an excellent example of this confounding of means. Large passages were painted with hatches of brilliant color juxtaposed on the thinnest oil washes in direct imitation of both Rubens and the watercolor and gouache style of his close friend John Frederick Lewis (1805–1876). Turner, of course, was the most adventurous in his use of watercolors as finishes over varnished oils; like Bonington, his reliance on watercolor for preparatory explorations of naturalistic effects and compositional alternatives also had an abiding influence on his easel pictures. In such a context, Bonington's art could not but excite interest.

Although no official exhibition was scheduled for Paris in 1826, French artists had been invited to submit pictures for a special exhibition to be organized at the Galerie Lebrun for the benefit of Greeks besieged by the Turks at Missolonghi. The gallery was managed by Charles Paillet and generally reserved for the Société des Amis des Arts. In the absence of a Salon, the Greek exhibition became the principal forum for the developments in French painting since 1824. Louis Vitet, a critic for *Le Globe*, described the event as "proof of the veritable schism existing between the elite of our painters and the official protectors of art; it is the prototype of the new Salon."[134] There were two installments, the first from May to July and the second through the remainder of the year. In the midst of such important pictures as Delacroix's *Marino Faliero*, *Greece on the Ruins of Missolonghi*, and *Combat of the Giaour and Hassan*, David's *Death of Socrates*, and Guérin's *Return of Marcus Sixtus* were Scott illustrations by Joseph West and Alexandre Colin and Bonington's hastily improvised entry *A Seated Turk* (no. 68). Hugo wrote an extensive review promoting the younger artists, who "have torn us from the numbness into which we were plunged by the second school of David," but it was never published, probably because it was too

divisive for an occasion meant to join together all French artists in a united panhellenic exercise. A passing reference to Bonington's *Turk* is the only mention of the artist in Hugo's writings.[135]

The reflection advanced by several modern commentators that the choice of *A Seated Turk* for inclusion in an exhibition mounted for the relief of the Greeks confirms Bonington's monumental indifference to the political or social import of his visual imagery may be flawed in that it fails to grasp the complexity of the French romantics' attraction to Eastern culture and mores. For instance, Alphonse de Lamartine, despite the affection he and his circle shared for the Greeks and their cultural legacy, could define himself as an "Oriental":

Nature had not made me for the world of Paris. The city offended and bored me. I am Oriental and will die as such. Solitude, the desert, the sea, mountains, horses, private conversation with nature, a woman to adore, a friend to entertain, long periods of physical inactivity brimming with spiritual inspiration, then violent and adventurous periods of action like those of the Ottomans or Arabs, this is my being: a life in turn poetic, religious, heroic or nothing.[136]

In Hugo's broader application, the Orient almost became a descriptive term for anywhere beyond the Paris suburbs:

The Orient, either as an image or as a thought, has become for our intelligence as for our imaginations a general preoccupation Oriental colors have imprinted all our thoughts, all our dreams; and these thoughts and dreams have been, in turn, and almost involuntarily, Hebraic, Turkish, Greek, Persian, Arabic, even Spanish.[137]

Bonington was probably no less sensitive to the plight of the Greeks nor less fascinated by the allure of the Near East, but his artistic engagement with both topical interests was limited and undoubtedly stimulated by Delacroix's immediate example. His "oriental" subjects were few in number, and in addition to the two versions of *A Seated Turk* and the *Arabian Nights* illustration, these included only several odalisques (fig. 43).

Shortly after painting *A Seated Turk*, Bonington relocated to his own quarters at 11, rue des Martyrs in the fashionable Montmartre district. Through Delacroix he had become acquainted with the premier "Orientalist" of the decade, the artist/collector Jules-Robert Auguste (1789–1850; no. 67), who offered him the lease on a spacious loft that was previously occupied by Horace Vernet (fig. 62). There are several references to Auguste in Delacroix's correspondence of January and February, and one can assume that both he and Bonington were frequent guests at Auguste's weekly salons. Prosper Merimée, Honoré de Balzac, and Théophile Gautier, three of Auguste's other regular visitors, were just commencing their brilliant literary careers.

Bonington shared his new studio for a brief period with the future president of the Society of Painters in Watercolours, Frederick Tayler, whom he had met, together with the mezzotint engraver S. W. Reynolds (1773–1835), the preceding summer at Calais. Tayler was a novice sporting artist upon whom Bonington's now mature watercolor style had a formative influence. Apparently, the artists also worked side by side in the Louvre sketching watercolor *aide-mémoires* after their favorite Italian and Flemish pictures. Reynolds, by this date, was the master of an internationally respected reproductive printmaking empire. He was also a landscape painter in an imaginary, rather than topographical, vein, whom Huet ranked with Bonington in his admiration and friendship. His few identifiable surviving works exhibit, as Huet observed, "something of the intelligence and elevation of Poussin, with a Rembrandtesque touch and a more modern sentiment," result-

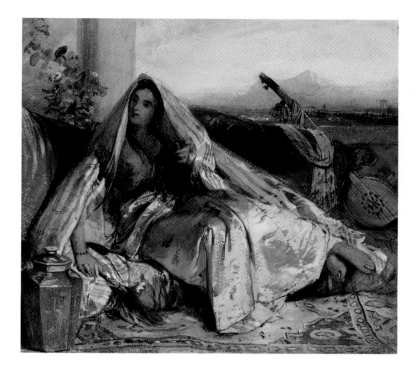

Fig. 43: *Odalisque in Yellow*, dated 1826
Watercolor and bodycolor 6 × 6⅞ in. (15.5 × 17.4 cm.)
Wallace Collection, London

133. Ibid., 1: 290–91 (26 August 1827).

134. Louis Vitet, *Le Globe* (3 June 1826).

135. Victor Hugo, "Exposition de tableaux au profit des Grecs: la nouvelle école de peinture," *Oeuvres complètes* 2: 984. Hugo had lauded Delacroix's *Greece on the Ruins of Missolonghi*, possibly because the *Journal des Débats* (13 July 1826), while applauding the exhibition, had been harsh: "Innate talent and an obvious grappling with the bizarre systems and chaotic process of artistic creation are perceivable in Delacroix's *Greece on the Ruins of Missolonghi*, just as one sees a glimmer of reason, the light of genius even, wretchedly cutting through the chatter of madmen."

136. Alphonse de Lamartine, *Premières et nouvelles méditations poètiques* (Paris, 1874), 185.

137. Victor Hugo, *Les Orientales* (Paris, 1828).

Fig. 44: *Tomb of the Scaligeri, Verona,* 1826
Graphite $14\frac{3}{4} \times 10\frac{1}{2}$ in. (37.5 × 26.5 cm.)
The Earl of Shelburne, Bowood

ing primarily from his "bold and mysterious coloring."[138] This derived from decades of studying closely for reproduction the paintings of Sir Joshua Reynolds and his own collection of seventeenth-century Dutch landscapes. Without doubt, the growing preoccupation of the artists in Bonington's immediate circle with Rembrandt owes something to Reynolds's infatuation with that master.[139] But it was as an engraver that Reynolds would best serve Bonington, for his mezzotints after Bonington's figure subjects, which began to appear in 1827, were crucial to promoting the artist's reputation in that genre on both sides of the channel.

Bonington had scant time to settle into his new accommodations, for on 4 April he and Charles Rivet left Paris for Italy. The trip had probably been in the planning for some time and with Delacroix as a potential third member of the party. Although Delacroix did not, in the end, accompany his friends, his letters of February and March allude repeatedly to such a voyage. The journal kept by Rivet, and his correspondence home, have vanished since Dubuisson first published extracts from both sources in 1924; however, it is possible to reconstruct the course of their journey, if not their day-to-day experiences, from Dubuisson's notes and more recently discovered drawings of visited sites. They traveled with extraordinary haste, covering the distances between Paris and Dôle in two days and between Dôle and Geneva in one. By the evening of 10 April they were in Brig, where they were awakened in the middle of the night and forced to cross the Simplon to avoid a threatened avalanche. The route from Geneva to Brig, then, took three days, and although Dubuisson recorded only that they "passed a few days" on the Lake of Geneva, surviving sketches carefully inscribed with place names indicate stops at Meyringen (no. 84), Lausanne, Vevey, St-Gingolph, St-Maurice (no. 85), and Sion. A second group of sketches made at Thun, Interlaken, Staubach, Berne, and Basel are of sites too far afield to fit comfortably in the rapid progress from Geneva to Brig and suggest that they returned to France in June also by way of Switzerland. This was a common practice of travelers of the period and would explain why it took them nine days to reach Paris from Turin, a stretch of their trip of which Dubuisson left no account.

After crossing the Simplon, a few days rest in Milan was sufficient, for Rivet wrote from that city that "Bonington thinks only of Venice." With that destination foremost in mind, they raced through the lakes, arriving at Verona on 18 April (nos. 87, 88) and at Venice several days later (figs. 44, 45). It had rained constantly since they left Switzerland, and Rivet would record upon reaching Venice, "He is in a dismal mood; he ought to have someone always with him to make him laugh." To distract themselves, they made frequent visits to the Accademia and to several private collections, including one of medieval and Renaissance costumes, although their studies after works in these collections, especially the masterworks of Titian and Veronese, have mostly disappeared. By the beginning of May, the weather, and their spirits, had improved:

My friend has been a little more docile these last days He has had a letter from his father, who tells him that not only has the price been received for all the pictures he has sold, but that every one that he had done, without exception, his view of Mantes even, has been bought and paid for, so that he finds himself in possession of a capital sum of 7000 or 8000 francs [approximately £320] *earned since January. It is splendid, and I have advised him to buy a house when he gets back. But what is still better for his traveling companion is that he has begun to complain less about the little he has done, and, apart from the few jeremiads on the meagre amount of strength which nature has put into his right arm, he has become quite bearable He works hard and adopts so readily the suitable style and method, that he is more and more successful and more and more easily so.*[140]

Rivet might have preferred a more casual pace, but intent on compensating for time lost to inclement skies, the two men labored studiously, if not furiously, allowing themselves few diversions and extending their stay in Venice by ten days.

Bonington was addicted to his work and, despite his facility, obsessively self-critical of his productivity. This was a personality trait in evidence from his student days and aggravated in these circumstances by the notion that he might never again have the opportunity to see Venice. Rivet avowed that Bonington experienced just such a premonition, but perhaps too much significance has been attached to this remark by modern interpreters of Bonington's conceptual approach to his Venetian subjects. It was probably not his own early death that he foresaw as an impediment to future visits, but the disappearance of Venice itself, for it was the orthodox belief of every French romantic writer from Madame de Staël to Nodier and Delavigne, and of a considerable number of French painters, that nature would reclaim this enchanting city within a decade. As the comte de Forbin observed in his *Une Mois à Venise*, which Bonington would certainly have perused prior to his departure: "Venice, it can be affirmed conclusively, is now in a state of agony: the sea will soon reconquer what the genius of man has torn from her; the lion of San Marco will be an effigy covered by the waves."[141] For romantics like Chateaubriand and Stendhal, Venice was a human artifice — the ultimate triumph of postclassical art and mores over nature; yet, simultaneously, as evidenced by its decay, resulting as much from social and political as from natural agencies, it was also a potent and melancholic warning that such triumphs were ephemeral and that finally nature alone survived the great flow of time.

The romantics needed a Venice in utter despair, but the French, more so than the English, were prone to exaggerate the actual state of affairs and the consequences of Venice's fall from power. Hazlitt had written: "The sense of final inevitable decay *humanizes*, and gives an affecting character to the triumphs of exalted art. Imperishable works executed by perishable hands are a sort of insult to our nature."[142] Consequently, he greatly enjoyed his visit to the city in 1825 and made no mention of its dilapidation in his published account of his tour, *Notes of a Journey Through France and Italy*. In fact, the ruinous state of Ferrara seemed to affect him more than the crumbling facades of Venice's abandoned palazzi. The French perspective, on the other hand, was probably best articulated by Antoine Valery, Conservateur-administrateur des Bibliothèques de la Couronne, whose guide to Italy, *Voyages historiques et littéraires en Italie, pendant les années 1826, 1827 et 1828* (Paris, 1831), was the *vade-mecum* of the romantics and a source for many of Chateaubriand's reflections on Venice in *Memoires d'Outre-Tombe* (Paris, 1833). A friend of Stendhal (as was Hazlitt), of Merimée and Nodier, Valery arrived for the first time in Venice just one month after Bonington's departure. For Valery the story of Venice from Attila to Bonaparte was a historical tragedy enacted on the highest aesthetic plane, but it was not until the Austrians occupied the city that its physical decline accelerated alarmingly. Amid observations on the exact number of inhabitants who had recently fled to the mainland and the paltry sums spent annually by the occupation on the preservation of palaces and churches, he mused:

The aspect of Venice has something in it more gloomy than that of ordinary ruins: nature lives still in the latter, and sometimes adds to their beauty, and although they are the remains of by-gone centuries, we feel they will live for centuries to come, and probably witness not only the decay of their present master's power, but of succeeding empires: here these new ruins will rapidly perish No time ought to be lost in visiting Venice, to contemplate the works of Titian, the frescoes of Tintoretto and Paolo Veronese, the statues, the palaces, the temples . . . tottering on the verge of destruction.[143]

Fig. 45: *The Colleoni Monument, Venice, and Figure Studies*, 1826
Graphite $9\frac{1}{8} \times 5\frac{5}{8}$ in. (23.2 × 14.2 cm.)
The Earl of Shelburne, Bowood

138. Huet, *Huet*, 95–96.
139. Poterlet and Arrowsmith were actually trying to persuade Reynolds to engrave mezzotints after Rembrandt in 1827.
140. Dubuisson and Hughes, 71–72.
141. Comte de Forbin, *Un Mois à Venise, ou recueil de vues pittoresques, dessinées par M. le Comte de Forbin et M. Dejuinne* (Paris, 1825); quoted from Maurice Levaillant, *Chateaubriand, Madame Récamier et les Memoires d'Outre-Tombe* (Paris, 1936), 121.
142. William Hazlitt, "The Marquis of Stafford's Gallery," *The Picture Galleries of England* (London, 1824; *Complete Works* 10: 28).
143. Valery, *Voyages*, 144.

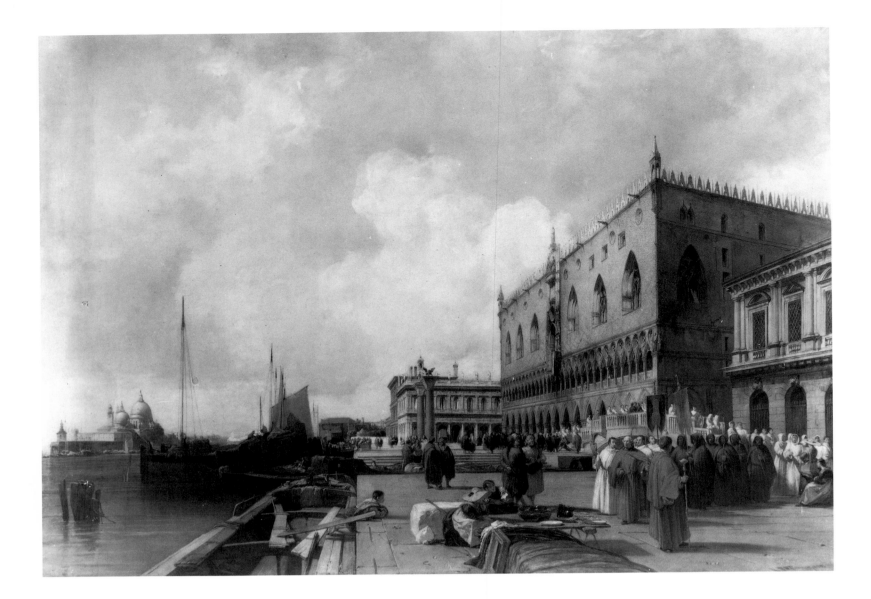

Fig. 46: *The Ducal Palace with a Religious Procession*, 1827
Oil on canvas 45 × 64 in. (114.5 × 162.5 cm.)
The Tate Gallery, London

In another passage he reflects: "There is a soft and melancholy pleasure in gliding amid those superb palaces, those ancient aristocratic dwellings ... which are the memorial of so much power and glory, but are now desolate, shattered or in ruins."[144] The image of gloom is both extravagant and self-indulgent. The black gondolas resemble floating sepulchers in mourning for the city. The Ducal Palace can only conjure up visions of Doge Marino Faliero, who was executed for treason in 1355, along with his architect Calendario, who initiated its construction. The palaces along the Grand Canal are little more than mausoleums, and the moon is the "sun" best suited to "this grand ruin" of a metropolis. Only the ubiquitous pigeons in the Piazza San Marco seem to flourish in this theater of solemn sadness.

Of special interest in this context are the remarks with which Valery opens his chapter on Venice:

The paintings of Canaletto have so familiarized us with the harbor, the squares, and monuments of Venice that when we penetrate into the city itself, it appears as if already known to us. Bonington, an English artist of melancholy cast, has painted some new views of Venice, in which is most perfectly sketched its present state of desolation; these, compared with those of the Venetian painter, resemble the picture of a woman still beautiful, but worn down by age and misfortune.[145]

Chateaubriand appropriated but modified this thought to describe his impressions on visiting, in 1833, his long-standing friend Lucia Mocenigo, one of Venice's last and most illustrious patricians: "Her portrait (the portrait of Mme Mocenigo) painted during her youth (an original and authentic verification of her beauty) was hanging on the

wall near her: sometimes a *View of Venice* in its first bloom, by Canaletto, makes a pendant to a *View of Venice* failing, by Bonington."[146] Valery's response to Bonington's depiction of Venice was not isolated or unique, for clearly Chateaubriand would not have paraphrased the allusion had he not sensed a more widespread agreement on this point, nor would Roger de Beauvoir have written more luridly in the same year of the morose attraction "of this dead city which Bonington alone has captured in not painting over her hollow cheeks, but in showing, by his color, what she truly is: a mummy."[147]

The comparisons with Canaletto that greeted Bonington's first exhibited views of Venice in 1827 and 1828 were inevitable because of the subject matter and because few other artists of his generation had portrayed the city. Preoccupied as they were with the well-established school in Rome and the traditions of Claude and Poussin, French landscapists were slow to heed Stendhal's advice of 1824 that they should abandon Rome for Venice and Florence. But the idea that Bonington had transformed Canaletto's neat, tidy, and festive view of the city into one of sober and resigned foreboding is more difficult for a modern audience to reconcile with the surviving works, which are generally resplendent in color and light. The later exhibition pictures, such as *View of the Ducal Palace with Procession* (fig. 46), certainly give little indication of a civilization in ruin, and in all likelihood Valery formed his opinion of Bonington's attitude on oil sketches like the *Palazzo Conterini-Fasan*, (no. 97) or the *Giudecca Canal* (no. 93), which he could have seen in the rue de Martyrs studio. The picturesque air of attention afforded the weathered surfaces and the profound stillness conveyed by such studies, in which figures or water craft are only sparsely and minimally represented, was perfectly compatible with Valery's bleak picture of desuetude; but a somewhat different impression is presented by the more numerous studies in graphite and watercolor, in which Bonington endeavored to capture the human animation for which this exotic portal to the Orient was justly and equally famous. It may well be that Bonington shared to some degree Valery's pessimism (we will probably never know), but it may also be that Valery's interpretation of Bonington's disposition was based on a misunderstanding of his working methods.

While in Venice Bonington produced three categories of works, distinguishable by medium and intended function. A plethora of studies, executed in so brief a period, attests to his extraordinary industry and to his desire to cull from his visit a varied store of visual documentation upon which to base later easel pictures. The bias of subject selection is topographical. The standard tourist views with the maximum commercial potential tend to dominate, but lesser monuments and unfamiliar churches or canals were not ignored. Very detailed and perspectively accurate graphite studies are the most numerous category by medium. These would be employed later in Paris for both finished watercolors and oils (figs. 47, 48). Certain watercolors appear to have been painted from the motif, either as quick studies (no. 101) or as finished works in their own right (no. 87). Finally, there are the oil sketches. The question of whether these were painted outdoors or in the studio back in Paris has been frequently raised. Invariably, these sketches were painted on Davy millboard, and, if packed closely, two dozen of these supports, roughly the number of Italian studies in the family's possession in 1829, would not have posed unusual transport problems. Oil sketches of Italian sites, attributed to Bonington and painted on paper laid onto more cumbersome canvas stretchers, are generally misascribed. William Callow's *Place Nettuno, Bologna* (fig. 49) is one such example. The close compositional correspondence between graphite and watercolor renderings of the same monument or view does not pertain to the oil

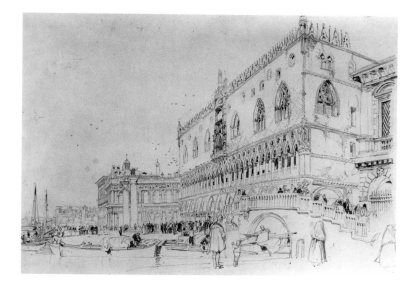

Fig. 47: *The Ducal Palace, Venice*, 1826
Graphite $10\frac{3}{4} \times 15$ in. (27.5×38 cm.)
The Earl of Shelburne, Bowood

144. Ibid., 160.
145. Ibid., 143.
146. Chateaubriand, *Memoires d'Outre-Tombe*, ed. Maurice Levaillant (Paris, 1982), 4: 375.
147. Roger de Beauvoir, *L'Eccelenza ou les soirs au Lido* (Paris, 1833); quoted from Levaillant, *Chateaubriand, Madame Récamier et les Memoires d'Outre-Tombes*, 355–56.

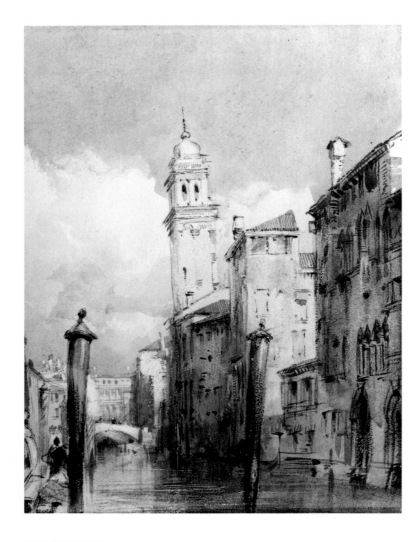

Fig. 48: *Rio dei Greci, Venice*, ca. 1827
Watercolor $7\frac{1}{4} \times 5\frac{1}{4}$ in. (18.5 × 13.5 cm.)
Private Collection

Fig. 49: Attributed to William Callow (1812-1908)
Piazza del Nettuno, Bologna, ca. 1830s
Oil on paper $8\frac{7}{8} \times 12\frac{3}{4}$ in. (22.7 × 32.4 cm.)
Yale Center for British Art, New Haven

Fig. 50: *Venice, with San Giorgio Maggiore*, 1826
Oil on millboard 14 × 20 in. (35.7 × 51 cm.)
Huntington Art Gallery, San Marino

sketches, which usually do not replicate compositions in the other media. This further suggests that the oils on millboard are original plein-air studies. Finally, the technique used in their production tends to settle the point decidedly in support of this proposition.

Most of the oil sketches were painted in single sittings, either *alla prima* or within a few hours. When architecture is the principal focus, as it is in most of the Venetian studies, the method of proceeding is relatively consistent from one sketch to the next. Cursory graphite underdrawing for the architectonic forms and lines of recession are visible in several. The architecture was then blocked-in with broad swatches of thick white or cream pigment and articulated either while still wet with other tints or when slightly dry with transparent films of brown or sepia. Comparably translucent washes of blue furnish what evidence there is of Venice's aqueous thoroughfares. A sketchy figure or gondola may be introduced for scale, but the absence of fully developed staffage elements is understandable, if we accept these oils as rapid studies intended to register only the dominant topographical elements and not as finished works of art. The skies vary greatly in their degree of elaboration and in certain instances, as probably in *The Ducal Palace, Venice, with Moored Barges* (no. 94), could be studio additions or reworkings. This also should not be surprising, for, with the exception of a sketch, *Corso Sant'Anastasia, Verona* (Private Collection), which Bonington worked up into a presentation picture for the London dealer Dominic Colnaghi in 1827, all of the Italian sketches appear to have remained with the artist until his death. In anticipation of executing a commission, such as the *Ducal Palace* (no. 132), the artist might well have utilized a compositionally related sketch to experiment with particular effects.

Characteristic of the Venetian studies is the absence of any meteorological information of a dramatic variety, as one encounters repeatedly in Turner's watercolor studies of several years later; and when such elements were required in later studio pictures like *Grand Canal Looking toward the Rialto — Sunrise* (no. 154), the artist must have relied entirely on his acute visual recall. Consistent with his uncomplicated topographical approach is the constrained palette typical of the Venetian group, although their pervasive blonde tonality does conform perfectly to the most vivid recollection of any first-time visitor to the city on a sunlit summer day. A brilliant midday light bleaches the marble facades to soft pastel harmonies as it chisels the ornate and intricate carvings into bold picturesque relief. Had Rivet not informed us to the contrary, we might deduce from surviving works that only brilliant skies greeted the fortunate travelers during their sojourn. Venice might have fallen on hard times, but for Bonington it remained a coruscant diadem capable of captivating the eye and enchanting the spirit of its northern guests, saluted, as even Chateaubriand admitted, "by every grace and every felicity of nature."[148]

Bonington would have been content to pass the rest of their trip in Venice, but Rivet insisted on visiting Bologna and Florence. On 19 May he reluctantly departed. At Padua they copied Titian's early frescoes in the Scuola del Santo (see no. 105) and at Ferrara were disappointed by the pictures of Raphael, Reni, and Guercino in the Accademia. From Bologna Rivet wrote only that "Bonington has said nothing since we left the lagoons He regrets Venice, though she treated him so badly with her rain and incessant storms."[149] Eventually Florence was gained on 24 May, after they traversed the Appenines and sketched briefly at Clavigliago and Mascheri. Unfortunately, no visual record survives of this passage, which had only recently furnished Hazlitt with some of his most sublime associations. On the activities of their week in Florence and Pisa, Rivet was silent, but graphite sketches after figures on the

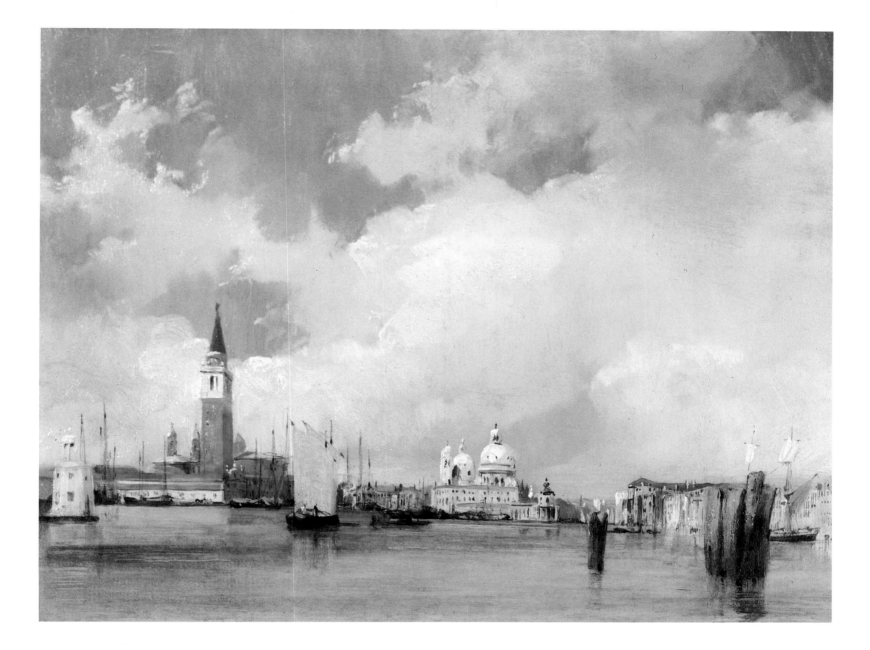

Baptistry's bronze doors, a watercolor copy of a Van Dyck portrait in the Uffizi, and several oil sketches of views in and from the Boboli gardens indicate a regimen similar to that followed in Venice. After Florence they traveled the exceedingly beautiful Ligurian coast, passing through Sarzana and resting for several days at Lerici (no. 102), Spezzia, and Porto Venere and for two days at Genoa (nos. 103, 104), the environs of which inspired the most ravishing of the pure landscape sketches painted in Italy. On 11 June they arrived in Turin and by 20 June were back in Paris. As suggested earlier, they probably returned to France via Switzerland.

Despite the brevity of the voyage, Bonington had gathered a surfeit of material for future commissions and exhibition pictures, the novelty of which would cater to the rapacious curiosity of French and English audiences for representations of more exotic lands and peoples. It was suggested by Jean Adhémar[150] that he actually prepared designs for a panorama of Venice for Daguerre's immensely popular theaters in London and Paris, but the anonymous journal reporter cited by Adhémar, who identified the 1830 panorama of Venice as Bonington's conception, was misinformed, for that was a diorama by Clarkson Stanfield. There is no evidence among Bonington's surviving graphite sketches, the bulk of which were acquired by the Marquess of Lansdowne at the 1829 studio sale, that he ever envisaged anything as grand or coherent as a 360 degree prospect of the city.

148. Chateaubriand, *Memoires d'Outre-Tombe*, 4: 337.
149. Dubuisson and Hughes, 74.
150. Jean Adhémar, "Les Lithographies de paysages en France à l'époque romantique," *Archives de l'art français*, nouvelle période (1935–37): 235, n.2.

Although less quantifiable, the experience of Venetian painting was no less significant to Bonington's increasingly comprehensive artistic interests, and on resettling in Paris he became immediately preoccupied once again with genre subjects. The dates for the 1827 Salon were yet to be determined, but Bonington was intent on making his third public appearance a display of his skills in that arena. For the next year, he was indefatigable in his production of watercolors with figure subjects, the one realm of genre painting in which he was decidedly more advanced than Delacroix, whose own use of watercolors for finished works of art (no. 110) was never again as sustained as during these years of immediate contact with his English friend.

Delacroix had written, in fact, that the trip to Venice had had "some influence on [Bonington's] way of painting."[151] Whether he was referring to the heightened contrasts of color and of light that are the most frequently observed characteristics of Bonington's post-Italian landscapes and to the obviously more learned response to Venetian color in the later genre pictures is unclear, for he also remarked in the same note to Théophile Thoré that Bonington "had become passionately interested in the use of tempera and had used this to sketch out several pictures." Tempera copies after Titian and Giorgione were actually recorded in the 1829 studio sale, and a small sketch in a private collection after Veronese's *La Calvaire* (Louvre) may represent one of those previously untraced copies. In the absence of any technical literature on Bonington's surviving oils, it is impossible to know the extent to which he combined tempera with oil in his last pictures. Nevertheless, in addition to its purely historical interest, tempera would have inevitably attracted the artist because it combined advantages of both the oil and the watercolor medium. Although a water-based technique, tempera offers a deeper color key and a higher impasto than opaque watercolors, but unlike oils, it dries rapidly and is not prone to discoloration with age. It could be a perfect *imprimatura* when used in combination with translucent oil glazes for the staged execution of studio pictures. If Bonington's innate facility often caused him difficulties, in that his hand occasionally outraced his reflections, he was certainly not seeking to meliorate his approach in electing to exploit tempera. More likely, he was attracted to it because it would allow him to achieve in oils the sophisticated effects he now sought from watercolor painting with a considerable savings in time. For an artist becoming overburdened by commissions to the point of physical exhaustion, this would have been an important consideration.

The development in technique of the watercolors painted over the next twelve months can be described with more assurance. They exhibit an increasing reliance on opaque colors, especially in the more brilliant chromatic or highlighted passages, and on generous admixtures of gum arabic binder to darker pigments so as to enhance their translucency and depth of tone. Even British observers accustomed to the feats of virtuosity that marked their annual watercolor exhibitions considered the painterly sophistication of such watercolors as *An Old Man and Child* unprecedented (no. 133). By the summer of 1827 there is little but scale to distinguish visually between figure subjects in either medium. The denser texture of oil painting is simulated with gouache in the watercolors, while the limpidity of translucent watercolors, particularly in interior scenes, has its analogue in the resonant oil washes used for shadows and for blocking in certain figures. Even the near-white ground of a primed canvas can be left uncovered or exposed by scraping away pigment to create decisive highlights; manipulation of the support in this fashion is characteristic of watercolor technique. In general, the color schemes may vary considerably, often dictated, as several contemporaries observed,[152] by an art-historical reference that the artist had chosen to make and fully expected his audiences to appreciate. The dominant red and black contrast of *Anne of Austria and Mazarin* (no. 118) of late 1826, for instance, is a conscious homage to Rubens's Medici cycle; the more subtle and tenebrous harmonies of gold, greens, and red in any number of examples are a celebration of Titian's palette.

In his obituary notice on Bonington, Auguste Jal claimed that the artist's final ambition was "to borrow from the Middle Ages subjects for a suite of easel paintings in which he desired to merge and exploit the finesse of the Dutch, the vigor of the Venetians, and the magic of the English."[153] By this he meant an amalgam of the type of descriptive detail for which Dutch genre painting was then most admired but without the painstaking finish that Wilkie or the School of Lyon had been imitating, of the saturation of Venetian coloring, and of the gestural éclat of Sir Thomas Lawrence, whom Bonington probably admired above all other British painters. In his unique fashion, Bonington achieved this style in his later watercolors and was close to mastering it in his final historical oils. Although often cited, Delacroix's appreciation of this attainment is worth repeating, since it was universally shared:

To my mind, some other modern artists show qualities of strength, or of accuracy in representation, which are superior to Bonington's, but nobody in this modern school, or possibly even before him, has had that lightness of touch, which, particularly in watercolor, makes his pictures, as it were, like diamonds that delight the eye, quite independently of their subject or of any representational qualities.[154]

The gem metaphor, not original to Delacroix but also used by him to praise Lawrence's style,[155] may seem tired to anyone familiar with the Bonington literature, but it remains the most apt for describing the declaratively optical allure of this exquisite style and that element of intimate preciousness which so appealed to contemporary connoisseurs.

Delacroix's concluding phrase, "quite independently of their subject or of any representational qualities," excuses a number of faults, from observable anatomical inaccuracies in the modeling of certain figures (no. 141) to an often exasperating opacity of narrative intentions. It also introduces a crucial theoretical issue. Most modern biographies have accepted the thesis put forward by Léon Rosenthal at the beginning of this century that Bonington was a "pure painter" — a paradigmatic art-for-art's-sake artist for whom subject matter was as irrelevant as it supposedly had been for Whistler's generation.[156] At the other extreme is the most recent attempt to define concealed layers of meaning — social, political, sexual — in the same genre pictures.[157] Neither perception of the artist — the uncomplicated prodigy or the conceptualist of images often so abstruse that not only we but his own contemporaries have failed to grasp their true substance — is totally inaccurate, but each begs a more comprehensive interpretation of Bonington's approach to subject painting.

Rosenthal's assessment of Bonington's contribution to modern French art, which he considered sweeping, appeared in his immensely intelligent and still provocative survey of romanticism. Central to his thesis was the notion that romantic painting was vital because, and to the degree that, its artists attached capital importance to the material process of painting while relegating didactic intentions to a subsidiary status. In other words, the touchstone of a painted work is its ability to *first* please the eye, arouse the senses, before you are aware of its subject. The subject is reduced to being a vehicle for this sensual expression.[158] Hence, Bonington becomes the most pure and the most modern romantic because in addition to his skill with the brush and his improvisatory color, "among the subjects he treats there is not the shadow of an intention, let alone a philosophical or abstract idea."[159] His motive for

painting figures and for selecting specific subjects from medieval and Renaissance history or literature was simply the urge to exploit the picturesque potential of historical costume. His chronic and seemingly nonchalant appropriation of figures from well-known old master pictures, a phenomenon remarked upon positively by Delacroix (see no. 121), is attributed to a presumed indifference to the traditional value placed on invention. Serenely detached from the prejudices of his age for anecdotal engagement and the academic painting techniques that abetted this process, he was nothing less than the artist who restored to French painting the art and the sensual joy of painting, which neoclassicism and its academic progeny had suppressed.

Rosenthal might be accused of simple prolepsis, but his seemingly modern perspective derives largely from the sacred cows of romantic theory. The possibility of a great Art springing from a preoccupation with its own intrinsic methods, uninhibited by all convention, including its very representational function, is implicit in Payne Knight's associationist theories, in Delacroix's writings, and in much of contemporary German theory.[160] In the wake of impressionism and cubism, Rosenthal was understandably comfortable in isolating instances of this in the work of the period. Furthermore, his analysis of Bonington's purpose was an elaboration of the less systematically developed views earlier expressed by people close to the artist or to his intimate acquaintances, including Gautier, Saint-Beuve, Flaubert, Thoré, and Baudelaire. His elevation of Bonington at the expense of Delaroche or Vernet or others of their generation who were "romancers or historians first and painters only by accident"[161] was anticipated in a terse nugget recorded by Delacroix in a notebook: "Bonington superior to genre painters. Such people never extend the limits of art."[162] And his emphasis on Bonington's preference for art over exegesis might seem perfectly reasonable in light of James Roberts's observation, "I never remember Bonington to have appeared excited by any thing that did not belong to art or was connected with it in some way or another or with his peculiar views of art at one particular moment."[163] It is impossible to look at a picture by this artist without sensing immediately a talent infatuated with the act and engrossed in the history of pictorial expression. But Bonington was more than the gifted pasticheur of Balzac's tale "Pierre Grassou," who was content to counterfeit old master paintings for an unwitting bourgeoisie. He was as profoundly a product as an explorer of his epoch's prevailing rhythms and requirements of taste. One of these interests, as previously argued, was painterly virtuosity, born of an eclectic fascination with art history, which rapidly evolved into the self-referential aesthetics of a doctrinaire art-for-art's-sake ethos; but there were other motivating influences. To accept unmodified Rosenthal's laudatory assertion that "nothing matches the insignificance of his historical pictures" is to deny the artist and his peers a very significant portion of their creative and historical identities.

Unfortunately, a complex set of intentions is difficult to unravel when an artist has left no verbal accounts of his thoughts or aspirations and when the circumstances that might actuate a particular conception or choice of subject, such as a patron's agenda of interests, are vague or unknown. Ingres's *Entry of Charles VI into Paris* (no. 144) is an excellent example of how the knowledge of such circumstances enlarges our understanding of his creative faculties beyond a basic appreciation of his stylistic innovations. We are not so fortunate in our documentation of Bonington's commissions. Rosenthal asked why he would compose so many pictures like *Woman Dressing Her Hair* (fig. 51), in which the emotive or moral drama we expect of romantic narrative representation is so utterly wanting, if he meant to communicate some idea or sentiment. The query demands a considered response if we are to understand

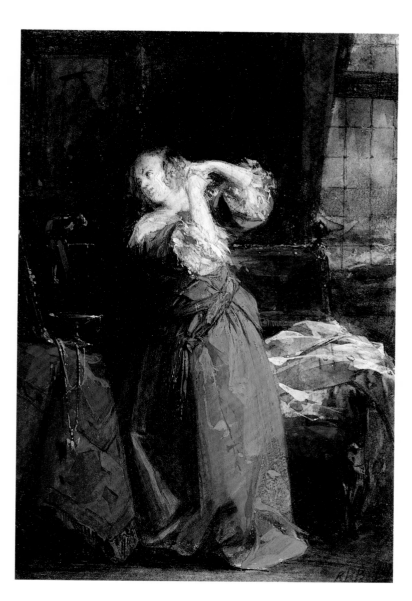

Fig. 51: *Woman Dressing Her Hair*, dated 1827
Watercolor and bodycolor 6 × 4 in. (15.2 × 10.2 cm.)
Wallace Collection, London

151. Delacroix, *Correspondence* 4: 287 (30 November 1861).
152. Jal, *Bonington*, 746, and Cunningham, *Lives*, 254.
153. Jal, *Bonington*, 746.
154. Delacroix, *Correspondence* 4: 286 (30 November 1861).
155. "[Lawrence's] picture is a type of diamond that shines alone in its setting, and which extinguishes everything around it." "Portrait de Pie VII de Sir Thomas Lawrence," *Revue de Paris* (1829); reprinted in Piron, *Delacroix*, 128ff.
156. Rosenthal, *Peinture romantique*, chapter 4, 190–201.
157. Pointon 1986.
158. Rosenthal, *Peinture romantique*, 158ff.
159. Ibid., 193.
160. Lecturing in Berlin in the 1820s, Hegel would claim for romantic art in its final and purest phase:
The Romantic artist can, on the one hand, take the objects of the external world just as they present themselves to his subjective consciousness The element of central importance is the artist's individual talent, his subjective intuition and representational skill in showing the object as it is. On the other hand, the artist may shift his focus to the heart's inwardness as such In either case, the artist's subjectivity stands above both the content and the forms of artistic representation, and that is the aesthetic standpoint of our most recent times. In his romantic subjectivity, the artist ceases to be dominated by any substantive religious or philosophical world view that predetermines what he shall represent and how he shall represent it. Quoted from Hegel, *Aesthetics*, 58.
161. Rosenthal, *Peinture romantique*, 191.
162. This observation, together with miscellaneous notes on art, appears in a Delacroix sketchbook of ca.1835–45 (Sérullaz, *Delacroix*, no. 1758 f°4v).
163. Roberts, BN Bonington Dossier.

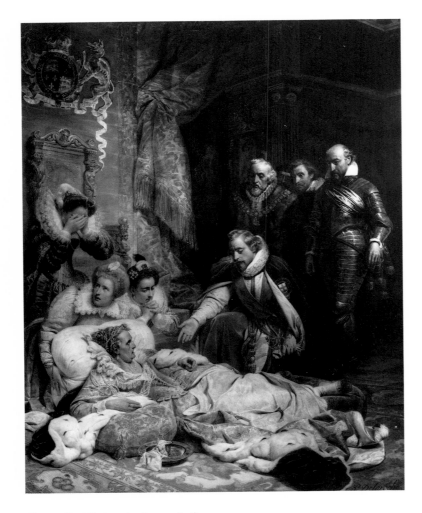

Fig. 52: Paul Delaroche (1797-1856)
Death of Elizabeth I, Salon 1827-28
Oil on canvas $165\frac{1}{2} \times 134\frac{3}{4}$ in. (422 × 343 cm.)
Musée du Louvre, Paris

thoroughly Bonington's originality. Delacroix, after all, described his friend as not only a magical painter, but a man "full of sentiment." He also recalled quite pointedly that Bonington was determined at the very end of his life to paint history subjects on a grand scale and that he was depressed by his inability to overcome the difficulties posed by this challenge. This does not describe a man disengaged from the aesthetic politics of his decade, but rather, one fully cognizant of their topical significance.[164]

In assessing Bonington's development as a painter of historical genre, several preliminary remarks may prove useful. Because of his fecundity, modern critics tend to think of him as an artist who enjoyed a normal life span and, consequently, attained the maturity of reflection that experience and age contribute to an artist's evolution. On the contrary, Bonington was still a student when he died, and like any precocious tyro he was extremely impressionable, eagerly assimilating new ideas, happily revising attitudes as readily as he improvised new styles. Furthermore, he did not begin seriously to paint figure subjects until 1825, and he came at the discipline without any substantial studio training. To seek any manifest intellectual program in the work of only three years, or to posit significance in the absence of such, is to ignore the very real possibility that Bonington's presumed indifference to invention, which is crucial to any narrative exposition, was partially a function of inexperience. Finally, the "meaningless" activity noted by Rosenthal that engages Anne of Austria and Mazarin or a knight and his page (no. 112) may only be meaningless as interpretive illustration because we no longer recognize a textual source, because the artist has reconstructed that source, or because he is reacting as a painter to another visual interpretation rather than to a verbal narration of an event. In any case, those two pictures would not have lacked iconographic or metaphoric interest in the broader contexts of Bourbon propaganda or of popular fiction.

According to Roberts, Bonington read most of the French medieval chronicles and was passionate for modern histories and romances informed by accurate historical research. The identifiable subjects he elected to illustrate from published literature conform to these interests. Walter Scott and Shakespeare were his earliest and most sustained inspirational sources, but after 1825, as his friendship with Delacroix and Huet and his acquaintance with the personalities and writings of French literary progressives intensified, he selectively illustrated other authors of the "proto-romantic" pantheon, such as Cervantes and Goethe (nos. 70, 111), as well as poets of that circle itself, including Jules de Resseguier and Pierre-Jean de Béranger (nos. 42, 159). Conspicuously absent are Dante and Byron or any literature of sublime drama, including Shakespeare's greatest tragedies. Published novels and Renaissance to modern histories may continue to furnish the motives for specific pictures, but the narrative specificity of a composition was never an imperative. Unlike Delaroche (fig. 52), who enjoyed tremendous popular success because his historical genre subjects and their sources were both melodramatic and immediately legible, Bonington glided freely between the conventions and expectations of literal illustration and a less rigid adherence to texts. We now have no way of knowing if the oil *The Lute Lesson* (no. 121) was intended to illustrate *Romeo and Juliet* or to simply allude to that or some other equally popular literary subject of lovers, like *Paolo and Francesca*. There is no interior serenade in Shakespeare's script, but if Turner's audience for *Juliet and Her Nurse* were prepared to grant him the license of transporting his heroine to Venice, they might readily indulge Bonington's less egregious fancy.

From the evidence deduced from compositions with subjects identi-

fied by the artist, one generalization can be made: Bonington was fastidious in his research of details appropriate to the historical setting for an illustration. In this he does not differ markedly from most of his contemporaries, and it is important to bear in mind when attempting to identify a potential subject. With their fifteenth-century habits, the figures in *The Lute Lesson* might just introduce Shakespeare's ill-fated lovers; they could not conceivably represent the equally unfortunate Mary Queen of Scots and David Rizzio. But it also must be stressed repeatedly that the reason why many of Bonington's figure subjects have eluded identification with a particular text is that he was not exclusively an illustrator, nor was he necessarily expected to be.

The published set of lithographs of late 1826, *Cahier de six sujets*, confirms this ambiguity of intentions. The iconographic coherence of traditional sets of images — the four arts, the five senses, Shakespeare's "seven ages of man" — is absent. The accompanying printed titles, which Bonington must have approved, are generic. *La Silence favorable*, for instance, is demonstrably an illustration to Walter Scott's *Kenilworth* (see no. 141), but Bonington's audience could not have known that fact, and he does not indulge their passion for the Scottish author. *La Prière* (no. 114), conversely, plays unequivocally to contemporary fascination with the personal life of Henri IV and the perception of this monarch, whose features are easily recognizable, as the devout champion of religious tolerance. It illustrates no specific written passage, but neither has the subject been plucked without reflection from the vast reservoir of chivalric imagery simply as a convenient vehicle for virtuoso draftsmanship.

One disquieting flaw of Rosenthal's approach was that failing to immediately discern in Bonington's oeuvre any instance of overt moral or political statement — on the order, especially, of such seminal masterworks as David's *Oath of the Horatii* or Delacroix's *Massacre at Chios* — to complement more obvious formal interests, he assumed a total absence of intellectual motive. However, Bonington's is an art, first of all, of studied and discrete selection. Just as his landscapes reveal only a nature transcendent in its radiant passivity, his genre subjects shun all theatricality. It is not that he is disinterested in human nature; he is simply not inclined to represent its every facet. Furthermore, he may have relied far more on his audience's erudition than many of his contemporaries, but his type of oblique, nonprescriptive dialogue, insisting as it does on the exercise of a viewer's imaginative correlation of sources and visual allusions, is one thoroughly romantic strategy. *Woman Dressing Her Hair* need not be an illustration to Keats's poem *The Eve of St. Agnes*, as has been suggested,[165] but it might well have been enthusiastically read as such by a literate member of the public like Pichot. Similarly, *The Antiquary* (fig. 53) does not illustrate a passage in Scott's novel of that title — the style of the costumes alone would confirm this — but it probably would not have perturbed the artist that it was engraved as such. As with so many of the "costume pieces" proliferated by his contemporaries and followers for the albums of private collectors, those watercolors could have had no more meaning than as tours de force of painterly skill, but they could also have stimulated a plentitude of significant historical or literary associations.

In probing Bonington's motives and aims, therefore, it would be as rash to discount totally the importance of this connotative dimension of a subject as it would be to seek a specific narrative source for every illustration. Allowing that Bonington's intentions were never exclusively illustrative, that the watercolor and oil versions of the posthumously titled *Use of Tears* (nos. 139, 140), for instance, might simply be demonstrations of painterly skills evocative of Rembrandt, it must also be allowed that such an attitude to genre painting in general was far

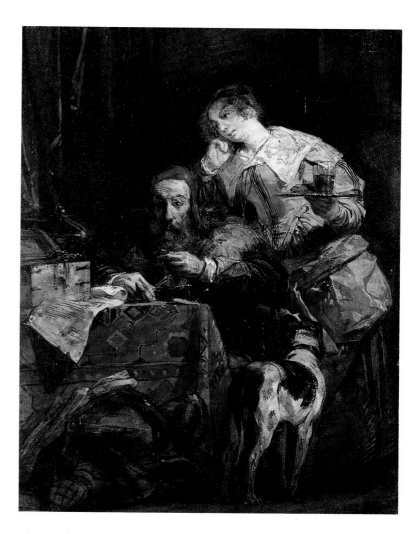

Fig. 53: *The Antiquary*, ca. 1827
Watercolor and bodycolor $8\frac{1}{8} \times 6\frac{1}{4}$ in. (20.7 × 16 cm.)
Wallace Collection, London

164. "It was his generous dream," Cunningham also wrote, "to acquire competency by painting commissions, and then dedicate his time and pencil to historical compositions" (*Lives*, 258).
165. Ingamells, *Catalogue* 1: 50.

from extraordinary. On one level, it was actually encouraged by the publishers of sentimental keepsakes and anthologies who often first assembled their visual material and only then commissioned authors to compose a prose or verse narrative to "illustrate" the illustration. Such inversions had happened before in the history of book illustration, but rarely with such deliberation. In trying to divine intentions, therefore, it might be safer to restrict speculation to works that actually address real or purported historicities.

The compulsion to recapture and to authenticate the past, specifically the medieval and Renaissance past, was so pervasive in the 1820s as to touch every creative enterprise. Whether it was prompted in Bonington's case by the usual sentiments of nationalism or Gothic spiritualism or by something as endemic as the affectation to escape the enervation of a post-Napoleonic bourgeois order — "to dream," as Alfred de Vigny wrote, "that there were once men stronger and grander, who did good or bad with greater resolve"[166] — is now indeterminate. We can argue, however, that Bonington did not adopt historical genre solely to have an opportunity to play with pretty colors and quaint costumes; he did so because this historicism, like connoisseurship, was as fundamental to his own emotional and intellectual fabric as to that of his era.[167] If the previous generation of artists had embraced the antique in its quest for moral identity, Bonington's substituted an interest in the broadest spectrum of pre-modern sources, until this entire contentious process of claiming for the pictorial arts their legitimacy and function through associative revivalism became itself the object of mimicry in Manet's work. Bonington contributed to the process; he did not, like Manet, parody it.

Since the traditional notion of what constituted history painting was subject to regular redefinition from 1800 onward, attitudes toward the representation of historical events were accordingly as nuanced as the methods employed. In attempting to describe Bonington's, our only point of departure is Roberts's recollection that "it was not so much the love of history that predominated in his mind . . . [but] the 'couleur de l'histoire' that exercised a fascination — this feeling which is characteristic of artists in general was peculiarly so with him."[168] If there is any single construct of the period that interrelates the methods of dramatization, pictorialization, versification, or analysis of historical events, it is that of "local color." A painter's term for the color of an object under natural light, it was appropriated by writers at the beginning of the century as a palliative to strict classicist convention. Prosper Merimée, whom Bonington would have known intimately through Auguste, published in July 1827 La Guzla, a pastiche of Serbian ballads specifically intended to appeal to contemporary interest in folk exotica and to embarrass, by its clever deception, the literary establishment. In an introduction to a later edition, he wrote:

Toward 1827, I was romantic. *We told the* classicists: *your Greeks are hardly Greek, your Romans scarcely Roman; you don't know how to give your compositions* local color. *Nothing succeeds without* local color. *We understood by* local color *what was called* mores *in the 17th century; but we were quite proud of our term and believed we had created it and its meaning.*[169]

Benjamin Constant offered one of the earliest definitions in 1809: "[local color] is a modification of images, thoughts, sentiments, figures of speech exclusively proper to the state of human nature and to the moment of civilization that it pleases the poet to represent."[170] The vagueness of such a formulation, like that of the picturesque to which it clearly relates, proved its utility, for beyond its principal concerns for expanding historical inquiry and for some semblance of descriptive verisimilitude in the process, it prescribed no hierarchy of subjects and

harbored no stylistic prejudices. It was understood that its successful application required a thorough knowledge of the events, habits, and personalities of the period described, or at least the impression of such erudition, but how one reconstituted that information was a matter for individual genius.

Stephen Bann has given a most lucid account of how this notion was adapted, variously and in different degrees, to the fledgling discipline of modern historiography.[171] Crucial to this process were the writings of Prosper de Barante (1782–1866), the one contemporary historian Bonington is known to have admired. In his *Histoire des Ducs de Bourgogne* (Paris, 1824–28), the *magnum opus* our artist apparently revered, Barante imitated historical chronicles by incorporating elements of their linguistic and narrative peculiarities into his own text, thus blending romance and verifiable data in a mellifluous expository style that sustained an illusion of an eyewitness account. It was the apparent purity and the obvious novelty of the style and not the critical or scientific scholarship of Barante's account that fired the imaginations of his contemporaries and just as quickly relegated it to a secondary status for succeeding generations of archivists.

On the most simplistic level, and certainly not in every instance, Bonington's approach to representing an actual historical event, such as the encounter between François Ier and Charles V (no. 138), pursues a parallel objective. In its direct quotation for the portrait of the French monarch, but more significantly in its stylistic ensemble, the picture insists on an allusion to the greatest visual chronicler of that epoch, Titian. The "color of history," insofar as it could be manifested by formal means, went beyond the trimmings — the accurate delineation of the artifacts, costumes, or portraits of the period, although these were essential ingredients — to a very personal interpretation of what Bonington perceived to be quintessential and translatable formal elements of the art of that historical moment. This method recurs more obliquely in his illustration of Scott's *Quentin Durward at Liège* (no. 143). Here he does not simply illustrate a passage from an historical novel set in the fifteenth century but endeavors to infuse that illustration with the potent atmosphere of specific time and locale by conceiving of the composition as an equivalent of a late medieval Flemish bas-relief. But he was prepared to take these allusions only so far, for he was not obliged, in his own mind, to slavishly imitate the painting style of Gerard David (see no. 123) or Albrecht Dürer, just as Barante did not feel compelled to employ the orthography of Froissart. He stops short, in other words, of a "primitivism" or "archaism" of technique that was more compatible with contemporary academic stylization, as evidenced by Ingres's eventual acceptance, and that Delacroix decried as "pernicious puerility" for its willful failure to concede supremacy in the pictorial arts to the example of Rubens or Titian.[172] Like Hazlitt, Delacroix considered the art of painting a modern invention that reached near perfection in the masters of the High Renaissance and Baroque. Any attempt to use painting to imitate antique sculpture or to create a hyperrealism of neo-Gothic description was necessarily a denial of its most cherished unique properties. Bonington clearly shared this view, and although he simply substituted, on occasion, Gothic for antique formal types, he insisted on the sophistication of later painting styles.

To proceed further with the strict analogy between the methods of one writer of history like Barante and of a novice painter of historical genre would be to court incongruities. The point offered is simply that Bonington's broader, peculiar application of art-historical borrowings may have had a fleeting inspirational source in the techniques of a contemporary author whom he admired, for there is that marginal difference, in addition to a more obvious stylistic divergence, between

Bonington's approach and that of the troubadour painters, who were the progenitors of his type of history painting.

The troubadour style made its initial appearance in the Salons of 1802 and 1804 in the works of two Lyonnais painters, Fleury Richard (1777–1852) and Pierre Révoil (1776–1842). It challenged the monopoly of neoclassical history painting by promoting an intimate cabinet art remarkable for its porcelaneous surfaces and indebted to the minutely finished and laboriously detailed pictures of Gerard Dou (1613–1675; fig. 54) and Gabriel Metsu (1629–1667). Its originality resided in its successful effort to resuscitate and ennoble eighteenth-century genre painting by replacing its familiar and often trivial or erotic anecdotes with historical profiles drawn from the lives of illustrious Renaissance artists, monarchs, and tragic lovers. To the extent that its major themes could be interpreted as either pious, nationalistic, monarchical, or sentimental, it easily accommodated the fluctuating tastes of the Empire and the Restoration; to the degree that its artist were tireless in their antiquarian research, it played equally well to the new historicism. So successful was the style among private collectors that after its advent, the expressions of establishment alarm that this type of painting would overshadow and erode the academic ideal of history painting, became increasingly clamorous.

By 1824, however, the polished surfaces and the preciously delineated compositions had lost their allure of novelty. The apt description of "ersatz authenticity" employed to describe the aims of Delaroche might equally apply to the school of Lyon, for both were jolting in their descriptive clarity, like Madame Toussaud's wax effigies, but ultimately lifeless in this very sensationalism. Ironically, on this issue, Delécluze was in concert with his opposition:

MM. Richard and Révoil would profit more from the progress that genre painters have made in certain areas, like the vagueness of contours, the truth in coloring, and the correct observation of chiaroscuro. M. Révoil seems to depend too much on precise strokes and exactitude of costume. In genre, erudition alone will not suffice today . . . an artist must enliven genre with sentiment.[173]

The conservative critic was perilously close to the prevalent definition of "local color" as modified in the 1820s, not by historians, but by the painters and literati of Bonington's circle. Hugo was rather opaque in his preface to *Cromwell* in declaring: "It is not sufficient to make, as they say, local color, in other words, to embellish after the fact with several telling touches here and there an otherwise perfectly false and conventional conception . . . it should, in some fashion, be in the air."[174] But Alfred de Vigny was considerably less rhetorical when he wrote in the preface to his admittedly Scott-inspired historical novel *Cinq-Mars*: "We want the philosophical spectacle of a man profoundly moved by the passions of his character and his time . . . the truth that must nourish the artist is the *truth of observation of human nature*, and not *factual authenticity*."[175] In imaginative creations, the evolving historicism had to humanize as well as elucidate history; hence, an unprecedented celebrity, among authors and painters, of Scott's novels coexisted with a growing uneasiness among the historians about the methods and ends of this author, even though those same historians, like Barante, had initially welcomed his first romances. Tentatively, the lines were already forming between the science of history and the art of historical representation; some twenty years later Ruskin could define, with the assurance of being instantly understood, a parallel distinction between the high art of Turner's landscapes and the mundane topographical nature of most other modern landscape painting as equivalent to that which elevated the historical novels of Scott above the stricter objectivity of the historian.

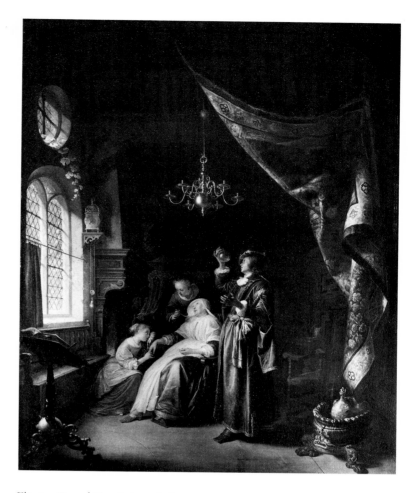

Fig. 54: Gerard Dou (1613-1675)
La Femme Hydropique, 1663
Oil on panel $32\frac{5}{8} \times 26\frac{3}{8}$ in (83×67 cm)
Musée du Louvre, Paris

166. de Vigny, *Cinq-Mars*, i.

167. The most important recent studies are Roy Strong, *And When Did You Last See Your Father? The Victorian Painter and British History* (London, 1978); Francis Haskell, *Past and Present in Art and Taste* (New Haven and London, 1987); and Stephen Bann, *The Clothing of Clio* (Cambridge, 1984).

168. Roberts, BN Bonington Dossier.

169. Advertisement for the 1842 edition.

170. Quoted from Hugo, *Cromwell*, 84 n.224.

171. Bann, *The Clothing of Clio*.

172. Piron, *Delacroix*, 409 (undated notes):
The taste for archaism is pernicious; it is that which persuades a thousand artists to reproduce forms that are worn out or without significance to modern mores. It is unforgivable to seek the beautiful in the manner of Raphael or Dante. If it were possible for them to return to this world, neither talent would have the same characteristics. In the present day we imitate the naive austerity of the one or the other's simple fresco effects, in which there is little color or effect [but] to return to the austerity of fresco after Rubens and Titian is only childish.

173. Delécluze, *Salon 1824* (5 September 1824): 1. Delaroche often prepared wax models in preparation for a figure. This was certainly the case for his *Cromwell Viewing the Body of Charles I* (Musée des Beaux-Arts, Nîmes). Gustave Planche was caustic in his criticism of Delaroche and especially of that picture:
The Cromwell *is the worst and the poorest of all Paul Delaroche's works. Never, it seems to me, has he so revealed in a more decisive or pathetic fashion the nullity of his thought Where has he read that the Protector, after having removed the one head that obstructed his way, stopped thus to contemplate it? I don't require an answer. Whether a thing is true or not doesn't matter, it is the artist's responsibility to make it plausible.* Cinq-Mars, *Richelieu, . . . are not the same in historical fact as they are in Alfred de Vigny's imagination; but if they are not real, they are true artistically Not only is the* Cromwell *not true, not only is it not believable, it is impossible.* [Salon 1831, 73–74].

174. Hugo, *Cromwell*, 84.

175. de Vigny, *Cinq-Mars*, ix–xii.

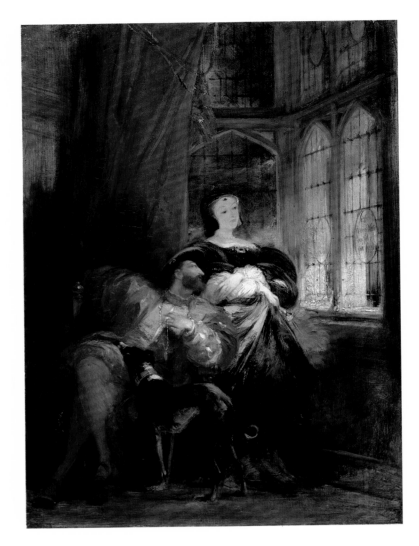

Fig. 55 *François Ier and Marguerite of Navarre*, 1827
Oil on canvas 18 × 13½ in. (45.7 × 34.5 cm.)
Wallace Collection, London

Despite the slide from prominence of its originators, the troubadour tradition continued to attract the interest of diverse and often antagonistic temperaments. Ingres produced some of his most brilliant formal abstractions in response to this genre and Delacroix some of his more idiosyncratic and prurient conceptions. Delacroix, of course, most closely approached de Vigny's revised definition of "truth" in historical representation by melding engaging psychological drama with his carefully researched details of costumes, decorations, portraits, and the like. The pertinent question is, to what extent and in what fashion did Bonington participate in this revision?

Bonington painted three history pictures for public exhibition during the last year of his life: *François Ier and Marguerite of Navarre*, a version of which is in the Wallace Collection (fig. 55), *Henri IV and the Spanish Ambassador* (fig. 57), and *Henri III of France* (fig. 58). The compositional source for the first was a picture exhibited by Richard in 1804 (fig. 56) and engraved repeatedly during Bonington's lifetime. The same historical anecdote was the subject of a picture, now untraced, exhibited by Lecoeur at the 1824 Salon. The second represented an equally well-known anecdote popular with the Bourbons because it stressed the paternal benevolence of the founder of their monarchal line. The pictorial sources were Révoil's oil exhibited in 1814 and again in 1817, when, incidentally, there were fourteen other Salon exhibits illustrating scenes from this monarch's life. Two interpretations of the same anecdote were exhibited by Ingres (fig. 30) and Vallin in 1824. The Henri III subject, which will be discussed later, appears to have no precedent in the art of the period.

Bonington's first version of *Henri IV and the Spanish Ambassador* was a watercolor of ca.1825 (fig. 29). His interest in this monarch, the popularity of the anecdote, and the recent success of Ingres's treatment would have been sufficient motives for him to attempt the subject. The great success in 1824 of other pictures illustrating the life of this "king of kings" (as Jal described the monarch) might also have induced him to develop the subject further in oils for exhibition at the next Salon. Marcia Pointon perceives in this decision a deliberate campaign to parody not only Ingres, but also the entire program of Bourbon propaganda that the troubadour tradition had engendered, but with which the repressive policies of Charles X, by 1827, were clearly at odds.[176] This conjectured parody, however, is contradicted by the duration, the diversity, and the tone of Bonington's involvement with historical genre and by his clearly deliberative treatment of this familiar subject. If any critique of Ingres or Révoil were intended, it was no more, nor less, than that they had failed, in Bonington's mind, to communicate the "philosophical spectacle" of a powerful monarch as an ordinary father. The *air glaciale*, to borrow Delacroix's expression, of Ingres's precisely defined figures and accoutrements and of his iconic spatial construction constricted the viewer's imagination. One of the crucial concepts Delacroix chose to define some years later in anticipation of composing a "Philosophical Dictionary of the Fine Arts" was *effect*. In his journal he wrote under the heading "effect on the imagination":

Painting is nothing but a bridge set up between the mind of the artist and that of the beholder. Cold accuracy is not art; skillful artifice, when it is pleasing and expressive, is art itself. The so-called conscientiousness of the great majority of painters is nothing but perfection laboriously applied to the art of being boring.[177]

For Delacroix, who grappled with the question of finish his entire life, a "pedantry of execution" had dominated French painting styles from David to Delaroche to the mid-century "Pompier" imitators of Ingres. Their collective achievement was to furnish mere tracings of outward

appearances, devoid of those qualities essential for striking a more vital chord of response. Arresting subjects and compositional invention were modes of opposing this pedantry and trivialization, but the most persuasive was the attainment of *effect*, which he defined in an earlier journal entry with the single word *chiaroscuro*, and by which he meant to imply the mastery of painterly expression at, and in, the service of animated imaginations. To Delacroix's thinking, Bonington was superior to a genre or troubadour painter because he was a master manipulator of color and light to emotive ends and, by means of this originality alone, was capable of bringing novelty and sentiment to any subject, including those he borrowed from other artists. Ingres's representation of the domestic frolics of Henri IV was a *tableau vivant*, Bonington's an exaction of the viewer's participation in the intimate dramas of history through the artifice of expressive technique.

But painterly virtuosity was only part of the story. For all the neo-medieval realism and the éclat of bright colors in Richard's *François Ier and the Queen of Navarre*, he depicts mannequins tiredly miming a script, like so many passionless book illustrations of the period. Frustrated by some lover, the king had engraved on the window of his apartments at Chambord the distich *Souvent femme varie/Bien fol est qui s'y fie*, which he then brought to the attention of his sister. In the surviving version of Bonington's conception, a subtle psychological exchange unfolds. The king coyly awaits the verdict of his devoted sibling, herself a reputable poet, on the cleverness of his satirical verse, while she stiffly ponders an appropriate response to this assault on the constancy of her sex. The affectation of his pose and gesture and the uncertainty of her reaction give this representation a piquant edge. There is, in effect, a greater merit to Bonington's treatment of figures than his beguiling technique, and it is usually a very fundamental sympathy for humanity that pervades his every conception, from the nameless fishmongers on the Normandy coast to the fictional characters of Scott or the potentates of recorded history. Small wonder that Rembrandt exercised such a hold on the young artist's imagination.

I would argue, in review, that Bonington's appropriation of costumes and other formal elements from historical visual sources served his purpose of creating an air of historical authenticity — the ambition of most every other artist of his generation — but that by transforming these borrowings through the agency of his own collaterally developed ideas and style, he endeavored as well to bring a degree of sentiment to his representation, consistent with other aspects of contemporary theory. The same motives were operative when he borrowed or responded to entire compositional devices like the Henri IV and François Ier subjects. In those instances, the issue was less the overt or delitescent meanings of such themes than the manner in which other artists had elected to represent the subjects. To a certain extent the same might be claimed, after all, for Ingres's intentions vis-à-vis Révoil. This compulsion to challenge the perspectives of other artists was, furthermore, consistent with Delacroix's idea of originality from the earliest date.[178]

In spring 1827 Bonington paid his second visit to London. The exact date and duration of this trip are unrecorded, but it probably occurred near the time of the Royal Academy exhibition, which opened on 4 May and to which he had submitted a single oil, *Scene on the French Coast* (no. 120). A receipt in his hand to the artist George Fennel Robson, dated 2 June, acknowledging payment of £15.15 for the watercolor *Old Man and Child* (no. 133), bears a six-penny postage stamp, suggesting that he may still have been in London at that date. He lodged at Green's Hotel, possibly because his friend Ensom had left the Warren establishment on Constitution Row. He might have traveled alone, and he did

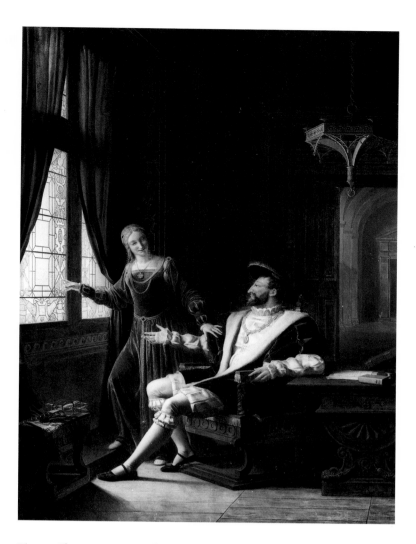

Fig. 56: Fleury-François Richard (1777-1852)
François Ier and the Queen of Navarre, 1804
Oil on canvas $30\frac{1}{4} \times 25\frac{1}{2}$ in. (77×65 cm.)
Musée Napoléon, Arenenberg

176. Pointon 1986.
177. Delacroix, *Journal* 3: 200 (11 January 1857) and 235 (23 January 1857), although he had already formulated this idea as early as 26 January 1824 after reading Madame de Staël and discovering Retzsch's illustrations to *Faust* (*Journal* 1: 59).
178. Delacroix, *Journal* 1: 102 (27 April 1824):
Dimier thinks that great passions are the source of genius! I think it is only the imagination, or what amounts to the same thing, that delicacy of the organs which allows one to see what others do not and in a different way.... What makes a man extraordinary is decidedly his unique manner of seeing things.... [also] my spirit is never more stimulated to create than when it sees a mediocre treatment of a subject that interests me.

not use a letter of introduction to Sir Thomas Lawrence, which Lavinia Forster had furnished, fearing that he was still not worthy of that artist's attention.[179] Rather, he appears to have focused, once again, on cultivating clients among the elite of London's art trade and on consolidating his professional relationships with those dealers and publishers from whom he had had prior commissions. Apparently, his efforts were successful, for his subsequent letters to Dominic Colnaghi, James Carpenter, John Barnett, and the Cookes repeatedly cite his burden of commissions by way of an apology for not promptly satisfying theirs. In a letter of 13 July he promised to illustrate for Barnett *A Midsummer Night's Dream* and mentioned "pictures" commissioned by Colnaghi and Carpenter.[180] Colnaghi desired Shakespearean subjects with Italian settings, but he received from Bonington in October only a topographical view, *Corso Sant'Anastasia, Verona* (see no. 155).[181] In the same month, Bonington again wrote to Barnett with details of the Carpenter commission:

My Dear Friend,

From your questions about the size of the picture I am about for Mr. Carpenter and your silence respecting the pictures Mrs. Carpenter wished to exhibit here, I fear you have not received my letter in answer to yours principally regarding Mrs. C's wish to exhibit. Should it so have happened you must have taxed me with a most rude indifference and neglect. On the contrary I should feel most happy in being the means of placing any of Mrs. C's works in our exhibition — respecting which I will repeat a few particulars of my last. The exhibition will open on the 4th of November and will continue for three or four months. At the end of each month the three paintings an artist has the right to exhibit may be changed for 3 others, so that should Mrs. C still wish to send, the paintings will yet arrive in time for the first or second renewal, in such case direct them to M. Lagache, Hotel Dessein, à Calais to be forwarded to me at Paris — in case frames are wanted write as soon as possible with the sizes — after this, the above mentioned epistle contained diverse happy conceits, marvellously pleasing, passing pretty, as well as well digested morality — looking over your waggon load of items and etc. — Mr. C's picture is some 3 feet by four. A view of Venice somewhat this [small sketch] etc. I hope to get a few drawings done very soon — for my larger picture I have promised the refusal of it to a person who was over here lately, for a friend of his, should I not dispose of it here, of which I fear there is but little chance, so the matter stands — the price I mentioned was 125 guineas. I hope to send it over for the winters exhibition in Pall Mall and should you be able to put the question of [sale ?] then, perhaps it may still be lucky enough to please Mr. C. — "somewhat too much of this," but I fear that I must end here for my wit is not over plentiful etc. I have none ready made for the present must need conclude in requesting you to remember me to all friends, especially W. Cooke Jr. but will write him very shortly, Ensom, etc. etc., am very happy to hear him doing my bridge — shall remember lots of things to say when this is gone but for fear of delay or accident I will ever beg you to believe me your most truly,

R. P. Bonington

Rue des Martyrs no 11
October 21 1827

[If] *I had a minute, two, three or three and one half, just time for the eggs to boil, "a putting while" as the man in the play says, even would I communicate things of much gladness etc.* [The following crossed out: *but when a man is pestered morning and evening*].[182]

"Painting is in the air" Delacroix observed of the anticipation in the fall for the opening of the much-delayed Salon. It was to be divided into two consecutive events, the first running from November through January and the second, for which substitutions were permitted with

Fig. 57: *Henri IV and the Spanish Ambassador*, 1827
Oil on canvas 15 × 20½ in. (38.4 × 52.4 cm.)
Wallace Collection, London

Fig. 58: *Henri III of France*, 1828
Oil on canvas 21¼ × 25⅜ in. (54 × 64.4 cm.)
Wallace Collection, London

179. Lavinia Forster was the wife of the Rev. Edward Forster. For a discussion of her daughters, one of whom married the sculptor Baron Henri Triqueti, see *Annals of Thomas Banks*, ed. C. F. Bell (Cambridge, 1938), 207 ff.
180. Dubuisson and Hughes, 81.
181. Letter to Colnaghi, dated October 1827, transcribed by Dubuisson and Hughes, 78–79, and a letter of 13 July 1827 to Barnett, cited by Dubuisson and Hughes, 91.
182. Manuscript letter in English to John Barnett, dated 21 October 1827 (British Library, London).

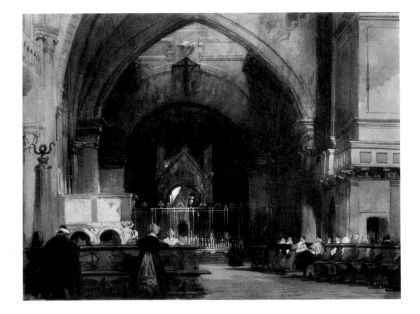

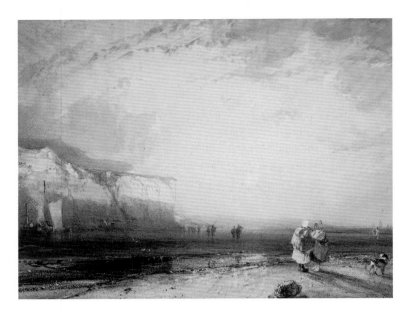

Fig. 59: *Milan: Interior of S. Ambrogio*, dated 1827
Watercolor and bodycolor $8\frac{5}{8} \times 11\frac{1}{4}$ in. (22.1 × 28.6 cm.)
Wallace Collection, London

Fig. 60: *Near Dieppe* or *Picardy Coast Sunset*, dated 1828
Watercolor and bodycolor $7\frac{3}{4} \times 10\frac{1}{4}$ in. (19.8 × 26.3 cm.)
Wallace Collection, London

Fig. 61: James Duffield Harding (1797-1863) after R. P. Bonington
Entrance to the Grand Canal, Venice, 1830
Lithograph $6\frac{1}{2} \times 8\frac{5}{8}$ in. (16.8 × 22 cm.)
Yale Center for British Art, New Haven

Fig. 62: Thomas Shotter Boys (1803-1874)
The Interior of Bonington's Studio, no. 11, Rue des Martyrs, 1827
Graphite on tracing paper $12\frac{1}{2} \times 15\frac{3}{8}$ in. (32 × 39 cm.)
The British Museum, London

the approval of a second jury, from February through April. This restructuring along the lines of the Galerie LeBrun exhibition in 1826 was intended to control both the number of pictures on view at any given time and the overall level of quality. The juries were instructed to be much more selective then in 1824, but since Bonington had submitted only two oils and a watercolor for the first installment, he fared better than many of his friends. Also by Bonington, but submitted by his publishers, were two lithographs: a view of the cathedral at Brou from Taylor's *Franche-Comté* volume, which was now complete, and one of the three prints after drawings by Maurice Rugendas for the publication *Voyage pittoresque dans le Brésil*, on which Bonington had been engaged since the beginning of the year. The premier entries were the oil *View of the Ducal Palace* (Tate Gallery, fig. 46), which was the "larger picture" referred to in his letter to Barnett; an untraced *View of Rouen Cathedral* (frame: 56 × 50 cm.); and the watercolor *The Tomb of St-Omer* (frame: 86 × 67 cm.), which the duc d'Orléans purchased and which was destroyed during the sack of the Palais Royal in 1848. As there were far fewer British artists exhibiting than in 1824, the "English threat" had abated somewhat, and even the previously hostile critics felt secure in offering polite praise for the Venetian picture.

Margaret Carpenter, the portraitist and daughter-in-law of James Carpenter, did manage to have a portrait accepted. William Daniell's (1769–1837) views of Windsor also were well received, possibly because of his connections with the duc d'Orléans, while the criticisms of Constable's single entry *The Cornfield* (National Gallery) and Lawrence's *Duchesse de Berry* (fig. 26) and *Master Lambton* (The Lord Lambton) were more dismissive than contentious. Delécluze actually described Bonington's Venetian pictures as "completely remarkable."[183] For the *Revue Encyclopédique*, Coupin offered a condescending reference to Canaletto.[184] Jal was slightly more verbose:

Bonington is a clever fellow. This watercolor representing the tomb of St. Omer is very beautiful. His view of the Ducal Palace in Venice is a masterpiece. I do love what the Canaletti so justly extol. Vivacity, firmness, effect, color, breadth of touch, all are present in this painting in which the water is admirable.
The figures are only sketched, but so grandly! — I prefer this manner of figure drawing to Granet's.[185]

For several decades Granet's specialty had been depictions of Italian monastic scenes and religious ritual, usually set in voluminous, darkened interior spaces. The comte de Forbin was his most loyal friend and protector, and it was generally known that he painted the figures in many of de Forbin's topographical landscapes. He was also allied to the

troubadour painters, but because of the former connection did not suffer their critical demise in the 1820s. His style was also less severe in its neatness than that of Révoil or Richard but far from the degree of freedom that would justify the appellation of "modern Rembrandt" given him by his contemporaries. If a *View of Posillipo* (Musée Magnin, Dijon) is actually his work, there is evidence that he occasionally imitated the style of Bonington's Italian pictures. The latter's *Interior of the Church of S. Ambrogio, Milan* (1827; fig. 59) is an obvious dalliance with the type of subject with which Granet was readily identified, but stripped of the atmosphere of Gothic-novel mysticism that pervades the Frenchman's finest conceptions. Less obvious, but no less referential, as Jal's comments imply, was the importance Bonington afforded the motif of the religious procession in *View of the Ducal Palace* and his slightly later *Corso Sant'Anastasia, Verona* (no. 155). Simultaneously, these pictures acknowledge in their subjects but challenge in their style and their interpretation of those subjects Granet's preeminence in this genre. Once again, whether a source of inspiration was contemporary — Robson, Francia, Turner, Delacroix, Ingres, or Granet — or remote — Rubens, Titian, or Rembrandt — Bonington consistently met the challenge of what he perceived as some aspect of the artist's unique genius. An obituary claimed that had he lived, Bonington intended to paint a suite of pictures like the *View of the Ducal Palace*. This too is consistent with his creative process, for he was unquestionably a painter who preferred to work at a particular idea until its potential was exhausted and some new fascination emerged to replace it or some innovative style was developed to reinterpret it. How he might have exercised his vision later is a matter of futile conjecture. It can be observed only that his very last landscapes exhibit a chromatic license that threatens to overwhelm their descriptive function (fig. 60).

The concluding months of 1827 must have been exceptionally hectic for Bonington, for in addition to the major pictures he was preparing for the Salon and for forthcoming exhibitions in London, he was staging yet another excursion to England and relocating his studio from the rue des Martyrs (fig. 62) to nearby rue St-Lazare. No visual record of the interior of the last studio survives, but one of the Alaux family of painters and decorators would later recall to the artist Alfred de Curzon that "Bonington had his atelier entirely whitewashed, with red borders at the ceiling and floor: he had several drapes of diverse colors to place behind his models."[186] This brief but valuable remark, if accurate, describes a working space deliberately spartan, decorated to maximize the ambient natural light and to eliminate other visual distractions. It should not surprise us that an artist preoccupied with color harmonies of the most subtle nature should opt for such a clean environment, but the space Alaux describes is the exact opposite of what most painters and writers of the period portrayed as a typical atelier — a jumble of historical artifacts, exotic collectibles, multicolored tapestries and weavings, etc. Acknowledging a possible virtue of Bonington's arrangement, Curzon further observed, "Our ateliers, with their fractured and dark tone, set pictures off to advantage, but they don't help us to make good ones."

A letter of 21 December from Comte Turpin de Crissé, an academic landscape painter who would participate in the second Salon jury, to the royal engraver Henri Laurent indicates that Bonington had asked the latter to act on his behalf concerning the submission of a specific picture for exhibition. The count responded that when the jury convened officially in January, it would probably accept Bonington's picture "if it is as splendid as the grand view of Venice by the same artist."[187] He was referring to the oil *Entrance to the Grand Canal* (fig. 61) which Carpenter had commissioned and which Bonington had probably only recently

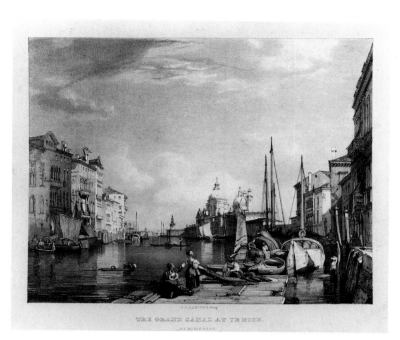

THE GRAND CANAL AT VENICE.
BY BONINGTON.

183. Delécluze, "Salon de 1828," *Journal des Débats* (25 April 1828): 2.
184. "Exposition de 1827," *Revue Encyclopédique* (January-March 1828): 316: "In a *View of Venice*, Bonington seems to want to rival Canaletto. It is a rude pastiche of Canaletto; however, he has not strayed so far from his model that it is impossible to admire this picture."
185. Jal, *Salon 1828*, 237.
186. Quoted in Miquel, *Art et argent*, 217.
187. Manuscript letter (Pierpont Morgan Library, New York) cited by Pointon, *Circle*, 113 and 116 n.56.

finished, as it appears framed in Boys's drawing of the rue des Martyrs atelier. The fact that Bonington did not conduct those negotiations personally may indicate that he had already left Paris for London or that he was too preoccupied with his studio relocation. He had to apologize to Colin again for neglecting their friendship as a result of these activities.[188] The jury did accept the second Venetian view, the oils *François Ier and Marguerite of Navarre* and *Henri IV and the Spanish Ambassador*, and three untitled watercolors.[189]

For the critical reception of these new entries, we have only Jal's opinion:

One would say, at first glance, that Henri IV avec l'ambassador d'Espagne *is by M. Poterlet, and that would be high praise for both artists; more closely, one finds in the* Henri IV *traces of a master, which are lacking in the works of M. Poterlet. It is annoying that M. Bonington has not given greater definition to his figures, and that he has presented them as phantoms moving in the midst of a brilliant colored vapor, which veils their features and does not permit perception of their movements.* François Ier et la reine de Navarre *is a small study totally Venetian in color; with a bit more in the indication of contours it would be a charming picture; the dogs are very beautiful in form and tone.* Un Vue de l'entrée du grand canal, à Venice, *is good, less so perhaps than its pendant of which I previously wrote.*[190]

Unfortunately, with the exception of *Henri IV*, all of Bonington's Salon entries are now untraced, destroyed, or so badly damaged that it is impossible to assess their impact and individual merits.

The two Venice pictures were the largest landscapes he had attempted thus far, and both would be copied repeatedly by French and British artists for the next two decades. Like Granet,[191] he had obviously arrived at the realization, after the 1824 Salon, that it was essential to demonstrate an ability to cope with the grander scale of the exhibition picture, for although the demand among private collectors for cabinet pictures was a constant and lucrative source of income, state acquisitions and commissions were, individually, more remunerative. The opening of the Musée Charles X, which comprised a series of refurbished galleries in the Louvre for the permanent display of antiquities and porcelain, and which coincided with the Salon, made this point obvious, for the painted ceiling decorations had been awarded to a heterogenous range of ministerial and younger painters who had previously demonstrated skill on such a scale. A typical example was Alexandre Fragonard's *François Ier and Marguerite of Navarre*, which was shown at the Salon prior to its installation. Stylistically more compatible with Bonington's taste was Eugène Devéria's (1808–1865) *Birth of Henri IV* (fig. 63), an acreage of Venetian color and Rubensian quotations that also created a sensation. Although not a Musée Charles X commission, it was acquired for the state and guaranteed Devéria a commission for the ongoing program of decorations. In landscape painting, scale and more palatable Italian subject matter were manageable concessions to establishment powers like de Forbin, and it is a pity that the present condition of the two Venice pictures precludes any fair analysis of how Bonington managed the stylistic modifications. The leap in scale was far more problematic in history painting, but if Devéria or Fragonard were capable of managing it, Bonington had every reason to hope for similar success with time.

The third trip to London coincided with the annual exhibition at the British Institution, where he had not shown since 1826. In November 1827 Bonington had written to W. B. Cooke, promising to send him, for engraving, views of Père Lachaise cemetery and of Venice and requesting that he submit to the British Institution on his behalf his oil *The Piazzetta* (no. 131), which he had previously forwarded with his water-

color *The Bridge at St. Maurice* (no. 85).[192] Sensing now that *The Piazzetta* might be too insignificant and taking advantage of the Salon substitution option, he replaced *View of the Ducal Palace* with Carpenter's picture, brought the former with him to London, and had it accepted at the British Institution before the opening of that exhibition on 4 February. A dated drawing of a seated female in seventeenth-century costume, which he gave to the fiancée of his London host, John Barnett, and a dated receipt for £131 from Carpenter for his as yet unseen picture of Venice establish the approximate dates of his visit between 31 January and 23 February.[193] He did not remain in London until the opening of the Royal Academy exhibition in May, as has been suggested. That he finally had the self-confidence to introduce himself to Sir Thomas Lawrence during this visit is well documented, for the president of the Royal Academy wrote to Lavinia Forster shortly after Bonington's death in September:

If I may judge from the later direction of his studies and from remembrance of a morning's conversation, his mind seemed expanding in every way, and ripening into full maturity of taste and elevated judgement, with that generous ambition which makes confinement to lesser departments in the art painfully irksome and annoying.[194]

The "lesser" departments might include printmaking and watercolors. The previous December the *Journal des Débats* had announced the publication of Charles Durozoir's *Relation historique, pittoresque et statistique du voyage de S. M. Charles X dans le département du nord*, to which Bonington was to contribute at least one lithographic illustration. That contribution was either rejected or, more likely, never executed because of more pressing and consequential commitments. But Bonington did not completely withdraw from the "irksome and annoying" business of book illustration, for he rapidly sketched this spring three sepia vignettes for a politically and aesthetically significant edition of Béranger's *Chansons* (no. 159). It was a monumental project to which every artist of his circle lent their support.

The London critics were no less enthusiastic for the *Ducal Palace* than their French colleagues. *The Literary Gazette* noted:

If it possessed a little more sunniness of effect, this fine picture might challenge comparison with the best of Canaletti's works. It has all the truth of the camera obscura. The execution is masterly; not only in the buildings, water, etc, but also in the figures, which are numerous, and to which, by a few bold and well-placed touches, Mr. Bonington has given a character and an expression rarely to be seen in the productions of this branch of the arts.[195]

In his introductory comments on the exhibition, the critic for *The London Weekly Review* observed that, "it is, perhaps, superior to any that has been witnessed for several years Mr. H. P. Briggs, Mr. Etty, Mr. R. P. Bonington, Mr. Lance, and Mr. Stanfield are among those who have particularly distinguished themselves."[196] The *Ducal Palace* he considered the "most spirited" picture in the exhibition, although *The Piazzetta* was a disappointment; nevertheless, the latter was acquired by Robert Vernon, who was then collecting modern pictures for a projected donation to the nation.

The feverish productivity of the winter months extended through the spring. The success of the Venice pictures had prompted a spate of commissions from Coutan, Sir Robert Peel, Sir Thomas Lawrence, and other collectors, while the approaching Royal Academy exhibition promised yet another opportunity for public exposure. In May Bonington elected to send to London three oils representative of the scope of his ambitions: an unidentified *Coast Scene*; *Henri III of France*, his first

Fig. 63: Eugne Devéria (1805-1865)
Birth of Henri IV, Salon 1827
Oil on canvas 189 × 153 in. (484 × 392 cm.)
Musée du Louvre, Paris

history subject to be exhibited in England; and Carpenter's *Entrance to the Grand Canal*, retitled for the occasion *The Grand Canal, with the Church of La Virgine del Salute*. *The London Weekly Review* confined its comments to the last picture: "Something in the broad style of Prout. The perspective of the long sheet of tranquil water is extremely true; but the atmosphere is hardly warm enough for Venice."[197] *The New Monthly Magazine* described *Henri III* as "certainly unfinished, but displaying a power and breadth of style that shows the hand of a master."[198] On 24 May *The Literary Gazette* recommended W. J. Cooke's engraving after *The Bridge at St-Maurice*, which Colnaghi had just published, and, in its exhibition critique, used the Venice picture as a pretext for the encomium, "In a very short period this able artist has so distinguished himself by the brilliant character of his pencil, that his name to any piece is a sufficient guarantee of its excellence."[199]

The previous week the same critic had voiced his anger with the Hanging Committee for its placement of the *Henri III* near the floor:

"Who put my man i' th' stocks?" said the indignant Lear, after having found his faithful adherent in that unenviable position. With a similar feeling we say, who put this picture here? Why is the pain of stooping till one's back is nearly broken to be inflicted as the price of the pleasure of looking at this able performance?— a performance which it would have done credit to the judgement of the Academy, had they placed it in the best situation the rooms afforded (the mantel of the Great Room would have been the proper place for this picture). Besides possessing a harmony of colouring which would be honourable to any school of art, the subject is treated in a masterly manner. As a graphic illustration of the character and habits of the French monarch, it may be ranked with some of the well-described scenes by Sir Walter Scott in Quentin Durward, or any of his historical novels.[200]

The appreciative writer could not have known that Bonington's most ambitious genre painting, *Quentin Durward at Liège* (no. 143), was then in the Paris studio awaiting payment from the duchesse de Berry.

188. A manuscript letter to Colin (Fondation Custodia, coll. F. Lugt, Institut Néerlandais), on paper watermarked 1826, probably dates to this period:
Mon cher Colin
Je te demande mille excuses de t'avoir negligé si long temps que me direz vous quand vous saurez que je pars demain pour Londres, sois un peu patient, je serais de retour un jour — du reste, mon déménagement et mille autres choses ont fait qu'il m'est impossible d'aller te voir . . . Croyez mon cher que je ne suis pas moins ton ami. R. P. Bonington.
189. The Salon catalogue lists only one watercolor, but the registry of submitted works indicates that three drawings were accepted. These were described simply as "aquarelles" with frame dimensions 39 × 35 cm.; 39 × 45 cm.; and 48 × 42 cm.
190. Jal, *Salon 1828*, 498.
191. In his memoirs, Granet wrote: "I was still turning out little paintings which I sold to collectors who came to visit Rome, but after doing a number of these small works I had the sense that I was wasting my time. Ideas of glory reawakened in my mind, and I began looking around for more important subject matter". Quoted from Edgar Munhall, *François-Marius Granet, Watercolors from the Musée Granet at Aix-en-Provence* (New York: The Frick Collection, 1988), 45.
192. Letter of 5 November 1827 to W. B. Cooke published by Dubuisson and Hughes, 79.
193. The drawing is in the National Gallery, Washington, D.C. The receipt, dated 23 February 1828, was cited by Dubuisson and Hughes, 81.
194. Dubuisson and Hughes, 82–83.
195. *The Literary Gazette* (9 February 1828): 90.
196. *The London Weekly Review* (16 and 23 February 1828): 92 and 124.
197. *The London Weekly Review* (31 May 1828): 348.
198. *The New Monthly Magazine* (1 June 1828): 254.
199. *The Literary Gazette* (24 May 1828): 332.
200. *The Literary Gazette* (17 May 1828): 315.

Fig. 64: Eugène Delacroix (1798-1863)
Illustration to Faust, 1827
Lithograph $12\frac{1}{4} \times 9\frac{3}{8}$ in. (31.5×24 cm.)
Yale Center for British Art, New Haven

Henri III did not sell in London, but there appears to have been some interest among the engravers for the rights to reproduce it.[201]

This review followed immediately the same critic's rather damning assessment of Turner's *Boccaccio Relating the Tale of a Birdcage* (Tate Gallery):

On land, as well as on water, Mr. Turner is determined not merely to shine but to blaze and dazzle. Watteau and Stothard, be quiet! Here is more than your match! If Mr. Turner . . . had called the present production "a sketch", in the manner of either of the above-mentioned artists, it might have been supposed that, although he had overshot the mark in glare and glitter, yet that, had he proceeded, he would have added those redeeming qualities without which such tinsel is an offence, not only against the principles of art, but against common sense.[202]

The critical juxtaposition of these pictures was undoubtedly intentional. Both were hung in the School of Painting, but since Turner was a member of the Hanging Committee, one can assume that the senior artist was given a more advantageous placement. Like Bonington, Callcott, and other landscape specialists, Turner appreciated the fashion for genre pictures and was endeavoring, with considerably less success, to respond to it in the mid-to-late 1820s. The *Boccaccio* is an enlarged vignette consciously echoing Thomas Stothard's Watteau imitations for an illustrated edition of the *Decameron* (London, 1825).

As a subject for historical genre, Henri III was not popular in France. Joseph Beaume's (1796–1885) *Henri III à son lit de mort* (Louvre) of 1822 was the only illustration of an episode from this monarch's life exhibited in Paris in the 1820s. As the last of the Valois line he was overshadowed by his self-appointed successor Henri IV, the very subject and message of Beaume's picture.[203] In the 1820s, opinion of his character was mixed. He was perceived as a cultivated and keen intelligence, but an indolent, effeminate, and ineffectual ruler governed by the whims of his mother, Catherine de' Medici, and of his dissolute coterie of *mignons*. In this and in his religious intolerance, he was the ideal foil to Henri IV, but his assassination for his instigation of the brutal murder of his political opponent Henri, Duc de Guise, however just nineteenth-century opinion considered the retribution, was a sensitive matter. There is no question that the revival of interest in this monarch at the end of the decade, when disillusionment with the repressive measures of Charles X was rife, had political motivations, but whether it was Bonington's intention to criticize or warn the incumbent regime is impossible to know; the picture was never exhibited in Paris. At best, it may be supposed that he was cognizant of potential allusions but playing to his English audience's distaste for Henri III as a conspirator in the Saint Bartholomew's massacre and as the rejected suitor of Queen Elizabeth, who was then assuming mythic stature, and to their awareness of political realities in Europe, which included their government's opposition to the recent armed intervention by France in the Spanish wars.

Bonington's characterization of the monarch is decidedly unflattering and, consequently, in marked contrast to Delacroix's nearly contemporary *Henri III at the Deathbed of Marie de Clèves* (Private Collection). As Lee Johnson has observed, Delacroix was attempting to resuscitate Henri's character by representing his intense personal sorrow at the loss of his mistress. He based the pose and portrait of Henri III on tracings in the *Recueil de F.-R. de Gagnières (1642–1715)* (Bibliothèque Nationale), and subsequently lent the portrait to Bonington. In turn, he borrowed from Bonington the latter's graphite sketch of the head of the virgin in Piombo's *Visitation* (Louvre) for his "portrait" of Marie de Clèves.[204] Bonington had previously used that study for the features of his invalid in *Use of Tears*. In other words, the

artists were quite familiar with each other's pictures and probably challenging, in the spirit of benign rivalry, their conceptions.

Johnson preferred to situate Delacroix's *Henri III* in the more personal context of his program to illustrate, with small cabinet pictures, the private amours of the French monarchy from Charles VI to Henri IV. Brantôme was one apparent historical source for both the general program and the specific anecdotes.[205] Bonington was certainly aware of his friend's sources, but, in this instance, totally unsympathetic to any redemption of Henri III. He was uncharacteristically specific in identifying his own literary source, for he included in the Royal Academy catalogue the following quotation from Alexandre Dumesnil's *Don Juan d'Autriche* (Paris, 1825):

I (Don Juan) had arrived this morning at the Louvre under the protection of the Gonzagas—the King had just presided at Council, we found him in his room with a half-dozen small dogs, his closest minions, parrots, and a monkey who leaped on the shoulders of his majesty.—The dogs and minions were sent away. We remained with the parrots. Hist. de D. Juan d'Autriche.[206]

The anecdote Bonington had selected was incidental, of no profound historical moment, but his purpose was to illustrate what he considered the essential character of the man. Henri's affected femininity of manners and dress is brilliantly concentrated in the pallid hand limply dangling the fan of peacock feathers. His notorious and pathological affection for his menagerie of animals was one of his more colorful prodigalities. However, the monkey, only mentioned in passing in Dumesnil's text, here assumes a more crucial narrative and possibly metaphoric function. For a British audience of the 1820s, a monkey was the standard derogatory zoomorphism for French character.[207] Its toying with a crucifix would have been readily understood as a satirical reference to the monarch's moral vacillation and religious hypocrisy, reinforcing the visible trepidation of Don Juan, who has presented himself in the disguise of an Italian noble for the specific purpose of discerning for his most Catholic liege, Philip II of Spain, Henri's true convictions.

As in Bonington's earlier pictures, the antiquarian bric-a-brac is plentiful. The glittering still life of crystal and gilt on the table is almost worthy of Rembrandt. The treatment of its green cloth looks back to Delacroix's *Faust and Mephistopheles* (Wallace Collection), which had appeared in the previous Salon. The incising or combing of a thick layer of paint to simulate coarser fabric textures was a favorite device of Delacroix's at this time, possibly inspired by the hatching technique he was using in his lithographs. The figure of a Spanish ambassador, borrowed from Adriaen van de Venne's (1589–1662) *Fête donnée à l'occasion de la trêve de 1609* (Louvre), served casually as a model for Don Juan. The awkwardness of the monarch's pose is often cited as a design flaw, and similar passages, artfully concealed, as in *Amy Robsart and Leicester*, might indicate to some that Bonington had yet to thoroughly master the foreshortening of the costumed human figure. It was Thoré's contention, actually, that the "airy and imponderable" character of the figures in this picture was a laudable negligence typical of the best British figure painting[208]; but a gracelessness of pose and modeling are also pervasive in Delacroix's work of this period and cannot be ascribed solely to a British influence nor dismissed as ineptitude, for his deliberate, and often extreme, anatomical distortions are what imbue his illustrations of Goethe's *Faust* (fig. 64), his *Cromwell at Windsor Castle* (no. 142), or his *François Ier and His Mistress* (no. 134) with their extraordinary psychological force.

In recalling the general reception of the *Faust* lithographs many years later, Delacroix was dismayed that they had been the subject of

Fig. 65: *Sketch of Figures in Martin Schongauer's* Christ Bearing the Cross, ca. 1825
Graphite 4¼ × 6 in. (11.1 × 15.1 cm.)
Private Collection

201. H. C. Shenton, whom he had met in 1825, was selected by Ackermann to engrave it for the latter's annual *Forget-Me-Not*. The publisher was prepared to pay £10.10 for the reproduction rights. In a letter of 10 July, Bonington requested Barnett's assistance in the negotiations, allowing that "fearing the picture to be an unsalable piece of goods, [he] wishes to draw any profit from it that may present itself, but would have been as glad of £15.15 as £10.10." See Noon 1981.

202. *The Literary Gazette* (17 May 1828): 315.

203. He was often presented as such in the histories of the reign of Henri IV; see in particular, Hardouin de Péréfixe, *Histoire du Roi Henri le Grand*, a nineteenth-century edition of which was well-known to Delacroix and Bonington.

204. Johnson, *Delacroix* 1, no. 126; 2, pl. 110; and "A New Delacroix: *Henri III at the Death-Bed of Marie de Clèves,*" *Burlington Magazine* (September 1976): 620–22. This interesting exchange of source material is discussed in detail by Johnson. It is possible, however, that Delacroix also directed Bonington's attention to the Piombo, rather than vice versa. The important point is that the two artists maintained a close creative relationship until Bonington's death.

205. The Monmerqué edition of Brantôme's complete works was published in Paris in 1822.

206. As printed in the Royal Academy catalogue:

Je (Don Juan) suis allé ce matin au Louvre sous les auspices de Gonzagues. Le Roi venait de présider au conseil, nous l'avons trouvé dans son cabinet avec une demi douzaine de petits chiens, ses plus affectionnés mignons des perroquets, et une guenon qui sautait sur les épaules de sa majesté, etc. Hist. de D. Juan d'Autriche.

207. See, for instance, Hazlitt, *Notes*, 139: "Because the French are animated and full of gesticulation, they are a *theatrical* people; if they smile and are polite, they are *like monkeys* — an idea an Englishman never has out of his head."

208. Thoré 1867, 12.

Fig. 66: *Evening in Venice*, ca. 1826-27
Oil on canvas 21½ × 18¼ in. (55 × 46.5 cm.)
Fogg Art Museum, Harvard University

numerous caricatures and that they had thrust him to the head of the "school of the ugly."[209] Ugliness was the term most used by Delécluze in 1824 to describe the character of the subjects and of the styles of romantic painters, but the "school" to which Delacroix referred also included his literary circle, whose doctrines received their most expansive elucidation in the preface to Hugo's drama *Cromwell*. Since the *Faust* illustrations and the preface were published almost concurrently, a critical linkage was inevitable. In Hugo's somewhat contracted survey of Western civilization, the "grotesque" was the central idea of post-classical thought, manifesting itself in the art, architecture, dress, superstitions, religious rites, and civic mores of every society. To deny that heritage, as the neoclassicists had done, was tantamount to renouncing modernity and to misunderstanding the complexity of both human nature and man's relationship to nature:

The beautiful has but one type; the ugly a thousand. What is beautiful, to speak humanely, is only form considered in its most simple aspect, in its absolute symmetry, in its intimate harmony with our makeup The ugly, on the contrary, is a detail of a grand ensemble that escapes us, that harmonizes itself, not just with man, but with all creation.[210]

Hugo's thesis was meant to justify, in the most general terms, much of what was then being penned, acted, or painted by his peers, to furnish a new slant on such dated aesthetic constructs as the picturesque, local color, or the sublime. For the pictorial arts, he cited Rubens and Veronese as successful manipulators of the grotesque through their insistent introduction of dwarfs, blacks, and other unexpected physical types into their magisterial compositions. But Hugo was, visually, both conservative and surprisingly illiterate, and while he may have felt that he was speaking for Delacroix and other artists, he was only glancing the surface of their preoccupations. Dwarfs and monsters, hideous subject matter, and the formidable cold angularity of medieval armor were potent visual stimulants, which is why caricature and the sensationally macabre in literary illustration became so popular in subsequent decades, especially within Hugo's own salon of draftsmen. However, the "ugliness" and, paradoxically, the ideal beauty of the *Faust* lithographs, which sets them apart from, and above, virtually all other romantic book illustration, derived from their extreme distortion of physiognomy and their utilization of totally improbable poses and unusual spatial constructions to embody the satanic Northern sentiment permeating the text, irrespective of the scene or personages represented. For Hugo, Delacroix's Marguerite resembled a tadpole; for Baudelaire, she was the essence of modernity. The fact that the *Faust* lithographs were book illustrations gave Delacroix a freedom he could not exercise in large pictures to the same degree, but more decorous instances of his subjective intuition or temperament subjugating representational form abound in the major and minor oils.[211] Comparable instances of seemingly strained formal arrangements heightening the dramatic force of a composition occur in Ingres, and although Bonington was less blatant or consistent in his use of like devices, he could punctuate a composition unexpectedly with the most awkwardly constructed figure, such as the page in the versions of *Evening in Venice* (no. 123; fig. 66) or Slender in the oil *Ann Page and Slender* (fig. 38). In this broader context of artistic license in the 1820s, such anomalies, when they appear, assume an intentionality that cannot be dismissed casually as mechanical lapses.[212]

Following the Royal Academy opening, Bonington wrote a short note to Barnett describing his condition as "tol-lol, neither good nor bad."[213] A brilliant sheet of sketches of late May of the actor Edmund Kean (no. 158), who was performing the role of Shylock for a Shake-

209. Delacroix, *Correspondence* 4: 303-5; letter to Philippe Burty dated 1 March 1862, in which Delacroix discusses the details of the Faust commission. He was poorly reimbursed by Motte, although he did receive an engraving after Lawrence's *Portrait of Pius* VII, about which he wrote a flattering article in 1829. In the same letter, he also recalls making one lithograph after an original Bonington watercolor:
Perhaps it might be mistaken by someone wishing to attribute it to Bonington. But my design is very far from the lightness that he put into his lithographs and, one must add, in everything from the hand of this admirable artist. I understand that the youth of today appreciate him little. He shares this rejection with the illustrious Charlet who, for this generation, is a man of the Empire and of outmoded style.
210. Hugo, *Cromwell*, 5off.
211. The formal invention of Delacroix's illustrations has often been traced to inspiration derived from his experience of English theater during his trip to London in 1825. However, his ideas were already coalescing before the London trip. His avowed ambition in the spring of 1824 was to create a new style of painting that would "render it interesting by the most extreme variety of foreshortening [*raccourcis*] and the most simple poses" (*Journal* 1: 63). From other observations in the journal during the same weeks, it is clear that Delacroix wanted this new style to merge the painting techniques of Ingres and Velásquez and the formal approach of Retzsch's *Faust* engravings and Goya's *Disasters of War*.
212. In the case of *Henri III* and *Amy Robsart and Leicester*, the intentional evocations of Watteau must also be considered. Bonington's interest in that artist is well-documented. Auguste-Joseph Carrier recounted to Dubuisson that Bonington offered him the "contents of his studio" in exchange for a Watteau oil then in Carrier's possession. The latter, however, had already sold the picture to his teacher, Daniel Saint. Selby Whittingham has proposed that this picture was *La Perspective*, now in the Museum of Fine Arts, Boston, but formerly in the Saint collection. The picture might have inspired Turner's overtly Watteauesque *"What you will"* (Sobell Collection) of 1822, but Whittingham's further speculation that Turner and Bonington actually met in Paris in 1821 seems improbable ("What you will; or some notes regarding the influence of Watteau on Turner and other British Artists," *Turner Studies* 5 (1985): 2ff.). John Ingamells (*Catalogue* 1: 27) has suggested Watteau's *Mezzetin* as a possible source for Henri III's pose.
213. Manuscript letter to John Barnett dated 5 May 1828 (Royal Academy of Arts Library, MSS. Collections, And/20/145):
Dear Barnett
The enclosed is the sample of the nut oil — news is scant here when you have a minute send me some everything with me is tol-lol neither good nor bad — hope all is well with you.
Yours truly
R P Bonington

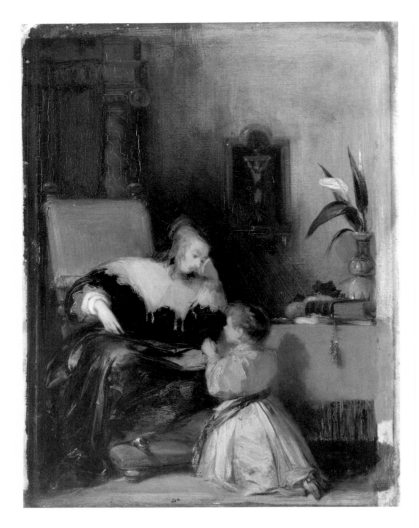

Fig. 67: *The Prayer*, ca. 1826
Oil on canvas 14 × 11 in. (35.9 × 27.9 cm.)
Wallace Collection, London

speare festival that had been in progress in Paris through the spring, gives no indication of any physical attenuation; but by the beginning of July he was incapacitated, unable to write his own correspondence, although still mentally alert and concerned with business. What happened in the interim is unclear, but most early accounts report that he suffered from sunstroke or nervous exhaustion while sketching, briefly revived, and then rapidly succumbed to a complication similar to pulmonary consumption.[214] The suddenness and severity of the illness shocked his close friends, who considered him rather robust. On learning of the calamity at the end of June, Paul Huet, who had planned to meet Bonington and Isabey at Trouville, abbreviated his sketching tour and returned to Paris. With the assistance of friends, Bonington gamely continued on through the summer, producing the occasional drawing of Paris from the privacy of a hired cab (nos. 161–63); but a note to a friend requesting that he visit urgently and bring a more comfortable chair confirms the desperateness of his condition by late July.[215] Medical assistance furnished by Carrier's brother proved ineffective, and in September Bonington's parents chose a more drastic course of action. A British specialist in lung disorders later to be discredited as a quack, John St. John Long, had received favorable press for his treatments as recently as June, and they decided to seek his consultation despite the strenuousness of the journey to London. Whatever treatment Bonington received there proved futile and on 23 September, one month before his twenty-sixth birthday, he died at the home of John Barnett.

The first of several generous obituary notices appeared in *The Literary Gazette* on 27 September, written apparently by the same art critic who had recently so admired Bonington's works at the Royal Academy. Aside from a glowing survey of his career and his filial devotion, it offered several interesting observations. Carpenter had purchased the large *Ducal Palace*, in addition to his commissioned Grand Canal view.[216] *Henri III of France* was considered worthy of only George IV's collection, for which its purchase was proposed. The Royal Academy had also decided that Bonington was to be remembered as a British artist and consequently arranged his funeral. Lawrence and Henry Howard officially represented that institution, while George Fennel Robson and Augustus Pugin were in attendance for the Society of Painters in Watercolours. The Rev. T. J. Judkin, an honorary exhibitor at the Royal Academy, officiated at the services. News of Bonington's death had reached Paris even before the publication of this notice. On the eve of his funeral, the *Journal des Débats* (28 September), whose art expert had been one of Bonington's most outspoken critics, published an equally flattering and, by its standards, lengthy obituary, elevating the artist's stature to that of Géricault while claiming his talent for the French school. The most informed notice, written by Auguste Jal for the *Le Globe* (5 October), commenced with a list of recently deceased younger painters, many of whom were Bonington's friends — Géricault, Michallon, X. Leprince, Enfantin. After briefly tracing Bonington's career, it concluded with the simple, but thoroughly appropriate, lament that "the new school has lost in him one of its glories; death has come to the aid of the classicists."[217]

What ensued was a remarkable surge in Bonington's popularity and influence, which did not ebb until around 1840. With the assistance of Lawrence, Prout, Colnaghi, and other sympathetic artists and dealers,[218] a series of four studio sales commenced in 1829 and ended only with his mother's death in 1838. The sale of 1834 was also preceded by a shrewdly staged public exhibition in London that mixed private loans with the gradually thinning supply of studio effects. The 1829 sale was the most impressive, for in addition to the bulk of Bonington's

working drawings and early watercolors, it included most of the Italian oil sketches and a dozen or more finished pictures. As agent for Gen. Edmund Phipps, William Seguier paid the highest price for any single lot (£105) for the sentimental *The Prayer* (fig. 67). The industrialist Joseph Neeld secured *Quentin Durward at Liège* (no. 143) for £94, while the Marquess of Stafford purchased for £73 *Corso Sant'Anastasia, Verona* (no. 155). Possibly because of its eccentric subject, *Henri III* had to be bought in by the family at £84. When one recalls that Constable had received £120 each for two of his greatest landscapes only a few years before and that Delacroix was commissioned by the state in 1828 to paint his monumental *Battle of Nancy* (Musée des Beaux-Arts, Nancy) for £160, it is apparent that Bonington's surviving canvases had become desiderata of a special order.

Seguier was relentless in the 1830s, but to no avail, in trying to cajole the trustees of the National Gallery into acquiring pictures for the nation, while on the opposite shores of the channel, Charles Rivet was equally unsuccessful in his efforts to donate pictures to the Louvre. Despite such official rebuffs, the artist's reputation grew prodigiously. Carpenter, Reynolds, and others profited handsomely from their publications of reproductive prints, and the London art journals persisted in fueling the enthusiasm with regular biographical and critical blandishments. French interest was no less pronounced. The periodical *Revue Britannique*, whose editorship Amédée Pichot would assume in 1835, published an article in which an anonymous author, perhaps Pichot himself, editorialized on the extent and reasons for Bonington's celebrity:

The nineteenth century . . . can have only one character in the arts, philosophy, and literature. It is eclecticism Happy the artist who, by fusing diverse genres and styles, arrives at a proper individual expression. In all the school of modern painting, Bonington's is perhaps the most original talent Without prejudices, without [allegiance to] any school, almost without a country to call his own, he was precisely the man needed to rejuvenate art, to prevent anarchy, and to preside over its brilliant metamorphosis. French painting today . . . is an extraordinary mix of historical recollections, ideas, diverse genii; the Middle Ages, Spanish Catholicism, papal Italy, eighteenth-century Germany. Some imitate Joinville, others Rabelais; some find inspiration in Scott, others in Dante Among those many influences Bonington must now be counted.[219]

In death Bonington had become a focus of the eclectic historicism that had engaged his own creative intuition.

Together with the vigorous commerce in his pictures, such promotions inevitably incited a host of forgeries and honest imitations, most notably in the landscape category. It is beyond the scope of this exhibition to represent that phenomenon; in fact, it would make for a rather tedious visual exercise, for although Bonington's bravura could be approximated by any competent painter — and there were scores who succeeded — his vivacious touch, his instinctive comprehension of difficult color arrangements, and, most significantly, the transcendence of his serene naturalism could not. His greatest contemporaries, like Huet, Isabey, Corot, Delacroix, Rousseau, Decamps, absorbed from his unique vision and technical innovations what was compatible with their own aims and transformed the course of French painting. That they would have managed to do so anyway is certain; but in isolating a corpus of authentic works from the welter of misattributions and by comparing them to a select group of pictures by several of these contemporaries, this exhibition attempts to persuade its visitors that without Bonington's contribution the history of romanticism would be measurably impoverished. In his "Essay, supplementary to the Preface" (1815), William Wordsworth wrote "of genius, in the fine arts, the only

infallible sign is the widening the sphere of human sensibility, for the delight, honor, and benefit of human nature."[220] If nothing else, the tributes with which we opened this essay, the stylistic pastiches, the sincere remembrances of friends like Delacroix and Huet were a grateful acknowledgment of just such a faculty.

214. Frederick Tayler was quite specific as to the cause of the initial collapse, recalling that Bonington suffered sunstroke while sketching on a barge on the Seine; see William T. Whitley, *Art in England 1821–1837* (Cambridge, 1930), 150–51. Cunningham (*Lives*, 256) published a letter to him from Lavinia Forster from which the following was extracted: "alas . . . the great success of his works, the almost numberless orders which he received for pictures and drawings, together with unremitting study, brought on a brain fever, from which he recovered only to sink in a rapid decline."

215. Manuscript letter postmarked 21 July 1828 (BN Bonington Dossier, AC 8021); reproduced by Dubuisson and Hughes, opp. 81. The letter is addressed to "Mons. Godefroy" and contains the salutation "Mon Cher Godefroy." It is usually assumed that Bonington's correspondent was his old atelier comrade Pierre-Julien Gaudefroy. The misspelling of his name is curious, but we must assume that this was an acceptable variation at the time, since the letter entered the Bibliothèque Nationale by way of Gaudefroy's son.

216. A manuscript letter (Pierpont Morgan Library, MA 4581) from Bonington to Carpenter, dated "Paris ce 26 Mai 1828," probably refers either to this transaction or to Carpenter's purchase of Bonington's *A Fishmarket Near Boulogne* (no. 29):
My Dear Sir,
I am quite ashamed at having so long delayed writing to you, nor can I invent any excuse that may at all plead in my favor. I am in such arrears with everybody as to writing that I know not which way to turn or what to hope — my friend Barnett writes me that you have received my picture and has flattered me I fear in saying that you felt pleased with it, should he have said true I should feel most happy — excuse me to Mrs. Carpenter Jr for having kept so long the picture confided to me. I only wish that I could keep it longer. a gentleman asked me the price I answered that it was a portrait and therefore most probably not for sale, but at all events I would ask when I wrote. My mother begs me to present her many thanks to Mrs. C. for her kind present. may I beg you to present my best remembrances to Mrs Carpenter and to Mr and Mrs W. Carpenter with thanks for their many kindnesses. believe me to remain my dear sir your most obliged and obedient
R P Bonington
when you wish to remit to me would do it through my friend Barnett's hands, he being so kind as to transact what little [business] I have in London — do remember me to Mr Burnett & Ensom when you see them.
Rue St Lazare N 32.
Margaret Carpenter's oil portrait was undoubtedly the picture she had exhibited at the Salon in November and for which Delacroix expressed great admiration. Mr Burnett might be John Burnet (1784–1868), the artist and theorist whose books Carpenter was then publishing.

217. "Bonington, Peintre de Genre," *Le Globe* (5 October 1828): 745–46.

218. Lawrence appears to have been especially helpful, as the following extract from a letter to him from Richard Bonington suggests (Royal Academy of Arts Library, MSS. Collections, LAW/5/307):
Paris 16th Feb 1829
Esteemed Sir,
Availing myself of your goodness, I have forwarded in one large case all the reliques of my dear child's talents and industry, which devolved to me after his fatally premature death. These I hope will reach you in safety and free from any injury, as I believe every possible care has been employed by the packer etc. — and the lists of the paintings, drawings, and sketches etc. etc. I transmit to you through the medium of my kind friend Mr. Barnett by tomorrow's post. The case I hope by this is shipped for London.
Rd. Bonington
Paris, rue des Mauvaises Paroles, no. 16

219. "Bonington et ses émules," *Revue Britannique* (July 1833): 158–67.

220. *William Wordsworth*, ed. Stephen Gill (Oxford, 1984), 659.

Catalogue Note

Although this exhibition includes a substantial portion of Bonington's known oil paintings and watercolors, the *catalogue raisonné* format for describing them was deemed inappropriate for the accompanying publication. Consequently, I have confined bibliographical citations to the most important critical and historical sources. Abbreviated references are cited in full at the end of the catalogue section. To the extent that it is now possible to do so, provenances have been reconstructed. The most reliable factual test of authenticity is if a work can be traced to an exhibition during the artist's lifetime, to one of the studio sales following his death, or to one of the loan exhibitions organized to promote those sales. The notion that works given to the artist during his lifetime by friends like Isabey or Huet might have passed undetected as authentic Boningtons in the studio sales is overly circumspect. Those events were supervised closely by his parents, who were thoroughly familiar with his oeuvre, zealous in their protection of his reputation, and innocent of any fraudulent intent.

The catalogue and exhibition are arranged chronologically. Mixing oil paintings with works on paper is always the nightmare of both curators and designers; in Bonington's case such an arrangement is crucial if we are to our understand his methods and development. Unless otherwise specified, the supports for graphic works are white or near-white wove papers, the majority of which were fabricated in England.

I

PORT DE PECHE, BOULOGNE ca.1818
Watercolor over graphite, with scraping out, on
laid paper, 4¾ × 8 in. (12 × 20.5 cm.)

Inscribed: False signature, in pen and ink, lower
right: *RPB*; in graphite, verso: *11 / Bonington*

Provenance: Anonymous (Sotheby's, 14 July
1988, lot 102).

Private Collection

This watercolor, a rare survival of an unfaded
early sheet, was painted shortly after
Bonington's arrival in France in late fall 1817.
Under Bonaparte, Boulogne was transformed
into a major port. The Duke of Rutland, a
seasoned continental traveler, noted with
interest on landing there again in 1815: "It is
indeed a surprising work; when it is considered
that what was formerly a simple and
contemptible inlet formed by the tide, is now
an excellent harbor... capable of containing
three hundred vessels."[1] Bonington's view is of
an anchorage reserved for fishing craft.

Although it exhibits few of the traits of the
style then practiced by his first professional
tutor, the Calaisian Louis Francia (no. 17),
this drawing is extraordinarily proficient for an
adolescent. At this date Bonington's watercolors
are more reminiscent of the late works of
Thomas Girtin (1775–1802), such as the
Eidometroplis studies (British Museum) or the
etched *Views of Paris and Its Environs* (1802/3;
fig. 3). Such prints, in addition to Francia's own
early marine drawings in imitation of Girtin and
published aquatints after Girtin-school painters
like Samuel Prout (no. 89), undoubtedly
provided the models for the breadth of touch
and subdued palette of Bonington's first essays
in watercolor.

The nervous yet delicate underdrawing on
the right side, which has its corollary in the
elaborate penwork of the rigging, confirms that
the artist sketched his composition in graphite,
then radically altered the design as he applied
his washes. Such in-process modifications are
characteristic of Bonington's technique.

1. The Duke of Rutland, *Journal of a Short Trip to Paris
during the Summer of 1815* (London, 1815), 7.

SMALL VESSEL IN A CHOPPY SEA ca.1818–19
Watercolor over graphite, with scraping out,
$5\frac{1}{2} \times 7\frac{5}{8}$ in. (13.8 × 19 cm.)

Inscribed: Signed, in pen and ink, lower left:
R P Bonington

Provenance: Probably purchased from the artist
by L.-J.-A. Coutan; by descent to Mme Milliet;
Milliet, Schubert, Hauguet Donation, 1883.

Musée du Louvre, Département des Arts
Graphiques (RF1467)

This type of composition, with its single vessel
braving channel swells and ominous sky, was
Francia's forte and would become the lucrative
refuge of many less inventive marine painters
like Théodore Gudin (1802–1880). A possible
pendant to this sheet (Barlow Collection)
depicts a similar craft returning to port under
more auspicious skies. The cursive form, as in
this example, is typical of the artist's signature
before ca.1820.

After his family's arrival in Paris in late 1818
or early 1819, Bonington began to paint small
marine watercolors intended principally for the
albums of collectors. Portfolios of old master
prints and drawings had always been a feature
of the connoisseur's cabinet, but not until the
nineteenth century did the taste and demand
for such intimate collections become a pervasive
factor influencing artistic production. Fostering
this interest were the novelty of landscape
watercolors and lithography, the fashion for
amateur drawing, and the evolving economics of
patronage. In his review of the 1824 Salon,
Stendhal would quip that apartments in Paris
had become so small that in the future
collectors would be able to house only
engravings.[1] Honoré de Balzac attributed the
shift in collecting — from monumental
paintings to cabinet pictures and graphics — to
a leveling of taste brought on by democratiz-
ation of the economic order.[2] It was apparent
that, more than at any other time, the
prosperity of an aspiring artist depended on the
official support of the state and its subsidiary,

the church, which alone could afford and then
house the Salon machine, and the appetite of
the bourgeoisie and aristocracy for more
manageable pictures and prices. By 1825 any
artist in Paris could derive a comfortable
subsidy from watercolors, and virtually every
major painter of Bonington's generation did
precisely that. Bonington's early celebrity was
founded exclusively on modest-sized landscape
watercolors, but as his career progressed,
he realized, according to Eugène Delacroix,[3]
that universal acclaim would require a
demonstration of his skills on a grander scale.

There has been considerable confusion about
the identity of one of Bonington's earliest
patrons, Louis-Joseph-Auguste Coutan
(d. 1830), primarily because of the existence of
a contemporary painter of no relation, Amable-
Paul Coutan (1792–1837). As stated in the
introduction to the catalogue of the final sale of
his collection in 1889, Bonington's patron was a
successful cloth merchant who resided near the
Place Vendôme. The Bonington family business
may have furnished an initial introduction
between artist and patron, although their paths,
even at this early date, would have crossed
frequently in the fashionable ateliers and
galleries of Paris.

An indefatigable enthusiast for the modern
school, Coutan was on intimate terms with its
leading artists, including Bonington's first
master, Baron Antoine-Jean Gros (1771–1835),
who pronounced a eulogy at his funeral, and
Delacroix, whom he first met in 1823. The sale

of 17–18 April 1830 immediately following Coutan's death had three Bonington oils and eight watercolors. An equally large part of Coutan's collection passed to his niece, Madame Hauguet (d. 1838) and thence by descent to the Milliet-Schubert-Hauguet families. Prior to its public auction, the heirs invited Vicomte Both de Tauzia, curator of paintings at the Louvre, to select works for the nation. From the remaining Boningtons he chose two oils, plus this and a second watercolor. The subsequent sale included ten additional Bonington drawings.[4]

1. Stendhal, *Mélanges*, 2 September 1824.
2. Balzac, *Lost Illusions* (Paris, 1837–43).
3. Delacroix, *Correspondence* 4: 287–88.
4. Paris, Hôtel Drouot, 16–17 December 1889, lots 37–46.

3

VIEW OF THE PONT DES ARTS FROM THE QUAI DU LOUVRE ca.1819–20
Watercolor over graphite, $8\frac{3}{16} \times 11\frac{3}{8}$ in. (21 × 29 cm.)

Inscribed: Signed (?), in pen and ink, lower right: *RPB*; watermark: *Cresw*[ick] / *1818*[1]

Provenance: Possibly Lewis Brown (Paris, 12–13 March 1839, *Pont des Arts and Notre Dame, sunrise*); James Mackinnon, 1988, from whom purchased by Paul Mellon.

Paul Mellon Collection

A scarcity of pocket money during his earliest days as a student confined Bonington's sketching tours to Paris and its immediate environs.[2] Of the same date and style as this work are watercolor views of the Hôtel des Invalides and of Paris from Père-Lachaise.[3] Slightly later in date are views of the Pont Neuf (Private Collection) and the Luxembourg Gardens (British Museum). Bonington returned repeatedly to this most popular of all tourist views of Paris.[4]

The inscribed signature may be a later addition. It was not Bonington's practice to initial his watercolors in this fashion before mid-decade. The incomplete definition of the foreground, sky, and bridge also calls into question the status of this watercolor as a "finished" work of art. Rather, it would appear to be a study from nature focusing on the effect of morning light and mist bathing the architecture of the Ile de la Cité. A similar method of selective study distinguishes his later plein-air oil sketches.

1. A crude watercolor copy (Yale Center for British Art) of Bonington's *Boulogne Harbor at Low Tide* (Nottingham 1965, no. 202, repr.) was painted on paper with an identical watermark.
2. Roberts, BN Bonington Dossier.
3. Christie's, 24 March 1987, lot 116, repr. color, and Victoria and Alberseum (Pointon, *Bonington*, no. 16).
4. Several watercolors of this title appeared in the studio sales: 1829, lot 43, bought in, and 1834, lot 108; 1834, lot 124, bought W. J. Cooke and his sale, Sotheby's, 16 March 1840, lot 130, bought in; see also no. 163 below.

4

THE INTERVIEW OF ELIZABETH I WITH THE
EARLS OF LEICESTER AND SUFFOLK ca.1821
Brown wash over graphite, with scraping out,
$3\frac{15}{16} \times 3\frac{1}{8}$ in. (10 × 7.9 cm.)

Inscribed: Signed, in pen and ink, lower left:
R P Bonington; verso, in graphite: *Kenilworth
p.137 / Quarrel and reconcilement between Sussex and
Leicester*

Provenance: Edward Basil Jupp (1812–1877), by
whom bequeathed to the Royal Academy.

Royal Academy, London

The subject of this composition, the interview
during which Elizabeth I demanded
reconciliation between the rival Earls of
Leicester and Suffolk, is taken from chapter 16
of Sir Walter Scott's romance *Kenilworth*. The
novel was published at the beginning of 1821.
The Hon. Henry Edward Fox recorded in his
journal that he had read it on 15 January and an
extensive critical review appeared in the
Literary Gazette on 20 January. Although it
would be several years before the simultaneous
publication of Scott's new novels in London and
Paris, it is likely that *Kenilworth* was available in
France by February.

When a student of Baron Gros, Bonington
often drew illustrations to raise money for the
excursions that he and Jules-Armand Valentin,
a fellow pupil, would make to the outskirts of
Paris. According to James Roberts:

*About this time, Bonington began to make small
historical drawings or vignettes seriously from subjects
furnished from the novels of Walter Scott all of which
at that period he had found time to read and all of
which were devoured with avidity. He found a ready
sale for these vignettes as they were sold in France at
first at a low price, even as low as 15 Francs, but even
this small price to a boy (for a boy he really was at
that period) who had been kept very sparingly provided
with pocket money was something considerable.*[1]

In style, the sheet does not differ markedly from
the watercolor *Portrait of a Seated Figure*
(possibly Pierre-Julien Gaudefroy, fig. 10),[2]
which bears an inscribed date of 1820. The
composition is uncomplicated and typical of the
vignettes being produced in England by
Richard Westall and Robert Smirke or in Paris
by their admirers like Eugène Lami (no. 5) and
Alexandre Desenne (1785–1827). Leicester's
costume was borrowed from a drawing in the
Recueil de Gagnières, an encyclopedic compilation
of illustrations of French costume and historical
personages then in the Bibliothèque Royale.
Inaccurate is the traditional assumption that
Delacroix introduced Bonington to this resource
in 1825.

An untraced Bonington watercolor of
Elizabeth interviewing Leicester was owned by
one of his first dealers, Claude Schroth, and
later by Anatole Demidoff, Duc de Rivoli.[3] But
his most ambitious treatment of a subject from

Kenilworth is the later oil painting *Amy Robsart
and Leicester* (no. 141). Monochrome wash
drawings of approximately the same
dimensions, *Prospero, Miranda, and Ariel* (*The
Tempest* 1 : 1) and *Anne Page and Slender* (*The Merry
Wives of Windsor* 1 : 1), and a vignette of *Olivia,
Maria, and Malvolio* (*Twelfth Night* 3 : 4), attest
to an equally early enthusiasm for Shakespeare.[4]

1. Roberts, BN Bonington Dossier.
2. This is possibly the watercolor of which Thoré
(1867, 6 n.2) remarked: "M. Carrier still owns another
charming portrait, painted in watercolors, by
Bonington, that of their fellow student, M. Godefroy
[sic], seated on a small rise in a clear landscape."
3. Claude Schroth (Paris, 18 March 1833); Duc de
Rivoli (Paris, 18 April 1834).
4. The first two are at the Huntington Art Gallery, San
Marino. Both Huntington drawings were in the 1834
studio sale, lots 27 and 29; cf. Robert Wark, *Drawings
from the Turner Shakespeare* (San Marino, 1973), 20, repr.
18 and 58. The *Twelfth Night* illustration is in the
British Museum (1857–2–28–164).

5

EUGENE LAMI (1800–1890)

DON QUIXOTE AT THE BALL ca.1820–21
Brown wash and white bodycolor over graphite,
$4\frac{1}{2} \times 3\frac{1}{2}$ in. (11.2 × 8.7 cm.)

Provenance: Louis Roederer, and by descent;
Dr. A. S. W. Rosenbach, 1922.

References: Cf. K. Rorschach, *Blake to Beardsley,
The Artist as Illustrator* (Philadelphia: Rosenbach
Museum and Library, 1988), nos. 20–23.

Rosenbach Museum and Library, Philadelphia
(54.672.26)

Eugène Lami began his career under the private
tutelage of Horace Vernet before entering Gros's
studio in 1818. Among his closest friends were
Géricault, with whom he collaborated on
a series of lithographic illustrations to Byron
(1823), and fellow pupils Bonington, Paul
Delaroche (1797–1856), and N.-T. Charlet
(1792–1845). At Bonington's urging he visited
England in 1825–26; he subsequently produced
two sets of lithographs, including *Voyages en
Angleterre* (1829–30) in collaboration with his
traveling companion Henry Monnier (see
no. 57). Although their circles of intimates and
patrons overlapped considerably, Lami was a
much more social creature than Bonington, and
he would flourish for decades as one of the more
brilliant chroniclers of French society and taste.
As one of the first truly professional French
watercolorists of the nineteenth century, and
through his talent, industry, and leadership in
the founding of the Société des Aquarellistes,
he made an inestimable contribution to the
legitimization of that medium in his native
country.

Lami's earliest illustrations were of military
subjects for commissions furnished by, and
often in collaboration with, Vernet. The eight
illustrations to *Don Quixote*, another project
with Vernet, who provided four original
designs, are his first foray into literary genre.
The scene depicted here is from chapter 62 of
the Dubornial translation of *Don Quixote* (Paris,
1821; engraved by Caron). At a ball given by
Don Antonio's wife, two coquettes endeavor to
seduce the knight-errant after exhausting him at
dancing. The mischievous assault on his virtue
and his already enfeebled physique cause him to
collapse while deliriously professing his
devotion to Dulcinea. This particular
composition would appear to be an original
conception, although several of Lami's other
designs for the novel are based on Robert
Smirke's illustrations to Cadell's 1818 English
edition.

Lami's handling of washes reflects his
mentor's influence, while the monochromatic
bias is typical of French book illustration at
this time. Like most of the illustrators of
Bonington's circle, he would rapidly advance
to a more facile and chromatic style by mid-
decade.

In addition to the Cervantes and Byron
commissions, Lami's most important projects
of the 1820s included vignettes to Amédée
Pichot's *Vues pittoresques en Ecosse* (no. 113); nine
designs for Gosselin's ongoing *Oeuvres complètes
de Walter Scott*, and the *Quadrille de Marie Stuart*
(1829), which commemorates the historical
costume ball hosted by the Duchesse de Berry
on the eve of the Bourbon collapse.

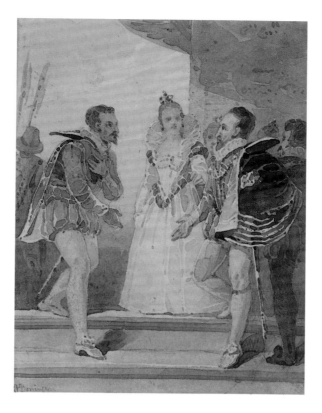

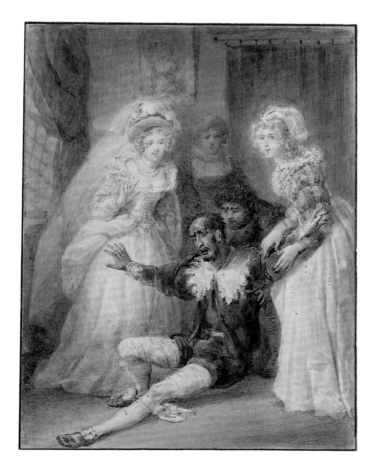

6

STUDY OF MLLE ROSE 1820
Black and white chalk with stump, $23\frac{3}{8} \times 17\frac{1}{2}$ in.
(59.5×44.5 cm.)

Inscribed: In the artist's hand, in pen and ink,
lower right: *Rose* / *April 30th 1820*

Provenance: Baron Charles Rivet, and by descent
to the present owner.

Exhibitions: Nottingham 1965, no. 3.

References: Dubuisson, 1909, 200 n.2, 203;
Dubuisson and Hughes, repr. opp. 32.

Private Collection

This is Bonington's only known academic study
from life, although others are recorded.[1] As
identified by the artist's inscription, the model
was Mlle Rose, of whom he also made a head
and shoulders chalk portrait.[2] There is no
evidence, however, to support Dubuisson's
conjecture that this professional model was also
Bonington's mistress.

A Delacroix oil sketch of Rose is dated
ca.1820 by Lee Johnson, who also recorded a
pastel study of the model by Jules-Robert
Auguste (see no. 67) and an anonymous chalk
drawing showing her similiarly coiffured.[3] In a
letter of ca.1820, Delacroix stated that he would
be using Rose as a model at R.-P.-J. Monvoisin's
studio, 11 rue de Sevres.[4]

At their meeting of 8 July 1820, the Ecole des
Beaux-Arts faculty decided to separate the
drawing academy into two classes, one for
copying from casts (Salle de la bosse) and the
other from the live model (Salle du modèle).
As a student of Baron Gros, Bonington had been
enrolled in the Ecole for just over a year. The
first competition for a place in the model room
was held on 3 October. Bonington's placement
(60th of 61) was an extremely poor showing,
given the evidence of this sheet and of his status
after the Salle de la bosse competitions of 6
August and 11 September.[5] He could have been
using Rose as a primer for such a competition,
and he would never again compete for a place in
the model room. One frequently cited reason for
the breach that occurred between Bonington
and Gros was the latter's refusal to admit
Bonington to the life class. As a pedagogic
attempt to enforce discipline, it would not have
been out of character for Gros to contrive to
have an overly self-confident student placed
near the bottom of the first competition lists.

Baron Jean-Charles Rivet (1800–1872), who
obtained this and many other works directly
from the artist,[6] was a friend of Delacroix from
their student days at the Lycée Imperial. He
served as a deputy in Martignac's cabinet
during the final years of the Restoration.
Following the 1830 revolution, he secured a
succession of influential political appointments
and elected positions, including prefect of
the Department of the Rhône. Although the
exact date of Rivet's first acquaintance with
Bonington is unrecorded, this and several other
early works in his possession indicate that an
introduction probably took place early in the
decade. They remained the closest of comrades,
with Bonington furnishing instruction in
drawing and painting and Rivet in turn
entertaining the artist frequently at his château
near Mantes. It was probably Rivet's purse that
funded their trip to Italy in 1826.

1. Bonington sale, 1834, lots 46 and 48.
2. Private Collection, Paris; Dubuisson 1909, repr. 202.
3. Johnson, *Delacroix* 1, no. 4 and fig. 4.
4. Delacroix, *Correspondence* 1: 66–67. Monvoisin won
the *Prix de Rome* in 1820 and passed the next three years
in Italy.
5. *Registre de l'Ecole des Beaux-Arts*, Archives Nationales,
AJ52.
6. See nos. 24, 35, 58, 106, 112, 121.

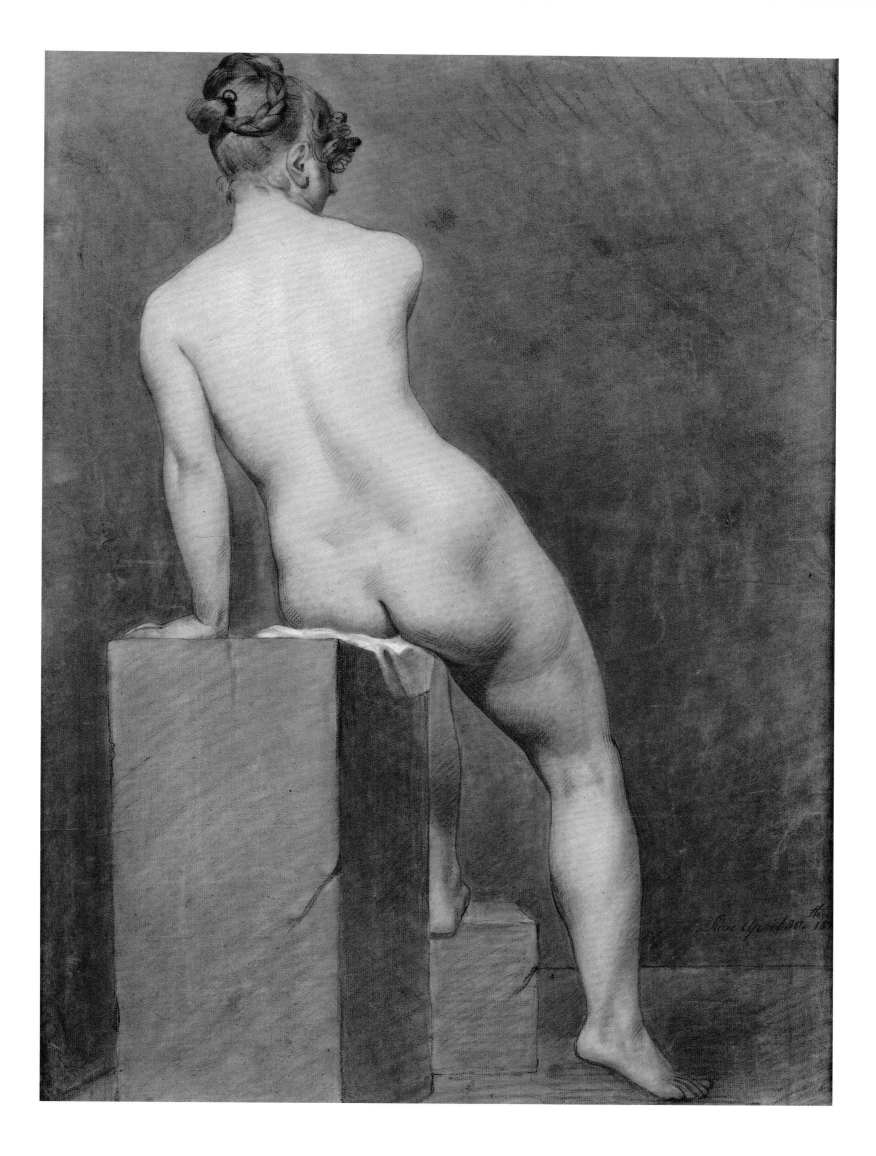

7

L'EGLISE ST-SAUVEUR, CAEN ca.1821
Graphite, heightened with white chalk, on buff
paper, 13 × 10½ in. (32.5 × 26.4 cm.)

Inscribed: In pen and ink, upper left: 59

Provenance: Bonington sale, 1829, lot 185, bought
3rd Marquess of Lansdowne; by descent to the
present owner.

Exhibitions: Agnew's 1962, no. 68; Nottingham
1965, no. 34.

References: Harding, *Works* (1829); cf. Curtis,
no. 7; Shirley, 86, pl. 10 (incorrectly titled);
Miller, *Bowood*, 42, no. 138.

The Earl of Shelburne, Bowood

In September 1821 Bonington abstained from
competing for a place in the sculpture rooms at
the Ecole for the winter semester (October to
April). During this period, he made his first
sketching tour beyond the suburbs of Paris.
Roberts observed only that he toured
Normandy and that he returned via Rouen.
Marion Spencer argues that his route was north
to Flanders,[1] but the surviving documentation,
a chronology of his earliest drawings based on
style, indicates that his primary course was in
the direction of Caen, the capital of Basse-
Normandie, with stops at Ouistreham, Dîves,
Trouville, Honfleur, Le Havre, Lillebonne, and
Rouen.

Because of its importance to the history
of both France and England and its surfeit of
Gothic architecture dating from the initial
subventions of William the Conqueror,
Caen would have been especially attractive
to an imagination fired by the chronicles of
Le Saintré, Chretien de Troyes, and Monstrelet.
This view of the choir of the fourteenth-century
church of St-Sauveur, exaggerating its physical
relationship to the rue St-Pierre, is probably
the most accomplished of the architectural
renderings from this trip. A watercolor of
contemporary date differs only in the staffage,[2]
and the composition was revived as a lithograph
for the series *Restes et fragmens* (see no. 19).
A second plate in that set reproduces the
intricately carved colombage facades just to
the east on the rue St-Pierre, on a building
that today houses the Musée de la Poste.

The drawings from this tour, which can be
appreciated in quantity only at Bowood, are
the earliest surviving examples of Bonington's
graphite technique. The touch is precise
without appearing overly fastidious; the
definition of the crevices and planes of this
weathered edifice relies on tonal rather than
linear exactitude. The similarity of his
technique to what is generally associated with
the "Monro school" style in England is too
striking to permit any conclusion other than
that Bonington had immediate access in Paris
to drawings by artists of this affiliation. In
addition to Francia, these included Henry
Edridge and Samuel Prout, both of whom were
active in the French capital in 1820 and 1821.
What is disarming is that we discover in
Bonington's adolescent studies a total mastery
of the technique in an unmistakable style that
does not pretend to prosaic fidelity. This
distinction was not lost on his contemporaries,
and Paul Huet (no. 56) would later observe:

*There is in the work of an artist something that no
instrument can yield; whatever the perfection of
photography, never will you find in it the vibrant hand
that engraved Rembrandt's etchings or that drew
Bonington's gothic churches . . . perfection in rendering
details robs a work of imagination, invention, and so
many other qualities that art alone can give it.*[3]

Artistic license in modifying the existing
features of a monument is another dimension
of formal inventiveness charactersitic of
Bonington's antiquarianism. He has eliminated,
for instance, from the three versions of this
composition the spire that would have been
visible above the apse to the right. Common to
many of these early architectural studies is the
tan paper used as a support. Bonington would
attempt, unsuccessfully, to duplicate this tone
later in the printing of his lithographs.

1. Spencer, Nottingham 1965; numerous antiquarian
studies survive, including those at Bowood, Stoke-on-
Trent, and the Fogg Art Museum.
2. Anonymous (Paris, Palais d'Orsay, 21 June 1979,
lot 4).
3. Huet, *Huet*, 78.

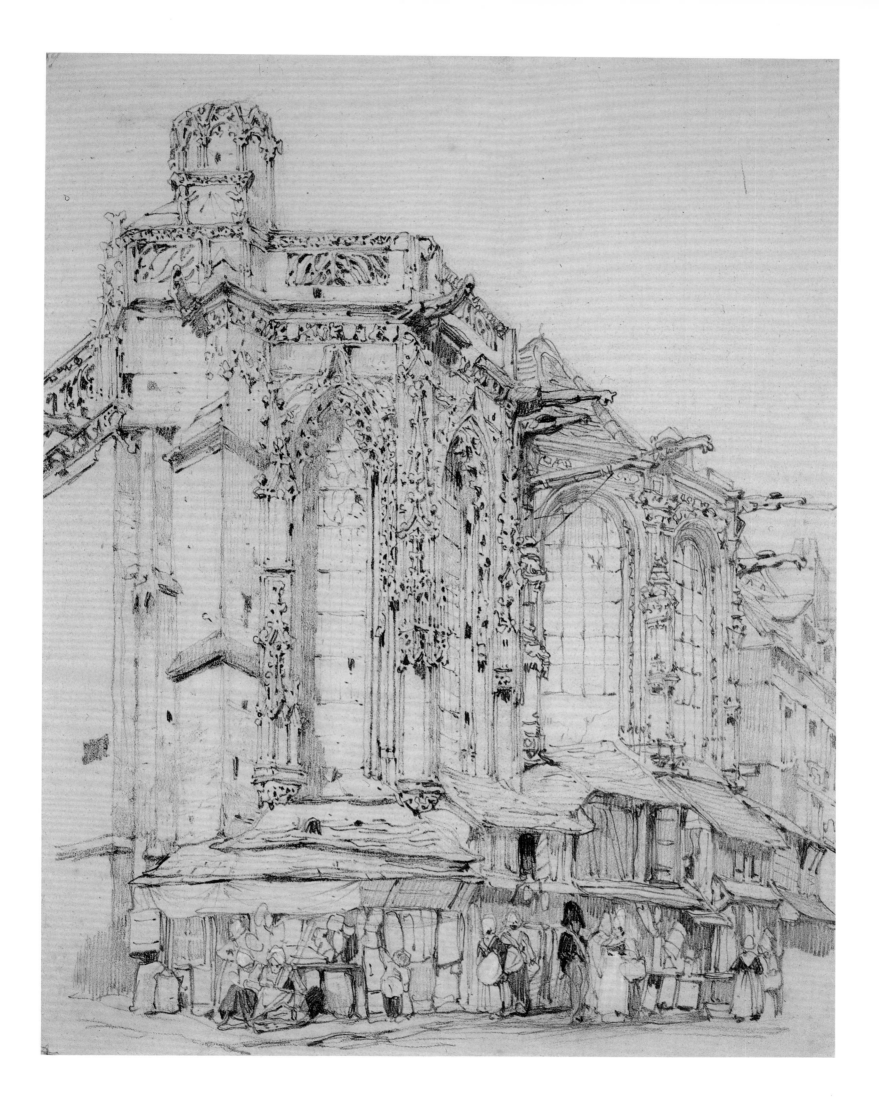

8

THE HARBOR, LE HAVRE ca.1821–22
Watercolor over graphite, $7\frac{3}{4} \times 10\frac{5}{8}$ in.
(19.7 × 27 cm.)

Inscribed: Signed, in pen and ink, lower right:
R P Bonington

Provenance: Acquired from the artist by Mme
Benjamin Delessert, and by descent (Paris,
Palais d'Orsay, 30 November 1978, bought
Spinks); Spink and Sons, 1979, from whom
purchased by present owner.

Private Collection

The traditional identification of this port as
Dunkerque is incorrect. The view is certainly of
the basin at Le Havre, with the fortified tower
of François Ier guarding its entrance. J. M. W.
Turner recorded a similar view in a watercolor
sketch of ca.1832.[1]

Bonington visited Le Havre during his first
Normandy tour in 1821. In April of the
following year he debuted at the Paris Salon
with two watercolors, now untraced: *Vue prise à
Lillebonne* and *Vue prise au Havre*, both acquired
by the Société des Amis des Arts. According
to family tradition, Baron Gros introduced
Bonington to Madame Delessert (1799–1891),
who hosted one of the most liberal salons in
the Faubourg St-Germain and whose husband
controlled one of the largest banking and
commercial concerns in France. The Delesserts
apparently purchased this and a second, slightly
later coastal view (no. 18) directly from the
artist.

Most nineteenth-century writers overplayed
Bonington's estrangement from Gros, which
occurred just prior to the Normandy trip.
An explanation for Gros's initial antipathy is
lacking, but most informed sources, including
Delacroix and Huet, later observed that painter
and pupil were reconciled before Bonington's
final departure from the atelier in the fall of
1822. The artist Pierre-Anthoine Labouchère

(1807–1873), who was related by marriage to
Baron Rivet and was an intimate friend of
Alexandre Colin (no. 136), attributed the
rapprochement to the impression made on Gros
by the finished watercolor views of "Rouen,
Caen and other French towns" that he had
chanced upon in the gallery of the dealer
Madame Hulin.[2]

1. Tate Gallery, Turner Bequest (CCLIX–83).
2. P. A. L., "R. P. Bonington," *Notes and Queries*
(10 June 1871): 502–3; see also, A. Labouchère,
"Mr. P. A. Labouchère ('P. A. L.')," *Notes and Queries*
(17 May 1873): 399–400.

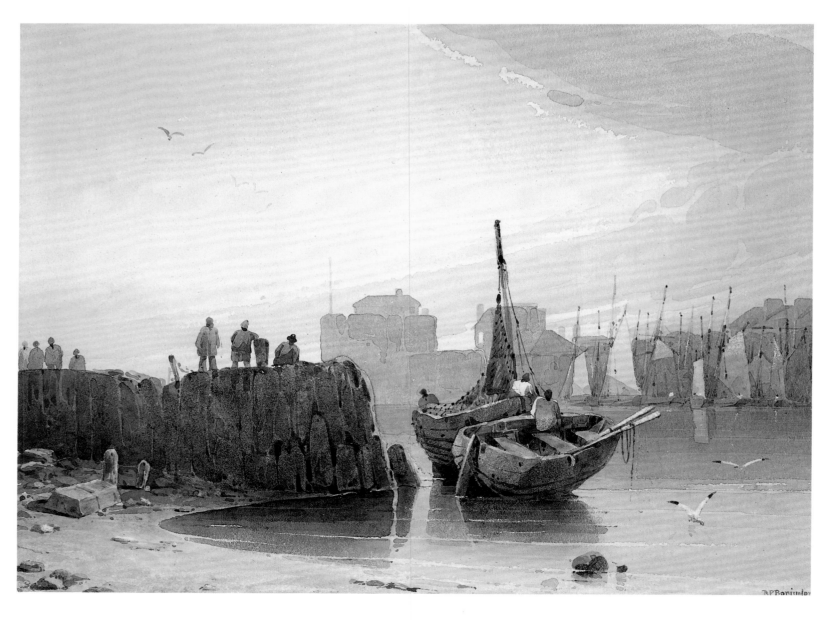

9

A FISHING VILLAGE ON THE ESTUARY OF THE
SOMME, NEAR ST-VALERY-SUR-SOMME
ca.1821
Watercolor over graphite, $6\frac{3}{16} \times 9\frac{1}{8}$ in.
(15.7×23.2 cm.)

Inscribed: Signed, in pen and ink, lower left:
R. P. Bonington

Provenance: Possibly Bonington sale, 1838, lot 47,
as *View of St. Valerie on the French Coast, with boats
and figures in the foreground, an early drawing*,
bought in.

A. S. Crans s/Sierre, Switzerland

Baron Gros was not the only artist amazed by
the novelty and naturalism of Bonington's
watercolors. Camille Corot (1796–1875), who
was still a draper's apprentice only dreaming of
a profession in art, was equally moved by an
accidental encounter with a Bonington
watercolor displayed in Schroth's window:

*No one thought of landscape painting in those days; it
seemed to me, in seeing this, a view on the banks of the
Seine, that this artist had captured for the first time the
effects that had always touched me when I discovered
them in nature and that were rarely painted. I was
astonished by it. This small picture was, for me, a
revelation. I discerned its sincerity, and from that day
I was firm in my resolution to become a painter.*[1]

This watercolor is a version of a brown wash
drawing of the same dimensions engraved by
Noël in 1829.[2] The distant port is identical to
that depicted in a later oil painting traditionally
titled *Near the Mouth of the Somme* (no. 35).
A view nearer this breakwater is furnished by
a Bonington watercolor (Birmingham Museum
and Art Gallery) recently reattributed,
inappropriately, to Francia.[3]

Allowing for minor compositional liberties,
it is possible that a watercolor copy (Ulster
Museum) of *A Fishing Village* is by Bonington's
father,[4] who began his checkered career as a
topographical draftsman and who was later
criticized, perhaps unjustly, for selling unsigned
copies of his son's designs.

1. Dubuisson 1912, 123.
2. Christie's, 18 March 1980, lot 87, repr.
3. Calais, *Francia*, 91; although that sheet might stand
more convincingly as an early Isabey, its provenance
certifies its authenticity: Bonington sale, 1829, lot 131
or 132, bought Bone for Neeld; Joseph Neeld, and by
descent until acquired by Birmingham. With the same
provenance is a second watercolor of ships, also at
Birmingham, which Pointon (*Bonington*, fig. 57) has
similarly misattributed to Francia.
4. Bonington sale, 1838, lot 90, described as a copy by
Bonington Sr. after lot 47, *View of St. Valerie*.

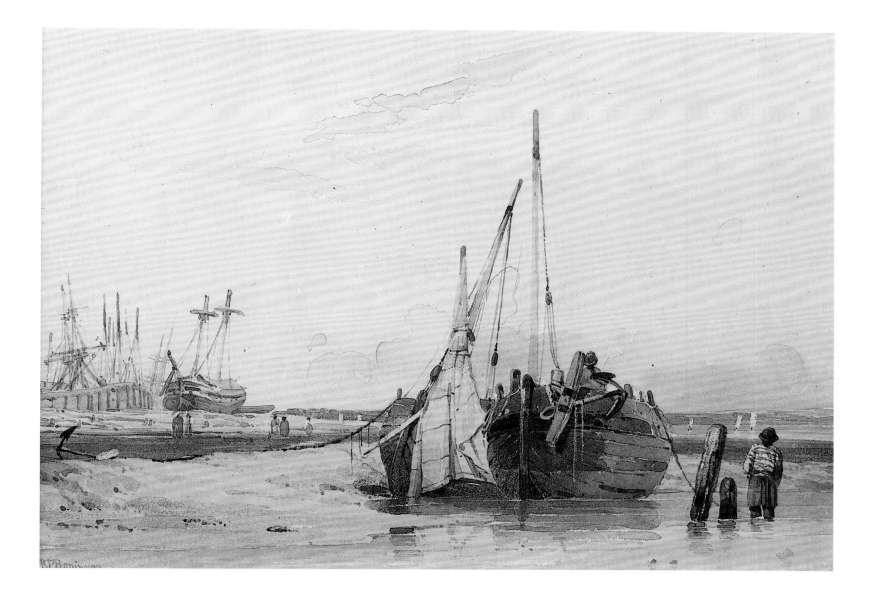

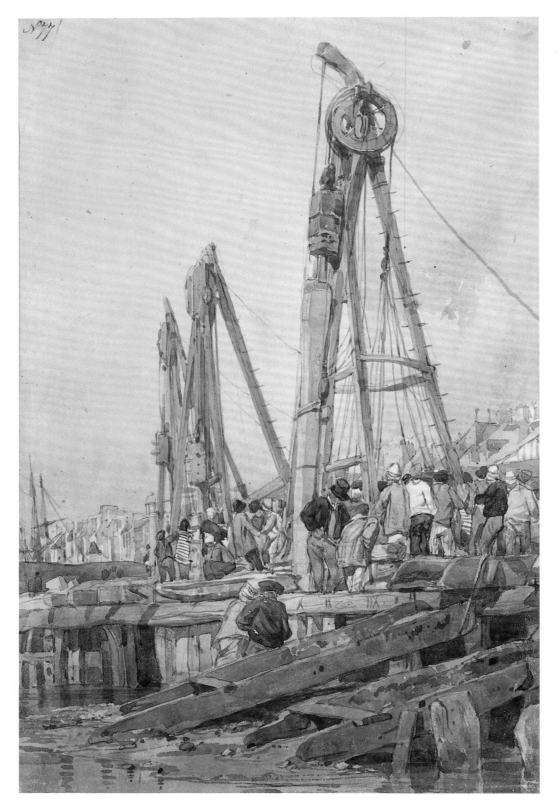

PILE DRIVERS, ROUEN ca.1821–22
Watercolor over graphite, $14\frac{7}{8} \times 9\frac{7}{8}$ in.
(37.8×25.2 cm.)

Inscribed: In pen and brown ink, upper left: 77;
watermark: *J. Whatman | Turkey Mill | 1821*

Provenance: Bonington sale, 1829, lot 45, as
*A Spirited Sketch — View of a machine for driving
piles*, bought Roles; Edward Croft-Murray;
Mrs. Edward Croft-Murray, by whom given
to the British Museum in 1981.

Exhibitions: Nottingham 1965, no. 198.

References: Cormack, *Review*, 286.

Trustees of the British Museum
(1981-5-16-12)

The number inscribed on the recto indicates
that the artist meant to retain this watercolor
for studio replication. As suggested by the
dated watermark, the study was executed on
the spot in late 1821 or early 1822. The
graphite version (no. 11), also drawn at Rouen,
augments the figure grouping and was the more
immediate study for a commissioned watercolor
(Fitzwilliam Museum).[1]

Bonington funded his first tour beyond Paris
with proceeds from the sale of his literary
illustrations and landscape watercolors, which
he was producing in larger numbers and for
which he was receiving ever higher prices. Of
the topographical studies resulting from this
trip, James Roberts observed:

*He first took wing in the direction of the coast of
Normandy making on this a number of miscellaneous
studies, mere precursors of a future harvest in that
quarter. He returned by Rouen where he made a
variety of sketches all of which were already remarkable
for brilliancy of coloring and breadth of touch, not of
that unmeaning character which has only breadth and
recommends itself as nonchalance, touch which has only
breadth to recommend it, but broad vigorous and
feelingly accentuated in the details where it was
necessary.*[2]

1. Cormack, *Bonington*, fig. 20.
2. Roberts, BN Bonington Dossier.

11

PILE DRIVERS, ROUEN ca.1821–22
Graphite on blue wove paper, $14 \times 10\frac{3}{8}$ in.
(35.7×26.4 cm.)

Provenance: Dr. John Percy (possibly Christie's,
22 April 1890, lot 102, as *Harbour Scene*);
O'Bryne (Christie's, 3 April 1962, lot 50,
bought Cecil Higgins Art Gallery).

Exhibitions: Nottingham 1965, no. 48.

Trustees of the Cecil Higgins Art Gallery,
Bedford

Sketched at Rouen, this drawing is a
preliminary study for a slightly later and
considerably larger watercolor (Fitzwilliam
Museum) commissioned by a "Miss C." for
two hundred francs.[1]

The pile-driving machines appear in another
Bonington graphite drawing, a panoramic view
of Rouen and the quays from Pont Corneille.[2]
Other representations of dock workers and their
machines are numerous among the sheets of a
dismembered sketchbook of ca.1824 now in the
Bibliothèque Nationale.

In a review of the 1829 studio sale, one critic
aptly observed: "Several of the rough sketches
of sea views, landscapes, pile-driving etc. appear
as though he had arrested the figures in their
progress and transferred them to his paper,
there is so much life and reality about them."[3]

1. This, according to an inscription in the artist's hand
on the verso. An oil version of the Fitzwilliam
watercolor (BFAC 1937, no. 13) appears to be a copy by
an unidentified artist.
2. Dubuisson and Hughes, repr. opp. 203.
3. *New Monthly Magazine* (1 August 1829): 349.

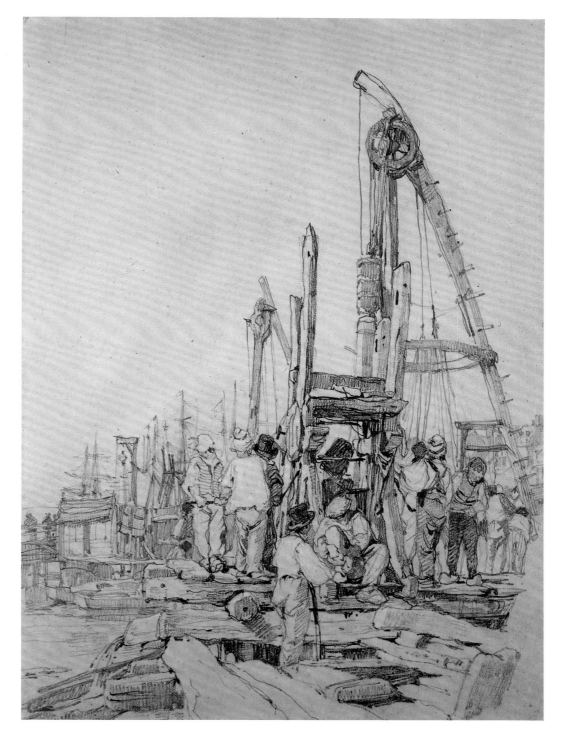

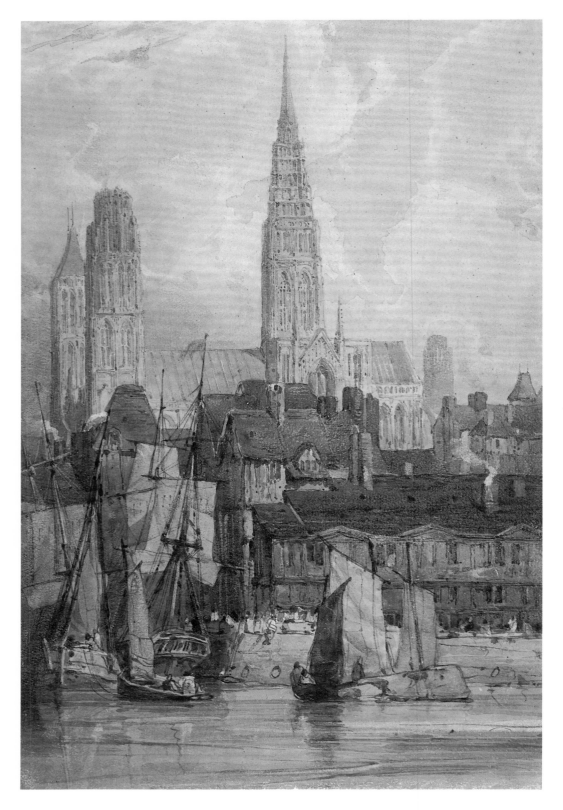

ROUEN CATHEDRAL AND QUAYS ca.1822
Watercolor over graphite, with pen and ink,
scraping and stopping out, on coarse wove
paper, $15\frac{7}{8} \times 10\frac{3}{4}$ in. (40.4 × 27.5 cm.)

Inscribed: Signed (?), on sail, lower left: *B*
[abraded]

Provenance: Possibly Bonington sale, 1829,
lot 35, as *View of the Cathedral of Rouen*, bought
Colnaghi; H. Palser.

Exhibitions: Nottingham 1965, no. 197, pl. 2.

References: *Portfolio* (1888) repr. as an etching by
Frank Short; Shirley, pl. 13.

Trustees of the British Museum
(1859-7-9-3251)

This composition was repeated with slight
modifications as a lithograph for *Restes et
fragmens* (see no. 19), and it includes the newly
finished section of the quay just to the west of
the construction work that furnished the
subject for no. 10. The title of the lithograph,
*Rouen Cathédrale de Notre Dame telle qu'elle était
avant l'incendie de 1822*, alludes to the fire of
15 September 1822, which destroyed the
central *flêche du clocher*.[1] This carefully finished
watercolor was probably painted shortly after
that event from studies drawn earlier at Rouen.
In the 1824 Salon James Roberts exhibited a
view of Rouen Cathedral with a similar note
that it antedated the 1822 fire. Given his
intimate knowledge of Bonington's first
Normandy tour, it is possible that he
accompanied the younger artist during part
of this trip.

Other views of the cathedral, slightly later
in date, are a watercolor of ca.1825 (Wallace
Collection) and a watercolor engraved by
Legrand for J.-F. d'Ostervald's *Excursions sur les
côtes et dans les ports de France* (1823–25).
An untraced oil of this title was exhibited
at the Salon in 1827.

1. For the extent of the damage, see Leger's lithograph
of 1823 for *Voyages Pittoresques, Normandie II*, pl. 125.

DIVES, PROCESSION AT THE EGLISE
NOTRE-DAME ca.1822
Watercolor and bodycolor over graphite,
12¾ × 15 in. (32.5 × 38.1 cm.)

Inscribed: Signed, on wall, lower right:
R P Bonington

Provenance: Bonington sale, 1834, lot 113, as *View of the Cathedral of Dives, with a religious procession entering the gateway — a capital drawing*, bought Colnaghi; possibly Lewis Brown (Christie's, 28 May 1835, lot 64, bought Houghton); possibly Anonymous (Christie's, 4 March 1864, lot 166, as *Dives Cathedral*); Miss I. A. Abram, by whom bequeathed to the Walker Art Gallery.

Exhibitions: London, Cosmorama Rooms, 209 Regent Street, 1834, no. 129, *View of the Cathedral of Dives in Normandy*; Nottingham 1965, no. 204, pl. 6.

Trustees of the National Museums and Galleries on Merseyside (Walker Art Gallery)

During the Middle Ages Dîves was a strategic port. Midway between Caen and Trouville, it served as the launching site for William the Conqueror's invasion of England. The fourteenth-century Eglise Notre-Dame-de-Dîves was a sanctuary for pilgrims during the religious wars.

The preliminary graphite study for this watercolor, without the procession (Walker Art Gallery), was drawn at Dîves in 1821. The watercolor dates to approximately the same time as the *Rouen Cathedral* (no. 12), and, judging from its size, must have been one of Bonington's most ambitious early drawings.

No studies for the processional figures are known, although later examples of similar motifs are among the sheets in a dismantled 1824 sketchbook (Bibliothèque Nationale). Since religion was perceived as a cornerstone of Bourbon monarchal legitimacy, such embellishments are common in the works of romantic draftsmen and frequently encountered in Bonington's oeuvre.

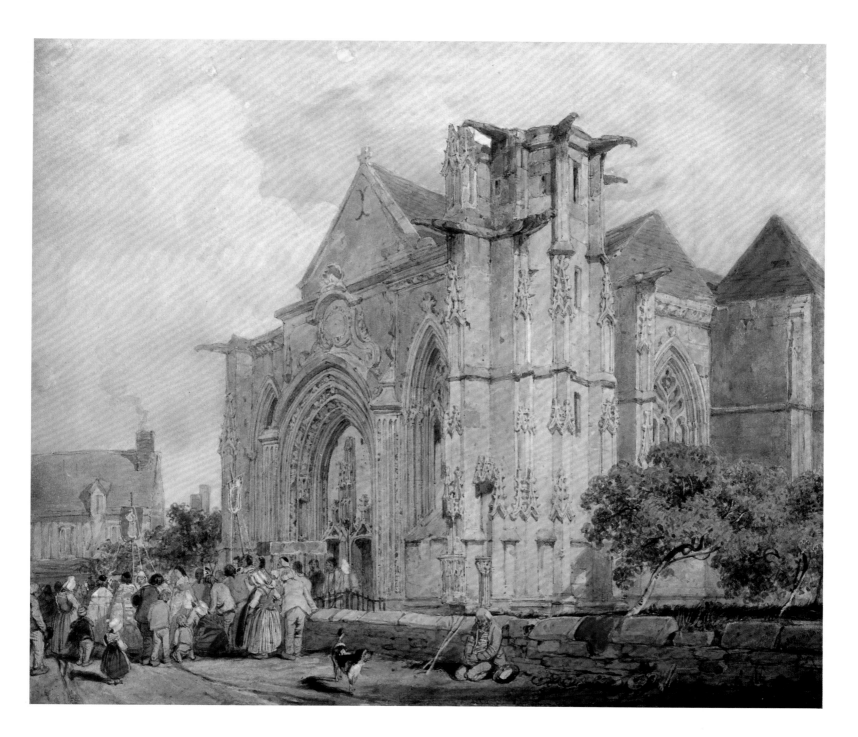

THE INNER PORT, DIEPPE 1824
Watercolor and bodycolor with scraping out,
$8\frac{1}{2} \times 12$ in. (21.5 × 30 cm.)

Inscribed: Signed and dated, lower right:
RPB 1824

Provenance: Mathieu Barathier

Musées de Narbonne

In 1823 the Swiss-born impresario of the picturesque, J.-F. d'Ostervald, who managed a gallery and a publishing firm on the quai des Augustins, launched an enterprising project titled *Excursions sur les côtes et dans les ports de France*, with a text by the industrialist N.-J. Lefebvre-Duruflé and illustrations by mostly Swiss and British draftsmen. He was concurrently publishing the second volume of his mammoth *Voyage pittoresque en Sicile*, to which Bonington had contributed two watercolors after designs by the Comte de Forbin.

Conceived in competition with Etienne Jouy and Louis Garneray's *Voyage pittoresque et maritime sur les côtes de la France* (Paris, 1823) as a picturesque antidote to the encyclopedic didacticism of Joseph Vernet's popular eighteenth-century *Ports de France*, it offered the French public some of its earliest views of the smaller ports that nestled among the *falaises* on the channel coast between the Seine and the Somme. In both its terrain and its indigenous culture, this section of the coast was considered consummately picturesque even by a Scotsman like David Wilkie, who wrote upon landing at Dieppe for the first time:

The difference between every thing I saw here, compared with what I had left on the other side, seemed as great as if one had been dropt in the moon I found that they were . . . in their buildings and everything else, much more antiquated than the people of Paris and, compared with the people of England, nearly two centuries behind.[1]

William Hazlitt expressed similar disbelief when he landed at Dieppe in September 1824:

This town is a picture to look at; it is a pity that it is not a nosegay, and the passenger who ventures to explore its nooks and alleys is driven back again by a "compound of villainous smells" which seem to grow out of the ground The houses and dresses are equally old fashioned. In France one lives in the imagination of the past; in England everything is on the new and improved plan In Dieppe there is one huge, misshappen, venerable looking Gothic church (a theological fixture) instead of twenty new-fangled erections, Egyptian, Greek or Coptic Life here glows, or spins carelessly round on its soft axle. The same animal spirits that supply a fund of cheerful thoughts, break out into all the extravagance of mirth and social glee. The air is a cordial to them, and they drink drams of sunshine.[2]

The latter assessment of Dieppoise life, which was something of a cliché about the untrammeled bliss of the provincial, would stand revision in a very short time. The sea baths established there in 1822 in emulation of English fashion were placed under the patronage of the duchesse de Berry during her first visit to the city in July 1824. She would return annually, and by 1830 Dieppe would become

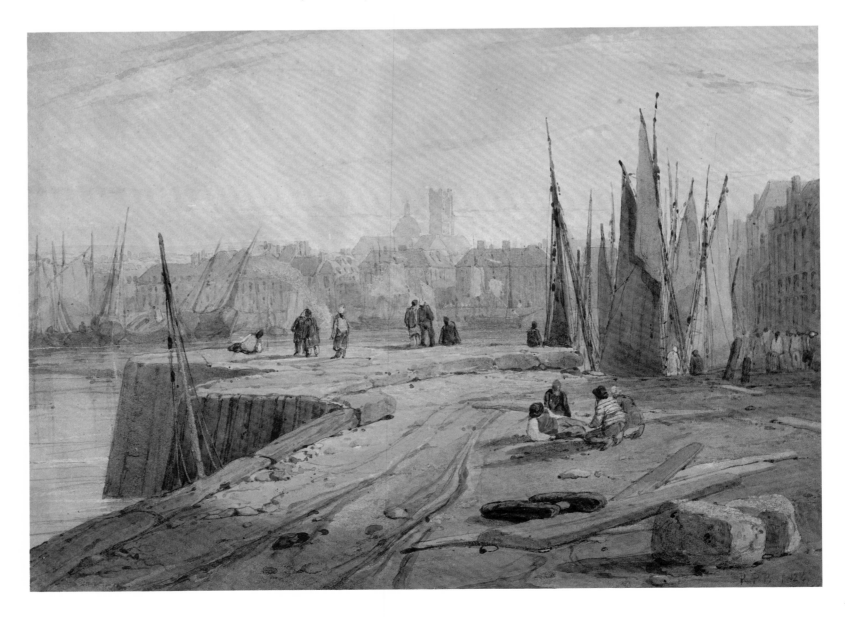

the most fashionable late-summer resort for the Parisian aristocracy.[3]

In cataloguing the d'Ostervald publication, J. R. Abbey listed forty-one aquatint plates issued between 1823 and 1825.[4] Since French publishers had virtually ignored the aquatint process, and as d'Osterwald was obviously intent on promoting the English fashion for landscape painting in watercolor by means of its most appropriate reproductive vehicle, he relied on etchers imported earlier for the Sicily project. These included Thales, Theodore, and Newton Fielding (no. 146) and George Reeve, who between them etched twenty-eight of the plates. Of the ten painters employed, Bonington was second only to Johann Luttringhausen (1783–1857) in the number of views contributed, with two each of Rouen and Le Treport and one each at Fecamp, Dieppe, and Le Havre. The weight of his participation attests to the rapid elevation of his reputation following the 1822 Salon. *The Inner Port, Dieppe* is the original watercolor for the Dieppe plate engraved by Reeve. Although Bonington met Newton Fielding in Dieppe between 24 and 29 July, at precisely the moment of the duchesse de Berry's descent on the city, this watercolor was probably painted in the Paris studio, in January or February, on the basis of sketches drawn or painted in 1823.

On the evidence of Lefebvre-Duruflé's unillustrated publication of 1833, *Ports et côtes de France, de Dunkerque au Havre*, Abbey surmised that d'Ostervald's original plan was to illustrate as well the coast of Picardy, probably as a second volume. An apparently unique copy, unknown to Abbey, of the first *livraison* of that publication is in the Bibliothèque Nationale. The title page is dated 1825, and d'Ostervald had enlisted by then two copublishers — Bonington's dealer Claude Schroth, and Sazerac, who would subsequently publish the *Cahier de six sujets* (no. 114). This *livraison* contains two plates after Bonington: *Dunkerque, entrée du port*, which repeats the composition of his first known lithograph, and *Gravelines, entrée du port*. That the project was initially more ambitious

can be deduced from the large number of Bonington watercolors of Picardy ports that are extant or were recorded in d'Ostervald's possession[5] and by the four additional aquatints submitted to the government censors in 1825. These reproduce views at St-Valery-sur-Somme, Le Crotoy, Boulogne, and Calais (see no. 15). The very laborious and costly process of aquatint, the competition from Jouy and Garneray, and the rapid ascendency of lithography at this time may have discouraged the publishers from continuing the project after the initial installments.

It is evident that Bonington spent much of 1823 and the first weeks of 1824 preparing watercolors for this publication. As a group they parallel, in the variety of their compositions and in their interest in diverse weather conditions, J. M. W. Turner's *Picturesque Views of the Southern Coast of England* (1814–26). In their actual watercolor technique, however, they are primarily indebted to Francia (no. 17), with whom Bonington was in regular contact both in Paris and Calais. Particularly reminiscent of the older artist are the flickering pen accents, the sparing but decisive touches of bodycolor, and Francia's autographic serpentine definition of foreground cart tracks. A Bonington sepia study for the right side of this compostion, from the quai Duquesne to the tower and dome of St-Jacques, was reproduced by Shirley.[6]

Although not individually identified in the catalogue, many of Bonington's watercolors for d'Ostervald were exhibited under the publisher's name at the 1824 Salon.[7]

1. Cunningham, *Wilkie* 1: 402, letter of 7 June 1814 to Thomas Wilkie.
2. Hazlitt, *Notes*, 92–93.
3. See A. Corbin, *La territoire du vide* (Paris, 1988), 310ff.
4. Abbey, *Travels* 1: no. 92.
5. For instance, his sale, Paris, 22–24 December 1823, lots 59–68.
6. Plate 31. Another watercolor view at Dieppe is Sotheby's, 15 November 1983, lot 187.
7. Salon livret no. 2028.

15

THE HARBOR, CALAIS ca.1823
Graphite, $4\frac{1}{2} \times 11$ in. (11.4 × 28.2 cm.)

Inscribed: In pen and ink, upper left: *95* (over graphite *38*)

National Gallery of Art, Ottawa (6822)

The drawing is a study for a much-faded watercolor (Bibliothèque Nationale), which was engraved in aquatint by Thales Fielding for d'Osterwald's *Excursions sur les côtes* (1825).[1]

There are several possible explanations for the two different drawing styles and densities of graphite: the panoramic view of the port may be earlier in date than the overlaid details, which correspond exactly to those in the watercolor and aquatint; or the panoramic view in sketchier and softer graphite may either have been done with a camera lucida, a device that Francia is known to have employed, or quickly sketched from nature, and the incidental details then added with greater deliberation in the studio. This last practice was followed by Bonington in several of his later Italian studies.

1. Pointon, *Bonington*, fig. 15. A related watercolor was lot 123, Christie's, 4 March 1975, bought Green.

16

NEAR HONFLEUR ca.1823
Watercolor over graphite, $8\frac{3}{16} \times 10\frac{11}{16}$ in.
(20.8 × 27.1 cm.)

Inscribed: In graphite, verso: *Present to Mrs Bonington*

Provenance: Martyn Gregory[1]; Davis and Langdale, 1979; Alan Stone, 1988, from whom purchased by Paul Mellon.

Paul Mellon Collection

The significance of France's coast for trade, for resorts, and as a bastion of traditional social and religious values received considerable attention in the 1820s and 1830s. D'Ostervald's *Excursions sur les côtes* was obviously intended to capitalize on this interest. Imitating the handling and conception of Francia's contemporary works, the Yale watercolor was probably executed in connection with that project, although it was never engraved. A reduced variant of the composition, in sepia, is in a private collection.

1. The early history of the work is unknown, but it is perhaps one of several early watercolors in the various studio sales described simply as views of Honfleur: 1834, lots 81 and 92; 1836, lots 44 and 96; 1838, lot 48.

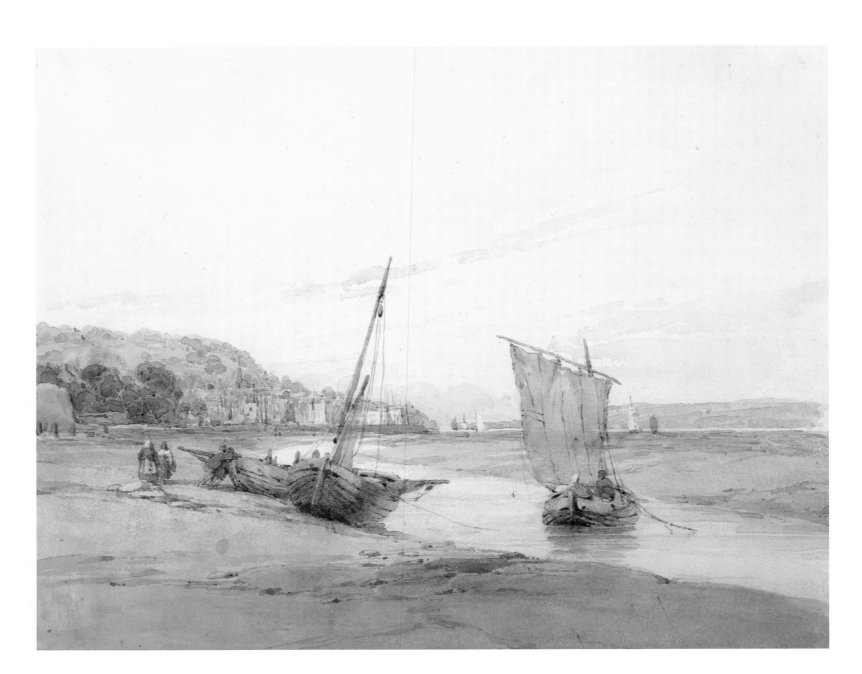

17

LOUIS FRANCIA (1772–1839)

THE PONT DE LA CONCORDE AND TUILERIES PALACE FROM THE COURS DE LA REINE 1823
Watercolor, bodycolor, pen and red ink, scraping and rubbing out, 6½ × 10½ in. (16.8 × 27.1 cm.)

Inscribed: Signed and dated, lower left: *L Francia/ 1823*

Provenance: John Morton Morris, 1985, from whom purchased by the Yale Center for British Art.

References: Calais, *Francia*, 100.

Yale Center for British Art, Paul Mellon Fund (B1985.11.2)

Louis Francia, the native Calaisian who spent his formative years as an artist (1789–1817) in close association with England's most progressive landscape painters, was unquestionably not only the most important early influence on Bonington, but also the crucial link in the ongoing dialogue between French and English art in the 1820s. Although he gave Bonington his first professional instruction in watercolor painting, quantifiable stylistic imitation does not become apparent in the protégé's work until ca.1823 with Bonington's first major commission for d'Osterwald. It appears that Francia passed most of spring 1823 in Paris. An impression of his lithograph *Colonne monumentale de Calais* was deposited at the Bibliothèque Royale on 21 March, as were two large Girtin-inspired lithographs of the Château de St-Ouen on 28 May. Between these dates he drew a series of elaborate graphite studies of Parisian architecture and topography, including a nearly exact study for this watercolor.[1] It has been suggested that he may have envisaged a series of engraved or lithographic views comparable to Girtin's *Paris and Its Environs*, which he knew intimately, although this sheet and the cited views at St-Ouen are the only testament to such an enterprise beyond the graphite studies. He also contributed at this time one watercolor for d'Osterwald's *Excursions sur les côtes*.

Bonington's movements during this year are undocumented, but he must have divided his time between extensively touring the coast to gather his own material for d'Osterwald and attending to business in Paris, which included preparing the stones for his *Restes et fragmens* (no. 19). It is likely that during the spring he learned the mechanics of lithography from Francia.

Several views of the Tuileries Palace by Bonington are recorded, although none have been traced.[2]

1. Calais, *Francia*, nos. 67–72, pp. 47–48, and repr. 47.
2. An oil version, known only from a later copy, is said to have been dated 1825 (Anonymous Gentleman, Sotheby's, 18 May 1838, lot 85, bought in). A watercolor of this title belonged to Lewis Brown (Paris, April 1843, unnumbered lot) and was possibly the original from which two other copies derive. Both are reproduced in Roundell, *Boys*, pls. 10–11. The first is attributed to Boys and may be the watercolor *View of the Tuileries* in the W. J. Cooke sale (Sotheby's, 16 March 1840, lot 140). The second, often attributed to Bonington, is inscribed with his initials and the date 1827. It is far too weak a drawing to be autograph. The red chalk used to mark the major compositional lines prior to painting is typical of Boys's practice, especially when he is replicating his own or someone else's designs.

COAST WITH BEACHED BOATS AND
FIGURES ca.1823–24
Watercolor over graphite, with scraping out,
6 × 8⅜ in. (15.3 × 21.3 cm.)

Inscribed: Signed, in pen and ink, lower left:
R P Bonington

Provenance: Acquired from the artist by
Mme Benjamin Delessert, and by descent
(Paris, Palais d'Orsay, 30 November 1978,
bought Spink); Spink and Sons, 1979, from
whom purchased by the present owner.

Exhibitions: Spink and Sons, London, 1979
(catalogue entry by Marion Spencer).

Private Collection

Spencer dated this watercolor ca.1825, but it
belongs to the group of coastal views executed
for d'Ostervald's *Excursions sur les côtes*. This
example, with its very neat signature, may be
the latest of the group, although no later than
the first months of 1824. The technique of
dappled washes and the pronounced pen accents
are from Francia. A most fastidious gradation
and blending of bluish-gray and paler blue tints
is visible in the sky.

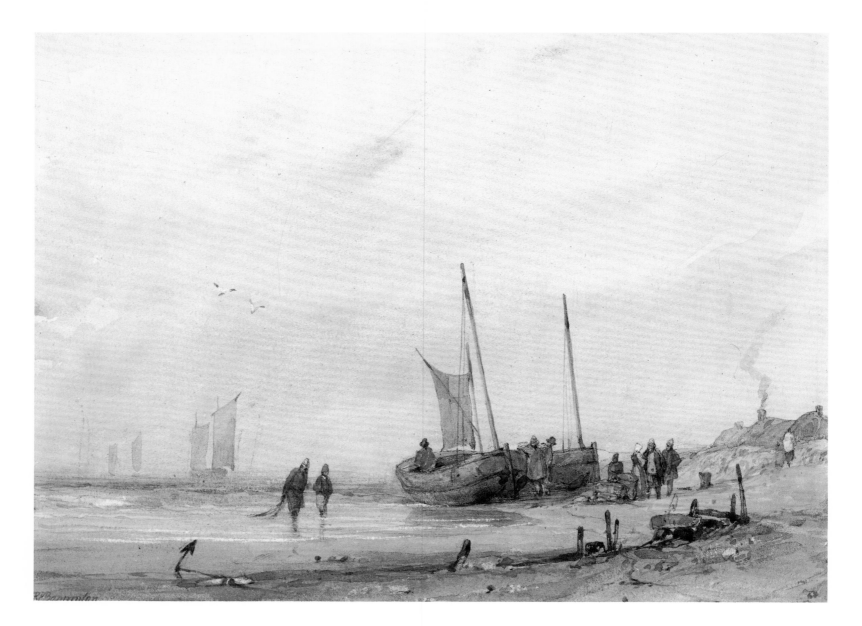

RESTES GOTHIQUES ca.1823–24
Lithograph on white wove paper, 6¾ × 4⅞ in.
(17.3 × 12.5 cm.)

Provenance: R. E. Lewis, by whom given to the
Stanford University Museum of Art in 1975.

References: Bouvenne, no. 37; Curtis, no. 2 (i/iii).

Stanford University Museum of Art (75.163.1)

This is one of four known impressions of the
first state (before letters and the addition of a
small dog on the steps) of the rejected title page
to Bonington's published set of ten lithographs,
Restes et fragmens [sic] *d'architecture du moyen age,
recueillis dans diverses parties de la France et dessinés
d'après nature par R. P. Bonington*, also called *La
petite Normandie*. The set was printed by Feillet
and copublished by Charles Motte, Madame
Hulin, Feillet, Gihaut, the artist, and, in
London, S. & J. Fuller.

The plates were issued in two parts, the first
submitted to the Bibliothèque Royale on 8 June
1824 and the second on 1 September 1824.
Bonington's letter from Dunkerque to James
Roberts, postmarked 3 March 1824, in which he
asks for information on his stones "with
Feillet," suggests that most of the plates were
ready for printing prior to his leaving Paris in
late February. In all likelihood the project was
commenced during autumn 1823.

It appears that Feillet printed the set on
white paper, on *chine collé*, or on white paper
with a tobacco-brown tint stone, an
experimental technique then being tested for
deluxe editions of Baron Taylor's *Voyages
pittoresques*. Those printed with tint tend to be
the most beautiful and numerous, but the
printing of the tint stone was so inconsistent
that many impressions were marred by
bubbling and an uneven texture. This may
account in part for the financial failure of the
publication. In London Colnaghi issued a
posthumous edition, printed from worn stones,
which did little to reverse critical opinion.

According to Bouvenne, the stone for *Restes
Gothiques* was too small to be printed efficiently,
thus obliging Bonington to redraw the title
page on another stone for the published edition.
This second version (Curtis no. 3), inscribed
"Caen" above the arch and "Architecture du
Moyen Age" within the doorway, reverses the
architecture but retains the figures on the left
side.[1] It is far more delicate in execution and
was probably drawn in late spring 1824. The
monument has not been identified, although it
may represent the side entrance of the twelfth-
century Chapelle St-Georges in the fortified
château at Caen. A related graphite drawing is
at Bowood.

1. Another lithographic version of this title page
(Curtis, No. 3bis) is possibly by the Bonington imitator
Eugène Lepoittevan.

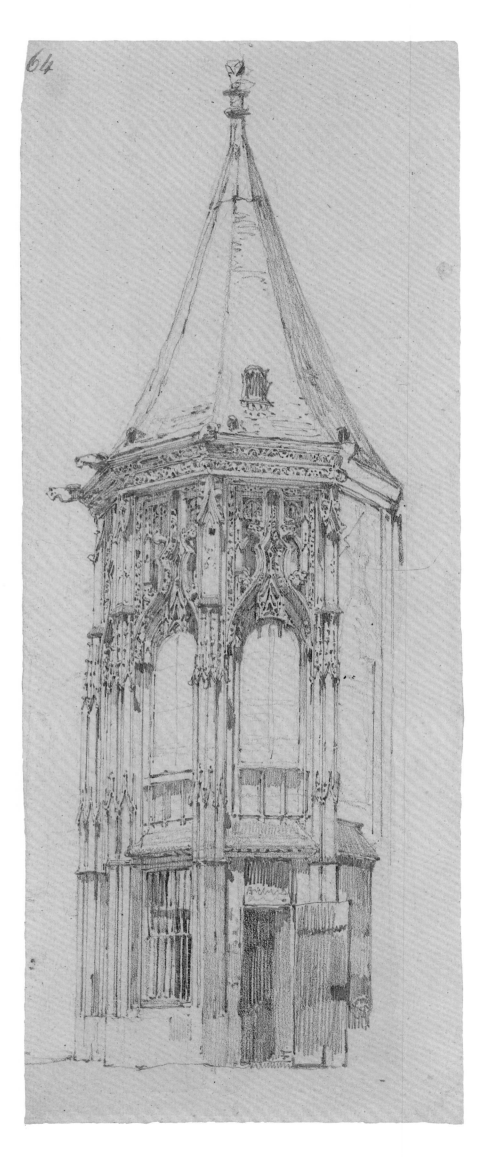

64

20

STUDY OF THE PALAIS DE JUSTICE, ROUEN
ca.1823
Graphite on buff paper, $11\frac{7}{8} \times 4\frac{3}{4}$ in.
(30.1×12 cm.)

Inscribed: In pen and ink, upper left: *64*

Provenance: Victor Reinacker, by whom given to
T. Girtin, 1933; Tom Girtin, from whom
purchased by Paul Mellon.

Exhibitions: Nottingham 1965, no. 47.

Yale Center for British Art, Paul Mellon
Collection (B1975.3.1097)

ENTREE DE LA SALLE DES PAS-PERDUS, PALAIS
DE JUSTICE, ROUEN ca. 1823–24
Lithograph with tint stone, 8⅛ × 9⅛ in.
(20.6 × 23.2 cm.)

Inscribed: In the margin, the title, and at lower
left: *R P Bonington*; and at lower right: *Lith de
Feillet*.

Provenance: James Bergquist, from whom
purchased by the Yale Center for British
Art in 1990.

References: Curtis, no. 11 (ii/iii)

Yale Center for British Art, Paul Mellon Fund
(B1990.24.13)

The ninth of ten plates in the set *Restes et
fragmens*, the lithograph illustrates a section of
the elevation of the late-Gothic Palais de Justice
at Rouen.[1] James Roberts claimed that
Bonington preferred the Flamboyant to all other
Gothic architectural styles. As one of the most
refined examples of that manner, the Palais de
Justice must have appealed strongly to his
antiquarian interests. Although no specific
studies for the composition of the print can be
identified, meticulously detailed graphite
drawings of portions of this edifice date from
1821 onward.[2] The interior elevation of this
great hall would later serve Delacroix as the
backdrop for his oil *Interior of a Dominican
Monastery*.[3]

1. A contemporary lithographic view of the entire
elevation and courtyard, by Vauzelle, Lanté, and Adam,
was published in the *Voyages pittoresques, Normandie I*
(pl. 164).
2. Other examples are at Bowood (ca. 1821) and were
with Colnaghi in 1972 (ca. 1823).
3. Johnson, *Delacroix* 1, no. 148; graphite drawings of
the windows by Delacroix are preserved in a sketchbook
in the Louvre (Sérullaz, *Delacroix*, no. 1753).

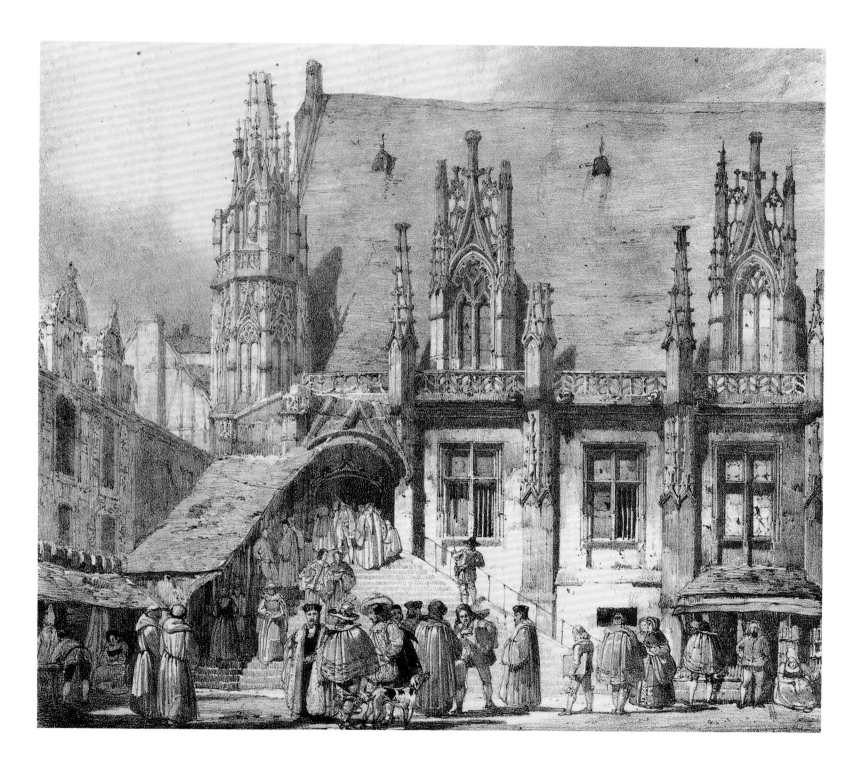

ABBEVILLE — PORTE DE L'EGLISE
ST-WULFRAN ca.1823
Graphite and white bodycolor, $15\frac{3}{4} \times 9\frac{3}{4}$ in.
$(40 \times 24.5$ cm.)

Provenance: P. R. Bennett; Anonymous
(Sotheby's, 19 March 1981, lot 179,
bought Yale).

References: See Curtis, no. 13.

Yale Center for British Art, Paul Mellon Fund
(B1983.9.2)

The drawing is a study for an unpublished
lithograph for the set *Restes et fragmens*, which
also included a distant view of Abbeville. Two
impressions only of the print are recorded by
Curtis, but a third, of undescribed state, is in
the Stanford University Museum of Art.
The artist has made a study of the west portal,
a superb example of Flamboyant Gothic begun
at the end of the fifteenth century.
 Bonington was a frequent visitor to
Abbeville, a city rich in medieval and
Renaissance associations and not far from St-
Valery-sur-Somme. Other graphite studies at
Abbeville include a colombage house facade of
ca.1821 (Bowood), a street with the tower of
St-Giles (Ingram Collection), and the Plâce du
Grande Marché (Louvre), with a view of the
side elevation of St-Wulfran of ca.1823.[1]

1. Thomas Shotter Boys repeated this view for his
lithograph in the Picardy volume of the *Voyages
pittoresques*. A watercolor in the Bibliothèque Nationale
based on the Louvre drawing is incorrectly attributed
to Bonington, although it may replicate a lost original.

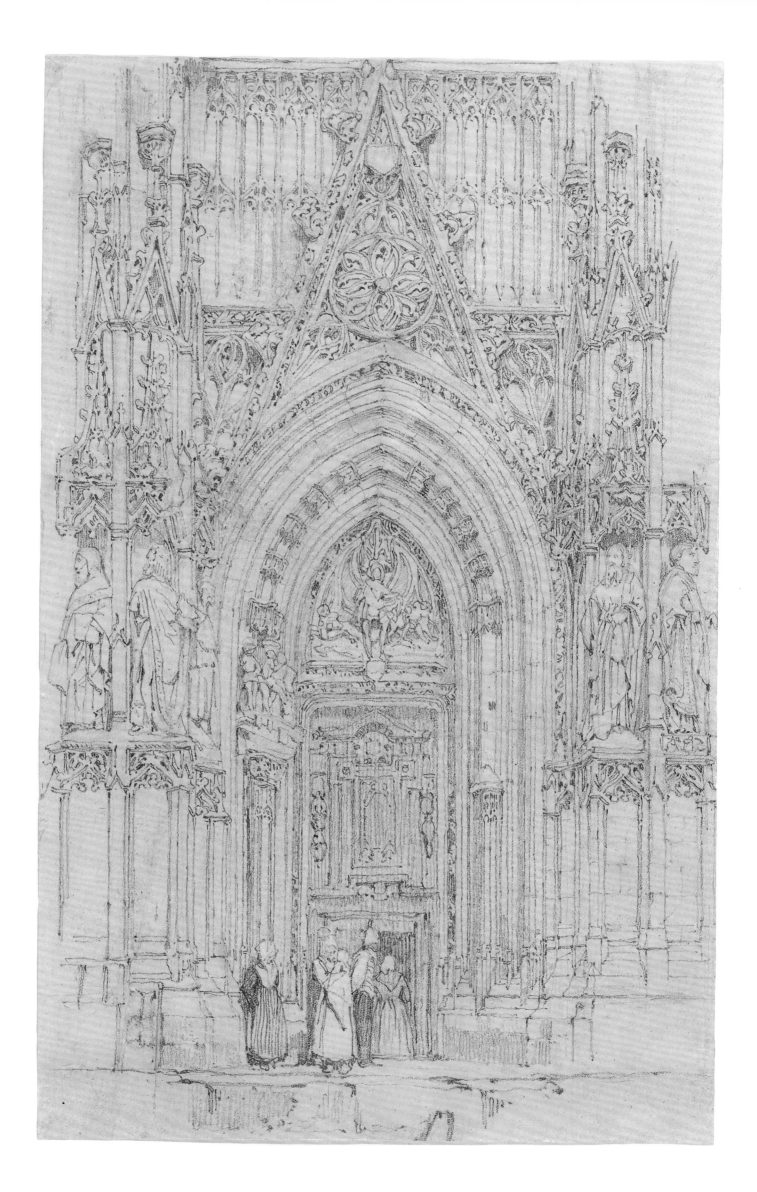

23

RUE DU GROS-HORLOGE, ROUEN 1824
Lithograph on *chine collé*, $9\frac{5}{8} \times 9\frac{3}{4}$ in.
(24.5 × 24.7 cm.)

Inscribed: In the stone, upper margin: *P 173*;
and lower margin: *Bonington 1824, Lith de
G Engelmann*, and *Rue du Gros Horloge*.

References: Curtis, no. 16 (ii/iii).

Stanford University Museum of Art

Since Bonington learned the technique of
lithography from Francia in 1823, he was not
enlisted by Baron Taylor for the *Voyages
pittoresques et romantiques dans l'ancienne France*
until well into the publication of the second
Normandy volume, which began in April 1822.
The twenty-sixth *livraison* of that volume —
the first to illustrate Rouen — was issued in
June 1823. *Rue du Gros-Horloge, Rouen*,
Bonington's initial contribution, appeared
in spring 1824. The stone was probably
completed, therefore, before his departure for
Dunkerque in February. He had finished his
remaining four prints for this volume by 8 July
when he notified Taylor that the *Tour des
Archives, Vernon* was available for collection and
that the price for his labor was two hundred
francs.[1] His two Gisors illustrations and the
Tour de l'Horloge, Evreux were based on drawings
made during the journey to Paris from
Dunkerque in May or June. An impression of
the *Rue du Gros-Horloge* was exhibited at the
Salon by its printer, Godefroy Engelmann.

 A masterwork of romantic lithography,
thoroughly illustrative of Charles Nodier's
claim in the prospectus that theirs was to be
"not just a voyage of discovery, but a voyage of
impressions," the *Rue du Gros-Horloge* reverses
the prospect looking west down the medieval
commercial artery of Rouen. The artist
has delighted equally in the delineation of
picturesque detail and of modern urban
life, without which such monuments would
have neither relevance nor animation.
The perspective of the entire composition is
intentionally distorted for dramatic effect: the
artist has made the foreground buildings much
taller than they would appear in reality so that
the axis of recession can rush precipitously
toward the monument of most significance,
the great clock. Such exaggeration was quite
common in British architectural drawings at the
beginning of the century but surprisingly rare
among Taylor's draftsmen, given the currency
of such images internationally and, if one is to
believe surviving descriptions, the regular
employment of plunging perspective for
dramatic effect by the artists of the very
popular Dioramas then exhibited in Paris and
London.

1. Manuscript letter postmarked 9 July 1824; repr. in
facsimile in the *Studio* 33 (1905): 100. In November 1827
Delacroix proposed to Charles Motte that he illustrate
Byron's *Giaour* at the same price per stone (*Correspondence*
1: 203).

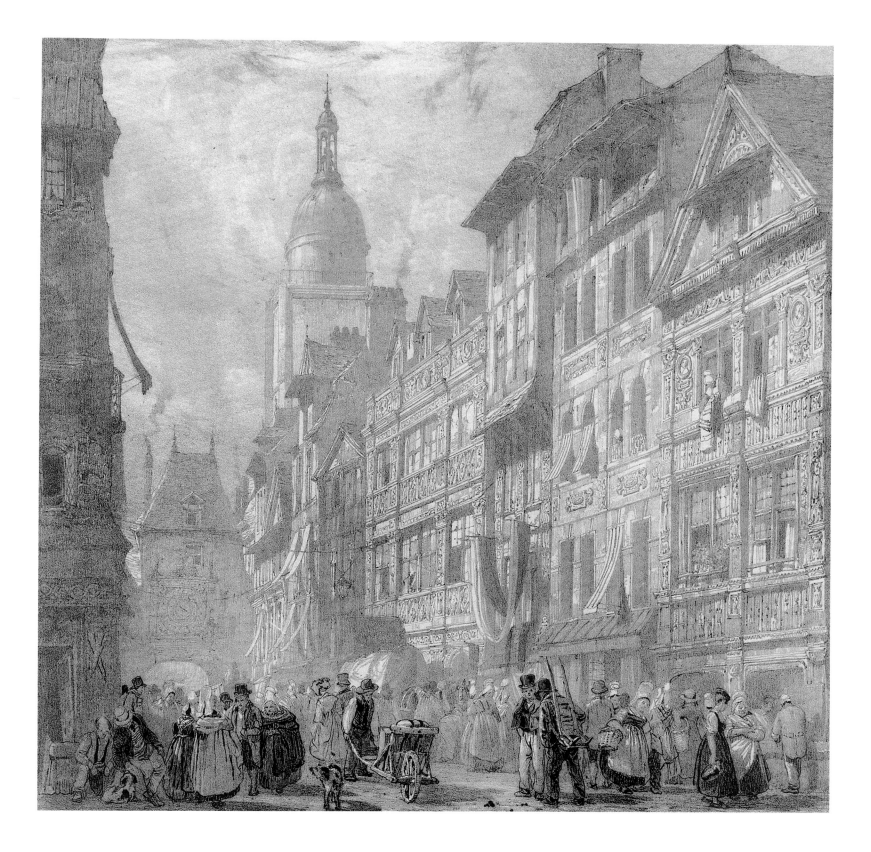

NEAR OUISTREHAM ca.1823
Oil on canvas, 10¼ × 17¾ in. (26 × 45.1 cm.)

Inscribed: Signed with initial, lower right: *B*

Provenance: Baron Charles Rivet, and by descent
to Mlle F. de Catheu; The Hon. Shaun Plunket,
to 1965.

Exhibitions: BFAC 1937, no. 4; Agnew's 1962,
no. 2; Nottingham 1965, no. 245, pl. 24.

References: Charles Damour, *Oeuvres inédités de
Bonington* (Paris, 1852), pl. 7; Dubuisson and
Hughes, repr. opp. 120; Shirley, 93, pl. 36.

Private Collection

A graphite sketch of the composition, inscribed
"Ouistraham," identifies the distant town, with
its twelfth-century Anglo-Norman church, as
the ancient port city of Caen near the mouth of
the Orne. That drawing, and two others with
prospects of Salinelles from the west and
Trouville from the heights of Bon Secour,[1] are
from a dismembered sketchbook in use during
the artist's first tour of Normandy in 1821.

Probably painted in Paris during fall 1823,
this picture is Bonington's earliest known
landscape in oils. As in the watercolors of this
year, the influence of Louis Francia manifests
itself in the pallid tonality, the elaborate cloud
structure, and the precise facture, especially the
controlled, and at times minute, modeling of
the vessels and staffage. Curiously evoking the
visual effects of Francia's elegant penwork is the
manner in which these compositional elements
are circumscribed by a fine border of burnt
umber ground. The foliage on the horizon is
painted with equal reserve and with little
transparency or breadth, while the relatively
low surface relief contradicts Delacroix's
assertion that Bonington's earliest seascapes
were heavily impasted.[2]

At what date Bonington began to paint
landscapes in oils and from whom he received
his initial instruction have not been ascertained.
Neither Francia nor Prout were productive in
oils,[3] and as a student Bonington was not with
Gros long enough to benefit appreciably from
that master. His father had exhibited several
landscape oils at the Liverpool Academy nearly
a decade earlier,[4] but in all likelihood Bonington
was largely self-taught, instinctively but
cautiously adapting the lessons of watercolor
painting to this less tractable medium.

1. Christie's, 5 November 1974, lot 46, repr.
2. Delacroix, *Correspondence* 4: 288.
3. Only two oil paintings by Francia (Norwich Castle
Museum) and one by Prout (Tate Gallery) are traceable
today.
4. Pointon, *Circle*, 33.

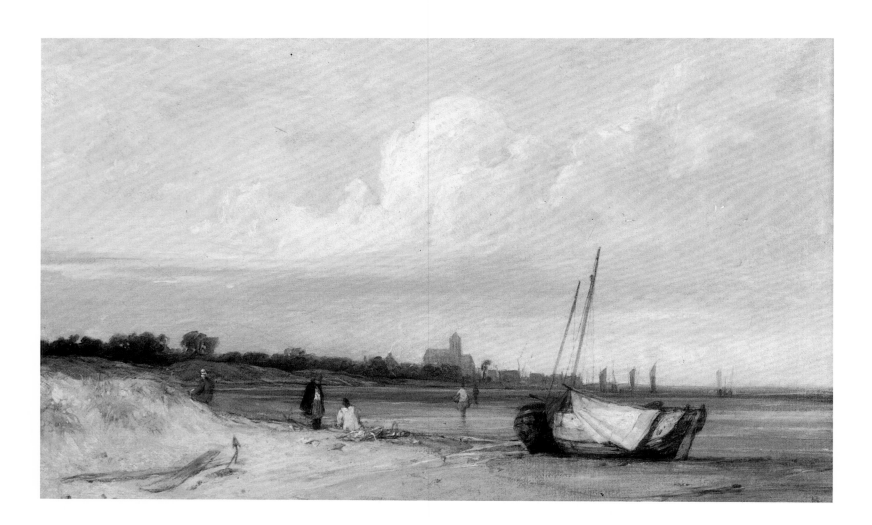

25

CALAIS JETTY ca.1824
Oil on wood panel, $11\frac{3}{8} \times 13\frac{7}{8}$ in. (29 × 35.3 cm.)

Inscribed: verso; paper label, in pen and ink: *View of Fort Rouge, Calais | Painted by R P Bonington | and purchased at the sale | of his pictures and sketches | at Sotheby & Sons in Wellington | Street June 29, 1829 | Being lot 24 First day's sale | —WmS;* verso: black wax atelier seal.

Provenance: Bonington sale 1829, lot 24, as *View of Fort Rouge Calais, oil sketch*, bought Seguier; William Seguier (Christie's, 4 May 1844, lot 58, as *Coast scene with a brig and fishing boat near the head of a jetty*); Dowager Lady Hillingdon, from whom purchased by Paul Mellon.

Exhibitions: London, Cosmorama Rooms, 209 Regent Street, 1834, no. 37, as *View of Fort Rouge*.

Yale Center for British Art, Paul Mellon Collection (B1981.25.57)

Although this picture was incorrectly described as a view of Fort Rouge, Calais, in the 1829 studio sale, a related graphite sketch, inscribed "Calais"[1], identifies the jetty, which extended to within a few hundred yards of that fortification. The composition, nevertheless, is more notional than topographically just.

A comparison with *Near Ouistreham* (no. 24) suggests a close proximity in date, but in its hypnotic stillness and lucid orthogonal design, the Yale picture is far less indebted to Francia. Exhibiting a more advanced system of aerial perspective, it was probably painted shortly after the artist's arrival at Dunkerque with Alexandre Colin (no. 136) in late February 1824. He would remain in that port city with the Perrier family, at their house on the quai des Furnes, for the better part of the year.

William Seguier (1771–1843), the original owner of this panel, in addition to his influential positions as keeper at the National Gallery and as superintendent of the British Institution, was a consultant for some of the most important collectors in England. A devout admirer of Bonington's art from their moment of first meeting in 1825, Seguier agitated constantly for the purchase of his pictures by the nation and helped organize the Cosmorama exhibition in 1834. His persistent promotion of Bonington greatly nettled John Constable.[2]

1. Nottingham 1965, no. 38.
2. *John Constable's Correspondence IV*, ed. R. B. Beckett (Suffolk, 1965), 8: 73; see also no. 68 below.

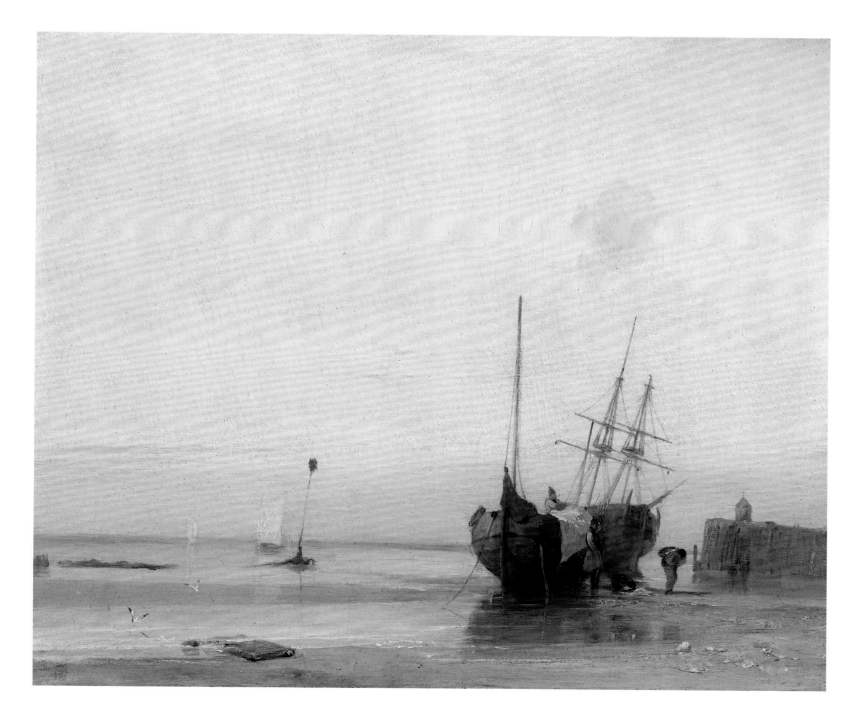

A DISTANT VIEW OF ST-OMER ca.1824
Oil on canvas, $12\frac{3}{8} \times 17\frac{1}{4}$ in. (31.5×44 cm.)

Provenance: James Price (Christie's, 15 June 1895, lot 38, as *Near Boulogne*, bought Agnew's); George Salting, by whom bequeathed to the Tate Gallery in 1910.

References: H. Hall, "Discovery of a Bonington Pencil Sketch," *Apollo* (August 1953): 37–39; Shirley, pl. 24; Peacock, pl. V.

The Tate Gallery

Previously identified as *Near Boulogne*, *Landscape in Normandy*, or *Near Mantes*, the picture actually represents a distant view of St-Omer from the Boulogne-Calais road. Dominating the horizon are the ruins of the Abbey St-Bertin, the Basilique Notre-Dame, and the Eglise St-Denis. In its cool tonality and vigorous brushwork, this oil complements *A Sea Piece* (Wallace Collection; fig. 21) and probably dates to the first months of Bonington's residency at Dunkerque.

Several sketches of the composition have been incorrectly attributed to Bonington. These include a replica in sepia with white highlights[1] said to have been sent by the artist to his friend Madame Perrier in December 1824. In a letter, however, Bonington mentions posting only information on Parisian fashions for Madame Perrier and her daughters, two sketches by Colin, lithographs "by a friend," and some "insipid" but fashionable romances.[2] Hall reproduced another version of the composition, in graphite and white chalk, inscribed on the mount "a sketch taken on the spot in the Plain of St. (?)Denis by R P Bonnington." He speculated inaccurately that the inscription might be in Samuel Prout's hand.[3]

The earliest history of the Tate oil is unrecorded, but a lithographic copy of 1851 by Jules Laurens, published in Paris, suggests that it may have belonged initially to a French collector. A contemporary oil copy of some quality is privately owned.[4]

In the year of the Salting bequest to the National Gallery, Edith Wharton observed of this picture in a letter to William Morton Fullerton: "I wished for you yesterday when I stood before the divine little Bonington in the Salting Collection, which makes the magnificent Constables close by look like 'literature,' it has such a kind of 'Grecian urn' completeness. Surely he was the Keats of painting."[5]

1. Paris, Hôtel Drouot, 6 December 1984, lot 62.
2. Transcription by Dubuisson of an original letter in the collection of Colin's descendents dated 31 December 1824 (BN Bonington Dossier).
3. This drawing, or more likely a lost original from which it was copied, belonged to the engraver W. J. Cooke (Sotheby's, 16 March 1840, lot 135, *A sketch made on the spot in the plains of St. Denis*, bought in, one of a group of drawings stated in the catalogue to have been acquired directly from the artist by Cooke).
4. Agnew's 1962, no. 24.
5. She had underbid Salting the previous year for another oil, *View of the Grand Canal* (National Gallery of Scotland), then thought to be by Bonington; see *The Letters of Edith Wharton*, ed. R. W. B. Lewis (New York, 1988), 185, 188.

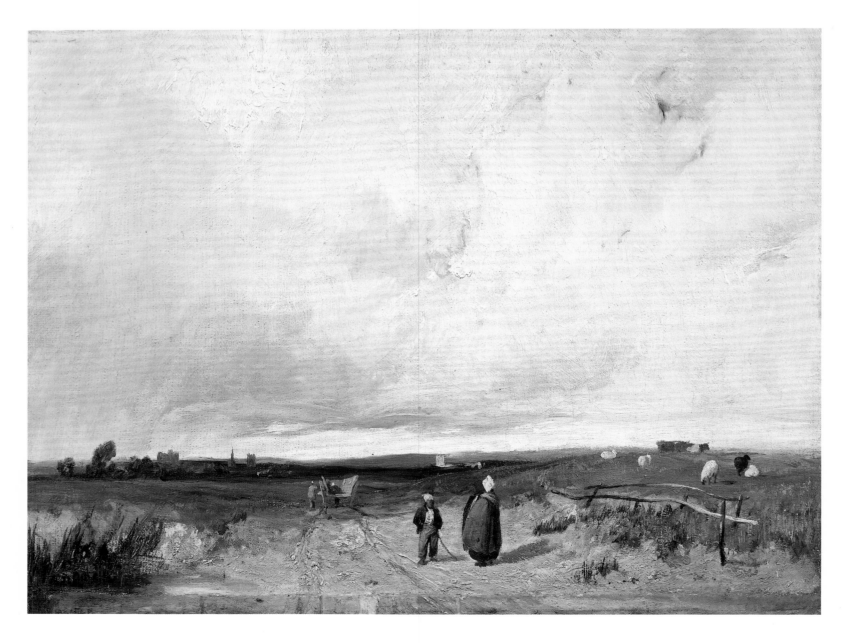

27

THE SUNKEN ROAD WITH A DISTANT VIEW OF
ST-OMER ca.1823–24
Brown wash over graphite, $5\frac{1}{8} \times 8\frac{3}{8}$ in.
(13×21.3 cm.)

Provenance: Comte de Faucigny, Paris, 1867;
possibly Léopold Fleming; Jules Michelin, to
1898 (Paris, 21–23 April 1898, lot 257); Percy
Moore Turner; A. C. Hampson (Christie's, 18
March 1980, lot 84, bought Reed); Anthony
Reed, 1980; Private Collection, to 1987;
Anthony Reed, from whom purchased by the
present owner.

References: Dubuisson and Hughes, 199;
Shirley, 95, 146, as *Mantes*.

Private Collection, New York

This distant view of St-Omer from the
southeast appears frequently in Francia's
oeuvre.[1] Although they differ in their
foreground details, *The Sunken Road* and the
version in oils (no. 26) are almost identical
in the treatment of the sky. A nearly con-
temporary date of execution is likely, with the
wash drawing anticipating the oil painting, as
was Bonington's practice at this time. The
drawing, however, should not be considered a
preparatory study for the oil but rather a
finished work of art intended for sale. Such
Dutch-inspired town prospects figure
prominently in Bonington's earliest exhibition
and graphic works. A view of Lillebonne from
the surrounding heights, for instance, was one
of two watercolors with which he made his
Salon debut in 1822.

The washes correspond only incidentally to
the loosely sketched graphite underdrawing.
The wet-on-wet technique is employed with
proficiency in the sky. In general, the execution
is typical of the watercolors of late 1823 and
early 1824, in which we see emerging a more
assured, facile, and economic application of
washes without any diminution of atmospheric
effects or definition. An indication of this new
bravura is the use of fingerprints to disperse the
thicker applications of wash in the foliage.

Coinciding with a flourishing public interest
in watercolor landscapes was a collective
appreciation for brown wash drawings fueled in
large part by the craze for albums of artists'
drawings. The masters of this genre were J.-B.
Isabey, Villeneuve, and Boug d'Orschvillier,
who regularly exhibited finished sepia drawings
of Italian and French sites at the Salons.[2] The
critical reception of such works, however, was
not always enthusiastic. Etienne Delécluze
would write in 1824 that "I may be deceived,
but small album drawings greatly hurt our
talented landscapists" in that the ease with
which they were dispatched promoted, to his
thinking, facile painting and frivolous content.[3]
For a brief period between 1823 and 1825,
Bonington produced a prodigious number of
such works,[4] including many marines that relate
immediately to Francia's practice and to the
sepia-toned plates of J. M. W. Turner's *Liber
Studiorum*.

The first recorded owner of this sheet,
Ferdinand-Victor-Amédée, Comte de Faucigny-
Lucinge (1789–1866) was a central figure of the
Bourbon restoration. A former aide-de-camp to
the Duc de Berry, he married, in the year this
drawing was made, Charlotte-Marie-Auguste,
the natural daughter of the duc de Berry and
Amy Brown. In 1830 he fled to England. At
least one other watercolor by Bonington is
recorded as having belonged to the count.[5]

1. Calais, *Francia*, several drawings, but especially no.
103, which similarly shows seated and standing
foreground figures.
2. Cf. Delécluze, "Salon de 1828–Paysage," *Journal des
Débats*, 25 April 1828.
3. Delécluze, "Exposition du Louvre–XXI," *Journal des
Débats*, 7 December 1824; for a hostile but unsigned
appraisal of the rage for albums, see also the *Journal des
Artistes*, 23 March 1828.
4. For example, *Sailing Vessels in a Calm*, signed and dated
1824, repr. *Jongkind and the Pre-Impressionists* (Smith
College Museum of Art, 1976), no. 34; *The Harbor
Boulogne*, signed and dated 1825, repr. Gobin, *Bonington*,
pl. 14; *Vessels in a Choppy Sea off Calais*, ca.1824 (Musée du
Louvre); and *Fishing Vessels on a Beach*, ca.1824
(Sotheby's, 16 July 1987, lot 125).
5. *Coast Scene with Beached Craft*, ca.1824 (Yale Center for
British Art)

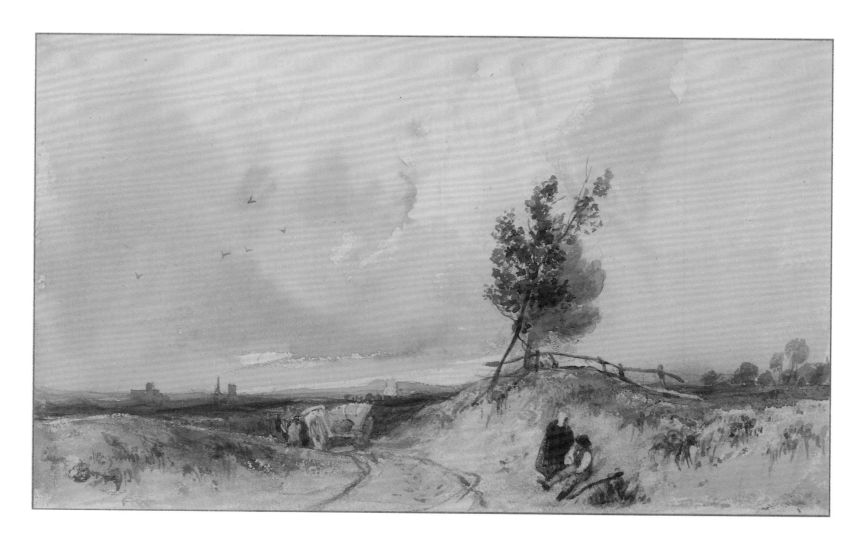

28

RUINS OF THE ABBEY ST-BERTIN,
ST-OMER ca.1824
Oil on canvas, 24 × 19½ in. (61 × 49.5 cm.)

Provenance: William Twopenny; James Orrock.

Exhibitions: BFAC 1937, no. 19; Nottingham
1965, no. 249, pl. 26.

References: Dubuisson and Hughes, repr. opp. 28;
Shirley, 90, pl. 23; Peacock, pl. XI; Lockett,
Prout, 131.

Castle Museum and Art Gallery,
Nottingham (7-85)

Samuel Prout claimed to have been present
when Bonington painted an oil sketch of this
title.[1] Traditionally, this meeting is presumed
to have taken place in 1823; however, Lockett
has suggested that it may have occurred a year
earlier. Regardless of the date of the untraced
sketch, the Nottingham version should be
dated, on stylistic evidence, no earlier than
1824. Although no preparatory drawings by
Bonington of the abbey ruins are known,
graphite studies of other monuments at
St-Omer include elaborate views of the south
porch of the cathedral (ca.1823; Bowood) and of
the Hôtel de Ville (Ingram Collection). A later
study of the abbey's tower (Bowood) was
drawn in late summer 1825 on the return trip
from London, when Bonington and Colin are
believed to have rejoined Delacroix and Eugène
Isabey (no. 46) at St-Omer. Two antiquarian
studies of the ruined nave by Prout are in the
Victoria and Albert Museum. More numerous
are the studies by Francia, who introduced all
of these artists to the antiquities of St-Omer
and for whom the abbey, in particular,
remained a leitmotif throughout his career.[2]
While not as sustained, Bonington's interest
inspired at least one late major commission —
a watercolor (destroyed 1848) of the tomb of
St-Omer, acquired at the 1827 Salon by the duc
d'Orléans.[3]

The treatment of the foreground anticipates
such later works as the sketch *Forest at
Fontainebleau* (no. 52). The description of the
architecture exhibits a close attention to detail
that is managed less by drawing, as in the later
Venetian pictures, then by close-valued, tonal
faceting. In this aspect, and in the reliance on a
soft, pervasive light, the handling parallels
Bonington's use of graphite in the drawings of
1823 and his subtle management of atmospheric
perspective in the lithographs of early 1824
(no. 23). He has also consciously avoided the
long-standing romantic tradition of exaggerating
the scale of ruins and silhouetting them against
a threatening sky.

The small figure in the foreground may be
intended as a quarrier, as similar workers appear
in Prout's drawings. The sale of monastic
buildings and ruins during and after the
revolution to entrepeneurs intent on

dismantling the edifices for dressed stone
became a *cause célèbre* in the 1820s and
prompted one of Victor Hugo's more bilious
editorials. Although he blamed the English for
the systematic destruction of Jumièges, he was
equally harsh with his countrymen, who had all
but effaced the remnants of the cloister at
St-Wandrille, among other Gothic remains:
"Lord Elgin's profanations are visited on us and
we profit by it. The Turks only sell Greek
monuments; we do them one better, we sell our
own."[4] Hugo does not mention the Abbey St-
Bertin, but it too was the victim of malignant
plundering. Demolition began in 1799, when it
was sold by the state, and continued through
the 1820s. A Francia drawing of ca.1821,[5]
showing the ruins from virtually the same spot
as Bonington's oil, indicates the alarming extent
to which this sanctioned vandalism was pursued
in just the few years separating the two works.
Ironically, Francia, who bitterly opposed such
activity, profited from his purchase and resale in
London in 1822 of the abbey's retable. Nor
were the civil authorities always solely to blame
for such destruction, if we are to believe the
antiquarian F.-T. de Joliment, who lamented in
1823 that the church of Ste-Paix at Caen was
permitted to crumble to ruin by its owner,
the artist Floriot, so as to enrich his daily
meditations on the ineluctable decay of
civilizations.[6]

1. Bonington sale, 1829, lot 114, bought Byng.
2. Calais, *Francia*, nos. 57, 94, and 127, for instance.
He also executed a series of finished watercolors, now
untraced.
3. An anonymous oil copy was reproduced by
Dubuisson and Hughes, opp. 156.
4. Hugo, "Sur la destruction des Monuments en
France," *Oeuvres complètes* 2: 569–72.
5. Calais, *Francia*, no. 57. An even closer replica of
Bonington's composition is an oil by an anonymous
contemporary in which the staffage consists of figures
dueling (Sotheby's, Monaco, 3 December 1989, lot 636).
6. De Joliment, *Description historique et critique et vues des
monuments du Calvados* (Paris, 1825), 42ff. This author also
made several copies after early Bonington marine
compositions.

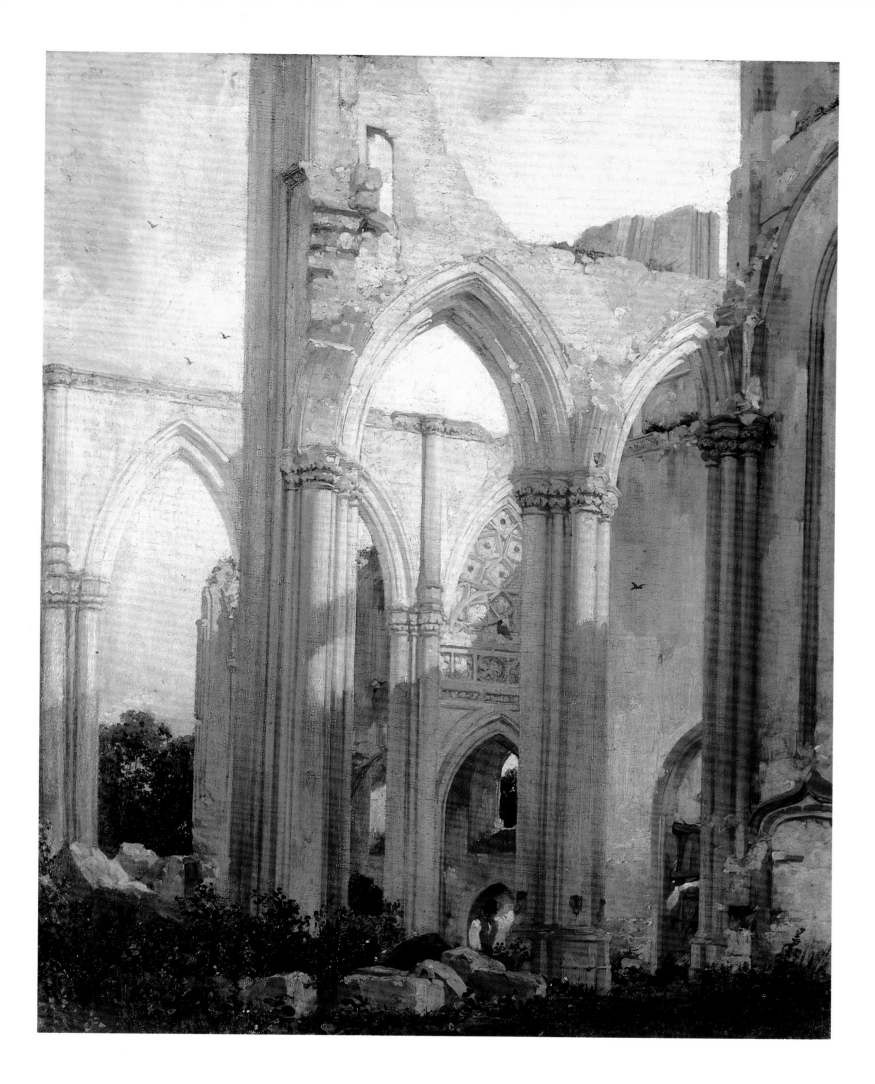

A FISHMARKET NEAR BOULOGNE ca.1824
Oil on canvas, $32\frac{3}{8} \times 48\frac{1}{4}$ in. (82 × 122.5 cm.)

Provenance: James Carpenter (d. 1852), by late
1830; possibly Anonymous (Carpenter ?)
(Phillips, 23 February 1833); possibly Sir Henry
Webb (Paris, 23–24 May 1837, lot 2); Hugh
A. J. Munro of Novar, by 1857 to 1878
(Christie's, 6 April 1878, lot 3, bought Agnew's
for Lewis); C. W. Mensil Lewis to after 1885;
Sir Charles Tennant by 1896 and by descent to
Sir Colin Tennant, from whom purchased by
Paul Mellon in 1961.

Exhibitions: Paris, Salon 1824, no. 191; Agnew's
1962, no. 5, repr.

References: E. Delécluze, "Salon de 1824," *Journal
des Débats* (30 November 1824): 2–3; Jal, *Salon
1824*, 417; "The Collection of Hugh Munro of
Novar," *Art Journal* (1857): 134; Dubuisson
1909, repr. 283; Dubuisson and Hughes,
118–20, repr. opp. 119; Noon 1986, 239–53;
Pointon, *Bonington*, 153.

Yale Center for British Art, Paul Mellon
Collection (B1981.25.50)

The genesis and significance of this picture,
Bonington's most ambitious and arguably
his most influential marine painting, was
considered at length in my 1986 article.
Its identification with the oil *Marine. Fishermen
Unloading Their Catch*, no. 191 in the 1824 Salon,
for which Bonington was awarded a gold medal,
was urged on the internal and critical evidence
and, while not conclusive, remains compelling.
With its riveting still life of beached skate, its
limpid expansiveness, its throng of graceless
fisherfolk, the painting is a signal exercise in
Anglo-Dutch naturalism, qualitatively
unparalleled in contemporary French landscape
painting and antithetic to the prevailing
academic taste.

In his review of the Salon, Auguste Jal noted:

*M. Bonington . . . is an Englishman transported to
Paris, where he has generated a mania. For some time,
the collectors have sworn by him; he has inspired
followers and imitators. His paintings are, from a
distance of several feet, the accent of nature, but they
are, in truth, only sketches. I prefer M. [Eugène]
Isabey's pictures. M. Bonington's figures are drawn
with spirit, but they are too slack.*[1]

The conservative protégé of David, Etienne
Delécluze, was less critical of the formal
innovations than of the challenge posed by the
mundane subject to the traditional sovereignty
of historical landscape:

*In order to assess the talents of this painter, one must
examine a marine in which fishermen are seen unloading
their fish. The exactness and finesse in rendering the
wan effects of the sky and sea on the channel coast are
genuinely worthy of praise, but I avow that a sad sky,
or a surging sea, or briny fishermen disputing in the
middle of a pile of fish have little attraction for me.
The truth of the imitation actually enhances my
aversion, and I inadvertently step aside to where I am
able to view the radiant landscapes of Greece and
Italy No, I will never believe that in order to
please it will suffice to be true; I would even avow that
I prefer a bad failure at depicting the bay of Naples to
a pile of pike executed by the most able master.*[4]

The site of this fishmarket as Boulogne was
first suggested in 1857. Although the picture
contains no architectural or topographical
landmarks to verify this proposition, there does
exist a sepia study for the composition on the
verso of a sheet with a finished wash drawing of
the inner port at Boulogne (Private Collection).
Presumably chalk drawings similar to no. 30
once existed for at least some of the figures, in
particular the woman hauling the large basket,
who in the painting appears three times in the
same pose but from different angles. Rapid
studies of fisherfolk, their markets, and the
paraphernalia of their trade abound in the
pages of dismantled sketchbooks of 1824
(Bibliothèque Nationale; figs. 16, 17).

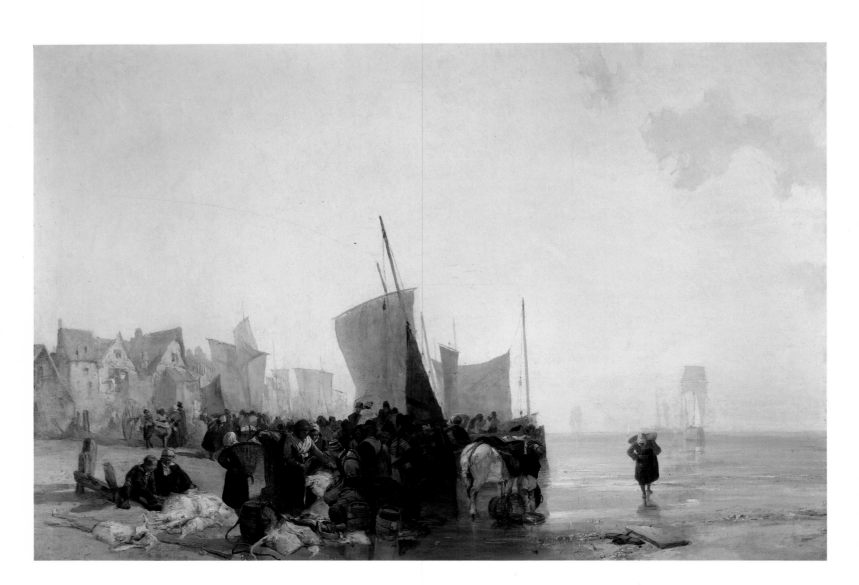

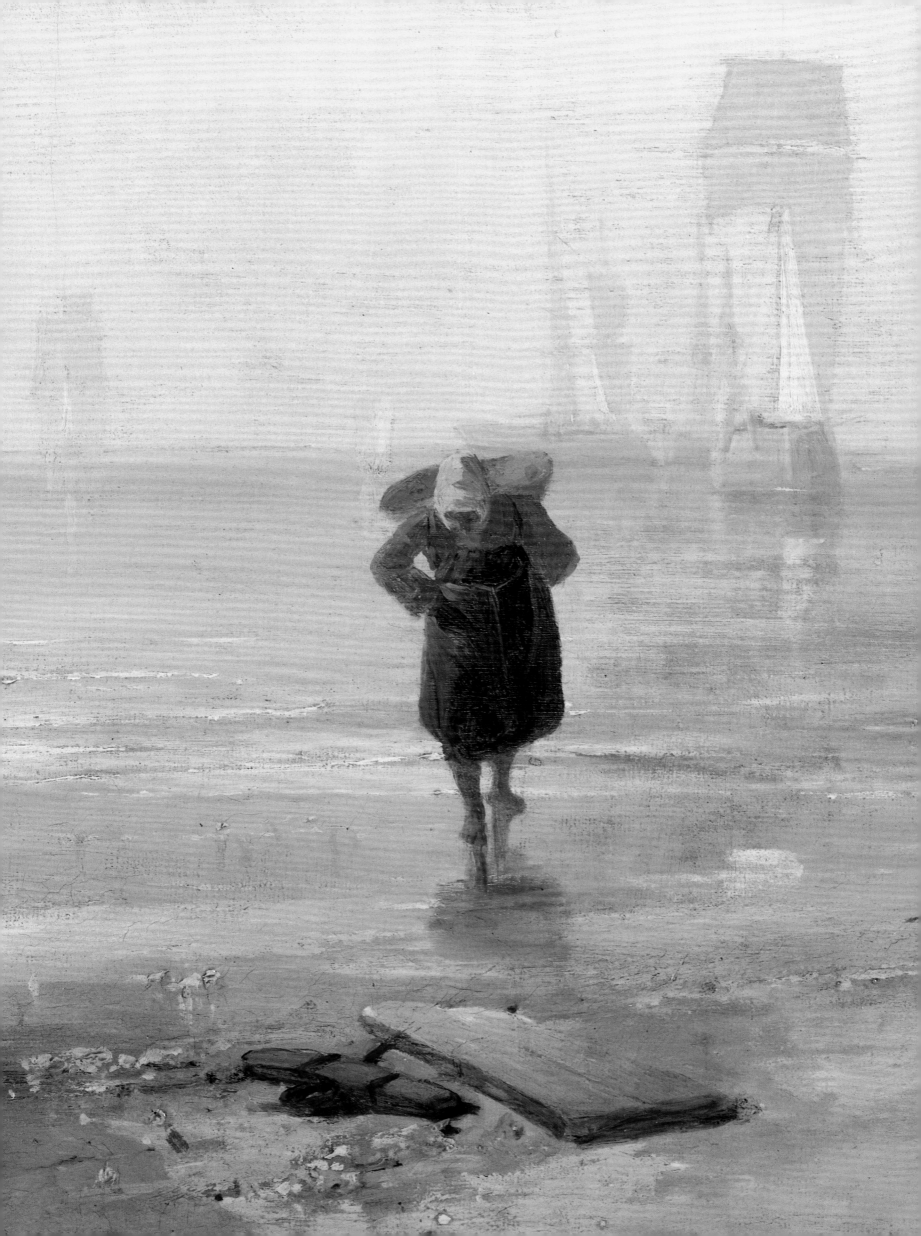

James Carpenter (d. 1852), the first recorded owner of Yale's painting, was a successful London bookseller and publisher, an early patron of John Constable, and the father-in-law of Margaret Geddes Carpenter, who painted Bonington's portrait (National Portrait Gallery, London) and whose sister was married to the marine painter William Collins. Carpenter probably became personally acquainted with Bonington in 1827 through their mutual friends in the print trade. His obiturist in the *Art Journal* (May 1852) credited him with having introduced Bonington to the English public, and although this distorts the chronology of Bonington's conquest of the London art scene, it is certainly accurate that Carpenter generously promoted the artist's interests through direct commissions and, after Bonington died, through his publication of engravings and of J. D. Harding's lithographic facsimiles, *A Series of Subjects from the Works of the Late R. P. Bonington* (London, 1829–30).

Among the prints Carpenter published was a mezzotint after this painting by J. P. Quilley (January 1831). His advertisement in the *Literary Gazette* (12 February 1831) indicated that the general public was already quite familiar with the composition by that date.[3] A defamatory critique of the mezzotint in the *Repository of Arts* (June 1833) may have persuaded Carpenter, if he had not previously decided on this course, to commission a line engraving from Charles Lewis as a pendant to Lewis's engraving after Carpenter's other major Bonington, *Entrance to the Grand Canal* (published 30 March 1831; fig. 61).[4] A perfunctory watercolor version of Yale's oil (Louvre; squared in chalk for transfer), which Marcia Pointon identified as a Bonington study, is actually Lewis's reduced replica preparatory to the engraving. Three anonymous oil copies, each lacking the building to the far left in the Yale picture, are based on this engraving.[5] Other copies in watercolor or in oil are also known.[6]

1. Jal, *Salon 1824*, 417.
2. Delécluze, *Salon 1824*, 2–3.
3. "Every lover of art remembers this admirable picture of Bonington, in which the grouping and composition vie with the best masters of the Flemish school."
4. Charles Lewis, the prominent Victorian engraver and brother of the artist John Frederick Lewis, began his career in the mid-1830s engraving major paintings by Bonington for Carpenter, Colnaghi, and other firms.
5. Formerly George Coats Collection; formerly Dr. Paul Müller Collection (Paris, 25 May 1910, lot 2); and John Nicholson Gallery, New York, 1948. One of these may be the copy now in Lord Belper's collection.
6. An oil signed "A G" was at Sotheby's Belgravia, 30 October 1972, lot 162, and a watercolor is in the Whitworth Art Gallery.

STUDIES OF FISHERFOLK ca.1824
Black, red, and white chalks and gray wash on
tan paper, $7\frac{7}{8} \times 10\frac{1}{4}$ in. (20 x 26 cm.)

Inscribed: False signatures, partially erased,
lower left

Provenance: Possibly E. V. Utterson (Christie's,
24 February 1857, lot 379) and, subsequently,
William Russell (Christie's, 10 December 1884,
lot 106, bought Dr. Rigall); Colnaghi, 1901,
from whom purchased by the British Museum.

Exhibitions: Nottingham 1965, no. 4, pl. 35.

References: Shirley, 94 and pl. 51.

Trustees of the British Museum
(1901-4-17-17)

This sheet of life drawings belongs with a group
of preparatory sketches of Normandy fisherfolk
for the series of marine pictures that Bonington
commenced in spring 1824. The studies for
three figures in the earliest of these oils,
Fisherfolk on the Normandy Coast (Viscountess
Boyd; fig. 18), appear on this sheet. Other
examples depict the fisherman and the woman
in the same or variant poses. Similar in style are
a group of studies of children.[1]

In a slightly ambiguous allusion to such
drawings, Bonington wrote from Dunkerque on
5 April 1824 to Colin, who had by that date
returned to Paris: "I thank you very much for
the care you have taken with my drawings, etc.
Also it is important that I not forget the
fishermen's costumes."[2] A careful study in
graphite (Private Collection) of the basket
held by the figures is inscribed "Trouville."
Less detailed and more numerous are the rapid
sketches of fisherfolk engaged in a variety of
daily activities that constitute a significant
portion of a dismembered sketchbook in use
during 1824 (Bibliothèque Nationale; fig. 16).

1. Two were formerly in the Seligmann collection,
another is in the Fitzwilliam Museum, and a third was
Sotheby's, 17 November 1983, lot 120. See also Shirley,
pl. 51.
2. Transcription by Dubuisson or Curtis (BN
Bonington Dossier) of an original letter then in the
possession of Colin's descendents: "Je te remercie bien
des soins que tu as au pour mes dessins. etc. Aussi il ne
faut pas que j'oublie des costumes des matelots."

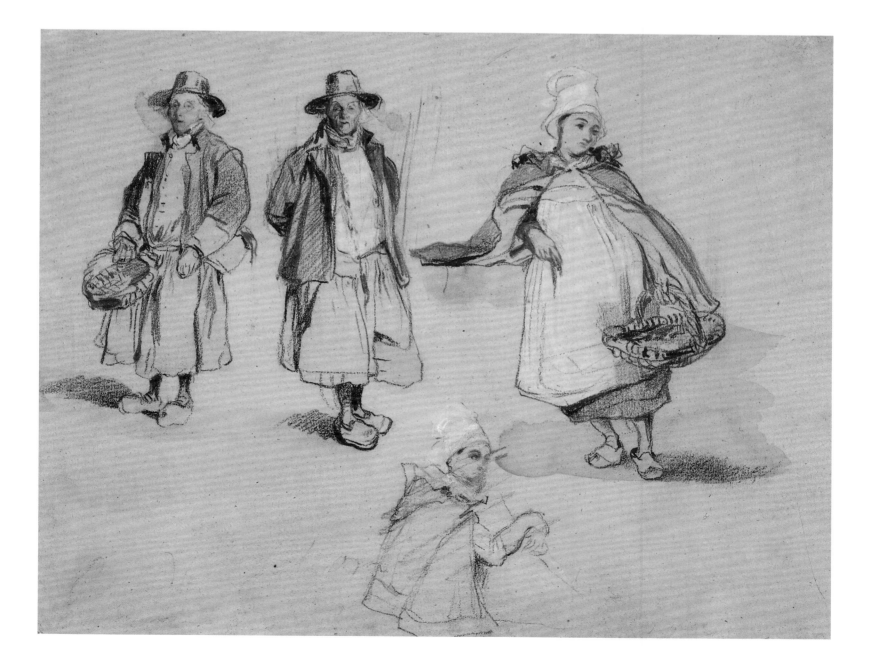

RIVER SCENE IN PICARDY ca.1824
Oil on canvas, 17 × 22 in. (43.2 × 55.8 cm.)

Provenance: Possibly Sir Henry Webb (Paris,
23–24 May 1837, lot 7, as *Shipping on the Canal at
Calais. Morning*); T. Horrocks Miller; Thomas
Pitt Miller (Christie's, 26 April 1946, lot 9,
bought Agnew's); Agnew's, 1952, from whom
acquired by Sir John Heathcoat Amory; Sir John
Heathcoat Amory, from whom acquired by The
National Trust in 1972.

Exhibitions: Agnew's 1962, no. 19; Nottingham
1965, no. 246, pl. 28.

The National Trust, Knightshayes
(Heathcoat-Amory Collection)

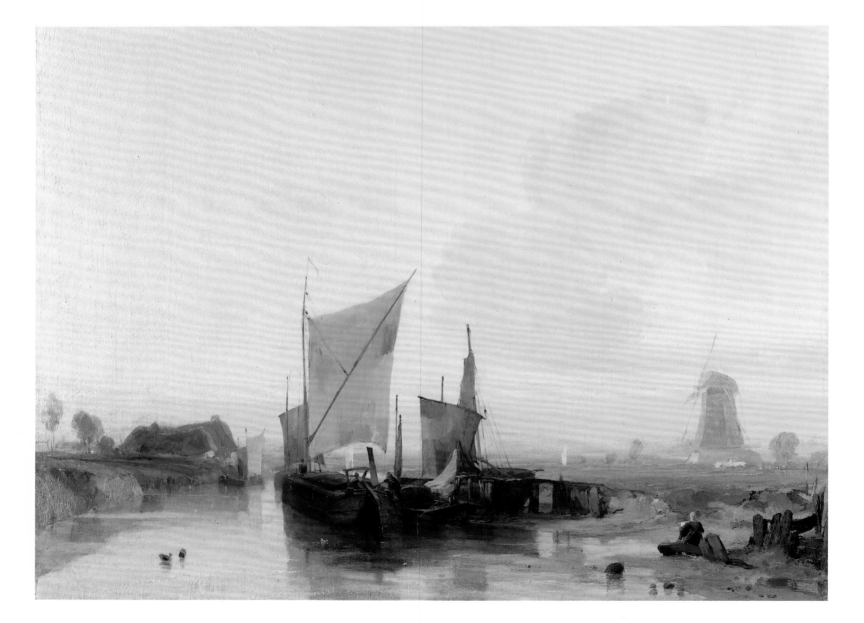

Representing with superb finesse the early morning mists that shroud the canals in the vicinity of St-Omer and Calais, the picture dates on style to spring 1824. In 1965 Spencer noted the existence of several copies, and the composition was apparently well known in the last century, possibly as a result of a version having been exhibited at the 1824 Salon.[1]

One of the most ambitious Bonington collectors in France was the somewhat mysterious "Chevalier Webb." Dubuisson identified him variously as Monsieur Webb and W. Webb, while Shirley compounded the confusion by referring to him as Captain Webb. He was, almost certainly, Sir Henry Webb, 6th Bart. (1806–1874), the only survivor and heir of Sir Thomas Webb and his first wife, Lady Frances Dillon. Sir Thomas and Lady Webb had resided in France from about 1800, and they are mentioned in the correspondence of Madame Récamier on several occasions from 1807 onward. Lady Webb (d. 1819) was the sister of the 1st Earl of Mulgrave and the Hon. Gen. Edmond Phipps, the former a director and the latter a governor of the British Institution; both were also active collectors of Bonington's pictures. Sir Thomas married his second wife, the Dowager Viscountess Boyne (d. 1826), at the British Embassy in Paris in 1822.

Henry Webb, who was born in Lyon, succeeded to the baronetcy at his father's death in March 1823. He began selling his patrimony on 6 June 1823 at an auction in Paris, where he was identified as "Webb, Baronet anglais." The sale was modest and included no Boningtons. Between January 1832 and May 1837, however, Sir Henry held eight sales in Paris, comprising over two hundred and fifty oils and six hundred watercolors and drawings by modern artists, many of them British. The final sale of 23–24 May 1837 included fifty-two Bonington oils, of which only three can be traced to Bonington studio sales at which Webb was a named bidder. After 1837 his name disappears from the sale rooms, and there was no auction recorded after his death at Würtemberg in 1874. This brief flurry of activity in the 1830s suggests that Webb was a *marchand-amateur*. He could have been in partnership with a Paris dealer like Arrowsmith, who went bankrupt in the late 1830s, or Claude Schroth, who was the *commissaire* of seven Webb sales. Whether he amassed his extraordinary collection of Bonington oils on speculation or because of genuine admiration will probably never be determined.

1. The Salon oil, *Étude en Flandre*, was acquired by the Société des Amis des Arts. It was subsequently lot 507 of an anonymous sale at Christie's, 3 June 1880, where it was described as *River scene with windmill, boats and figures. Signed. Société des Amis des Arts, 1824. From the collection of the late Madame du Cayla.*

FISHING VESSELS IN A CHOPPY SEA ca.1824
Watercolor over graphite, with scraping out;
verso: graphite sketch of a sail, $5\frac{1}{2} \times 8\frac{3}{8}$ in.
(14×21.3 cm.)

Inscribed: In graphite, upper right: *Sketch — | ad
naturam*; in graphite, verso, in Francia's hand:
R: P: Bonington | à Mr Arrowsmith: Ls Francia;
and: *3*

Provenance: Louis Francia, by whom given to
John Arrowsmith; Marquess of Lansdowne, by
1936 to 1970; Agnew's, from whom purchased
by Paul Mellon in 1970.

Exhibitions: BFAC 1937, no. 114; Agnew's 1962,
no. 57; Nottingham 1965, no. 206.

References: Shirley, 113, pl. 135 (reversed);
Ingamells, *Bonington*, 34, and *Catalogue* 1: 22.

Yale Center for British Art, Paul Mellon
Collection (B1977.14.6105)

Slightly less finished than the following
seascape, this watercolor appears to be the
preparatory study for an oil of comparable date
(Wallace Collection; fig. 21). The graphite
inscription suggests that it was a plein-air
sketch made during the period of Bonington's
residence at Dunkerque. That Bonington and
Colin were not averse to seeking their subjects
on the open sea is confirmed by several Colin
graphite sketches of Bonington at work "en
mer."[1] Another watercolor of similar
dimensions, dated 1825, is a replica of the
London oil, with which it agrees in most
details.[2] Compositionally similar types, in
monochrome washes, were a staple of the
artist's trade at this time.[3]

The verso inscription indicates that
Bonington gave the drawing to his friend Louis
Francia, who in turn transferred it to John
Arrowsmith, the Paris-based fine arts dealer
and amateur artist who keenly promoted
Constable's pictures in 1824 and who at the
1827 Salon exhibited his own oil, *An Interior*,
which one critic described as an imitation of
Bonington.[4] He was also one of the earliest and
most steadfast patrons of Théodore Rousseau.

1. Musée Carnavalet, Paris (nos. D437, D439).
2. Museum of Fine Arts, Budapest (no. 1935-2627);
reproduced in color by W. Koschatzky, *Watercolour
History and Technique* (London, 1980).
3. For instance, Musée du Louvre, Département des
Arts Graphiques (no. 31142); and Sotheby's, 12 March
1987, lot 112.
4. Jal, *Salon 1827*, 237. For an account of Arrowsmith,
see *John Constable's Correspondence IV*, ed. R. B. Beckett
(Suffolk, 1966), 8: 177ff.

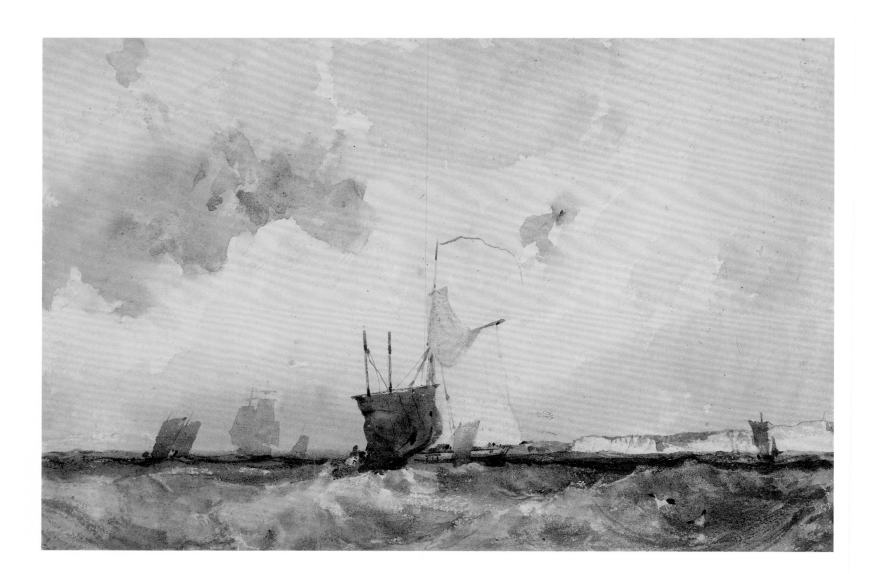

33

DUNKERQUE FROM THE SEA ca.1824
Watercolor over graphite, $7\frac{3}{4} \times 10\frac{1}{4}$ in.
(19.7 × 26 cm.)

Provenance: Baron Van Zuylen (Christie's,
14 June 1977, lot 96); Agnew's, from whom
acquired by the present owner.

References: Peacock, repr. 83.

Private Collection

According to Charles du Rozoir, Dunkerque
accepted 500 vessels a year between 1814 and
1820, but by 1826 that number had risen
precipitously to 2730.[1] It was, in effect, one of
the most rapidly expanding port facilities on
the channel coast during the decade in which
Bonington was a frequent visitor and part-time
resident. One influential inhabitant of this city
was Benjamin Morel (1781–1860), a collector
of considerable acumen to whom Francia had
introduced Bonington. He is mentioned in
Bonington's surviving correspondence of 1824,
the most likely date for this watercolor.

1. *Relation historique, pittoresque et statistique du voyage de
S. M. Charles X dans le département du nord* (Paris, 1827),
13.

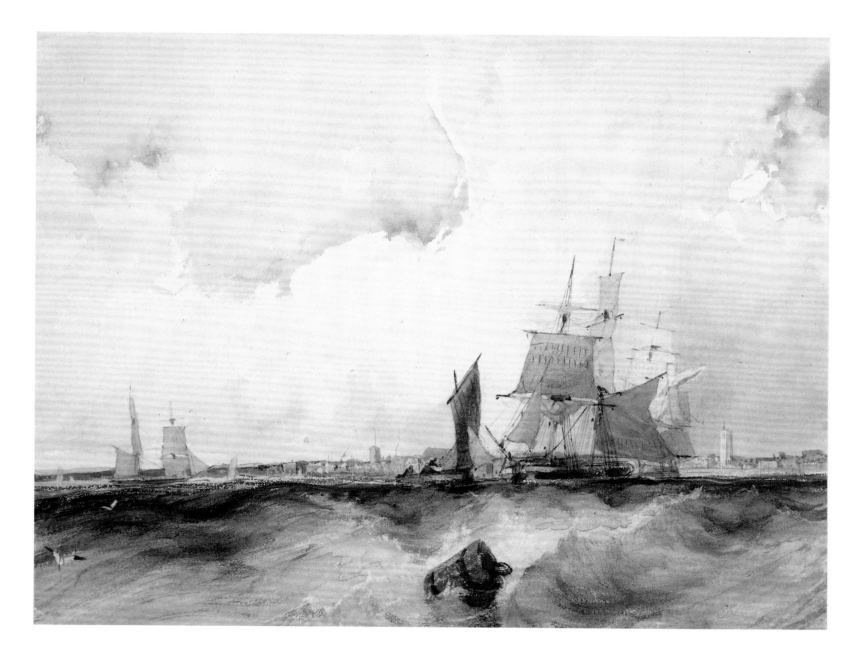

34

NEAR QUILLEBOEUF ca.1824–25
Oil on canvas, $16\frac{3}{4} \times 21$ in. (42.5 × 53.4 cm.)

Provenance: Baron Jean-Charles de Vèze;
Paul Barroilhet, (Paris, 1855, as *Environs of
Quilleboeuf*); Henry Didier (Paris, 15 June 1868,
as *A River Bank*); Baron Nathaniel de
Rothschild, by 1882; Mme Denain (Paris,
6–7 April 1893, as *Banks of a River*, repr. by
photogravure); Robert W. Redford, by 1937,
from whom purchased by Paul Mellon in 1960.

Exhibitions: BFAC 1937, no. 7.

References: Dubuisson and Hughes, 193, 195,
198–99; P. Oppé, *Burlington Magazine*
(September 1941): 99–101, pl. 2.; Peacock,
repr. 43.

Yale Center for British Art, Paul Mellon
Collection (B1981.25.49)

The dappling of brighter tints in the foreground
may reflect Constable's influence,[1] although in
every other respect the picture does not differ
markedly from the effects that Bonington
sought to achieve in his earliest oils. Once again
the sky provides whatever drama was intended,
although the romantic convention of sunlight
streaming in directed rays from breaks in the
clouds, so familiar from the works of Francia
and Turner, is far more sedately employed.
A graphite study for the left side of the
composition is in the National Gallery of
Scotland.

Baron Charles de Vèze (1788–1855), the first
recorded owner of this picture, was an amateur
landscape painter and lithographer who also
contributed to d'Ostervald's publications.
The opera singer Paul Barroilhet, who owned
the painting at mid-century and was an avid
collector of the modern French school, made his
collection accessible to the generation of
landscape painters most indebted to Bonington,
in particular the Barbizon school and the marine
painters Johan Barthold Jongkind (1819–1891)
and Eugène Boudin (1824–1898).

1. Constable's oils were being regularly imported over
several years beginning in 1824. In January 1825, for
instance, Claude Schroth collected three pictures from
the artist.

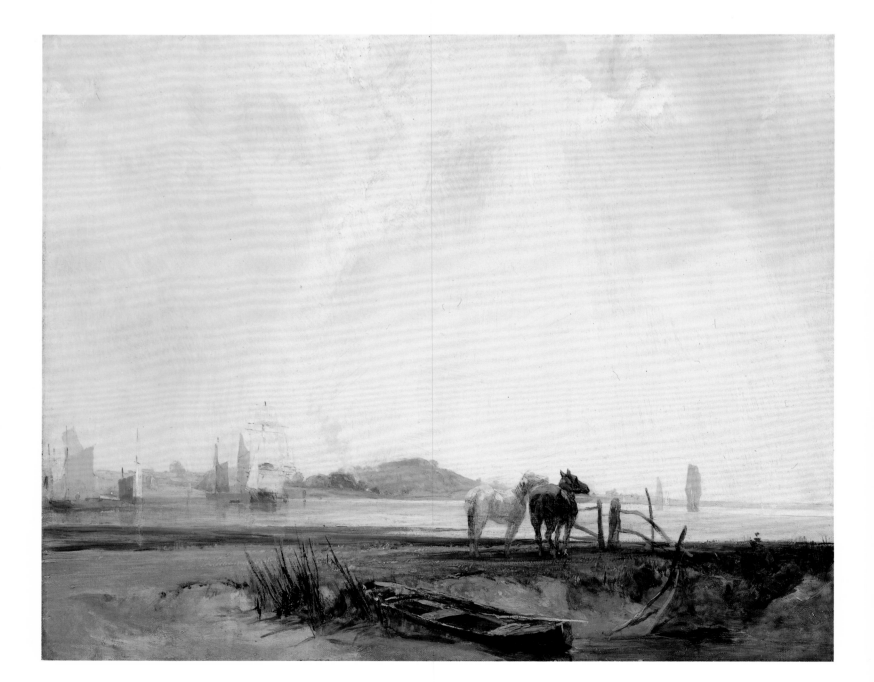

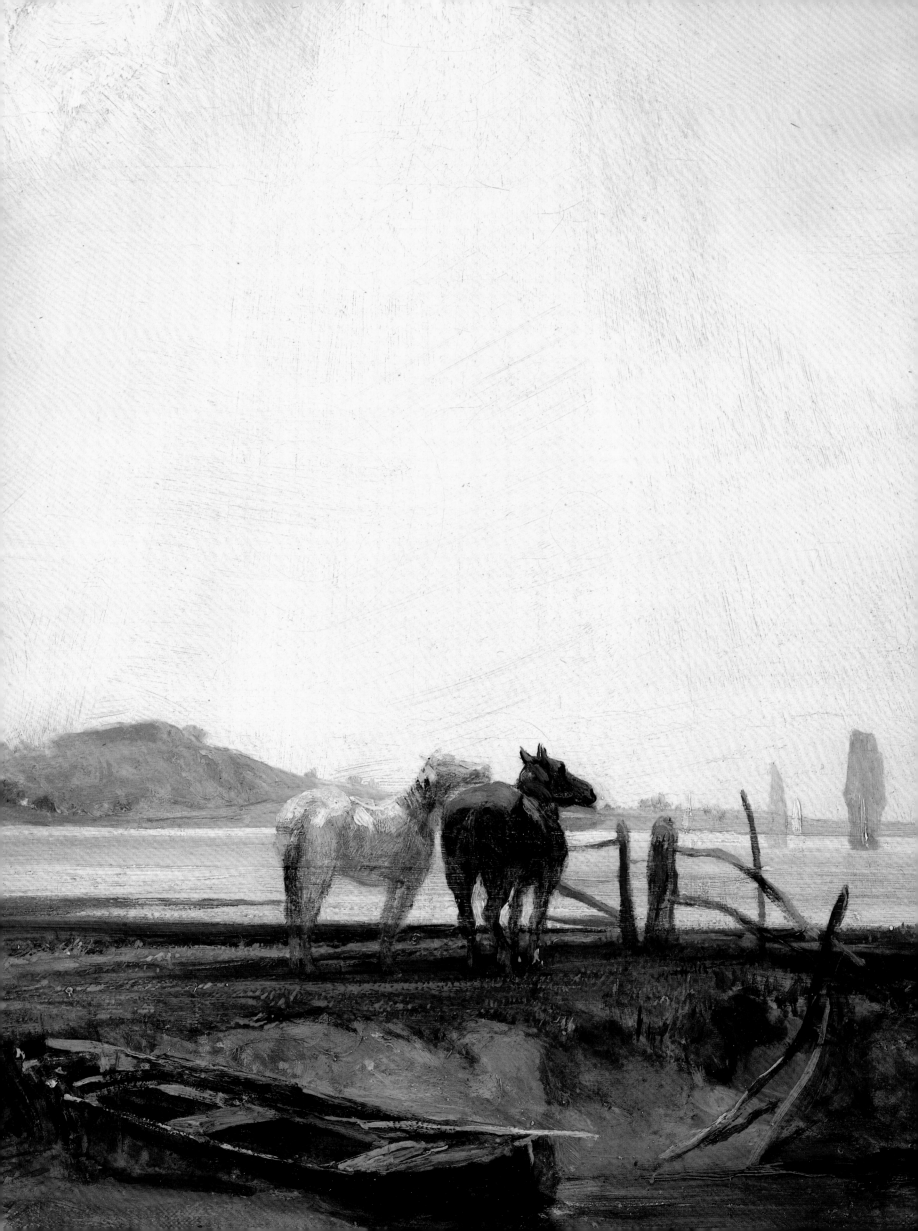

35

NEAR ST-VALERY-SUR-SOMME ca.1824–25
Oil on canvas, $31\frac{1}{2} \times 47\frac{5}{8}$ in. (80 × 121 cm.)

Provenance: Baron Charles Rivet, and by descent
to Mme Paul Tiersonnier, née Marie de Catheu,
1937; Baron Fairhaven, Anglesey Abbey.

Exhibitions: BFAC 1937, no. 29; Agnew's 1962,
no. 2.

References: Dubuisson 1909, 384–86, repr.;
Dubuisson and Hughes, 120; P. Oppé, *Burlington
Magazine* (September 1941): 99–101, pl. 1.

The National Trust, Anglesey Abbey
(Fairhaven Collection)

Baron Rivet offered this picture to the Louvre
shortly after Bonington's death, but it was
refused by the Comte de Forbin because the
figures were unfinished and the artist's "success
among the public is not sufficient grounds for
his acceptance in the galleries of the Louvre."
The baron responded that the picture would be
left to his family with the condition that it
never be sold or given to the nation.[1]

The painting exhibits many of the salient
traits of conception and execution found in
A Fishmarket Near Boulogne (no. 29), although
the modeling of the figures is perhaps a bit more
assured, thus arguing for a slightly later date.
It is unclear why the artist left some of his
foreground figures merely blocked in.[2]
Refinements of detail are not actually crucial to
the success of the picture and such "oversights"
or shortcuts appear elsewhere in Bonington's
works. Nevertheless, even de Forbin, who was
sympathetic to the romantic school, would have
condemned such nonchalance as an impropriety.

The distant buildings and quay recur in the
watercolor (no.9), identified as St-Valery-sur-
Somme or its nearby village of La Ferté. The
traditional title of this oil, *Near the Bay of the
Somme*, presumably originates with Baron Rivet
and corroborates the proposed identification.

1. Dubuisson 1909, 385 n.1, as recounted to him by
René Paul Huet, the son of Rivet's and Bonington's
friend Paul Huet.
2. Robert Shepherd has examined the picture under
infra-red light. Pentimenti include a cottage painted out
at left; a figure near the basket and barrel similar to the
central fisherman; and various minor corrections to
clothing and poses.

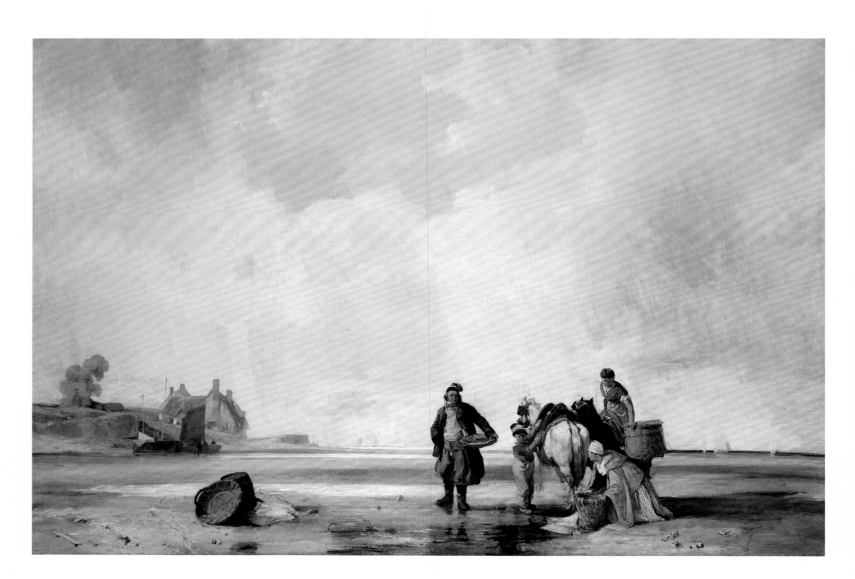

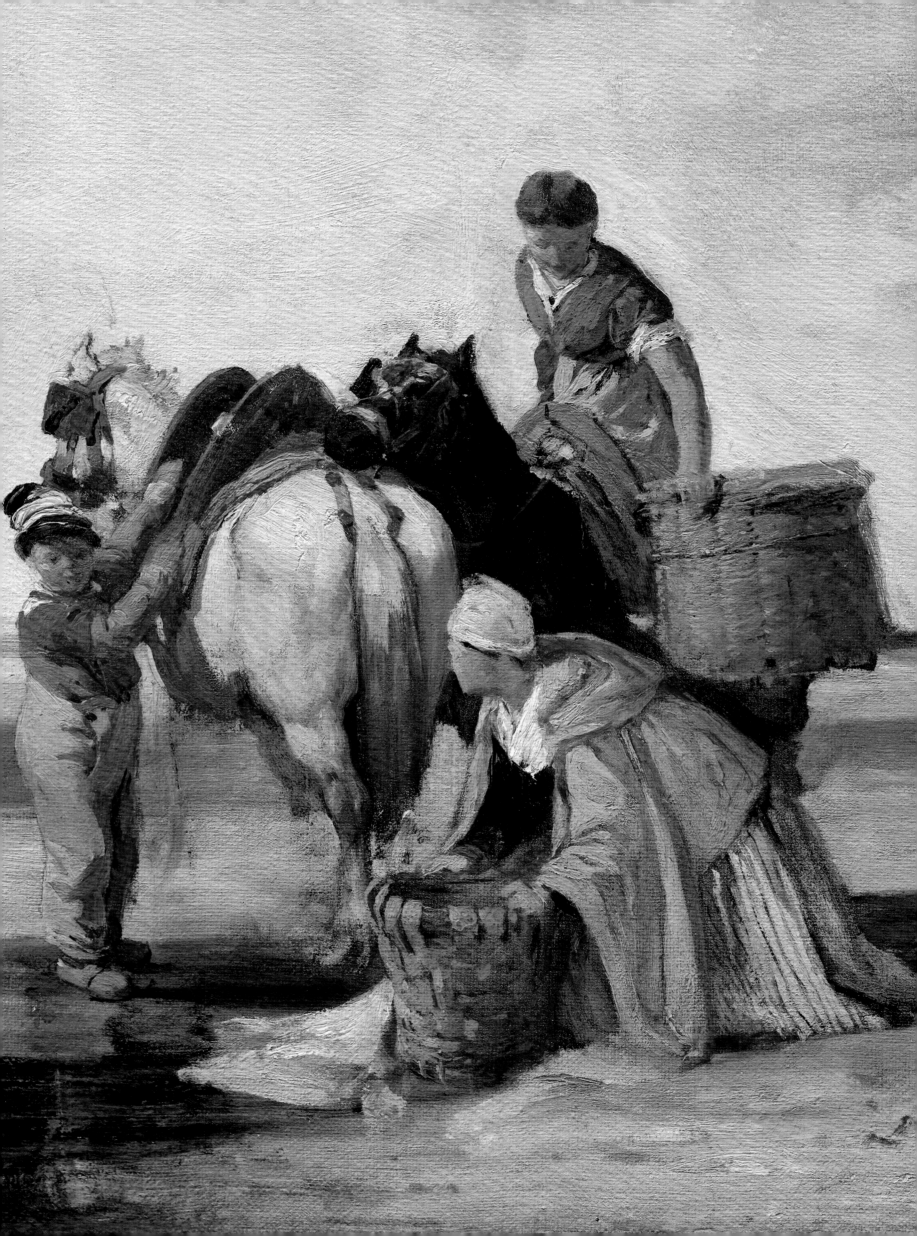

TWO SHEETS OF STUDIES AFTER THE
MONUMENT OF AYMER DE VALENCE, EARL OF
PEMBROKE, WESTMINSTER ABBEY ca.1825

Graphite, and watercolor over graphite,
$4\frac{3}{4} \times 4\frac{5}{8}$ in. (12.2 × 11.8 cm.) and $4\frac{1}{2} \times 7$ in.
(11.5 × 17.6 cm.)

Inscribed: The bottom sheet inscribed, upper
left: *72*

Provenance: Bonington sale, 1829, lot 64, as
Spirited sketches from ancient tombs, some tinted,
bought Utterson (2); E. V. Utterson (Christie's,
24 February 1857, lot 381, bought British
Museum).

Exhibitions: Nottingham 1965, nos. 234–35,
pl. 10.

References: Shirley, 89.

Trustees of the British Museum
(1857-2-28-142, 145)

The resounding success of the British school at
the 1824 Salon was the culminating event of the
Anglomania that had gripped younger Parisians
since the cessation of hostilities between the
two nations. Every nuance of English culture
had become a matter of intense fascination for
the artists of Bonington's circle. By December
he and Colin had proposed to visit London the
following summer. They arrived in June 1825
for a stay of approximately six weeks.

Spencer first identified these sheets as
studies of the relief pleurants on the funerary
monument of Aymer de Valence, Earl of
Pembroke, in Westminster Abbey. In the
company of Eugène Delacroix, Alexandre Colin,
and Edouard Bertin, Bonington, with a letter of
permission furnished him by the keeper,
William Westall,[1] visited Westminster at least
once in early July. Surviving studies by
Bonington and Delacroix, at times indistin-
guishable stylistically, attest to a remarkable
correspondence of interests. Drawing side by
side, they copied from the monuments of Lord
Norris (d. 1601; see no. 114), the Earl of
Shrewsbury (d. 1617), Sir Francis Vere, and
several fifteenth-century effigies.[2] Studies by
both artists of the coronation chair and the
hammer-beamed ceiling at Westminster Hall
also survive.[3]

J. T. Smith, then keeper at the British
Museum, to whom Bonington had a letter of
introduction, recorded the following
conversation between himself and Henry
Smedley on 25 July 1829, one month after the
first Bonington studio sale at Sotheby's:

*Bonington's drawings, held at a respectful distance
from the butter dish, were the next topic of
conversation. "I agree with you," observed my friend,
"they are invaluable; even his slightest pencil touches
are treasures. I have shown you the studies from the
figures which surround Lord Norris' monument in the
Abbey; have they not all the spirit of Vandyke?" Ay,
that drawing of the old buildings seems to be your
favourite; what a snug effect, and how sweetly it is
coloured! — there never was a sale of modern art so
well attended.*[4]

1. Manuscript letter in the BN Bonington Dossier.
2. From the Norris monument: a pen and ink sketch is
in the National Gallery of Scotland, Edinburgh;
drawings by Delacroix were at Sotheby's, 16 June 1982,
lot 569, and are in the Louvre (Sérullaz, *Delacroix*, no.
1304). From the Shrewsbury monument: pen and ink
and watercolor studies of Shrewsbury's kneeling
daughter are in a private collection and the Courtauld
Institute Galleries; Delacroix's studies are in the Louvre
(Sérullaz, *Delacroix*, no. 1305). From the de Vere
monument: three pen and ink studies of mourners are
privately owned; one is falsely inscribed "Delacroix."
A graphite study of the head of Elizabeth, Baroness
Daubeny (died ca.1508) is in a private collection.
A pen sketch of three recumbent figures is in the Royal
Academy; Delacroix's sketch of the same figures is in
the Louvre (Sérullaz, *Delacroix*, no. 1394).
3. Private Collection and National Gallery of Scotland,
Edinburgh; Delacroix's drawings of the ceiling are in an
unpublished sketchbook with an annotation
"Westminster 28 May." This information was kindly
communicated by Lee Johnson.
4. *A Book for a Rainy Day*, 3rd ed. (London, 1861),
260.

EUGENE DELACROIX (1798–1863)

ARMOR STUDIES 1825
Watercolor and graphite, $10\frac{5}{8} \times 7\frac{3}{8}$ in.
(26.5 × 18.5 cm.)

Inscribed: In brush and ink, center: *Samedi
9 juillet*; in graphite, lower left: *français /
infanterie*; atelier stamp: *ED* (Lugt 838)

Provenance: Delacroix sale, 17–29 February 1864,
with lot 655; Edgar Degas (Paris, 26–27 March
1918, lot 115).

References: Sérullaz, *Delacroix*, with no. 1460.

Trustees of the British Museum
(1975-3-1-35)

As early as October 1824 Delacroix wrote of
his fervent desire to visit England.[1] He had
received an invitation from Thales Fielding and
was no doubt responding to what he had been
told of that country by friends like Géricault,
Jules-Robert Auguste, Eugène Isabey, and
Charles Soulier, who had already made what
was rapidly becoming an obligatory pilgrimage.
He finally realized this ambition upon landing
at Dover on 19 May 1825. He would remain in
England until late August when, exhausted and
a bit testy with himself for failing to improve
his English, he returned to France with Isabey.

Henry Monnier was in London by May, and
Delacroix, who apparently traveled from Paris
alone, would be followed shortly by Bonington
and Colin, and then by Isabey, Hippolyte
Poterlet, Augustin Enfantin, and Delacroix's
friend from childhood, Edouard Bertin. On 7,
10, and 12 June Delacroix dined with Simon
Rochard, the French portrait miniaturist then
residing in London, and the architect C. R.
Cockerell, who took him to see the Marquess of
Stafford's collection at Cleveland House on 15
June.[2] Delacroix also called on David Wilkie (by
6 June), Sir Thomas Lawrence (by 1 August)
and possibly John Constable and Thomas
Phillips; visited Benjamin West's studio; and,
with Bonington, studied at Westminster and at
Dr. Samuel Rush Meyrick's collection in early
July. He also attended numerous theatrical
events, including three Shakespeare productions
in which Edmund Kean performed and an
operatic performance of *Faust* that convinced
him to illustrate that drama (fig. 64).

Most of Delacroix's identified drawings from
the London trip are either landscape watercolor
sketches or detailed armor and sculpture
studies. The attention that both Bonington and
Delacroix lavished on the latter indicates their
serious antiquarian purpose. Other drawings of
armor evocatively tinted with watercolor are in
the Louvre.[3]

1. Letter to Soulier, dated by Joubin 11 October 1823
(*Correspondence* 1: 150), but see Johnson's argument for
redating that letter to 1824 in *Delacroix* 1: 46 n.1.
2. Cockerell had previously befriended Ingres,
Géricault, and Auguste; see L. Johnson, "Géricault and
Delacroix seen by Cockerell," *Burlington Magazine*
(September 1971): 547ff.
3. Sérullaz, *Delacroix*, nos. 1459–60, 1462, and 1136v.

Gensdarmes
italien 1485

Brass
Red

TWO SHEETS OF ARMOR STUDIES ca.1825
Graphite, (left) 10¼ × 7⅛ in. (26 × 18 cm.);
(right) 7 × 5 in. (17.8 × 12.7 cm.)

Inscribed: In graphite, in the artist's hand, (left):
guerrier / italien 1485; and: *brass / red*; (right): *34*

Provenance: Bonington sale, 1829, lot 14, 15, or
16, *antient Armour from Dr. Meyrick's collection*
(a total of 27 sheets), bought Colnaghi and
Triphook; E. V. Utterson (Christie's, 24
February 1857, lot 381, bought British
Museum).

Exhibitions: Nottingham 1965, nos. 154, 163.

References: Shirley, 100.

Trustees of the British Museum
(1857-2-28-157,158)

Both sheets of armor studies were drawn during
a visit on 8–9 July 1825 to the home of Dr.
Samuel Rush Meyrick, 20 Upper Cadogan Place,
London. A plethora of such studies by
Bonington, Delacroix, and Bertin indicates that
these young artists made optimum use of their
time at one of the most distinguished private
collections of armor in Europe. Dr. Meyrick,
an advocate in the Admirality Court, had just
published his three-volume *Critical Inquiry into
Antient Armour, as it existed in Europe, but
particularly in England from the Norman Conquest to
the Reigns of King Charles II* (London, 1824).
An ambitious catalogue of his collection, much
of which is now preserved at the Wallace
Collection, would appear in 1830. Bonington's
introduction to this antiquarian might have
been furnished by Samuel Prout, whom Meyrick
would later nominate for fellowship in the
Society of Antiquaries.

 The smaller of these sheets illustrates the
armor of Thomas Sackville, Baron Buckhurst,
although at the time it was thought to have
been the Duc de Longueville's. The second
sheet includes the plated vest of an Italian
guisarmier with a detail, and another suit of
armor. Since both also appear on a single sheet
of Delacroix studies,[1] they presumably were
displayed side by side.

1. Sérullaz, *Delacroix*, no. 1468; see also, Toronto,
Delacroix, no. 28.

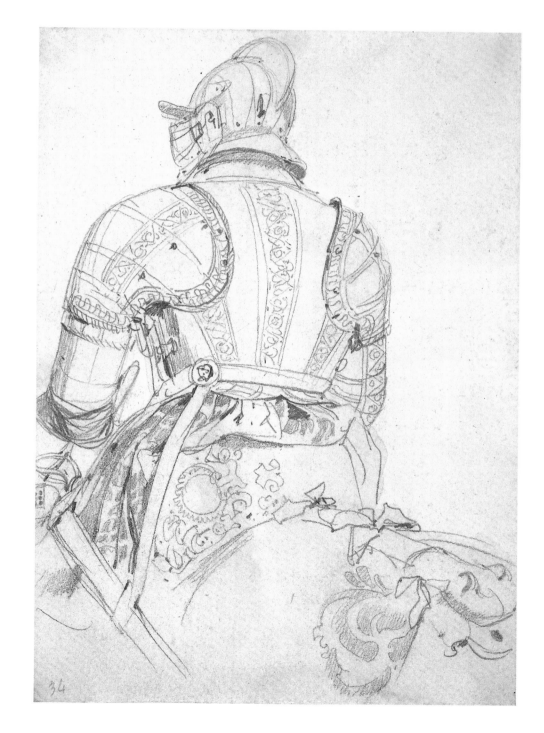

EUGENE DELACROIX (1798–1863)

STUDIES OF THE ARMOR OF THOMAS
SACKVILLE, BARON BUCKHURST 1825
Graphite, $7\frac{1}{2} \times 10\frac{7}{8}$ in. (19.1 × 27.6 cm.)

Inscribed: In graphite, upper center: *Le Duc de
Longueville 1555 | de son chateau en* [Brie]; and:
*machoire du cheval | velours rouge | fer | velours
rouge | fer | etoffe chamaree*; lower right: atelier
stamp, *ED* (Lugt 838)

Provenance: Delacroix sale, 17–29 February 1864,
with lot 655; Alfred Robaut; Etienne Moreau-
Nélaton, by whom bequeathed to the Musée du
Louvre in 1927.

References: Sérullaz, *Delacroix*, no. 1461.

Musée du Louvre, Département des Arts
Graphiques (RF 9846)

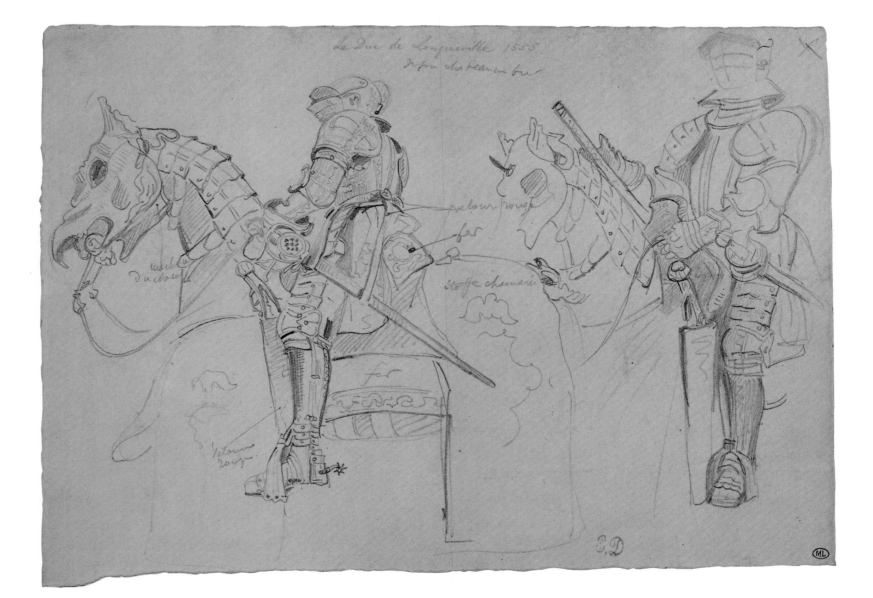

EUGENE DELACROIX (1798–1863)

ARMOR STUDIES, INCLUDING THE SUIT OF
THOMAS SACKVILLE, BARON
BUCKHURST 1825
Graphite, 7½ × 11 in. (19 × 27.8 cm.)

Inscribed: In graphite, upper left: *83 Newman
Street*; lower left: *Le Duc de | Longueville | de son
chateau | en Brie*; lower center: *Knight of S. George.
Rav* [Ravenna] *| 1534*; lower right: *Ferdinand |
Roi des Romains | 1548*; in ink, lower right:
Vendredi 8 juillet. | le soir chez Dr Meyrick;
lower center: atelier stamp, *ED* (Lugt 838)

Provenance: Delacroix sale, 17–29 February 1864,
with lot 655 or 656; A Lady (Sotheby's, 15
February 1950, lot 48, bought Mann); Sir James
Mann, by whom presented to Hertford House
in 1954.

Exhibitions: Nottingham 1965, no. 340.

References: Robaut, *Delacroix*, no. 1914 or 1915;
cf. Sérullaz, *Delacroix*, no. 1461.

Hertford House Library, London

These sheets present three suits of armor
sketched by Delacroix during a visit to the
collection of Dr. Samuel Meyrick on 8–9 July
1825. The Buckhurst suit, which appears in
both and which was also sketched by Bonington
(no. 38), and the two additional suits, of
German origin, on no. 40, were subsequently
illustrated in Meyrick's *Engraved Illustrations of
Ancient Arms and Armour*.[1] The suits identified
as belonging to Baron Buckhurst and to
Emperor Ferdinand are now in the Wallace
Collection; that of the "Knight of St. George"
is at Warwick Castle.[2]

Like Bonington, Delacroix carefully
annotated his studies, as he clearly intended
to employ them as source material for small
history paintings. For his earliest illustration
of a medieval subject, the oil *Rebecca and the
Wounded Ivanhoe*,[3] which he sold to Coutan in
1823, Delacroix made meticulous oil studies of
armor then in the Musée d'Artillerie, Paris.[4]
At that time, however, he was less attentive to
decorum in that he gave his twelfth-century
character a fifteenth-century suit of armor.

The address inscribed on the Hertford House
Library drawing is that of R. Davy, the color
merchant from whom Bonington purchased the
prepared millboards that he would use
repeatedly after this trip.

1. (London, 1830), 1: pls. xx, xxii, and xxix.
2. This information first recorded in Lee Johnson, et al.,
Delacroix (Royal Scottish Academy, Edinburgh and
Royal Academy, London, 1964), no. 95.
3. Johnson, *Delacroix* 3: 316.
4. Johnson, *Delacroix* 1, no. O4.

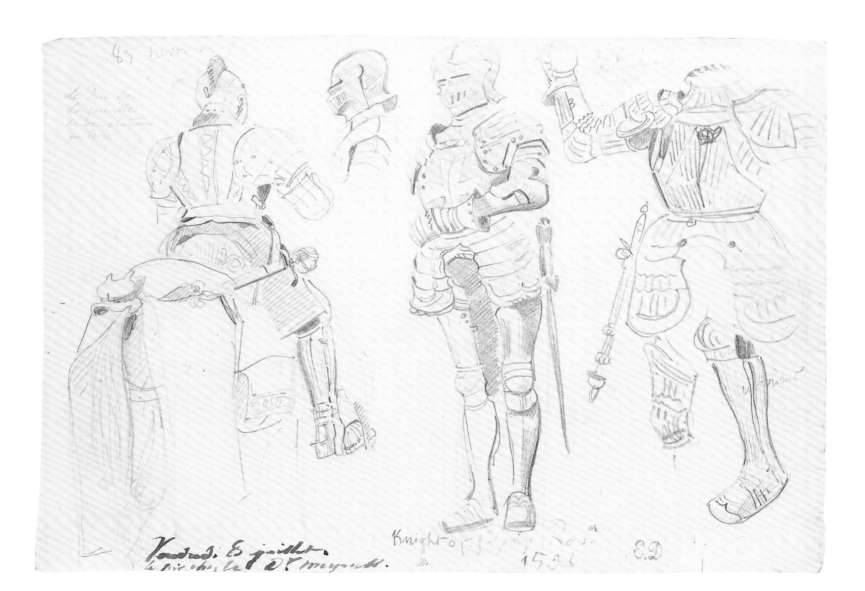

EUGENE DELACROIX (1798–1863)

AN INTERIOR, and A VIEW OF WESTMINSTER
FROM ST. JAMES'S PARK (f. 5v and f. 6r of the
"English Sketchbook") 1825
Watercolor, bodycolor, and gum arabic,
$5\frac{5}{8} \times 9\frac{1}{8}$ in. (14.3 × 23.4 cm.) (each page)

Inscribed: In graphite, inside front cover:
Mr Laporte | Winchester Row, New Road, no 21;
in graphite, inside back cover: *Martin Schon. |
le beau Martin | Wenceslaus Hollar*

Provenance: Delacroix sale, 17–29 February 1864,
with lot 662 (three sketchbooks), bought Roux
and Piot; possibly René Piot; E. Moreau-
Nélaton, by whom bequeathed to the Musée du
Louvre in 1927.

Exhibitions: See Sérullaz, *Delacroix*, no. 1751.

References: Robaut, *Delacroix*, no. 1503; Sérullaz,
Delacroix, no. 1751.

Musée du Louvre, Département des Arts
Graphiques (RF9143)

This is one of three extant sketchbooks that document Delacroix's activities and interests during his visit to London in 1825, although only its first six pages contain studies executed in England. These include watercolors of five landscapes, two interiors, and a copy of a female portrait, probably after Sir Thomas Lawrence, whom Delacroix visited, and graphite sketches of two horses belonging to his host, the horse breeder Adam Elmore. The remaining sheets of the sketchbook were used in Paris during the fall and consist of studies after Venetian paintings in the Louvre, Venetian heraldic banners, and medieval sword hilts and architectural details, all of which were drawn preparatory to the painting of *Execution of Doge Marino Faliero* (fig. 34).[1] Studies of Suliot costumes and two sheets of female nudes apparently unrelated to any pictures complete the contents.

The preponderance of landscapes in the English section reflects the interests of Delacroix's constant companions, the Fieldings, but also his own excitement about the countryside, which he expressed repeatedly in his correspondence. Delacroix had been introduced to English scenery as early as 1816 through the watercolors of his friend Soulier, who had studied the medium with Copley Fielding in London. On 6 June he wrote to Soulier of discovering constantly "the skies,

river banks, and all of the effects brought to life by your brush."[2] To another friend, Pierret, he wrote on 1 August that "it must be admitted that the beautiful verdant countryside and the banks of the Thames, which are a continuous English garden, are delicious sights."[3]

The view of Westminster was sketched en route to, but painted at, Dr. Meyrick's on 8–9 July. A larger watercolor view of the abbey from closer in was incorrectly published as a Bonington by Shirley,[4] as were two other Delacroix views at Greenwich and within St. James's Park.[5] A second watercolor study at the park is in the Louvre,[6] but over sixty landscape watercolors and designs drawn in England and sold in two lots (nos. 513–14) in Delacroix's studio sale are today untraced. There is little evidence of Bonington's influence in any of the identified sheets, including this sketch of Westminster painted in his company.

The inscription on the watercolor of the interior is partially effaced but may read "chez Mr Laporte's avec Mr. Elmore / le soir à Kensington Gardens." Laporte can be identified from the address inscribed by Delacroix at the front of the album as John Laporte (1761–1839), at that time a senior watercolorist of the British school, or his son, George Henry (1799–1873), with whom he lived and who specialized in sporting and oriental pictures. As a technical experiment utilizing gum arabic to enhance the

translucency of darker pigments, the watercolor is inept but not without relevance to both Bonington and Delacroix, as each would become increasingly reliant on this technique for their figure subjects after 1826. The practice of surcharging pigments with gum binder was becoming routine with British watercolorists at this moment. Thales Fielding certainly introduced Delacroix, and probably Auguste and Bonington, to its advantages. The inscription on the back cover is also of interest for the documentation of the working relationship between Bonington and Delacroix that would rapidly blossom as a consequence of this trip. Bonington was copying the grotesque figures in Martin Schongauer's prints in fall 1825 in connection with his *Quentin Durward* illustrations (nos. 59–60 and fig. 65).

1. Sérullaz curiously dates the album ca.1825–27, noting that the *Marino Faliero* oil was exhibited at the 1827 Salon, which is correct, although the picture was finished by 21 April 1826 (see Delacroix, *Correspondence* 1: 179).
2. Delacroix, *Correspondence* 1: 158.
3. Ibid. 1: 165.
4. Shirley, pl. 68.
5. Ibid., pls. 66–67; these might have been lot 512 of the Delacroix studio sale.
6. Sérullaz, *Delacroix*, no. 1136.

LA VILLAGEOISE ca.1825
Lithograph, $5\frac{7}{8} \times 6\frac{1}{2}$ in. (15 × 16.4 cm.)

Inscribed: In the plate, lower left: *R P Bonington del*; and lower right: *Lith de Berdalle*

Provenance: Atherton Curtis, by whom given to the Bibliothèque Nationale.

References: Curtis, no. 61.

Bibliothèque Nationale (Don Curtis 500)

The print is a headpiece to a chanson, music by Amédée de Beauplan and verse by Comte Jules de Resseguier, published in Paris by Frère, 16, Passage des Panoramas. This impression, printed on four pages of foolscap with an engraved score and both letterpress and lithographic verse, is the only surviving example of the print as published. An impression of the lithograph without text is in the British Museum. For the gist of the ballad, the first stanza will suffice:

Oh! pourquoi donc vas tu le soir,
jeune fille, dans la campagne,
quand nul ami ne t'accompagne,
quand il fait froid, quand il fait noir?
De fatigue toute épuissé,
toute couverte, de rosée,
dans mon château viens vite, allons,
viens essuier tes cheveux blonds.

Citing the 1828 publication of de Resseguier's first verse anthology, *Tableaux poétiques*, which included *La Villageoise*, Curtis assigned this lithograph to the last year of the artist's life. That volume (actually the second edition), however, was illustrated with two engravings by Adrien Godefroy after designs by Vicomte de Sennones. In its chanson format, *La Villageoise* appears to have been published separately, and, I would argue, considerably earlier. The soft, granular uniformity of the technique finds its most convincing parallel in the *Voyages pittoresques* lithographs of 1825, such as the *Tombeau de Marguerite de Bourbon.*[1] An additional argument for placing this print among the works of 1825 would be the overt Gothicism of its composition and figures. Conceiving the illustration as medieval bas-relief permitted the artist to introduce an architectural niche with decorations similar to those he had recently copied at Westminster (no. 36). He borrowed the figure of the thirteenth-century village maiden, for which there exists a graphite study (British Museum), from Joseph Strutt's *A Complete View of the Dress and Habits of the People of England* (London, 1796, pl. lxii). Strutt also furnished the source for the figures of Bonington's oil *Anne Page and Slender* (fig. 38). No model for the mounted knight has been identified, although similar types appear in a Delacroix sketchbook in use at mid-year[2] and in the Gothic surrounds to Colin's designs for an 1824 edition of Charles Nodier's *Poésies de Clotilde*.

Jules de Resseguier (1788–1862) was a principal poet of French romanticism. A staunch royalist, devout Catholic, and persuasive disciple of Alexander Guiraud's "style troubadour," he founded *La Muse Française* with Nodier, Victor Hugo, and Emile Deschamps in 1823. In August 1825 he was collaborating with Louis Vatout, librarian to the duc d'Orléans, and others, in publishing single elegies accompanied by lithographic illustrations.[3] His enthusiasm for this relatively new medium of printmaking was expressed in a review for *La Muse Française* in September 1823, about the time that Bonington was producing his first lithographs:

Lithography is drawing itself. In it we discover the hand, the crayon, the thought of its author: it is not a faithful copy; to our mind it is the echo of the model, it is a mirror that reflects and multiplies the original. Engraving has greater force and precision, lithography idealism and charm; it paints the vaporous sky, the water's froth, the night's fantastic images. They have life, they seem transient and we hesitate to ponder them for fear they'll only evaporate before our eyes.[4]

1. Curtis, no. 24.
2. Sérullaz, *Delacroix*, no. 1749.
3. P. Lafond, *L'Aube Romantique* (Paris, 1910).
4. "Un Samedi au Louvre: Exposition des Produits de l'industrie," *La Muse Française* 1 (Paris: Marsan edition, 1907): 215.

R.P. Bonington. Del.

Lith.ᵉ de Berdalle.

La Villageoise

Ballade.

Paroles de M.ʳ le C.ᵗᵉ Jules de Rességuier

Musique

de M.ʳ Amédée de Beauplan.

à Paris,

Chez Frère Passage des Panoramas N.º 16.

43

FISHING VESSELS NEAR THE FRENCH
COAST 1825
Watercolor over graphite, $9\frac{3}{8} \times 7$ in.
(23.9 × 17.8 cm.)

Inscribed: Signed and dated, lower right:
RPB 1825 [cropped]

Provenance: Charles Russell (Sotheby's, 30
November 1960, lot 64, bought Agnew's);
W. B. Dalton, by whom given to the Art
Gallery of Ontario in 1960.

Art Gallery of Ontario (60/12)

The final digit of the inscribed date is not
completely legible but appears to be a 5.
The coast is probably near Dunkerque and the
watercolor executed either during or shortly
after Bonington's return voyage from London
in July 1825. It is believed that he and Colin
remained for several weeks at Dunkerque and
St-Omer, where they were eventually joined by
Delacroix and Isabey. With the temperature in
Paris a blistering 100 degrees (Fahrenheit),
there was little incentive to return immediately
to their studios.

While it is important not to exaggerate the
impact of J. M. W. Turner's art on Bonington,
the large size of this sheet and the unusual
representation of a vessel bearing down on the
viewer recall certain works by Turner in Walter
Fawkes's collection, which Bonington probably
visited in London: *The Victory Returning from
Trafalger* (Yale) and *A First-Rate Taking on Stores*
(Cecil Higgins Museum and Art Gallery).

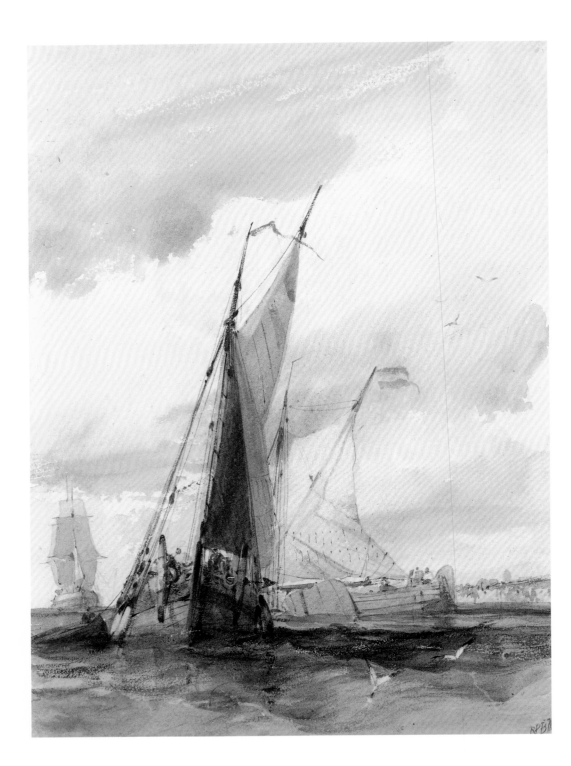

BEACHED VESSELS AND A WAGON NEAR
TROUVILLE ca.1825
Oil on canvas, 14¾ × 20⅝ in. (37.1 × 52.2 cm.)

Provenance: Comte de Pourtalès-Gorgier (Paris,
27 March 1865, lot 209); Charles E. Russell,
by 1937, and by descent to 1984; Michael
Voggenauer, 1984; Agnew's, 1985, from whom
purchased by Paul Mellon.

Exhibitions: BFAC 1937, no. 14.

References: Dubuisson and Hughes, 195;
Shirley, 93, pl. 40.

Yale Center for British Art, Paul Mellon
Collection (B1986.29.1)

The painting may have been a commission from
Louis Comte de Pourtalès-Gorgier, who, with
Bonington, contributed drawings to J.-F.
d'Ostervald's *Voyages pittorsques en Sicile* (1822),
and who was a patron of several artists in
d'Ostervald's circle. The Pourtalès family, based
at the château de Gorgier near Neuchâtel, but
owning vast properties across the continent,

were staunch royalists with strong Franco-
Prussian alliances. D'Ostervald also descended
from a distinguished Neuchâtel family, and it is
likely that some of Bonington's earliest contacts
among the French aristocracy were a
consequence of his employment by this Swiss
national.

The beach is that at Trouville, where
Bonington visited on several occasions and may
have worked briefly with Eugène Isabey during
a tour of the Normandy and Picardy coasts after
their return from England in summer 1825.
Spencer speculates that the prominence given
the wagon indicated a pressing influence of
Constable's *Haywain*.[1] Without querying
Bonington's admiration for Constable by this
date, it need merely be observed that similar
vehicles, a commonplace of the region, are
conspicuous in Bonington's earliest works. If a
pictorial model were required, the puissant dray
horses of Géricault's later works seems more
appropriate. The latter's representations of
horses were among the most coveted of his
graphic productions within Bonington's circle.[2]

1. Thomas Agnew & Sons, *Sir Geoffrey Agnew, 1980–
1986* (London, 1988), no. 1.
2. At about this time Colin actually drew for
Bonington's publisher Feillet six lithographic copies of
Géricault horse and animal studies.

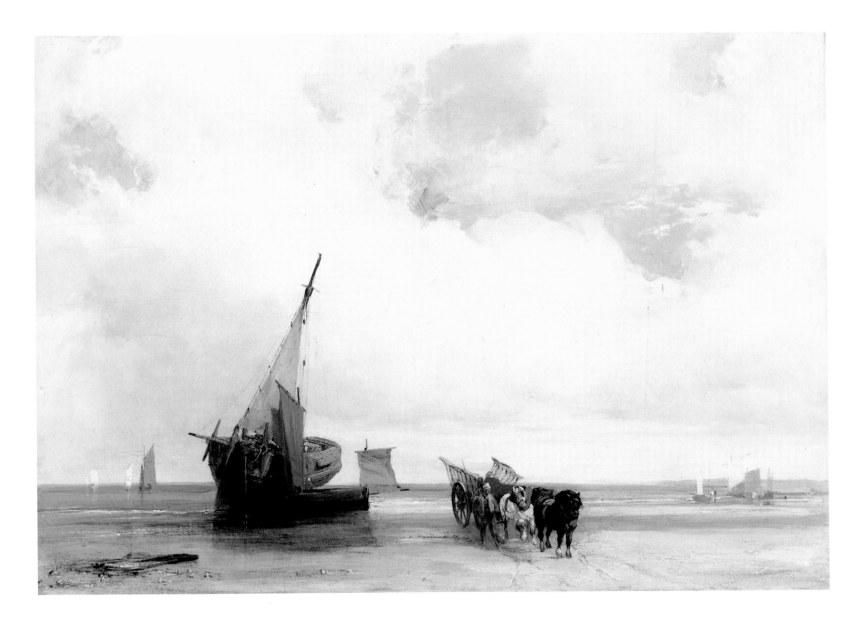

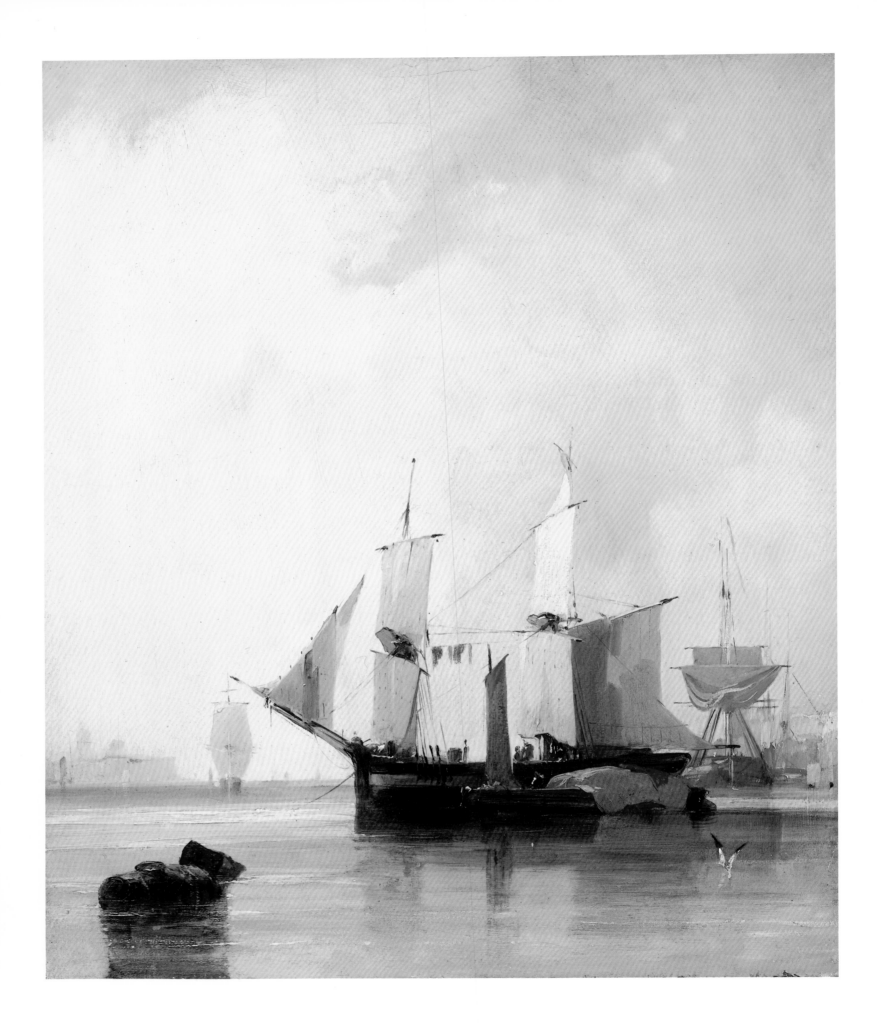

45

SHIPS AT ANCHOR ca.1825
Oil over graphite on millboard affixed to canvas,
$14\frac{1}{8} \times 12\frac{1}{16}$ in. (35.8 x 30.7 cm.)

Provenance: Joseph Gillot[1] (Christie's, 19 April
1872, lot 176, as *Entrance to a harbor with shipping
at anchor*, bought Agnew's); Messrs. Murrieta
(Christie's, 30 April 1892, lot 62, bought
Agnew's for G. Holt); Emma Holt Bequest,
Sudley Art Gallery, 1944.

Exhibitions: Nottingham 1965, no. 251.

References: Pointon, *Bonington*, fig. 55.

Trustees of the National Museums and Galleries
on Merseyside (Sudley Art Gallery)

The port scenes of Van der Cappelle or the Van
de Veldes are most frequently invoked in
discussions of this picture, which Bonington
painted shortly after returning from London.
The taut, precise modeling relate it directly to
Beached Vessels Near Trouville (no. 44); but by a
strict vertical and horizontal application of his
brush above and below the low horizon line,
Bonington effortlessly suggests a limitless
expanse of sea and sky beyond the more narrow
confines of his smaller upright panel.

John Mundy has identified the foremost ship
as a coastal trader of brig tonnage,[2] which
indicates that the port, unidentifiable
otherwise, was a commercial center of some
importance.

1. Gillot, a Birmingham architect, amassed an
impressive collection of modern British art. Although
especially fond of Turner, he owned eight Bonington
oils. The Gillot archives belong to the Getty Trust; see
J. Chapel, "The Turner Collector: Joseph Gillot, 1799–
1872," *Turner Studies* 6: 43ff. In 1866 Gillot paid the
animalier Thomas Sydney Cooper £10 for painting
figures into a Bonington landscape.
2. Letter in the documentation files at the Walker Art
Gallery.

46

UNKNOWN NINETEENTH-CENTURY,
possibly EUGENE ISABEY (1803–1886)

A FRENCH PORT ca.1825
Oil on millboard, 11³⁄₈ × 13³⁄₈ in. (28.8 × 34 cm.)

Inscribed: Verso: R. Davy label; in graphite: *No 4*

Provenance: Baron Nathaniel de Rothschild;
Baron Henri de Rothschild; Jacques Guerlain,
from whom purchased by Paul Mellon.

Yale Center for British Art, Paul Mellon
Collection (B1981.25.59)

Even a cursory stylistic comparison of this
picture, traditionally attributed to Bonington,
to the harbor scene of identical, but vertical,
dimensions at Sudley (no. 45) should assuage
any doubts that these oils are by different
hands. The Yale oil is a plein-air sketch,
whereas the latter is a finished picture. Whether
it was painted outdoors is ultimately moot.
To this point in his career, Bonington appears
to have relied entirely on watercolors as
preparatory studies for finished oils. He was
fully capable of dispatching *en premier coup* a
composition of these dimensions. Bonington
began to paint outdoors in oils in 1825, but
there is no measurable distinction in style
between the Sudley picture, the views near
Rouen (no. 55) or at Fontainebleau (no. 52),
the studio exercise of *Beach at Trouville* (no. 44),
or a later study from the motif near Genoa (no.
104). In each instance the work is marked by a
spatial expansiveness that proceeds from perfect
tonal control and a precision of formal definition
which are consistent regardless of the haste
with which Bonington touches down his
pigments. To the extent that execution is any
indicator, what distinguishes a "sketch" from
a "finished" picture is usually a nominal
difference in the elaboration of details.

For all its panache, the Yale panel comes
short of this expected control and acuity. The
definition of the craft and of the foreground
buoy or barrel — the fact that it is unreadable
is significant — is slack, and the sky is a
meaningless smear of impasto. That it was
painted by a professional conversant with
Bonington's style of ca.1825 is not disputed;
that it was painted on the same millboard
which Bonington discovered in England and
used repeatedly thereafter encourages
speculation that its author was possibly
someone with whom Bonington had traveled in
England. One candidate is Eugène Isabey, who,
on other evidence, also appears to have
accompanied him on tours of the Normandy
coast immediately after their return from
London and in subsequent years. It is possible
that the same hand painted three smaller
marine sketches, all on millboards, of which at
least two were attributed to Bonington in the
posthumous sale of Lord Henry Seymour's
collection.[1] A Seymour provenance is invariably
accepted as a cachet of authenticity;
nevertheless, seriously challenging this
assumption are the ludicrously low prices paid
for these oils in comparison to prices for other
Boningtons in the sale (in particular, the
watercolors, which were described at the time
as substantially faded), their style, and the
recent rejection of two other "Bonington"
pictures with traditional Seymour provenances:
Bergues: Market Day (Wallace Collection; also in
Seymour's sale) and *A Beached Vessel* (Stanford
University Art Museum).[2]

The problem of attributing any of these
sketches to Isabey is that too few of his oils
from the mid-1820s have been identified with
certainty. Two separate accounts cited in full
by Pierre Miquel[3] suggest that this artist,
prompted by Bonington and Camille
Roqueplan, launched his highly successful
career as a marine painter in 1821. One early
harbor scene of 1822 (Musée Rigaud, Perpignan)
is remarkably proficient and in the Anglo-Dutch
manner of Bonington, Gudin, Léopold Leprince,
and others of their circle. In 1824 he exhibited
at the Salon a frame of small marines
(untraced), which Auguste Jal preferred to
Bonington's pictures. His first important
public appearance, at the Salon of 1827–28,
included five oils (untraced), of which two
were views at Trouville. His more numerous
signed watercolors of 1824–27 are often
indistinguishable stylistically from Bonington's,
but by the end of the decade he had evolved the
more energetic and polished style for which he
is best remembered (no. 150).

1. Private Collection; Sotheby's, 6 July 1983, lot 259;
and National Gallery of Victoria, Melbourne
(Nottingham 1965, no. 261, pl. 30).
2. Ingamells, *Catalogue* 1: 72. The Stanford picture is
reproduced by Peacock, pl. 3.
3. Miquel, *Isabey*, 34–35.

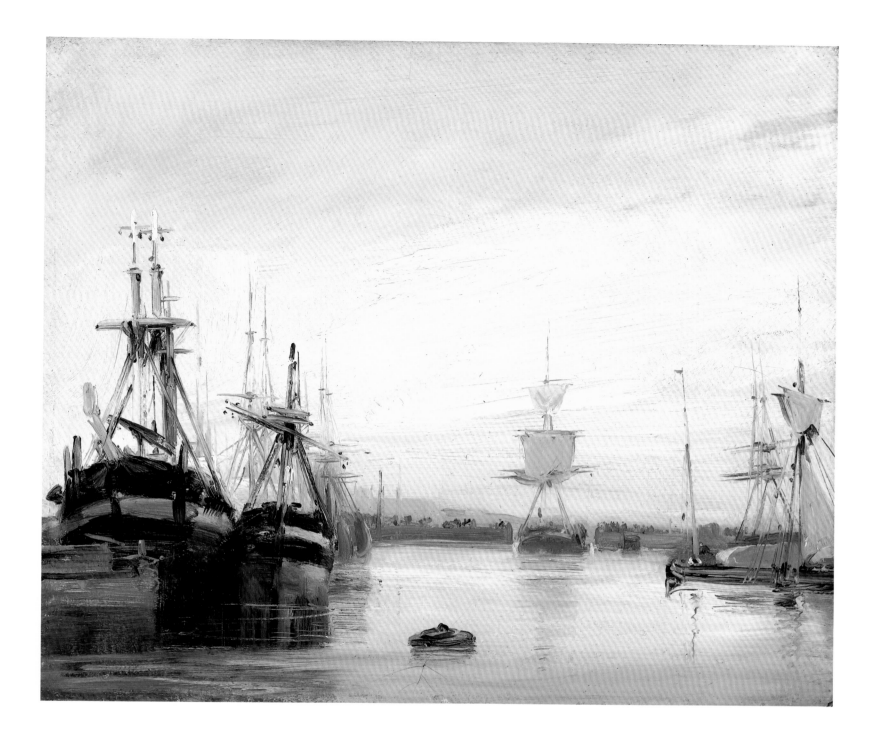

47

RIVER SCENE — SUNSET ca.1825
Oil on millboard, $10\frac{3}{4} \times 12\frac{3}{4}$ in. $(27.3 \times 32.5$ cm.)

Provenance: Probably given by the artist in 1825 to Joseph West, from whom acquired by George Cooke in 1830; John Sheepshanks, by whom bequeathed to the Victoria and Albert Museum in 1857.

Exhibitions: Possibly London, Cosmorama Rooms, 209 Regent Street, 1834, no. 54, as *View on the Seine*; Nottingham 1965, no. 257; Pointon, *Bonington*, no. 24.

Victoria and Albert Museum (FA 1)

A graphite study, *Distant View of Dunkerque* (Nottingham), with a similar disposition of trees and rectilinear tower, anticipates this composition and was drawn in Francia's company either in 1824 or August 1825.[1] The later date seems more likely since the drawing style is identical to that of the graphite studies made in the vicinity of St-Omer (Bowood) immediately after Bonington's return from London. A lithograph by Paul Huet reverses the composition of a Bonington watercolor derived from this graphite sketch.[2] The river in the oil, however, is far too broad to be any in this region and was obviously enlisted as a device for reflecting a sunset. The composition of this unfinished sketch is, therefore, almost certainly a recollection rather than a study from nature — a recollection perhaps of the terrain in the vicinity of St-Omer, but, more to the point, of Turner's river views or the classicizing topographical compositions of John Varley and other senior British watercolorists then exhibiting in London. As an imaginary composition, it may be the earliest of a series of landscapes of late 1825 and early 1826 in which Bonington arranged the stock motifs of a few silhouetted trees, a canal or river, and a distant tower in a variety of combinations and lighting conditions and which may or may not be identifiable sites.

As argued by Marcia Pointon, this may be the picture given by the artist Joseph West to the engraver George Cooke in 1830 and subsequently sold by him to John Sheepshanks. Bonington probably disposed of this study in fall 1825, when he is known from other documentation to have given West several drawings. Somewhat surprising is that George Cooke did not own any Boningtons prior to his acquisition of this work, since in 1840 his nephew W. J. Cooke sold at Sotheby's nineteen drawings and watercolors and one oil titled *View on the Medway*, which was purchased by his brother-in-law Thomas Shotter Boys (see no. 164). Bonington had met the Cookes in London in 1825 through an introduction from the engraver Abraham Raimbach, who had requested of W. B. Cooke that he arrange for Bonington and Colin to visit the collections of Walter Fawkes and Sir John Leicester, two of Turner's most important patrons. Engravings by the Cookes after Bonington watercolors first appear the following autumn, and a Bonington portrait of W. J. Cooke was recorded in the 1834 Cosmorama exhibition. Of the many engravings after Turner by, or published by, the Cookes, the following were listed in Bonington's 1834 studio sale: india proofs of *Views in Sussex* (London, 1816–20); the *Rivers of England* (London, 1823–27), also with prints after Girtin; and *Marine Views* (London, 1825; see no. 48). It is likely that Bonington acquired all of these prints while in London in 1825 and at the same time examined many of the original watercolors for them.

It is not known when precisely West met Bonington, but he was one of an ever-widening circle of younger admirers that included Boys, William Ensom, Frederick Tayler, Jules Joyant, and Charles Gleyre, with whom Bonington developed a casual teacher-student relationship in Paris. West's studio sale in 1834 disposed of 148 lots of drawings, watercolors, and oils copied from the same old master paintings and engravings that had attracted both Bonington and Delacroix from 1825 onward.[3] His original watercolor compositions, such as a *Romeo and Juliet* (National Gallery of Scotland), might easily pass for the work of Bonington and with equal skill unabashedly incorporate figures lifted from these sources.[4] A watercolor thought to be a depiction by Bonington of his own living quarters is actually by West.[5]

1. For Francia's study from a similar spot, see Calais, *Francia*, no. 81.
2. Delteil, *Huet*, no. 80.
3. An album of 465 such copies by West, formerly in the collection of his patron Lord Northwick, was at Sotheby's 9 March 1989, lot 3. Several hundred multiple lots of oil and watercolor studies after old master paintings in major European galleries were sold by West at Christie's, 6–7 June 1834.
4. In this instance, from a Tiepolo etching.
5. Pointon, *Circle*, fig. 18, where attributed to Bonington.

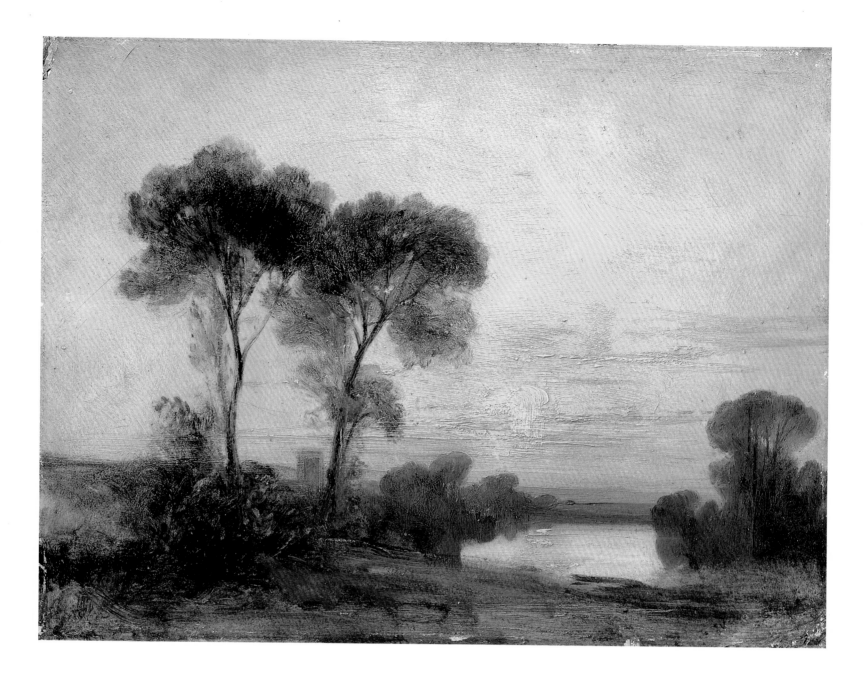

JOSEPH MALLORD WILLIAM TURNER
(1775–1851)

MARGATE FROM THE SEA: WHITING
FISHING 1822
Watercolor, bodycolor, gum arabic, scraping
and rubbing out, $16\frac{7}{8} \times 25\frac{7}{8}$ in. (43 × 65.7 cm.)

Inscribed: Signed and dated, lower left:
J M W Turner RA 1822

Provenance: W. B. Cooke; B. G. Windus;
Mrs. Fordham; Mrs. Henry Folland (Christie's,
5 October 1945, lot 5); Robert Slack, from
whom purchased by the Yale Center for British
Art in 1980.

References: Wilton, *Turner*, no. 507.

Yale Center for British Art, Paul Mellon Fund
(B1980.31)

Paul Huet observed that Bonington's landscape
painting was indebted to the English school but
especially to Turner, "of whom he spoke
constantly."[1] Parallels can be made between
Bonington's early marine paintings and
Turner's inventions, but any stylistic
similarities are almost certainly coincidental in
works dating before Bonington's first trip to
London in 1825.[2] The consequences of his initial
contact with Turner's painting was an
intensification of his coloring, a diversification
of his subjects, and an experimentation with
previously untried watercolor techniques.

In addition to works by Turner in private
collections, Bonington had access in 1825 to a
number of watercolors then in the possesion of
the Cookes. These included *Margate from the
Sea*, which was one of a series of marine
watercolors commissioned by W. B. Cooke
between 1822 and 1824. Cooke's intention to
publish a set of engravings from these never
materialized, but two mezzotints by Thomas
Lupton after *Margate from the Sea* and an
untraced watercolor, *Eddystone Lighthouse*, were
issued in 1825 and were in Bonington's
collection at his death.

1. Huet, *Huet*, 96.
2. For instance, Bonington's composition of *Fishing Boats Becalmed at Sunrise*, known from a lithograph (Curtis, no. 14) deposited with the censors in June 1824, and from a watercolor copy (Spink and Sons, 1989), probably by a member of the Nöel family, who published the print.

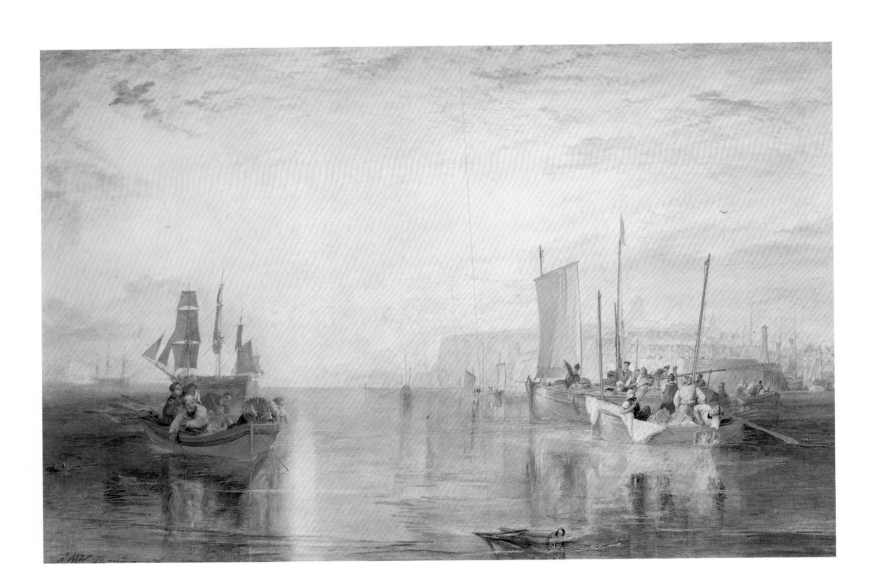

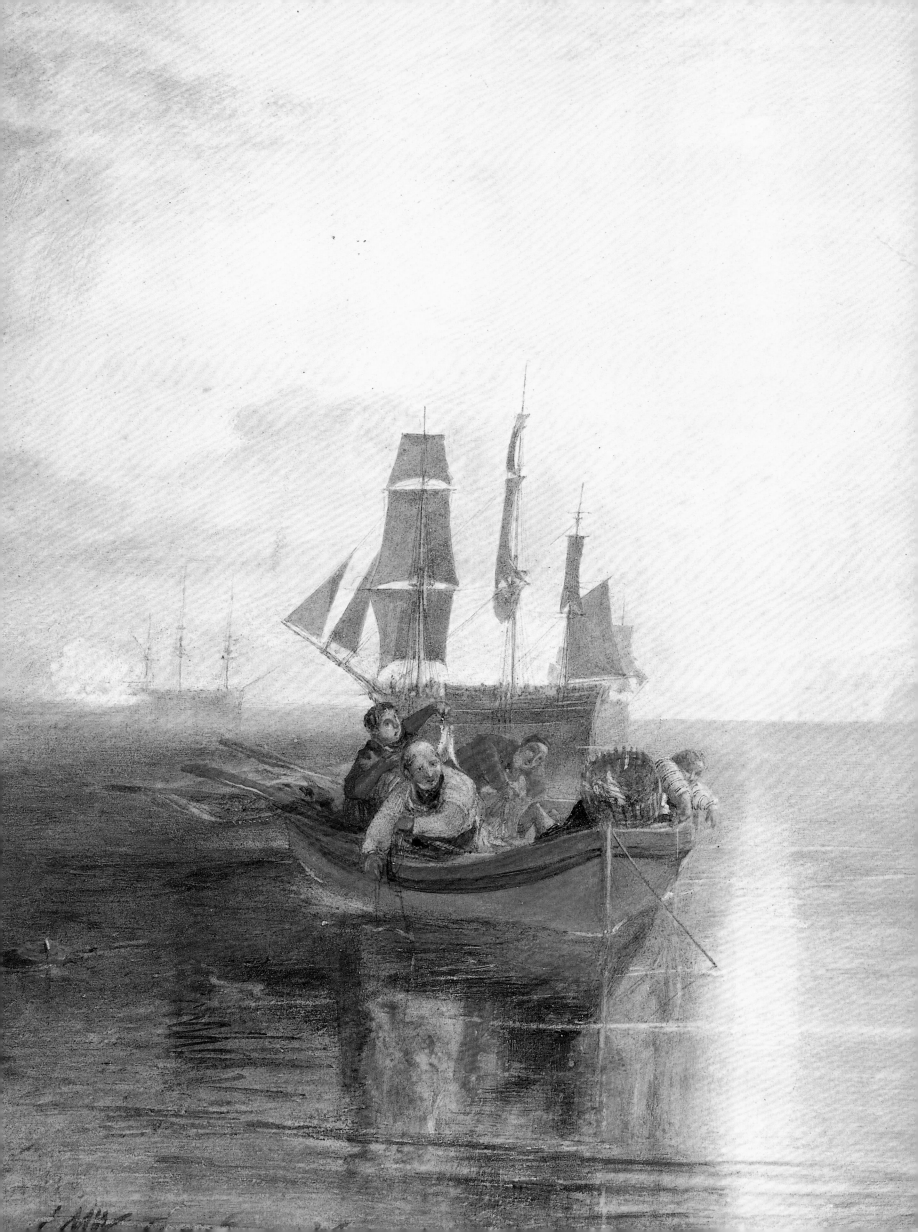

PICARDY COAST WITH CHILDREN —
SUNRISE ca.1825
Oil on canvas, 17 × 21 in. (43 × 53.2 cm.)

Provenance: Purchased from the artist at the
British Institution in 1826 by Sir George
Warrender (1782–1849) (Christie's, 3 June
1837, lot 15); Marquis Maison, Paris, from
whom acquired by Henry McConnel of
Cressbrook, Derbyshire (Christie's, 27 March
1886, lot 46, bought Agnew's); Sir Charles
Tennant, by 1891, and by descent to Sir Colin
Tennant (Sotheby's, 14 March 1984, lot 82,
bought Agnew's).

Exhibitions: London, British Institution, 1826,
no. 242, as *French Coast Scenery*.

References: *Literary Gazette* (4 and 18 February,
and 1 April 1826); *La Belle Assemblée* (March
1826); Harding, *Works* (1830); Dubuisson and
Hughes, 150, 197; Shirley, 30–31, 145.

Private Collection

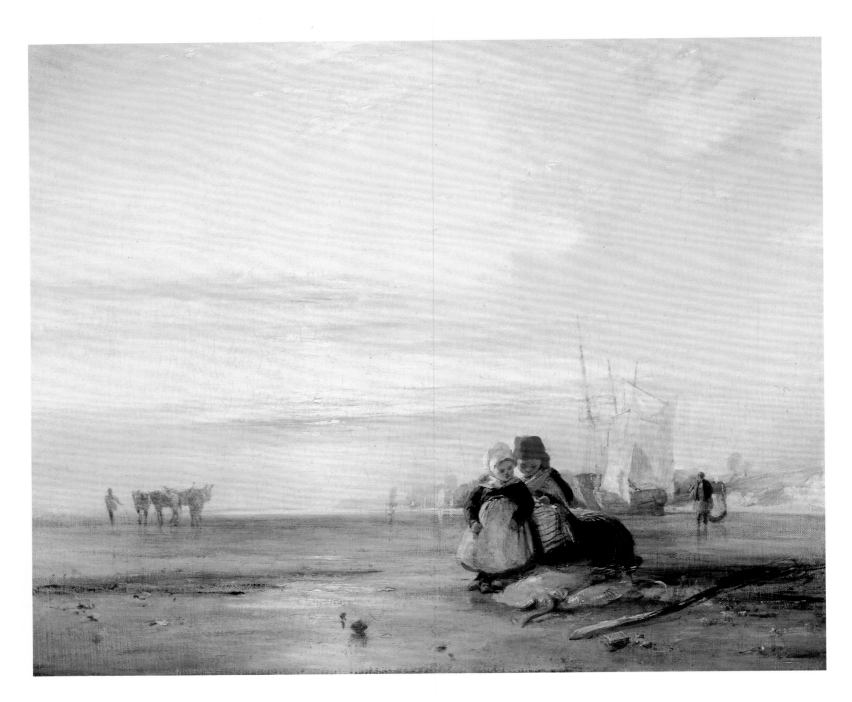

The annual exhibition of the works of living artists opened at the British Institution on 2 February 1826. With the recollection of the preceding year's show still fresh and with the encouragement of the artists and collectors he had met during his visit, Bonington decided to make his professional debut in London with two marine paintings, *French Coast with Fishermen* (untraced), which the Countess de Grey purchased, and this *Picardy Coast with Children — Sunrise*. It has become entrenched in the Bonington myth that these pictures were initially misattributed by the critics to William Collins, who painted similar subjects, but there is no evidence of this, and the first published review, in the *Literary Gazette* two days after the exhibition opened, made no such error in reporting authorship:

256. French Coast (also 242) R. P. Bonnington — Who is R. P. Bonnington? We never saw his name in any catalogue before and yet here are pictures which would grace the foremost name in landscape art. Sunshine, perspective, vigour; a fine sense of beauty in disposing of the colours, whether in masses or in small bits; — these are extraordinary ornaments in the rooms.

A second flattering appraisal followed on 18 February:

256. Few pictures have more skillfully expressed the character of open sunny daylight than the one under notice; and we have seldom seen an artist make more of the simple materials which the subject afforded. With a broad unfinished pencil, he has perceived the character of his figures and accessories; also a splendid tone of colour, glowing and transparent.

By the close of the exhibition on 20 May, Bonington had attracted the notice of numerous influential collectors, including Sir George Warrender, who purchased this oil, the Marquess of Lansdowne, who commissioned a version of it (no. 76),[1] the Earl Grosvenor, and the Duke of Bedford.

The distant town has not been identified, but the topography suggests the environs of Calais or Dunkerque. The richer color mixing in the sky and water, with their striations of ochre, sienna, blue, pink, yellow, and impasted white, and the wispy cloud formations tinted by this mélange are overtly Turnerian.

1. An oil on panel exhibited BFAC 1937, no. 8, as a study for the British Institution exhibit is a reduced replica by an anonymous hand probably based on Harding's lithograph.

50

COAST OF PICARDY WITH FISHERFOLK —
SUNSET 1825
Oil on canvas, 22 × 33 in. (55.9 × 83.8 cm.)

Inscribed: Signed and dated, lower right:
R P Bonington 1825

Provenance: Purchased from the artist in Paris in
1826 by or for the 2nd Earl Grosvenor, and by
descent.

Exhibitions: BFAC 1937, no. 43.

References: Waagen 1838, 2: 318; Mrs. Jameson,
*Companion to the Most Celebrated Private Galleries of
Art* (London, 1844), 275; Thoré, 1867, 7, repr.
as a wood engraving by Sargent; Dubuisson and
Hughes, 127, 157; Shirley, 96.

By Kind Permission of His Grace
The Duke of Westminster DL

This composition, with its prominent
foreground figures casually assessing the day's
bounty as if blissfully immune to the upheavals
of modernity, would become Bonington's most
popular formula among British collectors.
Although abraded, the final digit of the
inscribed date appears to be a 5. That is also the
date on a nineteenth-century oil copy (Private
Collection) and in C. G. Lewis's reproductive
engraving of 1836. The painting is, then, the
most ambitious and probably the earliest
example of this compositional type, and while
Turner inevitably and properly emerges as a
stylistic reference for the unusually dramatic
treatment of the landscape, other English
artists were equally adept at portraying such
effects. Bonington and his French colleagues
had carefully planned their trip to London to
coincide with the three major exhibitions at
the British Institution, the Royal Academy, and
the Society of Painters in Watercolours, which
between them offered a survey of the entire
spectrum of English landscape naturalism.

Graphite studies for the geese are at Bowood,
and a rapid sketch of three women in a related
grouping is at Nottingham.

The picture was acquired in 1826,
presumably from the artist's stock, by the Earl
Grosvenor, who annually expanded his already
celebrated picture gallery with purchases from
living painters. Like other directors of the
British Institution, he was quick to respond
to the sensation caused by Bonington's first
appearance there.

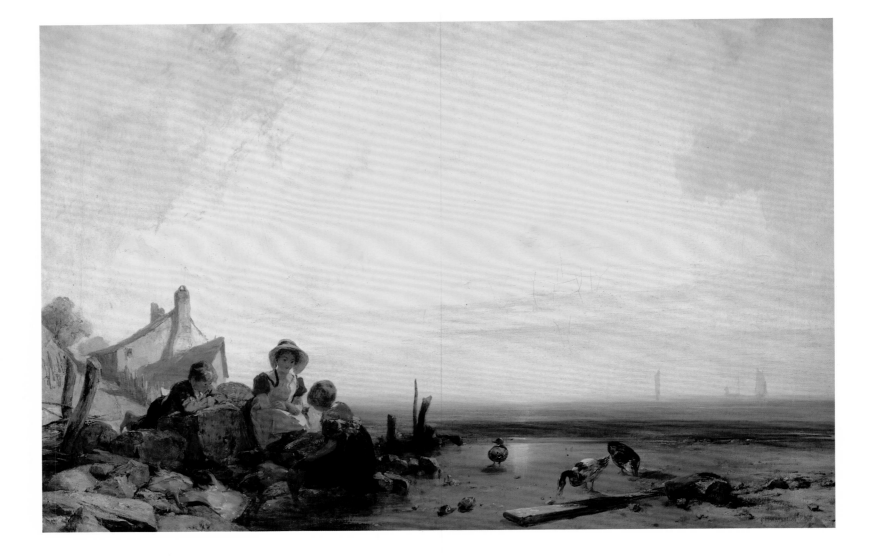

51

VIEW ON THE SEINE ca.1825
Oil on millboard, 12 × 15¾ in. (30.5 × 40 cm.)

Inscribed: Verso: red wax atelier stamp and an R. Davy label

Provenance: Possibly Bonington sale, 1834, lot 147; Prince Anatole Demidoff (San Donato sale, Paris, 21–22 February 1870); ? Joseph Gillot[1]; James Orrock, 1904; Viscount Leverhulme (Christie's, 17 February 1926); Mrs. Lincoln Davis, Richmond, by whom presented to the Virginia Museum of Fine Arts in 1962.

Exhibitions: London, Cosmorama Rooms, 209 Regent Street, 1834, no. 25 or 28; Nottingham 1965, no. 258.

Virginia Museum of Fine Arts, Richmond, Gift of Mrs. Lincoln Davis in memory of her son George Cole Scott on behalf of the family (62.18)

After the trip to London, Bonington's interests began to drift from the tranquil marines that had been his mainstay to equally serene twilight views along the lower reaches of the Seine. Always a serial painter working a particular theme in myriad variations until he had exhausted its potential, Bonington would concentrate on this new preoccupation until it, in turn, was supplanted by Venice. The change in subject matter may owe something to his growing friendship with Paul Huet and to his ongoing investigations of Dutch landscape, but, as Cormack first noted,[2] the *contre-jour* effects, the feathered foliage of the wispy trees, and the more dramatic chiaroscuro and coloring of many of these river views were an immediate consequence of his first substantive encounter with Turner's oils and watercolors. The impact of such free interpretations on his French contemporaries, especially Huet, whose enamorment with Turner was at this date based almost exclusively on engraved reproductions, can not be overestimated, nor, for the subsequent development of French landscape painting, ignored.

1. Spencer lists Gillot in the provenance, but this was not one of the eight Boningtons recorded in his major sale at Christie's, 19 April 1872.
2. Cormack, *Review*, 287.

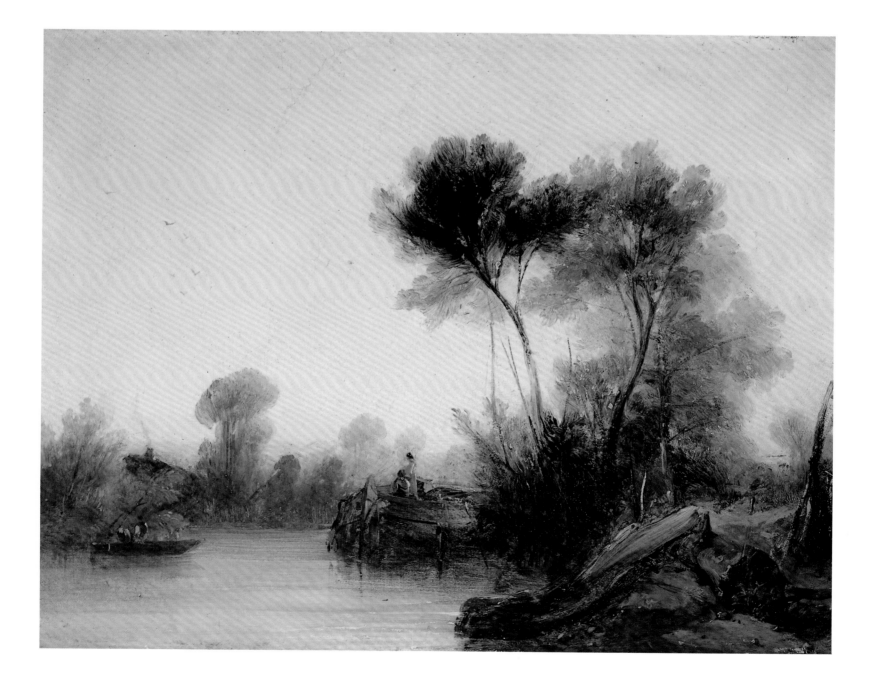

IN THE FOREST AT FONTAINEBLEAU ca.1825
Oil on millboard, 12¾ × 9½ in. (32.4 × 24.1 cm.)

Inscribed: In pen and ink on a paper label, verso:
*Sketch in the Forest of Fontainebleau by R. P.
Bonington from the collection of Mr. Carrier,
painter to the Duke of Condé and a fellow student
of Bonington from whom he received this sketch.*
[illegible signature]; verso: two red wax atelier
seals

Provenance: Possibly given by the artist or his
parents to Auguste-Joseph Carrier (1800–1875);
Fenton (Christie's, 17 April 1846, lot 33,
bought in); Roger Fenton (Christie's, 7 May
1900, lot 103, bought Colnaghi); Sir Evan
Charteris, by 1937, and by descent to Hon.
Mrs. George Dawney (Christie's, 22 November
1968, lot 97, bought Paul Mellon).

Exhibitions: BFAC 1937, no. 12; Agnew's 1962,
no. 33; Nottingham 1965, no. 250.

References: Shirley, 102; Ingamells, *Bonington*,
n.10; Noon, *Review*, repr.

Yale Center for British Art, Paul Mellon
Collection (B1981.25.55)

Although this plein-air sketch is painted on
Davy millboard of the type Bonington seems to
have discovered while in London, both Spencer
and Cormack have dated the work prior to
Bonington's English trip. There is no stylistic
justification for this, however, and a date of
mid- to late 1825 is perfectly appropriate.

With its picturesque topography and
proximity to the château constructed by
François Ier, the forest at Fontainebleau was
attracting ever-increasing numbers of landscape
painters in the 1820s. This picture is the only
evidence of Bonington's interest in its rugged
terrain.[1] More common are the oil sketches by
artists of his acquaintance like Camille Corot
and Léopold Leprince.

A.-J. Carrier, the presumed original owner
of this study, was Bonington's intimate friend
from their student days. He would become
a distinguished painter of portrait miniatures.
His brother was the physician who attended
Bonington in 1828. The attestation on the verso
of the picture may not be entirely accurate. The
wax atelier stamp, two impressions of which are
also on the verso, generally appears on pictures
that were in the artist's studio at his death;
however, no oil of this description was sold in
any of the studio auctions. Furthermore, the
stamp was not used to mark every picture in
the studio, and it is not even clear that it was
a proper atelier stamp. It could have been the
artist's own letter seal, employed by himself,
on occasion, and later by his family, more
frequently, to authenticate unsigned pictures.
Nevertheless, for Bonington to use it on a
sketch that he was giving to a close friend
seems uncharacteristically ceremonial, and it
is more likely that Carrier, or his brother,
received the picture from Bonington's parents
in gratitude for their assistance during the
artist's final illness.

1. A related graphite drawing is in a private collection
but should not be taken as a preparatory study;
Peacock, *Bonington*, 32, repr.

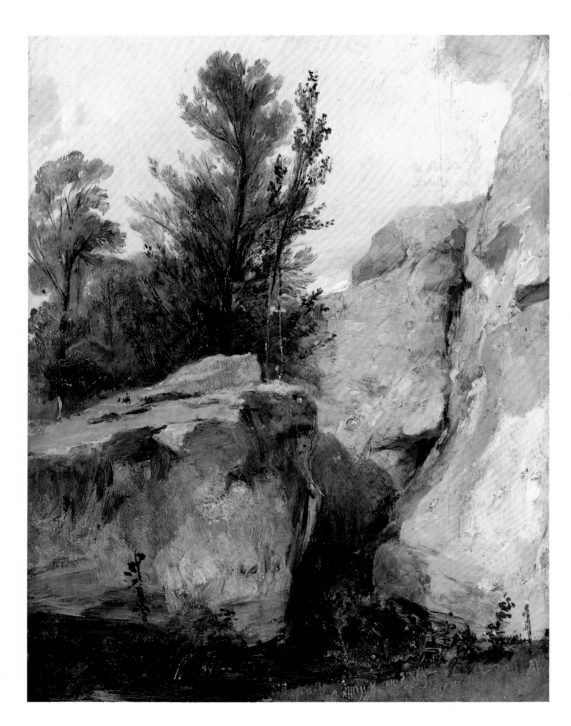

53

A WOODED LANE ca.1825
Oil on millboard, 11 × 9 in. (28 × 22.8 cm.)

Inscribed: Verso: black wax atelier stamp and R. Davy label

Provenance: Possibly James Carpenter, 1829; anonymous French collection until 1962, when purchased by Paul Mellon.

References: Possibly Harding, *Works* (1829); Cormack, *Bonington*, 105.

Yale Center for British Art, Paul Mellon Collection (B1981.25.51)

A nineteenth-century version of this composition, which an anonymous artist probably improvised from Harding's lithograph, was formerly in the Mellon Collection.[1]
A second replica, with more compelling stylistic claims to authenticity, is in the Stäatliche Kunsthalle, Karlsruhe. Sketched on its verso is a Teniers-like fragment of dead fowl and a pointer's muzzle.

Although the attribution of the Yale version has been queried, it is sufficiently close in handling to other Bonington oils of late 1825 to be considered autograph. Cormack proposed the influence of Constable in the subject and the manner in which the light slices through the foliage at left, but a more immediate source would be Paul Huet, who was especially fond of this format and rustic subject matter and whose vivid and decidedly rococo palette is most evident in Bonington's picture.

1. Sotheby's, 18 November 1981, lot 141.

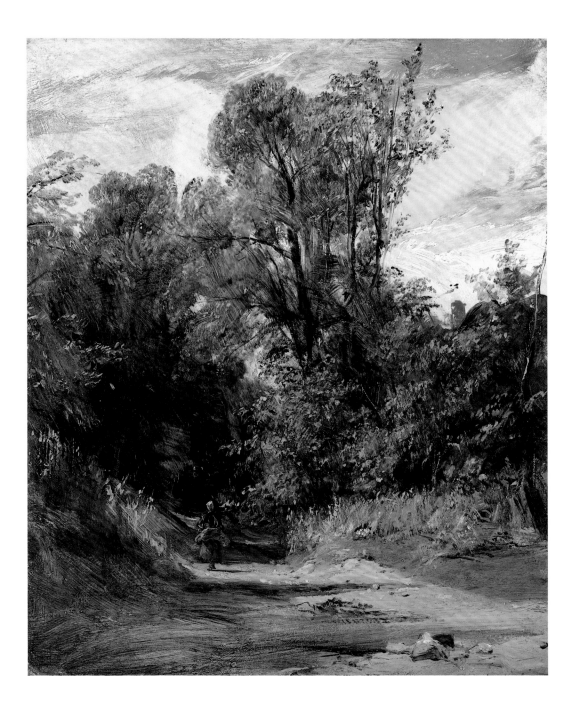

ROUEN WITH THE TOWER OF ST-OUEN —
SUNSET 1825
Watercolor over graphite, with scratching out,
$6\frac{7}{8} \times 9\frac{1}{4}$ in. (17.4 × 23.5 cm.)

Inscribed: Signed and dated, lower left: *RPB 1825*

Provenance: Dreux, 1850; Jullien; Henri
Marillier[1]; Percy Moore Turner, by 1940; (Fine
Arts Society, 1942); Miss M. Pilkington, by
whom donated to the Whitworth Art Gallery
in 1946.

Exhibitions: BFAC 1937, no. 102; Nottingham
1965, no. 209, pl. 7; Jacquemart-André 1966,
no. 31.

References: *Les Artistes Anciens et Modernes* 1
(1850), lithograph by F.-L. Français; Shirley,
101, pl. 80.

Whitworth Art Gallery, University of
Manchester

A reproduction of this drawing was incorrectly
described as *Environs de Mantes* in the suite of
six lithographs by Jaime, after Bonington,
published by d'Osterwald in 1829. The profiles
of the distant churches are unmistakeably those
of St-Maclou on the left and St-Ouen in the
center, although this view from the vicinity of
Ile Lacroix takes considerable liberties with the
actual topography of Rouen. Of the same date
and conveying the same late-summer evening
effect is the watercolor *View of Rouen* (Wallace
Collection).

1. Watercolors of this title are recorded in the sales of
David White (Christie's, 18 April 1868, lot 502) and
Thomas Woolner (Christie's, 21 May 1895, lot 73).
An anonymous watercolor copy is in the National
Museum of Wales.

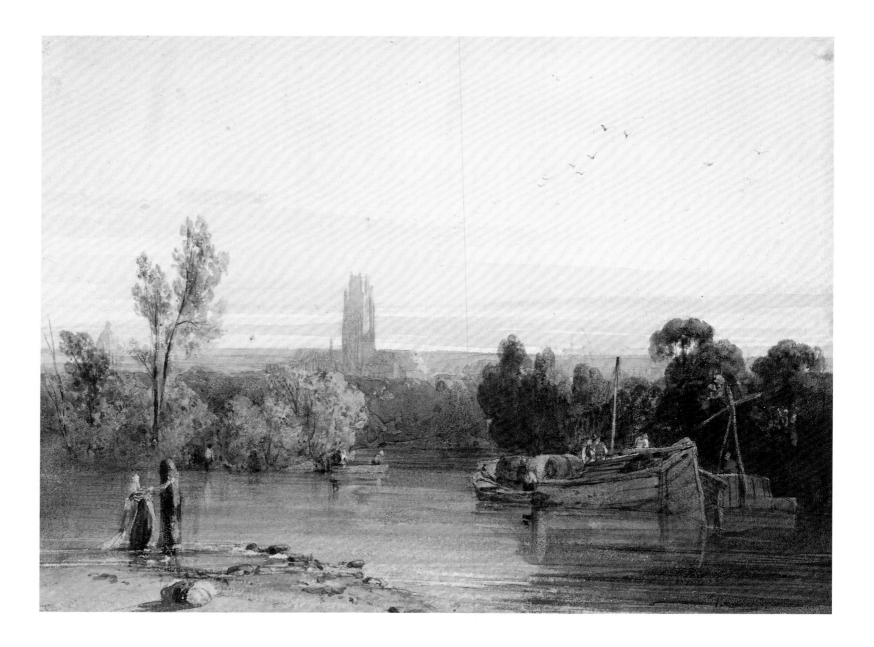

55

NEAR ROUEN ca.1825
Oil on millboard, 11 × 13 in. (27.9 × 33 cm.)

Provenance: Bonington sale, 1834, lot 139, bought
2nd Earl of Normanton.

Exhibitions: London, Cosmorama Rooms, 209
Regent Street, 1834, no. 33; Agnew's 1962,
no. 15; Nottingham 1965, no. 259, pl. 27.

References: Miquel, *Huet*, 1965, 11, as by
Paul Huet.

Private Collection

Pierre Miquel has attributed this picture to Paul
Huet, but it is unquestionably by Bonington.
Its composition is of a type particularly favored
by Huet at this time (see no. 56), and it is
somewhat less restrained in execution than
might be expected from Bonington; however,
it exhibits a disciplined touch and a precision
of observation beyond Huet's interests or
capacities. Furthermore, the picture was sold at
the 1834 studio sale as a Bonington, and
comparison with the oils *A Wooded Lane*
(no. 53), also a Huet-inspired composition, and
the *Forest at Fontainebleau* (no. 52), both of
which were painted in fall 1825, validates the
traditional Bonington attribution. A plausible
explanation for this pictures's affinities to
Huet's style is that these two young painters
were working side by side in 1825. Studies by
both from the same motifs at Rosny-sur-Seine
and at Roche-Guyon (see no. 63) suggest that
they made a joint excursion down the Seine to
Rouen in the fall.[1]

1. Huet's watercolor view of the château at Rosny is
in the Louvre (Département des Arts Graphiques);
Pointon, *Circle*, fig. 3. Bonington's view, from a slightly
different angle, is known from a watercolor in the
British Museum and an oil version in a private
collection. The watercolor version is the most
problematic in that its execution indicates a professional
hand, yet its style is neither that of Bonington nor of
Huet.

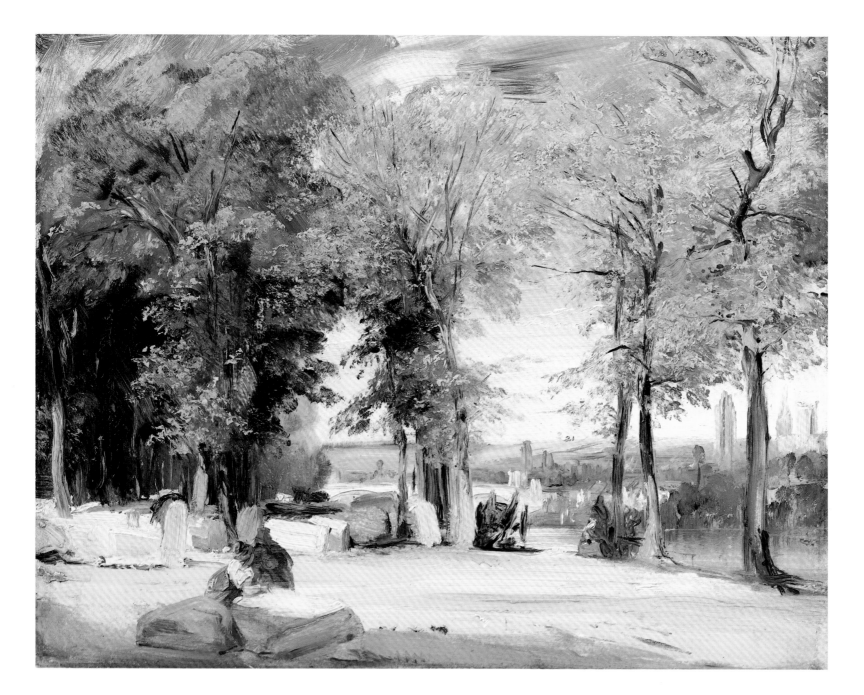

PAUL HUET (1803–1869)

INTERIOR OF THE FOREST AT
COMPIEGNE ca.1824
Oil on canvas, $8\frac{5}{8} \times 10\frac{5}{8}$ in. (21.5×26.5 cm.)

Provenance: René-Paul Huet, by whom donated
to the Musée du Louvre in 1896.

Musée du Louvre, Département des Peintures
(RF 1060)

Paul Huet was born in Paris in the same year
as Eugène Isabey. Of the French artists who
helped launch the new style of naturalistic
landscape in the early 1820s, he was possibly
the most influential, yet the least acknowledged
in subsequent literature. After a brief stint with
Guérin, he enrolled with Gros in 1820, but his
attendance at the atelier was sporadic as he
preferred to pursue his landscape studies at the
home of his friend Lelièvre on the Ile Seguin, at
St-Cloud, and in Normandy. While drawing at
the Académie Suisse in November 1822,
he met Delacroix, who from that moment
remained a devoted and generous supporter.

His acquaintance with Bonington began in
1820, but their friendship does not appear to
have set until 1825. The indelible impression on
Huet of the English landscapes shown at the
1824 Salon, as well as their mutual interests in
Walter Scott and Dutch, Flemish, and rococo
painting, inevitably drew these two sensibilities
together. Huet later recalled his fellowship with
Bonington as the fondest memory of his youth.
They seem to have traveled from Paris together
in fall 1825 at least as far as Rouen, where Huet
had relations, and subsequent sketching tours
are likely, although only one is documented —
a rendezvous at Trouville in 1828 that was
canceled owing to Bonington's failing health.

Of the eight paintings submitted by Huet to
the 1827 Salon jury, only one was accepted for
exhibition. Through the interventions of his
friends — Bonington, Delacroix, Hugo,
Roqueplan, Auguste, S. W. Reynolds,
Alexandre Dumas, and Saint-Beuve[1] — Huet
was able to endure the financial vicissitudes and
the emotional enervation occasioned by official
hostility to his early work. In the 1830s the
backing of the influential critic Gustave Planche
assured him at least a modicum of public
recognition.

At his death Huet left a quantity of
correspondence and articulate reflections on his
art. His ambitions as a landscape painter were
concisely acknowledged in his autobiographical
recollections to Théophile Silvestre:

*How I wished, with my imagination struck by the
immensity and power of nature, to render those great
spectacles that it constantly unfolded before our eyes, to
express the emotions we feel in penetrating each level of
its mysteries, the charm and melancholy of its
profundities. If art is the expression of an epoque,
perhaps more than anyone else have I borne the
reflection of the unsettled, dreamy and dramatic poetry
of my time.*[2]

In his notes on the art of landscape, he
summarized the historical sources most admired
by his circle in the 1820s: Claude for his
"tender and touching poetry"; Cuyp for the
"transparency and limpidity of his color";
Rubens for discerning character even in the
commonplace; Rembrandt, the "magical poet,"
more intimate, more tormented, who best
captured the anxious spirit of modern times;
Fragonard, who was always seductive; and
Hubert Robert, the "truest landscapist" of the
eighteenth century.[3]

With its impenetrable sylvan screen,
vigorous brushwork, and vibrant pastel
coloring, no. 56 is typical of the plein-air
sketches Huet painted in the mid-1820s as he
groped toward a stylistic synthesis of these
different interests. From 1822 he worked
regularly in the Compiègne forest, and the
present study probably dates to 1824, when he
spent the entire summer there. Like many of
Bonington's closest friends, and all of his
detractors, Huet had immense respect for the
Englishman's talent but an unconcealed distrust
of his facility of touch, probably because that
skill was what the amateurs and collectors of
the period valued most in a picture. Huet's
passionate nature was such that he admitted
difficulty at times in painting directly from the
motif, and, for his finished canvases, he
invariably forced himself to reflect for some
time before commencing a serious commission.
As a consequence his major pictures — *The
Guardian's House in the Forest at Compiègne* (1826;
Private Collection), for instance — are often
grandiose in scale and laboriously worked, much
to the detriment of the original conceptions so
brilliantly promised in studies like this.

Huet's son, René-Paul, took great care in his
biography to discredit the prevailing opinion
that Huet's art was influenced in any way by
Bonington, Constable, or Turner, despite the
artist's own admission that it was English
painting which first showed him how to merge
his naturalistic vision and the poetry of the old
masters. Overt appropriation of stylistic traits
peculiar to Bonington is not to be discerned in
Huet's work, although he did copy far more of
Bonington's watercolors and oils than modern
scholarship has allowed.

1. Delacroix, for instance, employed Huet to paint the
background of his *Portrait of Louis Auguste Schwiter*
(National Gallery, London), while Auguste was
purchasing his pictures at this time.
2. Huet, *Huet*, 6.
3. Miquel, *Paysage*, 196, and Huet, *Huet*, 81ff.

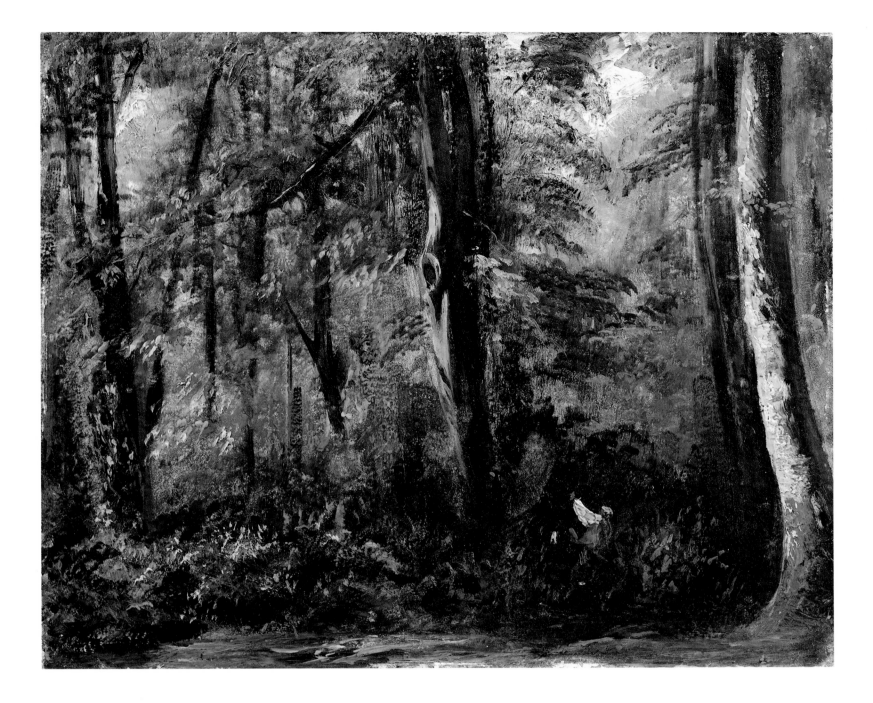

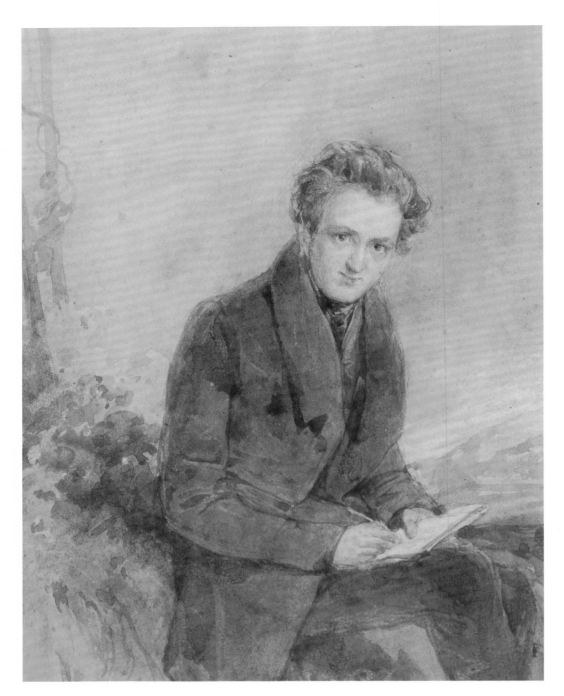

Lami (see no. 5) and Bonington (no. 145), and his taste in literary illustration was essentially that of Bonington's circle. In 1828, he designed with Devéria plates for Bernaud's edition of Béranger's *Chansons* and vignettes engraved in wood by Charles Thompson for an edition of La Fontaine. About the time that Bonington painted this portrait,[3] Monnier began his lifelong friendship with Honoré de Balzac, who claimed to have fashioned the character of his disgruntled bureaucrat Bixiou on the young humorist:

Brittle, aggressive and indiscreet, [Bixiou] *was malicious for its own sake; he especially attacked the feeble, respecting nothing, believing in neither France, nor God, nor art, nor the Greeks nor Turks . . . of small but well-proportioned stature, a fine figure, remarkable for a vague resemblance to Napoleon, thin lips, flat chin falling to the right, 27 years old, mordant voice, sparkling regard . . . a womanizer, smoker, comic and lively socialite . . . but somber and sad when alone.*

Although portraits in oil and in watercolors are recorded in the various sales following the artist's death, and although unconvincing efforts have been made to identify certain of these, it is evident that Bonington did practice formal portraiture more regularly than the few extant works would suggest. In addition to this one of Monnier, in which the face is modeled with the delicacy of a Carrier portrait miniature and the sky more boldly treated in the manner of Titian or Rubens, there are a half-length graphite portrait of a woman (British Museum, dated 1823); chalk portraits of Théodore Gudin (Royal Collection) and Mlle Rose (Private Collection); the studies of Count Palatiano (nos. 64, 65); and the watercolor of Gaudefroy (fig. 10).[4] In an anecdote that is somewhat confused in its chronology and vague in its allusions, A. de la Frizelière recounted that Isabey, Gudin, Raffet, and Montfort once visited Bonington's rue Michel le Comte address, on the portal of which was displayed a placard "Bonington. Portrait Painter."[5] While it is unlikely that Bonington ever set himself up professionally as a portraitist, his father may well have continued this practice as a sideline to his other commercial ventures.[6]

1. Marie, *Monnier*, 24.
2. Roberts, BN Bonington Dossier.
3. The date of 1824 assigned by Gaudefroy's son is too early. Bonington is not seen to appropriate Venetian backgrounds so deliberately until after the London trip in 1825, and, in any case, neither artist nor sitter were still pupils of Gros in 1824.
4. We do not include in this tally the more numerous studies from the life of unidentified women and children now principally in the Bacon and Ashmolean collections.
5. A. de la Frizelière, *L'Artiste* (1860): 99.
6. Sydney Race (*Notes*, 26–27) furnishes the most complete list of portraits known to have been painted by the senior Bonington prior to his departure for Calais in 1817. Portraits specifically identified as works by Bonington's father and his students also appear in several of the studio sales.

57

PORTRAIT OF HENRY MONNIER ca.1825
Watercolor, $7\frac{3}{4} \times 5\frac{7}{8}$ in. (19.5 × 14.9 cm.)

Inscribed: In graphite, verso: *Portrait d'Henri Monnier par R P Bonington / quand ils étaient ensemble à l'atelier du Baron Gros / 1824. Monnier avait alors 19 ans / d'après les notes du fils du peintre Gaudefroy cette / aquarelle a été fait en / 1824.*

Provenance: Pierre-Julien Gaudefroy; James Roberts, and by descent to 1909; Gosselin; Atherton Curtis, by whom given to the Bibliothèque Nationale.

Exhibitions: Jacquemart-André 1966, no. 72, pl. X.

References: Dubuisson 1909, 197, repr.; Shirley, 75, 106, pl. 81.

Bibliothèque Nationale (AC 8008)

Henry Monnier (1799–1877) had been a government employee before entering Girodet's and then Gros's atelier in 1821. The prevalent interest of Gros and his pupils in phrenology and English caricature undoubtedly determined Monnier's future as one of the most fecund graphic humorists of the century. A hellion of the atelier, his relationship with Gros, whom he derided as *Gros-eille* (Gooseberry),[1] rapidly deteriorated, and the final estrangement may have resulted, in part, from Gros's mistreatment of Bonington. Of Bonington's behavior as a student we have only Roberts's comment that he "might be observed casting a slow glance round the atelier in the midst of noise and boisterous mirth . . . and from his eye only would be discerned the inward working of thought in his appreciation of character Although he was never noisy and boisterous like his comrades, he was fond of mirth and amused at their playful tricks."[2]

Between 1823 and 1828 Monnier traveled repeatedly to London. He was there in 1825 during Bonington's visit, and for longer periods in 1826–27. He collaborated with both Eugène

SELF-PORTRAIT ca.1825–26
Brown wash on buff paper, touched with white,
$4\frac{7}{8} \times 4\frac{1}{8}$ in. (12.5 × 10.4 cm.)

Provenance: Baron Charles Rivet, and by descent,
to 1984; Andrew Wyld, from whom purchased
by the British Museum in 1984.

Exhibitions: BFAC 1937, no. 76.

References: Dubuisson and Hughes, 90;
Dubuisson 1909, repr. opp. 81; Shirley, pl. 72.

Trustees of the British Museum
(1984-10-6-28)

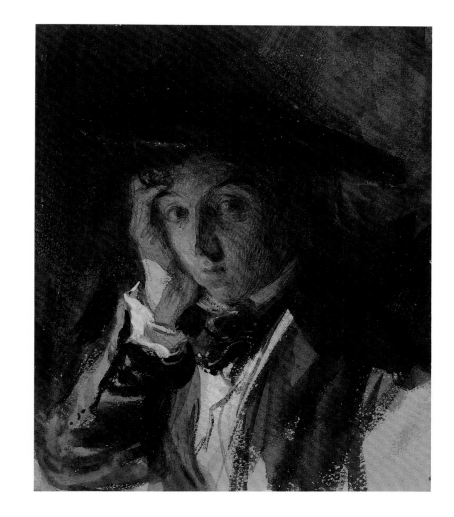

James Roberts described Bonington's features as
"not very remarkable for expression," while the
critic Auguste Jal observed in his obituary
notice that "no other expression than that of
melancholy defined his character."[1] A persona
of a brooding introspective is obviously
cultivated in this self-portrait, but, in fact,
Bonington was more gregarious than this image
or the public eulogists would admit. Delacroix
would later recall a more balanced impression:
"His British composure, which was
imperturbable, in no way diminished those
qualities that make life enjoyable."[2]

Although the artist included himself in his
conversation piece *Invitation to Tea* (no. 106),
this is the only known self-portrait proper. It
was almost certainly drawn during the period
when Bonington and Delacroix were sharing a
studio in winter 1825–26, and perhaps on the
same evening as Delacroix's chalk portrait of the
artist at work.[3] Thoré mentioned another self-
portrait in watercolor, now untraced, done at
about the time of the *Cahier de six sujets* (late
1826) for Carrier, who later gave it to Lewis
Brown.[4]

Of the numerous portraits said to rep-
resent this artist, few are correct in their
identification. The oval oil painting of a young
artist at Nottingham is neither by Bonington
nor likely to be a portrait of him. The same
must be said of the *Portrait of an Artist* (formerly
Renand Collection) reproduced as a frontispiece
to Shirley's monograph. Other than this self-
portrait and the Delacroix drawing, the only
portraits that can be accepted as authentic
likenesses are the black chalk head study by
Maragret Carpenter and her posthumous oil
version (both National Portrait Gallery,
London), which Delacroix described as a poor
facsimile[5]; a lithograph executed by Colin in
1829, also based on posthumous drawings
(Ashmolean and Musée Carnavalet) but
probably more accurate than Carpenter's
portrait; Colin's untraced graphite sketch
reproduced as a frontispiece to Curtis's
catalogue of the prints; several thumbnail head
studies in graphite sketched by Colin at
Dunkerque in 1824 (Musée Carnavalet; fig. 8);
and Léopold Boilly's head and shoulders
portrait on a sheet of chalk studies of Gros's
pupils in 1820 (fig. 9).

A watercolor of an artist standing at his easel
(National Portrait Gallery, London) has been
identified as a study of Bonington from its first
appearance in the Villot sale, but we view only
the sitter's back. It may be the work of Newton
Fielding (no. 146), as noted in the catalogue of
that sale. A watercolor portrait of a lanky
young man (fig. 7), traditionally unidentified
but attributed to Bonington on the basis of an
inscribed graphite notation, is possibly an early
portrait of Bonington by a fellow student at the
Ecole des Beaux-Arts. Not only his apparent
age, but also the elaborate watercolor study of a
"tête d'expression" on the verso corroborate
this dating.[6] Marcia Pointon's suggestion that
the sitter in Delacroix's *Portrait of a Young Man*,
tentatively identified by Lee Johnson as one of
the Fielding brothers, might be Bonington is
irreconcilable with known likenesses.[7]

This drawing was engraved by Frédéric
Villot in 1847. A friend of Bonington, Lami,
Isabey, and Delacroix, Villot eventually served
as curator of paintings at the Louvre under
Nieuwerkerke and as general secretary of the
museums. He learned etching from the Swiss
engraver Forster. According to Philippe de
Chennevières, he was "a connoisseur of the
colorists school, a distinguished and erudite
curiosity, ... who undertook with an audacity
that makes one tremble the restoration of
Rubens's Medici Cycle."[8] The drawing was also
etched in aquatint by Charles Damour as a
frontispiece to his *Oeuvres inédités de Bonington*
(Paris, 1852), a set of ten aquatints after
paintings and drawings then in Baron Rivet's
collection.

1. Roberts, BN Bonington Dossier, and Jal, *Bonington*,
746.
2. Delacroix, *Correspondence* 4: 286.
3. Private Collection; Ingamells, *Bonington*, fig. 4.
4. Thoré, 1867, 6 n.2. An untraced oil sketch described
as the artist with his portfolio was lot 110 in the 1838
studio sale.
5. Walker, *Regency Portraits*, 57–59; engraved by Quilley
for James Carpenter in 1831.
6. Shirley, pl. 4.
7. Pointon, *Circle*, 73; Johnson, *Delacroix* 1, no. 69.
8. Philippe de Chennevières, *Souvenirs d'un Directeur des
Beaux-Arts* (Arthena, 1979), 3: 84ff.

59

QUENTIN DURWARD AT LIEGE 1825
Watercolor, $5\frac{7}{8} \times 4\frac{1}{2}$ in. (14.9 × 11.5 cm.)

Inscribed: Signed and dated, lower right: *1825 /
R P Bonington*

Provenance: Possibly Bonington sale, 1834, lot
287; Lewis Brown (Paris, 16–17 April 1834, lot
64, as *Quentin Durward à Liege*); Berville, Paris;
de Coninck (Ghent, 1856, lot 96, bought
Fodor); Carl Joseph Fodor, by whom
bequeathed to the city of Amsterdam in 1860.

Amsterdam Historical Museum, Bequest of
C. J. Fodor

Walter Scott's historical novel *Ivanhoe* had had a
profound impact on French letters, inspiring
such seminal works as Augustin Thierry's
Histoire de la conquête des Normands (Paris, 1825)
and Prosper de Barante's *Histoire des Ducs de
Bourgogne* (Paris, 1824). The reception accorded
the first French translation of *Quentin Durward*
(May 1823) was no less enthusiastic because the
novel specifically and vividly portrayed one of
the most turbulent epochs of French history.
In the form of a manifesto supporting this new
genre of historical narrative, Victor Hugo
reviewed the publication almost immediately in
the first issue of *La Muse Française* (June 1823),
noting of the descriptive method and the
personages portrayed, "History has told us
much of this, but I would like to believe the
novel because I prefer moral truth to historical
truth."

This watercolor illustrates an episode from
chapter 19 of *Quentin Durward*. The protagonist,
wearing armor and the blue bonnet of the
Scotch archers, has been mistaken by the
Liègeois as part of an advance force sent by
Louis XI to assist in their rebellion against the
despised duc de Bourgogne. Despite his
protestations to the contrary, the stalwart but
politically naive Durward is conducted to the
Städthaus between the two *burghermeisters*,
Pavillon and the corpulent Rouslaer, amidst the
general tumult of the other citizenry, including

Blok, chief of the butcher's guild, and
Hammerlein, the "tall, lean, raw-boned, very
drunk . . . president of the mystery of workers in
iron."

This is Bonington's earliest illustration for
the novel, antedating his frontispiece for
Cadell's edition (no. 60) by at least several
months and the version in oil (no. 143) by
perhaps as much as two years. A graphite study
for an unspecified *Quentin Durward* illustration
was in the 1834 studio sale, and another
watercolor, *Louis XI, Isabelle de Croye and Quentin
Durward*, possibly a rejected design for the
Cadell project, was in the 1836 studio sale.

Bonington was not the first of his immediate
circle to illustrate the novel. Camille Roqueplan
had already exhibited at the 1824 Salon a work
with a title calculated to challenge academic
categorizations, *Paysage Historique. Isabelle de
Croye et Quentin Durward près de Plessis-les-Tours*.
Although Bonington did not require anyone's
encouragement to illustrate his favorite author,
it should be observed that Delacroix jotted
notes on possible *Quentin Durward* subjects in
one of the sketchbooks he was using in London
in May 1825.

Quentin Durward was one of the most popular
of Scott's historical novels among French
painters, including Delacroix,[1] A. Johannot
(1831), Pajou (1831), Regnier (1835), and Laure
Colin (1831), the daughter of Bonington's friend
Alexandre Colin. Yet there are no other
recorded illustrations of Quentin Durward and
the rebellious Liègeoise. We can only speculate
about whether Thierry's popular *Lettres sur
l'histoire de France* (Paris, 1820–27), which
analyzed the communal insurrections of the
Middle Ages as evidence of nascent democratic
impulses, colored Bonington's attitude toward
Scott's novel, but such histories were certainly
familiar to him.

This drawing is from an immense collection
of nineteenth-century French watercolors
bequeathed to the city of Amsterdam by the
coal magnate Carl Joseph Fodor (1801–1860).
A rare instance of an intact collection, it offers
evidence of the great diversity of what
Bonington's contemporaries considered
"romantic" and of the inestimable contribution
of the prosperous middle-class throughout
Europe to the promotion of watercolor as a
legitimate medium of expression.

1. Delacroix's oils include *The Murder of the Bishop of
Liège* (Johnson, *Delacroix* 1, no. 134) begun in 1827 and
Quentin Durward and the Balafré (Johnson, *Delacroix* 1, no.
137) of ca.1827–28. Robaut cites a watercolor *Quentin
Durward and the Countess de Croye* (Robaut, *Delacroix*, no.
271) and a lithograph (Robaut, *Delacroix*, no. 272). A
lost watercolor, *Louis XI à l'auberge des Fleurs de Lys près
de Plessis-les-Tours*, was exhibited at the Galerie Lebrun
in 1828; his illustration *Louis XI* for the *Chansons de
Béranger* of that year may relate to this composition.

QUENTIN DURWARD AND THE DISGUISED
LOUIS XI 1825/6
Watercolor over graphite, $5\frac{3}{4} \times 4\frac{1}{4}$ in.
(14.5 × 10.6 cm.)

Inscribed: Signed and dated, lower left: *RPB 1825* [or 6]

Provenance: Lewis Brown (Christie's, 28 May 1835, lot 48, bought Allnutt); Sir Thomas Allnutt and by descent (Christie's, 17 November 1987, lot 95, bought Feigen); Richard L. Feigen.

References: Dubuisson and Hughes, 164; Douglas Cooper, "Bonington and *Quentin Durward*," *Burlington Magazine* (May 1946): 116.

Richard L. Feigen, New York

This illustration to chapter 1 of Sir Walter Scott's novel *Quentin Durward* was engraved by Edward Goodall in 1831 as the frontispiece to volume 31 of Robert Cadell's complete edition of the Waverley Novels. The idea for an annotated edition illustrated by prominent British artists was first broached in 1826 following Scott's bankruptcy. Bonington was certainly approached at that time, but whether this particular watercolor (he also furnished the frontispiece to volume 28, *Peveril of the Peak*) was painted on commission or furnished from stock is unclear. The inscribed date can be read as either 1825 or 1826. In either case, its style would place the watercolor not much later than *Quentin Durward at Liège* (no. 59) or *The Lute Lesson* (no. 62).

The dress of the three figures adheres faithfully to Scott's detailed descriptions. The monarch's head was based on an engraved portrait in Montfaucon's *Monuments de la monarchie française* (vol. 4, pl. 62). Bonington's full-length graphite and wash copy of that print exists in a private collection, and a graphite *aide-memoire* of the head alone is on the verso of a sheet of studies of *bascinets* drawn at Dr. Meyrick's in July 1825 (Fitzwilliam Museum). Delacroix also copied this portrait in a sketchbook he was using in 1825 and early 1826,[1] and he must have referred to it when designing his vignette *Louis XI* for Perrotin's 1828 edition of Béranger's *Chansons* (see no. 159).

Lewis Brown probably acquired this watercolor directly from Cadell in 1831. A Bordeaux wine merchant of British nationality and an occasional diplomatic operative for the British consulate at Calais, Brown began collecting Bonington's watercolors in the mid-1820s. Either Francia or Schroth, who acted as the expert advisor for two of Brown's sales at auction, undoubtedly provided the initial introduction. For personal convenience, Brown kept all of his Bonington watercolors in a portable album. It was this folio that the painters E. W. Cooke, Frederick Nash, and William Wyld examined in London in April and July 1834 and of which Cooke said "nothing in art so much affected me before." Brown was possibly in London at that moment to view the Bonington exhibition at the Cosmorama Rooms and to attend the subsequent studio sale. As this watercolor has only recently been removed from a second album in which it had been mounted almost immediately after its acquisition in 1835 by Sir Thomas Allnutt, it offers a singular glimpse of the unfaded richness of Bonington's palette.

1. Sérullaz, *Delacroix*, no. 1750 f.34r.

THIRTEEN STUDIES ca.1825–26
The five largest are watercolor and brown wash,
heavily gummed, the smaller subjects are in
bodycolor and watercolor; various dimensions:
the largest 3½ x 2½ in. (9 × 6.4 cm.)

Provenance: E. Wanters; Fritz Lugt.

Exhibitions: Jacquemart-André 1966, no. 5.

References: Pointon, *Bonington*, fig. 68.

Fondation Custodia (Coll. Fritz Lugt), Institut
Neérlandais, Paris

Both before and during his student years,
Bonington spent much of his free time painting
watercolor copies in the Louvre. This practice
seems to have fallen in abeyance during the
years of his most intense concentration on
marine subjects but was resumed after he began
working intimately with Delacroix. The five
larger studies included here are after old master
paintings, four of which are in the Louvre. The
first (upper center) reproduces the left side of
Palma Vecchio's *Adoration of the Shepherds*. The
second (upper right) repeats the central section
of Jacob Jordaen's *The King Drinks*. The central
study is a copy of Van Dyck's *Portrait of a Lady
and Child*. The fourth (lower center) depicts
a small section of Rubens's *Village Festival*.
The composition at upper left has not been
identified. Most of these studies relate to
projects on which Bonington was working
in 1826.

The finished watercolor *Souvenir of Van Dyck*
(Wallace Collection), for instance, is a conflation
of the Lugt Collection composition and figures
from an engraving after Van Dyck's *Portrait of
John, Count of Nassau and Family*.[1] Other
watercolor sketches (Bowood) after Van Dyck
portraits were made at the Uffizi and the Brera
in 1826. The sky in the Vecchio, with its
brilliant striations of orange and deep blue, is
invoked in the portrait of Monnier (no. 57) and
the watercolor *The Earl of Surrey and Fair
Geraldine* (Wallace Collection; fig. 40).[2] For his
versions of *Quentin Durward at Liège* (nos. 59,
143), Bonington drew studies of the facial
expressions in Rubens's picture.

Of the smaller compositions, one may be a
memorandum of a baroque *Adoration of the
Magi*.[3] Another appears to depict Falstaff and
may be based on a Robert Smirke engraving,
while a third recalls Wilkie. The remainder
were possibly sketched as staffage studies for
the lithographs after Pernot's drawings for *Vues
pittoresques de l'Ecosse*, which commenced
publication in December 1825 and for which
Bonington is known to have improvised the
figures (see no. 113). On the other hand, the
majority of these studies, both large and small,
have a thematic common denominator in their
representation of women and small children or
infants. In this they relate to graphite studies of
approximately this date after Rembrandt's *Venus
and Cupid* (Louvre), numerous life studies of
Parisian mothers, and the oil *The Prayer* (Wallace
Collection; fig. 67). Of the same date and in
the same cursory style of execution is the
watercolor sketch (Bowood) after *A Religious
Procession* (Louvre), attributed to the Le Nains.

1. Ingamells, *Catalogue*, 1: 52–53 (P688).
2. Ingamells, *Catalogue*, 1: 46 (P675). Ingamells dates
this watercolor ca.1826 and after the Italian trip.
I propose a date closer to the beginning of the year.
3. A Bonington sepia study of this description was lot
565 in the John Brett sale, Christie's, 5–18 April 1864.

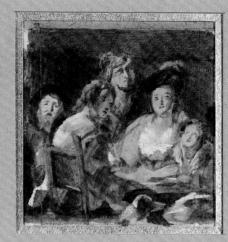

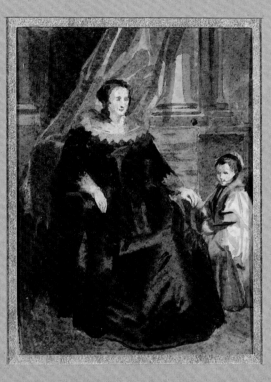

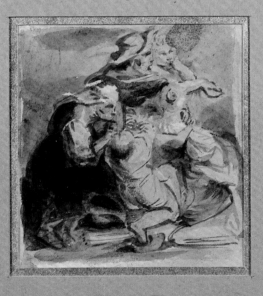

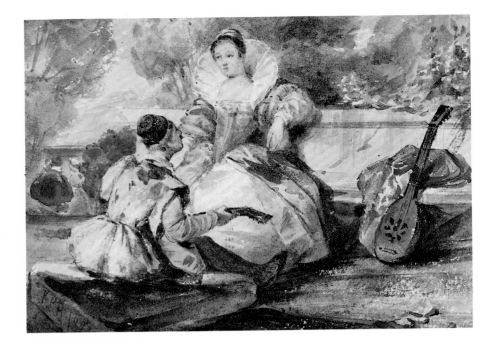

62

THE LUTE LESSON 1826
Watercolor and bodycolor, $3\frac{1}{4}$ × 5 in.
(8.3 × 12.8 cm.)

Inscribed: Signed and dated, lower left: *RPB 1826*

Provenance: Baron de Beaunonville (Paris, 21–22 May 1883, lot 148); possibly Fairfax Murray (Christie's, 30 January 1920, lot 1a, bought Bowden); Baron H. de Rothschild; Baron James de Rothschild, to 1966; H. M. Horsley (Christie's, 5 March 1974, lot 188, as *Queen Mary and Rizzio*, bought Bingham); Pierre Granville, by whom donated to the Musée des Beaux-Arts, Dijon in 1975.

Musée des Beaux-Arts, Dijon

The Dijon watercolor, traditionally known as *Mary Queen of Scots and David Rizzio*, presents two figures in costumes chronologically compatible with that identification. Just such a subject was one of four pictures painted by Louis Ducis (1775–1847) at Fontainebleau to illustrate the arts "sous l'empire de l'amour."[1] It was engraved by Heath in 1825 for the *Literary Souvenir* and would have been familiar to Bonington. However, the ubiquitous troubadour subject of lute serenades was, by this date and in Bonington's somewhat vague usage here, almost too generic to permit so specific an identification. In its diminutive size and rapid execution, the drawing relates directly to such preparatory sketches as *The Remonstrance* (no. 107) and the studies after old master paintings (no. 61) of late 1825 or early 1826. The signature, however, indicates that the artist was content to dispose of it as a "finished" work for inclusion in some patron's album.

An oil of two lutenists in an interior (no. 121), the watercolors *Meditation* and *The Earl of Surrey and Fair Geraldine* (fig. 40), and numerous graphite studies of the lutenists in paintings by Gerard Terborch and Joost van Craesbeeck in the Louvre and from engravings in Nicolas-Xavier Willemin's *Monuments français inédits pour servir à l'histoire des arts* (Paris, 1808) attest to Bonington's fascination with this genre. The actual instrument depicted here and in most other Bonington celebrations of this theme can be seen in Thomas Shotter Boys's 1827 rendering of the interior of Bonington's studio (fig. 62).

A related but more elaborately described composition was engraved in October 1828 by C. Rolls for Allan Cunningham's *Anniversary*. In addition to a more formal and expansive *château parterre*, the engraved version, titled *The Lute*, depicts figures in mid-seventeenth-century dress. Following Mantz, Dubuisson dated this lost version with extraordinary precision to May 1828.[2]

1. Ducis painted versions of these popular pictures for the duchesse de Berry. These were exhibited in the 1822 Salon (no. 398), as was a third version of the Mary Stuart subject (no. 399). At an unspecified date, Eugène Isabey sketched oil replicas of all four compositions.
2. Mantz, *Bonington*, 303, where it is noted that the watercolor was then in the Rothschild collection at Boulogne; Dubuisson and Hughes, 80.

63

HENRI IV'S BEDCHAMBER AT THE CHATEAU DE LA ROCHE-GUYON ca.1825
Oil on millboard, 9 × 14 in. (23 × 35.5 cm.)

Provenance: Possibly Bonington sale, 1829, lot 56 or lot 167, both bought Colnaghi; possibly Lord Dover, and by descent to Viscount Clifden (Christie's, 6 May 1893, lot 1, *Interior of the bedroom of Henry IV — a sketch*); Messrs. Wallis and Son, The French Gallery (Christie's, 18–19 November 1898, lot 126, bought Sampson); Anonymous (Christie's, 26 July 1902, lot 53); Anonymous (Sotheby's, 9 December 1981, lot 203, bought Feigen).

Richard L. Feigen, New York

During a visit to the Château de La Roche-Guyon, probably in fall 1825, Bonington painted this sketch of the bedchamber of Henri IV as a preparatory study for a history painting. Fifteen kilometers west of Mantes on the Seine, the château was erected in 1621 on the site of an earlier residence of François Ier. In 1590 Henri IV retired there after the battle of Ivry. At the time, he was enamored of Antoinette de Pons, Comtesse de La Roche-Guyon and later Marquise de Guercheville (d. 1632), who was renowned for her beauty and her marital fidelity. One apocryphal anecdote claimed that she fled the château before Henri's arrival in 1590 to avoid compromise. A more piquant version of that story appears in the *Memoires* of the Abbé de Choisy: on several occasions, the king organized hunting parties in the vicinity of La Roche-Guyon so as to have an excuse for spending the night at the château; conveniently losing his comrades in the chase, he would then request lodgings from the marquise, who invariably greeted him with the utmost civility, obeisance, and pomp before leaving him to his solitary amusements and spending the night at a nearby château.[1]

After 1816 the château became the property of Duc de Rohan-Chabot, an ordained priest who hosted frequent "medieval" receptions on the grounds. On visiting the château for the first time in August 1821, Victor Hugo was especially impressed by the king's bed. "Une des curiosités du château," it measured ten feet in length, was elaborately sculpted in oak, and was hung with bands of garnet velour and alternating bands of gold tapestry and petit-point silk. Hugo, who was put off by the ceremonial stiffness of his host, was lodged appropriately in the room of Duc de la Rochefoucauld, author of the famous *Maximes*.[2] Lamartine, who had visited the château in 1819, was more indulgent toward the Duc de Rohan and took particular delight in the fantastic subterannean chapel that had been constructed on the grounds and in which the duke conducted daily services "avec une pompe, un luxe et des enchantments sacres qui enivraient de jeunes imaginations."[3]

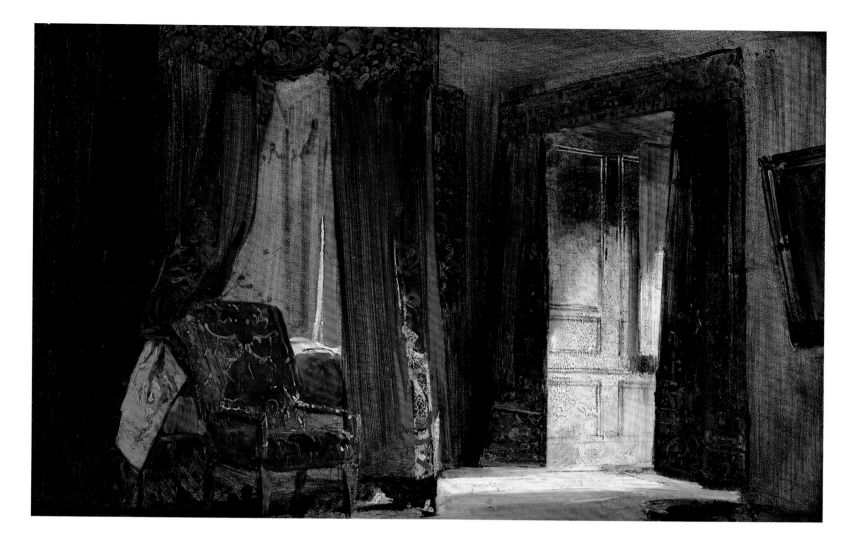

A finished oil of similar dimensions, possibly painted for Baron Rivet, shows the same interior and furnishings and a seated Henri IV gazing out the open window.[4] Another oil sketch and a watercolor, both with the figure, were in the 1829 studio sale (lots 30 and 210), as was a second watercolor (lot 49) lacking the figure. Graphite studies of the bed and chair are in the British Museum, and a graphite study of the entire interior was exhibited in 1937.[5] Pentimenti in the area of the window in no. 63 indicate that the artist's initial idea was to place the monarch standing in this bay. A nearly identical oil sketch by Paul Huet has been dated too early by Miquel,[6] as it is more likely that Bonington and Huet visited the château together in 1825 rather than 1821. Of perhaps coincidental interest, a lithograph by J.-B. Isabey of similar composition depicting the chamber of Henri IV at the Château des Mesnières appeared earlier in the year in the *Voyages pittoresques, Normandie II* (pl. 232).

The narrative intent of Bonington's untraced history painting is ambiguous, perhaps purposefully so. As an intimate representation of France's most popular monarch pondering either the onerous responsibilities of state or the personal frustration of unrequited passion, it would be typical of Bonington's attitude toward historical characterization and similar, in the first instance, to Delacroix's conception of the brooding Oliver Cromwell at Windsor Castle (no. 142). Henri IV had just won a decisive battle in his quest for the throne. Paris was his to seize, yet for motives that even his own chroniclers could not fathom, he delayed marching on the capital, thus necessitating a protracted siege.[7] Is the viewer then meant to see the king in a moment of atypical indecision? Delacroix offers his audience an entrée to Cromwell's musings by including a portrait of Charles I as his object of contemplation. In Bonington's picture there is no comparable indicator, and we are left to intuit the cause of Henri's distraction. It is impossible, however, to ignore the monumental presence of the royal bed. An extraordinary piece of furniture in its own right, the bed, with its picturesque visual attributes and its association with the amorous adventures of this monarch, alone offered a compelling pretext for the choice of subject. Its patriarchal symbolism would also have held a special meaning for a generation intent on demonstrating the legitimacy of Henri IV's lineage.

1. The same anecdote is found in the *Biographie Universalle* (Paris, 1817–19), 19: 18–19.

2. Hugo, *Oeuvres complètes* 2.

3. A. de Lamartine, *Premières et nouvelles meditations poetiques* (Paris, 1874), 137–38.

4. An etching by Charles Damour, *Oeuvres inédités de Bonington* (Paris, 1852), no. 4, records the composition.

5. BFAC 1937, no. 128.

6. Miquel, *Paysage* 2: 197; see also Miquel, *Huet*, 1965, pl. 43.

7. According to Hardouin de Péréfixe, *Histoire du Roi Henri Le Grand* (Toulouse, 1782), an edition of which Bonington had read, "Fear was so great in Paris after the news of this battle that if the king had gone straight there, there would have been little trouble. Some people say he was diverted by Marshall Biron because the latter feared that Henri, no longer having any need of him, would confide less in him. Others think that it was his Huegenot captains and ministers who dissuaded him, because they feared that he would accommodate the Parisians' religion, and thus urged starving the city After the battle, the king resided a few days at Mantes because of heavy rains [125-26]."

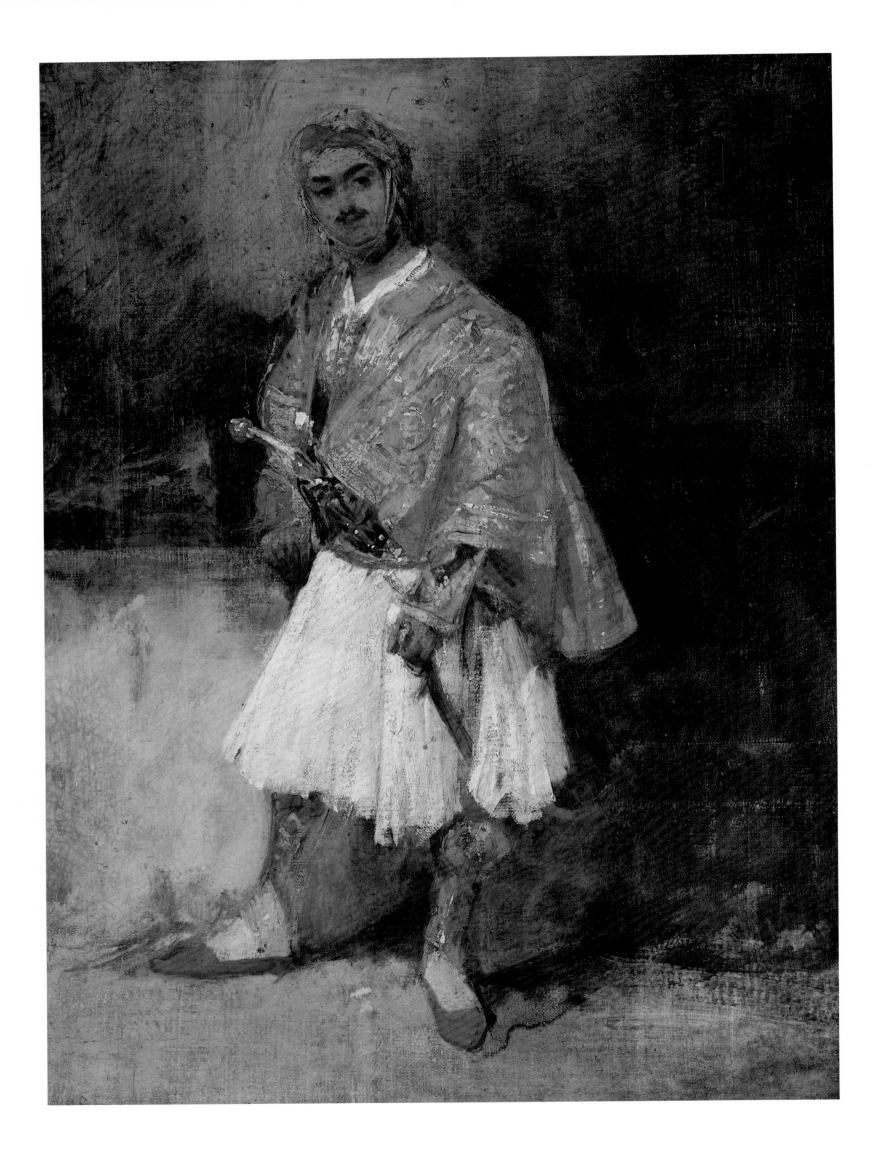

64

PORTRAIT OF COUNT DEMETRIUS DE
PALATIANO ca.1825–26
Oil on canvas, 14 × 9¾ in. (35.5 × 24.7 cm.)

Inscribed: Canvas stenciled, verso: *Génie des Arts |
Haro Md de Couleurs | Rue du Colombier no. 30*

Provenance: Damianos Kyriazis, by whom
bequeathed to the Benaki Museum, Athens.

Exhibitions: Paris, *Delacroix*, 1930, no. 176, as by
Delacroix; Nottingham 1965, no. 290.

References: Johnson, *Review*, fig. 55; Johnson,
Delacroix 1, with no. L80; and 3, with no. 81a.

Benaki Museum, Athens (No. 11197)

Born of patrician parents at Corfu, Count
Demetrius de Palatiano (1794–1849) traveled
widely in his youth. Lavish in his lifestyle
and somewhat unstable, according to his
descendents, he claimed to have been invested
with the title of count by his friend Maximilian,
King of Bavaria. In late 1825 he passed through
Paris en route to London, where he spent
nine years before returning to Greece with
his second English bride. His debts were
considerable when he died in Naples at mid-
century. This quasi-Byronic individual is the
subject of *Portrait de M. le Comte P. en costume
souliote*, exhibited by Delacroix at the 1827 Salon
and known today by two contemporary oil
copies and an etched replica by Frédéric Villot.[1]
Bonington painted several oil sketches of
Palatiano, in the dress of a Greek independence
fighter, while sharing Delacroix's studio during
winter 1825–26.

All previous discussions of Bonington's oil
studies of the count have assumed incorrectly
that, like Delacroix, the artist had painted a
finished portrait, now untraced but recorded in
a lithograph of 1830 by J. D. Harding (fig. 35);
however, this print bears an inscription
identifying the full-length, frontal portrait
(remarkably similar to Delacroix's lost Salon
picture) as a "sketch" in Lord Townshend's
collection. Among the eleven oils acquired by
Townshend at the 1829 studio sale was *Studies
of Grecian Costumes, Two Figures on One Canvas*
(lot 129). This subsequently appeared as two
sketches in his 1835 sale (lots 13–14), indicating
that in the intervening period, and probably
before Harding's lithograph, Townshend had
had his original purchase divided into separate
pictures, one reproduced by Harding and a
second profile study now in a private
collection.[2] Both belonged to Munro of Novar
by 1843.[3]

Although previously exhibited as a work by
Delacroix, this sketch was reattributed to
Bonington by Marion Spencer in 1965. A recent
technical examination disclosed that it was
painted on a canvas stenciled with the address
of Delacroix's color merchant, Haro, and that it
does not seem to have been cut from a larger
canvas. No other sketches of Grecian costumes
are listed in the Bonington sales, although Sir
Henry Webb owned two such studies,[4] and it is
possible that the artist had disposed of some
prior to his death. It may also be that such
studies were misidentified in the later studio
sales; for instance, lot 108 in the 1838 sale was
two portrait studies of a "Venetian." On several
occasions, Bonington employed the count's
costume for staffage figures in his Venetian
views, and it could be that the auction house
cataloguers were ignorant of the national origin
of Palatiano's dress. Although the attribution
of the Athens sketch should remain subject
to review, the stylistic evidence tends to
sustain it.

A replica of the untraced sketch that Harding
reproduced has been attributed to Paul Huet.[5]
A second, in watercolors, was painted by Jules-
Robert Auguste.[6] By the end of 1825 Huet was
on intimate terms with Bonington and could
have been in attendance when Palatiano posed
in Delacroix's studio. His almost exact
replication of Bonington's sketch, however,
suggests that his picture might be a later copy
rather than a study from life.

1. These biographical particulars on Palatiano were first
published by Lee Johnson; see *Delacroix* 1, no. L80 and
fig. 23.
2. Nottingham 1965, no. 289, pl. 45.
3. Anonymous mid-nineteenth-century copies were on
the market recently (Christie's, 2 November 1984,
lot 111).
4. Webb sale, Paris, 23–24 May 1837, lots 27–28,
A young Greek girl standing, full face, and *Another Greek
figure in a rich costume seen in profile*.
5. P. Miquel, *Paul Huet* (Paris, 1962), repr. 53.
6. Rosenthal, *Auguste*, 193.

STUDIES OF COUNT DEMETRIUS DE PALATIANO
IN SULIOT COSTUME ca.1825–26
Graphite, 11 × 9 in. (28 × 22.9 cm.)

Provenance: Possibly Bonington sale, 1829, with
lot 172, four sheets of graphite *Studies of Greek
Costume*, bought Roberts; George Cattermole;
Luc Albert Moreau, 1934; Arthur Tooth and
Sons, from whom acquired by the Castle
Museum, 1949.

Exhibitions: Nottingham 1965, no. 107.

References: Shirley, 99, pl. 74; Johnson, *Review*,
319.

Castle Museum and Art Gallery, Nottingham
(49-100)

This is the only recorded sheet of graphite
studies of Count Demetrius de Palatiano
attributed to Bonington. Delacroix's related
drawings (fig. 36) are more numerous and
include detailed studies of the habit as worn by
both the count and an unidentified model
(no. 66). A second sheet of pose studies with
the same provenance (also Nottingham) was
reattributed to Delacroix by Lee Johnson on the
evidence of a slight composition sketch for the
Execution of Doge Marino Faliero on the recto.
Johnson also queried the attribution of the
present sheet to Bonington.

Although their drawing styles can be
disarmingly similar, especially when the
medium is pen and ink, Delacroix's graphite
line is usually more fluid and less nervous in
the finer strokes than Bonington's and his
shorthand for interior shading generally less
precise and elaborate. The figures on this sheet
were drawn more rapidly, as would be normal
for life studies, than the meticulous drawings of
armor Bonington made at Dr. Meyrick's the
preceding summer, but to this compiler the
system of transcription seems identical.

Graphite sketches of a similar costume by
Colin indicate that he too may have been
present when the Count posed for his friends.[1]
Variations on the costume appear in two of
Colin's most important history paintings,
Le Giaour and *An Incident during the Greek War
of Independence*, both exhibited at the Galerie
Lebrun in May 1826.[2]

Suliots were Albanian Christians banished
from their native region near Jannina after their
defeat in 1822 by Ali Pasha. Byron, who donned
their habit for his famous portrait by Thomas
Phillips[3] and who employed them as body-
guards, portrayed them as a fearsome and
untrammeled race of primitives in *Childe Harold*.

1. Shephard Gallery, *Non-Dissenters*, 1976, no. 40.
2. See P. Joannides, "Colin, Delacroix, Byron and the
Greek War of Independence," *Burlington Magazine*
(August 1983): 495–500, and *Burlington Magazine* (June
1984), fig. 49.
3. An impression of one of the reproductive prints after
this oil was in the 1834 studio sale (lot 3). Delacroix
certainly, and Bonington possibly, visited Phillips's
studio in 1825.

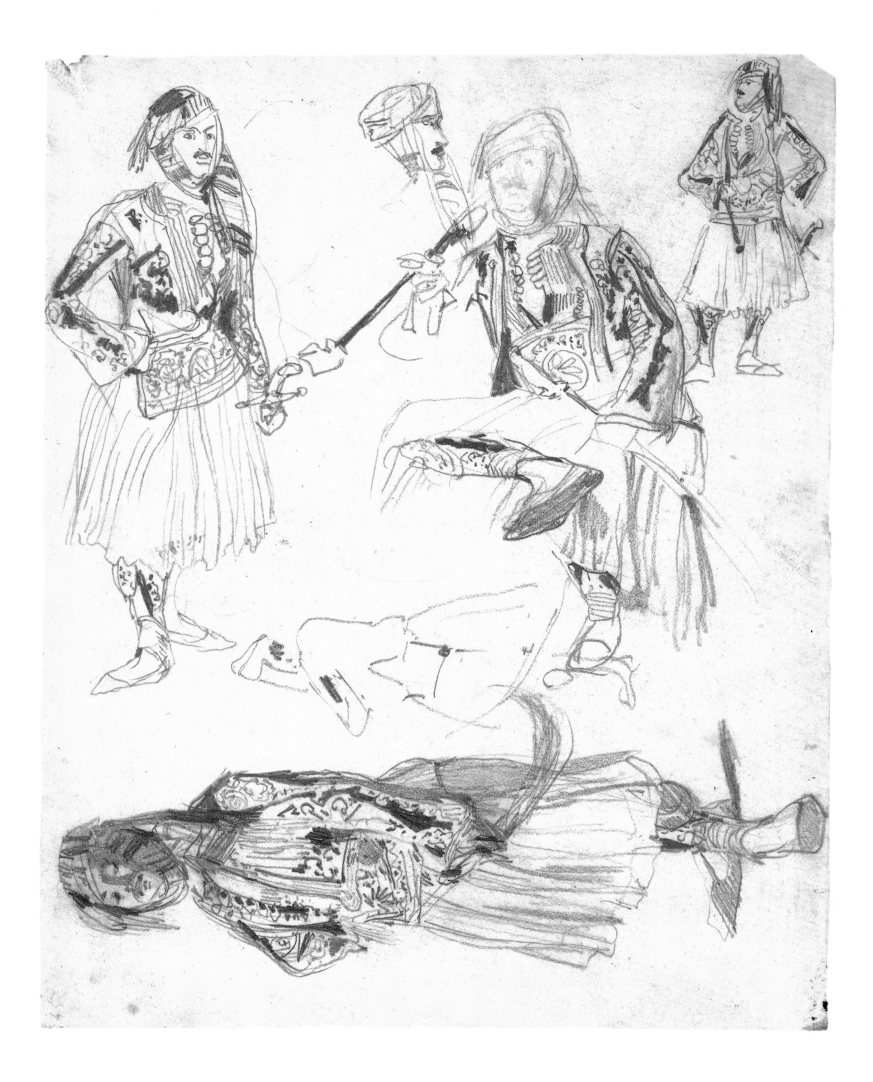

EUGÈNE DELACROIX (1798–1863)

STUDIES OF A MODEL IN GREEK
COSTUME ca.1825–26
Oil on canvas, $13\frac{7}{8} \times 18\frac{1}{4}$ in. (35.2 × 46.4 cm.)

Inscribed: Verso: wax atelier seal

Provenance: Delacroix sale, 17–29 February 1864, lot 182, bought Paul Huet; his son, René-Paul Huet, and by descent to M. Perret-Carnot.

References: Robaut, *Delacroix*, no. 1479 (as 1822); Johnson, *Delacroix* 1, no. 30 (with complete documentation); N. Athanassoglou-Kallmyer, "Of Suliots, Arnauts, Albanians and Eugène Delacroix," *Burlington Magazine* (August 1983): 487–91, fig. 38.

Musée du Louvre, Département des Peintures (MNR 143)

By contrast to Bonington's few surviving studies of Greek costume, Delacroix's graphite and oil sketches are numerous, appear to span a greater time period, and are not necessarily related to his own formal portrait of Count Demetrius de Palatiano. The earliest could be those at the end of the sketchbook purchased and partially used in England in summer 1825 (no. 41; f.12v–17r). That costume was worn by a model and possibly borrowed from Jules-Robert Auguste, whose collection of Greek and oriental clothing and weaponry was available to Delacroix as early as summer 1824.[1] In the Louvre are at least eleven identifiable graphite and wash studies of Palatiano in his own dress, which differs in minor details from that in the sketchbook.[2] Palatiano's appears to be the same costume depicted in the untraced formal portrait and a recently rediscovered sketch for it, as well as in four oil sketches of a model, variously posed, of which no. 66 presents a front and a side view.[3]

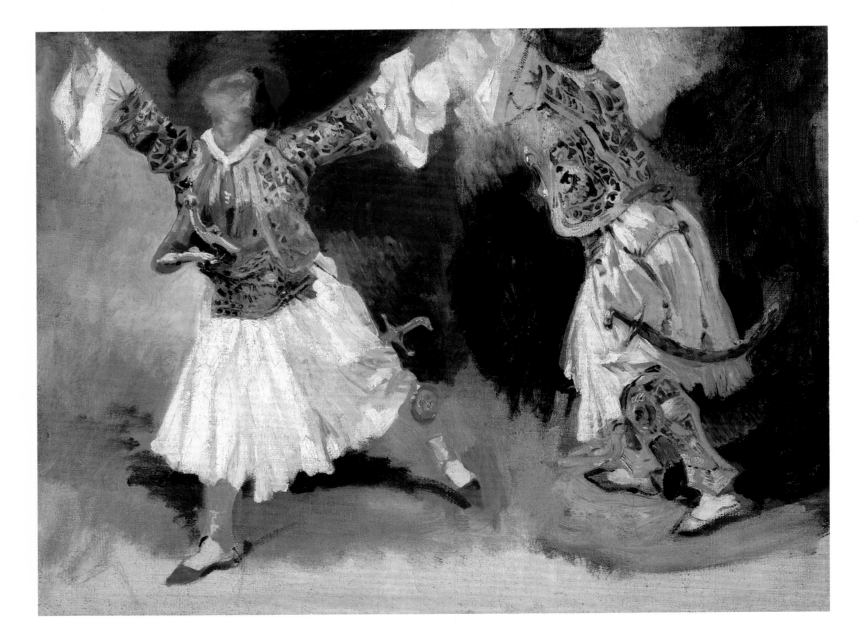

Robaut and Athanassoglou-Kallmyer date these oil sketches ca. 1822–23, connecting them with other copies drawn by Delacroix from plates in Joseph Cartwright's *Selections of the Costume of Albania and Greece* (London, 1822) and to preparatory work for the *Massacre at Chios* (Salon 1824). Johnson observes that they have no direct relevance to that picture and situates them closer in date to Palatiano's Paris visit in late 1825. As a group the oil sketches are meant to show every aspect of Suliot attire. The model in this sketch, who might otherwise seem to be dancing, has been deliberately posed for this descriptive purpose. The other posings are similarly varied and show the model in different states of undress.

In both Bonington's and Delacroix's portraits of Palatiano, the sitter wears the full regalia, consisting of leg armor, white kilt, girdle with sword and brace of pistols, and, from the waist up, a red sleeveless tunic under an embroidered jacket with full, flared sleeves and an outer jacket with half-sleeves slung from the shoulder. In the Louvre studies the model wears only the inner and outer layers, while in another sketch (Gothenburg), he is depicted from the rear, again with outstretched arms, wearing the long-sleeved garment.[4] As that sketch shows the same patterning as the costume in both Bonington's and Delacroix's portrait studies, it is reasonable to conclude that the group to which no. 66 belongs are, in fact, contemporary in date with the portraits. The placement of the figure against a background of deepest burgundy also accords with some of the watercolor studies of armor sketched at Dr. Meyrick's, while the facile brushwork, which invests these studies with a picturesque vivacity lacking in Delacroix's slightly earlier oil sketches of a figure in Indian costume,[5] may owe something to Bonington's presence in the studio. A lost oil sketch of the sleeve of the outer jacket on the same canvas as a sketch after Goya's *"Quien mas rendido"* is known from a Robaut copy.[6] Another oil sketch of a figure in Suliot costume with a dubious attribution to Delacroix might be the work of Achille Devéria, whose sepia study of a similarly posed model (dated 1828) is in the Louvre.[7] Whereas Bonington later employed such studies only for the occasional staffage figure in his Venetian topographical views, Delacroix would return to his repeatedly for major canvases: *Combat of the Giaour and Hassan* (1826; Art Institute of Chicago), *Scene from the War between the Greeks and Turks* (1826/7; Oskar Reinhart), and *Giaour Contemplating the Dead Hassan* (ca. 1829; Rudolf Graber).

1. Delacroix, *Journal* 1: 116–17; see also Auguste's own pastel studies in Rosenthal, *Auguste*, figs. 115–16.
2. Sérullaz, *Delacroix*, nos. 115–25.
3. Johnson, *Delacroix* 1, nos. L80, R33–34; 3, no. 81a; and 1, nos. 27–30.
4. Ibid. 1, no. 29; a possible pendant could be no. L38.
5. Ibid. 1, nos. 23–25.
6. Ibid. 1, no. L34.
7. Ibid. 1, no. D10; 3, 313; and Département des Arts Graphiques (RF 7232).

67

JULES-ROBERT AUGUSTE (1789–1850)

A LITERARY ILLUSTRATION ca.1830s
Oil on paper on board, $8\frac{1}{2} \times 6\frac{3}{8}$ in.
(21.5 × 16 cm.)

Provenance: Dr. Henri Rendu, by whom given to the Musée du Louvre in 1948.

References: Rosenthal, *Auguste*, 115, 172, cat. no. II-27, fig. 56.

Musée du Louvre, Département des Peintures (RF1948.39)

Jules-Robert Auguste belonged to a distinguished and influential family of Parisian artists and artisans. A student of the medallist F.-F. Lemot (1772–1827), he was awarded the prestigious *Prix de Rome* for sculpture in 1810. Following four years of study at the French Academy in Italy, he toured the Near East before settling in London from 1821 to 1823. While in England, he associated with the architect C. R. Cockerell and with Géricault, as well as with N.-T. Charlet, Léonor Mérimée, and the community of French artists and collectors then residing in London. These included Simon Rochard, the miniature painter, who introduced Auguste to Sir Thomas Lawrence, David Wilkie, and Benjamin Robert Haydon, and the Seguier brothers, who would soon become Bonington's most active supporters. He also had access to the brilliant Whig society of Holland House through the Marquess of Lansdowne. Without doubt, it was Auguste who orchestrated Delacroix's, and possibly Bonington's, introduction to many of the same individuals during their London visit of 1825. By 1824 Auguste was living in Paris, but his extensive travels and foreign contacts had helped him to formulate the essential traits of taste and character — for Watteau, English sporting art, orientalism, and an aristocratic elitism — that would color not only his own development as an artist, but also that of many younger French painters and authors.

As an artist Auguste never fulfilled his earliest promise. He worked mostly in pastels, favoring a precious scale and subjects of mild oriental eroticism or of the chase. Dutch and Flemish art of the seventeenth century left few visible impressions on his style, although he owned a prime collection of such pictures. Delacroix appears to have first met Auguste shortly after the latter's return to Paris. He made ample use of Auguste's collection of Eastern costumes, armor, and decorative arts, and he probably introduced Bonington to this singular character sometime during 1825. By the following spring Bonington had relocated his studio from the quarters he had been sharing with Delacroix to 11, rue des Martyrs. Auguste had owned apartments in that building in the fashionable Montmartre district since 1823. Bonington's new studio had previously been that of Horace Vernet, another of Auguste's close friends.

Like most fashionables of the period, Auguste hosted a weekly salon, and while the regulars tended to be painters, the list also included Prosper Mérimée and, after 1830, Théophile Gautier. Ernest Chesneau later recalled the heady intellectualism of these gatherings,[1] but an element of excess is also implied in Delacroix's complaint that the habits of Auguste's circle interfered with his work. In the same letter of 31 January 1826 he also mentioned the salutary effect of Bonington's presence in his studio, as if to disassociate his friend from such behavior.[2] The majority of Bonington's oriental pictures appear to date to this very brief period of intense contact with both Delacroix and Auguste.

The figures in this small oil are traditionally identified as Othello and Desdemona. As noted by Rosenthal, the episode from Shakespeare's play is not readily identifiable, although it would have to represent, with considerable license, act 4, scene 2, in which Othello accuses his wife of infidelity. That scene, although less popular with artists than the later murder scene,[3] had been engraved for the small *Shakespeare Gallery*, a source for numerous painters in Bonington's circle; however, in that illustration by Robert Ker Porter, Desdemona has fallen to her knees as called for in the stage directions. An alternative identification of Auguste's figures would be Selim and Zuleika at the conclusion of Byron's *The Bride of Abydos*, another extremely popular subject of the period.[4] In the arrangement of the figures, Auguste's composition has several points in common with a Colin illustration for the poem (1833) in which Zuleika similarly drapes herself around her lover's shoulders in an effort to forestall his tragic confrontation with Giaffir's men:

Dauntless he stood — 'Tis come — soon past —
One kiss, Zuleika — 'Tis my last.
(Canto II, stanza xxiii)

Since oil paintings are as rare in Auguste's oeuvre as literary illustrations, it is difficult to assign a date to such a work. The delicate brushwork in the costumes betrays Auguste's early fascination with rococo painting[5] and has parallels in the touch of his first pastels and certain of Bonington's oils, but the coloring is most reminiscent of Delacroix in the 1830s and 1840s.

1. Chesneau, *Petits romantiques*, 2.
2. Delacroix, *Correspondence* 1: 173.
3. To cite but one pertinent example, Colin's oil painted for Coutan (Paris, 17 April 1830, lot 17).
4. See L. Johnson, "Delacroix and The Bride of Abydos," *Burlington Magazine* (September 1972): 579–85, for Delacroix's three oil versions of the 1840s and 1850s. As is typical of Delacroix, however, the subject had occurred to him as early as 1824.
5. Ten oils attributed to Watteau were in Auguste's studio sale; a pendant to the Louvre picture, now also in the Louvre (RF1948–40), is a *fête galante* in imitation of Lancret.

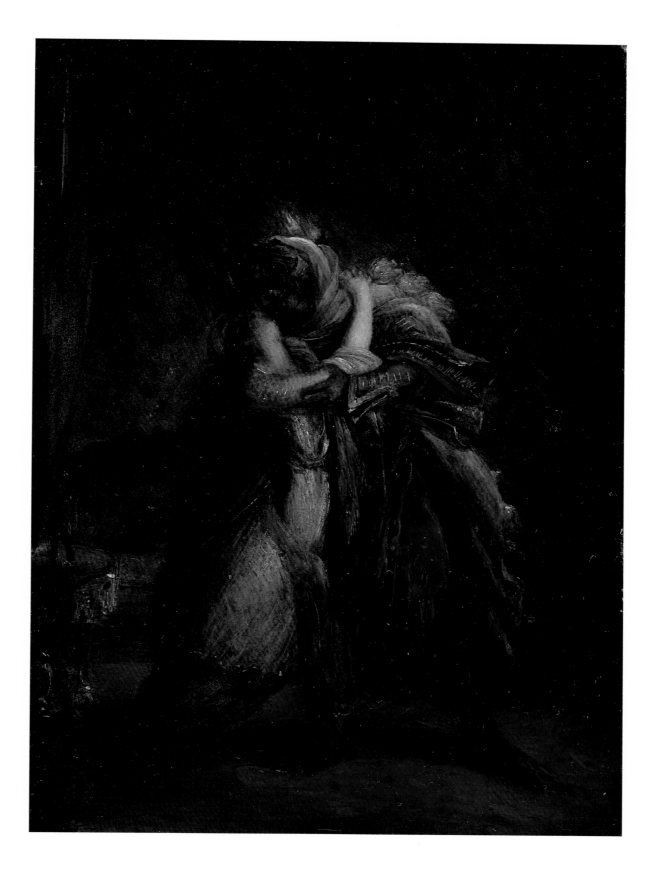

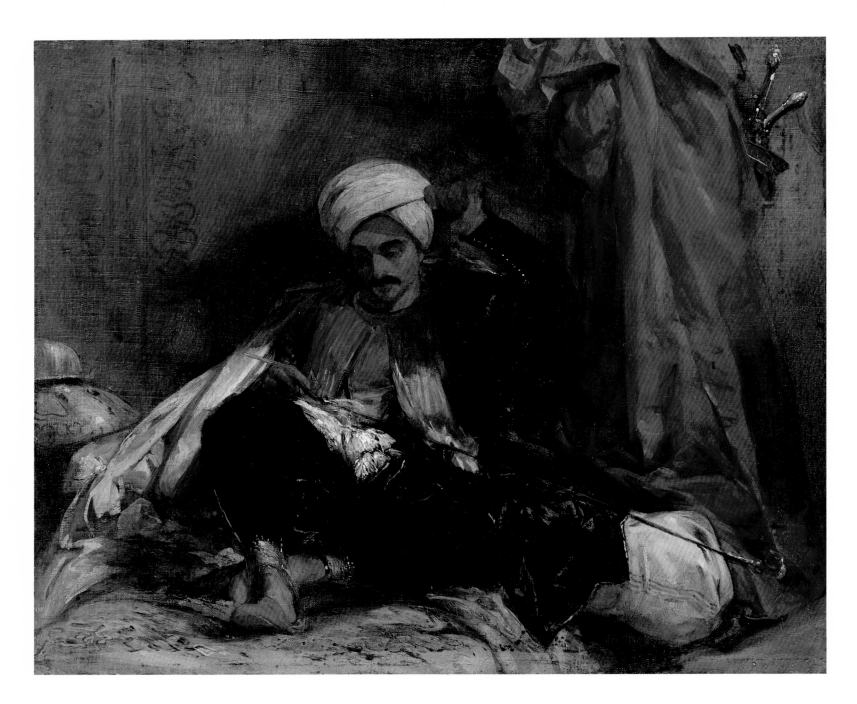

68

A SEATED TURK 1826
Oil on canvas, $13\frac{1}{4} \times 16\frac{1}{4}$ in. (33.7 × 41.5 cm.)

Provenance: Purchased by Sir Thomas Lawrence
at the British Institution, 1829 (Christie's, 15
May 1830, lot 87, bought Colnaghi); C. B. Wall
(or Ward), by 1832; Samuel Rogers, by 1834
to 1855 (Christie's, 28 April 1856, lot 703, as
A Turk enjoying the Siesta, bought Agnew's);
Thomas Birchall, by 1857 to after 1862;
probably Henry Sayles, Boston; Emmons to
1920 (American Art Association, New York, 14
January 1920, lot 127, repr.); Francis Nielson,
Chicago; Edward Norris; (Scott and Fowles,
New York); Patrick Henry, to 1988 (Sotheby's,
New York, 24 February 1988, lot 17, bought
Paul Mellon); Paul Mellon, by whom given to
the Yale Center for British Art.

Exhibitions: Paris, Galerie Lebrun (4, rue du
Gros-Chenet), *Exposition de tableaux au profit des
grecs*, 1826, no. 17, *Un Turc assis*; London, British
Institution, 1829, no. 58, *A Turk*; London,
British Institution, 1832, no. 109, *A Turk
Reposing*; London, Cosmorama Rooms, 209
Regent Street, 1834, no. 44, *A Turk Smoking*;
Manchester Art Treasures Exhibition, 1857,
no. 283 (original label on verso of stretcher);
International Exhibition, 1862, no. 180.

References: Victor Hugo, "L'Exposition de
tableaux au profit des grecs, la nouvelle école de
peinture" (unpublished), *Oeuvres complètes* 2:
1984; Richard Lane, *Lithographic Imitations of
Sketches of Modern Masters* (London, 1829),
pl. 13 (reversed); *Atheneum* (February 1829);
Anonymous, "On the Genius of Bonington and
His Works, part II," *Arnold's Magazine of the
Fine Arts* (June 1833): 46; (A. Pichot ?),
"Bonington et ses émules," *Revue Britannique*
(July 1833): 166; Waagen 1838, 2: 136;
G. Scharfe, *A Handbook of the Gallery of British
Paintings in the Art Treasures Exhibition* (London,
1857), 82–83; Théophile Thoré, *Tresors d'art en
Angleterre*, 3rd ed. (Paris, 1865), 428–29; Thoré,
1867, 10; Dubuisson and Hughes, 165;
Ingamells, *Bonington*, 19, 27, 75; Ingamells,
Catalogue, 1: 71–72.

Yale Center for British Art, Paul Mellon Collection

This recently rediscovered oil is a version of a watercolor composition in the Wallace Collection dated 1826. Bonington painted both works at approximately the same time and before his departure for Venice in the beginning of April. The picture was included in the May exhibition organized to elicit political and financial support for the Greeks besieged by the Turkish army at Missolonghi.

The rich chiaroscuro may owe something to Rembrandt, who had become an important source for Bonington at this time. Sensing this interest, the critic for *Arnold's Magazine* observed in 1833:

Bonington approached, wonderfully near, to the depth and mellowness of the old masters, in no instance more so than in the "Turk Reposing" exhibited last year at the British Institution, amidst an assemblage of the finest paintings in this country — placed too, not far from a Rembrandt of powerful brilliancy and extraordinary depth. And such was its power and harmony, that no comparison could lower its tone.[1]

Thoré, on the other hand, subsequently emphasized its tonal and chromatic affinities to the paintings of Velázquez and Delacroix:

Manchester has only one Bonington: a Turk enjoying the siesta; belonging to Mr. Birchall. The dreamer is seated on a cushion, full-face, legs crossed, in the shadow cast by a great red curtain. He wears a white turban, a vest and trousers, dark green; red slippers. In his right hand he nonchalantly holds a long pipe. Pearl gray background, in Velázquez's tones. The ensemble has something of M. Eugène Delacroix's color, with a more exquisite, if not more expressive sense of design. This small jewel is only one foot high.[2]

As the picture was painted in Delacroix's studio, Bonington had immediate access to his friend's copy of Carreno de Miranda's *Portrait of Charles II of Spain*, which Delacroix thought was an original Velázquez and of which Bonington made two graphite studies.[3] The most relevant stylistic comparisons, however, are with Delacroix's *Femme aux bas blancs* (ca.1826, Louvre) and *Turk Seated on a Sopha Smoking* (no. 69). The latter was in Delacroix's possession in 1825, and Bonington's oil should be considered not as an attempt at imitation but rather as a translation of his friend's composition into his own developing stylistic idiom, which was, as Thoré conceded, more exquisite in touch and possibly more sophisticated in its command of glazes. Not until Delacroix's *Odalisque Reclining* (ca.1827/8; Fitzwilliam Museum) is there a parallel transparency of coloring, although both artists, with Colin, were certainly experimenting simultaneously with advanced oil techniques approximating the visual effects of watercolor painting.

The catalogue for the sale of Sir Thomas Lawrence's collection claimed that the picture was a study from the life. Although the damaged head was extensively retouched in 1988, the vestigial features were sufficiently intact to permit identification of the sitter as the model who posed for a graphite portrait now at Bowood (fig. 37). Delacroix sketched the same person, whom Sérullaz identifies as Bergini — the model who posed for the horseman in his *Massacre at Chios* (1824). But it is questionable that the Delacroix drawings were preparatory to that picture.[4] If the model for *A Seated Turk* was Bergini, it is more likely that he posed again for both Bonington and Delacroix in winter 1825–26. The costume depicted by Bonington combines elements from several contemporary paintings, including Delacroix's *Young Turk Stroking His Horse*[5] and *Turk Seated on a Sopha Smoking*, as well as the Palatiano portrait studies (no. 64). The dry, porous highlighting of the trousers is especially reminiscent of Delacroix's technique.

The picture remained with the artist until his death and was sent by his father to the 1829 British Institution exhibition, where Lawrence "lost no time in making its acquisition," instead of Delacroix's *Marino Faliero*, for which he was then negotiating. It received considerable exposure and was probably one of Bonington's better-known oils in the nineteenth century. It was apparently for sale again when shown at the British Institution in 1832, for in a letter to C. R. Leslie of 6 July, Constable remarked bitterly:

Seguier is carrying on a humbugg at the Gallery which exceeds all his former fun and impudence. A picture by Bonnington is the object — it is not really worth a halfpenny, but Seguier says £500 has been offered for it, which is true. Poor Collins — is almost distracted about it, and wanted me to battle it out — but I have let it alone.[6]

It was acquired by Samuel Rogers and not the National Gallery, and when it was exhibited in Manchester in 1857 George Scharfe could observe, "There is one work of Richard Bonington here, A Turk Enjoying a Siesta, so rich and gemlike in colour, and so fine in chiaroscuro, that many will wonder, as they refer to the catalogue, to find an unknown name. Nine out of ten will ask, who was Bonington?" The previous year Lord Hertford, who had considered adding it to his already ample collection of Bonington's works, similarly noted an eclipse of the artist's reputation in England in his letters from Paris to his London agent: "I should likewise like to have the Bonington Turk, no. 703. I like this master very much, tho he is not muched admired in our country," and,

I am sorry to have missed the Bonington as I am very fond of the master and you know what high prices he fetches in this market You console me in your last letter by telling me that it was an "inferior quality of the master, it was a dark picture and only one figure of no interest" but in your previous communication you tell me "Bonington is a very good picture, painted with a free touch and desirable." It can not have changed in a couple of days and they are becoming more rare every day. So I am sorry to have lost my Turk, but after all I have nothing to say but thank you, if you thought it was running up to an extravagant price which seems to have been the case.[7]

At the turn of the century the picture virtually disappeared into American collections. Until recently an anonymous copy (National Gallery of Ireland), based on Lane's lithograph of 1829, has been misidentified repeatedly as the picture exhibited in 1826.[8]

1. *Arnold's Magazine* (June 1833): 46.
2. Thoré, *Tresors d'art en Angleterre*, 428–29.
3. For a discussion of Delacroix's picture, see Johnson, *Delacroix* 1, no. 21. Bonington's drawings are at Nottingham and in a private collection.
4. Sérullaz, *Delacroix*, nos. 81, 97v, 99; studies of several different heads, including this one, are on a sheet at Besançon; see R. Huyghe, et al., *Delacroix* (Paris, 1963), 148.
5. Johnson, *Delacroix* 1, no. 38.
6. *John Constable's Correspondence IV*, ed. R. B. Beckett (Suffolk, 1965), 8: 73.
7. John Ingamells, *The Hertford-Mawson Letters* (London, 1981), 78–81.
8. BFAC 1937, no. 30, and Ingamells, *Catalogue* 1: 72.

69

EUGENE DELACROIX (1798–1863)

TURK SEATED ON A SOPHA SMOKING
ca.1824–25
Oil on canvas, $9\frac{3}{4} \times 11\frac{7}{8}$ in. (24.7 × 30.1 cm.)

Inscribed: Signed, lower left: *Eug. Delacroix.*

Provenance: Baron de Mainnemaire (Paris, 21 February 1843, lot 6, bought Adolphe Moreau); Etienne Moreau-Nélaton, by whom donated to the Musée du Louvre in 1906.

References: Robaut, *Delacroix*, no. 977; Johnson, *Delacroix* 1, no. 35, with complete documentation.

Musée du Louvre, Département des Peintures (RF 1656)

According to Johnson, Delacroix probably exhibited this oil at the 1825 Société des Amis des Arts exhibition. It may still have been in his possession later that year when Bonington painted his similar subject (no. 68) employing a different model. The yatagan in its sheath is the subject of a separate oil sketch[1] and might have come as a loan or gift from his friend and patron General Coëtlosquet.[2] The sheath alone appears again in the foreground of Delacroix's *Odalisque Reclining* (ca.1827/8; Fitzwilliam Museum).

A first thought in graphite for the composition survives,[3] as do several watercolor studies of a differently costumed model seated on a divan. Sérullaz has inaccurately linked the tinted studies to this picture. The costume and the facial features of the figure in the watercolors are more precisely those of the model in a second oil, *Turk Standing*, of late 1825.[4] That model was the same person who posed for Bonington (fig. 37).

This is one of the few costume pieces of Turks exhibited publicly by Delacroix in the 1820s, although he painted many both in oils and watercolors. His general fascination with Byron and his very topical interest in the Greek war of independence were not as profoundly felt by Bonington who, in painting his few essays in this genre, was responding less to contemporary events than to the immediate stimulus of his studio confreres.

The development of Delacroix's oil technique from the choppy, somewhat dry handling in this picture to the more delicately touched and exquisitely colored *Young Turk Stroking His Horse* of 1826[5] must be attributed, in part, to Bonington's mediating influence, of which Delacroix wrote to Soulier in January 1826, "there is much to be gained in the company of this chap, and I can assure you I have made the most of it."[6] On the other hand, the simplicity and directness of Delacroix's composition and execution imbue his characterization with an expressiveness that disquiets the viewer in a manner Bonington rarely, if ever, intended.

1. Johnson, *Delacroix* 1, no. 27.
2. Delacroix, *Journal* 1: 90 (1 May 1824).
3. Sérullaz, *Delacroix*, no. 96
4. Ibid., *Delacroix*, nos. 97–98, and Johnson, *Delacroix* 1, no. 36.
5. Johnson, *Delacroix* 1, no. 38.
6. Delacroix, *Correspondence* 1: 173.

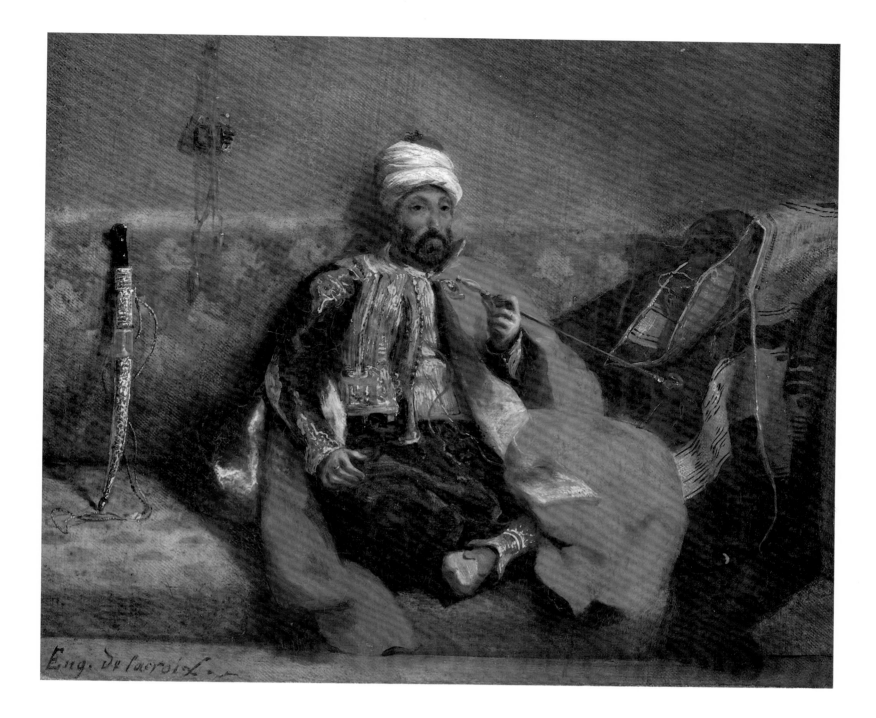

DON QUIXOTE IN HIS STUDY ca.1825–26
Oil on canvas, 16 × 13 in. (40.6 × 33 cm.)

Provenance: Possibly Bonington sale, 1829, lot 102, bought Triphook; William Benoni White (Christie's, 23 May 1879, lot 187, bought Wigzell); possibly S. Herman de Zoete (Christie's, 8 May 1885, lot 102, bought Carton); Thomas Woolner, by 1886 to 1895 (Christie's, 18 May 1895, lot 111, bought Dowdeswell, with the note that it was "from the collection of W. Benoni White 1879"); Paul Citroen, Paris; L. de Boer, Amsterdam, 1954; purchased by the Castle Museum, 1958.

Exhibitions: Nottingham 1965, no. 291, pl. 48.

References: Honour, *Romanticism*, 269, fig. 181.

Castle Museum and Art Gallery, Nottingham (58-56)

After Shakespeare, Cervantes was probably the most revered in the pantheon of pre-romantic authors. "What a thing it is to have produced a work that makes friends of all the world that have read it, and that all the world have read! Mention but Don Quixote and who is there that does not own him for a friend, a countryman and brother?" Hazlitt wrote this in 1824,[1] and virtually every French literary figure of note voiced a comparable appreciation, for Don Quixote was a paradigm of the romantic enthusiast, whose quest for universal truths, whose disregard for material comforts, and whose transcendent moral probity redeemed his near-lunatic behavior. Conversely, he was also a parody of the historical virtues extolled by the troubadour tradition. Perhaps for this reason oil paintings illustrating passages from *Don Quixote* were not that common in the Salons of the 1820s, although Dunant exhibited *Don Quixote Reading* in 1827.

As a subject for book illustrators, the novel remained extremely popular, and at least four illustrated French editions appeared during the 1820s. Saint-Martin's six-volume translation, with frontispieces by Eugène Devéria, was published in 1825, but it contains no illustration of Don Quixote in his study. Bonington may have utilized Dubornial's 1822 translation, with illustrations by Eugène Lami (no. 5) and Horace Vernet, if he did not have access to Tonson's English translation of 1742, with plates by John Vanderbank. Both have frontispieces illustrating the narrative episode of this picture, although neither composition includes the hunting dog. Robert Smirke's design for this passage was a simple vignette to the preface of volume 1 of Cadell's 1818 edition. Like Vanderbank, he depicted his protagonist as a contemplative, with his head resting on his hand and his eyes directed heavenward.

Following Dubornial's text, Quixote was "a campagnard — that is, he lived nobly with a lance on the wall, antique armor in the attic, a nag in the stable, and a racing dog always ready to fly He was meager of figure, tall, of robust temperament, although with a dry and bony complexion." As for his psychological state,

by dint of constant reading, constant meditation and lack of sleep, the poor man lost his spirit; his brain doubtless melted or dried up. His imagination thus replenished itself pell-mell with all that he had read of enchantments . . . and comparable chivalric reveries Finally, the seigneur Quixote so completely lost his faculties that he suddenly devised the most bizarre, extravagant, and ridiculous project that ever entered the imagination of a madman. He persuaded himself that he was destined to reestablish the noble, useful profession of knight-errant.

Bonington's conception for this passage is unusual for the period in that he depicts the hero in almost casual repose. As first noted by Auguste Jal, the intense inward agitation and total obsession are concentrated in Quixote's transfixed gaze. Vernet's illustration and Delacroix's oil of 1824, which combines this and a subsequent passage,[2] portray a more distraught and wildly gesticulating character, as do most later illustrations, such as Tony Johannot's.[3] In consciously avoiding such a theatrical dramatization of dementia, Bonington approaches in spirit the more clinical portraits of monomaniacs Géricault painted for Dr. Georget in the early 1820s. Whether Bonington subscribed to Georget's theories of obsessive delusion has not been documented; however, he was intimate with Géricault and would certainly have been familiar with his revolutionary portrayals of insanity.[4] One of the closest literary parallels is Balzac's description of Raphael de Valentin's transformation in chapter one of *The Fatal Skin* (Paris, 1832). Immersing himself in the bric-a-brac of ages that chokes the tenebrous shop of a Faustian pawnbroker, this hypersensitive aesthete halucinates his "escape from the realities of life, rising gradually toward an ideal world, and finally attaining the enchanted palace of rapture, where the universe appeared to burn in the shapes and forms of fire, as once on Patmos the future had flamed before the eyes of St. John." The chimeras that haunt the visionary and madman alike and that belong to a rich tradition of graphic personification from Jacques Callot's *Temptation of St. Anthony*, an impression of which Bonington's father owned, to Goya's and Gustave Doré's representations of Don Quixote, are left to the viewers' and readers' imaginations.

Like so many contemporary illustrations of alchemists (another popular romantic subject, especially for Eugène Isabey in the 1830s), or of the opening scene of Goethe's *Faust*,[5] Bonington's composition relates ultimately to Rembrandt's "Philosopher" pictures, although its format, particulars of setting, and portrait-like treatment of the head also recall Rembrandt's etchings of *Jan Six* and *Abraham Francen*. The thin, dragged lines of white highlight on the tapestry, the pasty delineation of the Don's face, and the mellow luminescence resulting largely from an accomplished use of glazes in the curtains and background are exceedingly Rembrandtesque in effect. Quixote's face also appears to merge features from Delacroix's studies of the head of Philip II[6] and the engraved portraits of Cervantes that were often frontispieces to the novel. The Spanish helmet on the floor was sketched at Dr. Meyrick's.[7] Marion Spencer cites a source for the hunting dog in Rubens's *Village Festival* (Louvre), which Bonington was copying from at this moment, but a more exact model is to be found in Frans Snyders's *Three dogs in a kitchen* (Louvre). The animal's action accentuates Quixote's distraction and was introduced for that purpose, but its aggressive stance also calls to mind the first appearance of Mephistopheles to Faust as a vicious canine. Bonington might have taken the idea for this narrative embellishment from Moritz Retzsch's illustrations to *Faust*, which Delacroix was copying, also about this time.

A watercolor that belonged to Lewis Brown and that corresponds in most details but lacks the avaricious canine was engraved by Sangster for Jal's biographical notice on Bonington in the *Keepsake Français* (Paris, 1831).[8] Jal observed that this watercolor was earlier, in style, than Bonington's watercolor *Amy Robsart and Leicester* (fall 1826), and a comparable date of late 1825 or early 1826 — that is, approximately contemporary with *Bedchamber of Henri IV* (no. 63) — is likely for the Nottingham picture. A grisaille oil sketch for the composition belonged to Baron Rivet.[9] Finally, the Nottingham picture was engraved in mezzotint by S. W. Reynolds in 1833, as a pendant to another Rembrandt-inspired interior, *The Grandmother* (see no. 107).

1. Hazlitt, *Notes*, 186.
2. Johnson, *Delacroix* 1, no. 102, purchased by Coutan in that year.
3. See U. Seibold, "Zur figur des Don Quijote in der Bildenden Kunst des 19 Jahrhunderts," *Wallraf-Richartz-Jahrbuch* 45 (1984): 145–71.
4. See Eitner, *Géricault*, 241ff.
5. Ary Scheffer, for instance, would borrow the traditional pose of the contemplative employed by Vanderbank and Smirke for their illustrations of *Don Quixote in His Study*, for his own painting *Faust in His Study*. Delacroix had previously used this pose in his lithograph *Faust and Wagner* (1827).
6. Sérullaz, *Delacroix*, nos. 1432–33.
7. Shirley, pl. 73.
8. Brown sale, Paris, 17–18 April 1837, lot 10.
9. Private Collection; a variant oil sketch exhibited at Gobin's gallery, Paris, 1936 (no. 34, repr.) is by another hand.

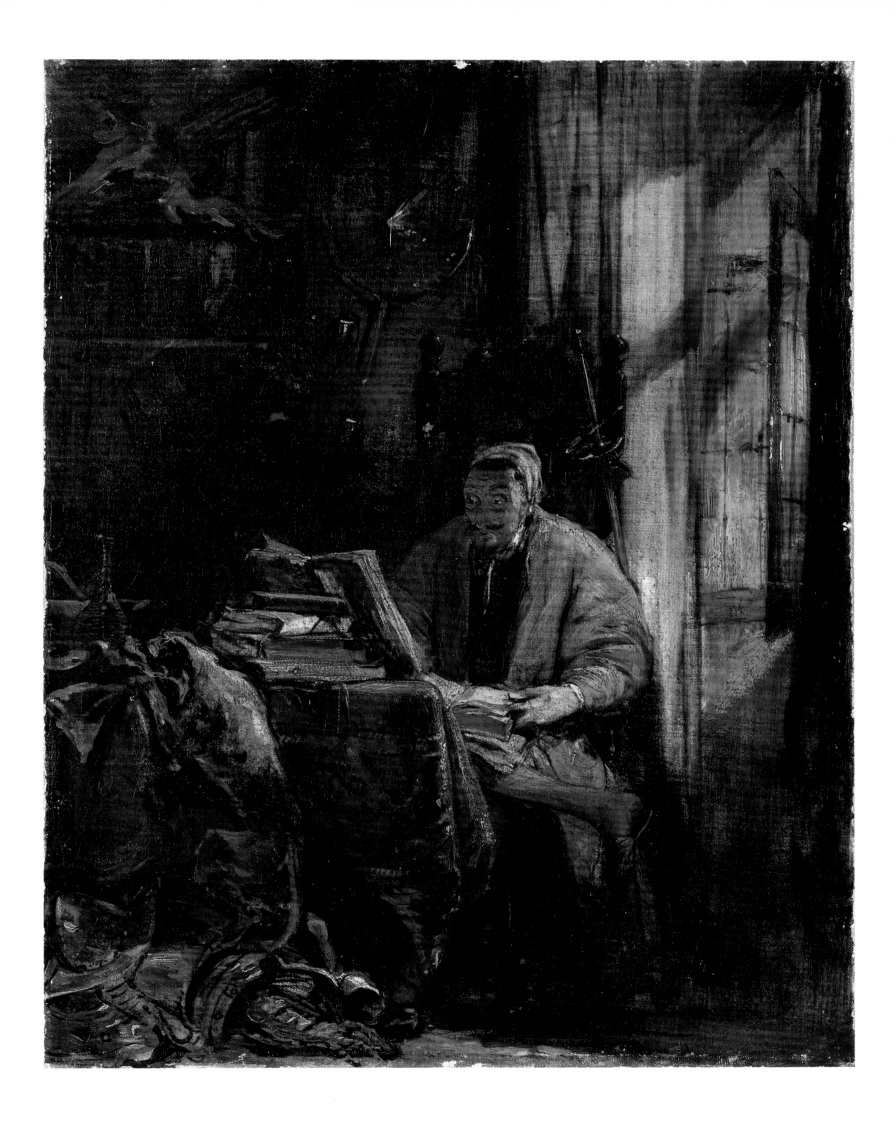

71

COTTAGE AND POND ca.1825–26
Oil on canvas, $10\frac{1}{4} \times 13\frac{3}{4}$ in. (26 × 34.9 cm.)

Inscribed: Signed, lower right: *R P B*

Provenance: Mrs. Worthington, Cullompton, Devon, to 1933[1]; Gooden and Fox, 1933; Ernest Edward Cook, 1933 to 1955; gift of the National Art-Collections Fund, 1955, to the Fitzwilliam Museum.

References: J. W. Goodison, *Catalogue of Paintings* (Cambridge: Fitzwilliam Museum, 1977), 3: 21 and pl. 40.

The Syndics of the Fitzwilliam Museum Cambridge (PD 11-1955)

This oil is a pastiche of Rembrandt's etching *Cottage with a White Paling*.[2] Two oil copies after other Rembrandt etchings were recorded in the studio sales,[3] but in these the artist took fewer liberties with the original compositions. Other replicas of Rembrandt, like that after *Tobit and the Angel* (Fogg Art Museum), have less authoritative attributions.[4] The sale of the prints in the possession of Bonington's father

at his death, a fascinating piece of primary documentation inexplicably overlooked in all previous Bonington literature, included thirty-nine Rembrandt etchings, in addition to one hundred and fifty prints by Du Jardin, Claude, Berchem, Van de Velde, and Wierotter, among the other Dutch and Flemish masters represented. Another lot, described as various copies after Rembrandt, included two "lithographic imitations" by Bonington.[5]

The importance of Rembrandt to the artists of Bonington's circle is well known. Hippolyte Poterlet actually traveled to Holland in 1827 to study and copy that master. Numerous oil sketches after Rembrandt figured in both Poterlet's and Colin's atelier sales. Bonington was copying Dutch pictures in the Louvre as early as 1819, but his interest in Rembrandt probably accelerated in 1825 when he began to explore landscape forms more varied than marines and when his friendship with both Delacroix and Huet intensified. Huet, in fact, painted a replica of this oil, and similar compositions, including his first major commission for the Duchesse de Berry, favored cottages nestled among trees.[6] In 1826 Huet also made an etched copy of Rembrandt's *Three Trees* from a plate in John Burnet's *A Practical Treatise on Painting* (London, 1826).

A Bonington watercolor version (Rhode Island School of Design) anticipates the oil, and a similar but reduced composition is the subject of a graphite vignette of 1827 (Yale Center for British Art).

1. The earliest history of the picture is unknown, but it may be identifiable with one of the following: *Cottage and Trees*, Sir Henry Webb (Paris, 23–24 May 1837, lot 46); *Cottage and Trees by a stream*, Lewis Brown (Paris, 1839); *Landscape with Water in Foreground and a Cottage under Trees*, Messrs. Murriata (Christie's, 27–30 June 1893, lot 189); *The Duck Pond*, Anonymous (Christie's, 27 June 1864, lot 48); *Cottage near the Edge of a Wood, a Small Study*, Lord Henry Seymour (Paris, 1860).
2. Goodison was the first to identify this source.
3. Bonington sale, 1836, lot 56, *Christ Peaching*, subsequently with the Fine Art Society, 1947; and 1838 sale, lot 117, *The Raising of Lazarus*.
4. Gobin, *Bonington*, pl. 18. Delacroix owned a Roqueplan oil copy of the Tobit, and an oil copy was in Colin's studio sale (Paris, 10 March 1860, lot 126).
5. Sotheby's, 24 February 1838.
6. See, for instance, Sotheby's, 19 March 1980, lots 15–16; Delteil, *Huet*, nos. 10, 18, 40, 43–44; and the oil, *Guardian's House Compiègne* (1826), reproduced in *The Age of Revolution* (Paris: Grand Palais, 1975), 283.

72

BARGES ON A RIVER ca. 1825–26
Oil on millboard, $9\frac{7}{8} \times 13\frac{7}{8}$ in. (25.1 × 35.3 cm.)

Inscribed: Signed, lower left: *R P B*; verso:
R. Davy label

Provenance: John Hinxman (d. 1848), by 1829
(possibly Christie's, 25 April 1846, lot 9); Lord
Taunton (not listed in the Taunton Heirloom
sale, Sotheby's, 15 July 1920); Mrs. E. W.
Tilling, by 1931; Mrs. Emily Potter, by 1934,
from whom purchased by Paul Mellon in 1962.

Exhibitions: BFAC 1937, no. 41; Agnew's 1962,
no. 12.

References: Harding, *Works* (1829); Shirley, 96.

Yale Center for British Art, Paul Mellon
Collection (B1981.25.54)

Although Bonington drew several graphite
studies of windmills in the vicinity of Mantes in
1825,[1] this picture, to borrow from the
contemporary parlance of the atelier, has the
"air of composition," and like *Cottage and Pond*
(no. 71) may casually derive its formal elements
and structure from a seventeenth-century
prototype. An etched copy by the Norwich
artist Henry Ninham (1793–1874) and a
watercolor copy based on Harding's lithograph
are recorded.[2]

1. Christie's, 16 November 1982, lot 51.
2. Sotheby's, 13 March 1980, lot 90.

73

A WAGON IN A STORM ca.1825–26
Watercolor, $8\frac{3}{8} \times 10\frac{3}{4}$ in. (21.4 × 27.3 cm.)

Inscribed: Signed, lower right: *R. P. Bon*[cropped]

Provenance: Possibly Bonington sale 1834, lot 28, bought Colnaghi; possibly Lewis Brown (Paris, 16–17 April 1834, lot 65); Humphrey Roberts, by 1906 (Christie's, 21 May 1908, lot 211, bought Agnew's for Paterson); W. B. Paterson, from whom acquired in 1910 for the Felton Bequest, National Gallery of Victoria.

Exhibitions: Possibly London, Cosmorama Rooms, 209 Regent Street, 1834, no. 123; Nottingham 1965, no. 212, pl. 8.

References: Dubuisson 1909, repr. 379; Dubuisson and Hughes, repr. opp. 109.

National Gallery of Victoria, Melbourne

The artists of Bonington's circle were partial to the subject of a wagon and its occupants threatened by the elements, and examples by Géricault, Francia, Huet, and Roqueplan are frequently encountered. They are an extension, without the implicit sublimity of heroics, of an earlier tradition, popular on both sides of the channel, of depicting military baggage carts buffeted both by the elements and by hostile bombardment. Roqueplan appears also to have been fond of illustrating diligences swamped by tidal bores.[1]

Although the terrain cannot be identified with any degree of certainty, it resembles the salt flats in the vicinity of Trouville represented elsewhere in a Bonington watercolor sketch of 1826 and its oil version of ca.1827–28 (no. 156).

1. Sotheby's, 23 November 1978, lot 20, a watercolor signed and dated 1829 which anticipated an oil version of the composition exhibited at the 1831 Salon.

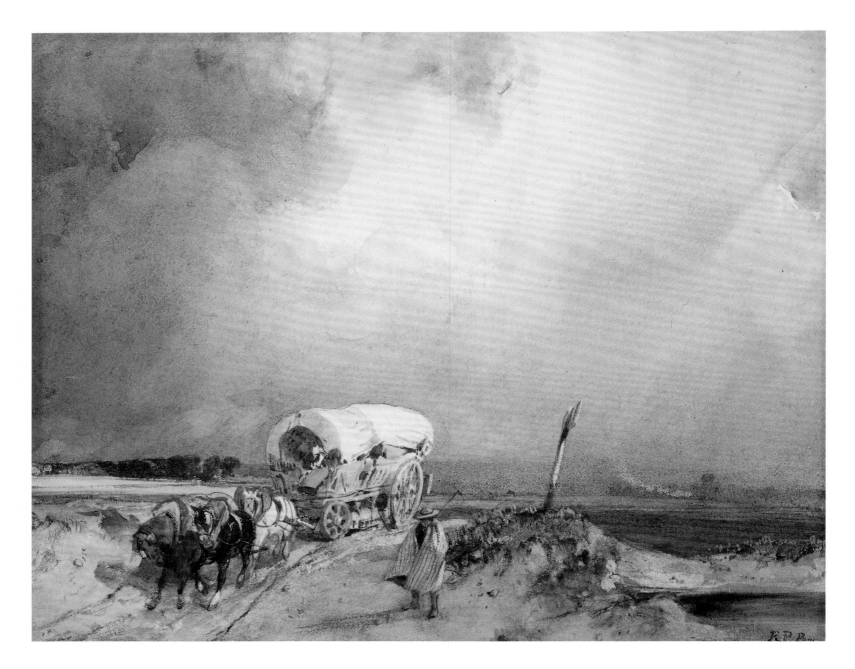

CAMILLE ROQUEPLAN (1800–1855)

WAGON ON A WOODLAND TRACK ca.1827–30
Watercolor, $13\frac{7}{8} \times 10\frac{1}{8}$ in. (34.7 × 25.2 cm.)

Inscribed: Signed, lower left: *Camille Roqueplan*

Provenance: James Mackinnon, 1983, from whom purchased by present owner.

Private Collection

Of Bonington's French colleagues, Camille Roqueplan was the most imitative of his style and his selection of subjects, an affinity noted by virtually every critic and too often dismissed as dependancy. With Delaroche, Carrier, Charlet, and Lami, he enrolled with Gros in 1818. His earliest inclination was landscape painting, and in 1821 he was a semifinalist in the *concours du paysage*. He exhibited two landscapes in oil at the 1822 Salon, and by 1824 he had broadened his repertoire to include a *paysage historique* illustrating Scott's *Quentin Durward*. On Bonington's recommendation he visited England and Scotland with Lami in 1826. For the 1827 Salon he submitted his most important rendering of a Scott subject, *Marée d'Equinoxe* (*The Antiquary*), which had been commissioned by the Duc de Fitz-William and is known today only by an *étude* (Private Collection) and an engraving. He continued to paint literary subjects from Scott with a dominant landscape element well into the 1830s.

Roqueplan's watercolor technique of the 1820s is almost indistinguishable from Bonington's, aiming at the same visual effects and employing the same technical tricks. His preferred landscape subjects — wooded lanes, vistas, beach scenes with children — are also comparable in their emotive reticence. A composition similar to *Wagon on a Woodland Track* is in the Wallace Collection.[1] Gustave Planche, who favored the "studied and intense poetry" of Roqueplan's friend Paul Huet, offered the prevailing critical opinion of such landscapes in his 1831 Salon review:

Camille Roqueplan is an ingenious and talented painter, formed by Bonington's example, less true, less conscientious, less poetic than the master who served as his model, but, all in all, to the same degree varied in his compositions, delightful in his choice of subjects, so adept in disguising problems of execution, which he seems to conjure away His faults consist generally in his sacrificing truth for effect, in relying a bit too much on improvisation and facility, instead of on observations that can only result from the incessant struggle with nature Roqueplan sees nature quickly, does not stop long to regard it, and is little concerned with idealising it.[2]

1. Ingamells, *Catalogue 2*, no. P652, signed and dated 1832.
2. Planche, *Salon 1831* 1: 91.

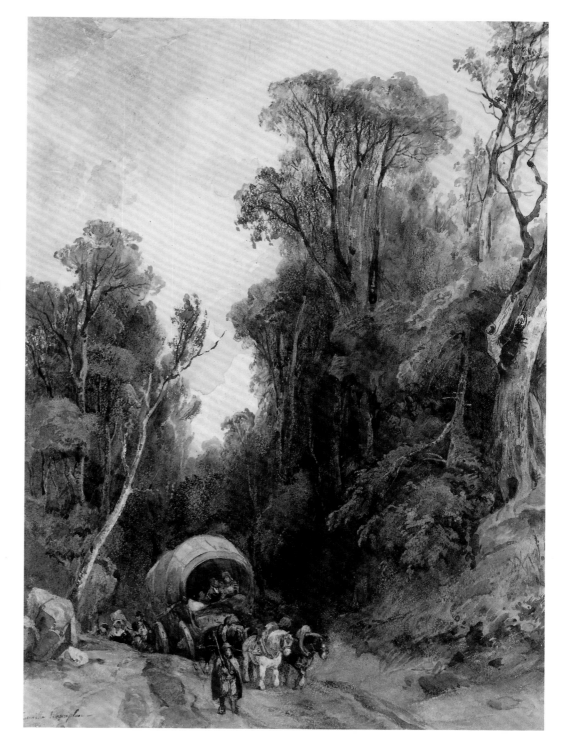

75

A FISHERMAN ON THE BANKS OF A RIVER,
A CHURCH TOWER IN THE DISTANCE
ca.1825–26
Watercolor over graphite, 7 × 9⅜ in.
(17.5 × 23.7 cm.)

Inscribed: Signed, lower left: *R P Bonington*

Provenance: Sir Ernest Debenham; Dr. H. A. C.
Gregory; C. R. N. Routh; Dr. William
Brockbank; Anonymous (Sotheby's,
11 November 1982, bought Leger).

Exhibitions: Agnew's 1962, no. 42; Nottingham
1965, no. 210.

References: Cormack, *Review*, pl. 37.

Private Collection, New York

Malcolm Cormack first noted the influence of
Turner on the group of river landscapes that
Bonington painted after his return from
England. A date after the London trip for this
example is appropriate, but not as early as the
River Scene with Fisherman (Bibliothèque
Nationale; inscribed 1825).[1] The sky treatment,
as a progression of blue and orange striations
blending gradually into an expanse of yellow at
the center and pale blue at the upper edges, is
identical to that in contemporary oils (see
no. 77).

The blocky Norman tower in the distance
has led several scholars to misidentify the
terrain in this watercolor as English. Similar
structures abound in the vicinity of Dunkerque
and St-Omer and appear in several Bonington
drawings of 1825 at both locations.

1. Pointon, *Circle*, fig. 17. Another composition of this
type, also dated 1825, was Reims, Hôtel Drouot,
18 March 1990, of which an anonymous copy was at
Sotheby's, 10 July 1986, lot 114.

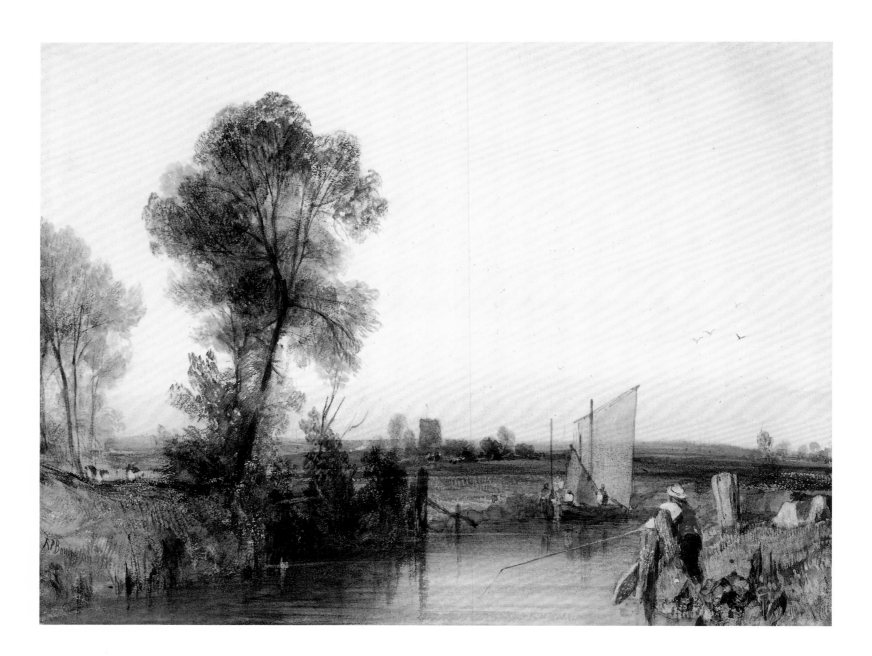

76

A PICARDY COAST SCENE WITH CHILDREN —
SUNRISE 1826
Oil on canvas, $18\frac{1}{4} \times 21\frac{3}{4}$ in. (46.2 × 55.2 cm.)

Inscribed: Signed and dated, in brown, lower
right: *R P Bonington 1826*

Provenance: 3rd Marquess of Lansdowne and
by descent to the 6th Marquess, to 1965;
The Hon. Patrick Plunkett, by whom given
to Her Majesty Queen Elizabeth II.

Exhibitions: BFAC 1937, no. 49; Agnew's 1962,
no. 7; Nottingham 1965, no. 264.

References: Shirley, pl. 56.

Her Majesty Queen Elizabeth II

This substantially revised version of the picture
exhibited at the British Institution in February
1826 (no. 49) was probably commissioned by
the 3rd Marquess of Lansdowne shortly
thereafter.[1] Like the other major commissions of
this year, the picture is fully signed and dated,
which had rarely been Bonington's prior
practice.

Henry Petty-Fitz-Maurice, 3rd Marquess of
Lansdowne (1780–1863), was a director of the
British Institution, a trustee of the National
Gallery and the British Museum, and an
enlightened advocate of modern British art.
He was also one of the more conspicuous
bidders at the first Bonington studio sale in
1829. His unrivaled collection of graphite and
chalk studies from every phase of Bonington's
career has fortunately remained intact at
Bowood House.

1. A contemporary copy by an anonymous hand is
privately owned.

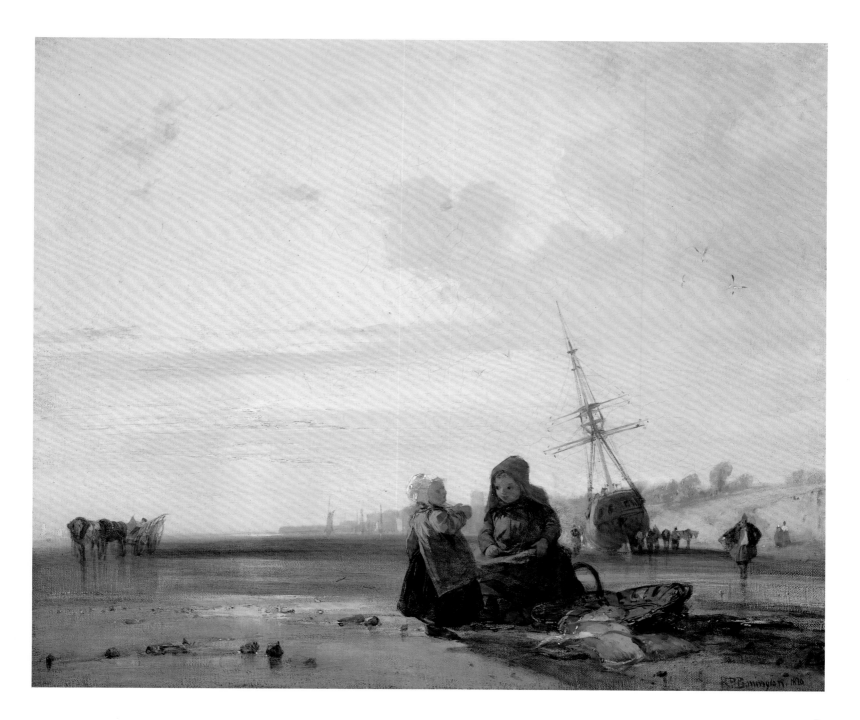

77

NEAR MANTES 1826
Oil on canvas, $21\frac{7}{8} \times 33\frac{3}{8}$ in. (55.6 × 84.7 cm.)

Inscribed: Signed and dated, lower right:
R P Bonington 1826

Provenance: Possibly Gérard (Paris, 10 December 1827, lot 76, as *Vue prise près de Mantes, sur la Seine, au soleil couchant. Ce tableau, d'un bel effet, rappelle les ouvrages de Cuyp*, bought Du Sommerard); possibly Alexandre Du Sommerard; possibly Lord Northwick (Christie's, 12 May 1838, lot 62, as *Evening — River scene on the Loire, splendid setting sun; towers of the cathedral of Nantes* [sic] *in the distance*, bought Lord Lansdowne); 3rd Marquess of Lansdowne; Earl of Normanton, Somerly, Ringwood, by 1854 to 1908; H. Darell Brown by 1910 (Christie's, 23 May 1924, lot 2, bought Arthur Ruck); Scott and Fowles, 1924.

Exhibitions: Paterson Gallery, London, *Bonington and Cotman*, 1913.

References: Waagen 1854–57, 4: 369 as a *River Scene*, but in the Earl of Normanton's annotated copy at Yale described as *Rouen*; Dubuisson and Hughes, 204 and repr. opp.; Fry, 1927, 268–74; Edwards, 1937, 35.

The Taft Museum, Cincinnati (1931.443)

Although thought in the last century to represent a view of either Nantes or Rouen, the picture was properly identified by Dubuisson and Hughes[1] as a view of Mantes from the southeast, with the Collégiale Notre-Dame, built over several centuries beginning in 1170, and the fourteenth-century Tour St-Maclou prominent on the horizon. Pentimenti reveal that the artist made minor adjustments to the height of the towers of Notre-Dame.

The facture and perspective are somewhat more assured than in the similarly conceived *On the Seine near Mantes* (Wallace Collection). That picture, which presents a view from nearer to the city, should be dated ca.1825 on both its thematic and stylistic evidence.[2] The influence of early Turner, especially such pictures as *Newark Abbey on the Wey* (ca.1807)[3] which Bonington might have seen in Sir John Leicester's collection in 1825, is limited to the sympathy that both artists exhibit for Albert Cuyp, as first noted at the 1827 Gérard sale.

An untraced oil of Mantes from the north was formerly in the collection of Baron Rivet's descendents.[4] Bonington was undoubtedly attracted to the city for its historical associations and would have had ample opportunity to depict the environs during any of his frequent trips to Rivet's nearby château.

1. Dubuisson and Hughes reproduced a copy, with variations. A more faithful replica, also by an anonymous hand, was at one time with Agnew's. Another picture of this description, but smaller, was in the Nieuwenhuys sale, Christie's, 10 May 1833, lot 94, bought Barchard.
2. Ingamells, *Catalogue* 1: 30.
3. Yale Center for British Art; Butlin and Joll, *Turner*, no. 65.
4. Dubuisson and Hughes, repr. opp. 117.

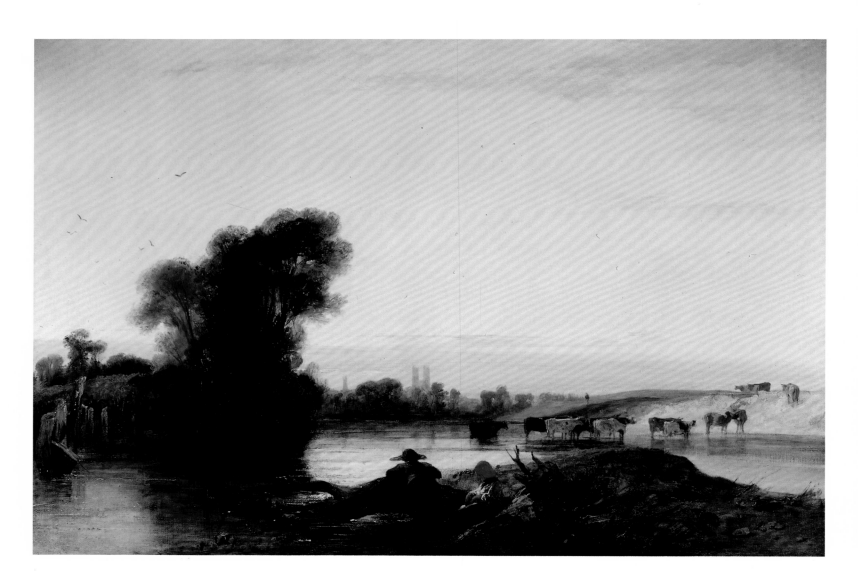

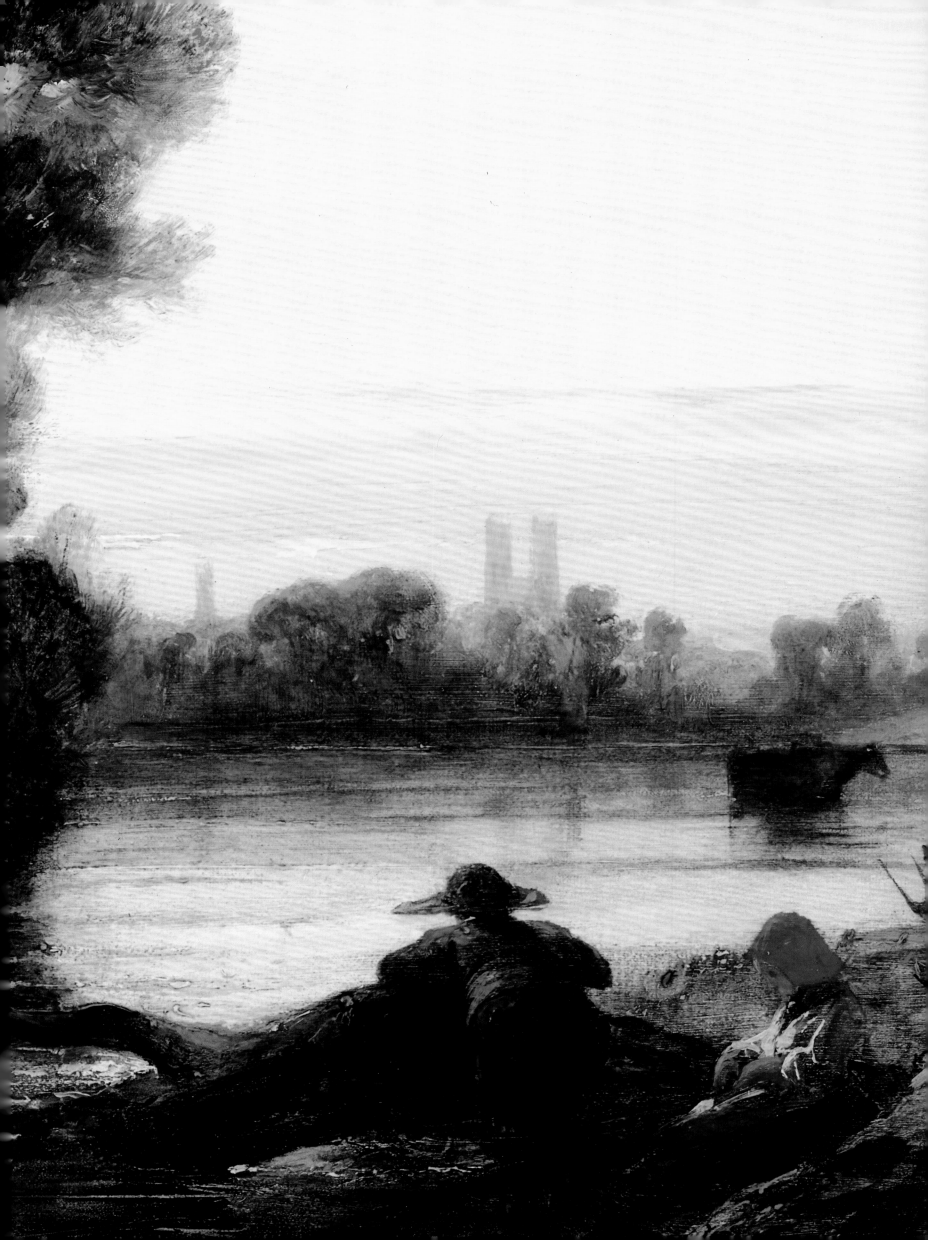

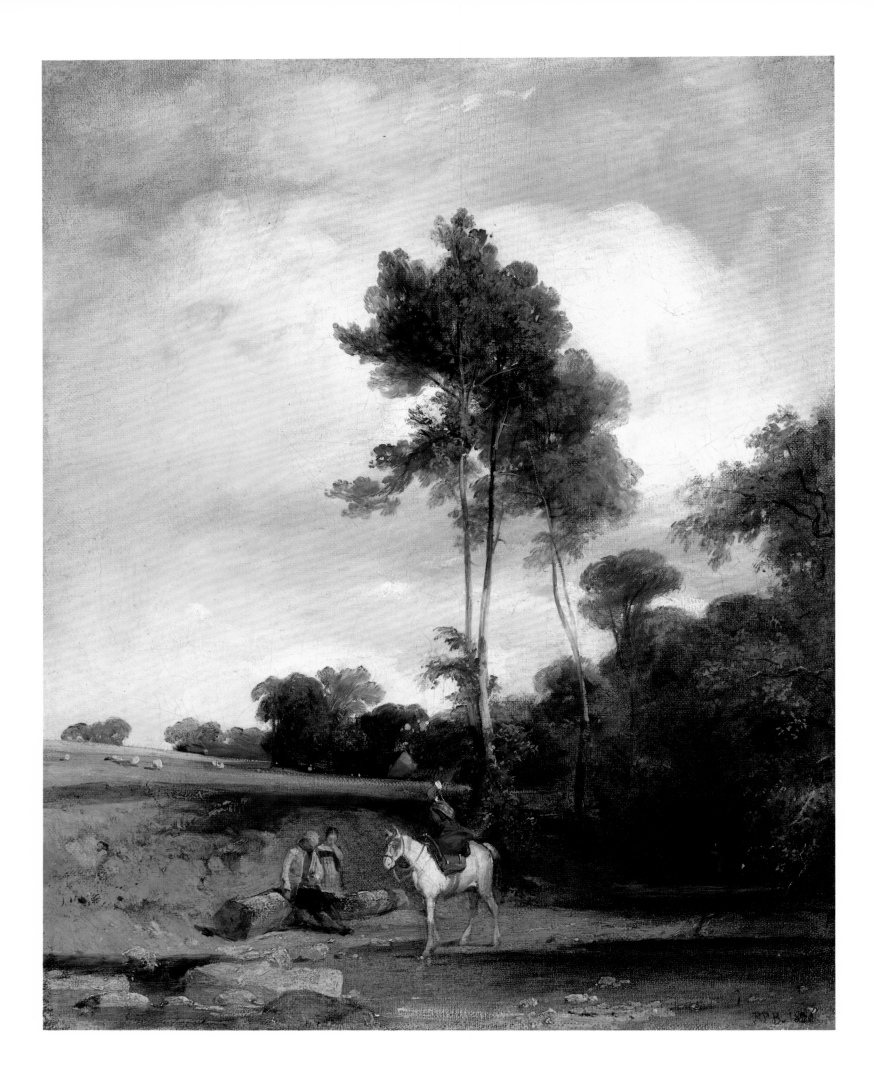

78

ROADSIDE HALT 1826
Oil on canvas, $18\frac{1}{2} \times 14\frac{7}{8}$ in. (47 × 37.8 cm.)

Inscribed: Signed and dated, lower right:
R P B 1826

Provenance: Probably L.-J.-A. Coutan (Paris,
17 April 1830, lot 5); Property of a gentleman
residing in Paris (Sotheby's, 18 May 1838, lot
84; the sale postponed until 15 June); the same
collection (Sotheby's, 15 June 1838, lot 117,
bought LD); possibly John Archbutt (Christie's,
13 April 1839, lot 109, bought in); Joseph Gillot
(Christie's, 19 April 1872, lot 178, bought
Agnew's); possibly Charles Cope (Christie's,
8 June 1872, lot 178, bought Agnew's); Jean
Louis Mieville (Christie's, 29 April 1899, lot 13,
bought Boussod); Francis Nielson, by whom
given to the Metropolitan Museum in 1945.

References: Shirley, pl. 12 (misdated 1819).

The Metropolitan Museum of Art,
Gift of Francis Nielson, 1945

Bonington here audaciously sports with a dual
perspective system favored by seventeenth-
century landscapists. The freestanding poplars,
situated virtually on the central axis, control
both devices. To the right, they initiate an
abrupt diagonal recession into deepest shadow;
to the left, they function as a *repoussoir* against
an expansive sky. As was typical of Bonington's
oil technique, the picture was painted over a
white ground to enhance the translucency of
thinly applied oil washes, most apparent in the
shadows and stream. Unfortunately, these were
overcleaned earlier in this century. Also quite
characteristic is the subtle color adjustment the
artist has effected by slightly reducing the
scale of the woman seated on the horse and
substituting blue for the original red of her
jacket.

In describing the sentiments addressed by
such a picture, one might invoke the appraisal
of Claude's exquisite stasis — actually intended
as stricture — by Pierre Henri de Valenciennes
(1750–1819), the foremost champion of the
academic landscape tradition:

*Such works quite simply offer landscapes where one
would want to own a dwelling, because it would be
situated in a beautiful view, and one could there
breathe the freshness of the moment of midday, could
stroll along the shady banks of a river, and plunge into
the dense forest in order to surrender oneself to the
reveries of sentiment; in short, all the sensations which
such works produce are only relative to oneself and do
not go beyond us.*[1]

In its purely personal reflections on nature,
devoid of the pastoral allusions of the *paysage
composée*, such pictures anticipate the nostalgia
for an elusive tranquility of rural life that would
dominate the interests of French landscape
painters in the next decades.

1. *Elements de perspective pratique, à l'usage des artistes*
(Paris, 1800), 376–77.

79

PAUL HUET (1803–1869)

LANDSCAPE IN NORMANDY 1826
Oil on canvas, $16\frac{1}{2} \times 11\frac{5}{8}$ in. (42×29.6 cm.)

Inscribed: Signed and dated, lower right:
P Huet 1826

Provenance: James Mackinnon, 1986, from whom
purchased by the present owner.

Private Collection

The composition of this oil, which is
contemporary with Bonington's *Roadside Halt*
(no. 78), is extraordinary by any standards and
is unusual for Huet at this date in that he has
denied himself the mystery, the color, the
inherent energy of his familiar canopy of forest
vegetation at St-Cloud or Compiègne and
confronted a near-denuded prospect, which was
Bonington's forte. He was apparently pleased
with the result, as a similar composition was
the subject of his first etching and of a vignette
in the suite of lithographic croquis *Macedoine*
(1829).[1]

The effect of this single tree arching toward a
momentary break in the clouds could be more
startling or more felicitous in conveying, by
minimal suggestion, Huet's preoccupation with
the immensity and the capricious power of
nature only had he introduced in its stead a bolt
of lightning. If asked, Huet would doubtless
have responded that whereas Bonington was the
eye of romantic landscape painting, he was its
soul, for the great spectacles of nature that
captivated his fancy were anathema to his
closest friend in youth. The quiessence of
Bonington's lyricism — his "sanity" as Thoré
described it — had little in common with
Huet's emotionally charged vision, yet, despite
this temperamental divergence, Huet could
acknowledge with admiration that Bonington
possessed "a genius of perception and of
indication: from the Flemish he had a fine and
just perception and from the master colorists a
thorough understanding of tone and harmony."[2]

1. Delteil, *Huet*, nos. 1 and 40.
2. Huet, *Huet*, 96.

SHIPPING IN AN ESTUARY, PROBABLY NEAR
QUILLEBOEUF 1825/6
Watercolor over graphite, $5\frac{3}{4} \times 8\frac{3}{4}$ in.
(14.5×22 cm.)

Inscribed: Signed and dated, lower right: *R P B
1826* [or 5]

Provenance: Madame Henri Leroux (Sotheby's,
21 March 1974, lot 114, bought Paul Mellon);
Paul Mellon, by whom given to the Yale Center
for British Art.

References: Pointon, *Bonington*, fig. 23.

Yale Center for British Art, Paul Mellon
Collection (B1981.25.2398)

The exact location is uncertain, although the
river's breadth strongly suggests that the view,
as in the oil painting of similar title (no. 34),
is along the banks of the Seine opposite
Quilleboeuf.

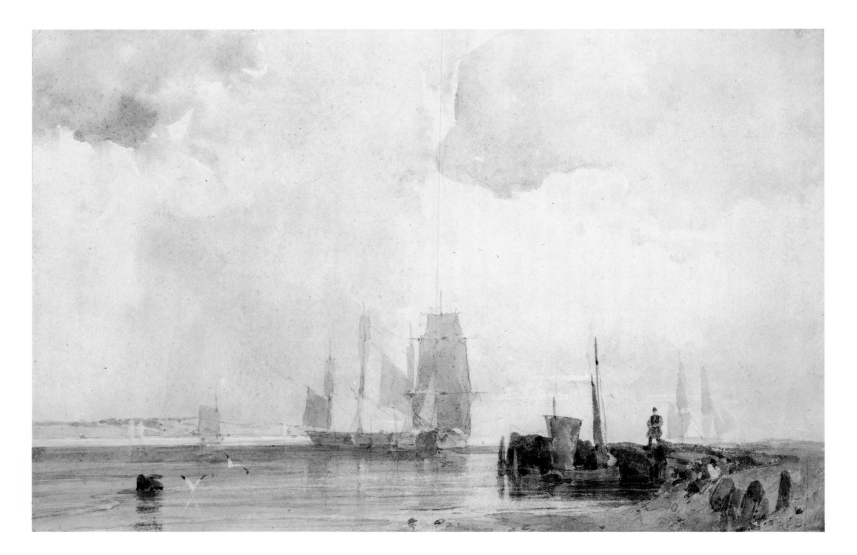

THE WHEATFIELD 1826
Watercolor and bodycolor, with scraping out,
$4\frac{1}{8} \times 6\frac{3}{4}$ in. (10.2 × 17.1 cm.)

Provenance: Possibly L.-J.-A. Coutan (Paris,
19 April 1830, lot 117, as *The Wheatfield*);
Anonymous (Christie's, 15 June 1971, lot 46,
bought Castle Museum).

References: Peacock, repr. 92.

Castle Museum and Art Gallery,
Nottingham (71–83)

A similar subject occurs in a graphite drawing
of a peasant in a cornfield with a distant view
of Geneva.[1] The texture of the vigorously abraded
paper creates the illusion of windswept sheaths.
Such aggressive manipulation of the support to
suggest a naturalistic event that is otherwise
too intangible to represent with pigments is
typical of Turner's technique.

1. Christie's, 9 November 1976, lot 36.

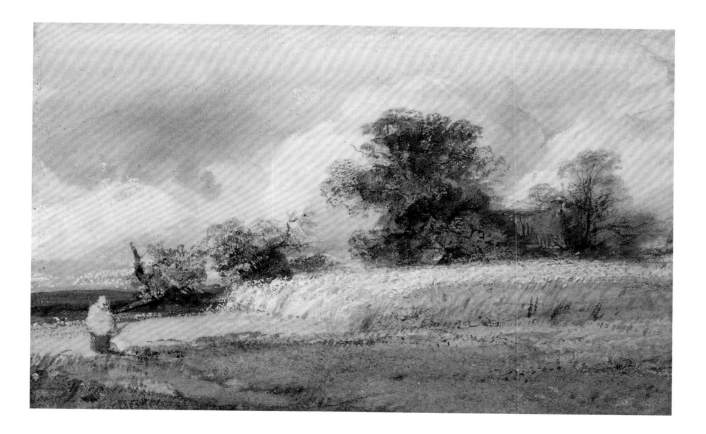

LANDSCAPE WITH HARVESTERS 1826
Watercolor touched with bodycolor, $5\frac{3}{4} \times 7\frac{1}{2}$ in.
(14.5×19 cm.)

Inscribed: Signed and dated, lower left:
R P B 1826

Provenance: A Lady (Christie's, 4 June 1974,
lot 135); Greenman, London, to 1988.

References: Peacock, pl. IV .

Private Collection

The vaporous radiance of an evening sky, with
its pale blue arc at the topmost edge and
corners, is common to both watercolors and oils
of the period between Bonington's trips to
England and to Venice. A copy of this
watercolor was in the Nettlefold Collection.[1]

1. Sotheby's, 23 November 1966, lot 226.

83

A HOUSE IN THE RUE STE-VERONIQUE,
BEAUVAIS 1826
Watercolor and bodycolor over graphite,
$7\frac{1}{4} \times 4\frac{3}{4}$ in. (18.4 × 12 cm.)

Inscribed: Signed and dated, lower left:
R P Bonington 1826

Provenance: Possibly Van Puten (Paris, 14
December 1829, lot 85, as *Vue du maison gothique*,
bought Charles)[1]; Frédéric Villot (Paris, 25
January 1864, lot 74, as *Ancienne maison de la rue
Sainte-Veronique, à Beauvais*); Baronne Salomon de
Rothschild, by whom donated to the Musée du
Louvre in 1922.

Exhibitions: Nottingham 1965, no. 228
(where incorrectly dated 1828).

Musée du Louvre, Département des Arts
Graphiques (RF 5614)

This is a later version of a composition first
essayed in graphite (ca.1822; Bowood) and again
in lithography as a plate for *Restes et fragmens*.
It differs from these antecedents in that the
artist has here substituted a copse of trees for
an elevation that abutted the central tower.
The inscribed date has been misread by all
previous commentators as 1828.

1. Two untraced watercolors of Gothic architecture in
Beauvais were in the 1829 studio sale, lots 38, 42.

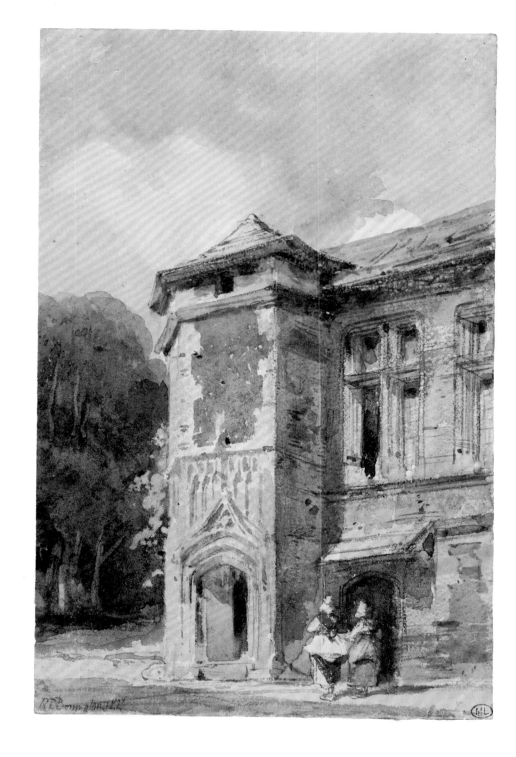

STUDY OF THREE SWISS GIRLS
AT MEYRIN 1826
Watercolor over graphite, $6\frac{3}{8} \times 6\frac{1}{2}$ in.
(16.3 × 16.6 cm.)

Inscribed: In graphite, in the artist's hand,
upper right: *100*

Provenance: Bonington sale, 1829, with lot 98,
Coloured sketches, Swiss costume (2), bought
Roberts for Northwick; Lord Northwick, and
by descent (Sotheby's, 5 July 1921, lot 120,
bought Colnaghi, from whom purchased by the
British Museum).

Exhibitions: Nottingham 1965, no. 236.

References: Harding, *Works* (frontispiece),
reversed; Shirley, 85.

Trustees of the British Museum
(1921-7-14-13)

On 4 April 1826 Bonington and Charles Rivet
departed for Italy and within three days had
reached Switzerland. Meyrin, a suburb of
Geneva, was one of several sites visited during
their perambulation around the Lake of Geneva.

The present study may have been used for an
untraced watercolor recorded in Lewis Brown's
collection, *View of Lake Brienz with Three Girls
under a Group of Trees.* Similar figures appear in
the finished watercolor *The Bridge at St-Maurice*
(no. 85). Graphite sketches of the same children
(Bowood and High Museum, Atlanta), of other
girls at Berne (National Gallery of Canada and
Royal Academy), and of a Swiss male (Private
Collection) attest to the contemporary
fascination with regional dress. In a letter of
September 1825 from nearby Vevey, David
Wilkie had observed:

*Of the Swiss costume, we saw at the weekly market at
Vevay many specimens from the neighboring country.
It is like what you have seen in books, though more
real, and fit for everyday use. It is very picturesque
and comfortable; and it is in the females chiefly that
it is distinct from our own.*[1]

1. Cunningham, *Wilkie* 2: 161.

THE BRIDGE AND ABBEY AT
ST-MAURICE ca.1826–27
Watercolor with gum and scraping out on wove
paper, $7\frac{3}{8} \times 9\frac{3}{8}$ in. (18.5 × 23.7 cm.)

Inscribed: Watermark: *J. Whatman 1823*

Provenance: Bonington sale, 1829, lot 197, bought
Monro; Dr. Thomas Monro (Christie's, 26 June
1833, lot 162, bought Colnaghi); Archdeacon
Burney; his daughter, Mrs. Rosetta Wood; her
daughter, Lady Powell, by whom bequeathed to
the Victoria and Albert Museum in 1934.

Exhibitions: Pointon, *Bonington,* no. 20, repr.

References: Shirley, 104.

Victoria and Albert Museum (P27-1934)

In a letter of 21 October 1827 (British Library),
Bonington referred to the engraver W. J. Cooke
as "doing my bridge." The etched state of the
engraving was submitted by Cooke to the
Bibliothèque Royale in January 1828, and the
finished print was published 20 March 1828 in
both Paris and London. Bonington probably
brought or sent the watercolor to England for
engraving in spring 1827.[1]

Virtually every illustrated tour book of the
route from Geneva to Italy through the Simplon
Pass included a plate of this famous bridge with
its 163-foot span and its origins in Roman
antiquity. The fourteenth-century monastery,
on a site dating back to its foundation in 360,
was the oldest in the Alps and a repository of
medieval treasures and manuscripts. William
Hazlitt wrote of the site during his 1824 tour of
the continent:

*The finest effect along the road is the view of the bridge
as you come near St. Maurice. The mountains on either
side here descend nearly to a point, boldly and abruptly;
the river flows rapidly through the tall arch of the
bridge, on one side of which you see an old fantastic
turret, and beyond it the hill called the sugar-loaf,
rising up in the center of immense ranges of
mountains The landscape painter has only to go
there, and make a picture of it. It is already framed by
nature to his hand! I mention this the more, because
that kind of grouping of objects which is essential to the
picturesque, is not always to be found in the most
sublime or even beautiful scenes. Nature (so to speak)
uses a larger canvas than man, and where she is
greatest and most prodigal of her wealth, often neglects
that principle of concentration and contrast which is an
indispensable preliminary before she can be translated
with effect into the circumscribed language of art.*[2]

In a previous passage he had written:

*The only picturesque objects between Vevay and Bex
are a waterfall about two hundred feet in height,
issuing through the cavities of the mountain from the
immense glacier in the valley of Trie, and the romantic
bridge of St. Maurice, the boundary between Savoy
and the Pays de Vaud. On the ledge of a rocky
precipice, as you approach St. Maurice, stands a*

hermitage in full view of the road; and possibly the inmate consoles himself in this voluntary retreat by watching the carriages as they come in sight.[3]

Antoine Valery, the French Royal Librarian, passing this spot only weeks after Bonington and Rivet, identified the hermitage as belonging to a seventy-year-old blind recluse, who obviously could not see the carriages below but who was quite capable of finding his way down to the monastery for his daily sustenance and his winter quarters. He was not, therefore, "as poetical as many Parisian travelers have made him out to be." Valery also observed that although St-Maurice was redolent of historical associations, it "sank into insignificance beside the might and majesty of nature which surrounds and overwhelms it."[4] There is nothing of this sentiment in Bonington's almost pastoral representation, and one wonders if the learned friend of Nodier and Chateaubriand had in mind, as he penned this recollection, Turner's more dynamically compressed vignette of St-Maurice for Samuel Rogers's *Italy*. The same subject by Samuel Prout was engraved for the *Landscape Annual* in the 1830s.

1. A graphite study of this title was lot 127 in the 1829 studio sale. A possible oil sketch of the composition was lot 126 in the 1838 studio sale, *View in Switzerland with a Bridge, Buildings and Figures*. Cooke exhibited an impression of his engraving at the Society of British Artists exhibition in 1829.

2. Hazlitt, *Notes*, 290.

3. Hazlitt, *Notes*, 284.

4. Valery, *Voyages*, 15.

86

LUGANO 1826
Oil on millboard, $10\frac{1}{2} \times 13\frac{5}{8}$ in. (26.3 × 34 cm.)

Inscribed: verso: *Von Rathnoner*

Provenance: Possibly Bonington sale, 1829, lot 158, as *On the coast near Genoa*, bought Lord Townshend (but not in his 1835 sale); possibly Anonymous (Dawson Thomas) (Christie's, 13 April 1878, lot 66, as *Lake Lugano*); Wallace (?), London, 1878; Mrs. Fisher, Melbourne, by 1888, from whom acquired by the Art Gallery in 1896.

References: Peacock, pl. XIII.

Art Gallery of Western Australia, Perth

Similar in composition to *Near Genoa* (no. 103) and probably mistaken as another view on the Ligurian coast in the 1829 studio sale, this oil appears to show the Lombard town of Lugano, which Bonington and Rivet passed on their way from Geneva to Milan, 7–11 April. The view is from the south with the church of S. Maria degli Angioli in the foreground and the broad valley of the Cassarate to the northeast.

Chateaubriand genially recalled these environs in his *Memoires d'outre-tombe*: "Surrounding Lugano, the mountains, hardly touching, their bases at the lake's edge, resemble islands separated by narrow channels; they call to mind the grace, shape and verdure of the Azores archipelago: that sweet light, brilliantly colored, fine yet vaporous."[1]

For Bonington, the journey from Switzerland had been disagreeable, and Rivet wrote to his family upon reaching Milan: "Bonington thinks only of Venice. He makes sketches, and works a little everywhere, but without satisfaction and without interest in the country. He makes no effort to learn Italian, keeps to his tea, and requires the help of an interpreter in everything."[2]

1. Chateaubriand, *Memoires d'outre-tombe*, ed. M. Levaillant (Paris, 1982), 4: 124.
2. Dubuisson 1909, 202.

CORSO SANT'ANASTASIA, VERONA 1826
Watercolor and bodycolor over graphite,
$9\frac{1}{4} \times 6\frac{1}{4}$ in. (23.5 × 15.8 cm.)

Inscribed: Signed and dated, lower left:
R P B 1826

Provenance: Probably given by the artist to
Thomas Shotter Boys (Sotheby's, 9 May 1850,
lot 7, bought Smith); W. Smith, by whom
bequeathed to the Victoria and Albert Museum
in 1876.

Exhibitions: Manchester, *Art Treasures*, 1865;
Nottingham 1965, no. 219, pl. 11; Jacquemart-
André 1966, no. 54; Pointon, *Bonington*, no. 21.

References: *The Gem* (London, 1830), engraving by
W. J. Cooke, the same republished in the *Token*
(London, 1833) and the *Bouquet* (London, 1835);
Shirley, 114, pl. 132; Noon 1981, 294ff.

Victoria and Albert Museum (3047-1876)

On April 18 Bonington's party reached Verona,
where they rested for several days. This view is
along the main street toward the baroque palace
of Count Scipio Maffei (d. 1755), the Veronese
historian and literatti, which fronts the Piazza
dell'Erbe (no. 88). The architecture of the city
was one of its primary tourist attractions, and
Théophile Gautier would observe that "as in a
Spanish city, every house has a balcony from
which may be suspended a silver ladder. Few
cities have better preserved their medieval
characteristics."[1] In addition to its antiquities
and its literary and artistic associations, Verona
also had a topical significance for Bonington's
generation. Here monarchs and diplomats had
convened in 1822 to decide the partitioning of
Europe and the fate of Spain.

This watercolor was either painted on
location or from memory with the aid of a
graphite study.[2] In the years immediately
following his death, it was one of Bonington's
most celebrated topographical compositions,
spawning copies and versions by many of
England's foremost professional watercolorists.[3]
As an Italian example of the type of
consummately picturesque thoroughfare that
the artist had previously found so congenial in
French cities, the scene seems equally to have
sustained Bonington's interest since he returned
to the composition for major commissions in
1827 and 1828 (no. 155).

Thomas Shotter Boys (no. 164), who first
owned this watercolor, made a soft-ground
etching of the composition in 1833, and it was
probably one of the drawings referred to in his
letter to Domenic Colnaghi of 1829: "I brought
down a drawing or two of Bonington's to show
you, I say show you as I really can not find it in
my heart to part with one of them."[4] Although
he would continue to acquire and dispose of
Bonington's works throughout his long career,
it was not until he found himself in the most
dire financial position that Boys sold this
example.

1. Gautier, *Travels*, 39.
2. Dubuisson and Hughes, repr. opp. 203; an
anonymous chalk copy was also reproduced in
Dubuisson 1909, 206.
3. For a discussion of Thomas Shotter Boys's role in
the popularization of this image, see Noon, 1981.
A watercolor copy by David Cox is at Birmingham.
A watercolor version by William Callow was at
Christie's, 28 March 1984, lot 162. Two other
anonymous watercolor copies are known.
4. Manuscript letter in the Huntington Library,
San Marino (HM 16679).

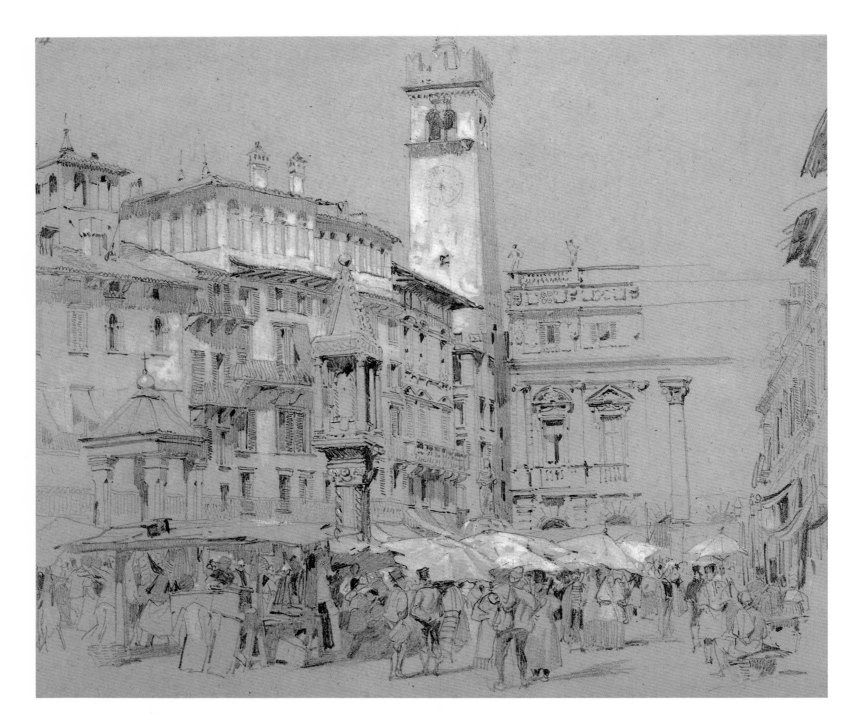

88

PIAZZA DELL'ERBE, VERONA 1826
Graphite and white bodycolor on buff paper,
$8\frac{1}{4} \times 10$ in. (20.9 × 25.4 cm.)

Inscribed: In pen and brown ink, in the artist's
hand, upper left: *14*

Provenance: Bonington sale, 1829, lot 150, bought
3rd Marquess of Lansdowne, and by descent to
the present owner.

Exhibitions: Agnew's 1962, no. 53; Nottingham
1965, no. 70.

References: Dubuisson and Hughes, repr. opp.
170; Shirley, 106; Miller, *Bowood*, 44, no. 162.

The Earl of Shelburne, Bowood

With the exception of Venice, Verona furnished
the most material for Bonington's oil and
watercolor compositions. This sheet is the
on-site study consulted in 1827 for an
unfinished watercolor of the subject (no. 126).
The Palazzo Maffei, only partially articulated,
dominates the far end of Verona's central
marketplace.

Although it is unlikely that Bonington
required any prior direction to this picturesque
square, he almost certainly had an introduction
to its charms in Samuel Prout's drawings of
1824 (no. 89). It was Prout who reportedly
quoted Bonington's own pet phrase that he
sucked in life "as a child does an orange,"[1] and
something of that breathless and exhilarating
concentration is evident in Bonington's Italian
sketches.

1. C. R. Grundy, *A Catalogue of the Pictures and Drawings
in the Collection of Frederick John Nettlefold* (London, 1933),
1: 15.

SAMUEL PROUT (1783–1852)

PIAZZA DELL'ERBE, VERONA ca.1824
Graphite, with stump, and white bodycolor,
14 × 10 in. (35.5 × 25.5 cm.)

Inscribed: In graphite, lower left: *Verona*

Provenance: Dr. H. A. Powell, by whom
presented to the Victoria and Albert Museum
through the National Art Collections Fund,
1936.

Exhibitions: Lockett, *Prout*, no. 44.

Victoria and Albert Museum (E956.1936)

For much of his career Samuel Prout was
content to record the architectural monuments
of Europe, a task for which his watercolor style,
in its perfect balance of descriptive penwork
and modulated color washes, was ideally suited.
Like Bonington, he harbored a passion for
the quiet retirement of coastal life, for the
associations and picturesque charm of Gothic
architecture, and for northern Italy. Although
separated in age by nearly twenty years, the
two artists nevertheless became close, if not
intimate, friends.

 An epitome of the professional topographer/
tourist, Prout conducted his first circuit of
northern France in 1819. Francia could have
introduced the two artists at that time; they
were definitely sketching together under
Francia's aegis at St-Omer in 1823. Prout was
possibly instrumental in introducing Bonington
to influential London artists and collectors,
including Dr. Meyrick and Walter Fawkes. His
patrons at this time were many who first
supported Bonington — Countess de Grey,
Lord Northwick, the Marquess of Lansdowne,
and Sir Thomas Allnutt, for example. On the
other hand, Bonington may have helped
negotiate Prout's first and only contribution of
three lithographs to Baron Taylor's second
Franche-Comté volume of the *Voyages
pittoresques*. By 1830 Prout was the best known
of the English antiquarian draftsmen in France,
because his watercolors were stocked by the
dealers d'Osterwald, Schroth, and Arrowsmith.

 Prout first toured Italy between August 1824
and January 1825, making protracted stays at
Verona and Venice. Since he ended his journey
via Paris, it is likely that Bonington was
afforded the opportunity to examine the mass of
graphic material produced on this excursion.
Prout's view of the Piazza dell'Erbe, from the
opposite direction from Bonington's (no. 88),
was sketched during this tour. Both men's
studies were drawn from the motif, although
Prout is far more economical in his description
and comparatively inattentive to structure and
tonality. Consequently, there is in Prout's
rendering a deception of greater spontaneity.

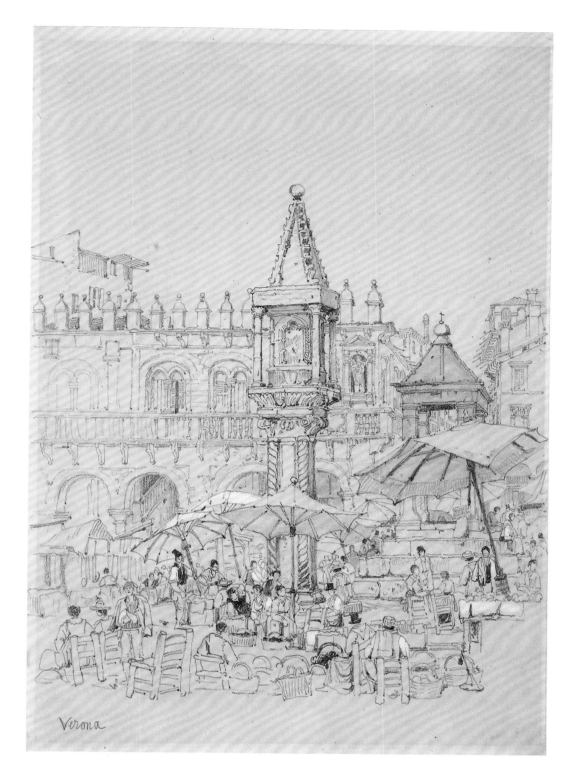

The finished watercolors that both artists
derived from such studies would be the primary
sources of visual information on northern Italy
for London and Paris audiences during the
1820s. As for the impact of their respective
graphic styles, Prout's graphite drawings would
become familiar only much later, when Ruskin
assumed the mantle of his promoter, whereas
Bonington's studies were circulated after his
death and had an immediate influence on David
Roberts, Thomas Shotter Boys, Alexandre
Dauzats, and J. D. Harding, who was Ruskin's
first teacher.

S. MARIA DELLA SALUTE FROM THE
PIAZZETTA 1826
Graphite on gray-green paper, 16 × 12 in.
(40.6 × 30.4 cm.)

Provenance: Bonington sale, 1829, lot 92,
bought Cawdor.

National Gallery of Canada, Ottawa (6128)

This is the on-site study subsequently
employed for an oil painting of 1827 (no. 131).
As is characteristic of Bonington's Italian
drawings, the composition was first lightly
sketched and then the shading and details were
reinforced with a darker, greasier graphite.
The scale and perspective of this view from the
corner of the Doge's Palace is also unerringly
accurate.

Although this was not an uncommon view
for topographers to record, the compositional
and delineative attention afforded the lion of
St. Mark is conspicuous. Appropriated and
partially mutilated by Napoleon's army,
the sculpture had only recently been returned
to its column. Valery's was not the only
condemnation of the vandalism, but possibly
the harshest:

*He should never have left it; though insiginificant as
a work of art, at Venice it was a public and national
emblem of its ancient power. It is venerable on the
piazza San Marco, but on the esplanade of the
Invalides it was merely a superfluous mark of the
bravery of our soldiers It was, moreover, a
singularly odious act of a rising republic to
humiliate . . . such old republics as Venice and Genoa.*[1]

1. Valery, *Voyages*, 148

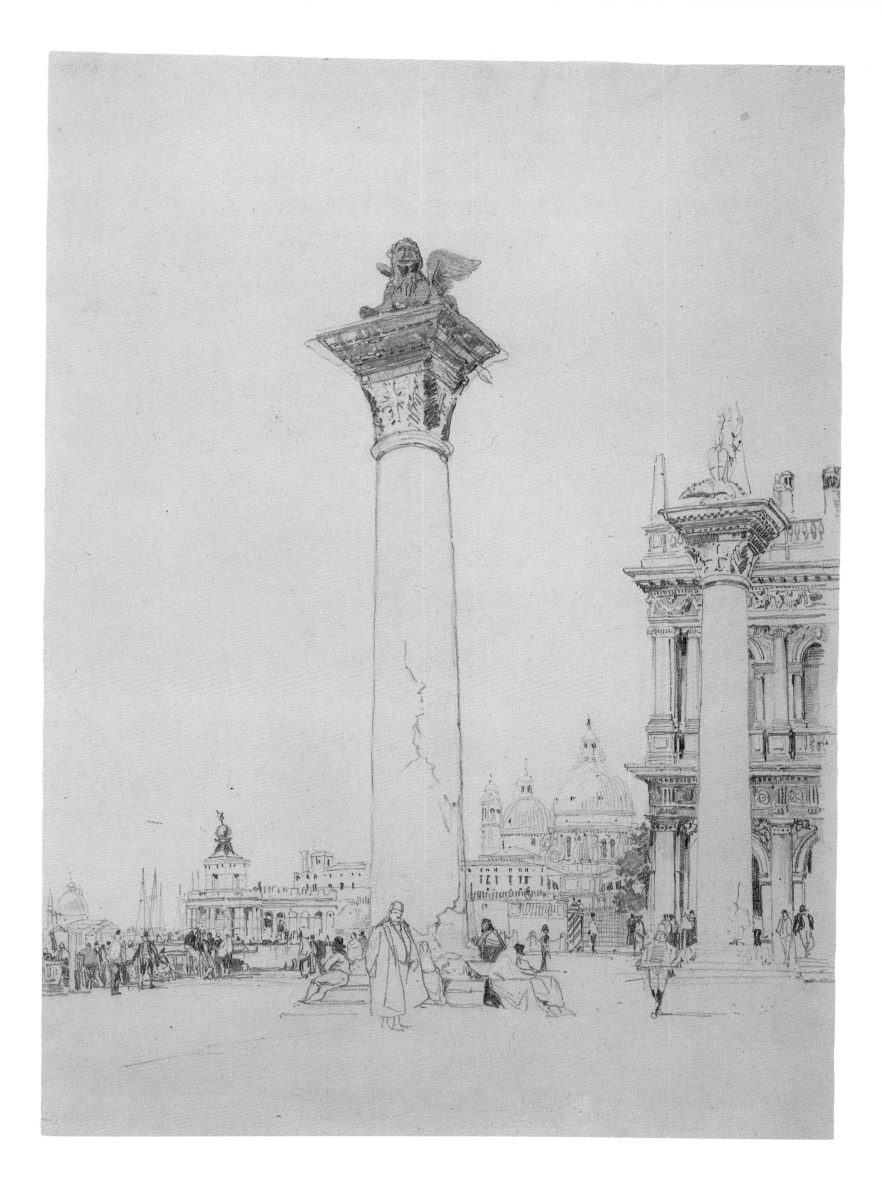

91

THE PIAZZA SAN MARCO, VENICE ca.1826
Watercolor over graphite, $10\frac{1}{4} \times 8\frac{1}{4}$in.
(25.9 × 20.8 cm.)

Inscribed: Watermark: *J Whatman | 182*[cropped]

Provenance: Possibly Bonington sale, 1829, lot
195, bought Colnaghi; possibly Francis Broderip
(Christie's, 9 February 1872, lot 414, said to
have been acquired at the artist's sale, bought
McClean for the Marquess de Santurce);
Marquess de Santurce (Christie's, 16 June 1883,
lot 64, bought Ellis); Charles E. Russell, by
1937; Agnew's, from whom purchased by the
Fitzwilliam Museum in 1961.

Exhibitions: BFAC 1937, no. 113.

References: Shirley, 104–5, pl. 94; Cormack,
Bonington, pl. 95, inaccurately described.

The Syndics of the Fitzwilliam Museum,
Cambridge (PD2-1961)

Like most Parisians of his generation, Bonington
was visually acquainted with Venice prior to his
visit through a few Canaletto and Guardi oils in
public and private collections, Canaletto's own
pellucid etchings, a set of which Bonington's
father owned, and probably Antonio Visentini's
indifferent engravings after Canaletto's pictures,
Prospectus Magni Canalis Venetiarum (Venice, 1735
and 1742). Of more recent date were Prout's
drawings from his first visit and the Comte de
Forbin's published account *Une Mois à Venise*,
with lithographs after de Forbin's sketches by
a number of Bonington's *Voyages pittoresques*
collaborators.[1]

This cheering midday view of the basilica
and campanile is undoubtedly the first image
that would have entered a contemporary's mind
on hearing the name of this fabled city. Antoine
Valery, whose influential guide to Italy appeared
in 1832 but who visited Venice for the first time
in August 1826, observed morosely:

*Venice still palpitates in the piazza San Marco; this
brilliant decoration costs a million annually in repairs;
while other distant quarters, some of which possess
magnificent palaces, are left to fall into ruins. This
corpse of a city, to use the expression of Cicero's friend,
is already cold at the extremities, the life and heat
remaining are confined to the heart.*[2]

As were Byron and de Forbin before him,
and as would be virtually every tourist of
distinction down to the present day, Valery was
convinced that the city would self-destruct
within his lifetime and that the mesmerizing
splendor of Venice's well-kept central square
was a deception. Whether Bonington shared
this cynicism is unknown, but Valery certainly
saw in his representations of the city evidence
of a kindred concern (see no. 97).

In contrast to Canaletto's numerous
renderings of the same view, Bonington's does
not include the Renaissance arcaded facade of
the Procuratie Vecchie and shows only a
fragment of the Procuratie Nuove, which
establish the northern and southern limits of
the piazza. The character of this precinct as an
elegant architecturally defined space, which
Canaletto strove to convey, was not what most
or immediatey impressed Bonington. Rather,
his enthusiasm centered on the disparate styles
of the two principal structures and their
disproportionate scale. In every other respect of
coloring, perspective, and detail, this watercolor
is as accurate a transcription as any antiquarian,
topographer, or photographer could desire or
produce, although the length of the red-striped
pennants on the mastheads in front of San
Marco might have been exaggerated for
chromatic effect.

This watercolor is not, as is sometimes
claimed, signed and dated 1826, but in
execution it belongs with the watercolors
painted in Italy or shortly afterward in Paris.
An elaborate graphite study that also belonged
to Domenic Colnaghi,[3] and an unfinished oil
(Wallace Collection) that enlarges the prospect
slightly to each side were in the 1829 studio
sale.

1. A notice in the *Revue Encyclopédique* (November 1824,
494) mentions Fragonard and Villeneuve among others.
2. Valery, *Voyages*, 145.
3. 1829 studio sale, lot 153, bought Colnaghi, and
subsequently Domenic Colnaghi sale (Christie's, 1 April
1879, lot 115, bought in).

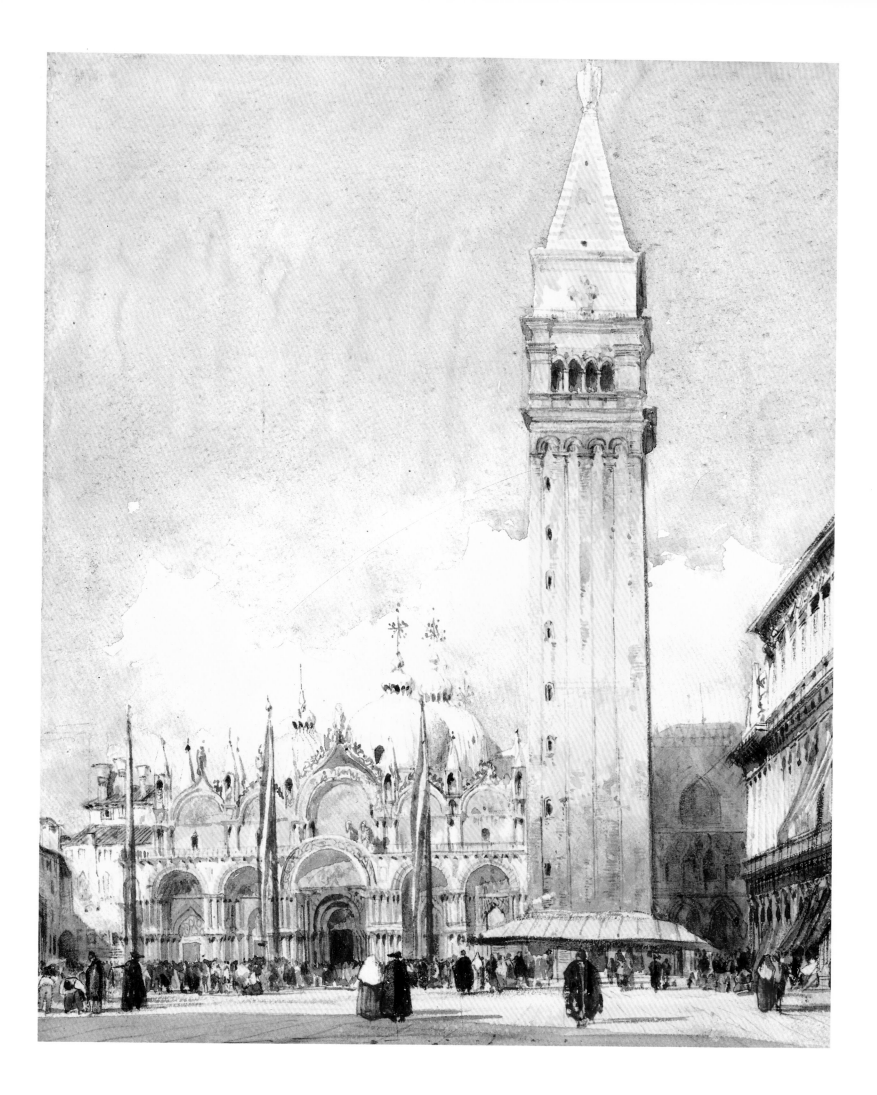

VENICE FROM THE LIDO 1826
Graphite, heightened with white chalk, on gray
paper, 6½ × 16¼ in. (16.5 x 41.2 cm.)

Inscribed: In graphite, in the artist's hand, upper
right: *Venise vue prise du Lido*; and lower right:
151 / 3; and upper left: *No 9*

Provenance: Bonington sale, 1829, lot 151, bought
3rd Marquess of Lansdowne, and by descent to
the present owner.

Exhibitions: Agnew's 1962, no. 63; Nottingham
1965, no. 74.

References: Shirley, 108; Miller, *Bowood*, 44,
no. 152; Peacock, repr. 58–59.

The Earl of Shelburne, Bowood

The metaphors and poetic exhalations that the
first sight of Venice "rising from the sea"
inspired in northern Europeans during the
1820s are inexhaustible, but few translate better
the ethereal impression of this drawing than
William Hazlitt's forthright admission that one
views the island "with a mixture of awe and
incredulity. A city built in the air would be
something still more wonderful The effect
is certainly magical, dazzling, perplexing."[1]

Bonington and Rivet arrived in Venice
during the third week of April, in a "dismal
mood" owing to constant rains. The weather
eventually cleared, and during the course of
their stay they had an opportunity to visit the
outlying islands. The city's silhouette from a
distance is the subject of other graphite studies
at Bowood and of one of Bonington's most
captivating oil sketches (fig. 50).

1. Hazlitt, *Notes*, 267.

93

VENICE FROM THE GIUDECCA 1826
Oil on millboard, 12½ × 9¾ in. (31.7 × 24.8 cm.)

Inscribed: Verso: R. Davy label, with pen inscription *141*; remnants of red and black wax atelier seals

Provenance: Possibly Thomas Woolner (Christie's, 12 June 1875, lot 107, *Venice from the Giudecca*, manuscript notation by the dealer McLean in his catalogue at Yale: "very sketchy"; bought Agnew's); possibly Robert Rankin (Christie's, 14 May 1898, lot 23, *Venice from the Giudecca, on panel*, bought Colnaghi); possibly Francis Baring (Christie's, 4 May 1907, bought Paterson); W. A. Coats (but not in his sale at Christie's, 10 June 1927); Fritz Lugt, by 1962.

Exhibitions: Agnew's 1962, no. 32.

References: Dubuisson and Hughes, repr. opp. 75.

Fondation Custodia (Coll. Fritz Lugt), Institut Neérlandais, Paris

This tranquil prospect, painted from a small boat or gondola, is along the Giudecca Canal with Massari's eighteenth-century I Gesuati church advancing its portico on the right. Maurice Gobin reproduced an equally expansive Bonington watercolor of the Fondamenta delle Zattere from a vantage point nearer the church,[1] and there exists in a private collection a watercolor view in the opposite direction toward S. Giorgio Maggiore. The Giudecca island, just visible to the left in this oil, is rarely mentioned in contemporary travel guides as it had yet to become a fashionable promenade.

Although not calculated to excite the tourist, this view is perfectly attuned to Bonington's compositional preferences and to the tradition of *vedute* painting, which cherished such glimpses of the less remarkable aspects of Venice. It would also have appealed to the literary set in Paris, who were apt to accentuate Venice's extraordinary relationship to its lagoons. Chateaubriand, for instance, would open his memoires of Venice with the observation that "you can believe yourself to be on the deck of a superb galley at anchor, on which you are feted and from the sides of which you can see many wonderful things."[2] A more melancholic Charles Nodier discerned in the contrast between the tumult of the city's life and the placid expanse of the surrounding sea a metaphor for the romantic condition — a life agitated to no end in the embrace of an eternal monotony.[3]

1. Gobin, *Bonington*, fig. 47.
2. Chateaubriand, *Memoires d'outre-tombe*, ed. M. Levaillant (Paris, 1982), 4: 334.
3. Nodier, *Jean Szborga*, rev. ed. (Brussels, 1832), 1: 141.

94

THE DUCAL PALACE, VENICE,
WITH MOORED BARGES 1826
Oil on millboard, 14 × 16¾ in. (35.5 × 42.5 cm.)

Inscribed: Verso: remnants of R. Davy label and
an unidentified wax seal

Provenance: Possibly Bonington sale, 1829, lot
215, *Ducal Palace, Venice*, bought Glynn; J. Wood;
William Benoni White (Christie's, 23 May 1879,
possibly lot 186, *Grand Canal Venice*, bought
Permain); possibly W. A. Turner (Christie's, 28
April 1888, lot 106, *St. Mark's quay — a sketch*);
Harari and Johns, London, from whom
purchased by the Cleveland Museum of Art
in 1985.

The Cleveland Museum of Art,
John L. Severance Fund (85-56)

The lower section of this sketch was painted on
the spot from a small boat moored in the San
Marco basin. Detailed graphite studies of barges
similar to those in the foreground are at
Bowood. The thick impasto in the sky, directly
above and contiguous to the palace facade, is
a correction to its height. Recent infrared
reflectography has revealed considerable
graphite underdrawing of the architecture, and,
in the sky, an inverted sketch of the outlines of
the boats and palace. This was probably drawn
after the main compositional elements had been
started to determine their proper scale.
The upper half of the sky, with its distinctly
eighteenth-century cloud schema, was added at
a later time. The artist elected not to include
the roof of the campanile, which ought to loom
above the darkened facade of the palace.

95

ENTRANCE TO THE GRAND CANAL,
WITH S. MARIA DELLA SALUTE 1826
Oil on millboard, 14 × 16⅞ in. (35.4 × 42.8 cm.)

Inscribed: Verso: R. Davy label; two red and one
black wax atelier seals

Provenance: Bonington sale, 1829, lot 218, as
Grand Canal, bought Townshend; Lord Charles
Townshend (Christie's, 11 April 1835, lot 16, as
*A view on the Grand Canal at Venice, looking towards
the sea, with the church of Santa Maria della Salute
and the Dogana. A clear and beautiful sketch.*); Isaac
Harrup (Christie's, 28 May 1926, lot 21); Evan
James, and by descent to the present owner.

References: Peacock, pl. XV.

On loan to the Ashmolean Museum, Oxford

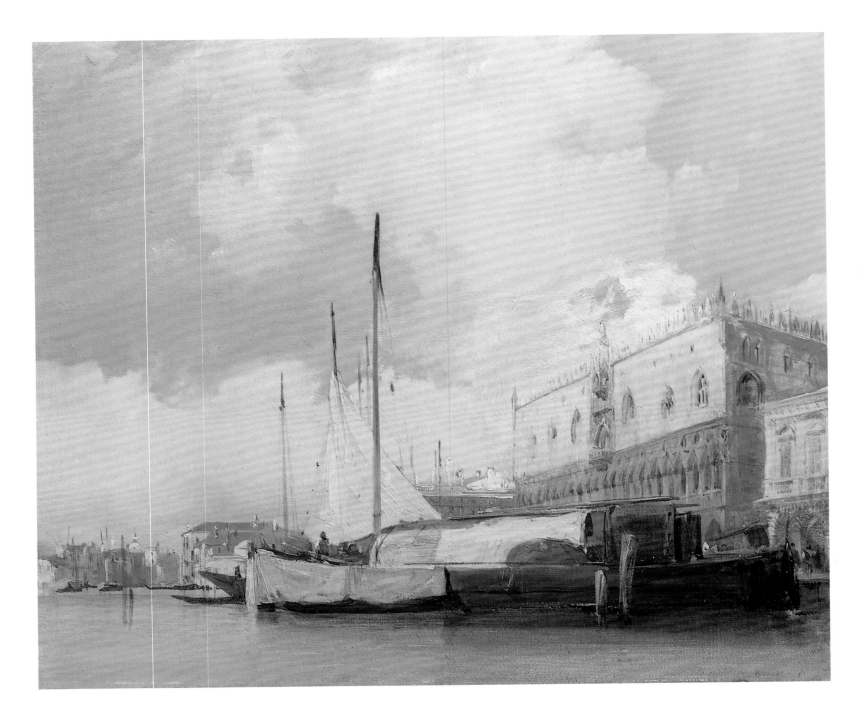

It is inconceivable that a nineteenth-century landscapist visiting Venice could ignore this inherently picturesque view with its quintessentially Venetian mélange of incongruous architectural styles set against, or reflected by, brilliant expanses of sky and water. This was undoubtedly the best known of Bonington's Italian compositions, because of its subject and its dissemination through prints by J. D. Harding[1] and Charles Lewis after James Carpenter's version. Disturbed by the unenthusiastic reception of his own *Landscape Scenery* mezzotints, Constable quipped sarcastically to Domenic Colnaghi in 1833: "Young Lewis has just brought me a present of two prints, Venice and a goat, 'admirable'. The views of Bonington are thus given and propogated with renewed splendour."[2]

This picture should be considered the on-site study for the large oil commissioned by Carpenter in 1827 and exhibited at the Salon in February 1828 and again at the Royal Academy in May 1828 (fig. 61).[3] The foreground of the exhibition picture includes a section of the landing of the Campiello della Carita at the Accademia from where Bonington has taken his view. Carpenter later sold the painting to H. A: J. Munro of Novar, who was reported to have stated that Turner so admired the work that he wished it always to hang near his own Venetian paintings.[4]

A nearly exact replica of this study, which is of professional quality but uncertain attribution, is at Nottingham. A less competent copy painted on a canvas with the stenciled address of Bonington's London color merchant is unquestionably by a pupil or a later hand.[5] A much reduced oil sketch on paper (National Gallery of Scotland), said to be a preparatory study for Carpenter's picture, is probably a later pastiche derived from the prints.[6]

Extensive graphite underdrawing in the sky appears to represent a crude perspective diagram composed of diminishing rectangles. As is typical of Bonington's Italian views, the rendering of incidental details, the linear and atmospheric perspective, and the perception of scale are far more accurate in such on-site graphite and oil sketches than in the replicas executed later for exhibition in London or Paris.

1. Harding, *Works* (1829); Harding's own large watercolor version of the subject (Yale) was probably based on Bonington's picture.

2. *John Constable's Correspondence IV*, ed. R. B. Beckett (Suffolk, 1965), 8: 164.

3. Nottingham 1965, no. 280; the picture was irreparably damaged in a fire at Warnham Court, ca.1901. A related graphite study was in the 1829 studio sale, lot 91.

4. "Novar Sale," *The Times of London*, 4 April 1878.

5. Formerly Renand Collection (Paris, Hôtel Drouot, 15 March 1988, lot 4, repr. in reverse).

6. Reproduced in color in L. Stainton, *Turner's Venice* (London, 1985), pl. 108.

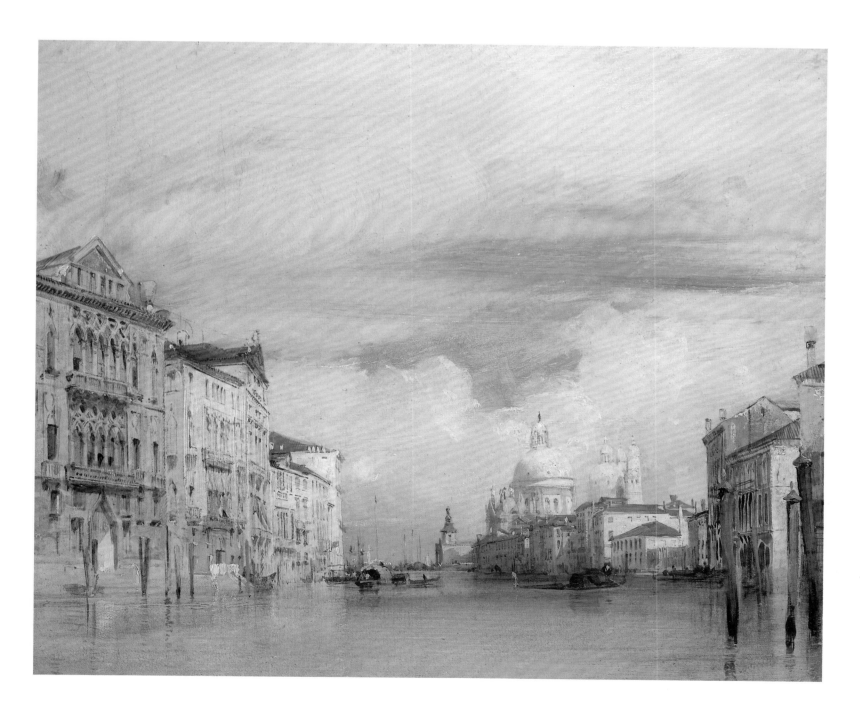

ON THE GRAND CANAL 1826
Oil on millboard, $9\frac{1}{4} \times 13\frac{3}{4}$ in. (23.5 × 34.8 cm.)

Inscribed: Verso: remnants of two red wax
atelier stamps

Provenance: Agnew and Zanetti, Manchester
(1828–35); Percy Moore Turner, by 1936;
R. A. Peto; Mrs. Rosemary Peto (Christie's,
18 June 1971, lot 108, bought Paul Mellon).

References: Shirley, 103, pl. 93 (with incorrect
title and measurements).

Yale Center for British Art, Paul Mellon
Collection (B1981.25.56)

Gautier identified one dimension of nineteenth-
century fascination with Venice when he
described the Grand Canal as "an immense
open-air gallery, in which the progress of art
over seven or eight centuries can be studied
from a gondola."[1] Chateaubriand had made the
same observation about the Piazza San Marco
and formulated his own theory of the
development of Gothic architecture from that
experience. For the romantics, there was no
more important textbook than Venice for the
study of the evolution of modern Western
culture and no more imperative a challenge than
to deduce that history from the mute testimony

of its monuments, which were commonly
thought, in France at least, to be within a
decade or two of total inundation. While
Bonington undoubtedly appreciated and catered
to these interests in certain oil renderings, his
primary concern was pictorial effect and not
Ruskinian fidelity.

Sketched from the water with breathtaking
assurance, this delicate study shows the
entrance to the Grand Canal with the Chiesi
S. Maria della Pieta and the Riva degli
Schiavone in the distance. The Ducal Palace and
Campanile are not visible from this vanatage
point. The palazzi, from left to right, are the
seventeenth-century Barbarigo, two minor
fifteenth-century facades, the massive late
seventeenth-century Flangini-Fini, and the
three Gothic buildings depicted in no. 97.
Deliberately left out of the composition,
however, is the Palazzo Pisani-Gritti, which
is adjacent to the Palazzo Flangini-Fini at the
S. Maria del Giglio *traghetto*.

1. Gautier, *Travels*, 62.

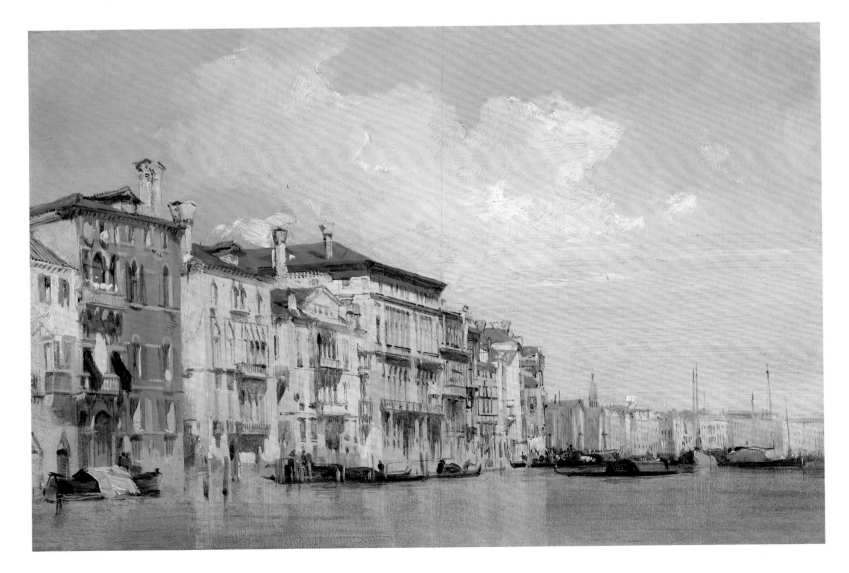

PALAZZI MANOLESSO-FERRO, CONTARINI-
FASAN, AND CONTARINI, VENICE 1826
Oil on millboard, 14½ × 18¾ in. (36.8 × 47.6 cm.)

Provenance: Gen. Sir James W. Gordon; Lord
Burgh (Christie's, 9 July 1926, lot 21, bought
Martin); Anonymous (Christie's, 24 April 1987,
lot 53, bought Feigen).

Richard L. Feigen, New York

Dating from the fifteenth century, these three
late-Gothic palazzi face S. Maria della Salute
near the entrance to the Grand Canal. The focal
point of the composition is the exquisitely
carved balcony of the central facade, which
fronts the palace apocryphally identified as the
"Casa di Desdemona." In its excellent state of
preservation, the picture demonstrates the
extent to which Bonington, with the instincts
of a watercolorist, relied on transparent
sepia-toned, salmon, and blue glazes for the
articulation of space and salient detail in his
Venetian studies. As a fragment seemingly
snatched at random from the procession of the
canal's constantly varied ornament, this study,
like several others of isolated facades and
palaces,[1] was not intended for replication as an
exhibition picture; nevertheless, it imparts more
successfully than any panorama of the piazzi or
any distant prospects of the bridges Venice's
most remarked upon characteristics — its faded
splendor and the tendency of its genius toward
"the showy, the singular, and the fantastic."

In the presence of such solemn studies devoid
of human life, it is impossible to ignore the
contemporary literary sources they invoke, such
as the soliloquy of the patrician Lioni in Byron's
Marino Faliero (Act 4, scene 1):

Those tall piles and sea girt palaces,
Whose porphyry pillars, and whose costly fronts,
Fraught with the orient spoil of many marbles,
Like altars ranged along the broad canal,
Seem each a trophy of some mighty deed
Rear'd up from out the waters, scarce less strangely
Than those more massy and mysterious giants
Of architecture, those Titanian fabrics,
Which point in Egypt's plains to times that have
No other record.

Certainly Valery had such representations in
mind when he wrote: "Bonington, an English
artist of melancholy cast, has painted some new
views of Venice, in which is most perfectly
sketched its present state of desolation; these
compared with those of the Venetian painter
[Canaletto], resemble the picture of a woman
still beautiful, but worn down by age and
misfortune."[2]

1. For instance, a graphite study of the Palazzo
Cavallini, repr. Dubuisson and Hughes, opp. 70.
2. Valery, *Voyages*, 143.

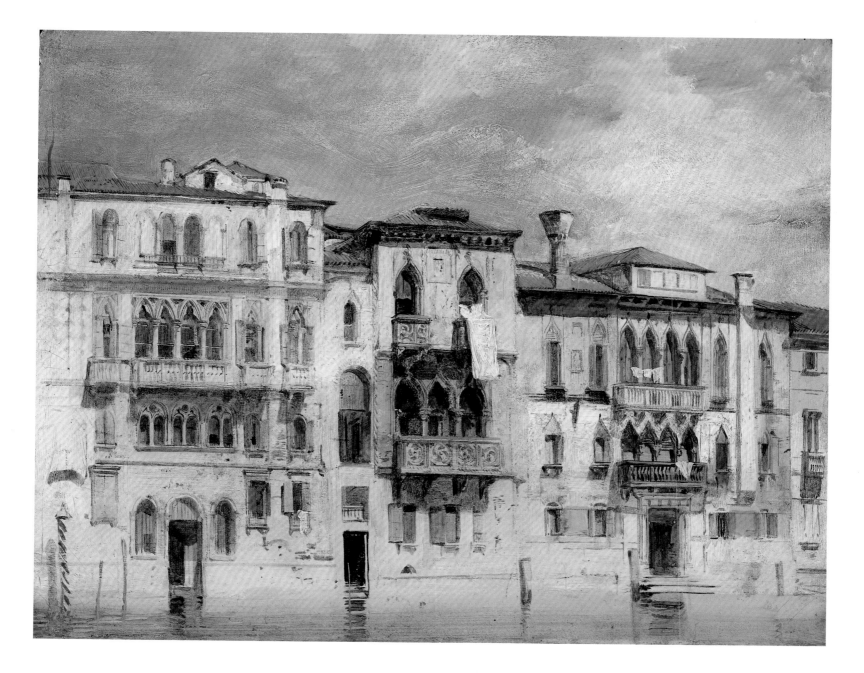

THE GRAND CANAL LOOKING TOWARD THE
PONTE DI RIALTO 1826
Oil on millboard, $13\frac{7}{8} \times 17\frac{7}{8}$ in. (35.2×45.4 cm.)

Provenance: Bonington sale, 1834, lot 145, *View of
the Rialto at Venice, with vessels, gondolas, and figures
— beautifully clear picture*, bought Webb; Sir
Henry Webb (Paris, 23–24 May 1837, lot 22);
Lady MacKintosh, from 1950 (Christie's,
20 November 1987, lot 61, bought Feigen).

Exhibitions: Nottingham 1965, no. 277.

References: Dubuisson and Hughes, 189, no. 20;
Shirley, 136; Johnson, *Review*, 319; Cormack,
Bonington, fig. 101, incorrectly reproduces
another version.

Mr. and Mrs. John Pomerantz, New York

Suggesting the breadth of Venice's main artery
as it approaches the Rialto and the flotilla of
small commercial craft that daily supplied the
city's markets, this view of the bridge from the
Riva del Carbone was probably the most
frequently painted in the nineteenth century.

The attribution of this painting has been
queried,[1] perhaps because of its less than
pristine condition, but the picture is
unmistakably autograph in execution and was
the basis for a later, slightly reduced studio
version that introduces bathers at the floating
platform to the right and several additional
vessels in the foreground.[2]

1. Johnson, *Review*, 319.
2. Private Collection; Agnew's 1962, fig. 16.

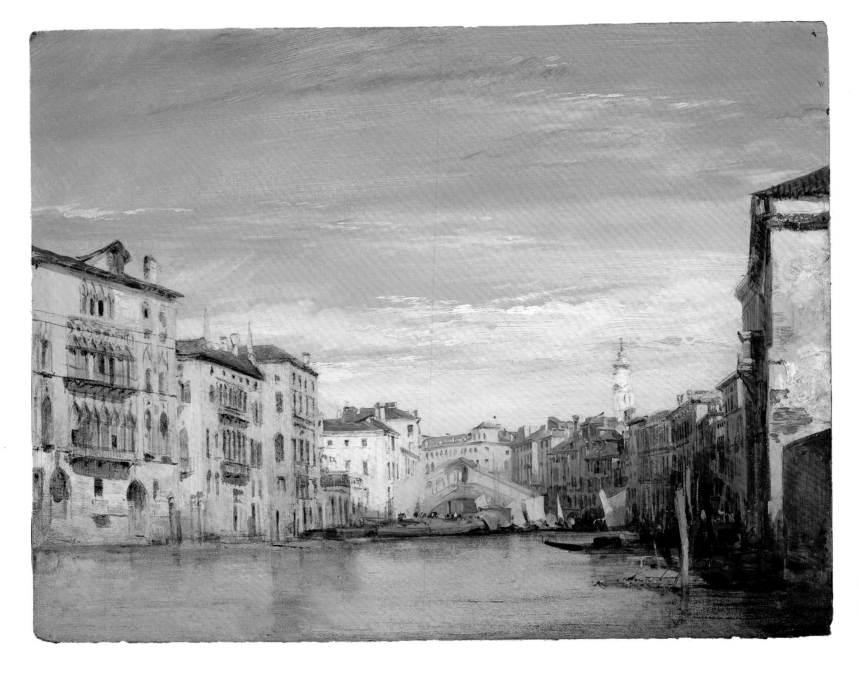

99

THE RIALTO, VENICE 1826
Graphite and white bodycolor on gray paper,
$8\frac{1}{8} \times 11\frac{3}{8}$ in. (20.6 × 28.9 cm.)

Provenance: Bonington sale, 1834, lot 71 or
lot 74.

The Tate Gallery

For his Italian drawings Bonington developed a graphic shorthand that was no less scrupulously descriptive than his earlier style, yet much better suited to the rapid pace at which he necessarily had to work. The premonition that he might never visit Venice again undoubtedly compounded the sense of urgency. Nevertheless, he was thorough in his coverage of the principal monuments, and he appears to have studied the Rialto bridge from every conceivable angle and distance. Both watercolor and oil versions of this particular view from near the Palazzo Bembo are in private collections.[1]

1. The watercolor is reproduced in Davis and Langdale, *English Watercolors* (New York, 1986). The oil was at Sotheby's, 16 November 1988, lot 102. Both were painted in Italy.

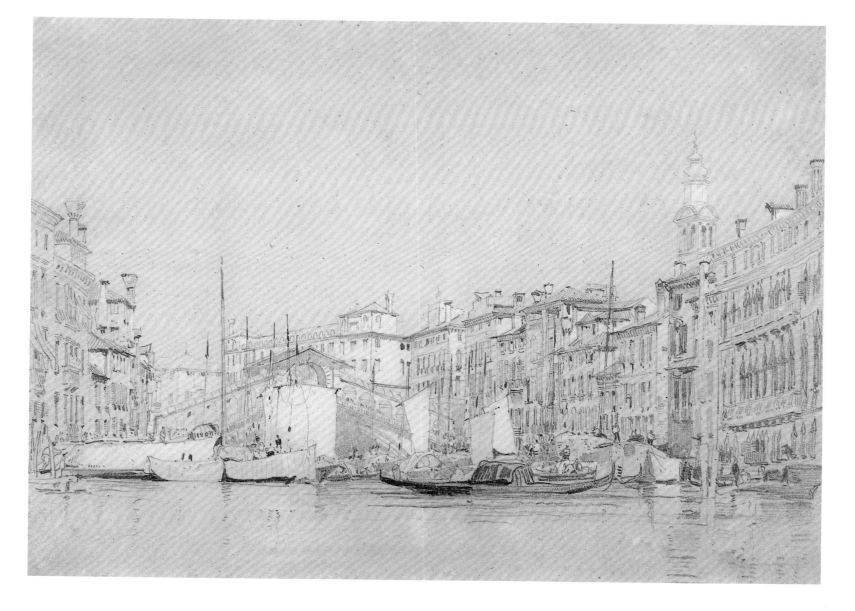

THE COLLEONI MONUMENT, VENICE ca.1826
Watercolor and bodycolor over graphite,
$9 \times 6\frac{7}{8}$ in. (22.7 × 17.5 cm.)

Inscribed: Signed, lower left: *R P B*

Provenance: Possibly Lewis Brown (Paris, 12
March 1839, unnumbered lot, *Equestrian Statue of
Fra Bartolomeo, Venice*); François Villot (Paris, 25
January 1864, lot 76, bought Musée du Louvre).

Exhibitions: Nottingham 1965, no. 221, pl. 12;
Jacquemart-André 1966, no. 59.

References: Mantz, *Bonington*, 299; Dubuisson and
Hughes, 127, repr. opp. 72; Shirley, 67, 69, 114,
and pl. 129; Cormack, *Bonington*, pl. 94.

Musée du Louvre, Département des Arts
Graphiques (MI 889)

Bartolemmeo Colleoni (1400–1475), one of
Italy's most renowned generals, designated in
his will a substantial sum for the erection of an
equestrian monument to his memory in the
Piazza San Marco. Since monuments were
prohibited there by law, it was eventually
placed near the basilica of Ss. Giovanni e Paolo.
Designed by Verrocchio, not without
considerable trouble, as recorded by Vasari, the
monument was praised by Ruskin as one of the
most glorious works of sculpture in existence.
It appears as a dramatic device in act 3, scene 1
of *Marino Faliero*, although Byron referred to the
sitter in his preface as "some now obsolete
warrior," an oversight that rankled the
historian Valery.
 Several graphite studies of the sculpture are
at Bowood (fig. 45), as are studies of other
monuments within the basilica. A watercolor
replica, in which the anonymous copyist ineptly
reproduced the oxidized whites of the Louvre
watercolor with gray bodycolor, was formerly
in the Chéramy collection.[1]

1. *Magazine of Art* (1902), repr. 111.

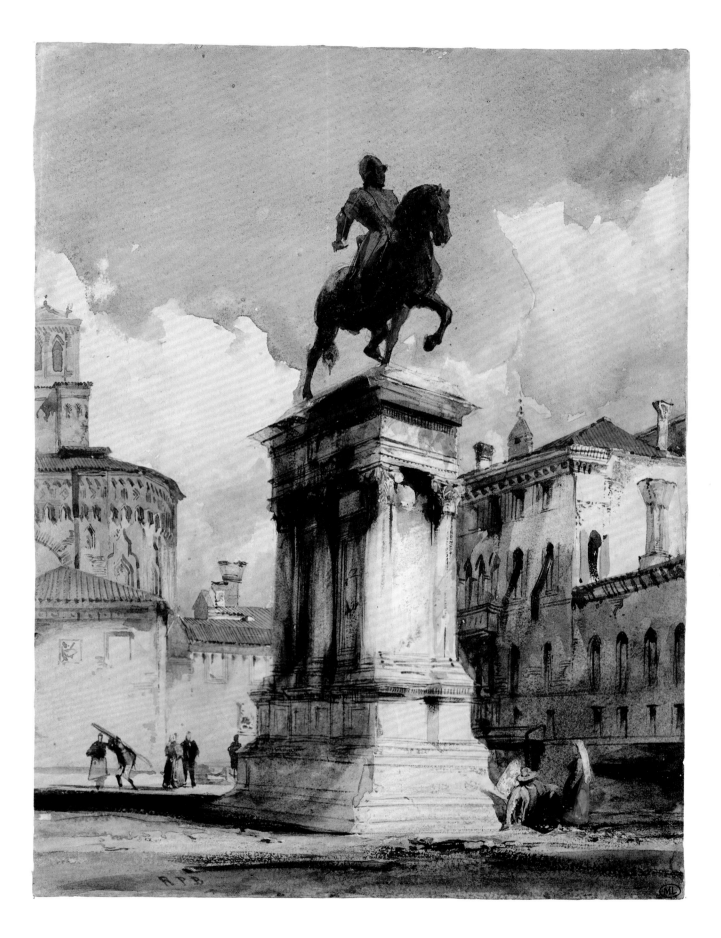

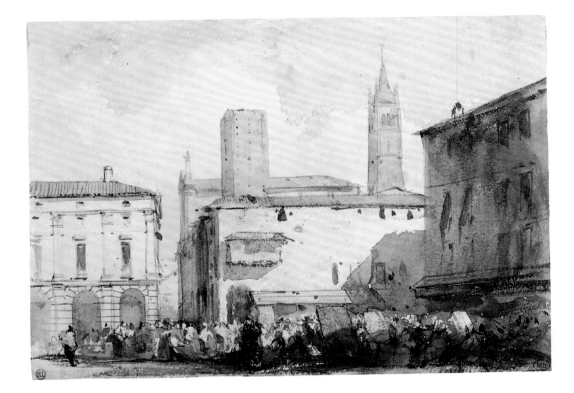

IOI

PIAZZA DEL NETTUNO, BOLOGNA 1826
Watercolor and bodycolor over graphite,
5 × 7 in. (12.5 × 17.6 cm.)

Inscribed: Collection stamp, lower left:
HL (Lugt 1332).

Provenance: Possibly Lewis Brown (Paris, 12–13
March 1839, unnumbered lots); His de la Salle,
by whom given to the Musée du Louvre in
1878.

Exhibitions: Jacquemart-André 1966, no. 53,
pl. VIII.

References: Dubuisson and Hughes, repr. opp.
132; Shirley, 105.

Museé du Louvre, Département des Arts
Graphiques (RF 808)

After leaving Venice on 19 May, Bonington and
Rivet visited Padua, Ferrara, and Bologna en
route to Florence, where they arrived on 24
May. Both Hazlitt and Valery designated as
Bologna's most engaging attractions the oblique
Asinelli and Garisenda towers, which are the
subject of a finished watercolor (Wallace
Collection) and of Bonington's only attempt at
etching (ca.1828), and the Piazza del Nettuno,
with its fountain statuary by Giovanni da
Bologna. The expeditious brushwork of this
small *aide-memoire*, sketched on the spot,
conveys deftly the animation so frequently
observed of Italian market squares.

A watercolor version by Thomas Shotter
Boys (Fitzwilliam Museum) is one of several
copies by that artist after Bonington's Italian
studies. Until recently, a William Callow oil
sketch (fig. 49) of the same view has been
ascribed to Bonington.

102

LERICI 1826
Oil on millboard, 10 × 15 in. (25.4 × 38 cm.)

Inscribed: Verso: remnants of a wax atelier seal, and a label, in Rogers's(?) hand: *The monastery at Spezia where Dante left his ms for the Inferno.*

Provenance: Bonington sale, 1829, lot 3, as *A sketch of the castle of Erici on the Mediterranean — very fine*, bought Heath); Charles Heath to 1832 (Sotheby's, 27 January 1832, lot 65, bought Rogers); Samuel Rogers, and by descent to the present owner.

Exhibitions: London, Cosmorama Rooms, 209 Regents Street, 1834, no. 38, as *View in the Mediterranean*; Nottingham 1965, no. 276.

References: Johnson, *Review*, fig. 53.

Private Collection

This view incorporates the medieval castle and port of Lerici with the promontory of the fortified Isola Palmaria guarding the entrance from the gulf of Spezzia. Bonington and Rivet spent several days at Lerici before moving on to nearby Spezzia and Porto Venere on 7 June.[1]

Napoleon had envisaged an "Antwerp of the Mediterranean" at Spezzia, but at a projected cost of over one million pounds the project never materialized. The immediate vicinity of Lerici had Byronic associations; perhaps more important for Bonington, if he were consciously selecting for potential British patrons sites laden with associative as well as picturesque currency, it was here that Shelley spent the last months of his life in summer 1822. Certainly, the subsequent popularity of engravings after Bonington's view owed something to this connection. Recollecting the days leading up to the tragic drowning, Mary Shelley wrote:

The heat sets in in the middle of June; the days become excessively hot The blue extent of the waters, the almost land locked bay, the near castle of Lerici shutting it on the east, and distant Porto Venere to the west; the varied forms of precipitous rocks that bound in the beach , . . . the tideless sea leaving no sands nor shingle, formed a picture such as one sees in Salvator Rosa's landscapes only . . . sunshine and calm invested sea and sky, and the rich tints of Italian heaven bathed the scene in bright and ever-varying tints.

Civilization and its comforts were remote and the "near neighbors of San Terenzo were more like savages than any people I ever before lived among."[2]

Of the two oil versions of this composition, this one is the primary sketch from nature. The larger and more structured version (no. 153) is less panoramic and includes a screen of foreground trees and the figure of an artist sketching, traditionally identified as Rivet. The definition in no. 102 is crisper, the atmosphere less humid, and the coloring more typical of the sketches done in Italy.

A graphite study exists of the castle from the most northern precinct of the town just below the hillside from which this view was taken.[3] An untraced oil sketch of the castle from closer in, on Davy millboard, may be one of the "three studies" executed at Lerici according to the notes extracted by Dubuisson from Rivet's correspondence.[4] Several untraced works titled *Spezzia* and attributed to Bonington in nineteenth-century sales may be related.[5]

1. A graphite study of Porto Venere is known.
2. Mary Shelley, *John Keats and Percy Bysshe Shelley, Complete Poetical Works* (New York, 1932), 715–16.
3. Christie's, 3 March 1970, lot 34, repr.
4. Dubuisson and Hughes, 75; Shirley, pl. 87; Jacquemart-André 1965, no. 62; Gobin, *Bonington*, pl. 54.
5. Christie's, 3 June 1880, lot 455, a watercolor from the Knowles Collection; Christie's, 1 December 1888, lot 110, oil. A watercolor in the 1837 Lewis Brown sale, *Vue du château et de la baie de genes* (lot 9), may be a misidentified version.

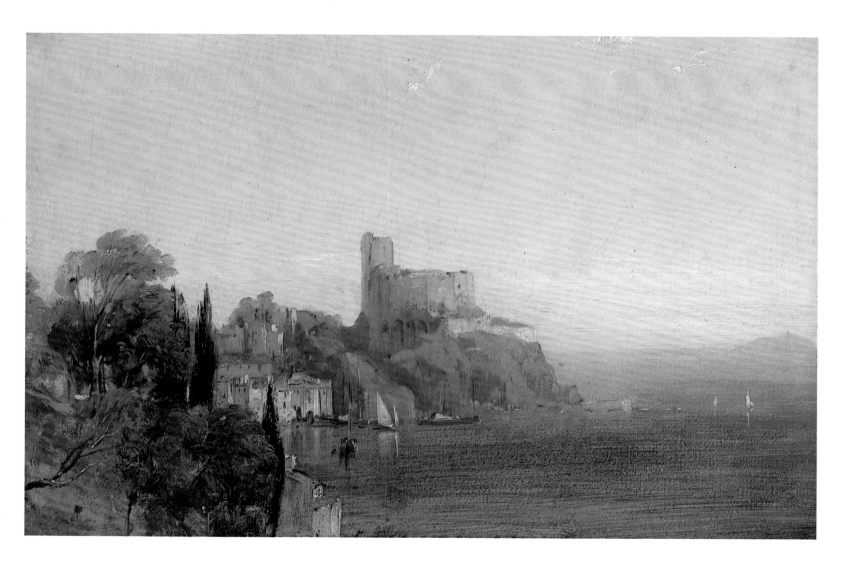

103

NEAR GENOA 1826
Oil on millboard, $9\frac{7}{8} \times 13$ in. (25.1 × 33.1 cm.)

Inscribed: In ink, verso: *Moon / d / Jan 1836*;
R. Davy label; on label, verso: *Bought of / E &
E Silva White / Fine Art Dealer / 104 West George
Street Glasgow*; letter removed from the back:
*209 Regent Street / May 8th 1834 / Sir, / By the
bearer of this I take the opportunity of returning your
picture, painted by my ever lamented son, which you
were so kind as to lend me during my exhibition, this
being now fully closed. I present my most grateful
thanks for the loan, and remain, — Sir, your most
obliged and devoted servant. / Rd. Bonington /
to — Moon, Esq.*

Provenance: Bonington sale 1829, lot 160, as
Environs of Genoa, bought Lawrence; Sir Thomas
Lawrence (Christie's, 17 June 1830, lot 28, as
Italian View with distant mountains, bought
Moon); Sir Francis Graham Moon, to after 1836;
possibly George Vaughan (Christie's, 21
February 1885, lot 68, *Landscape. With an
autograph letter of the artist's father on the back.*);
James Keyden, Glasgow, by 1888; Alexander
Reid, Glasgow, from whom purchased by the
National Gallery in 1910.

Exhibitions: Cosmorama Rooms, 209 Regent
Street, 1834, no. 32, as *View in Switzerland*;
Nottingham 1965, no. 270, pl. 37.

References: Dubuisson and Hughes, repr.
opp. 68; Shirley, 103, pl. 89.

National Galleries of Scotland, Edinburgh

There is no reason to doubt the title as given in
the 1829 studio sale, although the palatial villa
in the distance, of which there are several in the
immediate environs of Genoa, has not been
conclusively identified. On 8 June Bonington
and Rivet traveled the coast from Spezzia to
Genoa, where they stayed for two days.
Another oil sketch (no. 103), several graphite
drawings, and a watercolor of the port from the
sea are all that record this rapid progress
through one of Italy's grander scenic regions.

The relief of the most thickly painted
surfaces in this and the following picture has
been slightly flattened, as might be expected
when such plein-air sketches, only partially dry,
are packed closely for transport.

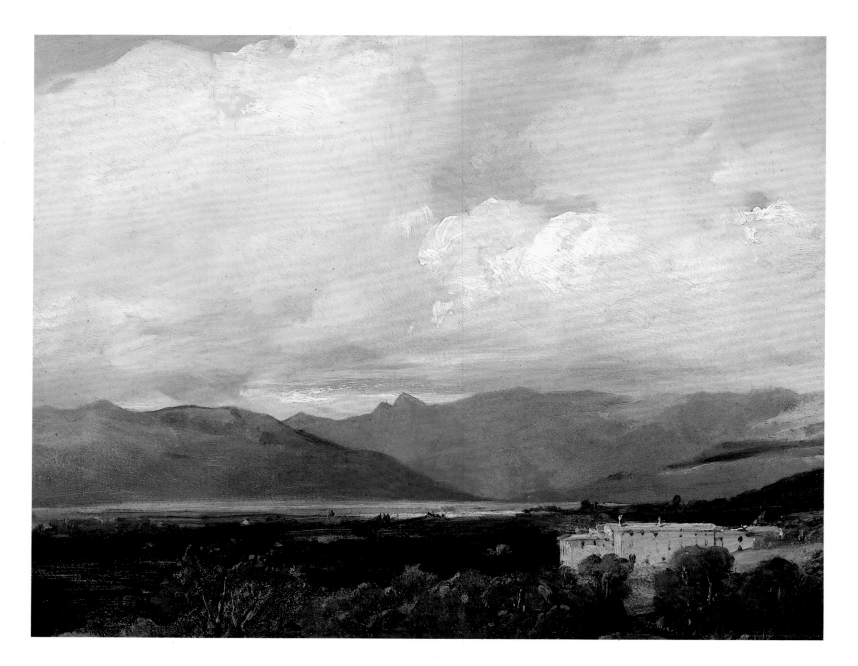

BOCCADASSE WITH MONTE FASCIA IN THE
DISTANCE 1826
Oil on millboard, 10 × 13 in. (25.4 × 32.8 cm.)

Provenance: Bonington sale 1829, lot 159, as *Part of Genoa and the Bay*, bought Rogers; Samuel Rogers, by whom bequeathed in 1855 to his nephew, William Sharpe; by descent to Prof. E. S. Pearson, who presented it to the Cranbourne Chase school, 1962; purchased by the Fitzwilliam Museum in 1983.

Exhibitions: London, Cosmorama Rooms, 209 Regent Street, 1834, no. 48, as *Lake View*; Nottingham 1965, no. 272, pl. 36.

References: Dubuisson and Hughes, 171.

The Syndics of the Fitzwilliam Museum, Cambridge (PD2-1983)

A traditional title of *Lake Garda* is incorrect, although it may have originated with Samuel Rogers, who had visited that site. One of the editions of Rogers's *Italy* included a design of "Mount Aetna" ascribed to Bonington, and he was an active collector of Bonington's paintings in the 1830s. A more recent identification of the view as Boccadesse, a suburb of Genoa, is consistent with the topography and the title assigned to the picture for the 1829 studio sale.[1]

Sketched en route to Genoa, this atmospheric study of the Appenines unites studied observation and concise execution, a combination typical of the Italian oils yet rarely as felicitous as here. As for the pictorial merits of such a subject, Hazlitt once again provided a ready appreciation: "The Appenines have not the vastness nor the unity of effect of the Alps; but broken up into a number of abrupt projecting points, that crossing one another, and presenting new combinations as the traveller shifts his position, produce, though a less sublime and imposing, a more varied and picturesque effect."[2]

1. This information kindly communicated by David Scrase.
2. Hazlitt, *Notes*, 208.

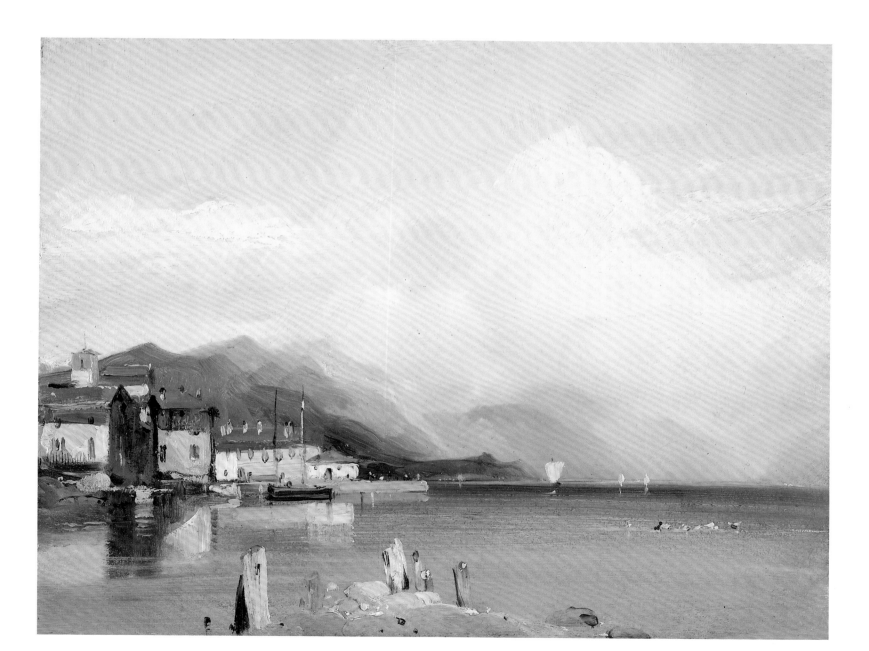

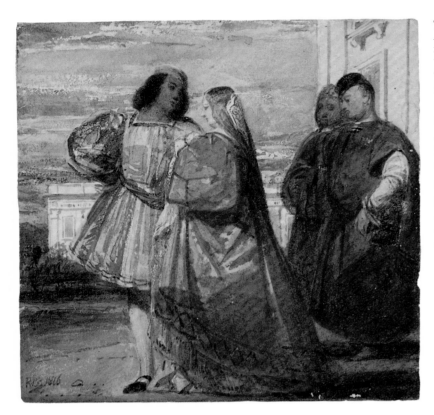

105

PROMENADE VENETIAN 1826
Watercolor and bodycolor, the darks heavily
gummed, $4\frac{1}{8} \times 4\frac{3}{16}$ in. (10.4 x 10.6 cm.)

Inscribed: Signed and dated, lower left: *RPB 1826*

Provenance: Lewis Brown (Paris, 17 April 1837,
lot 14); Count Anatole Demidoff, San Donato;
Baronne Nathaniel de Rothschild; Camille
Groult, from whose descendents acquired by
Pierre Granville in 1960; donated by Pierre
Granville to the Musée des Beaux-Arts, Dijon.

Exhibitions: Nottingham 1965, no. 241.

Musée des Beaux-Arts, Dijon

The subject of this watercolor is simply a
promenade with no specific literary associations.
In every discussion of similar Bonington
compositions, the art of Veronese is invariably
invoked. While the balustrades and brilliant
costumes of Veronese's pictures are certainly
recalled in such watercolors as the *Venetian
Balcony* of 1828 (Wallace Collection), it would
be more appropriate to describe the Dijon
watercolor as an homage to Titian. The two
figures on the right, for which there exists a
graphite study,[1] are taken from Titian's *St.
Anthony Healing the Foot of a Young Man*, and the
costume of the male on the left derives from
Campagnola's fresco *Miracle of the Miser*, both
in the Scuola del Santo, Padua, where Bonington
and Rivet worked briefly after leaving Venice.
A Delacroix watercolor copy of Titian's fresco
suggests the existence, at one time, of a similar
study by either Bonington or Rivet.[2] The
woman in profile was copied without alterations
from the figure of the patrician mother in
Titian's *St. Anthony Healing a New-Born Child*,
also at Padua. Bonington's watercolor may have
been improvised on the spot.

The image seems to have enjoyed some
popularity in the 1860s when Félix
Bracquemond etched a small reproduction of
the watercolor. An impression of this etching,
also in the Musée des Beaux-Arts, Dijon,
belonged to its first curator, the artist and
illustrator Celestin Nanteuil.

1. Nottingham 1965, no. 145.
2. Christie's, New York, 27 May 1983, lot 230.

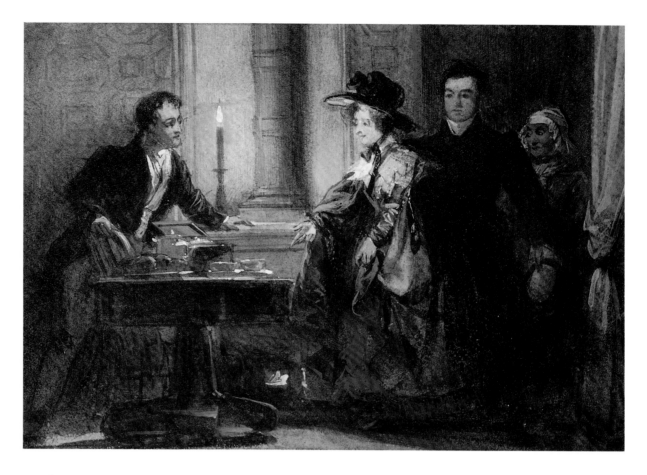

106

INVITATION TO TEA ca.1826
Watercolor and bodycolor with gum arabic,
$4\frac{1}{2} \times 6\frac{1}{4}$ in. (11.7×16.3 cm.)

Provenance: Baron Charles Rivet, and by descent
to the present owner.

Exhibitions: Nottingham 1965, no. 233;
Jacquemart-André 1966, no. 77, pl. xii.

Private Collection

According to family tradition, the scene
represents the artist offering tea to Charles
Rivet and Rivet's mother. The older woman
behind and to the right is Bonington's
housekeeper, whom he also used as a model (no.
140). Marion Spencer dated this watercolor
ca.1824–25, but this is perhaps too early given
the large amounts of gum arabic and bodycolor
that are in evidence.

Following the Italian interlude, Bonington
resumed the frantic social and professional pace
of life in the capital. Carrier recounted to Thoré
that at about this time he quite often took tea
in the evenings at Bonington's house.
During these sessions, his host would amuse
his guests with feats of virtuoso draftsmanship.
Such representations of intimate social
gatherings would become the stock-in-trade of a
generation of French watercolorists from Lami
and Nanteuil to Paul Gavarni and Constantin
Guys.[1]

As there was no Salon scheduled for the
near future, Bonington did not immediately
transform his Italian sketches into finished
pictures. Rather, he appears to have revived
his interest in figure subjects. And although he
was no longer sharing Delacroix's studio, they
continued to work in close association.

1. Miquel (*Art et argent*, 213) reproduces another
domestic "conversation piece" — a small oil on board
(16×19 cm.) of two figures traditionally identified as
Bonington's patrons Monsieur and Madame Paul Périer.

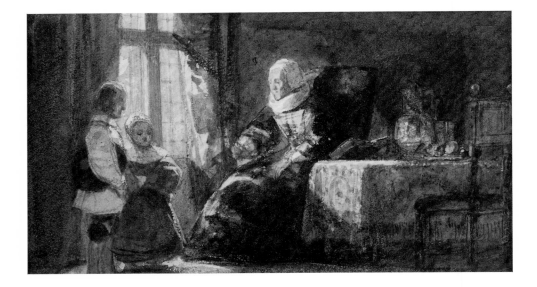

107

THE REMONSTRANCE ca.1826
Watercolor and bodycolor over graphite,
$2\frac{7}{8} \times 5\frac{1}{8}$ in. (7.2 × 12.8 cm.)

Provenance: Paul Périer (Paris, 1846, unnumbered
lot); Paterson Gallery, London, 1913, from
whom acquired by W. C. Alexander; by descent
to the present owner.

References: Dubuisson and Hughes, repr. opp.
165, with incorrect provenance.

Private Collection

A historical or literary source for this work,
if one exists, has not been identified, and the
composition has been known as either *The
Remonstrance; an old woman admonishing two
children*, or *The Grandmother*.

 This luminescent sketch, in which Bonington's
facility engenders forms with extraordinary
economy and surfaces that shimmer in the
warm half-lights, is a preparatory study for a
more vertical watercolor formerly in the
collections of Lewis Brown and Paul Périer.[1] In a
mezzotint by S. W. Reynolds (1833) after this
untraced version, the reproaching gesture of
the old woman, who has just interrupted her
reading, and the sullen faces of the reproved are
more legible. The print was issued with the
title *The Grandmother*, but in the 1834 studio sale
the watercolor was catalogued, presumably with
greater authority, by the first of the two titles
cited above. Marion Spencer suggests that the
old woman was Francesca Bridges, whose
portrait by Van Dyck Bonington had copied in
graphite[2]; however, she more closely resembles
in her features and dress the matron in a nearly
contemporary Bonington watercolor, *Use of
Tears* (Musée du Louvre), for which no specific
model in life or seventeenth-century portraiture
has been recognized. The two children reappear
similarly dressed, but differently arranged, in
the lithograph *Les Plaisirs paternelles* for the *Cahier
des six sujets* (see no. 114), also of late 1826.

 Although essentially a costume piece overtly
indebted to seventeenth-century Dutch genre
painting, Bonington's work should also be
viewed in the context of the numerous, and
often sentimental, poetic and pictorial tributes
to the elderly that became almost a cliché in the
1820s. To cite but one example: Béranger's
La Bonne Vielle, from which Ary Scheffer
composed an oil for the 1824 Salon and a
watercolor replica for L.-J.-A. Coutan (Musée de
Dordrecht). This juxtaposition of age and youth
undoubtedly had special relevance for a
generation raised without fathers and older
siblings during the chaos of the empire.

1. Bonington sale, 1834, lot 122, *The Remonstrance; an old
woman admonishing two children*, bought Colnaghi; Lewis
Brown (Paris, 16–17 April 1837, lot 16). A sepia version
was no. 75 in the 1834 Cosmorama Rooms
exhibition.
2. Nottingham 1965, no. 121.

108

THREE SEVENTEENTH-CENTURY FIGURES IN
AN INTERIOR ca.1826
Watercolor and bodycolor, 6 × 5⅜ in.
(15.2 × 13.7 cm.)

Provenance: Possibly Lewis Brown (Paris, 1843,
lot 15, bought Duchesne).

Castle Museum and Art Gallery,
Nottingham (67-194)

The subject is simply an interior with a
seventeenth-century family. The stance and
habit of the father are from a gentleman in
Tenier's *Village Festival with Two Aristocrats*
(Louvre), a graphite copy of which is in the
National Gallery of Canada on a sheet with
other studies after Terborch's *The Concert* and
Franchoy's *Portrait of a Man*.[1] He would appear
to be dangling a domino in his right hand,
which, together with the nearby lute, provide
what may be an oblique reference to the object
of their interest out of view — a fair or street
carnival. His features recall those of the
gentleman in the *Cavalier and His Lady*, Genoa,
(no. 116), and a comparable date of mid- to late
1826 for this sheet seems appropriate.

1. Both oils were in the Louvre and were also sketched
by Delacroix (Sérullaz, *Delacroix*, no. 1329). The
Franchoy was thought, at that time, to be the work of
Van Dyck.

109

PORTIA AND BOSSANIO ca.1826
Watercolor and bodycolor over graphite,
$6\frac{1}{2} \times 5\frac{1}{8}$ in. $(16.5 \times 12.7$ cm.$)$

Inscribed: Signed, lower left: *R P Bonington*

Provenance: J.-B. Gassies (1829–1882), by 1867;
Comte de Bouille; William Drummond, 1978,
from whom purchased by the Yale Center for
British Art.

Exhibitions: London, Covent Garden Gallery,
1978.

References: Thoré, 1867, repr. 11, in reverse, as a
wood engraving by Carbonneau, *The Present*.

Yale Center for British Art, Paul Mellon Fund
(B1978.43.165)

The difficulties in fathoming the narrative ambiguity of many of Bonington's figural compositions could not be better demonstrated than by this example.

The earliest recorded title, *The Present* — undoubtedly the invention of the critic Théophile Thoré, who first published it, or the artist Gassies, who owned it at that moment — offers marginal interpretive assistance. Most recently, it has been described as an English historical subject of a nobleman and a lady *enceinte*, or possibly an illustration to Shakespeare's *Henry VIII*,[1] in which case, textually, it would have to represent the king's introduction to Anne Boleyn at the masked ball (act 4, scene 1). Two untraced Bonington illustrations for this play are recorded: *Henry VIII and Cardinal Wolsey Greeting the Spanish Ambassador*[2] and *Queen Catherine*.[3] All three subjects have graphic precedents in the Boydell *Shakepeare Gallery* engravings, a set of which belonged to Bonington's father.[4] However, the costumes in the Yale watercolor are considerably earlier than mid sixteenth century, an anachronism that Bonington was not likely to commit in an illustration of so specific a date, and the figure of the gentleman does not correspond in dress or physiognomy to the two representations of Henry VIII by Bonington that have survived: the four-square figure at the top of the stairway in the watercolor *The Earl of Surrey and the Fair Geraldine* (fig. 40) and the processional figure in a pen and ink sketch of ca. 1826 (British Museum), which may well be a first thought for an illustration to the play.

A second possible literary source is Barante's *Histoire des ducs de Bourgogne*, a contemporary publication in which Bonington and Delacroix were keenly interested, both as an epitome of the new romantic approach to history and as a complement to Scott's novel *Quentin Durward*. Specifically, the Yale watercolor could represent the meeting of Duc Maximilian, later Maximilian I, and his future wife, Marie de Bourgogne, in August 1477, nine months after the death of her father Charles the Bold at the Battle of Nancy. Suggesting this association are the costumes and poses of the foremost woman and the young page, which were borrowed almost without alterations from plate 9, *The Marriage Ceremony*, of Hans Burgkmair's woodcut series *Der Weisskunig* celebrating the life of Maximilian.[5] A partial set of *Der Weisskunig*, possibly the edition printed in England by J. Edwards in 1799, also belonged to Bonington's father,[6] and plates specifically illustrating events involving Marie de Bourgogne were copied by Delacroix at this time.[7] The sartorial splendor of the principal couple and the decoration worn by the gentleman, if it were meant to represent the insignia of the Order of the Golden Fleece, founded by Charles the Bold's father, lend some credibility to this association.[8] Barante, on the other hand, was not very loquacious in his description of this momentous union of two of the most powerful houses of Europe, other than to observe that neither betrothed had command of the other's language. Bonington's composition, therefore, would have to be a somewhat fanciful recreation of the affiancing of this princess, "who saw in Maximilian the protector who had come to end her unhappiness and dispel her cruel afflictions." It should be noted, however, that every important contemporary portrait of Maximilian depicts the emperor cleanshaven, as was the custom of the time. These include the numerous representations of this prince in Dürer's monumental *Triumph of Maximilian* woodcuts, which Bonington's father also owned, and the engraved profile portrait in Montfauçon, another of the artist's favorite sources.

The final, and perhaps most persuasive, reading is that the watercolor represents the frequently illustrated act 3, scene 2 of Shakespeare's *The Merchant of Venice*. The *mise en scène* is Portia's palace at Belmont. Bossanio has come to win her hand and her immense fortune by submitting to the test of the caskets devised by Portia's father. Of the three caskets of gold, silver, and lead from which each suitor must choose, only the unadorned lead box contains the miniature portrait of Portia that is the nuptial guarantee. Portia has instructed her maid Nerissa and Bossanio's companion Gratiano, who is interested in wooing Nerissa, to stand away as Bossanio makes his selection. Bonington appears to have illustrated the moment after, when, realizing his good fortune, Bossanio obeys the command of the written message accompanying Portia's portrait, which bids the suitor to seal the betrothal contract with a kiss.

In his letter to his friend Pierret of 1 August 1825, Delacroix mentioned having just seen a performance of *The Merchant of Venice* in London. Bonington was possibly in attendance at this or an earlier performance advertised in the *Times* for 2 July. An untraced oil sketch, simply titled *Merchant of Venice*, was lot 107 in the 1829 studio sale. He certainly attended a performance by the English troupe in Paris in 1828 (see no. 158). He therefore undoubtedly shared Delacroix's enthusiasm for the play and for Edmund Kean's brilliant interpretation of the Shylock role. Whether he intended the Yale watercolor as an illustration to the play or not, his composition was immediately inspired by George Noble's engraving after Richard Westall's illustration to act 3, scene 2 for the Boydell series (fig. 42). The number and disposition of the figures, the vaguely Italianate loggia of Ionic columns, and the tapestry-covered table with its casket are common to both works. Bonington, however, may have been more faithful to the text in depicting Gratiano and Nerissa consorting in the background, whereas Westall introduced two female servants.[9] He also dramatically altered Westall's costumes, although he has retained Bossanio's beard and pendant and Portia's veil, which he has substituted for the inappropriate crown that graces the figure in Burgkmair's woodcut. In using Elizabethan costumes, Westall adhered to the traditional perception of the drama as evolving in the late sixteenth century, although there is no indication from Shakespeare, other than a most recondite allusion to a shipwreck, that the play was set at that time. Bonington was free, in other words, to improvise with the costumes as he had done previously in his painting to the *Merry Wives of Windsor* (fig. 38).

The treatment of the sky and architecture and the sparing use of bodycolor recall the works of 1825, but the handling of washes and the management of darker pigments charged with gum arabic is more accomplished. The absence of any Venetian architectural monuments in the background could mean that Bonington had not yet visited Italy when he painted this watercolor. On the other hand, the costume and features of Bossanio resemble, without actually replicating, those of the patrician father in Titian's fresco *St. Anthony Healing a New-Born Child* in the Scuola del Santo, which Bonington copied at Padua.

1. Marion Spencer, *Covent Garden Gallery*, 1978.
2. Bonington sale 1834, lot 121, and subsequently Lewis Brown (Paris, 17–18 April 1837, lot 76).
3. Bonington sale 1838, lot 20.
4. Bonington Sr. sale 1838, lot 128.
5. *The Illustrated Bartsch: Sixteenth-Century German Masters*, ed. W. Strauss, et al. (New York, 1980) 11, no. 80.
6. Bonington Sr. sale, 1838, lot 33.
7. Sérullaz, *Delacroix*, nos. 1284–86, 1296. Delacroix also drew copies after Burgkmair's *Theuerdank* (Sérullaz, *Delacroix*, no. 1753) and *Triumph of Maximilian* (Sérullaz, *Delacroix*, no. 1287), impressions of which also belonged to Bonington's father. Whether Delacroix availed himself of this collection is uncertain, as his copies after Burgkmair in a sketchbook (Sérullaz, *Delacroix*, no. 1752) are from single prints in a collection formed by the Abbé de Marollès and then in the Bibliothèque Royale under the classification *Vieux Maître en Bois* (Est. 25d res). On another sheet (Sérullaz, *Delacroix*, no. 1356), he mentions a *Triumph of Maximilian* in the collection of M. Gateaux.
8. Carbonneau's wood engraving clearly shows the golden fleece. Delacroix made several drawings of the Order's insignia (Sérullaz, *Delacroix*, no. 1748 f.19r) either in conjunction with his oil copy of a portrait of Charles II of Spain (Johnson, *Delacroix* 1, no. 21) or his costume designs for Hugo's *Amy Robsart* (see no. 141).
9. Closer in most respects to Bonington's interpretation is Gilbert Stewart Newton's oil painting of the scene (1831), which incorporates elements from both the Bonington and the Westall pictures.

110

EUGENE DELACROIX (1798–1863)

AN ILLUSTRATION TO *GOETZ VON
BERLICHINGEN* ca.1826–27
Watercolor and bodycolor with stopping out
and gum arabic, $8\frac{3}{8} \times 5\frac{5}{8}$ in. (21.3 x 14.4 cm.)

Inscribed: Signed, lower left: *Eug. Delacroix*

Provenance: Pullman Family, Chicago; Hanzell
Gallery, Chicago; Robert Glade, Chicago, until
1989; Jill Newhouse, 1989, from whom
purchased by the present owner.

Private Collection

A seminal work of *Sturm und Drang*, Goethe's play *Goetz von Berlichingen* dramatizes events in the life of a German baron who sought to protect his feudal privileges from Emperor Maximilian's efforts to centralize the political and social structures of his kingdom. The idea of such a warlord struggling irrationally to defend his independence and self-esteem against the reforms of modernization appealed to romantic sensibilities grappling with parallel sentiments of nationalism and with the absence of clarity in their own sociopolitical order. Among the writers of Delacroix's immediate circle, Goethe's tragedy was a paradigm of what a renovated French drama should embrace — the historicism or "local color" of Walter Scott's prose, as in *Quentin Durward*, and the emotive force of Shakespeare's plays. As Alfred de Rémusat observed while reviewing Prosper Mérimée's somewhat derivative *La Jacquerie, scènes foedales*, "Goethe's play is the first attempt, the first example of this imaginative return to the Middle Ages, of this taste for Gothic and national paintings which today invades all the arts."[1]

That this watercolor relates to Delacroix's interest in Goethe's tragedy was first proposed by Jill Newhouse. The composition does not illustrate a specific passage, but neither is Delacroix's *Death of Sardanapalus* a slavish visual reconstruction of the concluding act of Byron's play, which inspired its creation. On the basis of the following circumstantial evidence, I have accepted the *Goetz* identification, allowing that it is speculative but stressing that Delacroix, like Bonington, could be quite cavalier in interpreting given texts.

Between 1836 and 1843 Delacroix designed a series of seven lithographic plates illustrating this drama. His interest in such a project, however, dated as early as 28 February 1824, when in his journal he credited Pierret for suggesting this source. Furthermore, a handwritten list of seven possible subjects appears in an intermediate sketchbook now in the Louvre.[2] That list follows seven studies after figures from Hans Burgkmair's woodcut illustrations to Maximilian's *Theuerdank*. The date of these studies and the list of *Goetz von Berlichingen* subjects for which they were obviously drawn as costume references is uncertain, but it could be as early as late 1826, when Bonington was also referring to Burgkmair prints as sources for the figures in several of his own compositions (no. 109).[3]

With regard to the dating and purpose of this particular watercolor, notice should be taken also of Delacroix's oil sketch of a bearded man in similar armor, whom Lee Johnson has identified convincingly as the artist's factotum Bastiano Vicentini.[4] This model is mentioned on the verso of a sheet of studies drawn at Westminster Abbey in July 1825 and again in a Delacroix letter postmarked 18 June 1826.[5] An untraced watercolor depicting Goetz's loyal lieutenant Franz Lerse in a pose and armor similar to Vicentini's was reproduced by Robaut.[6] This originally belonged to Pierret. It is conceivable that Delacroix executed all

three works in connection with an unrealized project for illustrating *Goetz von Berlichingen* in the 1820s. Two other carefully elaborated watercolors in the Louvre that are stylistically contemporary, *A Wounded Cavalier*, variously identified as either the Chevalier Bayard or the *Goetz* character Selbitz, and *Seated Page with Lute*,[7] might also be a consequence of this interest, if not actually specifiable illustrations to the play. Interestingly, a half-length study of Vicentini in armor appears as a *rémarque* in the margin of the only lithographic copy of a Bonington composition that Delacroix is known to have made, *The Message*.[8] This composition is a variant of Bonington's *Faust and Mephistopheles* sepia design of ca.1826 (Private Collection).[9]

Of the two figures represented in the exhibited watercolor, the page might be identified as Goetz's attendant George. The knight would be either Goetz or Frans Lerse. An untraced and undated Delacroix sepia design for act 1, scene 2,[10] which Bonington appears also to have illustrated (no. 112), represents George arming Goetz, but in the presence of Frère Martin. Alternatively, it was George who announced in act 3, scene 6 the arrival of the mysterious knight Lerse, although he does not subsequently attend him in Goethe's stage directions.

If Delacroix was largely responsible for coaxing Bonington to broaden his repertoire to include finished cabinet pictures of historical and literary subjects, the English painter's example and success, especially in watercolors, undoubtedly compelled Delacroix to master a medium that had been, until ca.1826, a vehicle for studies and amusement.

1. *Le Globe*, 28 June 1828, 508.
2. Sérullaz, *Delacroix*, no. 1753, f. 25v.
3. Sérullaz has catalogued the sketchbook in reverse. His "back" cover is actually the front of the sketchbook as it bears the color merchant's etiquette pasted in the corner. He has also dated the entire sketchbook ca. July 1827 or later on the grounds that the giraffe depicted among the first seventeen folios did not arrive at the Jardin des Plantes until that month and year. At folio 20, however, the sketchbook inverts, which indicates that the unrelated concluding section, which includes the *Theuerdank* sketches and *Goetz von Berlichingen* list, was used on another occasion, either before or after July 1827.
4. Johnson, *Delacroix* 1, no. 32.
5. Delacroix, *Correspondence* 1: 184; Sérullaz, *Delacroix*, no. 1306.
6. Robaut, *Delacroix*, no. 637.
7. Sérullaz, *Delacroix*, nos. 552 and 557. All of the watercolors under discussion are also quite close in style to the signed watercolor *Pelikare de dos* (Sotheby's Monaco, 8 December 1990, lot 318), which relates directly to the portrait studies and sketches of Palatiano and undoubtedly dates to spring 1826. The *Pelikare de dos* was originally in an album belonging to Madame Delessert, about whom see nos. 8 and 18 in this exhibition.
8. Delteil, *Delacroix*, no. 52, and Robaut, *Delacroix*, no. 193, both of whom date the print to ca.1826.
9. A second *rémarque* in the margin of Delacroix's print, which is undated, is the sketch of a nude from the rear that relates to a figure in his oil sketch for the *Death of Sardanapalus* (Johnson, *Delacroix* 1, nos. 124–25).
10. Robaut, *Delacroix*, no. 634.

III

GOETZ VON BERLICHINGEN
BEFORE THE IMPERIAL MAGISTRATE ca.1826
Pen and brush and brown ink over graphite,
$4\frac{3}{4} \times 4$ in. (12 × 10.1 cm.)

Inscribed: Collection stamp, lower left:
Coutan-Hauguet-Milliet (Lugt 464)

Provenance: L.-J.-A. Coutan, and by descent (Paris, Hôtel Drouot, 16–17 December 1889, lot 42, as *Douglas and the Duke of Albany*, bought Michel-Levy); Michel-Levy (Paris, 17 June 1925, lot 24, as *Scene tirée de Shakespeare*, bought Rofe); William Turner (Sotheby's, 15 July 1959, lot 28, as *François Ier et Marguerite de Navarre*, bought Christopher Norris); Christopher Norris to 1987 (Christie's, 28 March 1988, lot 111, bought Morris).

Exhibitions: Agnew's 1962, no. 50; Nottingham 1965, no. 192, as an illustration to *The Fair Maid of Perth*.

Yale Center for British Art, Gift of
John Morton Morris

This vivacious monochrome sketch was probably acquired from the artist by his patron, L.-J.-A. Coutan. The identification of the subject by Coutan's descendants and again by Marion Spencer as a scene from Walter Scott's *Fair Maid of Perth* is difficult to reconcile with a novel set in fourteenth-century Scotland and with its publication date. In a letter to her son of 28 April 1828, Lady Holland noted that the work "is not only written but printed, not

published yet."[1] Although there is nothing in the execution to preclude absolutely the possibility that the drawing was made during the last two months of the artist's life, other internal evidence strongly supports an earlier date. Similar considerations may have persuaded Michel-Levy to retitle the drawing as an unidentified Shakespearean subject.

The seated figure in "Venetian" habit appears in the oil *Evening in Venice* (ca.1826–27; fig. 66). The foremost chevalier is borrowed from plate 70 of Hans Burgkmair's illustrations to the life of Maximilian, *Der Weisskunig*,[2] which was a source for other Bonington watercolors of late 1826. He is almost certainly the same figure depicted in the oil *A Knight and Page* (no. 112) and the brown wash study for that picture (National Gallery of Victoria, Melbourne). Rather than as unused studies for the *Cahier de six sujets*, to which they bear thematic affinities, the Yale sketch, with its manifest narrative intent, and the Melbourne sheet, which is of identical dimensions, should be seen as pendant illustrations to a literary work set in the late fifteenth century. I propose that they illustrate Goethe's tragedy *Goetz von Berlichingen*. The Melbourne drawing would be an illustration to act 1, scene 2, while the present study represents Goetz pleading his cause before Maximilian's unsympathetic magistrate in act 4, scene 2.

Neither Delacroix nor Bonington was fluent in German, but the play was readily accessible in Walter Scott's English translation of 1799. Heretofore, Bonington's only recorded interest in Goethe has been a brown wash illustration of ca.1826 to *Faust*.[3]

1. The Earl of Ilchester, ed., *Elizabeth Lady Holland to her son 1821–1845* (London, 1946), 83.
2. Bartsch 80(224)–70: *The White King Learning the Lombard Language*.
3. Formerly Lewis Brown (Paris, 16–17 April 1837, unnumbered lot); with Cailleux in 1966 and reproduced Cherbourg, 1966, no. 13.

112

A KNIGHT AND PAGE ca.1826
Oil on canvas, 18¼ × 15 in. (46.5 × 38 cm.)

Provenance: Given by the artist to Eugène Delacroix, by whom bequeathed to Baron Charles Rivet; by descent to Mlle F. de Catheu, 1936; Eliot Hodgkin, from whom purchased by Paul Mellon in 1962.

Exhibitions: BFAC 1937, no. 23; Agnew's 1962, no. 21.

References: Philippe Burty, *Lettres de Eugène Delacroix* (Paris, 1878), v; Shirley, 113, with incorrect measurements; Ingamells, *Bonington*, 70 n.31.

Yale Center for British Art, Paul Mellon Collection (B1981.25.52)

In his will Delacroix bequeathed to Baron Rivet this "unfinished picture by Bonington (Page and Chevalier) and a small grisaille with two subjects by the same artist."[1] Verrocchio's bronze portrait of Bartolemmeo Colleoni (1400–1475), which Bonington studied closely in Venice (no. 100 and fig. 45), furnished the facial features of this stern condottiere. His armor is based on a suit in the Meyrick collection, a graphite study of which is in the British Museum. The same armor was sketched by Delacroix.[2] The knight's pose and costume derive from Burgkmair's *Der Weisskunig* woodcuts, although the compositional type of a seigneur attended by his page is familiar from late Renaissance portraiture, such as Caravaggio's *Alaf de Wignacourt and Page* (1608; Louvre).[3]

Contemporary in execution with *The Prayer* (Wallace Collection; fig. 67) and *Evening in Venice* (Fogg Art Museum; fig. 66), which date to the winter months of 1826–27, the picture also relates compositionally to the lithograph *Le Retour* (published December 1826). A brown wash drawing for the composition (National Gallery of Victoria, Melbourne), which is a pendant to no. 111, is probably a preparatory version. The subject may also relate to a lost watercolor of a knight being armed by two pages, which was engraved in mezzotint by S. W. Reynolds as *The Knight Templar*.[4]

When he repeated a composition in oil, Bonington usually borrowed portraits and other embellishments from works of art that were historically or thematically suitable. This was done not only to infuse character and authority into the representation, but also to gratify or amuse the cognoscenti. If, as suggested in the discussion of the Yale sepia sketch (no. 111), this knight was meant to personify Goetz von Berlichingen, the choice of Colleoni as a model for Goethe's anachronistic warlord would be most congenial.

Delacroix may well have had this picture before him when he recorded in his journal on 31 December 1856:

Some talents come into the world fully armed and prepared. The kind of pleasure men of experience find in their work must have existed since the beginning of time. I mean a sense of mastery, sureness of touch going hand in hand with clear ideas. Bonington had it, but especially in his hand. His hand was so skilled that it ran ahead of his ideas. He altered his pictures because he had such facility that everything he put on canvas was charming. Yet the details did not always hold together, and his tentative efforts to get back the general effect sometimes caused him to abandon a picture after he began it. Note that another element, colour, is crucial to this type of improvisation.[5]

1. The last was probably the untraced double seascape also mentioned by Thoré 1867, 16.
2. Sérullaz, *Dealacroix*, no. 1468.
3. A graphite study of Caravaggio's page was drawn by Delacroix on the same sketchbook sheet (Sérullaz, *Delacroix*, no. 1751, f. 7r) as his studies after Cariani's *Portrait of Jacopo and Gentile Bellini*, to which Bonington referred when painting his *Evening in Venice* and possibly the seated figure in the sepia no. 111. Delacroix would use the figure of the page in a sepia illustration *Proteus and Julia Disguised as a Page (Two Gentlemen of Verona)* which Robaut (*Delacroix*, no. 191) dated 1826.
4. A sepia study for that watercolor was in the W. J. Cooke sale (Christie's, 16 March 1840, lot 138, *A Knight Arming*), where it was stated that the watercolor was painted in the presence of Thomas Shotter Boys. Bonington did not become intimate with Boys until autumn 1826.
5. Delacroix, *Journal* 3: 187–88; at some point between 1829 and 1835, when Delacroix was residing at 15, quai Voltaire, Auguste requested the loan of the Yale picture; see his manuscript letter reprinted in *Voyage de Delacroix au Maroc* (Paris: Musée de l'Orangerie, 1933), no. 291.

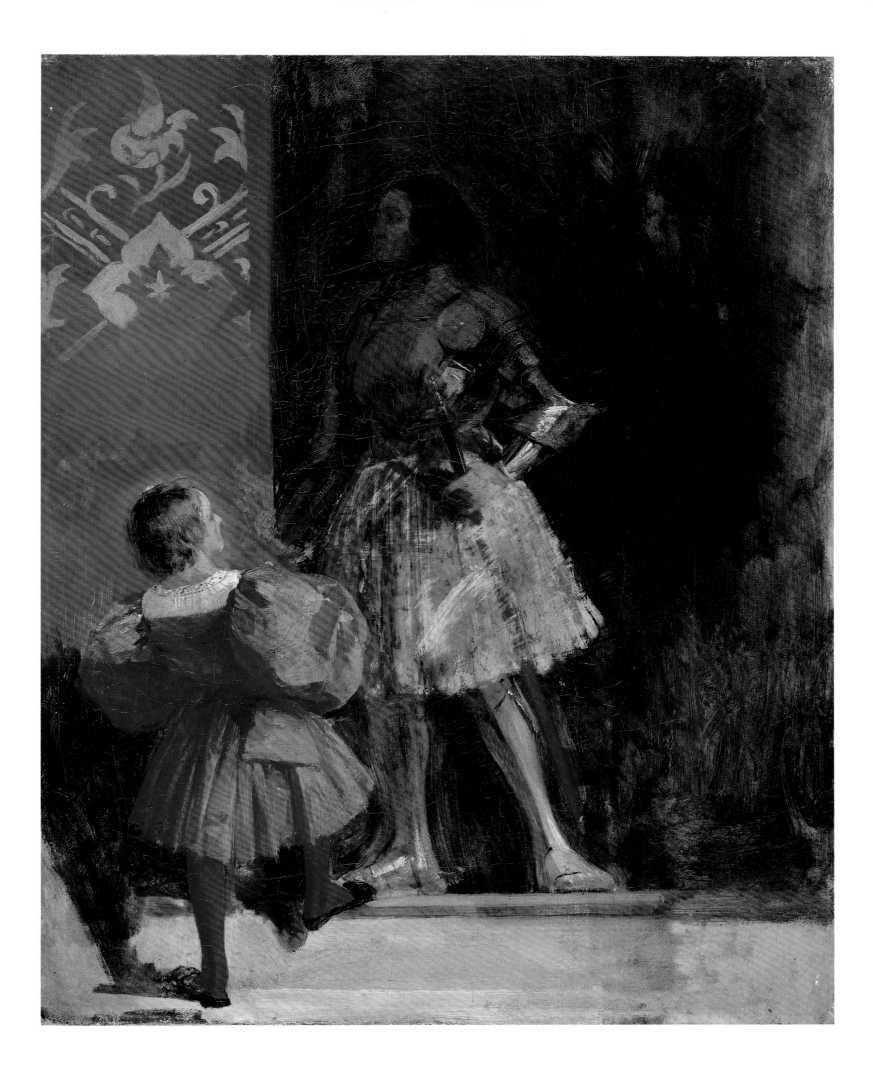

113

THE DUEL BETWEEN FRANK AND
RASHLEIGH 1826
Lithograph on white wove paper, $3\frac{7}{8} \times 5\frac{1}{8}$ in.
(9.9 × 13 cm.)

Inscribed: In the stone, lower left: *Peint et Lith par
Bonington*; and, lower right: *Lith de Villain. rue de
Sevres, no 23*

THE ESCAPE OF DUGALD DALGETTY AND
RANDAL MACEAGH FROM ARGYLE
CASTLE 1826
Lithograph with tint stone, $5\frac{1}{8} \times 6\frac{3}{8}$ in.
(14 × 16.3 cm.)

Inscribed: In the stone, lower left: *Peint et Lith par
Bonington*; and, lower right: *Lith de Villain. rue de
Sevres, no 23*

Provenance: Baron Henri de Triqueti (1802–
1874) (Lugt 1304).[1]

References: Curtis, no. 43 (i/ii); Curtis, no. 42
(i/iii).

Private Collection

The larger of these vignettes, based on an
untraced watercolor or sepia design, illustrates
an episode from chapter 13 of Walter Scott's *The
Legend of Montrose*, first published in 1819. It is
one of twelve tailpieces commissioned from
Bonington, Paul Delaroche, and Eugène Lami by
Amédée Pichot for his *Vues pittoresques de l'Ecosse*
(Paris, 1826). The publication consisted of
annotated text excerpted by Pichot from Scott's
novels and sixty topographical lithographs
reproducing F.-A. Pernot's on-site drawings of
the locations mentioned. Of the twelve
lithographers engaged on the project, among
whom were Francia and Enfantin and several of
Baron Taylor's regular draftsmen like David,
Joly, and Deroy, Bonington contributed the
most plates — eleven topographical views and
two vignettes. The second vignette illustrates
chapter 25 of *Rob Roy*. The title page incorrectly
lists J. D. Harding as a contributor. It also
makes no mention of Bonington's vignettes,
and the omission suggests that these were
commissioned as an afterthought at some point
between the publication of the first *livraison*,
announced in the *Journal des Débats* on
22 December 1825, and the final *livraison*, issued
in January 1828.

The publication, dedicated to the duchesse
de Berry, was printed in twelve parts of five
topographical views and one vignette. The price
of an installment was 13 francs printed on white
wove, 18 francs on *chine collé*, and 25 francs for
the deluxe edition printed on oversize sheets of
vélin. In September 1828 one of these deluxe
sets, together with Pernot's original drawings,
was offered for 6000 francs. As production
spanned thirty-two months, it is impossible to
date precisely Bonington's individual plates,
which appear in all but the first and ninth
livraisons, although it is likely that they were
executed in two or three stages between late
1825 and late 1826. The vignettes are very close
in style to the *Cahier* lithographs (no. 114).
Since they appear at the end of the eighth and
tenth *livraisons*, they may also be nearly
contemporary in date.

Although Bonington's landscape views are
based on Pernot's designs, comparison with
prints by the other artists of the project
indicates that he took exceptional liberties with
his foreground and staffage inventions, adding
prominent figure groups that range in type from
peasants engaged in everyday tasks such as
laundry drying to the more historical group of
the Glenfinlas view (fig. 33), which evokes,
without slavishly illustrating, Scott's narrative
of two hunters about to confront a specter. It is
possible that this image and the vignette *Escape*
were on Delacroix's mind when he composed
his lithograph *Faust et Mephistopheles galopant dans
la nuit du sabbat*. The *Glenfinlas* was certainly
finished before 2 October 1826, when it was
reviewed favorably in the *Débats*.[2] By
comparison, the staffage introduced by his
collaborators were miniscule, nondescript kilted
figures deployed only to indicate scale.

According to Atherton Curtis, Pernot was
perturbed by Bonington's presumption,
claiming that his translations were "too

romantic"; however, the critic for the *Débats*
extolled his contributions as "masterpieces of
lithography." Pernot subsequently authorized
a second edition to be published in Brussels
in 1827–28. The stones were redrawn by
P. Lauters, who faithfully, if feebly, copied
the original plates, with the exception of
Bonington's. In these he either removed or
reduced in scale most of the figures in each
composition. Finally, an English edition,
without text and with only Bonington's plates,
was issued in London by Colnaghi in December
1828. These were so palely printed that in most
sets watercolor washes were needed to reinforce
the design.

Vues pittoresques de l'Ecosse, inspired by the
success of Pichot's unillustrated *Picturesque Tour
of England and Scotland* (London and Paris, 1825),
was clearly intended as a guidebook for the
French readers of Scott who, by 1828, must
have included most of the literate population.
The following summation of its reception was
printed in the *Débats* on 28 September 1828:

*The poetry, but especially the novels, of this celebrated
author have completely changed the style and the
direction of study which readers, writers, and artists
have pursued for ten years. In France today we are so
much less concerned with Greek and Roman mythology
that we concentrate on the ballads and spectral histories
that have been retold by Scottish wetnurses since the
15th century. We take greater pains to know the course
of the Clyde and the Tweed than to know the location of
Troy or the court of Meandre Walter Scott has
the satisfaction of seeing his life treated as we have
treated Homer long after his death. In addition to his
imitators, the Scottish bard has his commentators,
geographers, and artists.*

1. Baron Triqueti, who originally owned this
impression of the *Escape*, was a sculptor best
remembered for his collaboration with Ary Scheffer on
the funerary monument of Férdinand-Philippe, Duc
d'Orléans (1810–1842). He knew Bonington personally
and toward the end of his own life began to compile a
catalogue of Bonington's prints. This survives in
manuscript in the archives of the Ecole Superièure des
Beaux-Arts, Paris.
2. The hunters on foot appear to derive from Hans
Burgkmair's woodcuts *Der Triumphzug Kaiser
Maximilian*, a set of which was owned by Bonington's
father.

Bonnington del Lith.de Lemercier.

LA PRIÈRE.

114

LA PRIERE 1826
Lithograph on *chine collé*, $5\frac{3}{8} \times 4\frac{1}{8}$ in.
(13.8×10.3 cm.)

Inscribed: In the stone, lower margins: *Bonnington
del. | lith. de Lemercier | à Paris, chez Mme Brossier,
au Dépot gal de lith., quai Voltaire, no 7 |
LA PRIERE*

References: Curtis, no. 45 (ii/ii).

Stanford University Museum of Art (75.163.29)

This lithograph is from a set of Bonington
prints published initially by Sazerac as *Cahier de
six sujets*. The printer Langlumé deposited four
of the prints with the government censors on
30 December 1826, which suggests that the
publication, like the *Contes du gai scavoir*
(no. 145) of the following year, was intended for
sale as a New Year's present. Watercolor or oil
versions of the six genre subjects are recorded,
as are several studies for individual figures. The
inferior quality of Langlumé's printing forced
the artist to engage another publisher in
Madame Brossier, and a far more competent
printer, Lemercier, for a second edition.

The knight in the *La Prière* reproduces
exactly one of the mourners on the monument
of Lord Norris (d. 1601) at Westminster Abbey.
The pose and costume of the child derive from
another funerary sculpture on the monument
of Lord Shrewsbury (d. 1617), also at
Westminster. Pen and ink studies of this figure
by Bonington are in several collections.
Delacroix also made studies of these sculptures.[1]
Regardless of the ultimate source for the figure
of the chevalier, he and his spouse bear a
striking, and probably intentional, resemblance
to Henri IV and Marie de' Medici.

In 1828 Alexandre Colin published *The Five
Senses*, a set of prints of historically costumed
figures.[2] Compositions or narrative devices
similar to those of Bonington's *Cavalier and His
Lady, Genoa* (no. 116), *The Lute Lesson* (no. 121),
and of two of the other *Cahier* plates, *Repose* and
Gentle Reproof, were assigned the titles "sight,"
"hearing," "taste," and "smell." There is,
however, nothing immediately discernable in
Bonington's set of prints to indicate comparable
iconographic coherence or intent.

The technique of the 1826 lithographs differs
from Bonington's earlier prints in the increased
reliance on liquid *touche*, applied with both pen
and brush, to sharpen details and contours.
The figures have greater plasticity, and the all-
pervasive luminosity of the *Restes et fragmens*
series yields to an equally irresistible contrast of
brilliant reflections within obscure interiors.

1. Sérullaz, *Delacroix*, nos. 1303–5 (no. 1304 inscribed in
part "du temps de Henri IV"), and Sotheby's, 16 June
1982, lot 569.
2. *Les Cinq Sens | desinées et lithographiés par A. Colin |
publiées par Nöel aîné et fils* (Bibliothèque Nationale).

115

THE MEETING 1826
Watercolor and bodycolor, $2\frac{1}{2} \times 5\frac{3}{4}$ in.
(6.3 × 14.8 cm.)

Inscribed: Signed and dated, lower left:
R P B 1826

Provenance: Thomas McLean (Christie's, 18
January 1908); M. Beurdeley (Galerie George
Petit, Paris, 30 February 1920, lot 32);
Anonymous (Hôtel Drouot, Paris, 10 March
1978, lot 55); Anonymous (Sotheby's, 13 March
1980, lot 63, bought Victoria and Albert
Museum).

Exhibitions: Pointon, *Bonington*, no. 22, repr.
opp. 96.

References: Dubuisson and Hughes, 200;
Shirley, 147.

Victoria and Albert Museum (P2-1980)

Although the presence of a signature and date
would suggest otherwise, this drawing is almost
certainly a preparatory sketch.[1] Pointon
compared it to the watercolor studies after old
master paintings of ca.1825–26 (no. 61), but a
date toward the end of 1826 would be more
appropriate on the stylistic evidence. The
composition has less in common with Rubens's
Self-Portrait with Family (Louvre), as has been
supposed, than with Abraham Bosse's
seventeenth-century engravings of Parisian
fashionables, from which Bonington made
numerous graphite copies.[2] The artist's
predilection for promenading figures as a vehicle
for compositions redolent of historical
atmosphere but without anecdotal specificity
may derive from Thomas Stothard's
illustrations for Bowyer's edition of Thomas
Hume's *History of England* (London, 1793–1806),
a source well-known to Bonington's circle.

1. A previous identification of the watercolor as *The
Meeting of Louis XIV and Charles II* is improbable.
Another watercolor, more highly finished, to which this
is related in conception but for which it is not a study
was in the Michel-Levy and Casimir-Périer collections;
Paris, 17 June 1925, lot 21, incorrectly titled *Charles I and
Family*.
2. Most of these are at Nottingham. Delacroix was
collecting Bosse engravings as early as 1824.

116

A CAVALIER AND HIS LADY, GENOA 1826
Watercolor and bodycolor, $6\frac{5}{8} \times 4\frac{3}{4}$ in.
(16.7×12 cm.)

Inscribed: Signed and dated, lower right:
RPB 1826

Provenance: Lewis Brown (Paris, 17 April 1837,
lot 3); P. M. Turner, by 1937; N. D. Newall
(Christie's, 13–14 December 1979, lot 4).

Exhibitions: BFAC 1937, no. 80.

References: Shirley, 71, 117, pl. 139.

Mr. and Mrs. Deane F. Johnson

This is another of Bonington's balcony scenes,
without obvious literary or historical
significance, in which figures interrupted in
conversation or other domestic activity direct
their attention toward some distant prospect.
As it shows the lighthouse at Genoa in the
background, the drawing presumably dates to
fall 1826. A graphite study of the actual
lighthouse and port is at Bowood.

As if some tacit understanding existed
between the two most ardent collectors of
Bonington's works, Sir Henry Webb appears to
have indulged his preference for oil paintings,
while watercolors were the exclusive preserve of
Lewis Brown. For a decade before his death in
1836, Brown aggressively emended his holdings,
which he mounted in an album that was
legendary and that was intended as the basis for
a public gallery devoted to the artist he
idolized. The envisaged installation was never
realized, and after Brown's death 110 lots of
Bonington's finest watercolors and drawings
were auctioned in Paris. Delacroix would later
recall to Thoré that such an assemblage of
Bonington's genius might never again be
possible. In its intimate scale and non-
interpretive subject, no. 116 typifies the
watercolors Brown commissioned from the
artist or acquired during the 1830s. In his
obituary, he was quoted as having asserted,
"I do not neglect drawings, which have given
me all the pleasures of a portable gallery most
commodiuous for the traveller; I reserve all
my attention for artists who are pleased to
accommodate their ideas to dimensions that suit
me, even at the risk of their own fame."[1]

The most iterant objections in France to the
patronage of watercolor painting were that
watercolors were neither durable nor public nor
sufficiently grand to admit a profound moral
sentiment. But such deprecation was rapidly
silenced, as it had been in England almost a
generation earlier, by the unremitting pursuit of
excellence, regardless of its means of expression,
on the part of collectors like Brown, who, for
whatever personal reasons, ignored the staid
wisdom of the establishment savants.

1. *L'Artiste* 11 (1836): 312.

117

CAMILLE ROQUEPLAN (1800–1855)

DON QUIXOTE AT HOME AFTER HIS
SECOND SALLY ca. 1825–30
Watercolor, $5\frac{3}{4} \times 4\frac{3}{8}$ in. (14.6×11.1 cm.)

Inscribed: Signed, lower right: *Clle. Roqueplan*

Mr. and Mrs. Deane F. Johnson

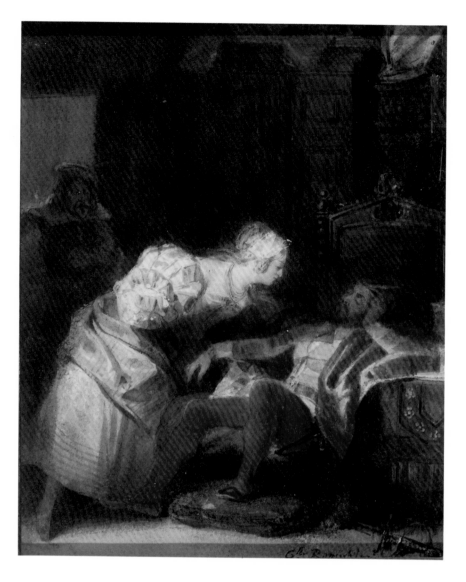

The illustrated episode appears at the end of part 2 of Cervantes's novel. Don Quixote, exhausted from his adventures, has returned home to the relief of, and to receive ministrations from, his concerned niece. The depiction diverges from the text but has a direct prototype in Robert Smirke's interpretation of the same passage for Cadell's 1818 English-language edition. Lami (no. 5) had previously borrowed compositional ideas from the same source, but he did not illustrate this particular episode. Here Roqueplan's execution is considerably less facile and his reliance on pure watercolor less technically daring than in his watercolors of the 1830s. The influence of Bonington's Teniers-inspired interiors is also evident in the coloring and costumes, and a date for this sheet in the mid-to-late 1820s appears most reasonable.

As with all of the artists of Bonington's circle, Roqueplan was enthusiastic about Dutch genre and the rococo, and became increasingly so as his career progressed. Contemporary critics Auguste Jal and Gustave Planche both described the style of his figure subjects as a hybrid of Bonington and Watteau. The lapse into executive and narrative vacuity, which Delécluze had predicted would be an inevitable consequence of the romantics' reversion to pre-Davidian models, became a problem for artists like Roqueplan, Lami, and Isabey with the serious critics, although their popularity as illustrators remained relatively undiminished. Possibly because of his friendship with Roqueplan and his brother Nestor, Gautier was more generous than most in his assessment of Roqueplan's achievement, and in a passage that he might just as easily have applied to Bonington, he dismissed the reservations of the "juste milieu":

When every romantic wanted to be formidable, gigantic, prodigious, he was content to be charming. Here was his originality He was a painter above all else, in the strict sense of the term: his interest did not consist of this or that anecdote, more or less adroitly illustrated, but rather in the grace of the composition, the harmony of the colors, the strength of the execution. He made art for the sake of art.[1]

1. Théophile Gautier, *Histoire du Romantisme*, 2nd ed. (Paris, 1874), 192ff.

ANNE OF AUSTRIA AND MAZARIN 1826
Oil on canvas, 13¾ × 10½ in. (35 × 26.7 cm)

Inscribed: Signed and dated, lower right:
R P Bonington 1826

Provenance: L.-J.-A. Coutan, and by descent to
Mme Milliet; Milliet, Schubert, Hauguet
Donation, 1883.

Exhibitions: Nottingham 1965, no. 297, pl. 50.

References: Shirley, 116, pl. 148.

Musée du Louvre, Département des Peintures
(RF 369)

The picture was probably commissioned by its
first recorded owner, Bonington's patron
Coutan. The subject may recount an episode
from Madame de Motteville's *Memoires pour
servir à l'histoire d'Anne d'Autriche* (Paris, 1723)
or Jean Ruget de la Serre's *L'Histoire et les
portraits des Imperatrices, des Illustrées Princesses
de l'Auguste Maison Autriche* (Paris, 1648), but
it is not immediately intelligible. Primarily,
Bonington's intention was a poignant
illustration of the overlapping private and
public lives of Anne of Austria (1601–1661)
and Jules Cardinal Mazarin (1602–1661).
The latter's complete domination of the
French throne from the Regency onward is
unequivocally evoked in the pictorial
construction by his voluminous presence, the
gestures of his flustered queen, and the
tenebrous existence permitted the monarch,
Louis XIV, in the background.[1]

Several graphite drawings after engravings
from de la Serre furnished the information for
Anne's wardrobe and probably her features,[2]
although Bonington seems also to have
improvised the likeness from a Rubens half-
length portrait (Louvre), even though it was
thought at the time to represent the queen's
sister-in-law, Isabelle de Bourbon. The
cardinal's features are based on engraved
portraits, but his pose and robes, generally and
erroneously considered to derive from Philippe
de Champaigne's *Portrait of Cardinal Richelieu*
(Louvre), are close replicas of those of Cardinal
de la Valette in the seventeenth episode of
Rubens's Medici series, *The Reconciliation of
Marie de' Medici and Louis XIII*.

All previous commentators have misread the
inscribed date as 1828. The final digit is a
cursive six, and the earlier dating makes more
sense of the obvious stylistic and thematic
affinities between this oil and such pictures as
A Knight and Page (no. 112) or *The Prayer*
(fig. 67), which has the same dimensions and
should be considered a pendant illustration to
the queen's life. The religious and monarchal
furnishings in *The Prayer* encourage
identification of the figures with the young
Louis XIV and his mother, who was celebrated
for her beautiful, clear skin, her superbly
delicate hands, and her unremitting devotion to
her maternal duties and her Catholic faith.[3]
Although not a striking resemblance, the
features of this lady are not incompatible with
those of the younger queen consort as she
appears in the thirteenth panel of the Medici
gallery, *The Exchange of the Two Princesses*. Finally,
since Anne was the sister of Philip IV of Spain,
it may not be coincidental that on the sheet of
pen studies for *The Prayer*, now at Edinburgh,[4]
Bonington also sketched the only Velázquez
oil then in the Louvre, *Portrait of the Infanta
Marguerite*, which was originally in the
collection of Louis XIV.

Bonington's concern for later seventeenth-
century French history was a logical extension
of his, and his patrons', interest in the
propaganda of the Bourbon Restoration. A more
immediate inducement to explore the personal
lives of Louis XIII's family might have been the
publication, and instant notoriety, of Alfred de
Vigny's *Cinq-Mars*, which appeared in March
1826 and was defended by Hugo in *Le Quotidien*
on 30 July. As de Vigny himself acknowledged,
it was a historical novel indebted to Walter
Scott, although its principal character was, in
his fatal opposition to Cardinal Richelieu
and his impetuous idealism, more of a Count
Egmont than a Quentin Durward. In its
profuse descriptive details and its dramatic
characterization, *Cinq Mars* was precisely the
type of modern romance for which Bonington
was known to harbor an irrepressible curiosity.[5]

1. No previous effort has been made to identify the two
male figures in the background. The figure posed
frontally, however, wears a diagonal blue sash generally
associated with the monarchy.
2. Nottingham 1965, nos. 118–19.
3. First proposed by Ingamells, *Catalogue* 1: 20–21.
4. National Gallery of Scotland; reproduced by
Cormack, *Review*, pl. 40.
5. J.-N. Robert-Fleury, a fellow pupil under Gros,
painted two watercolor illustrations to *Cinq-Mars* in
1830 (Wallace Collection). Paul Delaroche also
illustrated the novel in watercolors (1826; Louvre) and
in oils (1829; Wallace Collection). The oil was painted
for Bonington's patron Comte de Portales-Gorgier.

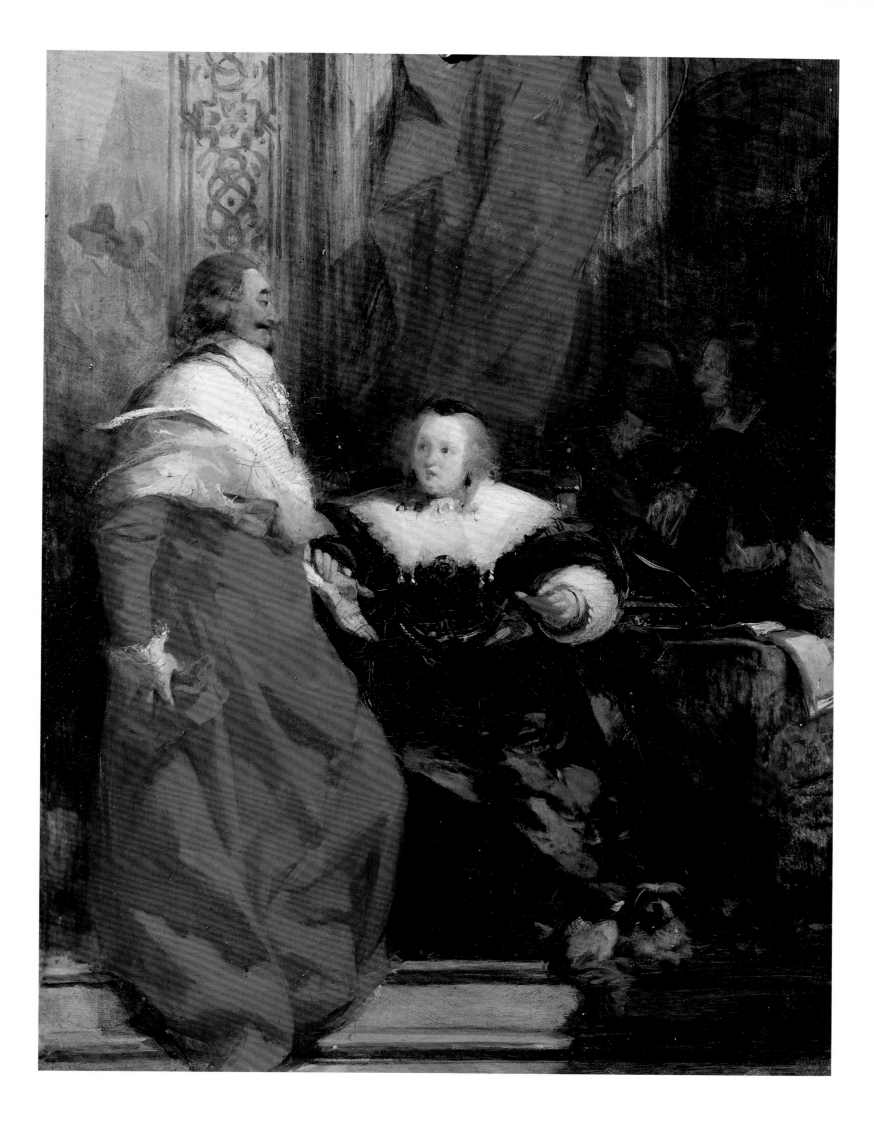

119

COAST OF PICARDY, NEAR ST-VALERY-
SUR-SOMME ca.1826
Oil on canvas, $26\frac{1}{8} \times 39$ in. (66.2 × 99 cm.)

Inscribed: Signed, lower right: *R P Bonington*

Provenance: Possibly Sir Henry Webb (Paris,
23–24 May 1837, lot 3, as *Le port de Saint-Valery
(Somme), bateaux pecheurs sur le rivage*); possibly
Thomas Woolner, 1872; T. Horrocks Miller, by
1889, and by descent to Thomas Pitt Miller
(Christie's, 26 April 1946, lot 8, bought Tooth
for the Ferens Art Gallery).

Exhibitions: Nottingham 1965, no. 267, pl. 31.

References: Cf. Dubuisson and Hughes,
pl. opp. 56.

Ferens Art Gallery, Hull City Museums and
Art Galleries

This picture dates to after Italy and is of
identical dimensions to *On the Côte d'Opale,
Picardy* (no. 120). Dubuisson and Hughes
reproduced two oil sketches they attributed to
Bonington and considered preparatory to this
canvas. Related watercolor (Earl of Swinton)
and graphite (Bacon Collection) sketches are
similarly ascribed, although a second watercolor
version has been attributed to Isabey.[1] This
last drawing appears to replicate one of the oil
sketches, and since these can no longer be
traced, the question of their authorship remains
open. In all likelihood, Bonington and Isabey
both sketched the view, of which this is a more
elaborate studio version, while touring the coast
immediately after their return from London in
fall 1825.[2]

The precisely articulated buildings of
Bonington's oil are similar to those in
lithographic souvenirs of St-Valery-sur-Somme
by both Isabey and Paul Huet[3] and in
Bonington's own rendering of the interior of
that port for d'Osterwald's *Excursions sur les côtes
et dans les ports* (fig. 14). A Thomas Shotter Boys
watercolor inscribed *St. Valery* (Fitzwilliam
Museum) shows the same village from closer in,
as does a Bonington graphite sketch inscribed
Ferté (Ottawa). In the 1820s La Ferté was a
small fishing port a few kilometers southeast of
St-Valery-sur-Somme. On the evidence of these
inscribed sheets, it is possible to identify this
site as the estuary of the Somme. This broad
stretch of tidal coast, so compatible with
Bonington's compositional interests, was
probably his most frequented haunt.

1. D. Messum 1980, pl. 10.
2. The oils reproduced by Dubuisson and Hughes were
in the collection of Rivet's descendents. It should be
noted also that lot 1 of the 1829 studio sale was an oil
sketch *Coast scene St Valerie* (bought Roberts) and lot 118
was another oil sketch *Coast scene, view of la Ferté, with
figures* (bought Knapp).
3. Delteil, *Huet*, no. 67, and Miquel, *Isabey*, no. 879.

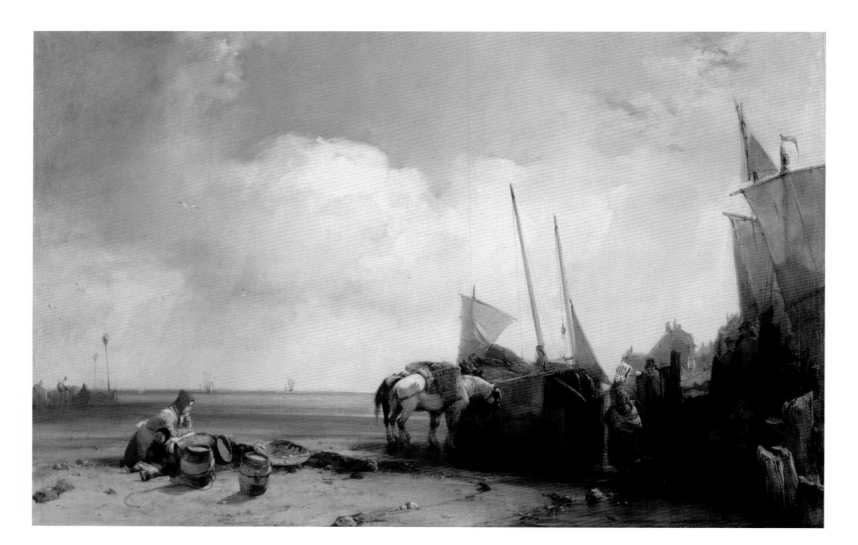

120

ON THE COTE D'OPALE, PICARDY ca.1826–27
Oil on canvas, 26⅛ × 39 in. (66.2 × 99 cm.)

Inscribed: Signed, lower right: *R P Bonington*

Provenance: Commissioned by the 6th Duke of
Bedford; by descent to the Marquess of
Tavistock.

Exhibitions: Probably London, Royal Academy,
May 1827, no. 373, as *Scene on the French Coast*;
possibly London, Cosmorama Rooms, 209
Regent Street, 1834, no. 47; Nottingham 1965,
no. 266, pl. 32; Washington, DC, National
Gallery of Art, *The Treasure Houses of Britain*,
1985, no. 548.

References: Waagen 1854–57, 4: 332.

The Marquess of Tavistock and Trustees of the
Bedford Estate

On the Côte d'Opale is one of the most
resplendent of Bonington's later coastal views.
The spatial organization of his first marine oils
generally relied on sweeping applications in the
sky, sea, and beach of a few close-toned hues in
a high key. In those, the illusion of atmosphere
was accentuated by the foreground juxtaposition
of prominent objects or figures, set off from the
landscape either by their own mass and lucid
shadows or, less circumspectly, by morsels of
bright primary colors, of which red is the most
recurrent. This system was an intuitive
adaptation of pure-watercolor technique, in
which the whiteness of the underlying paper
dictates the color value of the whole. Following
his initial contact with Turner's art, areas of
contrasting cool and warm colors begin to break
up what were formerly broader passages of a
single hue, although this "inversion of keys" is
not as pronounced nor as resonant as in
Turner's practice until the very last months of
the artist's life. The perspectival system of *On
the Côte d'Opale* is even more reflective and
introduces the traditional oil painter's method
of alternating horizontal bands of sharply
distinct light and shade. The diffuse radiance of
a space saturated with natural sunlight is
preserved, while that space is now more
dramatically defined below the horizon line.
The confidence gained from Bonington's study
of figure subjects in 1826 makes itself apparent
in the grouping of the foreground children.
Their shading is less transparent, and hence
flatter, but an impression of breadth is assured

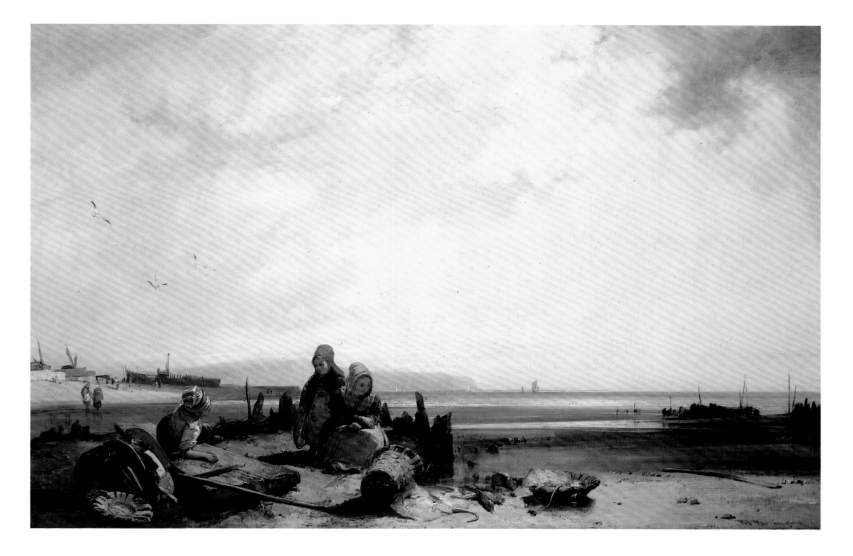

— as it is in the paintings of Cuyp and Claude, whom Bonington was now interpreting with ever more cogent enthusiasm — by a sharpness and clarity in the most proximate colors and a more generous touch in the modeling of forms.

The watercolorist William Wyld, who studied with Francia while attached to the British consulate at Calais in the mid-1820s and who was a friend of Bonington's most important Anglo-French patron, Lewis Brown, late in his life recollected that when he saw his first Bonington oil at the Royal Academy in spring 1827, "It struck me as a great revelation of beautiful truth by the side of the Callcotts, the Turners and other splendid conventionalities The picture had been painted for an English nobleman, and was lithographed by J. D. Harding."[1] If Wyld's memory was accurate, the picture exhibited in London in 1827 as *Scene on the French Coast* could only have been one of two oils commissioned or acquired directly from the artist by the 6th Duke of Bedford when he was residing in Paris in 1825–26 — the present picture and *On the Coast of Picardy* (Wallace Collection).

In a letter of 28 February 1826 to Lord Holland, his librarian Dr. Allen passed on the advice of Augustus Wall Callcott that he and the Duke of Bedford "go to the atelier of an English artist at Paris, a Mr. Bonington — in the Rue Mauvais he thinks — who is making a great deal of money there by small landscapes, I think which are in great request among the Parisians and from those Callcott has seen possess in his opinion great merit."[2] Since Bonington left Paris for Italy the first week in April and did not return until after the duke had departed in June, it is somewhat unlikely that he executed both paintings in the few weeks before his departure. A more plausible reconstruction of events would be that Bedford purchased from stock the picture now in the Wallace Collection, which is inscribed on the stretcher "Bonnington Paris 1826," and commissioned *On the Côte d'Opale*, which Bonington painted after the Italian trip and before his second visit to London in spring 1827. Several reasons for preferring to identify *On the Côte d'Opale* with the Royal Academy exhibit are its larger size, the presence of a full signature, and the number of contemporary copies of the composition.[3] For his more important English commissions and exhibition pictures, Bonington began to sign his canvases prominently. This was, of course, a method of self-promotion among his rapidly expanding network of patrician clients, but it also prevented confusion of his works with those of other marine painters like William Collins and Callcott, who favored similar compositions.

Anonymous copies of the picture are frequently identified as "near Dieppe," but this is topographically impossible. The sites of both Bedford pictures are almost certainly small estuary villages on the coast between Calais and Boulogne.

1. Quoted in P. G. Hamerton, "A Sketchbook by Bonington in the British Museum," *Portfolio* (1881).
2. Quoted in *The Treasure Houses of Great Britain* (Washington, DC: National Gallery of Art, 1985), no. 548; the original letter is in the British Library, Holland House Mss 52173,856. Callcott had undoubtedly admired the two pictures then on view at the British Institution (see no. 49).
3. In addition to the Harding lithograph (*Works*, 1830), an engraving by C. G. Lewis was published 1 May 1835. An oil copy based on this engraving has frequently been cited as a preliminary study: BFAC 1937, no. 47; Agnew's 1962, no. 23. Two other oil copies with the same dimensions are recorded in a private collection and at Sotheby's, 22 July 1981, lot 128. Finally, a watercolor version in the Tate Gallery, although of the highest professional quality, is probably not autograph.

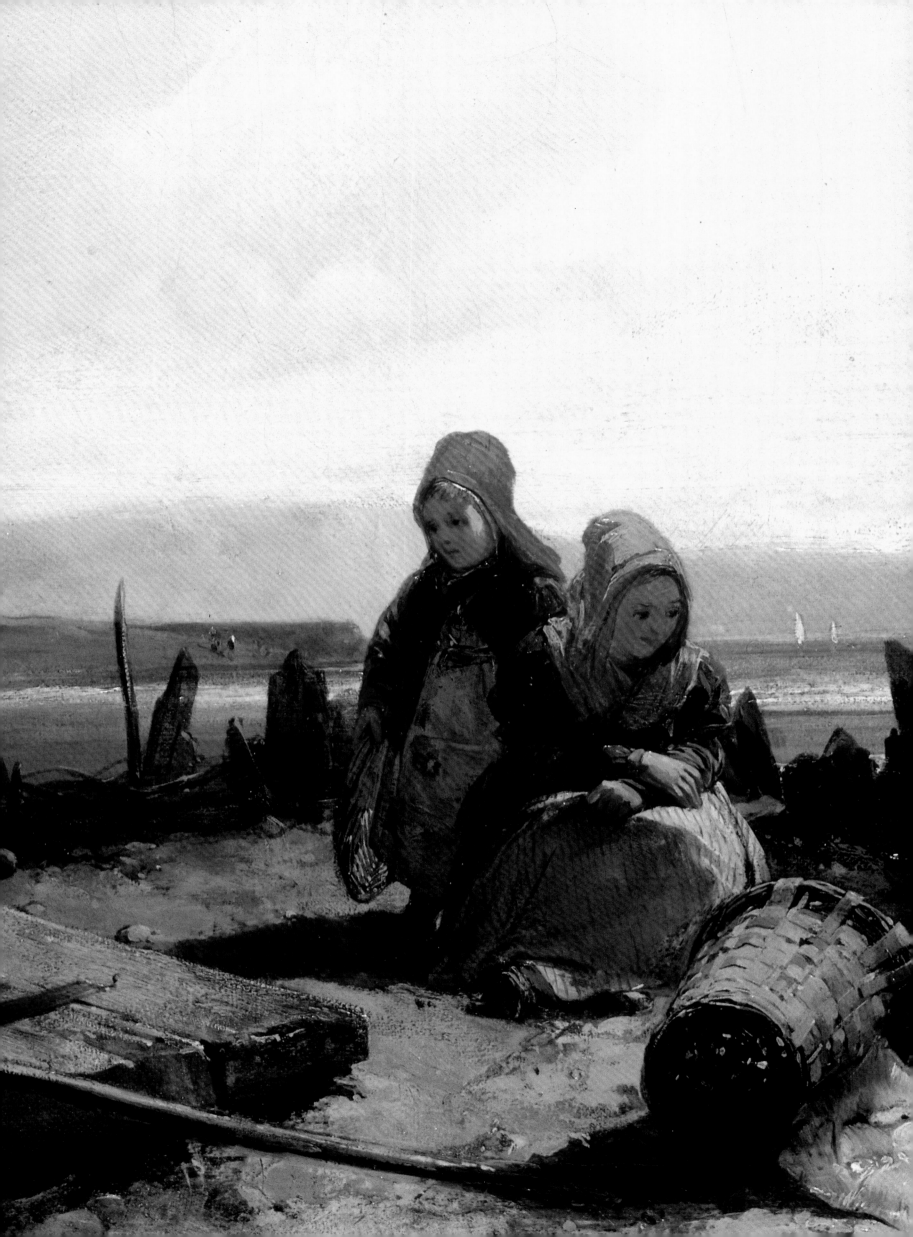

I 2 I

THE LUTE LESSON ca.1826–27
Oil on millboard, 13⅛ × 10¼ in. (35.7 × 26.1 cm.)

Inscribed: Paper etiquette, verso: *René Beauboeuf Doreur*

Provenance: Baron Charles Rivet, and by descent to the present owner.

Exhibitions: BFAC 1937, no. 28.

References: Charles Damour, *Oeuvres inédités de Bonington* (Paris, 1852), repr. as an aquatint; Dubuisson and Hughes, repr. opp. 77; Shirley, 116, pl. 141.

Private Collection

Bonington painted this troubadour subject for Charles Rivet, either as a commission or as a token of their friendship and mutual interests. Like Bonington, Rivet was passionate for the Venetians masters, especially after the trip to Italy. In an observation that recalls Hazlitt's remark about Raphael's color being "brick dust" in comparison to Titian's, Rivet wrote at Ferrara, "I hardly like to admit that Raphael looks to me all brick color, I have been spoiled by the Venetian school."[1] In its coloring and details, *The Lute Lesson* is close in date to *Evening in Venice* (fig. 66) and Delacroix's *Faust and Mephistopheles* (ca.1826–27; Wallace Collection), either of which would also have gratified Rivet's maturing tastes.

It was customary for artists of the period to borrow figures, particularly from the old master paintings they most admired. In this instance, the young man derives from the lutenist in the Titian/Giorgione *Concert Champêtre* (Louvre). Bonington's apparent addiction to this practice prompted Delacroix to recall much later to Thoré:

One saw in his works figures borrowed almost without alteration from paintings that everyone knew well, and this scarcely concerned him. This practice in no way diminished their merits; those details taken from the life, so to speak, and which he appropriated as his own (this was especially true of costumes), enhanced the air of versimilitude of his historical characters and never smacked of pastiche.[2]

Thoré further defended Bonington's practice by observing that "a scene by Molière is no less perfect for its having been lifted from Rabelais."[3]

If the picture has an illustrative purpose, the literary or historical source is not immediately obvious. Given Bonington's interest in the generic troubadour theme of seranading lovers, a specific text may not actually exist. No other versions of the composition are known, although several untraced drawings in the studio sales might have been preparatory studies.[4] A watercolor copy was made by Auguste in 1829.[5]

1. Dubuisson and Hughes, 77.
2. Delacroix, *Correspondence* 4: 287.
3. Thoré, 1867, 3, and 6 n.1. Baudelaire similarly defended Manet, when the latter was accused of painting pastiches of Velázquez.
4. Bonington sale 1834, lot 47, a chalk study for "a figure in the picture The Lute"; and 1838 sale, lot 35, a sepia study for the composition.
5. Rosenthal, *Auguste*, no. I–30.

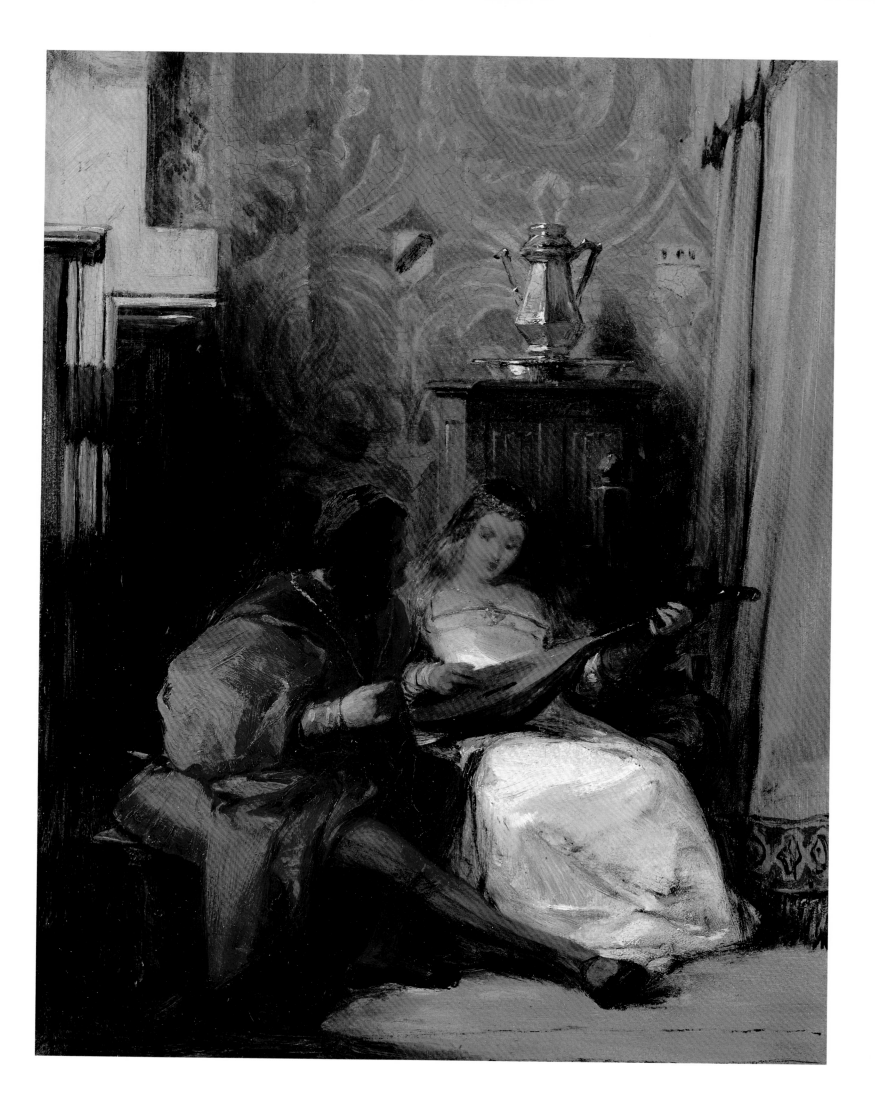

FIGURE STUDIES ca.1826–27
Pen and brown ink over graphite on two
separate sheets; verso of no. 1857-2-28-138:
graphite studies of two heads, $7\frac{5}{8} \times 4\frac{7}{8}$ in.
(19.4 × 12.5 cm.) and $7\frac{1}{4} \times 8\frac{1}{2}$ in.
(18.5 × 21.7 cm.)

Provenance: Both sheets: possibly Bonington sale,
1834, lot 24, *Seven sketches of figures in pen and ink*;
or 1838 sale, lot 9, *Studies of figures, pen and ink,
spirited*, bought Colnaghi; E. V. Utterson
(Christie's, 24 February 1857, lot 381, bought
British Museum).

Exhibitions: Nottingham 1965, nos. 178 and 170.

Trustees of the British Museum
(1857-2-28-166, 138)

Marion Spencer identified the sheet on the right as sketches of dancing couples drawn with the walnut juice with which Bonington was experimenting in 1828. Without analyzing the chemistry of the ink, it is possible to date this study to ca.1826–27. The two variant arrangements of the couple correspond to the poses of the principal promenading figures in the oil *Evening in Venice* (fig. 66) and its watercolor version (no. 123). The two subsidiary sketches of a stooping female are certainly additional pose studies for the figure in the watercolor, and they are also similar, in reverse, to the pose used in 1827 for the lost version of the oil *François Ier and Marguerite of Navarre*.[1] The second sheet presents studies of a dancer (Eugènie Dalton?) that anticipate the much reduced aerial figures in Bonington's illustration to Béranger's *La Sylphide* (no. 159).

The graphite sketches on the verso of the right sheet reproduce the torsos of figures in Lippo Memmi's fresco *The Conversion of St. Rainier* in the Campo Santo at Pisa, where Bonington and Rivet may have visited in July 1826. That they were actually drawn in Italy is uncertain, since Delacroix copied these and other figures from the set of engravings *Peintres à fresques du Campo Santo de Pise, dessinées par Joseph Rossi et gravées par Prof. J. P. Lasinio fils* (Paris, 1822).[2] The Delacroix copies appear in a sketchbook with other studies for *Greece on the Ruins of Missolonghi*, which was begun and finished between May and June 1826.

1. Reproduced in Thoré 1867, 3. The immediate pose study for the figure of Marguerite is a graphite drawing of a woman in nineteenth-century costume (Private Collection).
2. Sérullaz, *Delacroix*, nos. 1749–50.

The composition is a variant of that in an oil painting most frequently described as *Evening in Venice* (fig. 66). The two treatments differ primarily in the stances of the foremost female figure and in minor details of raiment and architecture. Pen and ink studies for both figure arrangements exist on one sheet (no. 122). The rich Venetian coloring, which Bonington progressively exploited with greater assurance after his Italian trip and which is more apparent in the oil than in this considerably faded watercolor, suggests a date for both versions in the first months of 1827. Bonington's predilection in 1826–27 for groupings of genteel couples admits no discernable program, but the possibility that the watercolor and its oil repetition are reworkings, in a more Italianate tone, of his earlier illustration to *The Merchant of Venice* (no. 109) cannot be discounted.

In developing the oil version, Bonington typically plundered a miscellany of readily accessible sources for picturesque details. The brocade dress and hair fillet worn by the lady in the foreground are Italo-Flemish and probably derive from the figure of a servant girl in Gérard David's *Marriage at Cana* (ca. 1508; Louvre).

The doublet of the young page is a slightly blousey version of that worn by a page in the same David picture, while his curious pose is a deliberately inelegant adaptation from a figure in Ingres's celebrated *François Ier at the Deathbed of Leonardo* (Salon 1824; Petit Palais). Graced by a conspicuous diamond fillet, the head of the second woman is a derivation from Leonardo's *La Belle Ferronnière* (Louvre). The habit of the male courtier incorporates features from several sources, including the costume of an Italian warrior in the Meyrick collection, copied in London by both Bonington (no. 38) and Delacroix,[1] and Raphael's *Self-Portrait with a Friend* (Louvre), which Bonington also sketched (Nottingham). The gesture of the unidentified person in the Raphael is, although perhaps only coincidentally, identical to that of Bonington's young man in the watercolor version. For the courtier's head, Bonington borrowed, with significant alterations to the face, from Cariani's *Portrait of Gentile and Jacopo Bellini* (Louvre), or from Delacroix's life-size oil replica of this particular head.[2]

The earliest recorded owner of this watercolor, M. Valedau, was a Parisian stockbroker who collected over five hundred oils and watercolors by French and English artists of the period. He donated the majority of these works to the Musée Fabre.

1. Sérullaz, *Delacroix*, no. 1468.
2. According to Lee Johnson (*Delacroix* 1, no. 13), Delacroix painted his copy as a preparatory exercise for *Execution of Doge Marino Faliero* (completed April 1826). Delacroix, for his part, may have relied on Bonington's sources for the costumes of two Venetian figures in the watercolors *Seated Page with Lute* (ca. 1826–27) and *Page in a Landscape* (ca. 1827) (Sérullaz, *Delacroix*, nos. 557 and 559), and for the costumes in certain of his *Faust* lithographs. One should also note that a *Seigneur Venetian* included in Delacroix's studio sale and described by Robaut (no. 273) as "very like Bonington" appears from Robaut's tracing to be similar in pose and costume to the figure in the Musée Fabre watercolor. An untraced Bonington watercolor of a "costume after Bellini" was in the 1829 studio sale, lot 98.

123

EVENING IN VENICE ca. 1827
Watercolor and bodycolor, $6\frac{11}{16} \times 5\frac{1}{8}$ in. (17 × 13 cm.)

Inscribed: False signature, lower left: *R P Bonington*

Provenance: Probably acquired from the artist by Valedau, by whom given to the Musée Fabre in 1836.

Musée Fabre, Montpellier (836.4.182)

124

VENETIAN BALCONY ca.1826–27
Watercolor and bodycolor, $6\frac{1}{2} \times 4\frac{1}{2}$ in.
(16.5 × 11.4 cm.)

Inscribed: Watermark: *J Whatman*

Provenance: Possibly Lewis Brown (Paris, 17
April 1837, lot 72, bought M. de Saint-Remi);
A. Stevens, by 1853; James Orrock, by whom
given to the Glasgow Museum in 1892.

Exhibitions: Paris, Société des Arts, 1860; BFAC
1937, no. 84; Nottingham 1965, no. 243, pl. 21.

References: *Les Artistes anciens et modernes* 2 (1853)
repr. as a lithograph, in reverse, by Mouilleron;
T. Gautier, "Exposition de 1860," *Gazette des
Beaux-Arts* (1860): 321–22, repr. as a wood
engraving; P. Burty, "Le gravure au Salon de
1870," *Gazette des Beaux-Arts* (August 1870):
135, repr. as a wood engraving; Mantz,
Bonington, 288, repr. as a wood engraving;
Shirley, 117, pl. 117.

Glasgow Museum and Art Gallery

The figures wear sixteenth-century costumes
comparable to those in the watercolor *Evening
in Venice* (no. 123) and the oil *François Ier and
the Duchesse d'Etampes* (no. 138). The graphite
underdrawing reveals radical design alterations
to the basilica of San Marco and the boy's
left leg.

A mezzotint by Quilley after a lost oil
version[1] and the three reproductive prints after
this watercolor, cited above, attest to the
popularity of the image throughout the
nineteenth century. Two anonymous watercolor
copies, sometimes attributed to Bonington, are
in the Lady Lever Art Gallery and the Fogg Art
Museum. It may be that one or both of these
were painted by Lewis Brown, who was known
to have been an expert copyist of Bonington's
watercolors.

1. Bonington sale 1829, lot 108.

THE CASTELBARCO TOMB, VERONA 1827
Watercolor and bodycolor over graphite,
$7\frac{1}{2} \times 5\frac{1}{4}$ in. (19.1 × 13.3 cm.)

Inscribed: Signed and dated, lower left:
R P B 1827

Provenance: W. A. Coats, by 1926, and by
descent to Maj. J. Coats (Christie's, 12 April
1935, lot 3, bought Turner); Percy Moore
Turner to 1953; Fine Arts Society, from whom
purchased by the Castle Museum in 1953.
Exhibitions: BFAC 1937, no. 110; Nottingham
1965, no. 223.

References: Dubuisson and Hughes, repr. opp. 75;
Shirley, 67, 114, pl. 131.

Castle Museum and Art Gallery,
Nottingham (53-22)

Bonington had spent much of his brief sojourn
at Verona in April 1826 sketching the dynastic
Gothic monuments of Can Grande della Scala
and his fratricidal successors, in particular that
of Can Signorio (d. 1375). In Antoine Valery's
opinion, "The tombs of the magnificent lords of
Verona, a species of long Gothic pyramid . . . are
some of the most curious monuments of the
town, but these old tombs in open air, are in a
situation too noisy and confined."[1] At some
remove from their site on the busy Piazza dei
Signori was the less ostentatious marble
sarcophogus of Count Gugliemo da Castlebarco,
perched above an archway next to the church
of S. Anastasia. A cautious friend of the fierce
Scaligari, Castelbarco contributed most of
the funds for the construction of that church
(begun 1261).
 A graphite sketch for this watercolor and the
most spectacular of the other tomb studies
are at Bowood (fig. 44).

1. Valery, *Voyages*, 105–6.

126

PIAZZA DELL'ERBE, VERONA ca.1827
Watercolor over graphite, $8\frac{1}{2} \times 10\frac{1}{2}$ in.
$(21.5 \times 26.5$ cm.)

Provenance: Possibly Lewis Brown (Paris, 17 April 1837, lot 95, *Vue d'un marché à Vérone; dessin garni d'un grande nombre de petites figures spirituellement touchées*, and again (Paris, 12–13 March 1838); Anonymous (Hodgsons, 20 June 1952, lot 575, bought Paul Oppé).

Exhibitions: Nottingham 1965, no. 218.

Private Collection

For the *officienado* of the picturesque, medieval Verona offered a surfeit of arresting visual material and a history steeped in literary associations. As one tourist mused, "Shakespeare and Dante seem to meet at Verona, the one through his works, the other through his misfortunes, and the imagination delights here in bringing together these two great geniuses, so tremendous, so creative and perhaps the most astonishing of modern literature."[1]

Of the Palazzo dell'Erbe, the principal market square, Théophile Gautier would later observe:

The houses covered with frescoes by Paolo Abasini, with their projecting balconies, their sculptured ornament, their robust columns, have a most romanesque appearance. Pillars with intricate capitals give the finishing touch to this square, which is full of admirable subjects for watercolor painters and decorators. It is the most animated part of the city; women are seen at every window, on every doorstep, and the crowd swarms between the stalls.[2]

The entire height of the tower to the left of the Casa Maffei has been scraped out and repainted, and it is evident that Bonington, disatisfied with these corrections, left much of the rest of the watercolor unfinished. For a related graphite study and a view of the opposite side of the piazza by Samuel Prout, see nos. 88–89.

1. Valery, *Voyages*, 105.
2. Gautier, *Travels*, 40.

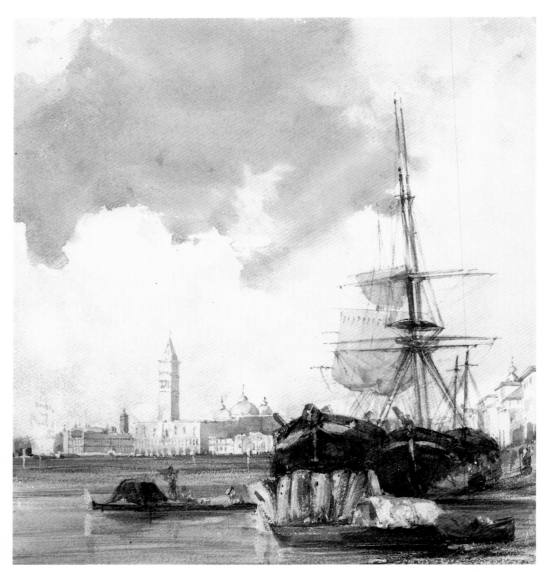

CHIESA DEI GESUATI, VENICE ca.1827
Watercolor over graphite, 11 × 7¾ in.
(28 × 19.7 cm.)

Inscribed: Signed, lower right: *RPB*

Provenance: W. B. Paterson, from whom
purchased by the Castle Museum in 1929.

Exhibitions: Nottingham 1965, no. 222, pl. 17.

References: Shirley, 114, pl. 131.

Castle Museum and Art Gallery,
Nottingham (29-40)

This superb outsized rendering captures the
strident geometric articulation of Giorgio
Massari's late-baroque I Gesuati as glimpsed
down the Calle d. Ponte. For the nineteenth-
century Gothicist, it was a church of no
architectural consequence. But Bonington's
apparent interest in representing the historical
continuity and the diversity of Venice's artistic
heritage was more inclusive. In this sense, he
was as much a tourist as an antiquarian and far
less pedantic than most later Victorians.

127

RIVA DEGLI SCHIAVONI, FROM NEAR
S. BIAGIO ca.1827
Watercolor and bodycolor over graphite,
7 × 6¾ in. (17.7 × 17 cm.)

Provenance: Possibly Bonington sale, 1838, lot 56;
Horatio G. Curtis; given to the Museum of Fine
Arts by Mrs. Horatio G. Curtis in 1927.

Museum of Fine Arts, Boston. Gift of
Mrs. Horatio Greenough Curtis in Memory
of Horatio Greenough Curtis (27.1331)

Finished watercolors of Italian subjects can bear
inscribed dates of 1826 or 1827. The earlier
sheets were possibly painted in Italy; those
dated 1827 are more numerous and were
probably executed on commission for clients
who chose their preferred compositions from
graphite studies. Between the two groups
of watercolors are discernable differences in
style that may assist in chronological placement
of undated works. The washes in the later
drawings, for instance, tend to be less
constrained, sometimes at the expense of
topographical accuracy. Their colors are also
more richly saturated, and, as in the later
watercolors of figure subjects, bodycolor and
gum arabic are in greater evidence. A later date
is proposed accordingly for this view of the San
Marco basin from the Arsenal *traghetto* at the far
end of the Riva degli Schiavoni.

129

VENICE 1827
Watercolor over graphite, $7\frac{1}{2} \times 9\frac{1}{2}$ in.
(19 × 24 cm.)

Inscribed: Signed, lower right:
RPB 1827[cropped]

Provenance: Richard Seymour-Conway,
4th Marquess of Hertford, to 1870; his son,
Sir Richard Wallace, to 1890; his widow, Lady
Wallace (d. 1897), by whom bequeathed to Sir
John Murray Scott (Christie's, 27 June 1913,
lot 1, bought Agnew's); J. T. Blair, from 1913,
by whom bequeathed to the Manchester City
Art Gallery in 1917.

Exhibitions: BFAC 1937, no. 111; Nottingham
1965, no. 220, pl. 15.

References: Dubuisson and Hughes, 202; Shirley,
66, 111, pl. 128; Cormack, *Review*.

Manchester City Art Gallery (1917.90)

A palace, prison, and tribunal, built in the most
elaborate Gothic style and housing many of
Venice's masterworks of civic art, the Ducal
Palace was, for Bonington's generation, a
doleful monument to the patriotism and the
aristocratic power of a bygone era. Conscious of
this interest, the artist was careful to record in
studies every possible view of the edifice. The
present watercolor, based on a large, detailed
graphite study at Bowood, shows the corner of
the treasury of San Marco, the Porta della
Carta, the Piazzetta facade, and the columns of
Saints Mark and Theodore.

Although Malcolm Cormack doubted the
attribution of this sheet, it is concordant in
style with the watercolors of Italian subjects
that Bonington was painting in Paris toward the
end of 1827. A second watercolor version
(Wallace Collection) is probably earlier in date
and is more faithful to the graphite study in
its composition, perspective, and delineation
of details. Graphite underdrawing in the
Manchester version reveals a precisely ruled
perspective system that is uncharacteristic of
the artist but not unparalleled in his last works.

This has resulted in a much less dramatic rise
of the northwest corner of the palace than is
discernable in the other versions. Persuant to
this adjustment, the Pilastri Acritani in the
foreground are also less exaggerated in scale.

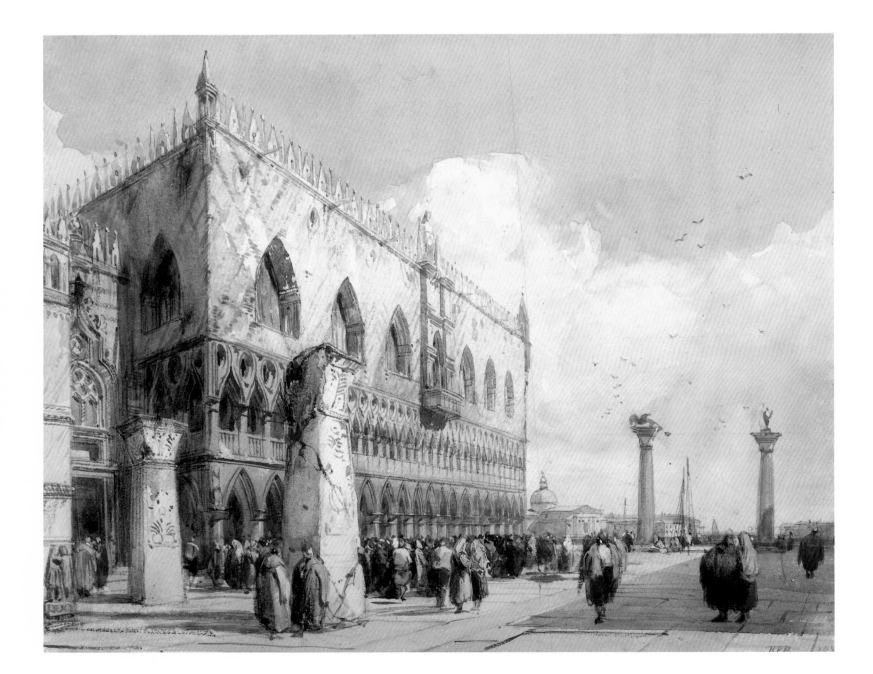

130

THE RIALTO, VENICE ca.1827
Watercolor and bodycolor over graphite, heavily
gummed, $6\frac{7}{8} \times 10\frac{3}{8}$ in. (17 x 26.4 cm.)

Provenance: Possibly Lewis Brown (Paris, 17
April 1837, lot 69); possibly J. Heugh
(Christie's, 24 April 1874, lot 44, bought in)
and again (Christie's, 10 May 1878, bought
Agnew's); Hollingsworth (Christie's, 11 March
1882, lot 53, bought McLean); H. de Zoete
(Christie's, 8 May 1885, lot 7, bought McLean);
E. V. Sturdy; Leggatt's, 1960, from whom
purchased by the present owner.

Private Collection

The Rialto bridge is here shown from the Ruga
degli Orefici near the Campo S. Giacomo di
Rialto, the central market square. Although
of interest in that it captures the mercantile
bustle for which the bridge was famous, this
perspective on the Ponte di Rialto was not
popular with later topographers of Venice.
A similar view, engraved by Samuel Prout,
could be based on this watercolor. A truncated
version by Bonington, lacking the left quarter
of the composition, is privately owned.

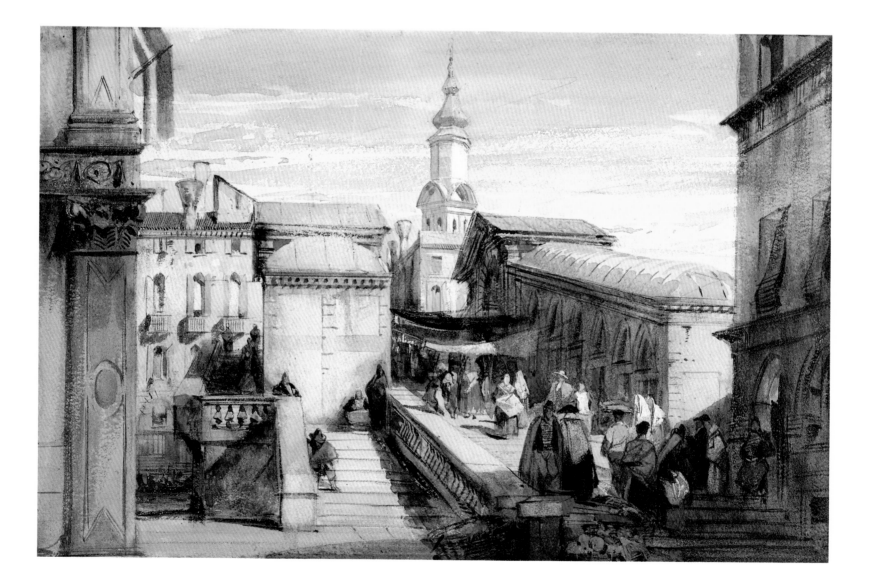

131

THE PIAZZETTA, VENICE 1827
Oil on canvas, $17\frac{1}{2} \times 14\frac{1}{2}$ in. (44.2 × 36.7 cm.)

Provenance: Acquired at the British Institution in 1828 by Robert Vernon, by whom donated to the National Gallery in 1847.

Exhibitions: London, British Institution, 1828, no. 198; London, Cosmorama Rooms, 209 Regent Street, 1834, no. 34.

References: *The London Weekly Review*, 23 February 1828, 124; *The Literary Gazette*, 22 March 1828, 186; *Book of Gems* (London, 1838), engraved by E. Finden; "The Vernon Gallery," *The Art Journal* ns 3 (1851): 192, engraved by J. B. Allen; J. Ruskin, *Pre-Raphaelitism* (London, 1851), 19.

The Tate Gallery

On 5 November 1827 Bonington wrote from Paris to the engraver W. B. Cooke requesting that he submit this picture to the British Institution. Presumably he painted it no later than early fall. The flat, horizontal bands of sky, the pronounced linear treatment of the architecture, and the cool tonality combine to give the oil a metallic cast, but the overall effect recalls certain Canaletto's, which could have been intentional, as such overtures would have appealed to the trustees of the British Institution. Allen Cunningham, who was not always so astute in his assessments, noted this affinity:

It cannot be denied that most of his Italian pictures are tinctured with his feeling for some of the great masters of the pencil. Instead of being contented with looking at what lay before himself, his desire was to borrow the eyes of Canaletto, or some other favorite of days gone by. All this gratified the connoisseur, but not those who judged from nature There is a painful precision about Canaletto — a disagreeable slavishness of fidelity Bonington had not the half of this minute precision, and yet he had too much; but his brilliant and poetical colouring threw a lustre over these mechanical over-accuracies.[1]

The British Institution opened on 4 February 1828. The most critical entry on Bonington's pictures appeared in *The London Weekly Review* on 23 February:

View of the Piazzetta near the Square of St. Mark at Venice. by R. P. Bonington. There are two paintings in this room by this talented artist. The other, the Ducal Palace at Venice, is by far the most spirited drawing in the exhibition. The Piazzetta is a small canvas, and the execution is miserably cold and meagre; but the palace is really beautiful: the deep blue sky, the Palladian architecture, and the scenic groups of characteristic figures in the foreground are all purely, uniquely Venetian.

In the only mention of Bonington in his voluminous critical writings John Ruskin criticized the artist as he defended the Pre-Raphaelites against the charge that their pictures were wanting in perspective. Ruskin referred his readers to Allen's engraving after this painting:

It was not a little curious, that in the very number of the Art Union which repeated this direct falsehood about the Pre-Raphaelite's rejection of "linear perspective" . . . the second plate given should have been of a picture of Bonington's — a professional landscape painter, observe — for the want of aerial perspective in which the Art Union itself was obliged to apologise, and in which the artist has committed nearly as many blunders in linear perspective as there are lines in the picture.

Ironically, it was Bonington's superb command of aerial perspective, of which neither this picture nor Allen's tepid engraving are exemplars, that generally obviated his disregard of mechanical perspective.

The on-site graphite study for the composition (no. 90) is far more accurate in its perspective. A thumbnail pen sketch of the columns, with Austrian soldiers, is in the National Gallery of Victoria, Melbourne. Numerous contemporary copies of varying quality are recorded, as are versions by Edward Pritchett.[2] Finally, an untraced Bonington watercolor of this description was in Lewis Brown's collection.[3]

1. Cunningham, *Lives*, 305–6.
2. Oil paintings in the National Gallery of Ireland and the Manchester City Art Gallery, for instance.
3. Brown sale (Paris, 1843, unnumbered lot, bought Veron).

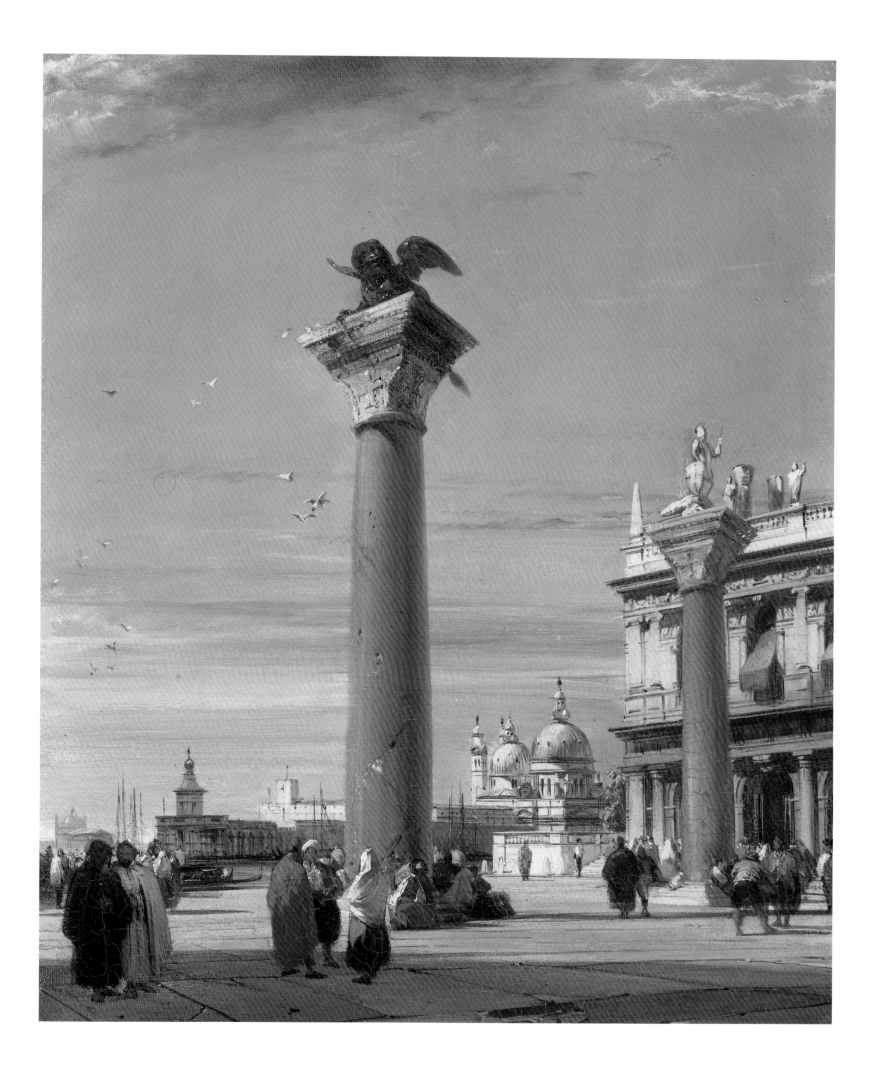

THE DOGE'S PALACE, VENICE, FROM THE RIVA
DEGLI SCHIAVONI ca.1827
Oil on canvas, 16⅛ × 21¼ in. (40.9 × 53.8 cm.)

Provenance: Probably commissioned from the
artist by L.-J.-A. Coutan; by descent to Mme
Milliet; Milliet, Schubert, Hauguet Donation,
1883.

Exhibitions: Nottingham 1965, no. 286,
incorrectly repr. as no. 283.

References: Shirley, 112, pl. 117.

Musée du Louvre, Département des Peintures
(RF 368)

This finished oil is a close replica of a graphite
study at Bowood (fig. 47), of which there is also
a watercolor version (Wallace Collection). A
cursory pen and ink sketch of the composition
(Louvre) was probably drawn for Coutan prior
to the commission. A similar view from further
east, which extends the facade of the prison on
the right and introduces S. Maria della Salute to
the left, formed the composition for a much
larger picture now in the Tate Gallery (fig. 46).
The Louvre version has been identified on

occasion as the oil exhibited by the artist during
the first installment of the 1827–28 Salon,
which opened on 4 November, and again at the
British Institution in February 1828; however,
the records of the works submitted to the Salon
jury indicate that the dimensions of Bonington's
entry, *Vue du palais ducal à Venise*, were 1.5 by 2
meters, or approximately the size of the Tate
version. Of that picture, Auguste Jal wrote:

*Bonington is a clever fellow His view of the
Ducal Palace in Venice is a masterpiece. I do love what
the Canaletti so justly extoll. Vivacity, firmness, effect,
color, breadth of touch, all are in this painting . . .
the figures are only sketched—but so grandly!—
I prefer this manner of figure drawing to Granet's.*[1]

Pentimenti at the right of the Louvre
painting indicate that the entire elevation of
the prison facade was substantially reduced in
scale. A wide band of canvas along the top edge,
now concealed by the frame, confirms that the
composition was originally to have
approximated more closely that of the Salon oil.
Also typical of all of Bonington's views of the
Ducal Palace is the absence of the Campanile
spire, which should be visible from this angle
but which the artist clearly considered
compositionally intrusive.

1. Jal, *Salon 1828*, 237.

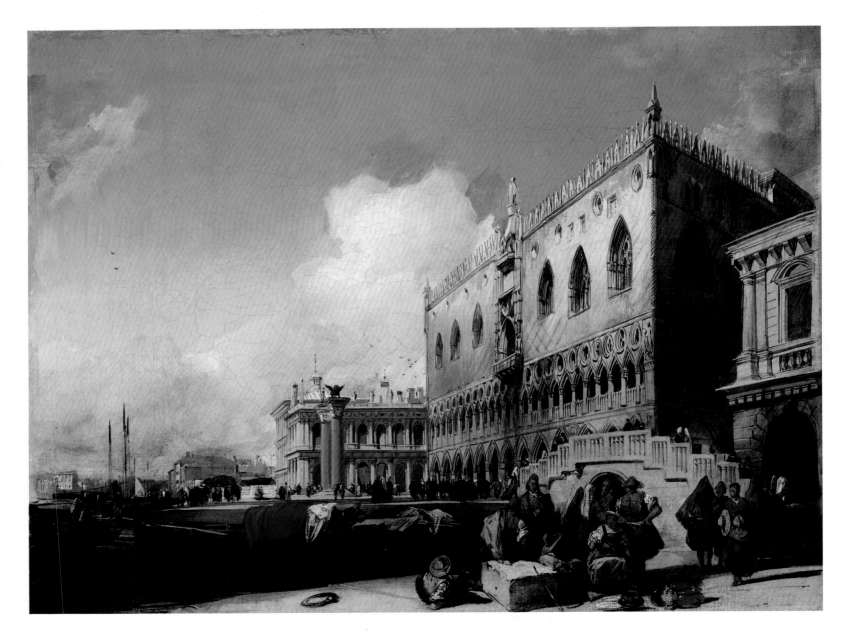

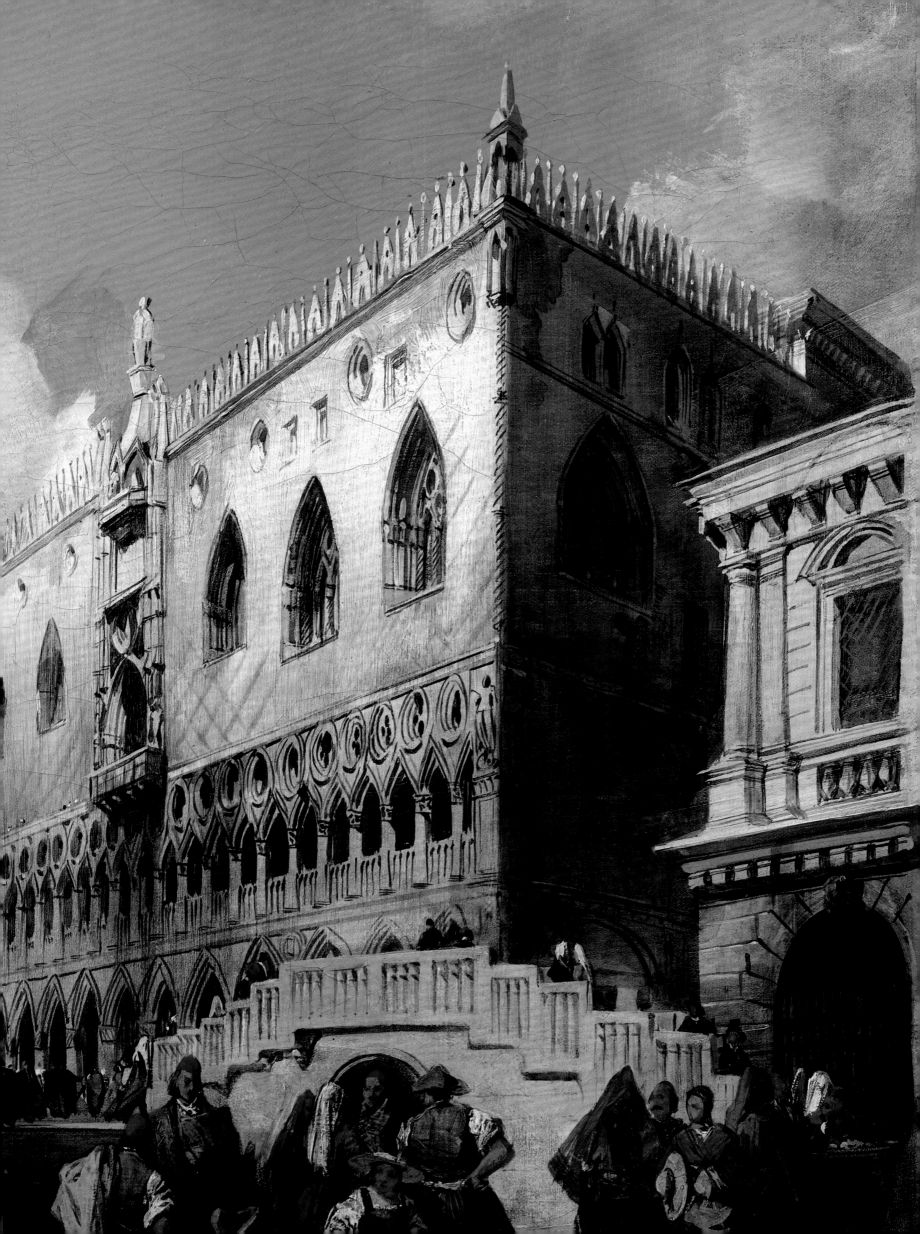

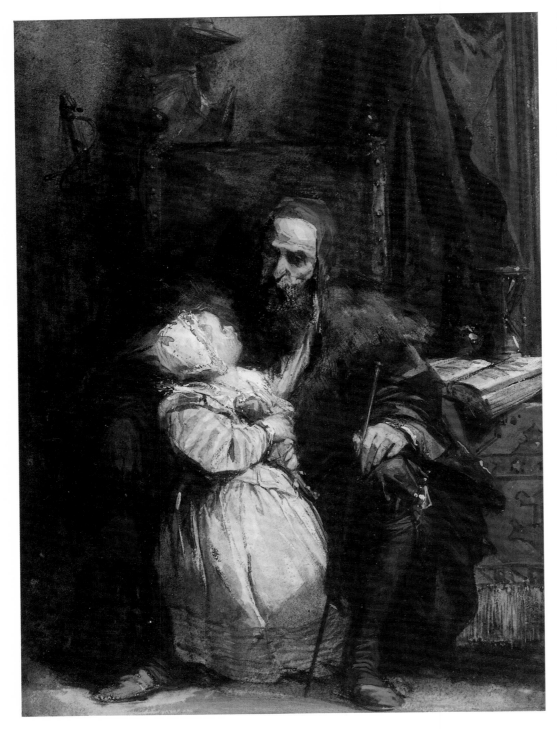

133

OLD MAN AND CHILD ca.1827
Watercolor and bodycolor, $7\frac{1}{2} \times 5\frac{1}{2}$ in.
(19 × 14 cm.)

Inscribed: Signed, lower right: *RPB*

Provenance: Commissioned by George Fennel
Robson for Mrs. George Haldimand (Christie's,
21 June 1861, bought Agnew's); Robert Clarke,
1883, and by descent (Christie's, 18 March
1980, lot 206, bought Reed for the present
owner).

References: Ingamells, *Catalogue* 1: 55.

Mr. and Mrs. Deane F. Johnson

As noted by John Ingamells, the girl's costume, which reappears in the contemporary oil *Henri IV and the Spanish Ambassador* (fig. 57), is probably derived from a costume engraving by Abraham Bosse (1602–1676). The ermine-lined cloak and the skull cap of the old man, who figures again in the watercolor called *The Antiquary* (fig. 53), are sixteenth-century Venetian in style. Following Marion Spencer, most commentators have identified the source for the old man's head in an engraving by Vosterman after Tintoretto's *Portrait of Doge Niccolo da Ponte*, which Bonington copied in graphite.[1] However, similarities in pose with engraved copies of Titian's *Self-Portrait* (Berlin) should also be mentioned, since that portrait was the source for the old man in Bonington's lost watercolor *The Message*, of which Delacroix made a lithograph in ca.1826,[2] and for Faust in the sepia study *Faust and Mephistopheles* of the same year. Delacroix's own watercolor copy of the Titian is on a sheet with other head studies after Titian's *Portrait of Philip II*.[3]

A nearly exact version of *An Old Man and Child*, dated 1827, is in the Wallace Collection. A third version, also painted in that year, was in the Montgermont sale.[4] For Bonington to replicate a composition three times in the same medium attests to both the contemporary appeal of subjects sentimentalizing the elderly and to the tremendous pressures on the artist to satisfy an ever-expanding list of commissions at this time. It is a tribute to Bonington's facility and professional integrity that no diminution in spontaneity and quality can be discerned between the versions of this delightful essay on life's contrasts.

In 1826 Mrs. George Haldimand, wife of a London financier, commissioned George Fennel Robson to assemble a collection of drawings. This watercolor was delivered to Robson in London on 2 June 1827 at a price of £15.15.[5] By 1828 Robson had gathered one hundred watercolors by virtually every British practitioner of the art. In the same year he officially represented the Society of Painters in Watercolours at Bonington's funeral.

1. Bowood; Nottingham 1965, no. 141.
2. Delteil, *Delacroix*, no. 52.
3. Sérullaz, *Delacroix*, no. 1432. Johnson (*Delacroix* 1, no. 112) connects these studies with preparatory work for *Marino Faliero*.
4. Paris, 16 June 1919 (Photo Witt Library).
5. The original receipt was BFAC 1937, no. 116.

EUGENE DELACROIX (1798–1863)

FRANÇOIS I^er AND THE DUCHESSE
D'ETAMPES ca.1827
Watercolor, bodycolor, and gum arabic over
graphite, $8\frac{7}{8} \times 6\frac{3}{8}$ in. (22.5 x 16.2 cm.)

Inscribed: Signed, lower right: *Eug Delacroix*

Provenance: Robert Caze (Paris, 30 April 1886);
Meta and Paul J. Sachs, by whom given to the
Fogg Art Museum.

Exhibitions: Toronto, *Delacroix*, no. 30.

References: Ingamells, *Catalogue* 1: 24; Johnson,
Delacroix 3, with no. 116a.

The Fogg Art Museum, Harvard University,
Bequest of Meta and Paul J. Sachs

Lee Johnson convincingly identified the female
in this watercolor as the king's mistress, Anne
de Pisseleu, Duchesse d'Etampes, by arguing
that the removal of the king's necklace was an
oblique reference to her elevation to the rank of
duchess upon her marriage in 1536 to Jean de
Brosse. Robaut had previously dated the work
ca.1827, although Johnson, noting the similarity
of the pose below the waist between the
duchess and the allegorical figure in *Greece on the
Ruins of Missolonghi* (1826), suggested a date of
1826/7. For several equally compelling reasons,
one is inclined to retain Robaut's later date.

In its scale and technical sophistication,
Delacroix's drawing most closely parallels
Bonington's watercolors of 1827, while its
composition recalls Bonington's oil *François Ier
and Marguerite of Navarre* (fig. 55) in which
the monarch, with comparable narrative
significance, toys with his collier. A possible
source for the duchess's gesture could have been
Henri-Joseph Fradelle's engraved illustration to
Kenilworth (see no. 141), which was issued in
Paris in 1827. The king's pose has affinities to
La Balafré's in Delacroix's oil *La Balafré Giving
His Chain to Quentin Durward*, which was
commissioned by the duchesse de Berry
ca.1827-28. Both the king and his mistress are
the subject of Bonington's oil of this date (no.
138). And finally, the costumes in Delacroix's
watercolor, and indeed the consciously
distorted pose of the duchess, are too
reminiscent of the *Faust* illustrations
(fig. 64) of mid-to-late 1827-to be entirely
coincidental.[1] The same might be observed of
Delacroix's watercolor *Paolo and Francesca*
(Private Collection), which is often misdated
ca.1825.[2]

Delacroix painted a surprising number of
small troubadour pictures in oil from 1824
onward, but it was not until he became
intimate with Bonington that he seriously
attempted such works in watercolors. In its
more liberal and painterly use of bodycolor,
François Ier and the Duchesse d'Etampes should be
viewed as an advance beyond the *Goetz von*

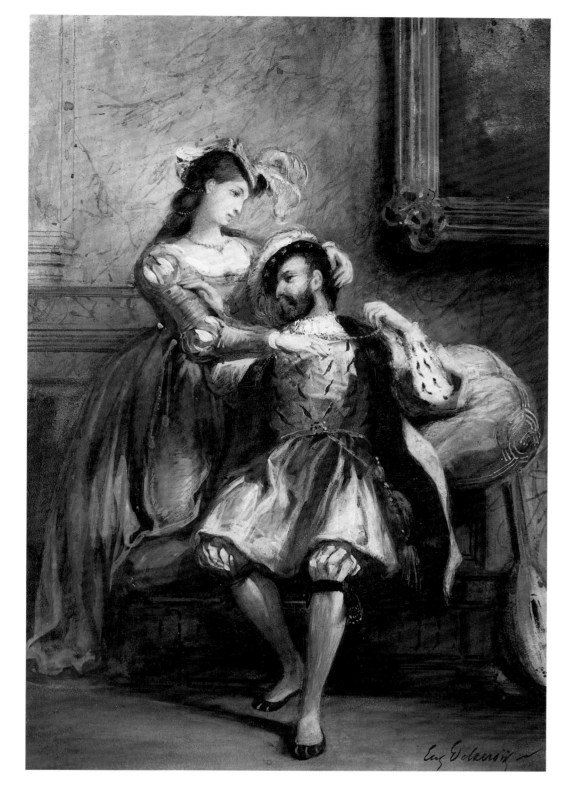

Berlichingen watercolor (no. 110) in Delacroix's
technical command of the medium. Fueled by
the example of Bonington's confident prowess,
Delacroix attains perfection in the splendid
equilibrium between the limpidity of
transparent washes and the gestural boldness of
opaque bodycolor in both this work and the
Paolo and Francesca. Gautier made an intersting
observation on Delacroix's technique for the oils
of this year, in particular the *Death of
Sardanapalus*, that "certain transparencies are
enhanced by sudden relief like the firmness of
oil applied over watercolor."[3] He attributed
this to Sir Thomas Lawrence's facture, but such
effects have an equally important equivalent in
Delacroix's and Bonington's near-contemporary
watercolors.

1. A similar observation was made by Johnson
(*Delacroix* 3, no. 116a) when he redated the picture
The Wounded Valentine ca.1826.
2. E. Goldschmidt, *Ingres et Delacroix* (Palais des Beaux-
Arts de Bruxelles, 1986), nos. 101–2. A Delacroix study
for Francesca's hand, dated 6 August 1828, is too
elaborate to be for the watercolor but might have been
drawn preparatory to an oil painting that was never
realized.
3. Gautier, *Histoire du Romantisme*, 2nd ed. (Paris, 1874),
212.

AN INDIAN MAID 1827
Watercolor and bodycolor over graphite, the
shadows heavily gummed, with scraping out,
$7\frac{1}{2} \times 5\frac{1}{8}$ in. (19 × 13 cm.)

Inscribed: Signed and dated, lower left:
R P B 1827

Provenance: Possibly E. V. Utterson, by 1831;
Lewis Brown (Paris, 17–18 April 1837, lot 68);
Paul Périer (Paris, 19 December 1846);
Mosselman (Paris, 1849, bought Musée du
Louvre).

Exhibitions: Nottingham 1965, no. 242;
Jacquemart-André 1966, no. 86, pl. XI.

References: T. Gautier, *Tableaux à la plume* (Paris,
1880), 199; Mantz, *Bonington*, 299; Shirley, 114,
pl. 138.

Musée du Louvre, Département des Arts
Graphiques (35281)

With the exception of academic life or cast
studies, the nude or partially draped female
figure rarely appears in Bonington's oeuvre, and
then only at the latter end of his career, when
his friendship with Delacroix and Auguste, who
were both somewhat preoccupied with erotica
in the mid-1820s, was most sustained.
Bonington had neither the opportunity nor the
inclination to perfect his skill at this most
academic of genres. This deficiency, and perhaps
a sense of modesty or propriety, no doubt
dissuaded him from plumbing his favorite
medieval and Renaissance raconteurs for their
more salacious anecdotes. Whereas Delacroix
was prepared to explore the potential eroticism
of the troubadour tradition, Bonington
remained within the less provocative arena of
"oriental" exotica, favored by Auguste and
Ingres and both popularized and sanitized by
the younger poets of his acquaintance.

In its technical sophistication *An Indian Maid*
is one of the most ravishing of Bonington's
extant watercolors. Its subject relates it to two
of his watercolors in the Wallace Collection,
Odalisque in Red (1827) and *Odalisque in Yellow*
(fig. 43),[1] and to a third odalisque subject
formerly in the Coutan and Michel-Levy
collections.[2] This last presents a reclining, half-
draped female cradling her head in one arm. He
perhaps borrowed that pose from Delacroix's oil
Lady and Her Valet,[3] although his representation
lacks the prurience of Delacroix's.

The Louvre watercolor was titled *The African
Daughter* in an engraving by Sangster for *Bijou*
(published 4 October 1829). This was
misleading, as the figure's skin is clear except
where shaded by the palms, and the *mis-en-scène*
is not that of a Nubian slave. Since the Périer
sale the subject has been described as an
Odalisque au palmier, also an erroneous
appellation in that the standard attributes of an
oriental concubine are lacking. This distinction
was certainly not lost on Lewis Brown, who

owned both this and the *Odalisque in Yellow*. In his 1837 sale catalogue he described the Louvre sheet as simply a seminude young female. A contemporary lithograph by Cuisinier for *L'Artiste* could be the most authorative in its title, *Jeunne Indienne*.

Unique to Bonington's treatment of similar subjects are the entirely natural setting for the Louvre sheet and the curious necklace of radiating pendants worn by the figure. Although not conclusive in its typology, this accoutrement could have been perceived as Incan. The red lily in the woman's outstretched hand, while not a true "lily of the Incas," might have reinforced this association and also denoted her state of innocence. The Peruvian struggle for independence, which was finally achieved by Simón Bolivar's defeat of the Spanish colonial forces in December 1824, aroused considerable sympathy in Paris and undoubtedly contributed to the pronounced revival of interest in Jean-François Marmontel's *Les Incas ou la destruction de l'empire du Perou*, first published in 1777. Numerous operatic adaptations of this classic were staged in the 1820s; equally popular was the extraordinary scenic wallpaper printed by DuFour and Leroy in 1826 with designs by Alexandre Fragonard illustrating the most important passages of the novel.[4] A new Firmin-Didot edition of the text with illustrations by Bonington's friend Colin (no. 136) was projected in 1825 but never materialized. We know that Bonington was focusing on the Americas and their history at this time, a result of his commission to illustrate Maurice Rugendas's *Voyage pittoresque dans le Brésil*, the first instalment of which appeared in May 1827.[5]

The theme of Marmontel's *Les Incas* is the tragic annihilation of an entire race of noble savages. Colin's concluding illustration to the book depicts the heroine Caro expiring on the tumulus of her recently deceased husband Alonzo after giving birth to their stillborn child. A similar theme, concerning the destruction of the Natchez, is to be found in Chateaubriand's epilogue to *Atala*. Delacroix's oil on that subject, begun in 1823, was certainly known to Bonington. It is impossible to determine if the young woman in the Louvre watercolor has just succumbed to sleep or to death; nevertheless, without claiming any specific illustrative purpose for the image, it would not be inappropriate to note a connection, however abstruse, between the current fascination with the demise of indigenous new world cultures and the elegaic tone of *An Indian Maid*.

1. Ingamells, *Catalogue*, 69–70. The *Odalisque in Red* (P734) might also have existed in an oil version, of which several copies are known: Private Collection, Paris (Shirley, pl. 126); Christie's, 14 December 1971, lot 9.
2. Dubuisson 1909, 375 repr.
3. Johnson, *Delacroix* 1, no. 8; 2, pl. 6.
4. A complete installation of this decoration is in the Musée des Arts Décoratifs, Paris; see also, Hugh Honour, *The European Vision of America* (Cleveland Museum of Art, 1976), no. 249.
5. Announced in the *Literary Gazette*, 19 May 1827, and the first installment reviewed on 14 July.

ALEXANDRE-MARIE COLIN (1798–1873)

AMAZALI SLAYING A SPANIARD 1825
Pen and brush and brown ink and white bodycolor over graphite, with extensive scraping and scratching out, 8 × 11 in. (20.3 × 27.9 cm.)

Inscribed: Signed, lower center: *A Colin.*

Provenance: Maurice Pereire (Paris, Hôtel Drouot, 28 April 1980, lot 255, bought Boerner); C. G. Boerner, from whom acquired by the present owner.

References: C. G. Boerner, *Catalogue 72* (Düsseldorf, 1980), no. 59.

Private Collection

Colin was Parisian by birth and studied with Girodet and at the Ecole des Beaux-Arts, where he befriended first Géricault and Delacroix and shortly thereafter Bonington and Corot. He remained Bonington's most devoted friend, although following their trip to London in 1825 and Bonington's emergence from his self-imposed provincial retirement, he became less of an influence in the younger artist's life than Delacroix.

Essentially unappreciated as an artist today, Colin was in the vanguard of the 1820s, both as an experimenter with oil techniques and as a purveyor of innovative subject matter. At the 1824 Salon he exhibited five marine paintings, including a *Drowned Fisherman*, now untraced but presumably based on an experience shared with Bonington, who recorded such an event at Dunkerque in a rapid graphite sketch and in a more histrionic watercolor composition.[1] In addition to Italian genre scenes of the type popularized by Léopold Robert, he submitted to the Salon of 1827–28 a *Sorcières de Macbeth*, which moved one critic to complain with vitriol generally reserved for Delacroix: "I can't believe that the aim of painting is to make us recoil in disgust. . .what difference does it make if there is great skill in the execution, if it is impossible to consider it."[2] A watercolor of similar subject by Thales Fielding had been, thanks largely to Stendhal's contentious defense of it, a *cause célèbre* at the preceding Salon. Colin's brightest moment was probably at the benefit exhibition for the Greeks at the Galerie LeBrun in April 1826, where he exhibited two pictures inspired by Byron and a third by Shakespeare. In these the reviewer for the *Journal des Débats* observed a "fresh and natural talent destined to create scenes of boldness and pathos."[3]

As a book illustrator and printmaker, Colin had interests that ranged widely over the serious literature of La Fontaine, Byron, and Goethe, nonnarrative historical costume pieces comparable to Bonington's *Cahier de six sujets*, theatrical portraiture, and satire of all of the above.[4] *Amazali Slaying a Spaniard* is one of four large illustrations for a projected deluxe edition

of Marmontel's *Les Incas ou la destruction de l'empire du Perou*. A popular novel from its first publication in 1777, *Les Incas* was revived in several editions of the 1820s in response to a waxing interest both in the historical novel as a literary form and in the political realities in South America. Colin was commissioned in 1825 to redesign Desenne's illustrations for the Firmin-Didot 1819 octavo edition. An enlarged format for the plates permitted more dramatic figure arrangements and more convincing landscape settings for the narrative episodes. For unknown reasons, the designs appear never to have been engraved.

As a draftsman Colin remained something of an academic stylist despite his close association with Delacroix and Bonington.[5] The flamboyance of Bonington's watercolor technique is intimated in Colin's treatment of the landscape, but the figure of Amazali is contoured with the chaste line of a neoclassicist and modeled by a dense system of cross-hatching derived from the technique of contemporary line engravers. The interest of his friend Auguste in the Elgin marbles and the reliefs discovered by C. R. Cockerell at Bassae — in particular, the amazonomachy frieze engraved by Thomas Landseer in 1820 and on view in London in 1825 — might have encouraged Colin's nonpainterly and heroic conception of Marmontel's Indians.[6]

1. The sketch is in the Bibliothèque Nationale. The watercolor of 1824 is known only from an engraving by W. J. Cooke for *The Amulet* (London, 1836).
2. *Revue Encyclopédique* 38 (April 1828): 278.
3. *Journal des Débats*, 29 May 1826, 3.
4. For example, *Album comique de pathologie pittoresque* (Paris, ca.1825–28), with satires of works by Fuseli and Byron and of Stendhal's *Racine et Shakespeare*.
5. Long after Bonington ceased to care, Colin continued to compete for places in the cast room of the Ecole des Beaux-Arts.
6. Numerous Colin studies after antique sculpture are now in one of the largest collections of his drawings at the Musée de Pontoise.

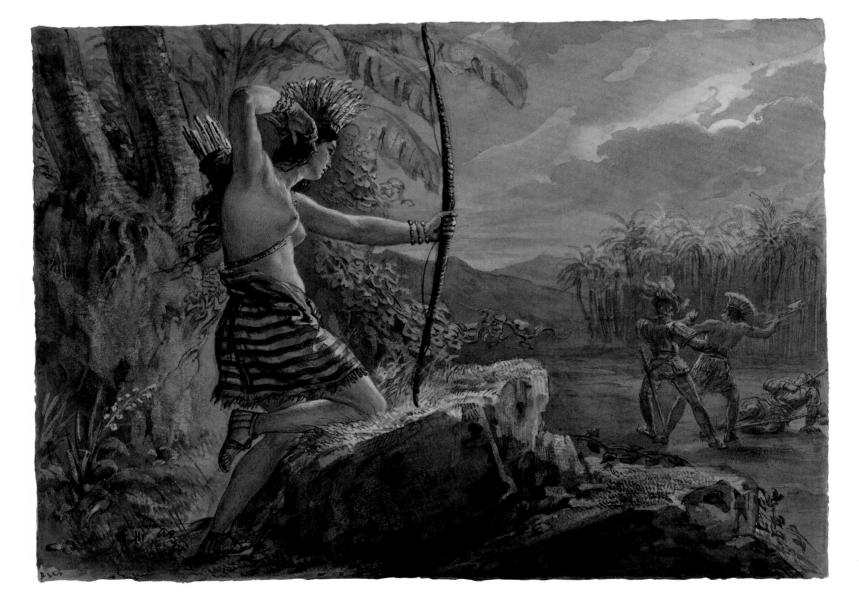

EUGENE DELACROIX (1798–1863)

WOMAN WITH PARROT 1827
Oil on canvas, 9⅝ × 12¹³⁄₁₆ in. (24.5 × 32.5 cm.)

Inscribed: Signed and dated, upper left:
Eug. delacroix. 1827

Provenance: L.-J.-A. Coutan (Paris, 9 March 1829,
lot 50); Frédéric Leblond, by 1832; Couturier de
Royas, by whom given to the Musée des Beaux-
Arts, Lyon in 1897.

Exhibitions: See Johnson, *Delacroix* 1, no. 9.

References: Robaut, *Delacroix*, no. 383;
Johnson, *Delacroix* 1, no. 9; 2, pl. 7; 3: 311.

Musée des Beaux-Arts, Lyon (B566)

This justly celebrated picture is almost identical
in its dimensions to two other contemporary
Delacroix oils in which a female nude dominates
the composition, but which illustrate specific
historical anecdotes in Brantôme's *Les Vies des
dames galantes* — *A Lady and Her Valet* and *The
Duc d'Orléans Showing His Mistress*.[1] No narrative
intent has thus far been divined or suggested for
this picture, and the spare subsidiary devices
of a divan, parrot, and the woman's headdress
and jewelry suggest that she is an oriental
concubine, like the female in the slightly larger
Odalisque Reclining on a Bed,[2] which also belonged
to Coutan. It may, therefore, be Delacroix's
earliest treatment of a subject to which he
would return frequently throughout his career.

As noted by Lee Johnson, the languid pose
may derive from Lambert Sustris's oil *Venus and
Cupid* (Louvre). The coloring has been described
repeatedly in the literature as Venetian and
"jewel-like," and it has close parallels in works
by both Delacroix and Bonington of this and the
preceding year; yet Delacroix's attempt to
emulate Titian's exquisite sensibility of flesh
has not been given sufficient attention.
Curiously, Léon Rosenthal described the
picture as mediocre, although interesting as an
essay in interior lighting and, as such, as a
prelude to the *Women of Algiers* (1832; Louvre).[3]

As an attempt to render a sculptural purity of
form within a tenebrous space, it diverges
markedly from Bonington's solutions to similar
formal concerns and might have appeared as too
tame or too conventional for Rosenthal, but it
was an essay not without relevance to the
problems posed by the *Death of Sardanapalus*
(Louvre), on which Delacroix was then
working.

1. Johnson, *Delacroix* 1, nos. 8 and 111.
2. Ibid., no. 10.
3. Rosenthal, *Peinture Romantique*, 219.

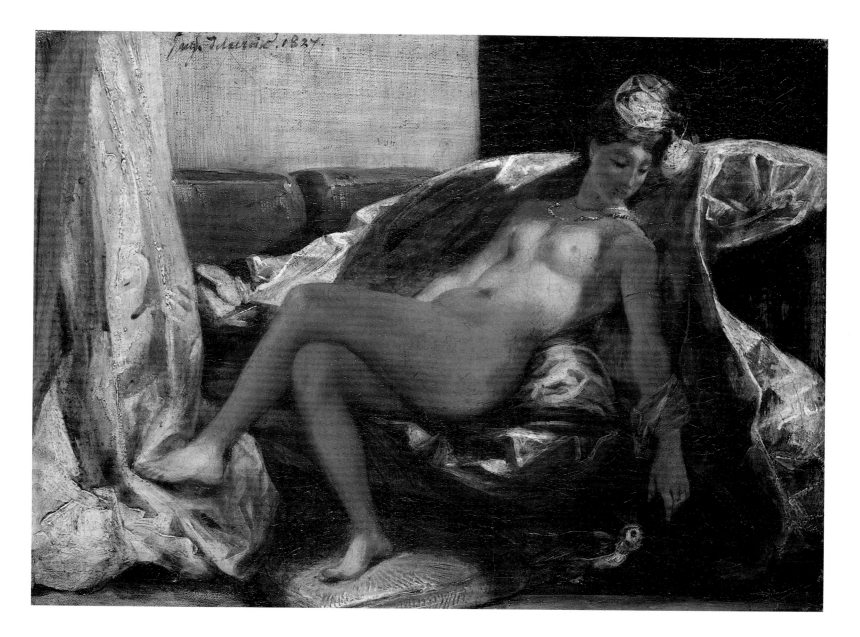

FRANÇOIS Ier, CHARLES QUINT, AND THE
DUCHESSE D'ETAMPES ca.1827
Oil on canvas, $13\frac{1}{2} \times 10\frac{1}{2}$ in. (34.2 × 26.7 cm.)

Inscribed: Signed, lower left: *R P Bonington*; verso
of stretcher: *sale Jardin*

Provenance: Vicomte Both de Tauzia; Mosselman
(Paris, 1849, bought Musée du Louvre).

Exhibitions: Nottingham 1965, no. 295.

References: *L'Artiste* 8 (1836), lithograph by Ch.
Hue; Thoré, 1867, repr. 5, as a wood engraving
by Carbonneau; Mantz, *Bonington*, 304;
Dubuisson and Hughes, repr. opp. 161; Shirley,
116, pl. 148.

Musée du Louvre, Département des Peintures
(Inv. 10045)

A decade after imposing on François Ier (1494–
1547) the punitive Treaty of Madrid in
exchange for his release from prison, Charles
Quint (1500–1558), Emperor of Spain and
Austria, requested passage of his brother-in-law
through France to suppress a revolt at Ghent.[1]
The king consented and also treated the
emperor to a series of lavish entertainments in
his progress toward Paris, where he arrived on
1 January 1540. At a ball at Amboise the
emperor was introduced to the king's mistress
Anne de Pisseleu, Duchesse d'Etampes. In the
process of flattering this courtesan, he was
cautioned by François Ier: "You see this
beautiful woman, my brother? She is of the
opinion that I should not permit you to leave
Paris until you have revoked the Treaty of
Madrid."[2] The avaricious and cunning duchess
was undoubtedly sincere in her opinion that the
emperor be held captive, but such perfidy
would have violated grossly François Ier's
chivalric pretensions. Although she stood to
gain from the revocation of the treaty, as it
might have furnished possible grounds for the
annulment of the king's marriage to the
emperor's sister, she was subsequently charmed
to the emperor's cause by the gift of a large
diamond, an episode depicted in a highly
celebrated painting by Pierre Revoil that was on
view in the Musée du Luxembourg from 1818
to 1843.[3] Bonington has chosen to illustrate the
moment when the king nonchalantly reveals to
his guest, who had suspected intrigues against
him from the moment he entered French
territory, the duplicitous advice of his mistress.

Brantôme characterized the duchess as
curiously disloyal for a woman whose
"profession was love and pleasure." In his
descriptions of the emperor, he was very
attentive to his modest taste in dress, especially
the bonnet of black velvet that Charles
preferred to the elaborate plumage then in
fashion.[4] The emperor's physique in
Bonington's oil corresponds to other
contemporary accounts, such as that of the
Venetian envoy Gaspard Contarini, who
observed in 1525, "The Emperor is of medium
build, neither too large nor too small, white of
skin, more pale than colored, well proportioned,
with very fine legs, strong arms, a nose a bit too
aquiline but very small; the demeanor is grave
but neither rude nor severe."[5]

The emperor's features may derive from
Revoil's portrait, which was borrowed from an
unspecified profile portrait in the Musée des
Monuments Français. This might have been
Hans Reichart's bust-length medallion, which
was also copied by Delacroix.[6] The head of
François Ier is borrowed directly from Titian's
oil portrait (Louvre) or Colin's replica of that
picture. The attire of both men relates to that
in Gros's monumental *Charles V Received by
François Ier at Saint-Denis* (Louvre; fig. 22), the
esquisse for which was exhibited at the Galerie
LeBrun in August 1826. There appears to be
no immediate source for the likeness of the
duchess, although engraved portraits appear
in several of the reference works regulary
consulted by the artist. Her dress derives from
Raphael's *Joanna of Aragon* (Louvre), a picture
painted for François Ier.[7]

The facture, especially in the duchess's dress,
places the picture chronologically near *Amy
Robsart and Leicester* (no. 141), while its subject
belongs with other illustrations of 1827 from
the life of the French monarch: the watercolor
Charles V Visiting François Ier (Wallace
Collection), and the two oil versions of *François
Ier and Marguerite of Navarre* (fig. 55 and an
untraced version exhibited at the Salon in
February 1828). Delacroix's finished watercolor,
François Ier and the Duchesse d'Etampes (no. 134)
probably dates to this year, although his first
treatment of a subject from the life of Charles
Quint dates from 1831.[8] Colin's oil *Charles Quint
Received by François Ier at the Louvre* (Louvre) was
not painted until 1843.

The pervasive golden tone is deliberately
Titianesque. The duchess's garment, which
establishes the dominant tonality, is
considerably less opaque and massive than
Mazarin's robes in the earlier *Anne of Austria
and Mazarin* (no. 118). A wash of brown,
so transparent that graphite or chalk
underdrawing is clearly visible in the right
sleeve, has been applied over the white ground
and the modeling restricted to strokes of a
brighter hue deftly dispersed over portions of
this surface. The definition of form is now both
more animated and more convincing, and, once
again, Bonington has translated techniques fully
worked out in his watercolors to his oils.
Something similar to this approach occurs in
Delacroix's treatment of Wildrake's dress
in *Cromwell at Windsor Castle* (no. 142).

As two of the great potentates of the late
Renaissance, François Ier and Charles Quint
fired the imaginations of the French romantics,
while their rival, Henry VIII, remained largely
the subject for English artists. Although the
initial manifestations of this enthusiasm
accented the more picturesque aspects of their
mutual interests in the revival of chivalry and
the arts, a less subjective historicism gradually
evolved the consensus that Charles Quint,
despite his religious intolerance, was
intellectually and morally superior. This
revision was championed by Bonington's early
acquaintance and defender, Amédée Pichot,
whose biography of the emperor appeared five
years after this picture was acquired by the
Louvre. In his surviving representations of these
two antagonistic personalities, Bonington
appears to anticipate this opinion.

This was the first Bonington oil to enter the
Louvre's collections. Its accessibility resulted in
numerous nineteenth-century copies, including
an oil by the American painter William Brigham
(1830–1862) and an etching by Léopold
Fleming. More feeble replicas are in the Musée
d'Art Roumania, the Snite Museum (Notre
Dame University), and a private French
collection.

The first recorded owner of this picture,
Both de Tauzia, was an avid collector of Gothic
and early Renaissance art. From 1858 he held a
series of influential posts at the Louvre. As
Conservateur des Peintures, he was responsible
for selecting for the Milliet-Schubert-Hauguet
donation almost all of the remaining important
Boningtons now in the Louvre. He is also
known to have bequeathed to Frédéric Buon,
Inspecteur des Beaux-Arts (1872–79), a small
picture by Bonington said to be after Jean-
Honoré Fragonard.

1. Elinor of Austria, sister of Charles Quint, was the
second wife of François Ier. Bonington's graphite copy
(Nottingham) of an engraved portrait of her was used
for the features of the King's sister in the oil *François Ier
and Marguerite of Navarre* (Wallace Collection).
2. Quoted from the probable source for Bonington's
subject, P.-L. Roederer's, *Louis XII et François Ier ou
memoires pour servir à une nouvelle histoire de leur regnes*
(Paris, 1825), 2: 87; the same anecdote, however, is to
be found in the *Biographie Universalle* 13 (1815).
3. M.-C. Chaudonneret, *La Peinture Troubadour* (Paris,
1984), 131, fig. 182.
4. *Oeuvres complètes du Seigneur de Brantôme*, ed. L.-J.-A.
Monmerqué (Paris, 1822), 1: 22–23.
5. A. Pichot, *Charles-Quint* (Paris, 1854), 73.
6. Musée des Beaux-Arts, Besançon; repr. in
H. Lassalle, et al., *Ingres et Delacroix* (Bruxelles, 1986),
no. 82.
7. A Bonington sepia study in the 1889 Coutan sale was
titled *Raphael Painting Jeanne de Aragon*.
8. Johnson, *Delacroix* 1, no. 149: *Charles V at the
Monastery of Tuste*.

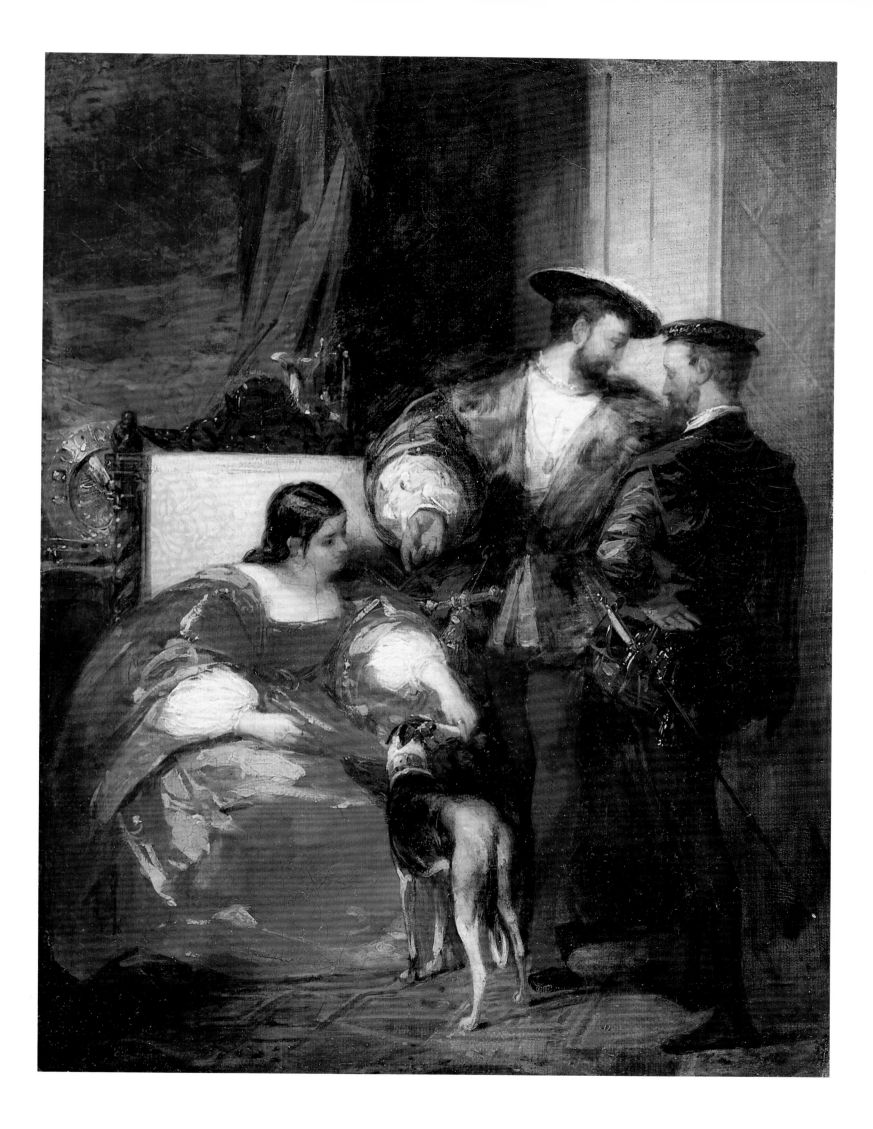

139

THE USE OF TEARS 1827
Watercolor and bodycolor over graphite, heavily
gummed, $9\frac{3}{4} \times 6\frac{3}{4}$ in. (24.7 x 17 cm.)

Inscribed: Signed and dated on footstool:
R P Bonington 1827
Provenance: L.-J.-A. Coutan, and by descent
(Paris, Hôtel Drouot, 16–17 December 1889,
lot 38, bought Milliet); Arthur Tooth; Norton
Simon (Sotheby's, 10 July 1980, lot 145).

References: Shirley, 71.

Private Collection

Three versions of the composition have
survived. The earliest is a small, coarsely
executed (possibly retouched) watercolor dated
1826,[1] which anticipates in its furnishings and
figure arrangement the Boston oil. The second
watercolor, exhibited here, incorporates a third
female figure in mid-seventeenth-century dress
and was painted with exquisite assurance.
Although the habit and facial features of the old
matron in both versions of 1827 may derive
ultimately from an engraving after Van Dyck's
Portrait of Francesca Bridges, which Bonington
copied in graphite and used with only slight
alterations in his watercolor *Meditation* (1826;
Wallace Collection),[2] a more immediate parallel
is Delacroix's oil, *Tête d'étude d'une vieille femme*,
rejected by the Salon jury in October 1827.[3]
The heads in both the Bonington and Delacroix
oils are too similar for coincidence and suggest a
common model. Moreau-Nélaton identified this
woman as Delacroix's aunt Madame Bornot,[4]
while Philippe Burty suggested that she was
Bonington's housekeeper, about whom we know
only that she was elderly and that she received
from the artist his oil study based on
Rembrandt's etching of *Christ Preaching*.[5] But
she is clearly the same woman, traditionally,
and with some authority, identified as
Bonington's housekeeper, who appears in
the background of the watercolor *Invitation to
Tea* (no. 106).

When the Delacroix oil was later exhibited
at the Exposition Universalle in 1855, Gautier
noted the influence of Bonington, but it is
unclear if he was referring to the bold,
naturalistic handling or the subject.[6] He may
have had in mind the *Portrait of an Old Lady*
(Louvre) considered at the time to be by
Bonington.[7] The influence of Rembrandt on this
particular Delacroix study has been frequently
observed, and while Johnson draws attention to
the copies after Rembrandt that Poterlet was
dispatching from Holland in summer 1827, it
should be noted that Bonington's own interest
in the Dutch artist, so brilliantly pursued in
these two works, developed considerably earlier
and that examples of Rembrandt's treatment of
the aged, such as the oil thought to represent
his mother reading (Louvre), were readily
available for study.

The source for the young woman is the figure
of the Virgin in Sebastiano del Piombo's
Visitation (Louvre), from which Bonington made
a graphite study.[8] It would appear that
Delacroix referred to this study when painting
his oil *Henri III at the Deathbed of Marie de
Clèves*.[9] The idea of a deathbed visitation,
although the subjects are completely different,
may link the two pictures chronologically.

The Boston oil was engraved by C. Rolls
for the *Keepsake* (1831) and reissued in *Heath's
Gallery* (1836) to illustrate a maudlin poem by
Lord Morpeth on the theme of lovesickness.
The watercolor was engraved in mezzotint by
S. W. Reynolds in 1829 with the title *Use of
Tears: Jeune fille malade*.[10] Representations of
death- or sickbed scenes in Bonington's oeuvre
are extremely rare; there exist only three other
documented examples — two small pen and ink

sketches of a woman mourning beside the deathbed of a man (British Museum) and the watercolor *Charles V Visiting François Ier* (Wallace Collection). It is unlikely that this composition has a specific literary source; rather, it should be seen in the context of the prevailing fascination for elegiac subjects. The first issues of the *La Muse Française*, for instance, introduced Saint-Valery's "La jeune malade," Tastu's "La jeune mère mourante," and Belmontet's "Gilbert mourante." Sensing an uncomfortable inundation by such poetic plaints, Emile Deschamps observed satirically, in a review of a recent publication of Guttenguer's works that included "L'Enfant malade":

André Chenier has written "La jeune malade" which is a masterpiece; since then we have seen successively "La soeur malade," "La jeune fille malade," "Le poete mourant," "La mere mourante" etc. and these diverse elegies, in spite of their apparent conformity of subject, have talent alone in common, but I did not believe it was possible to further extend this gallery of infirmities without risking the indisposition of people otherwise well disposed; M. Guttenguer has just proven me in error. I do not think it inappropriate, however, to affirm that from this day the exploitation of agonies and sickness must be banned from poetic commerce, and in order to discourage all future speculations in this genre, a young friend of mine ought to allow me to publish an elegy that he calls "L'oncle à la mode de Bretagne en plaine convalescence." This would certainly be the definitive termination of all pharmaceutical poetry.[11]

Painters, of course, found an equally receptive market for such melancholy. A possible prototype for Bonington's conception could have been Saint-Evre's 1822 Salon picture of an aged woman taking the pulse of a sick young girl, or Franquelin's *Convalescent* (Salon 1827, no. 414) which belonged to Bonington's friend Alexandre Du Sommerard.

1. Musée du Louvre; Cormack, *Bonington*, fig. 65.
2. Nottingham 1965, no. 1.
3. Johnson, *Delacroix* 1, no. 87.
4. Ibid., where Johnson queries that identification without rejecting it outright.
5. This oil was with the Fine Art Society in 1947. An inscription on the verso in Thomas Shotter Boys's hand describes its history. For Burty, see Johnson, ibid.
6. Gautier, "Exposition Universalle," *Le Moniteur universal*, 25 July 1855.
7. Race (*Notes*, 18) first queried the attribution, preferring, on stylistic grounds, an ascription to Bonington's father.
8. Nottingham 1965, no. 136.
9. See Johnson under references above and *Delacroix* 1, no. 126, where the picture is dated ca.1826/7.
10. An oil copy of the Boston picture of considerable quality is at Wimploe Hall, but its author is unidentified.
11. *La Muse Française* (Paris: Marsan edition, 1909), 2: 317 (June 1824).

140

THE USE OF TEARS ca.1827
Oil on canvas, $15\frac{1}{4} \times 12\frac{1}{2}$ in. (38.6×31.7 cm.)

Provenance: Van Praet, Brussels, to 1894; Boussod Valadon, Paris, 1895; Joseph Bradlee, from 1895 to 1903, when bequeathed by him to the Museum of Fine Arts.

Exhibitions: Nottingham 1965, no. 294, pl. 49.

References: Shirley, 70, 113, pl. 127; L. Johnson, "A New Delacroix: Henri III at the Deathbed of Marie de Clèves," *Burlington Magazine* (September 1976): 620–22, fig. 6; Johnson, *Delacroix* 1: 60.

Museum of Fine Arts, Boston

141

AMY ROBSART AND LEICESTER ca.1827
Oil on canvas, $13\frac{7}{8} \times 10\frac{5}{8}$ in. (35.2 × 27 cm.)

Inscribed: On the stretcher, verso: wax atelier
seal

Provenance: Alexander Hamilton Douglas, 10th
Duke of Hamilton, after 1833, and by descent
to Beckford Collection (Christie's, 6 November
1919, lot 109, as *The Declaration*, bought
Colnaghi); Mrs. W. F. R. Weldon (Christie's,
31 July 1925, lot 113, bought Gooden and Fox);
acquired by the Ashmolean Museum in 1933.

Exhibitions: London, Cosmorama Rooms, 209
Regent Street, 1834, no. 53, as *The Favorable
Silence*; BFAC 1937, no. 31, as *Amy Robsart and
the Earl of Leicester*; Nottingham 1965, no. 296,
pl. 46.

References: Shirley, 66, 71, 113, pl. 124; Martin
Kemp, "Scott and Delacroix with some
assistance from Hugo and Bonington," *Scott
Bicentenary Essays*, ed. A. Bell (Edinburgh, 1973),
217, fig. 6.

The Visitors of the Ashmolean Museum, Oxford

This picture received its present title,
identifying the subject as a scene from Walter
Scott's *Kenilworth*, when it was exhibited in
1937. In chapter 5 of the novel the tragic
heroine Amy Robsart, who is sequestered at the
Earl of Leicester's estate in an effort to forestall
Elizabeth I's learning of their clandestine
marriage, interrogates her husband on his
orders of rank, then pleads for a public
acknowledgment of their union. At this point,
Leicester's ambition has not yet invalidated his
affections, and he reproves her gently for her
impatience.

A lithographic version of the oil, in reverse
and introducing a more elaborate architectural
setting, appeared as *Le silence favourable* in
Bonington's *Cahier de six sujets* (1826). This
reproduced an untraced watercolor
commissioned for an album belonging to one
"Madame N" and identified by Auguste Jal as
Amy Robsart and Leicester.[1] The title of an early
engraving by Jazet after the oil, *Le deux reproche*
(1829), similarly supports the proposed
identification of the subject. Because of
Bonington's pronounced interest in *Kenilworth*
— at least three other illustrations are
recorded[2] — and Delacroix's contemporary
involvement with the costume designs for
Victor Hugo's dramatic adaptation of the novel,
the present title has been retained, although the
interpretation diverges as much from the
textual source as does Scott's literary collage
from historical fact. The lack of narrative
precision is markedly in contrast to the fidelity
of Bonington's illustrations to *Quentin Durward*
(nos. 59–60), but the concentration on the
figures' emotional interaction at the expense of
such precision relates the picture more directly
to mainstream literary theory and its
preoccupation with "la vérité sur la nature
humaine."[3]

A more faithful contemporary illustration
of the encounter is the oil by Henri-Joseph
Fradelle exhibited at the British Institution in
1825 and published as an engraving in Paris in
1827. In this, as in most illustrations of
Leicester's visit to Amy,[4] the couple appear
sumptuously attired in an interior, with Amy
examining the insignia of the Order of the
Golden Fleece suspended from a chain around
Leicester's neck. However, the distinction
Bonington makes between Leicester's stylish
wardrobe and the modest, domestic dress of his
wife is more in keeping with Scott's description.
A similar simplicity is to be found in Delacroix's
watercolor studies for Amy's costume[5] and
Hugo's detailed instructions for them.[6] The
figure of Leicester combines details from several
sources, including the Clouet-school *Portrait of
Charles IX* (Louvre),[7] costumes in the *Recueil de
Gagnières* also copied by Delacroix,[8] and
probably engravings after any of the numerous
oil portraits of Leicester. Another sketch after a
Clouet-school *Portrait of the Duc de Guise*
(Louvre) on a sheet of pen studies of 1826
(Edinburgh) might have been a first thought for
the figure in the watercolor version.

The treatment of the draperies is thoroughly
Venetian, while the modeling of Amy's sleeve
and face recall Watteau. The background and
sky, however, have their closest parallels in the
landscapes of Paul Huet, and, significanty, the
background of Delacroix's *Portrait of Louis
Auguste Schwiter* (National Gallery), which Huet
assisted in painting.[9] The forelegs of the dog,
who helps mask the awkward cross-legged pose
of Leicester in both the watercolor and oil
versions, were left unfinished. On the
assumption that the watercolor preceded the
oil, and on the stylistic evidence, the picture
should be dated to mid-1827.

Although Scott's novel may represent the
ultimate literary source, the immediate
instigation for treating the subject again in
oils must have been the Hugo-Delacroix
collaboration. Hugo's play was not staged until
February 1828, but the first four acts were
written by October 1826 and the concluding
acts by September 1827. It would appear that
Delacroix had begun his costume designs no
later than the following month.[10]

1. Duc de Rivoli sale, Paris, 18 April 1834, lot 6.
The details of the commission are given by A. Jal in
"Richard Parkes Bonington," *Le Keepsake Français* (1831),
283. Usually well informed, Jal also noted that this
watercolor was later in date than Bonington's
watercolor *Don Quixote in His Study*.
2. These include *The Interview of Elizabeth I with the
Earls of Leicester and Suffolk* (no. 4); a drawing *Elizabeth's
Entry into Kenilworth* (1836 sale, lot 38); and a watercolor
Elizabeth Interviewing Leicester (Schroth sale, 1833).
3. De Vigny, *Cinq-Mars*, ix.
4. For instance, C. R. Leslie's frontispiece for the
Cadell edition of *Waverley Novels*, vol. 12 (1831).
Bonington's father may have owned an impression of
Fradelle's print; see Bonington Sr. sale 1838, lots 102,
138, and 140.
5. Martin Kemp, *Scott Bicentenary Essays*, 217, fig. 2.
6. Hugo, *Oeuvres complètes* 2: 798.
7. A graphite study after the picture is in the
Nottingham Castle Museum.
8. See L. Johnson, "Some Historical Sketches by
Delacroix," *Burlington Magazine* (October 1973): 672ff.
and fig. 54.
9. Johnson, *Delacroix* 1, no. 82. The portrait was
painted and retouched over several years beginning
in late 1826. It was rejected by the Salon jury in
October 1827.
10. In 1824 Delacroix had painted an untraced oil
simply titled *Leicester*. Both Delacroix and Bonington
were likely familiar with Aubert's dramatic adaptation,
first staged at the Opèra Comique in January 1823.

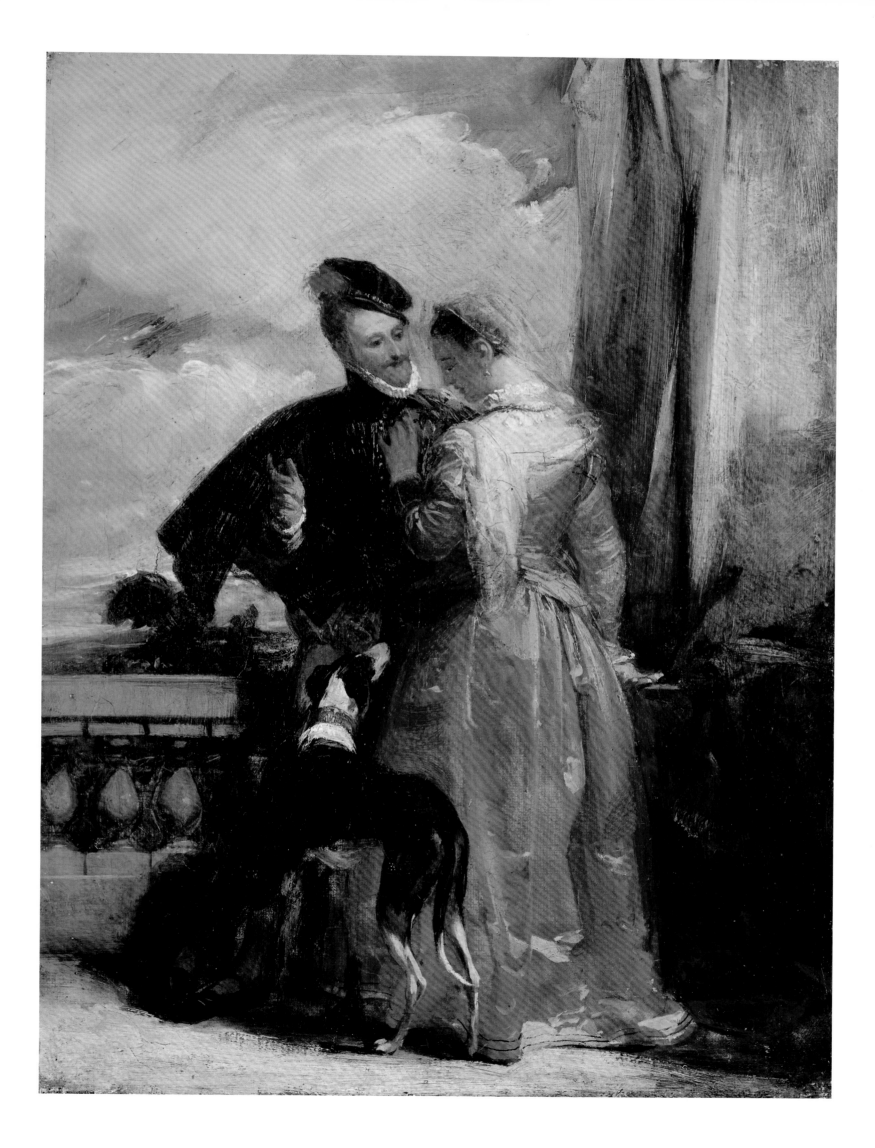

EUGENE DELACROIX (1798–1863)

CROMWELL AT WINDSOR CASTLE ca.1828
Oil on canvas, $13\frac{11}{16} \times 10\frac{11}{16}$ in. (34.8 × 27.2 cm.)

Inscribed: Signed, lower left: *Eug Delacroix*

Provenance: Edward, 6th Duc de Fitz-James
(1776–1833), by 1831; Bernheim, aîné (Brussels,
18 March 1884, lot 55, bought Rothschild);
Anonymous (Paris, 1 April 1889, lot 24, bought
in); Alfred Robaut; P.-A. Chéramy (Paris, 5
May 1908, lot 166, bought Oppenheimer);
O. Gertenberg, Berlin, to 1966; Peter Nathan,
Zurich; Robert Benjamin, New York
(Christie's, 3 July 1973, lot 3).

Exhibitions: Paris, Société des Amis des Arts,
April 1828; Paris, Salon, 1831, no. 514.

References: Robaut, *Delacroix*, 483 and no. 320;
Johnson, *Delacroix* 1, no. 129, with complete
documentation; 3: 315; and 6: 195.

Private Collection

When exhibited at the Salon of 1831, this
picture was described in the catalogue as an
illustration to chapter 8 of Walter Scott's novel
Woodstock, first published in French in January
1826. The depicted episode represents
Cromwell's chance encounter of a portrait of the
executed Charles I at Windsor Castle. A cavalier
spy, Wildrake, eavesdrops in the shadows:

*Cromwell, assuming a firm sternness of eye and manner,
as one who compels himself to look on what some strong
internal feeling renders painful and disgustful to him,
proceeded . . . to comment on the portrait. . . "that
Flemish painter," he said, "that Antonio Van dyke —
what a power he has! Steel may mutilate, warriors may
waste and destroy — still the king stands uninjured by
time.*

At the same Salon Paul Delaroche created a
sensation with his macabre *Cromwell Viewing the
Body of Charles I* (Musée de Nîmes). In addition
to the "dryness" of Delaroche's execution,
Delacroix criticized the poverty of his con-
ception, noting to Paul Huet:

*Delaroche's picture is a nonsense. Cromwell would never
have sought out and, by what sick, cynical curiosity I
can't say, have raised the lid of the coffin of his victim
as if it were a snuffbox. More likely, aware that the
body of Charles I was in the palace, but ignorant of
which apartment, he opened a door and found himself
suddenly facing the cadaver. He hesitates, is troubled,
utters involuntarily, and, fascinated by the spectacle of
this dramatic end, neither advances nor recoils.*[1]

Scott's plot takes place several years after the
execution of Charles I, but the vignette that
Delacroix illustrated was the author's
imaginative interpretation of the well-known
apocryphal event painted by Delaroche. It is
possible that Delacroix had seen Delaroche's
picture prior to the Salon and had persuaded
the owner of his own oil to exhibit it in 1831 as
something of a counter-statement. The picture
had been exhibited earlier at the Société des
Amis des Arts exhibition in April 1828. Lee
Johnson has dated it to that spring, arguing that
had Delacroix finished the picture before the
meeting of the Salon jury in January, he would
have submitted it for exhibition in the second
Salon installment scheduled to open in
February. Whatever the precise date of the oil,
the subject was actually treated by Delacroix
nearly a year earlier in a finished watercolor
version that reverses the composition.[2] While
the decision to paint an oil version might have
been stimulated, as Johnson suggests, by
dramatic adaptations of *Woodstock* staged in Paris
in March 1828, it was Victor Hugo's play
Cromwell and its prefatory manifesto, published
in December 1827, that seems most relevant
to an understanding of Delacroix's intentions.

In April 1827 Delacroix apologized to Hugo
for missing his lecture on *Cromwell*, but in light
of their friendship and their collaboration on
Amy Robsart at this time, there can be little
doubt that the principal tenets of Hugo's thesis
were well known to him before its publication.
As a historical prototype of Napoleon,
Cromwell had become a fashionable interest
following François Guizot's publication *Histoire*

de la Révolution d'Angleterre (1826–27). Hugo
portrayed Cromwell as "a complex,
heterogenous, and multiple being, composed of
all contradictions, a mix of all that is good and
evil, full of both genius and pettiness."[3] In
effect, he was the consummate blend of the
"grotesque" and the "sublime" that typified for
Hugo's circle the melancholic spirit of
modernity: "Men of genius, as grand as they
may be, always have in them their beast which
parodies their intelligence. It is for this reason
that they touch humanity, that they are
dramatic."[4]

In his oil Delacroix has portrayed an
enthroned Cromwell preoccupied with his own
conflicting ambitions, a righteous social
visionary and a potential usurper of the very
crown he has obliterated. As if to stress the
psychological dimension of his historical
"portrait," Delacroix did not employ, as was his
custom at this time, actual portraits for
Cromwell's features; rather, he has stamped
them with a distinctly simian cast that
complements an ungainly pose in betraying
Cromwell's simmering indignation for the
immortality afforded an enemy by the art of a
great portraitist. Wildrake's demeanor, on the
other hand, has the contrived elegance of a Van
Dyck and could have been inspired by any
number of the Flemish painter's court portraits,
although the immediate source appears to be
Portrait of a Gentleman (Louvre), of which both
Delacroix and Bonington had made graphite
sketches.[5] The contrast of physical types is
characteristic of the *Faust* illustrations, which,
like this work, defy the conventional literalness
of most contemporary narrative illustration. In
other formal respects, the coloring is, as in
Bonington's *Anne of Austria* (no. 118) and for
the same motive — veracity — an homage to
both Rubens and Van Dyck.

Both Colin, in 1833, and Desmoulins, in
1838, would exhibit oils of the same subject at
the Salon.[6]

1. Huet, *Huet*, 382.
2. Société des Amis des Arts, 1827, no. 23; Sotheby's,
23 November 1989, lot 469.
3. Hugo, *Cromwell*, 97–98.
4. Ibid., 64.
5. Sérullaz, *Delacroix*, no. 1329; the picture is now
attributed to Franchoys.
6. Wright and Joannides, 2: 111, who repeat Joubin's
assertion (Delacroix, *Correspondence* 1: 266 n.3) that this
oil was exhibited at the Royal Academy in 1830. The
only oil by Delacroix listed in the Royal Academy
catalogue that year was the *Murder of the Bishop of Liège*.
A second oil, possibly the *Cromwell*, was with Colnaghi
at the time.

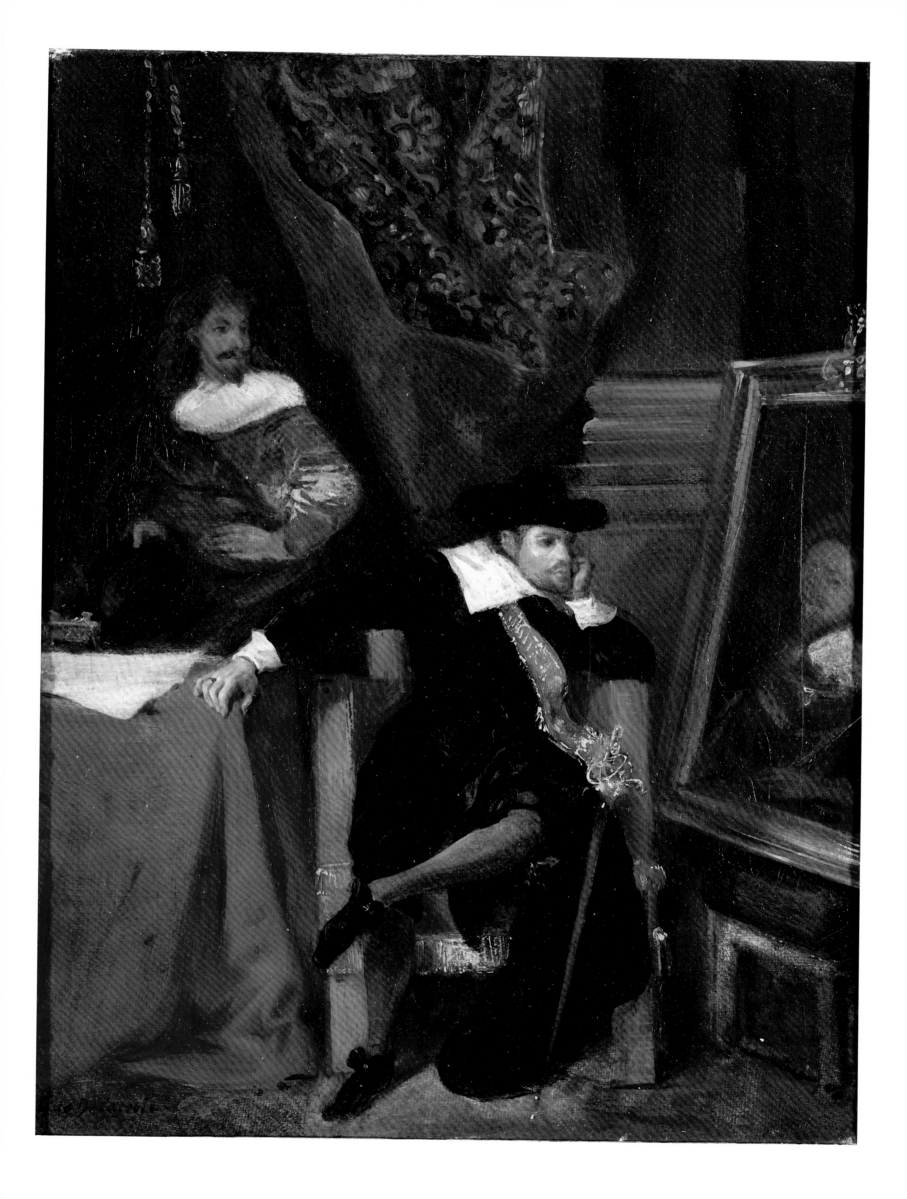

QUENTIN DURWARD AT LIEGE ca.1827–28
Oil on canvas, 24¾ × 20¼ in. (62.9 × 51.4 cm.)

Provenance: Probably commissioned by the Duchesse de Berry but never delivered; Bonington sale 1829, lot 222, bought Bone for Joseph Neeld; Joseph Neeld, and by descent (Christie's, 13 July 1945, bought Tooth); Mrs. Dudley Tooth, by whom given to the Castle Museum and Art Gallery in 1974.

Exhibitions: London, Cosmorama Rooms, 209 Regent Street, 1834, no. 56; Nottingham 1965, no. 293, pl. 44.

References: Douglas Cooper, "Bonington and Quentin Durward," *Burlington Magazine* (May 1946): 112–17; Pointon, *Circle*, 97.

Castle Museum and Art Gallery, Nottingham (74-76)

The most ambitious of Bonington's history paintings in its size and number of figures, this oil is an amplification of the 1825 watercolor illustration to chapter 19 of Walter Scott's novel *Quentin Durward* (no. 59). Of the many French and English illustrators of this novel, Bonington alone seems to have chosen this passage for pictorial treatment. In his unsympathetic account of the picture, Douglas Cooper criticizes the composition for its lack of pictorial grandeur and its seemingly prosaic exposition by comparison to Delacroix's *Execution of the Doge Marino Faliero* (fig. 34). More recently, Marcia Pointon has suggested David Wilkie's *Chelsea Pensioners* as a compositional model for the organization of this mob scene, and Hogarth, via Wilkie, for the near-caricature treatment of the figures. In general, however, the picture has attracted little scholarly notice.

Although one might query Bonington's selection of this particular episode for development on a large scale, his interpretation is more original than Cooper allows and faultless in conveying the dramatic intentions of the author. Considerable attention has been paid to historical decorum, to the characterization of the identifiable figures, and to the reactions of the mob, the artist having sought prototypes in broadcast Flemish sources. The heads of the portly Rouslaer and of the unidentified shouting man with upraised arm, as well as the pose of the inebriated ironmonger Hammerlein, who has fallen to the pavement, are based on graphite sketches after revelers in Rubens's *Village Festival* (Louvre),[1] from which Bonington also made watercolor copies (no. 61). A graphite study after three heads in Jacob Jordaen's *The King Drinks* (Louvre) is the source for the expression of the man brandishing his whip.[2] Durward's armor may be derived from a suit in Dr. Meyrick's collection or a half-suit in the artist's possession, of which an oil sketch exists.[3] The pose and dress of Rouslaer can be found, in reverse, in a graphite study of the fourth and fifth bas-relief of the eight-part,

outer choir screen at Amiens cathedral, which narrates the life of St-Firmin and which dates to the last years of Louis XI's reign (see fig. 13).[4] The concluding section of the screen, *St. Firmin Paraded through the Streets of Amiens prior to His Martyrdom*, proved the inspiration for the off-center placement and the composition of the principal figures of Durward and his two grasping companions. In fact, the entire composition, with its shallow, confined space, exaggerated foreshortening, and stepped arrangement of grimacing and near-grotesque heads is a tour-de-force of Gothicism inspired by late-fifteenth-century religious imagery; in particular, the St-Firmin cycle, and in general any number of engravings showing Christ taken prisoner or mocked, which invariably depict a stoic savior surrounded by jeering or fighting bystanders.[5]

By subtle paraphrase and more overt borrowing from works of art contemporary with the narrative setting or of complementary national origin, Bonington was attempting to infuse his representation with a historical authenticity beyond mere fidelity to external details of costume and setting. This was a more radical form of picturemaking than attempted by either the troubadour painters or their most popular beneficiary, Paul Delaroche, but has parallels in the work of Ingres (no. 144). Whether or not his audience perceived the extent or the iconoclastic wit of his quotations, it would be inappropriate to assess the merits of this conception, as is normally done, solely in terms of either baroque pictorial structures, which it denies, or nineteenth-century book illustration, which it transcends in the complexity of its allusions.

The dating of the picture remains problematic. The coloring and overt Gothicism recall *Anne Page and Slender* (ca.1825; fig. 38), probably his earliest figure subject in oils. The facture, however, has the assurance of the later history pictures. The contrapostal arrangement of the butcher Blok and the ironmonger Hammerlein indicates an advanced appreciation of Italian painting, such as Veronese's *Temptation of St. Anthony* (Musée des Beaux-Arts, Caen), which one does not expect until after the Italian sojourn. The new prominence given to Blok, who in chapter 21 slays the Bishop of Liège with his cleaver, is perhaps significant, and in all likelihood the picture is closer in date to Delacroix's oil *Murder of the Bishop of Liège* (begun 1827; Louvre), than to Bonington's own watercolor of 1825. Delacroix would later observe that toward the end of his life, Bonington "Seemed afflicted with depression, and particularly because of his keenly felt desire to paint large pictures. Yet he made no attempt, to my knowledge, to increase the size of his canvases; however, those in which the figures are the largest date to this period, notably the Henri III . . . which is one of his last."[6] *Henri III* (fig. 58) was certainly not painted until 1828, just prior to its exhibition at the Royal Academy in May, but its dimensions are virtually identical to those of *Quentin Durward at Liège*.

An untraced oil study for the composition representing a chronologically intermediate version was bought in repeatedly at the three final studio sales[7] and described in the second sale as "Quentin Durward with the rebellious liègois; this picture was the first of this subject painted by the artist — he made another for the Duchesse de Berry which has since been sold in London." That the Nottingham oil is identical to that commissioned by the Duchesse de Berry is almost certain. That it figures in the artist's posthumous studio sale in 1829 and is not mentioned in the catalogue published prior to the sale of the duchess's pictures following her precipitous flight to London in 1830,[8] could be explained by the conjecture that, although commissioned, it had never been paid for or delivered. In 1830 Delacroix was forced to reclaim, for reasons of default, two pictures commissioned by the duchess, including his *Quentin Durward and La Balafré*.[9]

1. Nottingham 1965, no. 130.
2. This study, with Phillips, London, 1988, was formerly in an album of drawings by Frederick Tayler, with whom Bonington shared his studio in 1826.
3. 1829 studio sale, lot 225, a partial suit of armour, bought Clarkson Stanfield; for the oil sketch, see Christie's, 16 November 1982, lot 50.
4. Private Collection.
5. Graphite studies of the grotesque peasants in Martin Schongauer's engraving *Christ Bearing the Cross* are in a private collection (fig. 65). Bonington's father may have owned an impression of this print. Lots 29–31, 119, and 178 of his 1838 print sale were impressions of Dürer prints and Marcantonio's copies of the *Passions*.
6. Delacroix, *Correspondence* 4: 287–88.
7. 1834, lot 146; 1836, lot 66; and 1838, lot 128, the last described as a study for the finished picture.
8. Paris, rue de Clery, 8 December 1830.
9. Johnson, *Delacroix* 1, no. 137, where dated ca.1828/9.

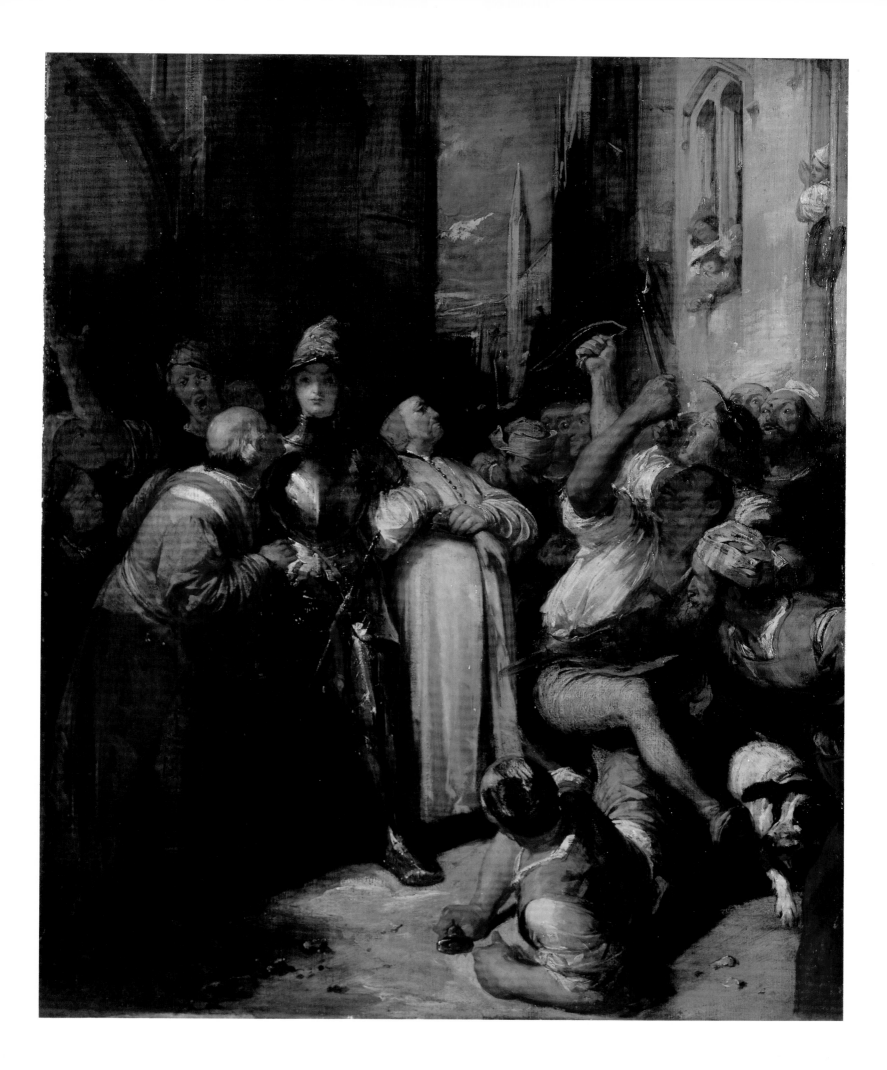

JEAN-AUGUSTE-DOMINIQUE INGRES
(1780–1867)

THE ENTRY INTO PARIS OF THE DAUPHIN,
FUTURE CHARLES V 1821
Oil on canvas, 18½ × 21¾ in. (47 × 56 cm.)

Inscribed: Signed and dated, lower left:
J. Ingres 1821

Provenance: Commissioned by Amédée-David
Comte de Pastoret (1791–1857); his daughter,
Marquise du Plessis-Bellière (Paris, 10–11 May
1897, lot 86, bought Haro); Frappier, Paris;
Besonneau d'Angers (Paris, 15 June 1954); Paul
Rosenberg and Co., by whom given to the
Wadsworth Atheneum in 1959.

Exhibitions: Possibly Paris, Salon, 1822, no. 719;
Paris, Salon, 1824 (not in catalogue); Petit
Palais, Paris, *Ingres*, 1967–68, no. 121, catalogue
by Daniel Ternois, et al., with complete
bibliographical citation.

References: Coupin, *Salon 1824*, 590; Edward
Bryant, "Notes on J. A. D. Ingres' 'Entry into
Paris of the Dauphin, Future Charles V',"
Bulletin of the Wadsworth Atheneum (Winter
1959): 16–21.

The Wadsworth Atheneum

In its subject, but most significantly in its
compositional format, this picture remains one
of the most neo-medieval of the small historical
and literary genre subjects conceived by Ingres
in the teens and twenties. Commissioned in
Florence, where Ingres was studying in 1821, by
Comte (later Marquis) de Pastoret, the painting
is also an exemplary piece of Bourbon
Restoration propaganda.

In March 1358 Charles, Duke of Normandy,
regent of France, and legitimate heir to the
throne, triumphantly reentered Paris after the
suppression of the Jacquerie, or peasants'
rebellion, which had threatened to annihilate
monarchal and aristocratic sovereignty. Jean
Froissart's chronicles furnished the narrative
description of the event, to which Ingres has
adhered faithfully. The future king would be
credited with the restoration of prosperity and
national unity after the decades of disasterous
military campaigns against the English which
preceded his reign. Parallels between the two
"restorations" were explicit, but an equally
felicitous motive for chosing this subject was
the Comte de Pastoret's avowed direct descent
from Jean Pastourel, the first president of the
Parliament of Paris, who remained loyal to the
Dauphin and is here represented as the central
figure greeting his sovereign's return to power.
The Comte de Pastoret had refused to work for
the Conseil d'Etat during the Hundred Days of
Louis XVIII's exile from Paris in 1815.

Although listed in the catalogue of the 1822
Salon, most of Ingres's biographers doubt that
the picture was finished and transported from
Italy in time to hang in that exhibition. It was
not listed as an entry in the 1824 Salon
catalogue, but pictures were constantly being
substituted during the course of that exhibition
and Coupin specifically cites the painting in his
Salon review of October. Among Ingres's other
pictures submitted in 1824 were *François Ier at
the Deathbed of Leonardo* and *Henri IV Playing with
His Children* (both Petit Palais, Paris; fig. 30),
both of which would subsequently inspire
Bonington, and *Vow of Louis XIII*, which was
proclaimed a triumph by most factions. Prior to
this Salon, Ingres's primitivism had been the
butt of the most abusive criticism, but in 1824
even this style would have seemed infinitely
preferable in conservative circles to those of
the younger painters like Delacroix or Xavier
Sigalon. Auguste Jal was more measured in
his overall assessment of Ingres's progress,
delighting for instance in *François Ier*, but, in
an oblique reference to this oil, questioning
Ingres's persistent "outré and gothic manner
that greatly impedes the development of the
richer qualities which nature has bestowed on
him. M. Ingres seems to be not of our century;
he speaks to us in the language of Ronsard, and
is astonished that we do not understand."[1]

Ingres's artistic intentions at this moment
were to combine his tastes for the Gothic and
the classical into an Italianate style of painting,
comparable to the German Nazarenes', that was
"mystical, simple, and grand," and that would
"give my works that beautiful unfamiliar
quality which has hitherto existed only in the
works of Raphael." On one of the preparatory
sheets of drawings for this picture (Musée
Ingres), he also wrote, "It is necessary to
compose like Raphael, that is to say, to adopt
his manner of proceeding, which was to
compose from nature and to concern oneself,
even in the composition of a hundred different
figures, first with the principal figures, as if the
others would not even enter into it."

This may indeed have been Ingres's
perception of Raphael's working method, but
the emphasis afforded the principal figures in
this picture is as much a consequence of the
elliptical processional arrangement, which owes
its immediate inspiration, as Ternois observed
in 1967, to Jean Fouquet's fifteenth-century
illuminations for the *Grandes Chroniques des Rois en
France* (Bibliothèque Nationale). Meticulously
researched details of costume, portraiture, and
heraldry were also borrowed from Montfauçon,
while recollections of the Raphaels, Mantegnas,
and Fra Angelicos that Ingres had before him in
Florence resound in the specific figure types.
Edward Bryant insisted on the influence of early
Renaissance depictions of Christ's entry into
Jerusalem, but a more plausible reference, if
such contextual transpositions were actually
part of Ingres's total program, might be
Cornelius Overbeck's large picture of that
subject, finished in Rome in 1824 but
commenced consideraby earlier.[2] In the 1967
catalogue Ternois downplayed any possible
religious allusions, but Ingres would have
appreciated that Fouquet's secular art was itself
based on such translations; furthermore, the
ultra-royalist de Pastorlet might have been
sympathetic to the notion of monarchal divine
right implied by such inversions. Ingres's *Vow of
Louis XIII*, in which the monarch is visited by
the Virgin and Child, could, in fact, be
construed as a less circumspect declaration of
that retrogressive position.

Bonington was probably oblivious to the
private symbolism of this picture, but as an
illustration to one of his favorite medieval
chroniclers, the painting would have keenly
interested him at precisely the moment when
he was about to take up the challenge of
anecdotal painting. Ingres's archeological
exactitude and his clever appropriation of a
chronologically authentic compositional
prototype as a solution to the problem of
organizing a medieval crowd scene were not lost
on the younger artist as he attempted such
subjects as *Quentin Durward at Liège*. Where the
two artists differ irreconcilably is in their
stylistic ideals. For Ingres, Raphael's firm
contours and polished touch were the *ne plus
ultra* of form and technique, while for Bonington
it was the bravura of later sixteenth- and
seventeenth-century masters that produced the
most profoundly emotive effects.

1. Jal, *Salon 1824*, 354–55.
2. K. Andrews, *The Nazarenes* (Oxford, 1964), pl. 20.

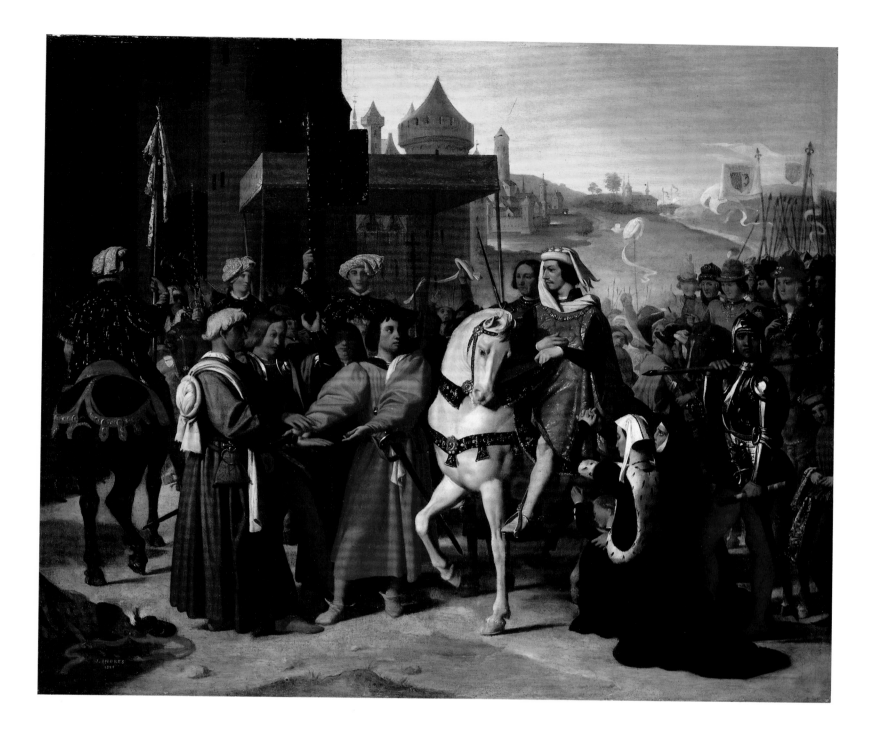

du Sacristain de Saint Angadresme.

du Braconnier.

la veillée des Fileuses.

du Jouvencel qui se marie à Madame Marie Mère de Dieu

Lith. de Villain, rue de Sèvres, 23.

145

LES CONTES DU GAY SÇAVOIR 1827
Lithograph on *chine collé*, $3\frac{3}{8} \times 3\frac{7}{16}$ in.
(86 × 87 cm.) (each image)

Inscribed: Each vignette titled: *de la Dame de
la belle Sagesse*; *du Sacristain de Saint-Angadresme*;
de la Dame sans merci; *du Braconnier*; *la veillée des
Fileuses*; *du Jouvencel qui se marie à Madame Marie
Mère de Dieu*

Provenance: Charles de Forget (d. 1873).[1]

References: Curtis, nos. 55–60.

Trustees of the British Museum
(1873-7-13-2714)

de la Dame sans merci.

de la Dame de la belle Sagesse.

The Gothic Revival had profound cultural ramifications throughout Europe and offered a wealth of new visual, literary, and thematic sources for artists of every persuasion. The troubadour style in France of the first quarter of the nineteenth century was simply one manifestation of this essentially anticlassical groundswell, although at its peak of popularity it remained thoroughly academic in its formal means, with the exception of Ingres's idiosyncratic archaism.

Coincident with this interest was a didacticism requiring ever more accurate reportage of historical facts. On one level, that was parlayed into the business of facsimiles of medieval manuscripts for those members of the general public who lacked the financial means to compete with such voracious collectors of pre-Renaissance art as Karl Aders in London and Alexandre Du Sommerard in Paris. Eugène Lami's *Hystoire et Cronicque du Petit Jehan de Saintré. . .collationnée sur les manuscrits de la Bibliothèque Royale* (Paris, 1830) was simply one of many elaborate illustrated publications of this type. In a phenomenon analogous to the Shakespeare craze in England at the end of the eighteenth century and emulating immediately the literary *supercherie* of Chatterton and Macpherson, the feverish pursuit of the Gothic also encouraged such French hoaxes as the "discovery" of the fourteenth-century poet Clotilde de Surville in 1804, a hoax prolonged by Charles Nodier's *Poésies inédites de Clotilde* (Paris, 1827), with engraved illustrations after the designs of Alexandre Colin. Less insidious were the pseudo-Gothic publications that imitated, in format, the annual keepsake volumes that had become popular in England — a collection of short stories, poems and sentimental engravings — and, in style, the verbal and visual languages of the medieval chronicle. Of this genre was the *Contes du Gay Sçavoir: Ballades, Fabliaux et Traditions du Moyen Age* (Paris, 1828), written entirely by the dramatist, and occasional necromancer, Férdinand Langlé (1798–1865) and illustrated by Bonington and Monnier with hand-colored pen lithographs in imitation of authentic manuscript illuminations like those in the *Hours of the Duc d'Anjou* (Bibliothèque Nationale).

As indicated in the book's concluding notes, the title was a variant of "gai science" — the medieval nomenclature for the "national literature of the troubadours." The publication also included a lexicon and explanations of the stories. The gesture of the *Dame sans merci*, for instance, is explained by the folk tradition of dropping a morsel of bread in running water on New Year's day to determine the fate of a lover. This reference, the dedication to the Duchesse de Berry "en janvier lorsqu'en voit la terre par les champs plus blanche qu'en oeuf," and the advertisements of 25 and 29 December 1827 in the *Journal des Débats* and *Le Globe*, confirm that the book was intended as a New Year's *étrennes* for the amusement of ladies and young girls.[2] Langlé would publish a second volume, *L'Histoire du Jongleur*, with illustrations by Monnier and Lami, the following year.

His prose lacks the ribald eroticism of Balzac's but otherwise anticipates the latter's *Contes drôlatiques* by five years.

Bonington's contribution consisted of a designed title page and the six vignettes on this sheet of *chine collé*, all of which would have been cut out, pasted to a page of letterpress, and crudely hand-colored by apprentices working for the publisher Lami-Denozan. As in most contemporary illustrations of this kind, the vignettes are set within Gothic architectural surrounds. Certain compositions like *du Sacristain* clearly allude to manuscript illuminations, while figures reminiscent of those illustrating Joseph Strutt's publication *Dress and Habits of the People of England* are deployed in others.

Without question, the collaborators on this project were partial to satire, and their stories and illustrations are occasionally both witty and topical in their allusions, but it would be inaccurate to describe this production as parody.[3] It is simply light entertainment that plays jocosely with an aspect of contemporary taste. It was not their intention to ridicule that taste or its association with Restoration propoganda, just as it was never Shotter Boys's intention to belittle their mutual friend Du Sommerard when he playfully inscribed within his lithographic representation of the recently founded museum of medieval art (now the Musée de Cluny, Paris) "Du Sommerard — Brocanteur."[4] The benignity of this phenomenon is implicit in Gautier's recollection of the character of his novella *Elias Wildmanstadius, l'homme moyen-age*:

Did he not belong with Lucas van Leyden, Cranach, Wolgemuth, Schoreel and Durer? There was nothing modern about this character, and to think of him as an imitation, a Gothic pastiche, would be wrong. This was a historical transposition, a spiritual change of venue, an anachronism; that's all. These inexplicable revivals of ancient motifs generated piquant surprise and quickly established the reputations for originality of the artists temperamentally disposed to them.[5]

1. Madame de Forget was Delacroix's mistress in the 1830s.
2. *Le Globe* wrote: "Il rappelle ces vieux missels sur vélin et ces antiques copiés des romans de la table-ronde que nos ancêtres offraient le jour de nöel en étrennes aux chatelaintes et aux demoiselles."
3. As Marcia Pointon has recently done; Pointon, 1986, 10.
4. Literally "Du Sommerard — Junk Collector." Du Sommerard's person and his passion for medieval art were the frequent butts of his friends' humor. J.-B. Isabey, whose caricatures Du Sommerard collected, portrayed his head as a kidney bean, while Vernet transformed his visage into a pear (tracings of both drawings by Eugène Devéria are in the Bibliothèque Nationale, rés. DC178K, Fol. I, 63). The most humorous caricature is Danton's plaster bust.
5. Gautier, *Histoire du romantisme*, 2nd ed. (Paris, 1874), 53. This was certainly true of Bonington's acquaintance Prosper Mérimée, whose earliest literary triumph, *La Guzla*, purported to be a collection of Illyrian folk ballads gathered by the author in the Balkans. Gautier's own novella was written to "illustrate" an engraved view of Nuremburg by Samuel Prout in the keepsake *Jeunes-France*.

146

NEWTON FIELDING (1797–1856)

THE HARE 1827
Watercolor, bodycolor, scraping out, and
gum arabic over graphite, 6⅛ × 8⅞ in.
(15.5 × 22.5 cm.)

Inscribed: Signed and dated, lower left:
Newton Fielding | 1827

Provenance: James Mackinnon, 1983–89,
from whom purchased by the Yale Center
for British Art.

Yale Center for British Art, Paul Mellon Fund
(B1989.19)

Newton Fielding was the youngest of four brothers who were all watercolorists, engravers, and drawing masters with professional ties to France. Theodore (1781–1851), Thales (1793–1837), and Newton were brought to Paris by d'Osterwald in 1821 to contribute watercolors and aquatints to his *Voyages pittoresques en Sicile* (1821–26) and *Excursions sur les côtes* (no. 14).[1] In 1823 Delacroix was installed in their rue Jacob atelier, where he painted portraits of both Thales and Newton. Although Theodore and Thales eventually returned to London, the business in Paris was conducted by Newton with the assistance of English apprentices until his death.

Of all the Fieldings, Newton was perhaps closest to Bonington, and two of Bonington's earliest watercolors, *Paris from the Meudon Road*[2] and a river scene (Musée Fabre; fig. 5), are exercises in the Fielding "house" style, of which the present watercolor is a later, although not appreciably more advanced, example. When Bonington returned to Dunkerque after a brief visit to Paris in July 1824, he traveled by way of Dieppe, where he had previously arranged to meet Newton, who was returning from a trip to London via the coast and the Loire valley. Newton's sketchbook from that excursion (Nottingham) indicates the speed with which one could travel from Calais (19 July) to Nantes (15 September), allowing for an entire week in Dieppe (21–29 August). A second Fielding sketchbook (Nottingham), used in the vicinity of Maintenon between July and October 1825, contains studies of cottages that anticipate Huet's and Bonington's interests in these subjects; notes on possible illustrations to La Fontaine that he would design in 1827[3]; a wash study in reverse for the hare in the Yale watercolor, on the same sheet as a profile portrait of a patrician hunter with his rifle (presumably his host); and sketches of a panoramic landscape similar to the background in *The Hare*.

By 1827 Fielding was well established in Paris as an *animalier* and sporting artist. In that year he was appointed drawing master to the household of the Duc d'Orléans, whom he probably also advised to purchase at the Salon Bonington's watercolor *Tombeau de St-Omer*. His own "frame" of unidentified watercolors at the Salon were undoubtedly similar in subjects to *The Hare* and were singled out for abuse by the critic of the *Journal des Artistes* (11 May 1828), who felt that English artists had pushed the technical means of watercolor painting too far. The traditional wash style was being increasingly "polluted" by admixtures of bodycolor and gum arabic, both employed in this example but not nearly to the extent found in Bonington's contemporary drawings. The resentment for this deliberate attempt to blur the distinctions between oil and watercolor painting was not peculiar to France, where the hierarchy of genres was especially rigid, but was shared by academic interests in London as well.

There is a pronounced whimsy to Fielding's animal drawings that is quite distinct from the drama of contemporary works by Edwin Landseer, Alexandre Decamps, Barye, and Delacroix, and that is thoroughly within the tradition of Thomas Bewick. It is this willingness to humorously scrutinize one's own or society's avocation that places him squarely within the circle of Bonington's closest associates and that almost certainly encouraged Delacroix to include boiled lobsters in his curious outdoor *Still-life with a Hare, Pheasant and Lizard* (Louvre). The tartan in that picture is probably a generic allusion to the rage in France for Scottish hunting, although it should be noted that one of the Fieldings seriously represented himself to Delacroix as a direct descendant of Robert Bruce, the fourteenth-century Scottish king.[4] Clearly relishing the prospect of exhibiting his oil at the 1827 Salon, when many of his friends were planning to submit serious sporting art, and when he was sending the *Death of Sardanapalus*, *Agony in the Garden*, and *Faust and Mephistopheles*, among other formidable creations, Delacroix wrote to Soulier on 28 September that "the amateurs have already been given a sneak preview and I think it will be quite amusing in the Salon."[5]

Compositions similar to *The Hare* appear in an aquatint set *Sporting Game*, published by Rittner in Paris in 1828, and in two sets of lithographs, *Croquis de Newton Fielding* and *Animals Drawn on the Stone*, published respectively by Motte and Gihaut in 1829. Evidence of Bonington's interest in sporting art is scant: a sheet of studies of a pointer (Private Collection) and his friendship with Frederick Tayler, who reported that a horse Tayler was portraying for Lord Seymour, a devotee of the *chasse* and a Bonington patron, broke its tether and nearly destroyed Bonington's studio in 1826.

Newton's influence on subsequent French painters resulted less from his own work than from the artists he trained and employed in Paris. William Callow, for instance, arrived in 1829 after a brief apprenticeship with Thales in London. Although generally considered a follower of Bonington, whom he claims never to have met, his earliest watercolor drawings are indebted to Boys and are remarkably similar to those of Huet. Many of Newton's larger and more ambitious watercolors were actually collaborative works, with Callow providing the backgrounds to Newton's animal vignettes. A number of Callow's landscape watercolors dated 1832–33 and copies by Delacroix after others are in a Delacroix sketchbook preserved in the Louvre.[6]

1. For the most detailed discussion of the family, see Pointon, *Circle*, 143ff.
2. Sotheby's, 10 July 1986, lot 108.
3. Mackinnon and Strachey, *Drawings*, 1983, nos. 21–22, and Musée du Louvre, Département des Arts Graphiques. These were published by Gauguin in 1829 as *Suite d'animaux, sujets tirés des Fables de la Fontaine*.
4. See Johnson, *Delacroix* I, no. 69.
5. Delacroix, *Correspondence* I: 197.
6. Sérullaz, *Delacroix*, no. 1739.

147

THE ABBEY ST-AMAND, ROUEN ca.1827
Watercolor, bodycolor, gum arabic, and washing
out, over graphite, $7\frac{5}{8} \times 5$ in. (19.2 × 12.6 cm.)

Inscribed: In graphite, upper right: *109*

Provenance: Bonington sale, 1829, lot 191, bought
3rd Marquess of Lansdowne; by descent to the
5th Marquess, from whom acquired by Agnew's;
Sir Geoffery Agnew, to 1988; Agnew's,
from whom purchased by the present owner.

Exhibitions: Agnew's 1962, no. 52; Nottingham
1965, no. 224.

References: Dubuisson and Hughes, repr. opp. 44;
Shirley, 116, pl. 143; Roundell, *Boys*, pl. VIII.

Private Collection

Established in the eleventh century and
magnificently endowed by a succession of
French monarchs, the Abbey St-Amand
formerly occupied the precinct between
St-Ouen and Rouen Cathedral. A victim of
desuetude, it was already beyond restoration by
the 1820s. A lithograph, similar in composition
but showing additional buildings to the right,
was contributed by Alexandre Fragonard to the
second Normandy volume of *Voyages pittoresques*
(plate 154). In the accompanying text, either
Nodier or Taylor seized the opportunity to
castigate the state for allowing such "sublime"
antiquities to be "prostituted to the most vile
usages and sacrificed to the most vile interests
by the most culpable cupidity"(p. 73).
A drawing by the artist Léon Feuchère (1804–
1837) similarly shows a structure rather than
trees to the right of the staircase,[1] as does a
second graphite drawing by either Boys or
Joseph West (Private Collection) that repeats

the general composition of, and certain details
unique to, Bonington's watercolor. That
drawing is probably a replica of Bonington's
untraced chalk study for no. 147.[2] A similar
view of the abbey was included by Boys in
his folio of chromolithographs *Picturesque
Architecture in Paris, Ghent, Antwerp, Rouen etc.*,
(London, 1839), in which he described the
complex at Rouen as a "heterogenous
assemblage of buildings, of various styles and
ages, inhabited by still more motley groups of
tenants." His composition is viewed from
further back, yet it has in common with
Bonington's watercolor the trees to the right,
while one of Boys's preparatory tracings for the
print also includes the washerwoman on the
stairs.[3] He had previously exhibited a
watercolor of this title at the Society of British
Artists in 1829.

This is one of Bonington's most sumptuous
late architectural drawings. It was possibly
painted at Rouen in 1827[4] or based on sketches
done much earlier, as was the case for the *Rue
Ste-Veronique* (no. 83), in which he also
substituted a stand of chromatically more
enticing trees for an existing masonry wall.

1. See W. Stechow, *Catalogue of Drawings and Watercolors
in the Allen Memorial Art Museum* (Oberlin College,
1976), fig. 24.
2. Bonington sale 1829, lot 95. The copy mentioned
here was sold at Bonham's, 4 August 1966, lot 43, with
an accompanying inscription to the effect that
Bonington had given the drawing to West in 1825.
A watercolor purported to represent the interior of
Bonington's studio (Pointon, *Circle*, fig. 18) is similarly
inscribed but is indisputably the work of West himself.
3. For the drawing, see D. Becker, *Drawings for Book
Illustration, the Hofer Collection* (The Houghton Library,
1980), 26a-d.
4. An untraced oil view of Rouen Cathedral was
exhibited at the 1827 Salon (catalogue no. 124;
56 × 50 cm. framed).

148

CLIPPER IN A HIGH SEA ca.1827
Watercolor over graphite, with scratching out,
$5\frac{5}{8} \times 7\frac{5}{8}$ in. (14.2 × 19.2 cm.)

Provenance: Edward Hull, by 1830; Henry
Vaughan; John Lewis Roget and descendents
(Sotheby's, 12 March 1987, lot 69, bought
Agnew's).

References: Harding, *Works* (1830).

Private Collection

The period bounded by the first studio sale
(June 1829) and the last (February 1838)
marked the zenith of the Bonington craze.
Most of the reproductive prints, such as S. W.
Reynolds's mezzotints of the figure subjects or
J. D. Harding's lithographic facsimiles of a
broader sampling of techniques, styles, and
subjects, were disseminated on both sides of the
channel early in the decade. Large selections
of his works were constantly before the public

in the exhibitions organized by his parents and in the collection sales of Lewis Brown and Sir Henry Webb, while artists and private collectors circulated watercolors and drawings widely among themselves.

J. D. Harding intended his portfolio of lithographs, including one after this watercolor, to serve as a testimonial to the artist's genius and as a manual for study. Almost immediately it became a ready source for copyists, both the earnest amateur and professional and the unscrupulous forger. Harding's own drawing style had benefited noticeably from such assiduous study, and he was never loathe to promote the honest copy. In a letter of 20 September 1832, for instance, he wrote to Rev. C. P. Burney, who had purchased several lots of drawings at the 1829 studio sale, "I have only a moment to say that I can now go to Spain without fear of the inquisition for I have fortunately discovered the long lost sketches by Bonington."[1] These and several of Bonington's drawings from his own collection he recommended to Burney's daughter Rosetta for copying.

Not everyone in Bonington's circle, however, greeted his ascendent reputation and its inevitable impact on landscape painting with the same proselytizing zeal. The sculptor David d'Angers would complain in a letter from Marseilles to Victor Pavie, "Instead of intriguing in Paris, instead of making pastiches of Bonington and the English, our artists ought

to be here in the face of sublime nature."[2] Ironically, Bonington's style had become a fashionable model of a particular aesthetic credo, as had been Jacques-Louis David's for an earlier generation, and the deleterious effects of slavish imitation on the progress of original art, the very point of d'Angers's complaint, was not lost on other critics. A more philistine but no less disturbing problem was that by 1831 there were already enough false Boningtons circulating in the marketplace for the editors of one art journal to publish in their first issue a complaint on the subject:

Having mentioned Bonington, perhaps I may be allowed to take notice of the many imitations of that excellent artist at present offered to the public as his productions, but which are, in fact, only got up by picture dealers for their own emolument" Real Boningtons" are daily brought forward, of course superior to all that have gone before, and the trumpt-up tale is too ingeniously and impudently told to excite suspicion. It is really lamentable to see men of unquestionable talent so infatuated as to embody in their works just so much as to lead the judicious eye to detect whence they borrowed their ideas.[3]

Two watercolor copies of this sheet, or of Harding's lithograph, have passed repeatedly for autograph Boningtons.[4] Both appear to be by the same hand and might be the work of the marine painter Charles Bentley, by whom we have signed copies of other Bonington marine subjects.[5]

In this exceptionally well-preserved watercolor, Bonington returned to the marine subject matter upon which his reputation was founded but which appears infrequently in the works of his last two years. A view of shipping off the coast near Genoa is another noteworthy example (Private Collection). Thoré also claimed that at least one marine was among the three watercolors exhibited by the artist during the second supplement of the 1827 Salon, which opened in February 1828.[6]

1. Manuscript letter postmarked 20 September 1832, Beinecke Rare Book and Manuscript Library, Yale University.
2. Quoted from H. Jouin, *David d'Angers: sa vie, son oeuvre, ses écrits et ses contemporaines* (Paris, 1878), 1: 250 (the original letter dated 22 August 1831).
3. *Library of the Fine Arts* 1 (February 1831): 59–60.
4. Private Collection (Christie's, 8 June 1976, lot 127, the verso inscribed: "[erased word] / by Bonington."), and Pilkington Collection, Eton College (Shirley, pl. 135), which enlarges the composition to the right by the addition of Calais pier, but which is virtually identical in coloring and in the scraping out of the highlights.
5. One such copy, privately owned, is after a marine watercolor in the Whitworth Art Gallery (Shirley, pl. 76).
6. Thoré 1867, 9. The published Salon catalogue lists "une aquarelle" as no. 1607, but the *enregistrement des ouvrages* (Archives du Louvre KK24) indicates that three watercolors were accepted under this number.

WINDMILLS IN NORTHERN FRANCE
ca.1827–28
Watercolor and bodycolor with gum arabic and
stopping out, $6\frac{1}{4} \times 8\frac{7}{8}$ in. (15.8 x 22.2 cm.)

Inscribed: Signed and dated, lower right:
R P B 18[illegible]

Provenance: L.-J.-A. Coutan (Paris, 19 April 1830,
lot 118, bought in); by descent to Madame
Milliet; Milliet, Schubert, Hauguet Donation,
1883.

References: Shirley, pl. 144; Pointon, *Bonington*,
fig. 51.

Musée du Louvre, Département des Arts
Graphiques (RF 1466)

The inscribed date is only partially legible, but
on the stylistic evidence the watercolor can be
situated in the last two years of the artist's life.

EUGENE ISABEY (1803–1886)

NEAR ETRETAT ca.1828
Watercolor and bodycolor over graphite,
8 × 12⅝ in. (20.2 × 32 cm.)

Inscribed: Signed and dated, lower right:
E Isabey 182[9?]

Provenance: James Mackinnon, London.

Private Collection

Eugène Isabey was to become the dominant painter and lithographer of marine subjects in France during the second quarter of the nineteenth century. His father was Jean-Baptiste Isabey (1767–1855), one of Europe's great portrait miniaturists, a pupil of David, an early promoter of lithography, a friend of Géricault and the Duchesse de Berry, court painter to Louis XVIII and Charles X, and, if that were not sufficient, one of the most successful and influential artists of the century. Eugène, whom he described as "mon fils, mon élève, mon ami," undoubtedly learned the techniques of watercolor and oil painting and of lithography from Jean-Baptiste, although his first marine watercolors of ca.1821 already exhibit an indebtedness to the English style. This interest he might have acquired from contact with British watercolorists active in Paris, for, like Bonington, he was associated with d'Osterwald's projects, or during his tour of England and Scotland in the entourage of Charles Nodier in autumn 1820. There is sufficient evidence to suggest that Bonington and Isabey were friends from about this date and that Bonington was instrumental in persuading him to become a professional artist, despite the initial misgivings of his father. The Isabey family connections would have been invaluable as Bonington endeavored to establish himself outside the official patronage structure.

Isabey's oil paintings of the 1820s are mostly untraced. Those exhibited in 1824 were described by Auguste Jal as small marines, fundamentally English in style, yet "firmer" in their effects and "less clumsy" in the modeling of the figures. The marine oils exhibited at the 1827 Salon, for which he was awarded a gold medal, have also disappeared but were generally described as "Anglo-Venetian" in style, which meant that naturalism and brilliant coloring were their principal virtues. Of his surviving early watercolors, however, there are a sufficient number to observe that those of the mid-1820s are often identical to Bonington's in their mannerisms of style. By the end of the decade Isabey had developed the more precise and neat technique of *Near Etretat*.

Etretat was one of Isabey's favorite sketching sites from 1820 onward. The present watercolor probably dates to the last two years of the decade and is essentially a "souvenir" composed in the studio. Its composition anticipates, in reverse, that of his celebrated oil *Port à marée basse* (Louvre), purchased by the state at the 1833 Salon. Although the critic Gustave Planche tended to publicly support the innovations of the younger marine painters, he was more guarded in his opinion of Isabey, who appeared as too dependent on English style: "Isabey is obstinate in his fecund indolence . . . poetry is absent . . . his color is false in its brilliance, he outrageously violates perspective and his unsteady cottages dance as if drunk."[1] Such criticism was far too severe, for whatever Isabey's faults, he was, even at the outset of his career, one of the most accomplished draftsmen of the century and probably the most original interpreter of English romantic landscape traditions.

1. Planche, *Salon 1833*, 221.

CROIX DE MOULIN-LES-PLANCHES 1827
Lithograph, $8\frac{1}{2} \times 7\frac{1}{4}$ in. (21.6 × 18.6 cm.)

Inscribed: In the stone, upper margin: *Pl. 77*; and lower margin: *R P Bonnington lithog.*; and: *Imprimé par C. Hullmandel*; and the title.

References: Curtis, no. 26.

Yale Center for British Art, Paul Mellon Collection (B1977.14.10773)

Of the nine lithographs drawn by Bonington for the two Franche-Comté volumes (1825–27) of Baron Taylor's *Voyages pittoresques*, only four are identified by inscriptions in the stones as based on sketches by Charles Ciceri, Jean Vauzelle, or Taylor. This has led to speculation that Bonington may have toured the region after 1825 and drawn his own studies for the other plates. Although the artist did rapidly traverse the Franche-Comté en route to Italy, it is almost certain that he never made a special tour in connection with the baron's commission and that the remaining five lithographs were also improvisations on sketches and verbal descriptions furnished by Taylor and Nodier. The latter were already familiar with the region when, in July 1825, Urbane Canal commissioned them, together with Victor Hugo and Alphonse de Lamartine, to collaborate on an illustrated, narrative, and poetic tour to Mont Blanc. Taylor was charged with providing eight designs to be engraved in London. The travelers, without Lamartine, who refused to leave his natal refuge at Mâcon, made their circuit in August and September, stopping at Tournus, Chamonix, and eventually Brou (11–12 August), Château d'Arlay and Moulin-les-Planches (30 August), a hamlet south of Orgelet on the Ain river. With the exception of material later culled for the *Voyages pittoresques* volumes, a rhapsodic appreciation of Mont Blanc by Nodier, and an unpublished diatribe by Hugo cited previously (see no. 28), little came of Canal's commission.[1]

A composition study and a sheet of details for this lithograph (Musée des Beaux-Arts, Besançon) are probably Taylor's on-site sketches. The figures in the lithograph are Bonington's inventions. That Taylor should not be credited in this or the other lithographs is not so anomalous. An extra-illustrated volume of *Normandie I* (Yale Center) includes unpublished lithographic "croquis" by Taylor that were transformed by professional lithographers into the more finished illustrations issued with the text, often without any acknowledgment of Taylor's contributions.

Bonington may have begun work on the Franche-Comté stones as early as November 1824. In a letter to Colin dated the first of the month, he thanked his friend for meeting with Baron Taylor and for sending "necessary materials."[2] The work progressed sporadically through 1825, after which Bonington turned his attention to other matters. It was resumed again in 1827.

Nodier's explanation for including an illustration of this remote and minor Renaissance monument is indicative of the great charm and the serious purpose of the *Voyages pittoresques*: "We desired to reproduce it, because the extreme delicacy of its carving made us apprehensive that the polution in the air would rapidly destroy this elegant monument"(p. 91).

1. For a full account of this project, see Hugo, *Oeuvres complètes*, 2: 555–72; 1542–71.
2. The manuscript letter is now in the Institut Néerlandais, Fondation Custodia, Paris.

Pl. 77

R. P. Bonnington del.

Imprimé par C. Hullmandel.

Croix de Moulin les Planches.

152

THE PONT DES ARTS AND ILE DE LA CITE FROM
THE QUAI DU LOUVRE, PARIS ca.1827–28
Oil on millboard, 14 × 17¾ in. (35.6 × 45.1 cm.)

Provenance: Bonington sale 1834, lot 141, *View of
the Pont des Arts from the quay of the Louvre — a
capital sketch*, bought Sibley; possibly Sir Henry
Webb (Paris, 23–24 May 1837, lot 41, *View of
Paris, unfinished*); James Price (Christie's, 15 June
1895, lot 37, bought Agnew's); P. Ralli, by
whom bequeathed to the Tate Gallery in 1961.

Exhibitions: London, Cosmorama Rooms, 209
Regent Street, 1834, no. 20.

The Tate Gallery

At first glance this unfinished picture on Davy
millboard is reminiscent of the Italian sketches,
yet the compositional device of balancing
sharply contrasted areas of deepest shadow and
brightest highlights is most prevalent in the
watercolors and oils of 1827–28. Somewhat
unusual, in that it is not necessarily dictated by
the subject, is the very emphatic linear
perspective by which the receding diagonals,
converging strictly on the point of intersection
of the bridges and barge rudder, propel the eye
into the area of most pronounced contrast.
Such a system is not present in Bonington's
watercolor version of this view.[1]

1. Private Collection; formerly the collection of Lewis
Brown (Paris, 1837, lot 29); reproduced in Shirley,
pl. 133. A version by T. S. Boys, dated 1830, was at
Sotheby's, 12 March 1987, lot 35.

LERICI ca.1828
Oil on millboard, 14 × 18 in. (35.5 × 45.7 cm.)

Inscribed: Verso: R. Davy label

Provenance: Bonington sale 1829, lot 217, as *Painting of a castle in the Mediterranean*, bought Sir Thomas Lawrence; Lawrence sale (Christie's, 17 June 1830, lot 29, bought Lord Northwick); Northwick sale (Christie's, 12 May 1838, lot 54, as *Sea View — Morning. It represents the castle and part of the fine bay of Spezia near Genoa; and was painted for Sir Thomas Lawrence*, bought B. Smith); Francis Baring, by 1907 (Christie's, 4 May 1907, lot 12, bought Agnew's); Sir Gervase Beckett, by 1920 (Christie's, 23 July 1920, lot 44a, bought King); Anonymous (Sotheby's, 12 March 1980, lot 122, bought Feigen).

Exhibitions: Nottingham 1965, no. 275.

Richard L. Feigen, New York

According to Valery, "The new road from Sarzana to Genoa, so sweetly varied and picturesque, recalls at every step the remark of Plutarch, a moralist who loved to select images from navigation, that the most agreeable journeys by land are those along the seaside, and when we embark at Lerici, that the pleasantest sea voyages were those made along the coast."[1]

Both oil versions of this composition (see no. 102) were in Bonington's studio at his death and correctly described in the 1829 sale catalogue as a "sketch" and a "painting," respectively. The sketch was painted on the spot. This more elaborately composed version, with its figure of Rivet sketching in the foreground, was intended as a finished picture, possibly commissioned in spring 1828 or earlier but unclaimed at the time of the artist's death. Whether the work was requested by Lawrence, to whom Bonington had shown several undescribed studies in the spring, as the annotation to the Northwick sale catalogue suggests, is uncertain. When acquired by its present owner, the picture was still in its original frame. Having never been revarnished and protected by its glazing, it remains one of the best preserved of Bonington's oils.

An engraving of this version by Charles G. Lewis was published by Hodgson, Boys, and Graves (12 August 1834) as *Bay of Spezzia*.

1. Valery, *Voyages*, 674.

154

GRAND CANAL, THE RIALTO IN THE
DISTANCE — SUNRISE ca.1828
Oil on canvas, $17\frac{1}{8} \times 24$ in. (43.3 × 61 cm.)

Provenance: Sir Robert Peel, 2nd Bt., by ca.1836[1];
Sir Robert Peel, 3rd Bt. (Robinson and Fisher,
11 May 1900, lot 237, as *A View on the Grand
Canal, Venice*, bought Duveen); Leggat Brothers,
1951; Mrs. J. A. MacAulay, by 1965; Hirschl
and Adler, New York, 1980; Anonymous
(Sotheby's, 8 March 1989, lot 94, bought
Feigen).

Exhibitions: Nottingham 1965, no. 282, pl. 41.

References: S. C. Hall, *The Book of Gems* (London,
1838), engraving by J. Miller, opp. 41.

Richard L. Feigen, New York

The resonant palette and chiaroscuro, markedly
more dramatic in their effects than the uniform
blond tonality of most of the oil sketches
painted in 1826, are exemplary of Bonington's
evolving formal ideas during the final twelve
months of his life. The composition adheres
descriptively to a meticulous graphite rendering
(Bowood),[2] which lacks only the shipping and
any meteorological information. Although the
picture has always been described as a sunset on
the Grand Canal, the axis of recession is
actually nearly due east, from the Grimani and
Bernardo palaces to the distant Rialto and
tower of S. Bartolemmeo. This distinction
would account for the cooler morning light that
bathes the facades, and the movement of the
barges, laden with provisions, toward the
mercantile heart of the city. The prospect was
taken from the *traghetto* at the Palazzo Corner-
Spinelli.

This finished easel painting does not appear
in any of the studio sales,[3] and it was
undoubtedly either commissioned by Sir Robert
Peel, the great statesman and collector, or
acquired on his behalf from the artist by
William Seguier, who generally acted as Peel's
advisor.

1. *Sir Robert Peel's Manuscript Inventory of His Gallery of
Paintings* (Surrey Record Office, ca.1836), no. 1, *View in
Venice*.
2. Dubuisson and Hughes, repr. opp. 171.
3. The only possible candidate would be a *View in
Venice*, 1829 sale, lot 220, which was purchased by Lord
Charles Townshend and subsequently described in his
sale (Christie's, 11 April 1835, lot 18) as *View of a canal
in Venice. A capital finished picture* (bought Nieuwenhuys).
A picture in a private French collection with a later
inscription identifying it as the Townshend oil
represents the old wharf and S. Trovaso on the
rio S. Trovaso. Although not by Bonington, the oil
probably replicates a lost original.

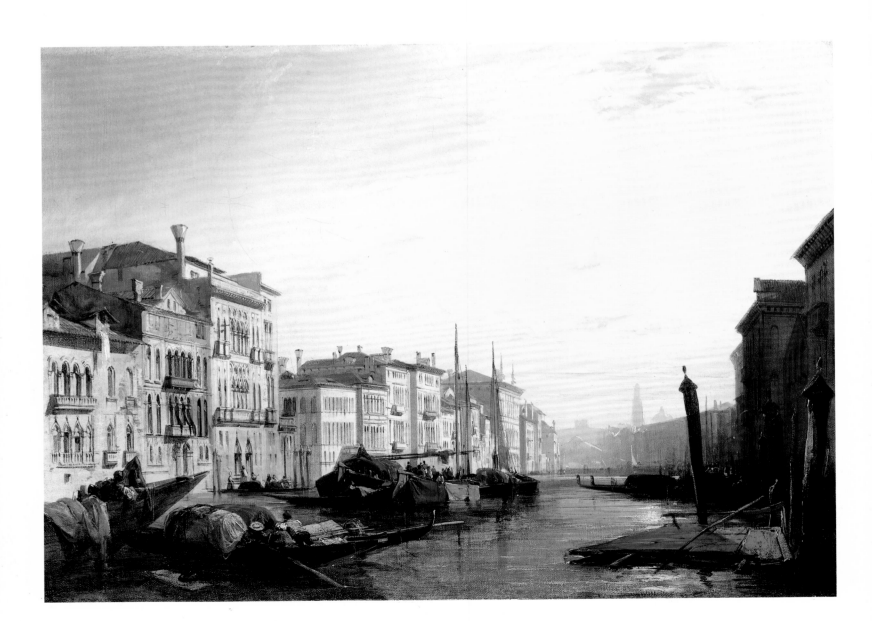

155

CORSO SANT'ANASTASIA, VERONA 1828
Oil on wood panel, $23\frac{5}{8} \times 17\frac{3}{8}$ in. (60 × 44.2 cm.)

Provenance: Bonington sale 1829, lot 110, as *A highly finished view of the Palace of Count Maffei at Verona*, bought Marquess of Stafford; by descent to Lord R. Sutherland Gower (Christie's, 26 January 1911, lot 32, bought Gooden and Fox); D. C. Erskine, 1911 to 1922 (Sotheby's, 28 July 1922, lot 19, bought Leggatt); purchased in that year from Leggatt by "Mr. Perman" (P. M. Turner ?); Mrs. D. Turner (Christie's, 16 July 1965, lot 90, bought Paul Mellon).

References: Harding, *Works* (1829); Dubuisson and Hughes, 87, 202, 204; Shirley, 148, 152.

Yale Center for British Art, Paul Mellon Collection (B1981.25.58)

In a letter of 25 April 1829 to Samuel Prout outlining plans for the auction of his son's studio effects, Bonington's father advised his correspondent: "The picture of Verona I should wish you to keep until I have the pleasure of seeing you, when everything shall be done satisfactory to all parties, as it is my intention at all times as far as lies in my power to be governed in all my actions by that excellent moral of our divine law given 'Do unto others etc.' "[1] From this it is evident that the Yale panel had been commisioned but not paid for by the time of the artist's death. One of the few finished oils to be auctioned in 1829, it was acquired by the Marquess of Stafford, whose extraordinary collection of old masters Bonington might have seen in 1825. It may very well be the last painting that Bonington completed before the onset of his fatal illness in July.

Incorporating the processional motif and specific figures from his larger *View of the Ducal Palace* (Tate Gallery; fig. 46), the composition is an elaboration of that sketched in watercolor in Italy (no. 87) and essayed in a smaller oil version (Private Collection).[2] The latter had been forwarded to Domenic Colnaghi in October 1827 with the note:

Availing myself of the kind offer of Mr. Pickersgill, I have forwarded to you a small painting in the hope of completing the order you honor'd me with, when in England last. I must beg you to look with charitable eyes, at least till you may see it in a frame or varnished — the subject is a street in Verona, the building that advances is the Casa Maffei.[3]

Indulging in typical romantic pessimism over the decay of Italian civilization, Maria Callcott lamented the "neglected state" of Verona's public buildings in an essay accompanying Cooke's engraving after the watercolor version.[4] Closer in sentiment to Bonington's transcribed impressions, however, were those of William Hazlitt: "Its streets and squares are airy and spacious; but the buildings have a more modern and embellished look [than Ferrara], and there is the appearance of gaiety and fashion among the inhabitants."[5] In 1825 David Wilkie observed in a letter to the landscapist William Collins that in Italy "everything is seen clearer...the sky is bluer, the light is brighter, the shadows stronger and colours more vivid."[6] French critics as disparate in their allegiances as Stendhal and Delécluze repeatedly criticized artists returning from a sojourn at the academy in Rome for forgetting this fact and for lapsing almost immediately into a mode of depicting Italian sites as if tinted by the drab atmosphere, and under the leaden skies, of the Bois de Boulogne. In Bonington's last works, there is an opposite tendency toward an almost decorative intensification of color and chiaroscuro.

1. Dubuisson and Hughes, 87.
2. Christie's, 15 July 1983, lot 41, repr.
3. Dubuisson and Hughes, 78.
4. *The Gem* (London, 1830).
5. Hazlitt, *Notes*, 276–77.
6. Cunningham, *Wilkie* 2: 200–1.

156

LES SALINIÈRES NEAR TROUVILLE ca.1828
Oil on millboard, $8\frac{1}{2} \times 13\frac{1}{2}$ in. (21.6 × 34.3 cm.)

Provenance: Lady Binning, by whom bequeathed to the National Gallery of Scotland.

References: Roundell, *Boys*, pl. 7; Peacock, pl. VI; Pointon, *Bonington*, fig. 14; Cormack, *Bonington*, pl. 102.

National Galleries of Scotland, Edinburgh

Although it offers no traceable history before its acquisition by the National Gallery, this oil sketch has been accepted unqueried as the work of Bonington in all recent literature. In support of this ascription is a graphite and wash study of a related composition, inscribed on the verso: "Drawn for me by R. P. Bonington to show me the place of Chancre, 1826, Rue des Martyrs. Thos. S. Boys."[1] This was probably drawn from memory in the fall in anticipation of some excursion to Normandy that Boys was planning for himself. Certainly Bonington would not have made the watercolor if the Edinburgh sketch were still in his possession and if his intention were simply to illustrate for Boys a site of particular interest.

Boys's version of the composition[2] echoes Bonington's description of the middle distance, but it introduces compositional features shared only with the Edinburgh oil — an elevated horizon line, smoke rising from the building to the right, and the entire foreground with its tidal rivulet, bank, and projecting timbers. It would appear that Boys's watercolor is either a pastiche of the two compositions attributed to Bonington, a plein-air study from approximately the same vantage point as the oil, or a model from which the oil sketch derives. In any case, the usual early dating of the oil cannot be maintained, as it bears little resemblance to the conceptually coherent group of plein-air sketches of late 1825, when Bonington actually

visited Trouville, or to the Italian sketches of mid-1826. Since no landscape sketches of comparable style are known, one would be inclined to associate this study with Roqueplan or Huet, if such a determination were based on the resonant juxtapositions of greens, aquas, and Prussian blues, on the dramatic slice of impasted white in the middle ground, and on the impetuous treatment of the sky; however, there are parallels in Bonington's watercolors of 1827–28 (nos. 162, 165)[3] and in the backgrounds of figure paintings such as *Amy Robsart and Leicester* (no. 141) that are sufficiently persuasive to sustain the attribution but to situate the sketch chronologically near the end of the artist's life. It could be a studio improvisation based on Boys's version, although Bonington may have visited Trouville in 1827 or 1828. Both Huet and Isabey frequented Trouville during those years,[4] but the Edinburgh picture, for all its bravura, is too tectonic and constrained to be the product of either hand.

1. Private Collection; Roundell, *Boys*, pl. 5.
2. Roundell, *Boys*, pl. 6.
3. The watercolor frequently titled *Near Burnham* (Agnew's, *English Watercolours*, 1990, no. 69, repr.) is another appropriate comparison.
4. See, for instance, Huet's signed and dated oil sketch *Beached Boats at Trouville* (Sotheby's, 20 June 1984, lot 377, repr.)

STUDY OF A SEATED WOMAN ca.1827
Graphite (verso: graphite offset of a caricatured
head), $7 \times 5\frac{1}{8}$ in. (17.5 x 13.1 cm.)

Provenance: P & D Colnaghi, 1969, from whom
purchased by Paul Mellon.

Yale Center for British Art, Paul Mellon
Collection (B1975.4.70)

Pen sketches of the same unidentified woman
are in the National Gallery of Victoria and,
similarly posed, the Ashmolean Museum.
Two other graphite studies of the sitter, three-
quarter-length seated, are also known.[1]
The graphite drawings would appear to be pose
studies for the single figure in the oil painting
called either *The Green Skirt* or *Le Billet Doux*,[2] as
it was titled in S. W. Reynolds's 1829 mezzotint
reproduction of it. Although depicted in
seventeenth-century costume, the woman in the
genre painting has the same facial features as
this sitter. Another pen sketch of an idealized
female type in seventeenth-century costume,
which Bonington drew for the daughter of his
London host in January 1828, is a variation on
the pose used in the oil, as well as on the
arrangement of the seated figure of Marie de'
Medici in the oil *Henri IV and the Spanish
Ambassador* (Salon, February 1828). The drawing
technique of the Yale sketch, rapid and
somewhat dense and angular in the shadows, is
also identical to that of the studies after a figure
in Adriaen van de Venne's *Fête donnée à l'occasion
de la Trêve de 1609* (Louvre), which has long
been recognized as the source for the courtier in
the Salon picture.

 This woman was undoubtedly more than a
casual acquaintance, since she sat for the artist
in different contemporary dresses and since
several of the pen sketches of her are actually
portraits rather than pose studies. She could be
a professional model, but in all likelihood she
was one of the artist's friends, such as a
daughter of Rev. Edward Forster, the
Protestant minister in Paris whom Bonington
had befriended several years earlier and whose
wife, Lavinia Banks, furnished him with the
letters of introduction to Sir Thomas Lawrence
in 1827 and again in 1828. The sudden death of
one of Forster's daughters in 1828 is reported to
have greatly distressed the artist.[3]

1. With Colnaghi in 1969, and The Wadsworth
Atheneum.
2. Johnson, *Review*, fig. 54. For the figures in his very
last history paintings, Bonington began to rely more on
rapid pose studies from live, clothed models and less on
figures borrowed from painted or engraved sources.
3. "Memoir of Richard Parkes Bonington," *Library of
the Fine Arts* (March 1832): 208. Forster also died in
spring 1828.

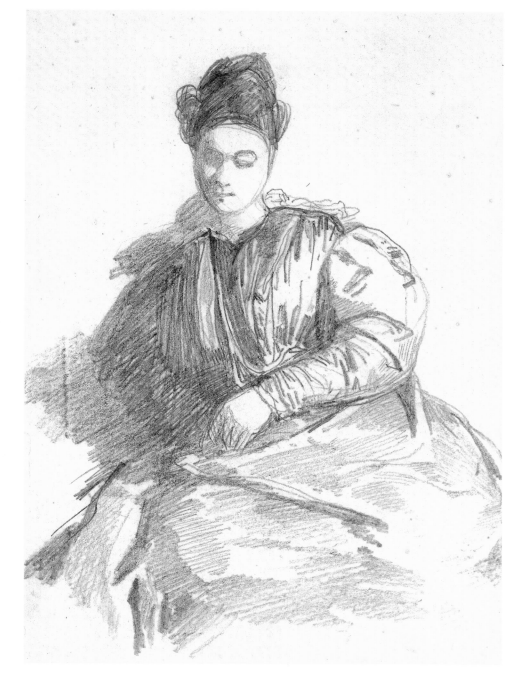

158

STUDIES OF EDMUND KEAN AS
SHYLOCK ca. 1828
Pen and brown ink on two joined sheets of laid
and wove paper, the right side made-up and
primed with white, 9 × 14 in. (22.5 × 35 cm.)

Inscribed: In pen and brown ink, on cropped
mount, lower left: *in Shylock etc*; and lower right:
Bon; stamped, lower left: *SG* (not in Lugt);
watermark of left sheet: *1821*

Provenance: Bonington sale, 1838, lot 11;
Sutton Palmer; Percy Moore Turner, by 1937;
Jacques Seligmann, from whom purchased by
Paul Mellon in 1962.

Exhibitions: BFAC 1937, no. 77.

References: Shirley, 99, pl. 73.

Yale Center for British Art, Paul Mellon
Collection (B1977.14.6104)

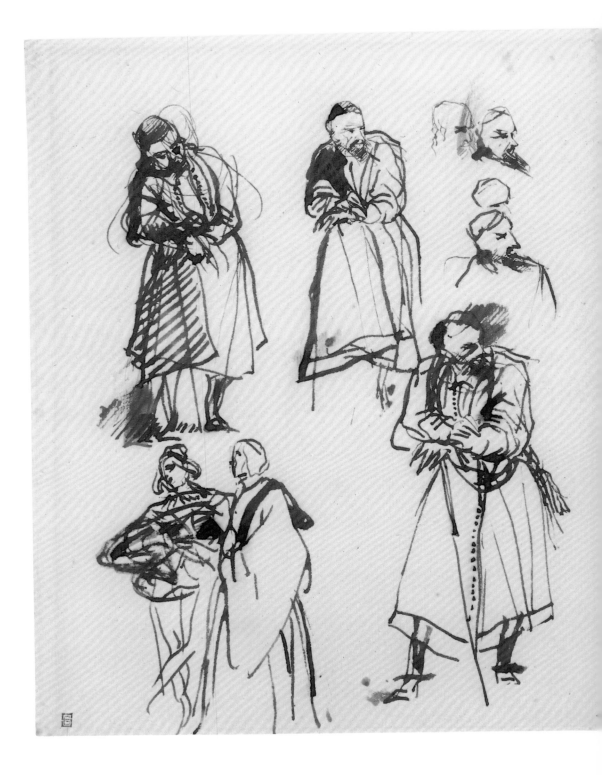

After a disastrous attempt to introduce English theater to Paris in August 1822,[1] a second campaign was mounted successfully by Baron Taylor, under the patronage of the duc d'Orléans, at the Théâtre-Français in autumn and spring 1827–28. A three-month engagement commenced on 9 April with John Kemble, William Macready, and Miss Smithson as the principal cast in predominately Shakespearean productions. In May Edmund Kean, whose arrival was eagerly anticipated, replaced Macready and performed in succession the parts of Richard III (12 May), Othello (16 May), and Shylock (23 May). His final appearance as Shylock was reported on 20 June.[2]

Edmund Kean (1787–1833), the romantic embodiment of thespian virtuosity whom the noted French actor François-Joseph Talma described as a "magnificent uncut gem," made his sensational debut at Drury Lane in the Shylock role in 1814. William Hazlitt, who admired Kean immensely, recalled this momentous event in March 1828:

Fourteen years ago we desired to go see a young actor from the country attempt the part at Drury Lane; and, as we expected, add another to the list of failures. When we got there, there were about fifty people in the pit, and there was that sense of previous damnation which a thin house inspires. When the new candidate came on, there was a lightness in his step, an airy buoyancy and self-possession different from the sullen, dogged, goal-delivery look of the traditional Shylocks of the stage. A vague expectation was excited, and all went on well; but it was not till he came to the part, when, leaning on his staff, he tells the tale of Jacob and his flock with the garrulous ease of old age and an animation of spirit, that seems borne back to the olden time, and to the privileged example in which he exults, that it was plain that a man of genius had lighted on the stage.[3]

Kean was to play Shylock regularly thereafter, and it was in this role that Delacroix, probably in Bonington's company, saw him perform on 2 July 1825 in London. That experience profoundly impressed Delacroix, who made a drawing of the actor in costume.[4]

On 15 June 1828 Hazlitt used some adverse French criticism of Kean's performance as an excuse to castigate, yet again, French taste:

Mr. Kean stands alone, — is merely an original; and the French hate originality: it seems to imply that there is some possible excellence or talent that they are without. Besides, it appears that they expected him to be a giant. Mon Dieu, qu'il est petit! — he is diminutive it is true: so was the Little Corporal: but since the latter has disappeared from the stage, they have ceased to be a great nation.[5]

This was grotesquely unfair as, in general, the French press was generous to a fault in its praise of the actor and the company.

Drawn from life on scraps of writing paper with the rich brown nut-oil with which Bonington was then experimenting,[6] this double sheet of studies is one of the artist's most spontaneous drawings, capturing the essence of Kean's brilliant mannerisms with an exuberance of touch and observation that belies Bonington's own physical incapacitation.

1. See Delécluze, *Journal*, September 1827.
2. For notices and reviews, see *Journal des Débats*, 19 May and 23 June 1828, and *Revue Encyclopédique*, 36 (May 1828): 354–56.
3. Hazlitt, "Actors and the Public," *The Examiner*, 16 March 1828 (*Complete Works* 18: 376–77).
4. Sérullaz, *Delacroix*, no. 542, as probably an illustration to *Faust*; the figure is more plausibly identified as Shylock in G. Doy, "Delacroix et Faust," *Nouvelles de l'estampe* (May–June 1975): 18–23.
5. Hazlitt, "Mr. Kean," *The Examiner*, 15 June 1828 (*Complete Works* 18: 416).
6. In a letter of 5 May (Royal Academy), Bonington mentioned sending a sample to his friend John Barnett.

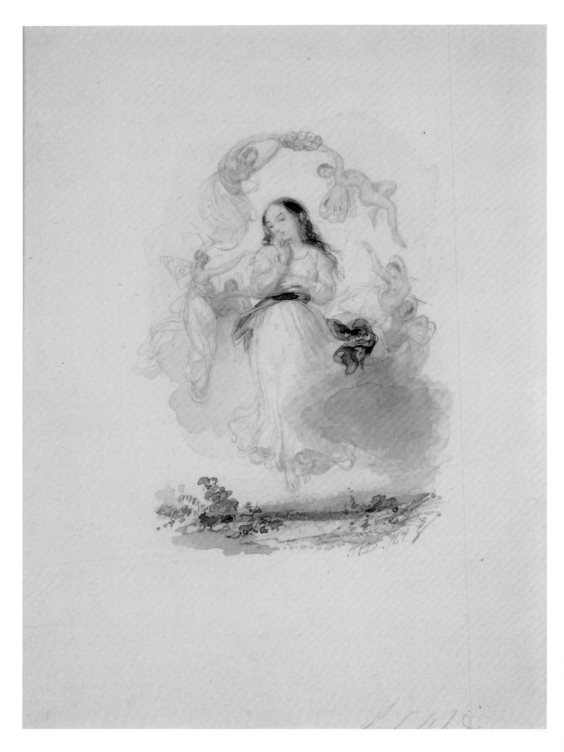

Of the three Bonington illustrations, *The Swallows*, *The Sylph*, and *The Storm*, only the first was engraved. For the poems *La Sylphide* and *L'Orage*, Perrotin selected designs by Achille Devéria and N.-T. Charlet. The Devéria illustration was a variant of a design used earlier when *La Sylphide* was published in the first volume of Soulié's *Keepsake Français* (1830). In both instances, Devéria offers an unimaginative, literal interpretation of Béranger's sylphide as a contemporary *grisette* casually reclining in modern finery on a draped divan. This female type appears frequently in the Devéria brothers' works, but perhaps never more successfully than in the oil *Young Women Resting* (1827; Louvre).

J.-M. Roulin has analyzed in detail the typology of the female sylph in French romantic literature.[3] Beginning with Nodier's *Trilby*, the mythic type finds expression repeatedly in the poetry of Hugo and Béranger, in Chateaubriand's *Mémoires d'outre-tombe*, in Gautier's *Spirite*, and, most popularly, in Nourrit's ballet *La Sylphide*, first staged in March 1832. In her earliest manifestations, the sylphide tended to be an aerial figuration of ideal feminine beauty, who, as in Béranger's verse, is capricious and vulnerable, a real but inaccessible embodiment of romantic femininity. Bonington's conception admirably conveys the paradox of this being's elusive reality, and, in her costume, crown of roses, winged companions, and levitation "on the points" anticipates to a remarkable degree the basic visual and technical components of Nourrit's production, in which Marie Taglioni danced the principal role. The costumes for that production were actually designed by Lami.[4] Some connection between Bonington's own conception of the sylphide's attributes and contemporary dance is suggested by the poses of the winged sylphs, which appear to derive from pen studies of a dancing female (no. 122).

1. BN Bonington Dossier.
2. Two days after Perrotin advertised his new edition, Baudouin advertised in the *Journal des Débats* his own edition with illustrations by Devéria and Monnier.
3. Roulin, "La Sylphide, rêve romantique," *Romántisme* 58 (1987): 23–38.
4. Alfred Chalon's lithographic portrait of Taglioni in *La Sylphide* (1832) depicts the dancer in the prototype of the modern tutu, a billowy, short-hemmed silk tulle affair in white.

159

LA SYLPHIDE ca.1828
Brush and brown ink over graphite, $6\frac{1}{4} \times 4\frac{1}{2}$ in. (15.6 × 11.4 cm.)

Inscribed: Signed and dated, lower right: *RPB 1828*; in graphite, upper left: *110*; and in ink, lower right: *La Sylphide*

Provenance: Bonington sale, 1829, lot 96, with another sepia sketch titled *The Storm*, bought Marquess of Lansdowne; by descent to the present owner.

Exhibitions: Agnew's 1962, no. 81; Nottingham 1965, no. 193.

References: Shirley, 118, pl. 154; Miller, *Bowood*, 46, no. 173.

The Earl of Shelburne, Bowood

Following all previous authorities, James Miller mistitled this drawing *The Sylph and the Storm*. The confusion has resulted from the listing in the 1829 studio sale catalogue of two separate illustrations as one lot. Only *The Sylph* went under the hammer to the Marquess of Lansdowne; *The Storm*, withdrawn for unspecified reasons, reappeared as lot 13 in the 1834 studio sale, where it was purchased by Edward Vernon Utterson.

In a memorandum Atherton Curtis mentioned the existence of a manuscript note in Bonington's hand to the publisher Perrotin offering three illustrations for the latter's edition of *Les Chansons de Béranger*.[1] Perrotin's edition was advertised on 19 April 1828 in *Journal des Débats* as "a completely national enterprise," employing only the best French artists and engravers.[2] The final publication was delayed until 1834 because of a succession of government censorship actions against it.

ON THE STAIRCASE 1828
Watercolor and bodycolor, $7\frac{3}{4} \times 5\frac{5}{8}$ in.
(19.8 × 14.3 cm.)
Inscribed: Signed and dated, lower left:
R P B / 1828

Provenance: Richard Seymour Conway, 4th
Marquess of Hertford, to 1870; his son, Sir
Richard Wallace, to 1890; Lady Wallace to 1897,
by whom bequeathed to Sir John Murray Scott
(Christie's, 27 June 1913, lot 2, bought Arnold
and Tripp); possibly Sarah Barclay (Christie's,
4 May 1914, bought Squire Gallery); H. A.
Robinson (Christie's, 9 July 1920, bought
Agnew's, from whom acquired by the
Whitworth Art Gallery).

Exhibitions: BFAC 1937, no. 81; Nottingham
1965, no. 244, pl. 22.

References: Shirley, 71, 117, and pl. 153.

Whitworth Art Gallery, University of
Manchester

This late watercolor of unidentified subject
offers one of Bonington's most inventive
compositions. It merges the favored devices of
elegant promenading couples and an elaborate
spatial construction that inevitably recalls
Delacroix's interests but that Bonington's
earlier watercolor *The Staircase* (1825; Wallace
Collection) fully anticipates.

The sheet suffered considerable water
damage along the top and right edges in 1952.
Shirley's reproduction, antedating this accident,
indicates the extent of the damage, especially to
the uppermost heads and to the page on the
right, where pigment loss has exposed an
original design for the right leg. Two amateur
copies, one inscribed "TF after RPB," confirm,
independently of Shirley's reproduction, that
the daring truncation of heads along the upper
edge was intentional.

The watercolor does not appear to have been
engraved, although a unique impression of a
previously unrecorded lithograph by J. D.
Harding after the two armored figures, possibly
a rejected vignette for his 1829 set of facsimiles
after Bonington, is in an album of prints by and
after Bonington compiled for the Duc d'Orléans
(Morgan Library).

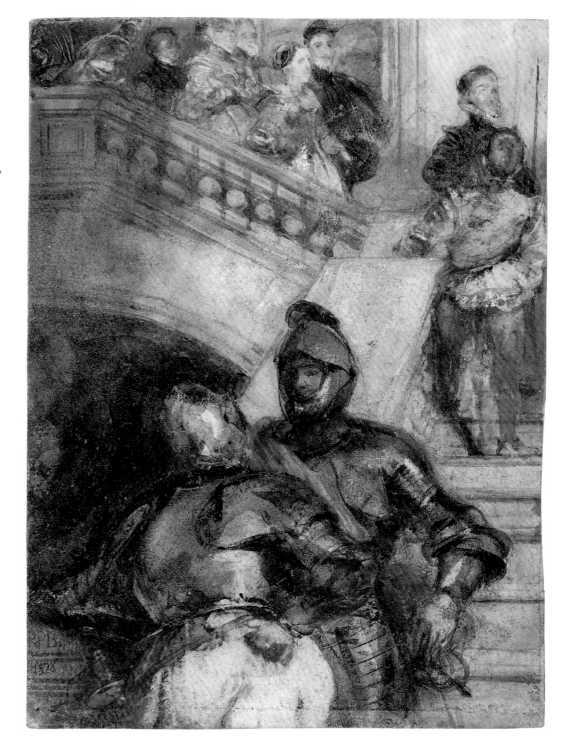

161

L'INSTITUT, PARIS ca.1828
Graphite, white and red chalks, white
bodycolor, and gray wash on blue-gray paper,
14 × 10¼ in. (35.8 × 26.2 cm.)

Provenance: Bonington sale 1829, lot 51, as *View
of the Ecole des Arts, Paris, in pencil and chalk, very
spirited*, bought Colnaghi; E. Martin; Fine Arts
Society, 1968, from whom purchased by the
Cecil Higgins Art Gallery.

Trustees of the Cecil Higgins Art Gallery,
Bedford

162

L'INSTITUT, PARIS ca.1828
Watercolor and bodycolor over graphite,
with scraping out, 9¾ × 8 in. (24.7 × 20.1 cm.)

Provenance: Probably Bonington sale, 1834,
lot 117, as *View of the Institute at Paris, with
figures — a capital drawing*, bought Colnaghi;
George Salting, by whom bequeathed to the
British Museum in 1910.

Exhibitions: Nottingham 1965, no. 277, pl. 18.

References: Dubuisson and Hughes, repr. opp. 84;
Shirley, 113, pl. 134; Pointon, *Circle*, 86, where
dated ca.1825.

Trustees of the British Museum
(1910-2-12-224)

After canceling a planned excursion in
Normandy with Huet and Isabey in June
because of illness, Bonington was reported to
have occupied himself during his final two
months in Paris by sketching from a hired cab
so as not to be bothered by passersby. There is
no reason to doubt this anecdote, since it was
communicated to Thoré by Delacroix.[1] As
evidenced by this and the works following, his
artistic powers remained initially unimpaired.

The attribution of the chalk drawing has
been queried unnecessarily.[2] Not only is it one
of Bonington's finest topographical drawings,
for which Colnaghi paid the comparatively
exorbitant price of £26 in 1829, but it is also
evidently the study from which the pendant
watercolor derives. An anomaly of both
compositions is the absence of the Pont des
Arts, the first iron bridge to be constructed
over the Seine. Designed by Villon, it was
virtually completed by 1818 and, in its novelty,
figured prominently in every contemporary
illustrated tour of Paris,[3] as well as in other
Bonington watercolors and oils. Apparently,
in this instance, the artist considered it
compositionally disruptive. More accurate, if
less spirited, are views from the same quay by
Boys, who was Bonington's constant companion
at this time. The earliest, dated 1829 and on
paper identical to that used for no. 161, extends
the prospect to the left but appropriates certain

staffage elements from Bonington's graphite
study.[4] A watercolor version at Yale, dated
1830, is more original in its foreground
invention but otherwise identical in its vertical
composition.[5]

Dubuisson reproduced a related graphite
sketch[6]; an anonymous copy of that drawing,
frequently misattributed to Bonington, is in the
Musée Carnavalet.[7]

1. Thoré 1867, 4.
2. Letter from Marion Spencer on file in the museum's
archives.
3. See, for instance, two plates to Robert Batty's *French
Scenery* (London, 1821) and the engraving in Frederick
Nash's *Picturesque Tour of the River Seine* (London, 1821).
4. Christie's, 8 July 1986, lot 151.
5. *English Drawings and Watercolors in the Collection of Mr.
and Mrs. Paul Mellon*, (New York: Pierpont Morgan
Library, 1972), fig. 137.
6. Dubuisson 1909, 391.
7. *Dessins Parisiens des XIXe et XXe siècles* (Paris: Musée
Carnavalet, 1976), no. 5; BFAC 1937, no. 96.

THE PONT DES ARTS AND ILE DE LA CITE FROM
THE QUAI DU LOUVRE ca.1828
Black, red, and brown chalk and bodycolor on
blue-gray wove paper, 14 × 20 in.
(35.5 × 50.7 cm.)

Inscribed: In pen, on an old label: *Bonington | Paris
— the last production of Bonington*; watermark:
BE&S | 1815

Provenance: Bonington sale, 1829, lot 201, as *View
of Paris, the last production of Bonington*, bought
Seguier; William Seguier (d. 1843)[1]; Richard
Dawson; J. Leslie Wright, and by descent to
Mrs. Williamson, by whom given to the
Birmingham Museum in 1954.

Birmingham Museum and Art Gallery

This panorama was probably taken on the same
day as the study of the Institute (no. 161) and
similarly was the basis for a finished watercolor
dated 1828.[2] In both versions the artist has
exaggerated the height of Notre-Dame's towers.

There is evidence to suggest that Bonington
had been commissioned to execute a series of
Paris views for engraved reproduction.[3]
Whether these were intended to rival Girtin's
Picturesque Views of Paris and Its Environs (fig. 3)
cannot now be determined, but the irony that
two of Britain's greatest watercolorists should
end their brief careers transcribing the urban
landscape of this foreign capital is no less
poignant.

Bonington was partial to this particular
subject, and other untraced watercolors of
his description appeared in the studio sales.
A second panoramic composition from beyond
the Pont Royal is known from several copies,
including a Harding lithograph (*Works*, 1830)
and a watercolor by Boys at Yale.[4] A graphite
sketch by William Callow (Victoria and Albert
Museum) from approximately the same vantage
point as the Birmingham study was employed
by Boys for several watercolor variants.[5]

The contemporary inscription accompanying
this sheet and the remark in the 1829 sale
catalogue that this was Bonington's "last
production" are contradicted in the 1838 studio
sale with reference to *The Undercliff* (no. 165).

1. This does not appear among the Bonington drawings
in Seguier's sale at Christie's, 2 May 1844, lots 485–86.
2. Private Collection; reproduced in Roundell, *Boys*,
pl. 24.
3. Delacroix, *Correspondence* 4: 288.
4. C. White, *English Landscape 1630–1850* (New Haven:
Yale Center for British Art, 1977), pl. 37, where
attributed to Bonington.
5. Sotheby's, 28 November 1974, lot 76, dated 1831,
and Institut Néerlandais, Fondation Custodia (Fritz
Lugt Collection), dated 1833.

THOMAS SHOTTER BOYS (1803–1874)
PONT DES ARTS, PARIS ca.1830
Watercolor over graphite, $6\frac{5}{8} \times 13\frac{1}{4}$ in.
(16.8 × 33.5 cm.)

Inscribed: In graphite, lower center and upper right: *Pont des Arts. Paris*

Provenance: Robinson and Foster; L. G. Duke; Bernard Squire; Sir Michael Sadler; Agnew's; L. G. Duke, from whom purchased by Paul Mellon in 1961.

Exhibitions: BFAC 1937, no. 137.

References: Roundell, *Boys*, pl. 12.

Yale Center for British Art, Paul Mellon Collection (B1977.14.4938)

In 1817 Thomas Shotter Boys apprenticed for seven years to the engraver George Cooke. Among his first recorded prints are etchings after an antique vase in Baron Denon's collection (dated 1823) and of the Prison de l'Abbaye, Paris (dated 1824).[1] In the 1820s Paris was a mecca for English-trained engravers, and it was sensible for a young artist of such training to relocate to the French capital. The exact dates of Boys's move and his first acquaintance with Bonington are uncertain, although it is generally assumed that they occurred before 1825 and that Boys provided Bonington with an introduction to the Cooke family. A more plausible scenario is that established professionals like Abraham Raimbach and Prout furnished Bonington's introduction to the Cookes and, as a consequence, to Boys. Initial documentation of their friendship appears only in mid-to-late 1826 in the form of a watercolor drawn by Bonington in his rue des Martyrs studio for Boys's instruction and of a note inviting Boys to a soirée at the same address in honor of Auguste.[2] During Bonington's last two years, Boys was to become his closest English friend in France.

In November 1827 Boys debuted at the Salon with three reproductive prints, including an etching after Joseph Vernet. An engraving after Claude's *Cephelus and Procris* (National Gallery, London) was published by McQueen in London at about this time, and it is apparent that Boys continued to entertain the prospect of a career in reproductive engraving on both sides of the channel. Under Bonington's influence, however, he began seriously to paint topographical watercolors in the same year.[3] Although his pupil William Callow later denied that Boys was a Bonington student, his complete stylistic dependency at this time and his abundant

extant versions of Bonington's watercolor designs contradict this curious assertion. In return, it would appear that Boys taught Bonington, and possibly Huet, the technique of etching in the summer of 1828. As a sedentary exercise, it was clearly intended to keep Bonington mentally active during his confinement. The single plate resulting from this collaboration replicates Bonington's watercolor *Bologna* (Wallace Collection).[4]

The exhibited watercolor is a plein-air study that anticipates by several years Boys's fully mature style of 1832–33 and his preoccupation with producing a series of lithographic views of Paris "as it is." He realized this ambition in 1839 with the publication of *Picturesque Architecture in Paris, Ghent, Antwerp, Rouen etc.*, a set of chromolithographic plates of extraordinary technical sophistication.

1. Von Groschwitz, *Boys*, no. 2, and Roundell, *Boys*, 19. His earliest known print is an engraving after W. T. Fry's portrait of the poet Thomas Moore, published by Boys on 1 November 1822.
2. La Bibliothèque d'art et d'archéologie, Paris.
3. To cite but one example, the watercolor *Tour Alexandre, Paris*, dated 1827 (Musée Carnavalet, D5871).
4. According to Baron Triqueti's manuscript notes in the library of the Ecole Supérieur, only two impressions of the unfinished plate were pulled in Bonington's lifetime. One of these Triqueti received from Boys (British Museum). Because the plate had been etched too lightly to permit an edition, Colnaghi commissioned Boys to re-etch every line of the composition and add a sky prior to its publication on 15 October 1828. The result, according to Triqueti, was the total effacement of "la legereté, l'air, l'immutable pureté de la point de Bonington." Another etching of the market at Bologna (Curtis, no. 69), based on a Bonington watercolor (no. 101), is probably also by Boys.

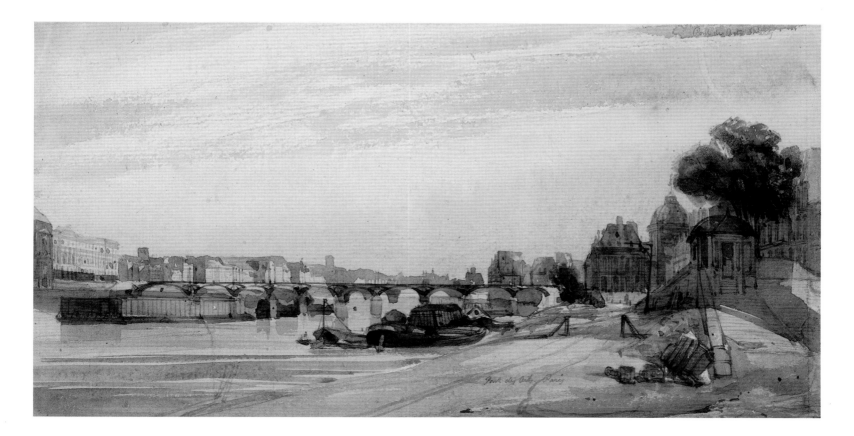

THE UNDERCLIFF 1828
Watercolor with scraping out over graphite,
$5\frac{1}{8} \times 8\frac{1}{2}$ in. (13 × 21.6 cm.)

Inscribed: Signed and dated, lower left: *R P B 28*;
verso, in Mrs. Bonington's hand, in pen and
ink: *August 6th and 7th 1828. The last drawing
made by our dear son about prior to his fatal
dissolution. Never to be parted with,* E. Bonington.

Provenance: Bonington sales 1836, lot 49, *A Coast
View at Sunset, the last drawing made by Bonington*,
bought in, and 1838, lot 54, *Coast Scene with
Smugglers*, bought Austen; Sara Austen (?);
Charles Frederick Huth (Christie's, 6 July 1895,
lot 128, bought Vokins); Stephen Holland
(Christie's, 25 June 1908, lot 140, bought
Agnew's); William Lowe (London, June 1924,
lot 4, bought Reinecker); Victor Reinecker, by
whom presented to the Castle Museum in 1928.

Exhibitions: London, Cosmorama Rooms, 209
Regent Street, 1834, no. 109; Nottingham 1965,
no. 232.

References: Shirley, 70, 117.

Castle Museum and Art Gallery,
Nottingham (28-171)

The *falaise* depicted in this watercolor is that
adjacent to Dieppe, which was a notorious
haven for pirates and smugglers during the
Napoleonic era. The composition is a
recollection of the watercolor *Picardy Coast,
Sunset* (fig. 60), for which graphite studies of
ca.1824 and later survive.[1]

Although a chalk drawing (no. 163) was
described in the 1829 sale as Bonington's "last
production," the affidavit of Eleanor Bonington
that this watercolor was her son's final graphic
endeavor is probably the most accurate.

The identification of the subject in the 1838
sale catalogue as a coast scene with smugglers is
borne out by the activities of the sailors who
await in a secluded shelter, with pack mules and
wagons, the arrival of a distant vessel. Such
traffic in contraband was common on both sides
of the channel, and it may be worth recalling
that the lacemaking industry that Bonington's
father helped to establish at Calais was made
possible by the illegal export of British
machinery.

Marine views with narrative content are rare
in Bonington's work and include only a
lithographic illustration of Captain Manby's
salvage device for shipwrecks and an untraced
watercolor, *The Drowned Fisherman*.[2] The coloring
in the Nottingham watercolor is portentous.
Considering the artist's circumstances by late
July — he was scarcely capable of writing his
own correspondence — one is tempted to
identify the solitary crouching figure at left as a
self-portrait. One must also marvel at his
indomitable spirit, for it took two days to finish

a work that would previously have required
only an hour's concentration.

In desperation, Bonington's parents decided
in late August to seek the advice of a London
specialist, John St. John Long, who had been
advertising cures for various lung ailments in
the journals that summer. On 6 September
Eleanor Bonington wrote en route from
Abbeville that "the Great Power above only can
save him thro' means perhaps permitted by his
goodness . . . we even fear at being able to
accomplish the object of our journey. Our
hearts are breaking."[3] A fortnight after their
arrival, Richard Parkes Bonington died
peacefully among English friends.

1. Seattle Art Museum; Spencer incorrectly noted the
existence at Nottingham of a preliminary study. A copy
of no. 165, by Bonington's father, was reported as lot 95
in the 1838 studio sale.
2. Engraved by W. J. Cooke for *The Amulet* (1836),
the design dated in the plate, 1824. Similar graphite
compositions of 1824 are in the Bibliothèque Nationale.
3. Dubuisson and Hughes, 82.

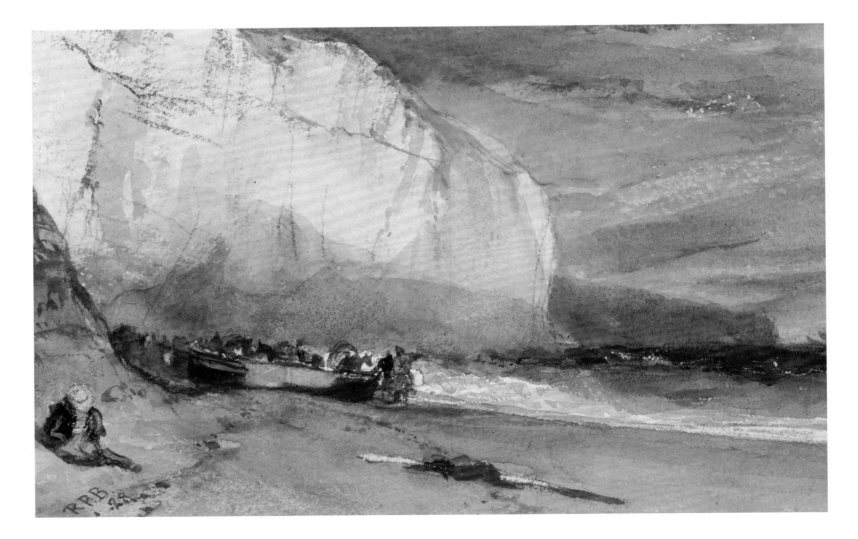

Abbreviated References

Abbey, *Travels*
 Abbey, J. R. *Travel in Aquatint and Lithography, 1770–1860*, 2 vols. London, 1956.
Agnew's 1962
 Pictures, Watercolours and Drawings by R. P. Bonington. London: T. Agnew and Sons, 1962.
Baudelaire, *Salons*
 Charles Baudelaire, Art in Paris 1845–1862: Salons and Other Exhibitions. Trans. and ed. J. Mayne. London, 1965.
BFAC 1937
 R. P. Bonington and His Circle. London: Burlington Fine Arts Club, 1937.
BN Bonington Dossier
 Bibliothèque Nationale, Paris, Cabinet des dessins, réserve, documentation file.
Bonington sale 1829
 Catalogue of the Pictures, Original Sketches, and Drawings of the late much admired and lamented artist, R. P. Bonington. Sotheby and Son, London, 29–30 June 1829.
Bonington sale 1834
 A Catalogue of the Collection of Exquisite Pictures, Water-Colour Drawings, and Sketches of that celebrated painter, the late Richard P. Bonington, Collected by, and the Property of, his Father. Messrs. Christie and Manson, London, 23–24 May 1834.
Bonington sale 1836
 A small sale at Foster's, London, 6 May 1836, following the death of Richard Bonington. The contents reprinted in Shirley, 132–34.
Bonington sale 1838
 Catalogue of a Collection of Original Sketches, in pen and ink, and pencil; Highly Finished Drawings, in water colours and sepia; and Cabinet Pictures, of that much admired and lamented Artist, R. P. Bonington, the property of the late Mr. Bonington, Sen. Leigh Sotheby, London, 10 February 1838.
Bonington Sr. sale 1838
 Catalogue of a Miscellaneous Collection of Engravings, including those of the late Mr. Richard Bonington. Leigh Sotheby, London, 24 February 1838.
Bouvenne
 Bouvenne, A. *Catalogue de l'oeuvre gravé et lithographié de R. P. Bonington*. Paris, 1873.
Brantôme, *Oeuvres complètes*
 Oeuvres complètes du Seigneur de Brantôme. 7 vols. Ed. L.-J.-N. Monmerqué. Paris, 1822.
Butlin and Joll, *Turner*
 Butlin, Martin, and Evelyn Joll. *The Paintings of J. M. W. Turner*. 2 vols. London and New Haven, 1984.
Calais, *Francia*
 Le Nouëne, Patrick, et al. *Louis Francia, 1772–1839*. Calais: Musée des Beaux-Arts, 1988–89.
Chesneau, *Petits romantiques*
 Chesneau, Ernest. *Peintres et statuaires romantiques*. Paris, 1880, chapter 2.
Collins, *Life*
 Collins, Wilkie. *The Life of William Collins, Esq., RA*. 2 vols. London, 1848.
Cormack, *Bonington*
 Cormack, Malcolm. *Richard Parkes Bonington*. Oxford: Phaidon, 1989.
Cormack, *Review*
 Cormack, Malcolm. "The Bonington Exhibition." *Master Drawings* 3 (1965): 286–89.
Coupin, *Salon 1824*
 Coupin, P.-A. "Notice sur l'exposition des tableaux en 1824." *Revue Encyclopédique* 23 (July–September 1824): 551–60; 24 (October–December 1824): 18–40, 289–304, 589–605; 25 (January–March 1825): 310–35.
Cunningham, *Lives*
 Cunningham, Allan. "Richard Parkes Bonington." In *The Lives of the Most Eminent British Painters and Sculptors*. New York, 1834, 4: 245–58. Originally published in London in 1832.
Cunningham, *Wilkie*
 Cunningham, Allan. *The Life of Sir David Wilkie*. 3 vols. London, 1843.
Curtis
 Curtis, Atherton. *Catalogue de l'oeuvre lithographié et gravé de R. P. Bonington*. Paris, 1939.
Curtis, *Isabey*
 Curtis, Atherton. *Catalogue de l'oeuvre lithographié de Eugène Isabey*. Paris, n.d.

Delacroix 1930
 Eugène Delacroix: centenaire du romantisme. Paris: Musée du Louvre, 1930.
Delacroix, *Correspondence*
 Correspondance générale d'Eugène Delacroix. 5 vols. Ed. André Joubin. Paris, 1935–38.
Delacroix, *Journal*
 Journal de Eugène Delacroix. 3 vols. Ed. Paul Flat and René Piot. Paris, 1893.
Delécluze, *Journal*
 Journal de Delécluze, 1824–28. Ed. Robert Baschet. Paris, 1948.
Delécluze, *Salon 1824*
 Delécluze, Etienne. "Exposition du Louvre 1824." *Journal des Débats*, Paris. Twenty-six articles from 1 September 1824 to 19 January 1825.
Delteil, *Delacroix and Huet*
 Delteil, Löys. *Le Peintre-Graveur Illustré (XIXe et XIXe Siècles)*. Paris, 1906–30. Vol. 3: *Ingres et Delacroix*; vol. 7: *Paul Huet*.
Dubuisson 1909
 Dubuisson, A. "Richard Parkes Bonington." *La Revue de l'Art Ancien et Moderne* 26 (July–December 1909): 81–97, 197–214, 375–92.
Dubuisson 1912
 Dubuisson, A. "Influence de Bonington et de l'école anglaise sur la peinture de paysage en France." *The Walpole Society* 2 (1912–13): 111–26.
Dubuisson and Hughes
 Dubuisson, A., and C. E. Hughes. *Richard Parkes Bonington: His Life and Work*. London, 1924.
Edwards 1937
 Edwards, Ralph. "Richard Parkes Bonington and His Circle." *Burlington Magazine* (July 1937): 35.
Eitner, *Géricault*
 Eitner, Lorenz E. A. *Géricault, His Life and Work*. London, 1983.
Fry 1927
 Fry, Roger. "Bonington and French Art." *Burlington Magazine* (December 1927): 268–74.
Gautier, *Travels*
 Gautier, Théophile. *Travels in Italy*. Vol. 4 of *The Complete Works of Théophile Gautier*. Ed. and trans. F. C. De Sumichrest. New York, 1901.
Gobin, *Bonington*
 Gobin, Maurice. *R. P. Bonington*. Paris, 1943.
von Groschwitz, *Boys*
 Groschwitz, Gustave von. "The Prints of Thomas Shotter Boys." In Carl Ziggrosser, ed., *Prints*. New York, 1962, 191–215.
Harding, *Works*
 Harding, James Duffield. *A Series of Subjects from the Works of the Late R. P. Bonington*. London, 1829–30.
Hazlitt, *Complete Works*
 The Complete Works of William Hazlitt. 21 vols. Ed. P. P. Howe. London, 1930–34.
Hazlitt, *Notes*
 Hazlitt, William. *Notes of a Journey through France and Italy*. London, 1826. Vol. 10 of *Complete Works*.
Hegel, *Aesthetics*
 Hegel, Friedrick. *Vorslungen über die Ästhetik*. In Henry Paolucci, ed., *Hegel: On the Arts*. New York, 1979.
Honour, *Romanticism*
 Honour, Hugh. *Romanticism*. London, 1979.
Huet, *Huet*
 Paul Huet (1803–1869) d'après ses notes, sa correspondance, ses contemporains. Ed. René Paul Huet. Paris, 1911.
Hughes, *Notes*
 Hughes, C. E. "Notes on Bonington's Parents." *The Walpole Society* 3 (1914): 99–112.
Hugo, *Cromwell*
 Hugo, Victor. *Préface de Cromwell*. Paris: Librarie Larousse, 1972.
Hugo, *Oeuvre complètes*
 Victor Hugo: oeuvres complètes. 18 vols. Ed. Jean Massin. Paris: Le Club Français du Livre, 1967–70.
Ingamells, *Catalogue*
 Ingamells, John. *The Wallace Collection Catalogue of Pictures*. Vol. 1: *British German, Italian, Spanish*; vol. 2: *French 19th Century*. London, 1985.
Ingamells, *Bonington*
 Ingamells, John. *Wallace Collection Monographs: Richard Parkes Bonington*. London, 1979.
Jacquemart-André 1966
 Bonington, un romantique anglais à Paris. Paris: Musée Jacquemart-André, 1966.

Jal, *Bonington*
 Jal, Auguste. "Bonington, Peintre de Genre." *Le Globe* (5 October 1828): 745–46. A revised reprint in *Le Keepsake Français* (Paris, 1831), 280–84.

Jal, *Salon 1824*
 Jal, Auguste. *L'Artiste et le philosophe: entretiens critiques sur le salon de 1824*. Paris, 1824.

Jal, *Salon 1828*
 Jal, Auguste. *Esquisses, croquis, pochades ou tout ce qu'on voudra, sur le salon de 1827*. Paris, 1828.

Johnson, *Delacroix*
 Johnson, Lee. *The Paintings of Eugène Delacroix, A Critical Catalogue*. 6 vols. Oxford, 1981–89.

Johnson, *Review*
 Johnson, Lee. "Bonington at Nottingham." *Burlington Magazine* (June 1965): 318–20.

Knight, *Principles*
 Knight, Richard Payne. *An Analytical Inquiry into the Principles of Taste*. London, 1805.

Lockett, *Prout*
 Lockett, Richard. *Samuel Prout (1783–1852)*. London: Victoria and Albert Museum, 1985.

Mantz, *Bonington*
 Mantz, Paul. "Bonington." *Gazette des Beaux-Arts* (October 1876): 288–306.

Marie, *Monnier*
 Marie, Aristide. *Henry Monnier (1799–1877)*. Geneva: Slatkine Reprints, 1983.

D. Messum 1980
 Les Jeunes Romantiques. Beaconsfield: David Messum Gallery, 1980.

Miller, *Bowood*
 Miller, James. *The Catalogue of Paintings at Bowood House*. Privately published, 1982.

Miquel, *Art et argent*
 Miquel, Pierre. *Art et argent, 1800–1900*. Maurs-la-Jolie, 1987.

Miquel, *Huet*, 1965
 Miquel, Pierre. *Paul Huet*. Rouen: Musée des Beaux-Arts, 1965.

Miquel, *Isabey*
 Miquel, Pierre. *Eugène Isabey, 1803–1886; la marine au XIX^e siècle*. 2 vols. Maurs-la-Jolie, 1980.

Miquel, *Paysage*
 Miquel, Pierre. *Le Paysage français au XIX^e siècle, 1824–1874*. 3 vols. Maurs-la-Jolie, 1975.

Noon 1981
 Noon, Patrick. "Bonington and Boys, some unpublished documents at Yale." *Burlington Magazine* (May 1981): 294–300.

Noon 1986
 Noon, Patrick. "Richard Parkes Bonington: *A Fishmarket, Boulogne*." In *Essays in Honor of Paul Mellon*. Washington, D.C.: National Gallery of Art, 1986, 239–54.

Noon, *Review*
 Noon, Patrick. Review of Carlos Peacock, *Richard Parkes Bonington*, and John Ingamells, *Richard Parkes Bonington*. *Drawing* (July-August 1981): 39–41.

Nottingham 1965
 R. P. Bonington, 1802–1828. Nottingham: Castle Museum and Art Gallery, 1965. Exhibition catalogue by Marion Spencer.

Oppé, *Review*
 Oppé, Paul. Review of A. Shirley, *Richard Parkes Bonington*. *Burlington Magazine* (September 1941): 99–101.

Peacock
 Peacock, Carlos. *Richard Parkes Bonington*. New York, 1980.

Pichot, *Tour*
 [Pichot, Amédée]. *Historical and Literary Tour of a Foreigner in England and Scotland*. 2 vols. London, 1825.

Piron, *Delacroix*
 [Piron, A.]. *Eugène Delacroix, sa vie et ses oeuvres*. Paris, 1865.

Planche, *Salon 1831* and *Salon 1833*
 Planche, Gustave. *Etudes sur l'école française*. Paris, 1855, 1: 7–231.

Pointon 1986
 Pointon, Marcia. "'Vous êtes roi dan votre domaine': Bonington as a painter of Troubadour subjects." *Burlington Magazine* (January 1986): 10–13.

Pointon, *Bonington*
 Pointon, Marcia. *Bonington, Francia & Wyld*. London: Victoria and Albert Museum, 1985.

Pointon, *Circle*
 Pointon, Marcia. *The Bonington Circle*. Brighton, 1985.

Race, *Notes*
 Race, Sydney. *Notes on the Boningtons: Richard Bonington the Elder (1730–1803); Richard Bonington the Younger (1768–1835); Richard Parkes Bonington (1801–1828)*. Nottingham, 1950.

Raimbach, *Memoirs*
 Memoirs and Recollections of the late Abraham Raimbach, Esq. Ed. M. T. S. Raimbach. London, 1843.

Robaut, *Delacroix*
 Robaut, Alfred. *L'Oeuvre complet de Eugène Delacroix*. Paris, 1884.

Roberts, BN Bonington Dossier
 Roberts, James. "Bonington's Biography." Manuscript notes in the Bibliothèque Nationale, Paris, Cabinet des dessins, réserve, documentation file.

Rosenthal, *Auguste*
 Rosenthal, Donald. "Jules-Robert Auguste and the Early Romantic Circle." Ph.D. dissertation, Columbia University, 1978.

Rosenthal, *Peinture romantique*
 Rosenthal, Léon. *La Peinture romantique*. Paris, n.d.

Roundell, *Boys*
 Roundell, James. *Thomas Shotter Boys, 1803–1874*. London, 1974.

Ruskin, *Works*
 The Works of John Ruskin. 39 vols. Ed. E. T. Cook and Alexander Wedderburn. London, 1903–12.

Sérullaz, *Delacroix*
 Sérullaz, Maurice, with Arlette Sérullaz, Louis-Antoine Prat, and Claudine Ganeval. *Inventaire général des dessins école française, dessins d'Eugène Delacroix, 1798–1863*. 2 vols. Paris: Musée du Louvre, Cabinet des dessins, 1984.

Shirley
 Shirley, The Hon. Andrew. *Bonington*. London, 1940.

Smith, *Francia*
 Smith, Colin Shaw, Jr. "From Francia to Delacroix: The English Influence on French Romantic Landscape Painting," Ph.D. dissertation, University of North Carolina, Chapel Hill, 1982.

Spencer
 Spencer, Marion. *R.P. Bonington, 1802–1828*. Nottingham: Castle Museum and Art Gallery, 1965.

Stendhal, *Mélanges*
 Beyle, Henri [Stendhal]. "Salon de 1824." 17 articles published in *Le Constitutionnel* between 29 August and 24 December 1824; and "Des Beaux-Arts et du Caractère Français," published in the *Revue trimestrielle* (July–October 1828). Both republished as *Mélanges d'art et de littérature*. Paris, 1867.

Thoré 1867
 Thoré, Théophile [W. Burger]. "R. P. Bonington." In Charles Blanc, *Histoire des peintres de toutes les écoles, école anglais*. Paris, 1867, 1–14.

Toronto, *Delacroix*
 Johnson, Lee. *Delacroix*. Toronto: Art Gallery of Ontario, and Ottawa: National Gallery of Canada, 1962–63.

Valery, *Voyages*
 Valery, Antoine [Antoine Pasquin]. *Historical, Literary and Artistical travels in Italy*. Trans. C. E. Clifton. Paris, 1839. The original French edition, *Voyages historiques et littéraires en Italie, pendant les années 1826, 1827, et 1828*. 5 vols. Paris, 1831.

de Vigny
 de Vigny, Alfred. *Cinq-Mars ou une conjuration sous Louis XIII*. 2nd ed. with preface. Paris, 1827.

Waagen 1838
 Waagen, G. F. *Works of Art and Artists in England*. 3 vols. London, 1838.

Waagen 1854–57
 Waagen, G. F. *Treasures of Art in Great Britain*. 3 vols. London, 1854. Supplemental volume: *Galleries and Cabinets of Art in Great Britain*. London, 1857.

Walker, *Regency Portraits*
 Walker, Richard. *Regency Portraits*. 2 vols. London: National Portrait Gallery, 1985.

Wilton, *Turner*
 Wilton, Andrew. *J. M. W. Turner, His Art and Life*. New York, 1979.

Wright and Joannides
 Wright, Beth S., and Paul Joannides. "Les romans historiques de Sir Walter Scott et la peinture française, 1822–1863." *Bulletin de la Société de l'histoire de l'art française* (1982): 119–32, (1983): 95–115.

Additional Bibliography

(Anonymous). *Notice des Tableaux exposés dans la galerie du Musée Royal*. Paris, 1823.

(Anonymous). "Biography: R. P. Bonington." *The Literary Gazette, and Journal of Belles Lettres* (27 September 1828): 619–20.

(Anonymous). "Bonington." *Journal des Débats* (28 September 1828): 3.

(Anonymous). "Artists and Dealers. Letter to the Editor." *Library of the Fine Arts* 1 (February 1831): 58–61.

(Anonymous). "Exhibition of the Society of Painters in Watercolours." *Library of the Fine Arts* 1 (July 1831): 507–16.

(Anonymous). "Memoir of Richard Parkes Bonington." *Library of the Fine Arts* 3 (March 1832): 201–9.

(Anonymous). "Bonington Exhibition." *Morning Chronicle* (21 February 1834).

(Anonymous). "On the Genius of Bonington and His Works." *Arnold's Magazine of the Fine Arts* 1 (May 1833): 29–34; and 1 (June 1833): 144–51.

(Anonymous). "Bonington et ses émules." *Revue Britannique* (July 1833): 159–67.

(Anonymous). "Les Aquarellistes Anglais." *L'Artiste* (1857): 304.

Adhémar, Jean. "Les Lithographies de paysages en France à l'époque romantique." *Archives de l'art français* 19 (1935–37): 193–364.

Athanassoglou-Kallmyer, Nina. "Of Suliots, Arnauts, Albanians and Eugène Delacroix." *Burlington Magazine* (August 1983): 487–91.

Bann, Stephen. *The Clothing of Clio*. Cambridge, 1984.

Bayard, Jane. *Works of Splendor and Imagination: The Exhibition Watercolor 1770–1870*. New Haven: Yale Center for British Art, 1981.

Beckett, R. B., ed. *John Constable's Correspondence IV*. Suffolk, 1966.

Benesch, Otto. "Bonington and Delacroix." *Munchener Jahrbuch* 2 (1925): 91–98.

Béranger, P.-J. *Oeuvres complètes*. 4 vols. Paris, 1834.

Bisson, L. A. *Amédée Pichot, A Romantic Prometheus*. Oxford, n.d.

Brejon de Lavergnée, Arnauld. *Catalogue sommaire illustré des peintures du Musée du Louvre*. 5 vols. Paris, 1979–86.

Brigstocke, Hugh. *William Buchanan and the 19th Century Art Trade: 100 Letters to His Agents in London and Italy*. London: Paul Mellon Centre for Studies in British Art, 1982.

Bromwich, David. *Hazlitt, the mind of a critic*. Oxford, 1983.

Chaudonneret, Marie-Claude. *La Peinture Troubadour*. Paris, 1980.

Chauvin, A. *Salon de Mil Nuit Cent Vingt-Quatre*. Paris, 1824.

Cherbourg, Musée des Beaux-Arts. *Bonington, les débuts du romantisme en Angleterre et en Normandie*. 1966.

Cooper, Douglas. "Bonington and *Quentin Durward*." *Burlington Magazine* (May 1946): 112–17.

Corbin, Alain. *Le Territoire du Vide*. Paris, 1988.

Cotman, John Sell, and Dawson Turner. *Architectural Antiquities of Normandy*. London, 1822.

Delécluze, Etienne-Jean. *Souvenirs de Soixante Années*. Paris, 1862.

Delestre, J.-B. *Gros et ses ouvrages ou mémoires historiques sur la vie et les travaux de ce célèbre artiste*. Paris, 1845.

Delestre, J.-B. *Gros, sa vie et ses ouvrages*. Paris, 1867.

Dorbec, Prosper. "Les Paysagistes Anglais en France." *Gazette des Beaux-Arts* (October 1912): 257–81.

Doy, Guinervere. "Delacroix et Faust." *Nouvelles de l'estampe* (May 1975): 18–23.

Du Sommerard, Alexandre. *Les Arts au Moyen Age*. 10 vols. Paris, 1838–46.

Ewals, Leo. *Ary Scheffer, 1795–1858*. Paris: Institut Néerlandais, 1980.

Foisy-AuFrère, Marie-Pierre. *La Jeanne d'Arc de Paul Delaroche*. Rouen: Musée des Beaux-Arts, 1983.

Frantz, Henri. "The Art of Richard Parkes Bonington." *Studio* 33 (1905): 99–111.

Gautier, Théophile. *Les Beaux-Arts en Europe*. Paris, 1855.

Gautier, Théophile. *Histoire du romantisme*. 2nd ed. Paris, 1874.

Gautier, Théophile. *Fusains et eaux-fortes*. Paris, 1880.

Gigoux, Jean. *Causeries sur les artistes*. Paris, 1885.

Goodison, J. W. *Catalogue of Paintings*. 3 vols. Cambridge: Fitzwilliam Museum, 1977.

Gowing, Lawrence. *Painting from Nature*. London: Arts Council of Great Britain, 1981.

Hamerton, P. G. "A Sketchbook by Bonington in the British Museum." *Portfolio* (1881).

Haskell, Francis. *Past and Present in Art and Taste*. New Haven and London, 1987.

Hovenkamp, Jan Willem. *Merimée et la couleur locale*. Nijmegen, 1928.

Huet, H. "Critique d'art: peinture anglais, paysage." *L'Art en Province* (1835–36): 119.

Huyghe, René, et al. *Delacroix*. Paris, 1963.

Jameson, Anna. *Companion to the Most Celebrated Private Galleries of Art in London*. London, 1844.

Joannides, Paul. "Colin, Delacroix, Byron and the Greek War of Independence." *Burlington Magazine* (August 1983): 495–500.

Johnson, Lee. "Eugene Delacroix et les Salons." *Revue du Louvre* (1966): 217–18.

Johnson, Lee. "Géricault and Delacroix seen by Cockerell." *Burlington Magazine* (September 1971): 547–51.

Johnson, Lee. "Delacroix and *The Bride of Abydos*." *Burlington Magazine* (September 1972): 579–85.

Johnson, Lee. "Some Historical Sketches by Delacroix." *Burlington Magazine* (October 1973): 672–76.

Johnson, Lee. "A New Delacroix: 'Henri III at the Death-Bed of Marie de Clèves'." *Burlington Magazine* (September 1976): 620–22.

Johnson, Lee. "A New Delacroix: 'Rebecca and the Wounded Ivanhoe'." *Burlington Magazine* (May 1984): 280–81.

Josz, Virgile. "Le Centenaire de R. P. Bonington." *Mercure de France* s.m. 39 (1901): 315–43.

Jouy, Etienne. *L'Ermite en Province*. Paris, 1826.

Kemp, Martin. "Scott and Delacroix, with some assistance from Hugo and Bonington." *Scott Bicentenary Essays*. Edinburgh, 1973. 213–27.

Labouchère, P.-A. [PAL]. "R. P. Bonington." *Notes and Queries* (10 June 1871): 502–3; (17 May 1873): 399–400.

Lemoisne, P.-A. *L'Oeuvre d'Eugène Lami*. Paris, 1914.

Lesage, Jean-Claude. *Peintures des côtes du Pas-de-Calais*. Amis du Musée de la Marine d'Etaples-sur-mer, 1987.

Lloyd, Rosemary, ed. *Selected Letters of Charles Baudelaire, The Conquest of Solitude*. Chicago, 1986.

Lochnan, Katherine A. "Les Lithographies de Delacroix pour *Faust* et le théâtre anglais des années 1820." *Nouvelles de l'estampe* (July 1987): 6–13.

Lodge, Susan. "French Artists Visiting England 1815–1830." Ph.D. thesis, London University, 1966.

Long, Basil. "The Salon of 1824." *Connoisseur* (February 1924): 66–76.

Mellors, Robert. "Richard Parkes Bonington." *Transactions of the Thoroton Society* 13 (1909): 41–54.

Nodier, Charles. *Promenade de Dieppe aux Montagnes d'Ecosse*. Paris, 1822.

Noël, Alexis, and Alexandre Colin. *Portraits d'Acteurs*. Paris, 1825.

Pupil, François. *Le Style Troubadour*. Nancy, 1985.

Roger-Marx, Claude. "Eugène Delacroix, his relationship with England and the English artists of his day." *Creative Art* 8 (January 1931): 36–41.

Rosen, Charles, and Henri Zerner. *Romanticism and Realism*. New York, 1984.

Rosenberg, Pierre, et al. *French Painting 1774–1830: The Age of Revolution*. Detroit Institute of Arts, Metropolitan Museum of Art, and Réunion des Musées Nationaux, 1975.

Rosenthal, Donald. "Ingres, Géricault and Monsieur Auguste." *Burlington Magazine* (January 1982): 9–14.

Sainte-Beuve, C.-A. *Nouveaux Lundis*. 3 vols. Paris, 1863.

Sainte-Beuve, C.-A. "Paul Huet." *Portraits contemporains*. Paris, 1870, 2: 243–48.

Sandilands, G. S. *Famous Water-Colour Painters IV — Richard Parkes Bonington*. London: The Studio, 1929.

Seznec, Jean, and Jean Adhémar. *Diderot Salons*. 5 vols. Oxford, 1963.

Spencer, Marion. *Richard Parkes Bonington (1802–1828)*. Ph.D. thesis, University of Nottingham, 1963.

Spencer, Marion. "The Bonington Pictures in the Collection of the Fourth Marquess of Hertford." *Apollo* (June 1965): 470–75.

Stokes, Hugh. *Girtin and Bonington*. London, 1922.

Strong, Roy. *And when did you last see your father? The Victorian Painter and British History*. London, 1978.

Szeemann, Harald. *Eugène Delacroix*. Zürich, 1987.

Tscherny, Nadia. "An English Source for Delacroix's *Liberty Leading the People*." *Source* (Spring 1983): 9–13.

Wainwright, Clive. *The Romantic Interior*. New Haven and London, 1989.

Wallis, G. H. "Character of Bonington's Paintings." *Transactions of the Thoroton Society* 13 (1909): 54–6.

Whitley, William T. *Art in England 1821–1837*. Cambridge, 1930.

Willemin, Nicholas-Xavier. *Monuments français inédits, pour servir à l'histoire des arts*. 2 vols. Paris, 1806.

Wisdom, John Minor. *French Nineteenth Century Oil Studies: David to Degas*. Chapel Hill, 1978.

Index

Figures in the introductory text are indicated by *italicized* page numbers.